Art and the Roman Viewer presents a fresh analysis of a major intellectual problem in the history of art: Why did the arts of late antiquity move away from Classical naturalism towards spiritual abstraction? Arguing from a close examination of ancient art, images and texts, Jaś Elsner shows how an understanding of Roman viewing practices greatly deepens our insight into this fundamental transformation. The sophisticated arts of the early Empire, such as Pompeian painting, sculpted reliefs and silverware, entertain the potential for irony, parody and deconstruction. By contrast, the symbolic arts of the Christian empire, notably the mosaics of Ravenna, eschew irony although complexity remains, indeed intensifies, as multiple meanings compete to enrich a fundamentally sacred truth. By addressing the subtleties inherent in ancient viewing, this study embarks on a quest to enrich our understanding of an era of profound artistic change.

ART AND THE ROMAN VIEWER

CAMBRIDGE STUDIES IN NEW ART HISTORY AND CRITICISM

General Editor: Norman Bryson, *Harvard University*

Advisory Board:
Stephen Bann, *University of Kent*
Natalie Kampen, *Barnard College*
Keith Moxey, *Barnard College*
Joseph Rykwert, *University of Pennsylvania*
Henri Zerner, *Harvard University*

Other books in the series:
Reading "Rembrandt": Beyond the Word-Image Opposition, by Mieke Bal
The True Vine: On Visual Representation and the Western Tradition, by Stephen Bann
Deconstruction and the Visual Arts, edited by Peter Brunette and David Wills
Calligram: Essays in New Art History from France, edited by Norman Bryson
The Gothic Idol: Ideology and Image-Making in Medieval Art, by Michael Camille
The Rhetoric of Purity: Essentialist Theory and the Advent of Abstract Painting, by Mark A. Cheetham
The Canonical Tradition in Ancient Egyptian Art, by Whitney Davis
The Aesthetics of Power: Essays in Critical Art History, by Carol Duncan
Art and Text in Ancient Greek Culture, edited by Simon Goldhill and Robin Osborne
Narrative and Event in Ancient Art, by Peter Holliday
Postmodernism and the En-Gendering of Marcel Duchamp, by Amelia Jones

Art and the Roman Viewer

The Transformation
of Art from the Pagan World to Christianity

JAŚ ELSNER
Courtauld Institute of Art

CAMBRIDGE
UNIVERSITY PRESS

Barnard

Published by the Press Syndicate of the University of Cambridge
The Pitt Building, Trumpington Street, Cambridge CB2 1RP
40 West 20th Street, New York, NY 10011-4211, USA
10 Stamford Road, Oakleigh, Melbourne 3166, Australia

First published 1995

Printed in the United States of America

Library of Congress Cataloging-in-Publication Data
Elsner, Jaś.
 Art and the Roman viewer/ Jaś Elsner.
 p. cm. – (Cambridge studies in new art history and
criticism)
 Includes bibliographical references and index.
 ISBN 0-521-45354-2
 1. Art, Roman – Themes, motives. 2. Art, Early Christian –
Themes, motives. 3. Aesthetics, Roman. I. Title. II. Series.
N5760.E48 1995
709'.37–dc20 94-4687
 CIP

A catalog record for this book is available from the British Library.

ISBN 0-521-45354-2 hardback

For M and D,
S and K,
and, especialmente, S.

Crede mihi; plus est, quam quod videatur, imago.

Believe me: an image is more than it appears to be.

Ovid, *Heroides* 13.155.

CONTENTS

viii

ILLUSTRATIONS

ACKNOWLEDGEMENTS

This book was originally (a long time ago) a Ph.D. thesis. I must thank my supervisors, Mary Beard, Keith Hopkins and Roger Ling, for their help, encouragement and advice over a period of many years. My friends, John Henderson and Robin Cormack, have read every part of this book in its process of gestation – their support has been invaluable. Anthony Snodgrass and Andrew Wallace-Hadrill, my thesis examiners, provided a fundamental critique and many useful suggestions. At crucial stages, Peter Brown, Geoffrey Lloyd and Robin Osborne have made important criticisms which led me to restructure elements of the argument or to add substantive sections. Portions of the draft have been much improved at different times by the comments of Myles Burnyeat, John Drury, Peter Garnsey, Simon Goldhill, Chris Morray-Jones, Christopher Rowland and Christopher Walter.

In many ways this book is a product of the very exciting times in Cambridge Classics in the second half of the 1980s. I should like to thank all those (then) graduate students and research fellows who collaborated in the shared enterprise of knocking down a few established subject boundaries – especially Tamsyn Barton and Catharine Edwards, who were my partners in founding an interdisciplinary seminar, and Sue Alcock, Margaret Atkins, Sarah Currie, Penny Glare, Emily Gowers, Valérie Huet, Chris Kelly, Jamie Masters, Sitta von Reden, Peter Singer, Greg Woolf and Maria Wyke. In the latter stages of my work, I have had the benefit of comments from Yun Lee Too and of the detailed scrutiny of Jeremy Tanner. Outside Cambridge, Charles Barber and Martin Kauffmann provided excellent company during a stay in

Italy, while Liz James and Ruth Webb have always kept me on my toes.

Institutionally, this project could not have proceeded without the support of three great centres of learning. At King's College, Cambridge, I had the benefit of a wonderfully open academic atmosphere in writing the original thesis. The Master and Fellows of Jesus College, Cambridge, by their award of a research fellowship, allowed me to complete the bulk of rewriting and re-rewriting in the quiet and comfortable atmosphere of Chapel Court. The Courtauld Institute, in appointing me to a lectureship, afforded me the invaluable opportunity to try out some of my ideas on a series of M.A. students. I hope that those who became guinea pigs will one day forgive me! Finally, this book could never have been what it has become without my enjoying the intellectual company and friendship of a number of people outside classics and art history – especially Thupten Jinpa, Simon Coleman, Joan Pau Rubiés and Silvia Frenk.

On the bibliographic side, I should register my regret that John Clarke's *The Houses of Roman Italy, 100 B.C.–250 A.D.*, a book germane to my subject in Chapter 2, reached the United Kingdom only in mid-1992 (although it was published in the United States in 1991). It arrived too late for my final rewriting – from my point of view a most unfortunate casualty of the difficulties which seem recently to have beset trans-Atlantic book distribution.

I am grateful to the following societies for permission to reuse material originally published in a rather different form in their journals: a portion of Chapter 3 appeared as "The Viewer and the Vision: The Case of the Sinai Apse" (*Art History* 17, 1 [March 1994]: 81–102), for which I thank the Association of Art Historians; material from Chapter 4 appeared as "Pausanias: A Greek Pilgrim in the Roman World" (*Past and Present: A Journal of Historical Studies* 135 [May 1992]: 3–29), for which I thank the Past and Present Society which holds world copyright in the article; a section from Chapter 6 appeared as "Cult and Sculpture: Sacrifice in the Ara Pacis Augustae" (*Journal of Roman Studies*, 81 [1991]: 50–61), for which I thank the Roman Society.

In the final straight of producing a book, I am grateful to Cambridge University Press for its support, to its many anonymous referees for their comments and to Beatrice Rehl and her team at CUP – including Janet Polata and my long-suffering production- and copy-editors, Camilla Palmer and Susan Greenberg – for helping bring this book to press. Kim

Bowes went through my manuscript with admirable care and detail to correct errors and check references; Jamie Masters and Silvia Frenk came to my aid in compiling the index. In the acquisition of photographs I am especially grateful for the help of David Buckton, Ilene Forsyth, Martin Kauffmann and Marlia Mango. At every stage, Norman Bryson has proved an unstintingly supportive and encouraging editor.

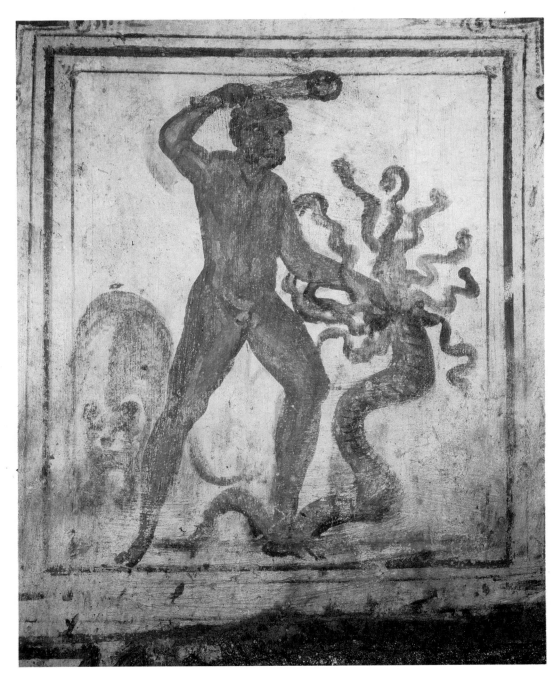

Plate 4. Hercules fighting the Hydra, righthand arcosolium, *cubiculum N*,
Via Latina Catacomb, Rome, fourth century A.D. Photo: Pont. Comm. di
Arch. Sacra, Rome.

xxvi

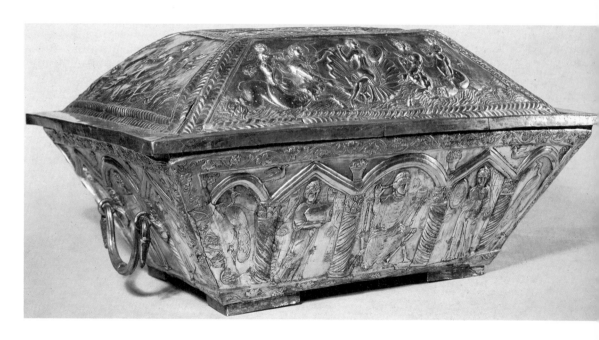

Plate 3. The Projecta Casket seen from the front, fourth century A.D.
Esquiline Treasure, British Museum. Photo: Courtesy of the Trustees of
the British Museum.

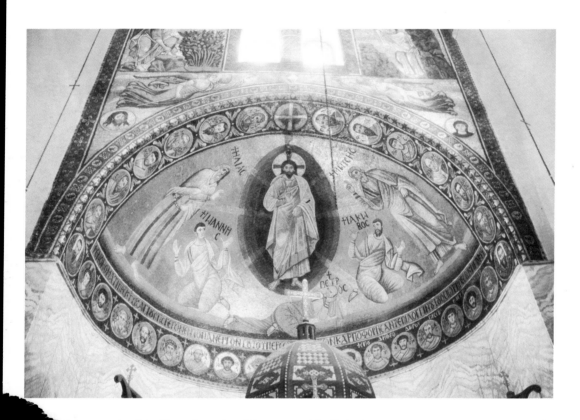

Apse mosaic of the Transfiguration, Monastery of St Catherine at
ixth century A.D. Photo: Ernest Hawkins Archive, Courtauld

xxiv

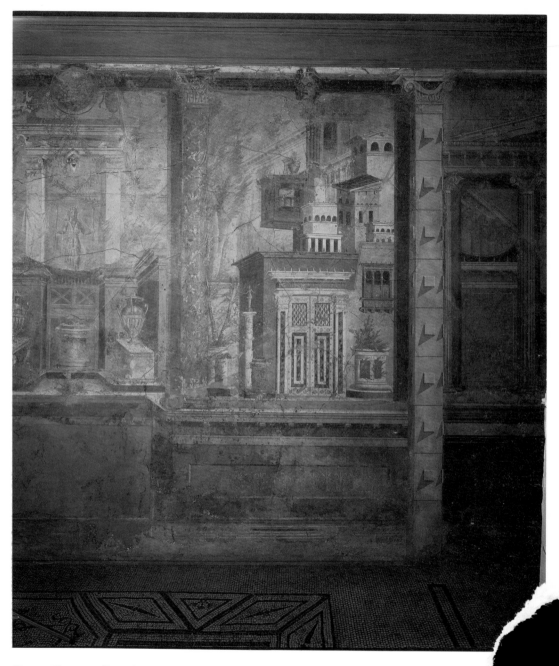

Plate 1. Fresco on lime plaster, from the Villa of P. Fannius Sinistor, Boscoreale (now in the Metropolitan Museum), first century B.C. Photo: Metropolitan Museum of Art, Rogers Fund, 1903.

COLOR PLATES

INTRODUCTION

I want a History of Looking . . .
　　　　　Roland Barthes[1]

I

At the core of this book is a simple proposition: People relate
to works of art in different ways, depending upon different
contexts and at different times. Confronted with an image of
a fish, a Roman dinner party host, a modern angler or a
cookery book writer of any period might see a picture that
corresponded as closely as possible to the real fish which he
or she might eat, catch or cook; each person would notice
differences from and similarities to the real thing – how
realistic the picture was. Take for instance the various marine
animals displayed in any of a number of Roman mosaics,
such as the mosaic in Figure 1, depicting fish and an octopus,
originally from the House of the Faun in Pompeii and now in
the Naples Museum. Such images evoke associations not only
with the sea, by which Pompeii was situated, but also with
the sea-food on which Pompeii's inhabitants dined. Con-
fronted with the *same* image, an early Christian might see not
the picture of a real fish, but a sign, a symbol for what the
fish represented to him or her in the religious system of early
Christianity.[2] On the walls of the catacomb of Calistus in
Rome are two images, each representing a fish with a basket
of loaves (Figure 2). Despite their associations with eating,
these frescoes in their explicitly Christian funerary context
evoke not an ordinary meal, but such scriptural meals as the
miracle of the multiplication of the loaves and fishes and such
ritual meals as the eucharist. Moreover, beyond the image of
dining, the fish evokes Christ himself and his apostles as
fishers of men. For a Christian in the early centuries of the
first millennium, the symbol of the fish stood as a sign for

I

Christ; and the word "fish", in its Greek form of ICHTHYS, was an acronym consisting of the first letters of the formula "Jesus Christ, Son of God, Saviour".

These are remarkably different ways in which people choose to understand what may appear to be (from a formal point of view) rather similar pictures. Such different understandings presuppose very different processes of interpreting what one might have thought was the rather unproblematic image of a fish. In effect, to move from the initial perception of a picture to the meaning or referent which one understands the picture to be evoking is rather a complex process which is not the same for every individual. It is a dynamic of interpretation. This book is not about the process or psychology of

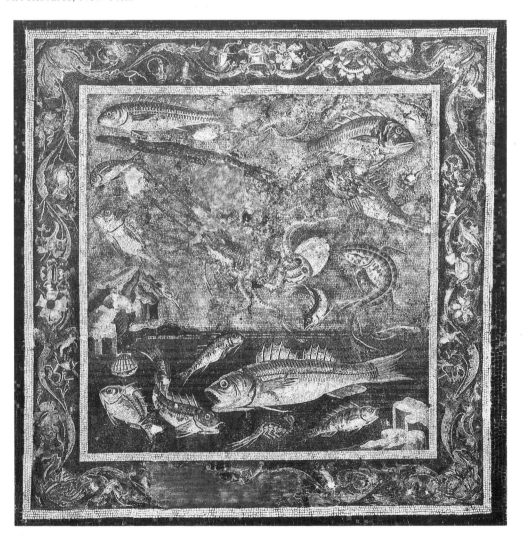

Figure 1. Mosaic of fish and octopus, from Pompeii (now in the Naples Museum), first century B.C. Photo: Alinari-Art Resource, New York.

looking, but rather about the different conceptual frameworks which interpret what is seen to make it *meaningful*.[3]

Different viewers' frames of interpretation, whether literal or symbolic, metonymic or metaphoric, naturalistic or allegorical, are what tend to constitute the kinds of meanings which images bear. In principle, any work of art can give rise, in different observers (and sometimes even in the same viewer), to a multitude of varying and even contradictory responses and meanings. The transformation in the *forms* of art, which in part this book investigates, was in the first place a transformation of *content* whereby *different* viewers, such as a pagan Roman and a religious Christian, might see the *same* image in such profoundly different ways. For one, it might have a realistic meaning relating to the natural or material world; for the other, a symbolic meaning, relating to the Other World – the Sacred.

The following pages explore some aspects of the transformation of Roman art. Part I examines a great variety of ancient texts and images to discover the ways in which Romans looked at their art. The taxonomy of viewing which is presented divides essentially into realist ways of viewing on the one hand – with the enormous range of psychological,

Figure 2. Fresco of fish and bread-basket, from the Catacomb of Calistus, Rome, third century A.D. Photo: Pont. Comm. di Arch. Sacra, Rome.

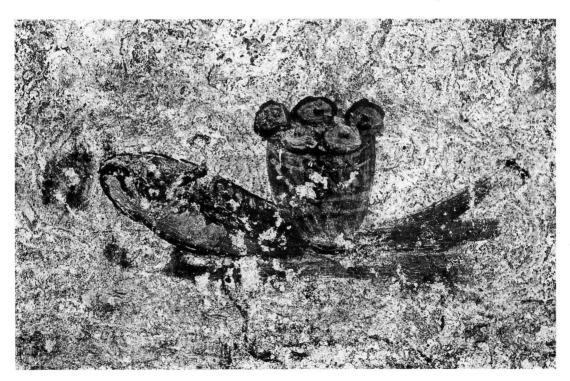

dogmatic and political implications that these display – and symbolic ways of viewing, on the other, which are primarily (though not exclusively) the domain of religious and initiate cults such as Mithraism, Neoplatonism and Christianity. Part II explores a number of important monuments, dating from the age of Augustus at the turn of the first centuries B.C. and A.D. to the age of Justinian in the sixth century A.D., in the light of how they were viewed. By comparing these monuments – by observing the changes both in their formal characteristics and in the ways they were looked at over the period from the first to the sixth centuries A.D. – we can trace the contours of one of the most remarkable and comprehensive transformations of culture that took place in the Western world before the Renaissance. Part III, by way of an epilogue, turns from this broad taxonomic approach to look briefly at some of the modulations and complexities in what was a very gradual and multifaceted *process* of change. I look there at the genesis of a specifically Christian exegetic mode of viewing – how it resembled and how it differed from the kinds of initiate viewing in pagan antiquity out of which it arose.

II

What, then, is viewing? One answer is that viewing is one activity in which people confront the world. They themselves may change under the influence of what they see, or what they see may cease to be a neutral object and become something interpreted by them according to the prejudices and associations present in their minds. Viewing is always a dual process of interpretation in which what is seen becomes fitted into the already existent framework of the viewer's knowledge and thereby, very subtly, changes both the content of what the viewer knows (because something new has been added) and the meaning of what is seen (because it is now framed by the viewer's knowledge).

The history of viewing, expressed in this way, becomes in principle a history of how people interpret anything in their world – nature, art, other people. By focussing on art, I have limited the theme to a very narrow range of the totality of objects that influence and are interpreted by human consciousness. However, the viewing of art is a special case that can perhaps elucidate other kinds of viewing too. This is because Greek and Roman intellectuals were more self-

4

conscious about how they interpreted and viewed their art than they were about how they interpreted and viewed other material objects in the culture. They even wrote at considerable length about the subject. One reason for the importance of the viewing of art is that it is a *secondary* process. Looking at an image, a beholder is assessing a view of the world already created by an artist. In the viewing of art, the artist's own creative viewing of objects is a critical mediator between the beholder and the world. The Greeks and Romans were particularly interested in the mediating processes of artists, and some – like Plato – were very worried by them.[4]

By tracing the multiplicity of responses to art in ancient texts, and by examining the presuppositions that give rise to these responses, we can learn a great deal about the different kinds of subjectivity – the many ways of viewing – which existed in Roman times. We can get close to some of the deeper inclinations of Roman thought. In effect, the ways Romans looked at the world were in some sense conditioned by the ways they looked at art and vice versa. To examine the relatively limited area of Roman responses to art gives us a means of approaching the much larger theme of the ways in which Romans responded to other features in their culture.

The focus on viewing offers a precise way of approaching a central issue in the interpretation of Roman art: How are we to understand the change between Classical art, with its emphasis on likeness to the natural world, and the abstraction of late-antique art? This is a problem which has exercised art historians since Vasari in the sixteenth century. Some have looked to a "decline" of technical skills, some to changes in the structure of society, some to religion and the rise of Christianity. Most approaches to the transformation of Roman art or to the rise of Christian and Byzantine art (which is usually another way of describing the same phenomenon) focus not on the total process of change from the Classical period of Roman art under Augustus to the first full flowering of Christian art under Justinian, but on the particular moment of transition. Scholars have tended to cite specific groups of objects from the third and fourth centuries (such as the art of the Dominate, the Arch of Constantine, the church and synagogue of Dura Europos or the catacombs of Rome) as the key to change.

An exclusive exploration of the "moment of transition" is adequate only if the differences between the art of Augustus and Justinian are self-evident. These differences – which certainly exist in the style and appearance of works of art – are

not self-evident *or* self-explanatory, unless one has a formalist approach to art by which *style* becomes the primary criterion of change. Because I am questioning formalism or style as the main criterion for judging art, I do not see the differences between art in the first century and art in the sixth century as obvious or self-explanatory. On the contrary, I believe they need understanding and explaining. And the arena of explanation must lie in a broader conception of art than formalism, in a conception that gives due weight also to the functions and meanings of art within Roman culture – that is, to the ways in which art was viewed. But to understand such a broad span of change requires a grasp of the art at both ends of that span, as well as an investigation of the period of transition.

It is more interesting, therefore, and more revealing, to employ a broad comparative method in which one both grasps and then compares the relationships between objects, their producers and their viewers at different moments within the process of change. Only when we understand the changing principles of viewing and looking at art *throughout* the period of transformation (from Augustus to Justinian) can we grasp what the *differences* are between art in the first century and the sixth.

The empirical and inductivist creed of academe would have us approach a body of material, for instance, Roman art, with an open and entirely unprejudiced mind – prepared to construct an interpretation motivated solely by the suggestions of the evidence. Unfortunately, our minds are not like that. Like the viewers of art, any writer or researcher brings to what he or she studies the history of his or her intellectual training, personal attitudes, unconscious prejudices. Moreover, we must tread carefully through our chosen area, strewn like a minefield with the intellectual wreckage (the views, positions and prejudices) of centuries of scholarship. It is on these foundations that we build; it may often be against them that we find ourselves fighting. In this sense, academic study is no different from the ways of viewing I explore in this book. Like the viewing of art, the study of the evidence is prey to the multiple human fallibilities of subjectivity.

In looking at the transformation of Roman art, there are, it seems to me, two attitudes in particular by which one might characterize the nature of scholarly approaches. These may be summarized (and parodied) by the sentences: "Everything changed" and "Nothing changed". In a way, I agree with

both these views. I accept the position of the Renaissance – a position repeated in this century by distinguished scholars such as Bernard Berenson, Ernst Gombrich and Ernst Kitzinger – that there was a fundamental transformation in the making and understanding of art in late antiquity.[5] It was part of a fundamental transformation in culture, society and identity. However, I disagree strongly with the characterization of this change as "decline".

On the other hand, I accept that almost everything in Christian art (indeed, in Christian culture) is the direct descendant of elements, attitudes and forms present for centuries in Classical civilization. Nonetheless, such elements were clearly transformed by aspects of the Jewish culture out of which Christianity emerged. From this point of view, one can argue that nothing changed radically, that there was a slow, delicate and subtle process of modulation and transformation.[6] Modern scholars have been particularly distinguished in their careful tracings of the dynamics underlying this process. Indeed, art history has recently been commended for its judiciousness in not portraying the contrast of pagan and Christian themes as a life-and-death struggle.[7] Art historians have traced the delicate process of the rise of late-antique abstraction from numerous angles. Some have explored socio-political influences (looking at the impact of social change,[8] of non-Classical artistic modes from the periphery of or beyond the borders of the empire,[9] including especially Jewish art,[10] or of class-conflicts between "plebeian" and "patrician" elements within Roman culture).[11] Some, on a more conceptual level, have looked at the impact of late-pagan philosophical thought, especially that of Plotinus, which advocated a less descriptive or literal discourse so as to emphasise the spirituality of what was represented.[12] Some have turned to the rhetorical and literary background of ancient culture to explore developments in imagination and audience response.[13] All these approaches have the considerable merit of not seeing decline as the crucial characterization of change in late-antique art. My problem with them, however, is that they tend – by emphasising elements of continuity – to downplay the significance of change. Despite the fact that Christian art (indeed, Christian culture) owed pretty well everything to the combination of its Graeco-Roman environment with its Jewish origins, I believe it to have become (very early on) something distinctively, even radically, different.[14] In Part III, I try to examine something of this difference by looking at the origins of Christian visual typology.

7

III

This book began as an attempt to look again at the formal and stylistic change in Roman art from what has been called "naturalism" to what has been characterized as "abstraction", between the first and sixth centuries A.D.[15] My aim was to look at cultural contexts and at the ways art was viewed, to see if a broader historical explanation could help us understand artistic change. But as it progressed, the book became something a little different.

What *Art and the Roman Viewer* has come to explore are two radically different conceptual frames within which viewing (and many other aspects of social life) took place in the ancient world. Whether one looks at first-century images of Roman domestic wall-painting (Chapter 2), of sacrificial ritual (Chapter 6) or of silverware from the context of elite dining (Chapter 7), one finds a complex potential for irony, parody and deconstruction. Like the subtle complexity of many Roman texts of this period (from the poetry of Horace, Ovid or Juvenal to the prose of Petronius and Tacitus), such imagery gently (or cruelly) mocks its own context, subverts any simple or straightforward view of its iconographic and social function and undermines not only what it represents but also its own potential for subversion. Of course, this is only one aspect of the complexity of Roman culture in the early empire. Its "deconstructive" possibilities flourished in an age which was also deeply religious and whose art, art criticism (see the discussion of Cebes in Chapter 1) and viewing (see the discussions of "mystic viewing" and Pausanias in Chapters 3 and 4) could take on quite un-, indeed, anti-, ironic modes of religious allegory, symbolism and initiation. I must emphasise that I see such "deconstruction" as only one aspect of Roman culture, but I also believe that not to see it (as some scholars do not) is the price (or prize) of not wanting to see it.

By contrast, the arts and literature of the sixth century exhibit no such "deconstructive" or ironising self-reflections. This does not mean they are "simple". On the contrary, religious images such as the pilgrimage mosaics of the monastery at Mt Sinai (Chapter 3) or the cycle of martyrs and Christian sacrificial images at Sant' Apollinare Nuovo in Ravenna (Chapter 6), as well as the sixth-century imperial iconography of San Vitale in Ravenna (Chapter 5) and even some seventh-century dining silver (Chapter 7), show remarkable sophistication and polysemic complexity. But this range of

signification essentially aims through iconography to *support* its subject-matter with the scriptural underpinnings on which Christian culture and identity came to be founded. The reference of such Christian imagery was not to what it appeared to represent, but to the symbolic meanings of a sacred text. In the end, all the arts of Medieval Christian culture came to be based on a brilliant and symbolic pattern of scriptural typology and exegesis.

My argument is that these two cultural contexts were profoundly different *frames* for the ways viewers formulated their responses to images. In first-century Roman culture, it was always possible to find an ironic or polemical place from which to look askance at the culture's social construction and self-representation. Naturalism, as a style, broadly goes with such a context, for naturalism – the art that imitates as closely as possible *but never is* what it represents – always exhibits a gap between the object represented (which the image so desires to be) and the imitation or image. It is precisely this gap, and the analogous gap between the image as imitation of a real object to be desired or possessed and the viewer as one who desires but cannot possess what turns out to be a mere illusion, which all the "deconstructions" of naturalism (like the surrealism of Campanian walls or the skeletons who dance on banqueting cups from Roman feasts) make explicit. In sixth-century Byzantine culture, however, images had an exegetic, a scriptural, relationship with what they represented. Indeed, everything was an "image" – the emperor was an image of Christ, the state of the divine economy, the good Christian life of the lives of the saints. Underlying such a conceptual frame lay a virtuosic typological system whereby everything in the world could be explained as an allegory or symbol of the Other World where God dwelt. In such a system, art did not need to imitate natural things. "Abstraction" – by which I mean less a stylistic "abstraction" than the abstract relationship whereby an image of a fish means Christ and not a real fish – was a natural visual product of such a context.

How we assess such changes and differences between cultures and frames of viewing seems to me largely a matter of polemical nomenclature. Roman culture of the first century A.D. has certainly been seen as decadent (especially its Neronian apogee or nadir). But its ironic arts and literature can also be seen as allowing viewers a creative space in which to assess, disagree with and attack the political and social *status quo* which controlled them. Any appreciation, however, of

the freedom of such a system should be tempered by the reflection that tyrannical states are that much more effective when they allow limited space for apparently subversive activities – that is, for licensed subversion. Likewise, the arts of late antiquity and the Medieval world have for generations (with gallant exceptions, of course) been labelled a "decline", in the main by apologists of the Renaissance. But it is bigoted to use such a term for an art which brilliantly fused text and image to do profound cultural work through Christian typology and exegesis in helping to create and uphold the prevailing Christian forms of identity in the Middle Ages. The very way in which Christian images tend to bolster and support their themes through scriptural allusion has (especially in the realm of imperial art) been seen as coercive. But such "coercion" depends on the agenda of the modern viewer, for although it undoubtedly existed (perhaps not necessarily more so than the very different forms of coercion in first-century Roman society), it went with different kinds of escape – spiritual rather than ironic, sacred rather than material, mystic rather than natural.

To summarise my proposal. Roman culture of the early Empire did not lack symbolic, allegorical or initiate ways of viewing. On the contrary, it combined such broadly religious functions of art with the more "deconstructive" and ironic qualities of civic and domestic iconography. What changed was the gradual elimination of the self-ironising (even "post-modernist") elements in Roman imagery in favour of a different kind of religious frame of cultural interpretation – a frame overwhelmingly scriptural. With this drainage of the deconstructive went a transformation of pagan methods of allegory and interpretation, that is, the religious modes of ancient viewing. Chapter 7 attempts to isolate at least one crucial aspect of this transformation by showing how *Christian* exegesis – based on a single canonical scripture and a tradition of scriptural commentary – created a typological method of biblical interpretation which owed much to Judaism but was radically different from any of the mainstream forms of allegorical exegesis known to Roman culture.

IV

One question which might be worth raising at this preliminary stage is the ways in which this book is incomplete in its

account of the subject it attempts to tackle. By enticing ways of viewing out of ancient texts, I necessarily privilege the responses recorded by the intellectual elite of the Roman Empire. Such people were not the only viewers of art – not even of those monuments which I discuss in relation to texts in the pages that follow. Indeed, Chapter 2, "Viewing and Society", is based on the conflict between the ways of viewing which are prescribed by polemical writers for Roman domestic wall-painting and the very different kinds of viewing which Roman houses themselves seem to evoke.

A related problem is that most of the texts I use tend to privilege the centre. Sociologically speaking, they generally seem to flow with the mainstream. One thing that architects like Vitruvius, orators like Cicero, teachers like Quintilian or Philostratus and philosophers such as Plotinus have in common is that their target audience was the wealthy elite of the Italian cities and particularly of Rome. But how typical were the attitudes of this audience by comparison with the great bulk of the empire's subjects who were both more peripheral in relation to the centre of power and much poorer? Again, the Church Fathers, whose writings have survived and been handed down canonized by the posthumous sanctity conferred on their authors by Mother Church, are not exactly the partisans of positions opposed to the orthodox establishment. How typical of the views of Christians in the first to the fourth centuries were these writings, produced by men judged to be orthodox or at least acceptable by the ecclesiastical and doctrinal hierarchy? Even a writer like Pausanias (whom I examine as an exception to the "Romanocentric" bias of most of my non-Christian texts) was a thoroughly unusual member of his own provincial society. How many men in the second century A.D. were wealthy enough to travel at their own expense for many years, spending great quantities of time and money on interests that were simultaneously pious and antiquarian?

In focussing on the specific theme of transformation, the partiality is still more conspicuously marked. My case-studies in Part II centre on two themes: the transformation of the imperial image and the transformation of religious art, which are certainly important but by no means the only areas of change. The importance of *religious* art is in part the product of a *retrospective* view from the perspective of the Christian art that took over the artistic production of the Roman world.

Such retrospective views are always methodologically worrying, for they have a flavour of teleology, of seeing the beginning in terms of the end. Was Roman art really how I have presented it in the light of its Mithraic and Christian successors? In some respects it was, but my discussion inevitably under-emphasises the respects in which it was not. Further, my focus on imperial and sacrificial imagery ignores significant changes in other kinds of representation which took place at the same time, for instance, changes in funerary art.

An additional problem of case-studies is the question of generalising. In particular, to what extent is the art of the capital city (Rome from the first to fourth centuries, Ravenna in the fifth and sixth) typical of the rest of the empire? Would the kinds of responses and viewings found in the centre have been normal in the smaller (or even more cosmopolitan) religious and artistic sites on the periphery? Related to this question is the difficulty of defining Roman religion as a whole. How typical of the religious practices of the empire were the state cult of the imperial city and those cults like Christianity and Mithraism which manifested as structural variants of the state religion in the city of Rome? Would the imperial cult of Aphrodisias or Alexandria (let alone of small provincial towns in Britain or Greece) have had the same forms or meanings as the state cult in Rome? Would other cults (including private devotions) in Rome or elsewhere necessarily have had any direct relation to official state religion? These questions do not admit simple answers. But they clearly highlight the limitations of my project. My discussion of transformation always operates in the realm of public and official religion (that is, the cult of the state, of the establishment, in Rome or Ravenna) and in the area of culturally sanctioned and centrally available alternatives such as third-century Mithraism. Again, this privileges the centre and the elite. Such an emphasis can be justified on a number of grounds, such as the tremendous and pervasive influence of the centre, but it is important to remember that it does not provide a complete or comprehensive view.

Finally, my analysis is largely taxonomic. I attempt to measure the sheer extent and nature of the change between the civic art of the Classical period and later Christian art, the art of initiates. Such an approach may appeal to people who perceive the world in terms of difference, in terms of change; but equally it may repel those who see the world in terms of continuities, in terms of sameness. Of course, my approach

inevitably underplays the speed, modalities and causes of change. It takes one away from the complexities of a multifaceted process, from the individual trees in all their particularity, to a broad overview of the forest as a whole. Part III, very briefly, attempts to redress this imbalance a little. There I explore some elements of the process by which a specifically Christian initiate viewing came about.

Nevertheless, I would be happy if this book as a group of combined arguments at least helped to throw doubt on two deeply held assumptions about Classical art and indeed art generally. The first of these may be summarized in the historical point made so influentially by Giorgio Vasari in the sixteenth century:

> We can see from the buildings constructed by the Romans that, as emperor succeeded emperor, the arts continually declined until gradually they lost all perfection of design.[16]

Implicit in Vasari's historical assumption of a *decline* from naturalism is an aesthetic creed about the priority of naturalism, well expressed by Sir Ernst Gombrich:

> Western art would not have developed the special tricks of naturalism if it had not been found that the incorporation in the image of all the features which serve us in real life for the discovery and testing of meaning enabled the artist to do with fewer and fewer conventions. This is the traditional view. I believe it to be correct.[17]

This *is* the traditional view. But I believe it to be quite false. For it was created by the practitioners of Renaissance naturalism (such as Vasari himself) as a self-justification for their rejection of Medieval art. Underlying the thesis of this book and, I hope, supported by its arguments, is a very different conviction. I believe that the naturalism or abstraction (that is, the style) of objects is dependent on a great many conceptual, sociological and essentially historical factors rooted in the way art is viewed at particular times. I do not believe, as Gombrich seems to, that naturalism has any natural psychological or physiological priority. I do not accept a formalist hierarchy of better and worse art based on some cross-cultural and ahistorical aesthetic truth such as the priority of nature. As Tom Stoppard has a character say in his play *Artist Descending a Staircase:*

> And what after all is the point of excellence in naturalistic art – ? How does one account for, and justify, the very notion of emulating nature? The greater the success, the more false the result.[18]

V

*Under the imaginary table that separates me from my
readers, don't we secretly clasp each other's hands?*

Bruno Schulz[19]

Those who write about the process of interpretation, and
especially about the ways interpretations change, must be
acutely aware that they themselves are interpreters. Just as
Roman viewers looked at art, so I too am a viewer of Roman
art as well as an explorer of Roman views about their art. And
my survey is itself a view which my readers will interpret and
review in their turn. This endlessly reflexive process gives
birth to a kind of humility. Although our interpretations are
what make our world, the only certainty they carry is that
they will be superseded. In calling to mind the impermanent,
insubstantial nature of all of our views, there is a certain
perspective: How limited are our knowledge and our activity.
It is in this spirit that I offer this book to my readers.

WAYS OF VIEWING IN THE ROMAN WORLD

FOREWORD

Even in ancient times, the history of Classical art was written as a history of the rise and triumph of naturalism. For Roman writers of the first century A.D., like Quintilian and Pliny the Elder, the art of painting developed gradually from the mono-chrome efforts of its earliest exponents to the acme of Apelles, an artist "who surpassed all the painters that preceded and all who were to come after him" (*Natural History* 35.79).[1] Pliny presents the development of art as a passage from winter to spring in which the great artists were those who brought inno-vations into the practice of painting, allowing it to become in-creasingly more realistic.[2] Eumarus of Athens was "the earliest artist to distinguish the male from the female sex in painting" (35.56). Cimon of Cleonae "first invented '*catagrapha*', or pro-file drawings" (35.56). Panaenus of Athens "is said to have in-troduced actual portraits" (35.57). Polygnotus of Thasos "in-troduced expression in the countenance in place of stiff archaic features" (35.58). Apollodorus of Athens "was the first to give realistic presentation of objects" (35.60) and into the gates which he had thrown open, there "entered Zeuxis of Heraclea . . . who led forward the already not unadventurous paint-brush . . . to great glory" (35.61).

Lest we believe this story too keenly, let us reflect that it represents a Roman synthesis of a long tradition of Hellenistic scholarship and art criticism. This Hellenistic literature, which unfortunately is now largely lost, was produced at the courts of the successors of Alexander the Great. For reasons perhaps more political than factual, the zenith of Greek art – in the persons of the painter Apelles and the sculptor

Lysippus – was constructed to coincide with the reign of Alexander. Apelles was Alexander's court painter (*Natural History* 35.85–7) and Lysippus his court sculptor (34.63–4). The story may of course be true, but it reflects all too clearly a concerted scholarly effort at the behest of Alexander's successors to justify a conqueror from Macedon (a country which had always been perceived to be semi-barbarian) as embodying the apogee of *Greek* culture.

The Plinian pattern represents an artistic relay-race with each artist handing on the torch of naturalistic imitation in an ever-increasing crescendo of illusionistic verisimilitude. This description puts an emphasis on the figure of the artist as innovator and on the goal of art as naturalism which Western art since the Middle Ages and the historiography of Western art have never yet been able to shake off. When great painters have defects, these are that they fall short of the naturalistic ideal at the heart of Pliny's picture. "Zeuxis is criticized for making the heads and joints of his figures too large in proportion" (35.64). Parrhasius of Ephesus, "the first to give proportions to painting and the first to give vivacity to the countenance . . . won the palm in the drawing of outlines" (35.67) but "seems to fall short of his own level in giving expression to the surface of the body inside the outline" (35.69). Moreover, because naturalism is an *ideal*, a sculptor like Demetrius can be "blamed for carrying realism too far", for he "is less concerned about the beauty than the truth of his work" (Quintilian, *Inst. Or.* 12.10.9).

Inevitably, given the structure of this account based on rise and fall, the (Roman) painting of Pliny's own day is a decline from the supreme peaks achieved by the Greeks (e.g., *Natural History* 35.2 and 28: "thus much for the dignity of a decaying art"). And yet the Plinian pattern always leaves room for innovations in the cause of naturalism. Even in the days of Augustus, Studius "introduced a delightful style of decorating walls" (35.116). The Plinian pattern of the art of the past as an ascent to naturalism (with the present seen as a state of decline) is not original. We find exactly the same formula in the architect Vitruvius, writing in the last quarter of the first century B.C. (during the reign of Augustus and the career of the fresco painter Studius). For the latter, in *De Architectura* (7.5), painting arose as an imitation of nature. Its decline is represented by the surrealism of the murals of Vitruvius's own time which imitate not existing things but all sorts of *monstra* and *falsa*.

This ancient view presents the development of Greek art

as an evolution of illusionism. It sees the most triumphant achievements of art to be those statues or paintings which are so realistic that the viewer is deceived into believing they *are* real. In the most famous of Pliny's anecdotes (*Natural History* 35.65):

Parrhasius and Zeuxis entered into competition. Zeuxis exhibited a picture of some grapes so true to nature that birds flew up to the wall of the stage. Parrhasius exhibited a linen curtain which was painted with such realism that Zeuxis, swelling with pride over the verdict of the birds, demanded that his rival remove the curtain and show the picture. When he realised his error, he yielded the victory, frankly admitting that whereas he had deceived the birds, Parrhasius had deceived Zeuxis himself, a painter.[3]

At the heart of this anecdote, the genius of illusionism is ultimately defined by its ability to deceive. The more skilfully art can deceive even those, like the painter Zeuxis, who are skilled in deception, the more realistic and hence the better it is. In the myth of Pygmalion, the supreme myth of Classical art as realism, as it was formulated in Ovid's *Metamorphoses* (10.245–97), this process reaches its peak. Pygmalion's ivory statue deceives not the non-human birds, nor a rival artist, but the very maker himself into believing that it is real. Pygmalion falls in love with the woman he has created, and eventually, in a miracle performed by Venus, is granted his heart's desire when the ivory woman is turned into real flesh.

Clearly these Roman texts present a coherent theory on the nature and history of ancient art. They chronicle an evolution and highlight the complex psychology implicated in realism. But do they tell the whole story? What do we lose in understanding ancient art when we rely principally on the Roman historiographical pattern retailed by Vitruvius and Pliny? Other ancient texts about images, rarely found in any art-historical discussion, such as the *Tabula* of Cebes (a well-read work in antiquity, so far as we can tell), give a very different impression about what at least some people wanted to see in art. Moreover, the most famous images from antiquity, such as the Olympian Zeus and Athena Parthenos of Phidias, were cult statues much larger than human size, executed in ivory and gold, and displayed in artificial lighting inside impressive temples. They do not survive. But there is no evidence that they would have appeared the slightest bit "naturalistic" (whatever that term may mean in the religious context of a cult deity for whom there was no prototype in nature).[4] Naturalism may have been less comprehensive and less significant in the ancient world than those who exclusively trust

Pliny and Vitruvius might like to claim. But there is a second point. In antiquity, naturalism was *not* an objective imitation of the natural world, as ancient, Renaissance and modern writers have imagined. Its history, as we have seen, was told by Alexandrian writers with a clear political interest in where the peak of its development should be placed. Naturalism, like all styles propagated by political states, had a politics. It was, as I suggest in Chapter 2, the aesthetic and stylistic standard-bearer for the visual self-presentation of the Roman Empire itself.

In the four chapters which constitute this part of the book, I seek to replace the Plinian picture with a portrait of Roman art which emphasises the variety of kinds of viewing in the ancient world. The psychology and the politics of naturalism are certainly part of this picture. But no less important are the kinds of religious images which occasioned the dialogue written by Cebes or the pilgrimage through Greece of Pausanias in the second century A.D. It was this persistent association of images and religion, of sight and the sacred, throughout *pagan* antiquity that would be the ancestor of *Christian* art after the conversion of Constantine. For those viewers, whether Christian or pagan, who wished to be initiated into the deeper meaning of sacred images, naturalism became explicitly unacceptable. Naturalism, as the Younger Philostratus – one of the last of its ancient apologists, writing in the fourth century A.D. – admitted, was inherently deceptive. For Philostratus, the inevitable *deception* of the naturalist attempt to imitate objects was "pleasurable and involves no reproach".[5] But this very deception became a sign for ethical deviation in the minds of those who were seeking religious *Truth*. Deception could not co-exist with Truth. This is why certain Church Fathers, like Epiphanius of Salamis – a contemporary of the Younger Philostratus, writing in the latter part of the fourth century A.D. – would accuse images of "lying". Painters "lie" because they cannot depict Christ or the saints as they actually were and instead present them "in different forms according to their whim".[6] Likewise, Augustine, in the *Soliloquies*, believed art was "unable to be true". Because of the inevitable deception by which image-making works: "A man in a painting cannot be true, even though he tends towards the appearance of a man".[7]

In essence, my argument is that naturalism – never the only mode of representation in the ancient world – became an untenable mode by late antiquity. In a culture which subjected the artefacts it produced to increasingly complex

symbolic, exegetic and religious interpretations, art was expected to stand for symbolic and religious meanings rather than to imitate material things. Not only was the mimetic illusionism of naturalistic art no longer necessary to late-antique culture, but its very attempt to deceive was a barrier for those who sought truth or religious edification in images. Art became "abstract" or "schematic" not because of a decline in taste or skill, or for simple reasons of political appropriation, but because viewers, patrons – in fact, the collective taste and subjectivity of the culture – wanted it that way.

In structure, this section of the book is not arranged chronologically. My aim rather is to elaborate and explore synchronically two motifs, which were highly significant for viewing throughout antiquity, interwoven in a sort of fugue. In Chapter 1, I introduce two themes or modes of viewing which I suggest were always present in Graeco-Roman culture. One (which I expose through the elegant discourses on pictures delivered by the Elder Philostratus) involved the viewer's flirtation with the deceptions and *trompe l'oeil* of naturalistic images as representations of the material world. The other (which I explore through the religious interpretation of a picture by Cebes) engaged viewers in an allegorising exegesis of images which may have resembled items in the material world, but were explained in a religious context as referring to the Other World. These two ways of viewing, which may be said to correspond broadly (but not precisely) to the "secular" and the "sacred" as social or cultural definitions, were both implicated in the ideologies and politics of ancient society.

The next three chapters address the theme of viewing and subjectivity. How does the act of looking at art condition and create the identity of individuals? I explore this problem by taking three case-studies from the ancient world – viewing in a domestic context, viewing in a sacred context and viewing in the complex situation of a pilgrim whose journey is through a social and secular world, but whose goal is religious. These three studies expand the basic dichotomy examined in Chapter 1 between Cebes and Philostratus, between reality as seen to be something otherworldly, open only to allegorical description, and reality as located firmly within the material grasp of the desires of this world. Chapter 2, on Roman domestic housing, aims to illuminate some of the many constraints and contradictions – individual, social and political – which inevitably press upon and compete in the production of an identity in the secular and day-to-day world. Chapter 3, on mystic viewing and the mosaics at Sinai, presents

admittedly an elite and extreme version of the formation of subjectivity in a sacred context within Christianity. Chapter 4, on the traveller Pausanias, illustrates through an exploration of a single individual, as he looked at art and recorded his views, some of the problems involved in bridging these two antithetical worlds.

The cases I present in these chapters are *exempli gratia*. I do not mean to imply that socio-political viewing of the kind I evoke in first-century wall-painting did not exist in later periods; nor to suggest that mystic viewing of the sort I explore in the Christian mosaics at Mt Sinai did not flourish in, say, the Julio-Claudian period. On the contrary, the first-century date of Cebes is proof that such sacred viewing *did* exist in the pagan Roman world. Moreover, the theological language of Christian discourse should not disguise the often deeply political content which such language came to subsume. Nonetheless, I do suggest that the development of Christianity was attendant upon, perhaps even was to some extent caused by, a shift of emphasis towards the sacred over the socio-political, towards the mystagogic over the secular. If these two strands have always existed side by side in human experience, then to some extent different periods are marked by the predominance of one over the other. My argument is that the change from the ancient to the Medieval world was precisely attended by such a shift of emphasis, and that in such rare and fascinating works as the book of Pausanias we can observe that shift as it was happening. By presenting the poles of secular and sacred through objects from the temporal limits of my study, I risk misrepresenting the complexity of the process by implying that Augustan art is secular and Justinianic is sacred. I do not mean to suggest this. The positive point of my strategy is to underline the poles (both conceptual and temporal) in an attempt to make clear what exactly the differences were (despite all the numerous caveats and exceptions). For I do believe, perhaps unlike some scholars, that there really was a fundamental change not only in art forms and social structures but also in the very notion of identity and in the frameworks governing people's subjective responses to the world. The period of late antiquity, notwithstanding such late and passionate apologists for naturalism as the Philostrati and Callistratus, saw a general move towards initiate and exegetic modes of interpreting art (essentially religious modes) which gradually came to dominate, often eventually to exclude, the emphasis on seeing images as referring naturalistically to the material world.

VIEWING AND "THE REAL": THE *IMAGINES* OF PHILOSTRATUS AND THE *TABULA* OF CEBES

THIS chapter examines two ancient texts about the viewing of art which appear to have been somewhat influential in antiquity. As a twin exploration of two parallel but different texts, it tells a complex story. Both the *Imagines* of Philostratus and the *Tabula* of Cebes are ancient interpretations of art whose consummate rhetorical sophistication makes them difficult but rewarding works to analyse. The problems of relating words and images have never been adequately resolved, because it is impossible to reconstruct fully a visual and essentially non-verbal experience (that of looking at a picture) in a text, however imaginative and creative the text may be.

Although significantly different in the kinds of expectations which they presuppose about images, the *Imagines* and the *Tabula* both treat art as a means of education. They demonstrate to their readers how to create a contextualizing narrative (a very different kind of narrative in each case) through which the viewer may assimilate a picture into his or her experience. This process of assimilation is reflexive; it changes the painting by subjecting it to the interpretative eye of its beholders, but it also changes the beholder by the educational process of his or her confrontation with a didactic image.

What nobody has examined in terms of its formal implications for the history of art is the reflexivity of viewer and object each constructing the other. This reflexivity is highly complex: It is the aim of this chapter to show some of the ways in which it works in the cases of both these texts. Once we understand how this reflexivity operates, we can use it to analyse both an ideology of viewing (the extent to which certain viewer strategies of assimilation are prevalent

at different times and contexts) *and* a formalism of objects (why certain kinds of art, such as naturalistic or abstract, are dominant in different periods and societies). Indeed, these two projects are hardly separate.

Behind both these texts there turns out to be a deep philosophical basis on which is predicated the kind of viewing that each advocates. The formalism of Philostratus's paintings – their naturalistic verisimilitude – is grounded in a theory which sees "reality" as being constituted by the world of the viewer's ordinary physical and psychological experience, a world of common sense and materialist expectations. By contrast, the abstract or schematic nature of the tablet described by Cebes (the content of which is consistently personified and allegorized) is rooted in an anti-materialist religious conception of "reality" which is defined as the transformation of the world of ordinary assumptions through initiation. In each case an analysis of the reflexivity of images and the ways they are viewed can lead us to an understanding of the very different presuppositions about "reality" which underlie very different kinds of viewing and very different kinds of art.

In effect these two texts turn out to offer contrasting ways of relating art to life and of relating the viewer's life to the art he or she looks at. In Philostratus, the sophist, whose text propounds the interpreter's view of the works of art it describes, the paintings are presented as highly naturalistic. The viewer is offered a number of strategies for assimilating these images into his or her phantasy life. The viewer is encouraged in the illusion that he or she can control the "other", the picture, by incorporating it through a narrative contextualization into the world of the viewer's psychological and cultural experience. By contrast, Cebes presents the hearer's view – the experience of a neophyte listening to a profound religious exegesis and gradually initiated into a new understanding of the world. For Cebes, the picture is a door into a reality which is entirely outside his cultural or psychological expectations. In this allegorical version of art, the viewer (far from controlling the "other") is subservient to the initiatory effects of the image and the exegesis of its interpreter. For Philostratus, paintings are a realistic illustration of the world we ordinarily know and can best be experienced through our normal response to the world. In Cebes, the picture is an allegorical bridge out of the world we ordinarily know into a reality and a way of life that is spiritually superior.

Si (como el griego afirma en el Cratilo)
El nombre es arquetipo de la cosa,
En las letras de rosa *esta la rosa*
Y todo el Nilo en la palabra Nilo.

Jorge Luis Borges[1]

Picture a villa on the Bay of Naples. Its layout is lavish; its
appointments exquisite. The owner is a wealthy and cultured
man: He possesses a choice collection of paintings displayed
in a special gallery. Into this gallery comes a professional
interpreter of art, a critic from outside Naples so famous that
numbers of young men come to him, eager to hear what he
has to say. This critic is Philostratus. At the express invitation
of his host, the owner of the villa, and particularly as a result
of the persistent urging of the owner's young son, Philostratus
delivers a series of interpretations of the paintings to the
group which has gathered to hear him.

This is the setting for the *ekphrases*, that is, "descriptions",
of the works of art collected in the *Imagines* of the Elder
Philostratus.[2] We know next to nothing about their author,
save what he himself chose to tell us about his own distinction
as a critic of art. He shares his name with a number of other
writers from the second and third centuries A.D.[3] He himself
probably wrote in the mid-third century, and his two books
of descriptions were sufficiently successful to be imitated by
later authors.[4] Certainly the display he gives to the audience
gathered in the Neapolitan gallery is dazzling.[5] Historic and
grandiose subjects are brought into the living-room of the
present and personal. By his exemplary skill in the art of
description he can cause remote and epic themes to penetrate
the privacy of viewers' and readers' phantasy lives. At 1.4 (4),
before an arresting painting of the death of the hero Men-
oiceus at Thebes, which illustrates a poignant moment from
the great epic poem, the *Thebaid*, Philostratus urges:

Let us catch the blood, my boy, holding under it a fold of our
garment; for it is flowing out, and the soul is already about to take
its leave, and in a moment you will hear its gibbering cry.

The freshness and vitality of his rhetoric have carried his
listeners deep into the tragedy which the picture depicts. The

viewers of these paintings, in the hands of this critic, seem themselves to have become part of the painted reality. Clearly the critic is a master of his art. These ekphrases, taken as a whole, perform a Callimachean master-stroke in taking the genres of Graeco-Roman literature from epic to fable, from landscape to still life, and conflating them into a pair of little books. The remote has been made vivid, the distant immediate, and the themes of epic verse have been transformed to prose – and, to cap it all, Philostratus is pretending that this is not at all a self-confident act of literature, but simply the faithful description of art!

Every game, every move on the writer's part, is a deliberate revelry in the literary possibilities of his text and in his own abilities as a master rhetorician. And so, we are entitled to ask, does the setting he describes represent a real occasion or an imaginary one? Did the gallery really exist, or was it a figment of Philostratus's rhetorical imagination – a literary device for the fictional framing of his descriptions?[6] Did the paintings themselves ever exist, or are they too the result of a vivid descriptive imagination seeing in its mind's eye what need not exist? These questions cannot be answered, because there is no external evidence other than the text of Philostratus himself. And this text is an example of scintillating and at times very complex rhetoric. But the fact that the text allows a deep doubt about the actual existence of anything (whether paintings or gallery) described in these ekphrases is extremely important. For the literary genre of ekphrasis, or "description", in the ancient world was not intended (as modern descriptions are) to go beside and to supplement the real painting or statue being described; it was intended to *replace* the sculpture or painting. The truly triumphant ekphrasis was the one which brought to mind its subject so vividly that the subject was no longer necessary. Its effects had already been achieved.

Before we can plunge into the psychological subtleties of viewing so effortlessly evoked by Philostratus, we must pause and examine more deeply the genre in which his work is cast. What, then, is an ekphrasis?[7] Fortunately, we do not have to rely only on modern theory. There survive from the first to the fourth century a series of prescriptions for ekphrasis in the *progymnasmata* (exercise manuals) of various rhetoricians including Hermogenes of Tarsus, Aphthonius and Theon.[8] The remarkable thing in reading these texts is how everything – the words used, the order of ideas and even the exempla cited – is repeated from one writer to the next. This

not only indicates something about the repetitive nature of
text-books, but also implies a fairly static notion of what an
ekphrasis was. The *progymnasmata* are invaluable as a compar-
ison with those descriptions which purport actually to fulfil
the instructions of the rhetors. No text should be more suit-
able for comparing with the text-books than Philostratus,
for he was a rhetor-sophist presenting a series of rhetorical
declamations in the form of ekphrases to young men. I shall
quote Hermogenes on ekphrasis in full.[9]

Ekphrasis is a descriptive account; it is visible – so to speak – and
brings before the eyes the sight which is to be shown. Ekphrases
are of people, actions, times, places, seasons and many other things.
An example of people is Homer's "he was bandy-legged and lame
in one foot" [*Iliad* 2.217]; of actions, the description of a land or sea
battle; of times, peace and war; of places, harbours, sea-shores and
cities; of seasons, spring, summer and festival. You could also have
a mixed ekphrasis – such as the night battle in Thucydides. For
night is a time, but battle is an action.

 We try to describe actions from the point of view of what pre-
ceded them, what happened in them and what occurred after them.
For example, if we were to make a description of war, first we
would tell of the events before the war, the levying of armies, the
expenditures, the fears; then the engagements, the slaughters, the
deaths; and then the trophy, the paeans of the victors and – of the
defeated the fears and the enslavement. If we describe places or
seasons or people, we will present the subject through a description
and an account that is beautiful or excellent or unexpected.

 The special virtues of ekphrasis are clarity and visibility; the
style should contrive to bring about seeing through hearing. How-
ever, it is equally important that expression should fit the subject: if
the subject is florid, let the style be florid too, and if the subject is
dry, let the style be the same.

It is noteworthy that in none of the rhetors is the description
of a picture cited as an example of ekphrasis. However, there
is a strong emphasis in all the *progymnasmata* on clarity (*saphê-
neia*) and visibility (*enargeia*), which are presented as "the
special virtues of ekphrasis".[10] The ekphrasis is a descrip-
tion – which is to say, a reading – of a particular object or
event so as to "bring it to sight", to make it visible. It is
therefore a reading that is also a viewing. In the ideology of
rhetorical declamation in the Second Sophistic (that golden
age of Greek intellectual life in the heyday of the Roman
Empire), to hear an ekphrasis is also to see what was de-
scribed, and to write an ekphrasis is to make the description
visible.

 But what is "visible" to the rhetors is far more than what

we would claim to be able to see. Hermogenes wants the whole fact of an "action" (including, specifically, its narrative qualities) to be contained in the description – the total effect, for example, of war in its economic, strategic and psychological reverberations. Although these are expressed in terms of all the time-honoured tropes – from levies to trophies, from death to enslavement – what he wants is in effect an *interpretation* and not a "description". The reader's seeing will come about from hearing the totality of the event as interpreted by the sophist, plus a stylistic mimesis of the "quality" of the event effected by the virtuosity of the sophist's rhetoric.

Here the theory and practice of ekphrasis (as defined in the *progymnasmata* and exemplified by Philostratus) are deeply indebted to Stoic views of *phantasia*, which means "visualisation" or "presentation".[11] The precise role of *phantasia* in Stoic philosophy is still controversial, but there is little doubt that (as the criterion for truth[12]) it was an essential concept.[13] To the Stoics, *phantasia* was a visualisation or presentation from an object. It imprinted itself upon and in some sense altered the soul.[14] By extension the term came to describe "the situation in which enthusiasm and emotion make the speaker see what he is saying and bring it visually before his audience" (Longinus, *De Sublimitate* 15.1).[15] It was explicitly both a vision seen through the mind's eye which had been evoked and communicated in language and a mental vision which in its turn gave rise to language.[16] In the context of descriptions of art such as the *Imagines*, *phantasia* was the vision which gave rise to ekphrasis as well as being the vision which ekphrasis communicated to those who listened.

Through its essential relation with *phantasia*, the very practice of ekphrasis in itself implied a theory of art. A work of art aroused in the mind a vision, *phantasia*, which in its turn gave rise to an utterance, ekphrasis. The person who heard that ekphrasis received through it the vision, the *phantasia*, which the work of art had originally inspired in the speaker. Moreover, *phantasia* was the vision which the original artist had had when creating the work of art.[17] It was the quality by which an artist was inspired to create in art even such things as cannot be seen with the eyes. As the author of the *Life of Apollonius of Tyana* (also called Philostratus, but almost certainly a different man from our sophist) wrote: *Phantasia* "is wiser than *mimesis*. For imitation will represent that which can be seen with the eyes while *phantasia* will represent that which cannot, for the latter proceeds with reality as its basis".[18] This quotation is tantalising indeed. It suggests that in

the kind of thought influenced by Stoic philosophy – that is, the kind of thought to which ekphrasis is heavily indebted – *phantasia* (the vision of what cannot be seen with the eyes) has access to a truer reality than *mimesis* (the mere imitation of what can be seen). What matters is not so much the artistic form or the verbal utterance, but rather the *phantasia* itself, the creative vision in the mind's eye, which gave rise to the painting, sculpture or description. But the great value of a work of art or an utterance is that it can convey again to viewers and listeners the original *phantasia* which gave it birth. The theory of *phantasia* begs fundamental questions about what is ultimately *real*, for it regards the natural world (which can be perceived through the senses and represented by *mimesis*) as something graspable through mere imitation, whereas it points to an intelligible world beyond the senses as ultimately more real. It is to this intelligible world which cannot be seen with the eyes that *phantasia*, which "proceeds with reality as its basis", gives access.

So ekphrasis, through the artist's *phantasia* which gave it birth and the listener's *phantasia* to which it in turn gives rise, tells the *truth*. It offers access to reality. This is a remarkable claim – much more elevated than the job description most art historians or critics would give of their trade. But it helps us to understand the place of ancient commentators on art like Philostratus or Cebes. They were offering more than the mere description of objects; they were educating their audience into truth. Their descriptions were not simply parasitic on pictures; rather, they competed with the pictures. Their descriptions were, like pictures, the creative product of *phantasia* itself and works of art in their own right. This has formidable implications for our reading of ancient texts on art: These descriptions were not seen as dependent on prior images (as a modern art historian's description would be); they were independent and self-sufficient works of rhetorical art in their own right. They existed and so they were true – true to the *phantasia* that brought them into being.

Ekphrasis is therefore always concerned with Truth. It is true, however, not to the material reality of a particular image or sculpture, but to the *phantasia* which the speaker experienced in seeing the work of art and which he experiences in delivering his description. In other words, reading ancient ekphrases is not a good way of exploring what particular paintings or sculptures were actually like for the reason that ekphrasis competes with the actual image or sculpture in attempting to evoke *phantasia*. But ekphrases are a superb

source for examining how Greeks and Romans looked at art, because ekphrasis is essentially concerned with evoking the vividness of vision, that is, with evoking how art is viewed. This is why it does not matter in the slightest whether or not the paintings which appear in Philostratus actually existed. On the contrary, what matters, and what Philostratus's descriptions are constantly telling us, is how such paintings were viewed.

PHILOSTRATUS AND THE PSYCHOLOGY OF REALISM

With nothing can one approach a work of art so little as with . . . words.

Rainer Maria Rilke[19]

Only with a sense of what might in the third century be a normal expectation of ekphrasis can we move to the text of Philostratus. Otherwise, we shall always be in the boat with those critics who profess themselves amazed at "completely gratuitous additions". In discussing the hair of the horses in *Imagines* 1.8, B. P. Reardon, for instance, suggests that this is merely bravado erudition – "details not at all necessary for the interpretation of the picture, but well designed to show off a knowledge of Homer".[20] But he has missed the point. What Philostratus is expected to do is precisely to expand his discourse beyond any simple description, to interpret and elaborate in order to present his reader with a *viewing*.[21] It is revealing that the same problems of critical expectation arise in the reading of Renaissance ekphrasis. Svetlana Alpers asks of the ekphrases in Vasari's *Lives of the Artists:* "How can we then explain both the psychological and narrative interest of the descriptions?" She concludes that "looking at art and describing what he saw legitimately involved for Vasari what we today might think of as 'reading in' ".[22]

If ekphrasis is not a simple description at any stage in the history of the literature on art, but is always an interpretation, a "visualisation", what is its purpose? Of course, Philostratus sets himself up in the introduction as an educator of the young, an interpreter of images, a sophist (1. introduction.4f.). In this he accords with the view that what most sophists did most of the time was teach the art of rhetorical declamation to young men.[23] However, the *Imagines* are not a lesson in rhetorical declamation. They are self-declaredly (although this is something not picked up by the modern

commentators) "addresses which we have composed for the young, that by this means *they may learn to interpret paintings and to appreciate what is esteemed in them*" (*Im.* 1.introduction.3; emphasis added). G. Anderson does not say enough when he comments that "Philostratus also plays the role of the *Sophos* instructing the child". Alpers is much closer in her perception that "ekphrasis concerns the *viewer's* education" (my emphasis). Philostratus is providing training in how to look.[24]

Philostratian viewing is not a subversive or alternative kind of looking at art – as for example was the project in John Berger's *Ways of Seeing*. On the contrary, from the evidence of comparisons with other collections of picture descriptions, such as by the Younger Philostratus or Callistratus, what the *Imagines* offer is a "right and proper" appreciation of art, a technique of viewing that all young men of good family ought to possess. This is a normative text about how to naturalise the "other" of art into one's social and ideological context. Again, what Alpers says of Vasari is as true of Philostratus: "This kind of ekphrasis, with its narrative emphasis, was beneath rationalisation, for it represented the normal way in which art was then seen and described" (p. 196). What one could learn from Philostratus was how cultured people looked at paintings. The *Imagines* are strategies of how to view; they are, in effect, a (culturally acceptable) ideology of viewing.

At the same time we must always bear in mind that Philostratus offers us the rhetor's view. He is the sophist selling his learning, the interpreter representing himself and his listeners as *he* wants them to be seen. We cannot read the text as it was received, but only as it presents itself. Thus the normative nature of the *Imagines* is a self-image, a sales pitch. Nevertheless, I tend to think that salesmen (such as sophists in the Roman Empire) are fairly good guides as to what would prove acceptable, saleable, from among their wares. Later we shall turn from the interpreter's line to views of art which are presented as lessons learnt from an exegete; but at this stage it is worth stressing that the very space of ekphrastic discourse – of a speaker, a hearer and an object described (whether real or imagined) – places great power in the hands of the sophist.[25] As the *Imagines* consistently demonstrate, it is the speaker who provides the point of entry, the angle, into the interpretation of a work of art.

Folks who seek surety while looking at art reach for collateral reading. They are following a millennial tradition exemplified with marvellous candour in that classic of literary description, the *Imag-*

ines of Philostratus. Here, in his first ekphrasis, the preceptor teaches his pupil that the way to master pictorial meaning is to keep eyes averted and fixed on a text.[26]

So says Leo Steinberg. He is right. The very first instruction in the first description is to "turn your eyes away from the painting and look only at the events on which it is based" *Im.*1.1(1).[27] But the first lesson is not quite to look for a text, although it comes down to a text in this case; it is, rather, to look for a *context* ("the events on which it is based").[28] The sophist is offering his pupil something to hold on to so as to make sense of the otherwise unassimilable "other", the confusing and disconcerting image presented to the viewer as in: "Have you noticed, my boy, that the painting here is based on Homer, or *have you failed to do so because you are lost in wonder as to how in the world the fire could live in the midst of the water?* (*Im.*1.1[1]; emphasis added). What Steinberg elegantly calls "the Philostratian anxiety to adduce a text" is actually the utterly normal need of the viewer to naturalise the "other", by finding a context in which the work of art will be part of the viewer's own reality. The first strategy of viewing is that the cultured beholder cannot be "lost in wonder" but must always have recourse to a contextualising hermeneutic tool.

The leap to Homer, however, is also the transformation of Homer.[29] At every stage Philostratus modifies the *Iliad*'s narrative of the wrath of the river Scamander against Achilles. He ignores the symbolism of the river's anger and the anger of Achilles, which is important to Homer's narrative as a whole. He introduces Hephaestus as a running figure – an actor made concrete in the image – as opposed to Homer, who presents Hephaestus as the cause for conflagration rather than a concrete participant in battle. Both painting and the ekphrasis of painting must make concrete, make explicit, what was implicit in the Homeric text. In actualising, in substantiating, in embodying the implications of a story, art and its ekphrasis conduct a wholesale transformation of the original narrative. The result is something quite different from Steinberg's turn to a text. It is a new text, created from a conflation of the Homeric narrative, of the painting's transformation of that narrative by freezing its sequence and making concrete its implications and of the viewer-sophist's reworking of the image in his own terms and context.[30]

In terms of the strategy of viewing, the painting described alludes to a literary context which Philostratus seizes and rearranges so that the picture can become its centre. The

context belonged to Philostratus already – all the sophists knew Homer, and this description quotes him at length (which both proves Philostratus's erudition, his fitness as a teacher, and fulfils the prescription of Hermogenes as to the appropriate style in which to cast the rhetoric). Now, when the image is contextualised, the painted "other" also belongs to Philostratus and to his pupils by its appropriation of and into the Homeric context. The Philostratian strategy of viewing might be described as using any available means to contextualise the image and therefore to appropriate its "otherness" into the viewer's own private world. It does not much matter if the artist intended his picture to be of Scamander or not. If he did, then the viewer is only playing out a game within the artist's intentions. If Philostratus has got his interpretation wrong (as has been suggested of the description at *Im.* 1.2 – which some critics think should be Hymenaeus rather than Comus[31]) it makes no difference. What matters is not the rightness of interpretation, but the viewer's need for contextualising the external "other" and a strategy of contextualisation to employ.

Essential to the Philostratian strategy of viewing is the need to interpret the image into a context. The second description, not this time of an epic theme, illustrates this well:

The spirit Comus, to whom men owe their revelling (*kômazein*), is stationed at the doors of a chamber – golden doors I think they are; but to make them out is a slow matter, for the time is supposed to be at night. Yet night is not represented as a person, but rather it is suggested by what is going on . . .(*Im.* 1.2[1])

The subject is at once identified, as is almost always the case throughout the *Imagines*, and it is at once made relevant – this is not just Comus, but that Comus who gave men (gave us) revelling. It is night – not simply because of what is represented but because the sophist's own discourse is enacting night ("golden doors I think they are; but to make them out is a slow matter, for the time is supposed to be at night"). Finding the context is not merely a matter of identifying a subject and the placing of that subject where every beholder can relate to it (in this case, alluding to the literary topos of the revel and the "real" experience of revelling). It is also the ekphrastic performance itself – the drama whereby the rhetor can act his own viewing and thereby his viewers into the image.

The rhetor-observer is constructed as a narrator. He is no simple describer or even interpreter, but rather has become

inventor, author of his own story. In the same way, Ovid's Pygmalion is not only the viewer and lover of his ivory statue – he is also its creator. Both Ovid and Philostratus see the act of realist viewing as a creative one, a narrative of self-deception told to himself by the viewer and imposed through his phantasy on the image.[32] The ekphrasis, as all the descriptions in the *Imagines*, has become a voyeurist identifying phantasy where the viewer's experience can be extended into a narrative created by the image. Comus is asleep "under the influence of drink"; his left leg is bent towards the right "for fear lest the flames of the torch come too near his leg"; his right hand is at a distance "that he may avoid the breath of the torch". Philostratus's "reading in" is a strategy of psychological motivation based on "real life" experience and literary tropes (which amount to the same thing – it is through topoi and clichés that we construct and classify "real life").

There is, moreover, a persistent praise of mimesis or of how well the painting has done to approximate to the viewer's (superior) world. The discussion of the relaxed hand moves from painted image to generalization about life – the hand is limp "as is *usual* at the beginning of slumber, when sleep gently invites *us* and the mind passes over into forgetfulness of its thoughts". The delicacy and tenderness of the crown are praised, and the roses praised for being a painting of fragrance itself. One should not forget here the pun that underlies the text – that *graphein* which is Greek for "to paint" means simultaneously "to write".[33] In Philostratus anything that is a painting is also a writing . . . But the point of the praise of mimesis is to flatter the viewer – to persuade him that the image is straining to reach out of its "otherness" into his reality. And yet, the fact is that it is the viewer who needs an interpreter (cf. 1. introduction. 3) to make sense of the image, and not the painting itself.

The aim of this rhetoric is persuasion,[34] but it is not the persuasion that convinces us of a fact. Rather, Philostratus wants to establish a relationship. The viewer is being persuaded that he is in the position of power, that he has control (through the agency of the rhetor-sophist or the techniques of interpretation learned from the sophist) of the "otherness" of art. This control – represented precisely by the hermeneutic enterprise, by the ability to "read in" – is entirely illusory. It has no basis other than in the complicity of interpreter and viewers in the authority of their own viewing. The logical next step from Philostratus's contextualising of Comus within a generalization of "real life" (that is us), is to transgress the

boundary altogether: "What else is left of the revel? Well, what but the revellers? Do you not hear the castanets and the flute's shrill note and the disorderly singing?" (1.2.[5]). But what if we do not hear? The whole project of realist art and the viewing it engenders is a transgression of boundaries that depends entirely on our suspension of disbelief. The real revel that is taking place is the orgy of voyeurist phantasy narrative – which the viewer keeps up in order to maintain the desperate illusion that he *has* a relationship with that thing out there.

There are several moments in the *Imagines* when the soph-ist's viewing narrates away the boundaries of observer and observed, and there seems to be a union of realities between beholder and image. These are the moments when the text comes closest to its own deconstruction, when the premises of deception and illusion as realism – which underlie the entire realist enterprise (whether as image or ekphrastic text) – come closest to exposure. Perhaps the most potent example is the "Hunters" scene (1.28).[35] I quote the first part of this (section 1–2) at length:

Do not rush past us, ye hunters, nor urge on your steeds till we can track down what your purpose is and what the game is you are hunting. For you claim to be pursuing a fierce wild boar, and I see the devastation wrought by the creature – it has burrowed under the olive trees, cut down the vines, and has left neither fig tree nor apple tree or apple branch, but has torn them all out of the earth, partly by digging them up and partly by hurling itself upon them, and partly by rubbing against them. I see the creature, its mane bristling, its eyes flashing fire, and it is gnashing its tusks at you, brave youths; for such wild animals are quick to hear the hunter's din from a very great distance. But my own opinion is that, as you were hunting the beauty of yonder youth, you have been captured by him and are eager to run into danger for him. For why so near? Why do you touch him? Why have you turned towards him? Why do you jostle each other with your horses?

How I have been deceived! I was deluded by the painting into thinking that the figures were not painted but were real beings, moving and loving – at any rate I shout at them as though they could hear and I imagine that I hear some response – and you [addressed to the listener or reader] did not utter a single word to turn me back from my mistake, being as overcome as I was and unable to free yourself from the deception and stupefaction induced by it. So let us look at the details of the painting; for it really is a painting before which we stand.

This remarkable passage begins by pole-vaulting us, whether viewers or readers, directly into the image – with Philostratus actually addressing the hunters in the painting: "Do not rush

past us, ye hunters, nor urge on your steeds till we can track down what your purpose is and what the game is you are hunting". The rhetoric of the description is enacting the image it describes – we, the viewers, are also hunters "tracking down" (*exichneuein*) our prey. Whereas the description raises many of the issues we have already touched upon – deception, the emphasis on reality, the use of clichés from common-sense experience ("such wild animals are quick to hear the hunter's din from a very great distance") – it is particularly explicit about its initial establishment of the viewers' reality as being the same as that of the image.

The game of the text becomes extremely complex once this single reality for viewer and image has been established. The hunters claim (*phate*) to be pursuing a wild boar – but that boar is a text from Homer (*chlounên syn*, *Iliad* 9.539). They hunt a boar that is also a quotation; we hunt an image (this ekphrasis) that is actually a text. But our quarry is their game – we both are hunting a Homeric text, but it is a text whose presence (its quotation here) spells, above all, its absence – for Philostratus (for all his erudite quotation) is not Homer. The narrative becomes dramatic as the viewer surveys the "devastation" and as the hunters close in on the boar. But even as we (hunters and viewers) appear to have reached the goal of the chase, the very aim of the hunt is cast into doubt by the authority of the sophist-critic:

My own opinion is that, as you were hunting the beauty of yonder youth, you have been captured by him and are eager to run into danger for him. For why so near? Why do you touch him? Why have you turned towards him? Why do you jostle each other with your horses?

The whole hunt, theirs and ours, was but a metonymy of sublimated desire! The pursuit is of neither text nor boar – it is the *hôra* (the bloom of youth, the beauty) of yonder youth as object of desire. Nothing so establishes the authority of the critic as the ability to read concealed and deeper motivations through the deceptive surface of text or, for that matter, of life. Here Philostratus is the dominant authorial presence typical of so many nineteenth-century novels – except that he is not author, but merely viewer of an image which is trying so desperately to be real that it has persuaded us into itself. The very rhetoric of the description (all those questions directly addressed) is contrived to carry us into the image, to persuade us that we relate with it and that it is striving to relate with us.

34

As we reach the point where the hunters' deception is pierced and erotic desire revealed as the true aim of the hunt – that is, the point where the deeper perception of the hunter-critic penetrates the "truth" of the painting – suddenly the authority of the viewer is revealed for the deception that it is: "How have I been deceived! I was deluded by the painting into thinking that the figures were not painted but were real beings, moving and loving . . ." The mimetic enterprise of realism, as presented by Philostratus, is to persuade the viewer that the painting's "other" world is in fact his own. But its very achievement of that goal can only be the brutal revelation of the exclusion of the viewer – the fact that the narrative by which self can appropriate "other" is ever a (self-) deception.

The very transgression of the boundary of image and the real is simultaneously the relentless reassertion of that boundary. But Philostratus is saved from the complete loss of hermeneutic authority. Even as the image slips firmly back into its status as "other", Philostratus addresses his reader as "you", maintaining the illusion of a single world shared between the writer and the reader of the text. The very phantasy that has fallen to pieces in its operation between viewer and painting is that on which (in its operation between reader and ekphrasis) the remaining pages of this description are based. By implicating the reader-viewer in his own self-deception, the sophist maintains not so much his own authority as interpreter, but rather the authority of (or at least the need for) a strategy of illusionist interpretation. Without it, we are excluded from the "otherness" of the image, that is, we are lost. With it, as this ekphrasis proves, we are no less excluded – but we have always phantasy, desire and the hermeneutic narrative (ekphrasis itself) to generate the illusion of a relationship ultimately doomed to fail. "Realist" art offers the viewer no means of relationship other than the discredited ekphrastic strategy. The sophist's authority is dependent not on the success of his "reading," but on the fact that in the final analysis we need *some – any* – strategy for reading.[36]

What can we learn from Philostratus's bravura performance? An ekphrasis is not only a complex literary text, it is also – by the prescription of the rhetors – the rhetorising of a view. And ideologically inscribed within such a rhetorised view must be the presuppositions of what viewing is to be. Ekphrasis gives us an ideology of viewing because such an ideology cannot but be what an ekphrasis is predicated upon.

Philostratus is teaching, through his ekphrastic perfor-
mance, an hermeneutic means of relating to images. This
means is the viewer's narration of himself (Philostratus's audi-
ence are all male, as is typical of antiquity) into the reality of
the image ("the other") by assimilating the image into the
framework of his own subjective consciousness, his personal
context. The beholder constructs the object into his subjectiv-
ity, makes the other – which previously had no place in his
experience – a constituent of that unique and intimate set of
objects by which he defines his identity. The "Hunters" scene
ceases to be an image of men pursuing a boar and becomes a
portrayal (both a subjective metaphor and more than a meta-
phor) of erotic desire. This is the viewer's own particular
"meaning".

The premise beneath this strategy is that the viewer is
always apart from the object he views, is always excluded
from the reality of the object. The strategy of the excluded
viewer must be to construct the object out of its autonomous
reality into his subjectivity. Hence the hermeneutic enterprise
of ekphrasis – the excluded viewer must narrate, or describe
or associate the image into the terms he knows, the discourse
he uses. But there is a price to pay. The image is no longer
itself – it is a subjective construct with a personal meaning
for the beholder.[37] As Philostratus discovers in the "Hunters"
description, that meaning need have no relation with the
object itself. As the influential French psychoanalyst Jacques
Lacan put it (his italics): *"What I look at is never what I wish to
see. And the relation . . . between the painter and the specta-
tor, is a play, a play of trompe-l'oeil".*[38]

And yet it is clear that the very essence of realism is to
entice the beholder, to persuade him that the image's reality
is his own. Thus in 1.23 (2):

The painting has such regard for realism (*alêtheia*) that it even shows
drops of dew dripping from the flowers and a bee settling on the
flowers – whether a real bee has been deceived by the painted
flowers or whether we are to be deceived into thinking that a
painted bee is real, I do not know.

Whatever happens, realism is dependent on deception as the
image strives to do its best to elide the unbridgeable gap
between life and art. Mimesis is always illusion. In the gap
between viewer and object (between the bee and the flowers
or us and the bee), there is ultimately Lacanian "alienation",
"the lack". In the gap between the image and what the image
is of (as Narcissus, in 1.23, who is in love with his own image

and who cannot "see through the artifice (*sophisma*) of the pool", cannot perceive that the likeness will never be its referent) there is likewise only Lacanian despair. The text brilliantly dramatises the tensions of the "realism" in the art it describes.

Earlier in this chapter, I argued that ekphrasis is inevitably concerned with the problem of what is real. On the one hand, ekphrasis purports to describe material objects (such as the paintings in the *Imagines*), but, on the other, it evokes *phantasia*, which has access to a deeper truth or reality than material objects have – an intelligible rather than a sensible reality. The genius of Philostratus is that he uses *this* problematic – the tension in the reality to which ekphrasis refers – to dramatise the problematic of realism. His collection of ekphrases serves not only to describe particular pictures but also, more significantly, to represent the complexities of the realism with which those pictures are painted. Like all ancient ekphrasis, his subject is only apparently actual works of art susceptible to the senses; in fact, he is evoking the *phantasia* of a conceptual (rather than merely a sensual) problem – namely, What is realism?

Even the devices of his rhetoric, as taught by the rhetorical text-book writers like Hermogenes of Tarsus, continually probe the issue of realism. For instance, *enargeia*, or "visibility", one of the crucial constituents of ekphrasis (something insisted upon by Aphthonius, Hermogenes and Theon among the rhetorical writers), renders with equal colour and evidence the face of real things and imaginary things.[39] It is precisely the play of real and imaginary that lies at the heart of the "realist" art that Philostratus describes and at the heart of the games with deception and reality that the text of the *Imagines* displays. Indeed, one might say that the very complexity of these descriptions is dramatising the complexity of the art they re-present.

Moreover, the rhetorical devices self-consciously used by Philostratus within his ekphrases in order to evoke *enargeia* and *phantasia* in his readers, are extended by him *beyond* the descriptions themselves to the frame in which he presents them. It has been shown that, within the ekphrases, one of Philostratus's favourite rhetorical devices is to portray a single and perhaps incongruous individual within a crowd or group against which he can be dramatically contrasted.[40] However, in a brilliant move which radically disturbs one's sense of where the real begins and ends in the context of the *Imagines*, Philostratus employs this technique in the *introduction* to his

37

descriptions. At section 4 of the prologue, he tells us the occasion for his *logoi* (discourses) – the games in Naples, the resplendent villa of his host, the son of his host "quite a young boy, only ten years old but already an ardent listener and eager to learn". The sophist is importuned by young men and by this still younger boy to speak in praise of the paintings:

"Very well", I said, "we will make them the subject of a discourse (*epideixin*) as soon as the young men come." And when they came, I said, "Let me put the boy in front and address to him my effort at interpretation (*spoudê tou logou*); but do you follow, not only listening but also asking questions if anything I say is not clear.

And immediately we are launched into the first description: "Have you noticed, my boy . . ."

The very discourse in which so many of the ekphrases are cast (the posing of the individual against the group) is the discourse which sets up the reality in which the pictures are purported to exist and in which these descriptions are claimed to have been delivered. For the boy and the young men are nothing other than a rhetorical device of ekphrasis. The only "reality" of this text (*pace* those who believe *there actually was* a Neapolitan gallery) is constructed out of its rhetorical nature as text. It is the rhetorical performance itself (in the form of the contrast of individual and group, of young men and younger boy) that sets up the didactic basis of the text. Without the prescription presented by the prologue, that these ekphrases are an act of education, we would not know what the rest of the text was doing.[41]

What can we make of it, when ekphrastic method has become the means for representing "life" outside and around the images and the ekphrases themselves? What can we make of it, when the same method (and nothing else) is responsible for setting up the programme and the validity of a text whose parts are but a display of that method? Like the circularity of the Narcissus description (1.23) – where "the pool paints Narcissus and the painting paints the pool and the whole story of Narcissus" – we are in a circle (or in a series of reflecting mirrors) in which the text's notion of "reality" is caught.

We can read in Philostratus both a methodology of appropriating the image by the viewer (the contextualizing narrative) and a means ("realism") by which the image can entice its beholder. There is a reciprocity. The viewer constructs the work of art into his own world. But the reverse is also

true. The work of art, by its very existence as an "other" that demands to be assimilated, constructs the viewer *as* assimilator, forcing the beholder to take up the role of interpreting the object, despite even the interpreter's defeat at the failure of his own hermeneutic in the "Hunters" passage quoted earlier ("So let us look at the details of the painting; for it really is a painting before which we stand"). Just as the viewer constructs the object and thereby makes it other than it was, so the object constructs the viewer as assimilator and thereby makes him other than he was.

By an irony that our sophist would have relished, what we learn from the *text* of Philostratus is the power of a *work of art*. It is unassimilable without a context – and it generates that context from the beholder as a descriptive or narrative contextualisation within the beholder's subjectivity. The viewer himself (~~qua viewer~~) is generated by the object as the producer of such a subjective construction. The role of the artist as author is that (by choice of subject and form) he forecloses the potentially infinite number of subjective contextualisations that a viewer might choose. The implication is that *meaning* in the visual arts lies not in specific significations but rather in the types of relationships and assimilative strategies that different kinds of art generate from their viewers in different contexts.

CEBES AND THE PSYCHOLOGY OF ALLEGORICAL INITIATION

It is the spectator, not life, that art really mirrors.

Oscar Wilde, *The Picture of Dorian Grey*,
Preface

The *Imagines* of Philostratus offer two elements in their exposition of viewing. The first frames the text and presents an authoritative interpreter who provides viewers with a means of narrating themselves into the reality of an image. The viewer appropriates art's otherness by inventing a contextualising story. This frame applies not only to Philostratus but also to a number of other ancient presentations of art.[42] The second element, this time particular to Philostratus, emphasises realism and the way art itself appears to be striving to imitate the viewer's world. This is a brilliant strategy brilliantly displayed – and is perhaps *the* classic description of realism; but it is not the only method available to viewers in

39

their efforts to make sense of images. If art mirrors the spectator and not life, then the reflections that images offer will depend on the initial self-image of the beholder.

"When I was hunting in Lesbos, I saw in the grove of the nymphs a spectacle the most beauteous and pleasing of any that ever yet I cast my eyes upon. It was a painted picture (*eikona graptên*) reporting a history of love". Thus begins the proem of Longus's *Daphnis and Chloe*. This novel, dating from the late-second or early-third century,[43] purports to be an ekphrasis – one of the longest extended descriptions of painting that have come down to us from antiquity.[44] In the prologue Longus authorises his narrative as being more than merely fiction or a subjective phantasy about a work of art not by relying on his own view but by turning to an interpreter (*exegeten tes eikonos*, Proem 2).[45] Whereas the *Imagines* of Philostratus are presented as an exegete's lesson in interpretation, the roughly contemporary narrative of *Daphnis and Chloe* anchors its validity in just such an exegesis by appealing to the authority of a guide with superior knowledge. Here Longus is not alone. In his celebrated description of the "Calumny of Apelles", the second-century essayist Lucian of Samosata also turns to a guide (*periegetes tes eikonos*).[46] Because this painting is unknown from any other source and because Lucian hopelessly confuses his facts in the anecdote accompanying the description, it has been suggested that he was "misled by an ignorant cicerone".[47] However, what matters for our purposes is not the correctness of attribution or context but rather the need for them and the need to authorise them in an external interpreter. It may be that Lucian and Longus have invented the paintings they claim to describe;[48] certainly they are more interested in the narratives purporting to be descriptions than in the images which give rise to them. Nevertheless, the figure of an interpreter provides a crucial touchstone to verity not only for the existence of the paintings but, more importantly still, for the correctness of the interpretations which these authors provide.[49]

The most spectacular and complex example of such valorization through the authority of an interpreter is the *Tabula* of Cebes. This text, which in all likelihood was written during the first century A.D.,[50] is a religious-philosophical interpretation of a picture (*graphê*) set into a votive tablet (*pinax*) in a temple of Kronos (*Tabula* 1.1).[51] It has received virtually no literary or art-historical discussion, despite its elegance as a literary construct and its importance as ancient evidence for the allegorical interpretation of religious art.[52] In fact, only

two monographs have ever been devoted to it, and these – like most of the scholarly discussion – have focussed primarily on issues of dating and on whether the exegesis of the picture is primarily Pythagorean, Eleatic, Socratic, Platonic, Stoic, Cynic or eclectic.[53]

The *Tabula* begins with the narrator and a group of friends strolling through the temple. They discover the picture and are "unable to make out what its meaning could possibly be" (1.1). "What was depicted seemed to us to be neither a walled city nor a military camp" (1.2). The viewers' check-list of the known and familiar fails rapidly before the enigma of the picture, and description collapses into obscurity – "a circular enclosure (*peribolos*) having within itself two other circular enclosures one larger and one smaller" (1.2). Having dramatised the perplexity of the uninitiated who approach such images without esoteric knowledge,[54] the text brings us an old man (*presbytes tis*) as the rescuing interpreter (2.1). However, the *presbytes* does not take upon himself the authority for revealing the truth, but explains that the tablet was put up in his youth by a foreigner of rare wisdom and sense (*emphrôn kai deinos peri sophian*), both a Pythagorean and a Parmenidean, who was himself then a very old man (*polychroniotaton*) (2.1–3). It was this man, the philosopher-dedicator of the tablet, who expounded the meaning of the image to the old man now confronting the narrator. As all mystic and religious interpretations must, the *Tabula* validates itself by appealing to a detailed hierarchy of authority and an oral tradition of secret exegesis. Even "many of the local inhabitants do not know what the fable could possibly mean" (2.2).

The keenness of the narrator (and by implication of us as readers of his narration) to penetrate the mystery and hear the meaning is met with a warning: "Exegesis carries with it an element of danger" (3.1).

> "What sort of danger?" I asked.
> "Just this," said he, "if you pay attention and understand what is said, you will be wise and happy. If on the other hand you do not, you will become foolish, unhappy, sullen, and stupid, and you will fare badly in life, . . . If one does understand, Foolishness (*aphrosynê*) is destroyed and one is saved (*sôzetai*) and is blessed and happy in one's whole life". (3.1–4)

The *presbytes* raises the stakes from explanation as the satisfaction of a casual interest to exegesis as existential solution to the problems of life, exegesis as salvation.[55] In comparing his explanation to the riddle of the Sphinx (3.2–3), the old man

conducts a remarkable reversal. Instead of the viewer having control or power over the "other" – an inert picture – it turns out that the viewer's own life forever after depends upon this moment of viewing, depends upon a correct understanding of the picture. The image can teach: To be taught is to be saved, but to miss the teaching is to be forever lost. Power here is the prerogative of the "other", with the *presbytes* as its mediating exegete. We, the viewers within the *Tabula* or its readers, are unexpectedly confronted with the unrelenting demands of a religious choice.

This challenge leads to great desire on the part of the viewers (*megalên epithymian*) to learn the secret of the image, a desire explicitly related to the greatness of the penalty (*toiouton epitimion*) if the meaning is not understood (4.2). But as the exegesis begins, the text self-consciously plunges us into a further and brilliant reversal:

So, taking a staff, he [the *presbytes*] pointed towards the picture and said "do you see this enclosure?"
"We do".
"You must know, first of all, that this place is called Life, and the large crowd standing at the gate consists of those who are about to enter Life. The old man (*gerôn*) standing up here – who has a scroll in one hand and who appears to be pointing at something with the other – is called Daimon. To those who are entering he prescribes what they must do upon entering into Life; he shows them what kind of path they must take if they are to be saved (*sôzesthai*)". (4.2–3)

The picture is re-enacting the frame which has just introduced it. As the *presbytes* points to the picture in order to enlighten his neophyte audience – the visitors to the temple and us the readers of their account – so, within the image, the *gerôn* (also an old man) points out the path of salvation to those about to enter the enclosure of Life. But we have already been told that a correct reading of this picture is precisely a lesson in salvation (the same word is used: *sôzesthai*). What we are doing at this moment in reading the exegesis of the *presbytes*, what the viewers are doing in hearing the same explanation, is nothing other than an enactment of the very situation which the image itself depicts. And in terms of a theory of salvation and happiness in one's future life, such as the *presbytes* just announced in his preamble to presenting the interpretation, we (the readers and the narrators) are precisely in the position of the large crowd about to enter Life. We too are about to be offered a transformative initiation in the right path to follow. Just as the rhetoric of Philostratus enacted a

remarkable homology between the frame of the text and the descriptions themselves, so here the picture mirrors its literary context and the frame turns out to be enacting the prescriptions of the picture it purports to describe. This is explicit at 30.1–2:

I said, "You have not yet made clear to us this point, namely what the Daimon commands those entering Life to do".

"To be confident", he said, "Therefore, you also be confident, for I will explain everything and omit nothing".

The *gerôn* in the picture – now elevated to deity as Daimon – himself becomes the mystical authority for what should be happening outside the picture to its viewers and to the readers of its ekphrasis.

To look at the image on the tablet and to understand it, is actually to fulfil its own prescription about the path from deceit (*apatê*) and ignorance (*agnoia*) (5.2–3) to salvation (*to sôzesthai*). The effect of the frame is for the picture to prescribe itself as the solution to the existential problem which its own enigmatic obscurity first posed and which its exegesis foregrounds! The key to salvation is viewing and correctly understanding what one has looked at. Such understanding is of course not different from the act of exegesis itself. The very act of reading the *Tabula* and of following the interpretation as it leads us deeper into the mystery of the picture is itself an initiation into the true path – a truth whose implications are not confined to the interpretation of art but become the means of transforming the viewers' life.

The text frequently reminds us of the picture's homology with its narrative frame. At 6.2–3, the members of the crowd within the tablet meet a number of women called "Opinions, Desires and Pleasures" who lead them off. All promise happiness, but some lead to destruction (*to apolusthai*), while others lead to being saved. Like the narrator and his readers confronted in the proem by the perplexity of the image and the riddle of the Sphinx (3.2–4), the crowd in the picture need a guide whose higher knowledge can demonstrate the "true way in life" (6.3). If they miss the truth they wander about aimlessly, "even as you see now those who have entered previously wander about wherever they chance to go" (6.3). The word for chance here (*tychê*) leads into the personification of Fortune (*Tychê*), blind and mad, who is herself the cause of much of life's misery (7–9). Again we are thrown out of the picture into its context – the first words of the *Tabula* are *etugchanomen* (from the root *tychê*) *peripatountes*, "we chanced

43

to be wandering". The aimless state described in the image where Chance seduces man off the right path turns out to be precisely *our* state, the narrator's and readers' state, before our initiation by the *presbytes* into the meaning of this picture. It was aimless chance that brought the viewer (as well as the reader) to this temple, to this image, to this text through which we are taught to see the crowd, the image of ourselves in the perplexity of aimless chance, and we can perceive through this lesson how to walk the right path to salvation.

The detailed and consistent collapsing of the themes of the picture into the narrative of the frame is an extremely effective device for highlighting the significance of the image and the exegesis that describes it. The image and text are presented as a commentary on life: The explanation of the image becomes a commentary not only on the narrator's life but on our lives (those of the readers) and an allegory of life in general. The effect of this is to emphasise the act of viewing. Viewing – the right view religiously, the right ethical interpretation, the right path to salvation – becomes the real theme of the *Tabula*. Like the *Imagines* of Philostratus, Cebes's text is a lesson in how to view. Unlike the *Imagines*, it is not a lesson in realism or in how art may imitate the commonsense world. On the contrary, it offers a picture of how sacred art, by presenting a True Reality (a mystic concept into which one must be initiated), transforms the commonsense world – the world which we erroneously thought was real when we wandered aimlessly in deception.

Like Lucian's "Calumny of Apelles", the *Tabula* uses the method of personification to present its theme.[56] It paints a picture of progress to the figure of "true Education" (*alêthinên paideian*), a phrase repeated thirteen times.[57] However, for our purposes it is not the specific allegorical meanings of the personifications that matter, but rather the way in which Cebes uses the allegorical technique as a method of viewing.[58] We are in a world where nothing is what it seems. The *gerôn* at 4.3 is in fact *Daimôn;* the women (*gynaikas*) at 16.1 turn out to be Self-Control and Perseverance; the group of women (*choron gynaikôn*) at 20.1 are a veritable panoply of virtues (Knowledge, Courage, Justice, Goodness, Moderation, Propriety, Freedom, Self-Control and Gentleness) by 20.3, and so on.

What you see on the surface becomes something deeper, truer and yet more general when you see it through the eye of the *hermeneus*. This method of transformation – a rhetorical device mirroring a salvific religious claim – is shot through

the text. By the end, not only are all the figures in the picture personified into abstract qualities, not only is the viewer-reader ethically and spiritually transformed by being initiated into the picture's meaning, but even the picture itself has changed. That change is a transformation of depth: The short and perplexing description of 1.2–3 has become the huge and extended symbol of life of 4.2 – 40.4 (some thirty pages in Praechter's Teubner text). It is a transmutation of content from obscurity to clarity, from ignorance to insight, from the "other" debarred to the "other" known and penetrated. But perhaps most remarkably, the text of the *Tabula* suggests that the very tablet itself changes as a result of exegesis. At 1.2 the narrator describes a "circular enclosure having within itself two other circular enclosures, one larger and one smaller". However, the three enclosures apparent to the uninitiated viewer become *four* enclosures by the time the exegesis has reached 17.2.[59] Form itself is transformed in the mysterious act of exegetic viewing.

The *Tabula* of Cebes, for all its rhetorical parallels with Philostratus and its formal similarity with *Daphnis and Chloe* (both have a picture as frontispiece and Longus's novel has also been, if rather speculatively, interpreted as a religious allegory),[60] represents a remarkably different kind of viewing. Like the interpreter in the ancient art of physiognomics, astrology or dream-interpretation,[61] the *presbytes* has a field day in producing entirely unprecedented interpretations of an image which could not otherwise be understood. That readers of the text would never even see the picture which is transmuted with such virtuosity beneath the alchemy of exegesis only adds to the effect. The authority for this reading lies in the hierarchy of wise men suggested by the text, in the fact that the narrative frame enacts the injunctions of the picture it describes and in the great claim (to ultimate salvation) which the *Tabula* unexpectedly springs on its reader as the raison d'être for explanation. This justifies the extraordinary tyranny of the exegete's line which is final, open to no question and must be accepted (for the cost of doubt is misunderstanding and hence perdition). The viewing which is proffered as the path to enlightenment is radically different from that of Philostratus. It is polysemic, for every figure has at least two meanings – its appearance and its allegorical transformation to something else (something truer) through the exegete's words. Above all, reality in this text does not relate to the viewer's ordinary or commonsense world (the world which Philostratus's pictures strive to imitate).

45

"Reality" here lies in another world of allegorical exegesis – in a call to salvation and to a religious Truth. In antiquity this "reality" was as "real" for numbers of people as was the mundane reality of matter and psychological motivation explored by Philostratus. For those who accepted the injunction to allegorical viewing, the "Other World" that such viewing produced was more "real" than the material world to which non-initiates were confined. We know that, by contrast with many authors in antiquity, Cebes was widely read – by the pagans Lucian and Julius Pollux and probably by the Christian Tertullian (all active in the second century A.D.).[62] The *Tabula* was an influential, perhaps even a popular, text, translated in later times into Latin and Arabic and known in Byzantium.[63] It prescribes an exegetic and religious method of viewing which, for all its unfamiliarity to us, gives important testimony for attitudes and approaches to art that were widespread in the ancient world.

CONCLUSION

Representation and reality occupy one single space.

Ludwig Wittgenstein, *Philosophical Remarks*,
proposition 38

Viewing is apparently the simple act of pre-self-conscious looking – virtually a physiological reflex – loaded with unrationalised assumptions and associations about life. Yet, when we investigate the *Imagines* of Philostratus and the *Tabula* of Cebes, we find a serious determination in both these texts to train viewers in the art of how to look. In comparing these books, we discover a remarkable difference in the types of viewing which these texts presuppose. Both books provide authoritative voices which claim to educate their readers into the art of viewing. The hidden agenda behind each text is the "reality" to which it claims to refer; and it is revealing that both writers use the same Greek word, *alêtheia* or its cognates,[64] to denote "the real", despite the fact that the authors mean fundamentally different things when using this word. But neither text prescribes an ideology or a theory *about art* to be bought wholesale: Each educates its readers *about reality*, by training them through examples into a *method* of looking at art.

These two texts do not offer (as modern art history does) a history or theory of how art has come to be as it is; rather,

they offer (very different) strategies for the contextualization and assimilation of paintings by their viewers. In this sense, neither Philostratus nor Cebes seeks to legislate how one should take images. Instead, each offers his own persuasive set of paradigms indicating ideal ways of understanding art. In other words, both texts imply that viewing is creative and can be developed creatively by readers along the lines offered by these exemplary didactic texts. Clearly, viewing is not monolithic. There are as many ways of looking at art as there are viewers. Ways of viewing are themselves constructed by the prejudices and commonsense assumptions that viewers bring with them when they confront images.

However, at the heart of the divergence between the strategies of viewing in these two texts is a difference in different viewers' assumptions about what "reality" itself might ultimately be. For Philostratus, the "real world" which art imitates is the world of the beholders' physical and psychological experience – the world of our commonsense expectations. Art subverts these expectations precisely by being so realistic, so successfully imitative of them, that we cannot (for a brief but dramatic moment) be sure where the line between art and life should be drawn. For Cebes, the "real world" (in its correlation with salvation, happiness and true Education) is precisely and constitutively not the world of everyday experience and phantasy (the world of Philostratus). On the contrary, Cebes's "reality", as the goal of true Education, lies in a wholesale rejection and transformation of commonsense expectations according to an initiate allegorical system. The goal of art in the *Tabula* is not to imitate the viewers' world at all, but rather to initiate viewers out of their ordinary assumptions into a new exegetic reality, a truth that brings salvation. In this kind of viewing, if art is imitative at all then it imitates that exegetic Truth and has as little as possible to do with the kind of reality explored by Philostratus.

Quite simply, these texts present antithetical versions of "reality" as the goal of art. The kinds of viewings they signal existed simultaneously. Cebes's allegorical exegesis is contemporary with the Elder Pliny's classic anecdotes about art as illusionism – Zeuxis's grapes which were so realistic that birds flew to peck at them (*Nat. Hist.* 35.65–6), Apelles's portraits whose likeness was so perfect that a physiognomist could tell how long the sitter had to live or had already lived (*Nat. Hist.* 35.88–9), or Apelles's horse which alone caused real horses to neigh when they saw it (*Nat. Hist.* 35.95). The realism of Philostratus coincides with Porphyry's remarkable

47

mid-third-century allegory of the Cave of the Nymphs based on *Odyssey* 13.102–12,[65] and with Iamblichus's Neoplatonic presentation of images (*eikones*) as symbols within the occult philosophic system of theurgy.[66]

Moreover, the very same image might be subjected to these radically different kinds of viewing (either at the same time by different viewers or at different times), and might carry divergent and even contradictory meanings according to the spectator's initial presuppositions. The essential nature of the difference in viewing so dramatically embodied by the texts of Philostratus and Cebes is hugely important. The meanings viewers located in images depended on the kind of "reality" they ultimately wanted those images to represent. Such meanings might be single or multiple, simple or complex, material, political, psychological, ethical or religious. The understanding of *mimesis* itself must finally depend upon what space, what "reality", one believes is being imitated. Wittgenstein observed that reality and representation occupy the same single space; what one understands this space to be is crucially dependent on the reality which different viewers presuppose when they look at images.

VIEWING AND SOCIETY: IMAGES, THE VIEW AND THE ROMAN HOUSE

THIS chapter addresses the theme of viewing in a domestic context. I examine the social experience of Roman housing on three levels: first, the state's prescriptions for housing and decoration; second, the material forms of some ancient houses surviving from Campania and third, the ways individuals viewed their houses. The interrelation of these three themes, the political, the material and the personal, can throw light on the collective subjectivity and tastes of the Roman middle class. As anthropologists have shown, buildings and their decor are a "cultural system". The sensibility of which they give evidence is "essentially a collective formation, and . . . the foundations of such a formation are as wide as social existence and as deep".[1]

The text of the Augustan architect Vitruvius illuminates the politics of style in Roman wall-painting and in particular the moral agenda belying the Augustan emphasis on "realism". Moreover, Vitruvius is explicit about the socio-political constraints which governed the structure of Roman housing and the way that housing was designed to enshrine the hierarchies of a class system. However, the architectural and decorative schemes of actual houses (dating from a little before Vitruvius) exhibit no imposed straightjacket, but rather a spectacular series of symbolic inversions. The complexity with which such houses visually deconstruct the decorative and social categories on which they were based hints at a remarkable taste for the transgressive. Between the constraints of the state and the symbolic inversions of the decoration in his or her own home was situated the Roman viewer. One way in which the allusive images of Roman illusionist decoration could be assimilated in the beholder's subjectivity

49

was through the shared cultural goal of *desire*, centred on an obsession with the *view*. This concern with the view, attested by a number of ancient texts as well as actual houses surviving from Pompeii and Herculaneum, is related to the importance of the visual field in the Roman *ars memoriae*.

Whereas the Vitruvian agenda betrays the Roman *state's* interest in the social hierarchy of housing, the desire for the view offers access to the *individual's* concerns in the house. Despite, his polemical emphasis on the "real" in decoration, Vitruvius himself recognised the need to adapt building to the needs of the view. In the face of the deconstructive revelry of the Roman house, even the social prescriptions of the state had to compromise. Together, these two motifs – semi-official prescription and private *mentalité* – offer us a glimpse into the "deep play" of at least some aspects of Roman culture.[2] The anthropologist Clifford Geertz has argued that "the central connection between art and collective life does not lie on . . . an instrumental plane, it lies on a semiotic one".[3] Interpretations of art in its cultural context should not be merely functional or stylistic ("instrumental") but should also examine the process by which art constructs and signifies its meaning. This "semiotic" process is inevitably related to other systems of constructing and signifying meaning within the culture.

Archaeology may sometimes wish to present the understanding of Roman housing as grounded in a scientific evaluation and classification of the remains of material culture. But it is as well to remind ourselves of the truism that any such understanding is necessarily dependent on the fragments of an ancient conceptual frame which we rescue from the textual sources and use to interpret the material remains. Above all, in the field of domestic housing and decoration we are indebted to the very limited and cryptic remarks on the subject embedded in the writings of Vitruvius. This is not an expansive disquisition on housing, as the *Imagines* of Philostratus are on paintings. Rather, it purports to be a handbook on architecture, in which housing and house decoration have a brief allotted place. The text of Vitruvius is not only limited; it is also – as I hope to show – highly political and polemical. We cannot use it as if it told an objective story or reported the factual truth. On the contrary, it tells an idealised and rhetorical story, explicitly designed to win favour from Augustus. For this reason, the writings of Vitruvius are not only all the more difficult to use, but all the more interesting. Vitruvius's work shows the extent and the depths to which a desire to

foster Augustan propaganda and moral policies dominated even those who may not have been directly employed or paid by the state.

For Vitruvius, modern wall-painting was subversive. By examining some artistic and decorative programmes from Roman houses in Campania, and relating these decorations to the categories used in Roman texts for the social articulation of domestic architecture, we can see how this subversion worked. But it remains true that precisely those subversive or deconstructive qualities in Roman painting (against which Vitruvius inveighs) were licensed within the Principate's design. Wall-paintings did not simply question or undermine the socio-architectural system envisaged by Vitruvius: They were *allowed* to do so. Their "surrealism" was not outside the system, but was actually part of it. The emphasis on the *view* (not only in surviving Roman houses but also in texts which describe them, such as the letters of the Younger Pliny) enabled Roman viewers not so much to see the socio-architectural system dismantled as to learn from this dismantlement precisely *how* the system worked. Roman domestic viewing was an education. It taught the viewer how to be a *subject* – not only in the personal but also in the political sense.

VITRUVIUS AND THE POLITICS OF HOUSING

AFFIRMING THE "REAL": VITRUVIUS AND THE POLITICS OF STYLE

In one of the most influential outbursts of "violent abuse" in the history of art – influential because as a piece of "normative criticism" it set up the "concepts . . . and categories of corruption" which would later be borrowed by Vasari, Johann Winckelmann and the founders of modern art history – the Roman architect Vitruvius, writing in the last quarter of the first century B.C., made a passionate plea for realism in the decoration of Roman walls.[4] The passage is *De Architectura* 7.5. This outburst is highly significant. We can use it to assess not only what "realism" meant to Vitruvius (both aesthetically and as part of an ideological agenda) but also what the wall-paintings he castigates were implicitly denying. In the context of the social construction of the Roman house and the viewer within it, we must question what the ideal of realism implies about Vitruvius's view of art and of viewing.

Before we focus on Vitruvius's invective, however, we

must situate it within the rhetorical conventions of its time. Vitruvius was writing not an objective description but rather a loaded polemic. For Romans like Vitruvius, as for those Englishmen whose home is their castle, a house was more than a "machine for living in". Just as the idea of "home" in English means a great deal more than "domestic situation", the metaphorical evocations of *domus* in Roman culture were rich and manifold. Vitruvius's attitude towards art – like the rhetorical attitudes of Romans towards their houses – is neither neutral nor disinterested but is involved in his relationship to his culture and, in particular, is part of an ideological and moral programme. Before picking apart some of the axioms upon which the programme is based, let us sketch its relationship to other, similar, invectives in Roman culture.

As early as Plautus, a playwright at the turn of the third and second centuries B.C. whose works were already classic by the late Republic and early Empire, the image of the Roman house (*aedes*) served as a metaphor. In his play *Mostellaria*, the education and upbringing of a man is compared extensively with the building of a new house, and the decline of a spendthrift is paralleled with rotting timbers and negligent upkeep.[5] For example:

Just look at me. I was a lad
Of modest manners, blameless life,
 While they were building me.
Left to my own devices – well,
It didn't take me very long
To undo all the builders' work
And make the house a ruin.

 (Plautus, *Mostellaria*, vv. 133–6)

This early metaphorical usage for the image of the house opened the possibility for the theme to be used in invective; by the late Republic and early Augustan periods, extravagant buildings had become a polemical theme symbolising the corruption of individuals or of society as a whole.[6] In Horace's verse, architecture emerged as a poetic metaphor, evoking the futility of opposing death and the unnatural extravagance of contemporary society.[7] Most important for understanding Vitruvius is understanding that art and architecture were seen as *unnatural* impositions on the pure and essential state of humanity; they were modern innovations on the *veterum norma*, the righteous ways of previous generations. The early Romans never lived in a world of huge porticoes and fishponds larger than the Lucrine lake:

> This is not the norm
> Our ancestors divined, that Romulus
> And rough-bearded Cato prescribed.
> For them private wealth was small,
> The commonweal great . . .
> (Horace, *Odes* 2.15, vv. 10–14)

In the diatribe of Papirius Fabianus both paintings and the buildings they adorn (particularly those constructed into the sea) are *adversum naturam* (opposed to nature), sustained by a deplorable *fastidio rerum naturae* (disdain for the ways of nature).[8] By the first century A.D., extravagant building was seen as a rebellion against the natural order.[9] The epitome of luxury,[10] it is a deceit which disguises a man's vices from himself beneath the veneer of marble and gilding.[11] It is the luxurious price at which the once free Romans have bought themselves into slavery.[12] What is crucial here is the rhetorical assimilation of extravagance or excess in building to the contravening of what is *natural*. But *natura* in this heavily moralistic rhetoric means a good deal more than merely "the natural world": It stands as a *moral* term for the old way, the right and proper way, of doing things.

Vitruvius's attack on modern painting is a classic instance of the same trope. The ancients, we are told:

> used definite methods of painting definite things (*constitutae sunt ab antiquis ex certis rebus certae rationes picturarum*). For by painting an image is made of what exists or what can exist (*quod est seu potest esse*): for example, men, buildings and ships and other things from whose definite and actual structure (*e quibus finitis certisque corporibus*) copies are taken and fashioned in their likeness. (7.5.1)

Then, in one of those classic evolutionary passages from the ancient primitive past to the present so beloved of writers in the late Republic and early Empire,[13] he offers a myth of the development of imitation to the representation of the forms of buildings, columns, pediments, theatrical façades and landscapes:[14]

> Hence the ancients who first used polished stucco, began by imitating the variety and arrangement of marble inlay; then the varied distribution of festoons, ferns and coloured strips. Then they proceeded to imitate the contours of buildings, the outstanding projections of columns and gables; in open spaces like *exedrae* they designed scenery on a large scale in tragic, comic or satyric style; in covered promenades, because of the length of the walls, they used for ornament the varieties of landscape gardening, finding subjects in the characteristics of particular places. (7.5.1–2)

53

The movement to and achievement of a zenith in this progress of imitation (from *ingressi sunt ut . . . imitarentur* to *pinguntur*) is marked by the list:

They paint harbours, headlands, shores, rivers, springs, straits, temples, groves, hills, cattle, shepherds. In places some have also the anatomy of statues, the images of the gods, or the representation of legends; further, the battles of Troy and the wanderings of Ulysses over the countryside with other subjects taken in like manner from nature (*cetera . . . similibus rationibus ab rerum natura procreata*). (7.5.2)

The importance of the list is that it asserts the variety and the breadth – the full splendour of the achievement of mimesis. The Vitruvian list is remarkably similar to that other great celebration of the range of realism, the list of wall-painting subjects associated with the Augustan painter Studius in the Elder Pliny.[15] But it is to be a splendour already past; the evolution of painterly progress has even by Vitruvius's own lifetime given way to the Fall: "But those which were imitations based upon reality (*ex veris rebus*) are now disdained by improper attitudes (*iniquis moribus*)" (7.5.2).[16]

Before we turn to the depravities upon which Vitruvius's full moral censure will descend, a word on his criteria for the "real". Whereas the prescription *quod est seu potest esse* (what exists or can exist) seems to point to a modern materialist conception of reality, that Vitruvius has no doubts about including legends and heroes in "subjects taken from nature" shows that we must be wary of equating Roman notions of the "real" too closely with some of our own theories. Vitruvian "realism" (like the realism of Renaissance art) does not question the acceptability of what might be to us problematic "truths," such as myths. Rather (this time more rigidly than in Renaissance practice), Vitruvius wants his subjects to be depicted in a "realist" manner which allows them to appear as if they existed in the three-dimensional "real world". His attack on the corruption of modern taste is directed against the "monsters painted on the wall instead of truthful representations of definite things (*ex rebus finitis imagines certae*)" (7.5.3). The "monsters" turn out to be fantasies which could not exist according to the logic and the rules of the "real world", like images in Mannerist or Surrealist art:

Candelabra uphold pictured shrines and above the summits of these, clusters of thin stalks rise from their roots in tendrils with little figures seated upon them at random. Again slender stalks with

54

heads of men and of animals attached to half the body. Such things neither are, nor can be, nor have been . . . For how can a reed actually (*vere*) sustain a roof or a candelabrum the ornaments of a gable? or a soft and slender stalk a seated statue? or how can flowers and half-statues rise alternately from roots and stalk? Yet when people view these falsehoods (*falsa*), they approve rather than condemn, failing to consider whether any of them can really occur or not (*si quid eorum fieri potest necne*). (7.5.3–4)[17]

This polemic is extreme. After all, no painted illusion could ever finally match Vitruvius's criteria for "what can really occur". In effect, Vitruvius is the first and perhaps most insistent apostle of a dogmatic reflexivity version of "realism", where the history of art is to be seen as the rise to the achievement of imitative verisimilitude.[18] Anything else, "however fine and craftsmanlike" (*si sunt factae elegantes ab arte*, 7.5.4), is a symptom of the Decline and Fall. "For pictures cannot be approved which do not resemble reality" (*neque enim picturae probari debent, quae non sunt similes veritati*, 7.5.4). Just as his rhetoric of decline was a foundation for the rhetoric of corruption in the later history of art, so Vitruvius's myth of the ascent to realistic mimesis was the precursor of Pliny and all his followers from Vasari to Ernst Gombrich.[19] But we must not forget that the decadence against which Vitruvius inveighs is actually the normal practice of his time. Vitruvian realism and the myth of verisimilitude as the aim of art is a prescription and an ideology; it is not any kind of objective description of the visual evidence.

The most revealing terms in the Vitruvian onslaught are *vere* and *veritas* (7.5.4). These mean much more than "lifelike", for they carry the whole weight, the value judgment, of "Truth" as an ethical and aesthetic norm. Vitruvius's attack is couched in the most censorious hyperbole of Roman moral rhetoric (*iniquis moribus*, "improper attitudes", and *monstra*, "monsters", 7.5.3) coupled with an appeal to the *veritas* ("truth") values of the *mos maiorum*, or traditions of the past. This is a dogmatic moral prescription presented as both a nostalgia for the imagined art of a lost past and a rejection of the art of the present. What, we are entitled to ask, is the purpose behind the outburst? What is Vitruvius's hidden agenda? The question matters because art historians' readings of Vitruvius and of Pliny after him have set the aesthetic criteria (the myth of the ascent and the decadence of verisimilitude) that have defined the discussion of art since the Renaissance and have been hugely influential on our own attitudes towards painting.

55

We must begin by being clear about the status of Vitruvius's treatment of the Roman house within his whole project. For Vitruvius was working, as Paul Zanker has so brilliantly shown, at a time when all imagery and building in both the public and private spheres was being marshalled to propagate the new Augustan ideology and the imperial myth.[20] Vitruvius's architectural discourse is not an ideologically innocent manual for architects, but a highly partisan text-book for fulfilling the Augustan political project as it was directed to buildings.

If Augustus could boast that he found Rome built in brick and left it built in marble (Suetonius, *Augustus* 28.3) and devote three chapters of his autobiography to the extent and splendour of his building activities in Rome (*Res Gestae* 19–21), then Vitruvius – both as architect and as writer – was part of the team which provided the know-how for the programme (*De Arch.* 1. praef.). He is quite explicit about the purpose of his book: It is "a detailed treatise" to help Augustus by ensuring that "public and private buildings (*publicorum et privatorum aedificorum*) correspond to the grandeur of our history and will be a memorial to future ages" (1. praef. 3). Insofar as the Augustan project entailed the continuation of late Republican differentials of social class, Vitruvius was quite happy to tie that social programme to his own *métier* of building and to the architectural and decorative injunctions of his sixth and seventh books, which are explicitly dedicated to domestic housing. Indeed, there is no reason why he should ever have supposed that building need not enshrine the distinctions of social class and the preservation of a particular and at least in some respects a repressive system. The implications of "realism" as the aesthetic plank of this social and ideological project are that every object (the taxonomy of the Vitruvian and Plinian lists) can be labelled and ordered according to the criterion of *veritas* (7.5.4). The immense rhetorical and ethical authority of concepts such as "truth" and "nature" was pressed into service as the guarantee for the acceptability of art. Such concepts are a moralising and ideological justification for an art which, as "realism", was to carry the visual standard for the new Augustan settlement.[21] Only in the case of *divus* Augustus, whose "*divina . . . mens et numen*" (divine mind and godhead) dominates the world as early as the publication of Vitruvius's book in the 20s B.C. (*De Arch.* 1. praef. 1),[22] does the system not work in quite the same way. For the emperor is a god and not merely a man; he

formulates, administers and if it suits him alters the rules to which all are subject.[23]

Even if Vitruvius is voicing a personal prejudice rather than the official views of the Principate, his polemic is cast in the moral and ideological rhetoric of the Augustan regime. He sees his book as upholding the dignity of Rome's past and present by prescribing the kinds of buildings and decoration most suited to its greatness (*De Arch.* 1. praef. 3). An insistence on "realism" is a rejection of subversion – a strongly prohibitive stance against the subversive questioning which the paintings of Roman houses pose to the categories by which they are defined. The images Vitruvius attacks (*monstra*) are insidious because they are unreal and anti-realistic (as if the painting of which Vitruvius approves is any more "real"!). But this rhetorical onslaught is merely the self-righteous prose of the system's own self-defence. In fact, Vitruvius does not discuss *actual* examples, but – like Pliny – he presents a list of the proper subjects of naturalism (at the same time an ideal and a nostalgia) which he can then use as a stick with which to beat the degenerate present.

The Vitruvian response to the *monstra* is one of moralistic vituperation. An alternative view of the spectator's attitude is given by Horace in the ekphrasis with which he opens the *Ars Poetica:*

If a painter chose to join a human head to a horse's neck and to introduce variegated feathers all over the juxtaposed members so that a woman beautiful above could taper off into a dark fish, would you, my friends, restrain your laughter when you came to look? (vv. 1–5)

Laughter and caricature (for instance, a wall-painting from a villa near Stabiae that shows Anchises, Aeneas and Ascanius as dog-headed apes with huge phalli),[24] which is to say seeing the joke and laughing at the system, is a response far removed from Vitruvian condemnation. And yet, as Ovid learned, the one attitude with which the system could not cope and which it ruthlessly punished was ridicule; before the serious face of the *mos maiorum* and the republic at last restored, laughter was subversive. Thus, even as he opens his *Ars Poetica* with this ekphrasis, Horace must apologise for it: "Believe me, dear Pisos, the book whose idle fancies are shaped like a sick man's dreams would be like such pictures . . ." (vv. 6–8). Vitruvius, less witty and less subtle than Horace, simply launches into the "sick man's dreams" with all the formidable

rhetoric of "realism". And the history of art, mindful of the Vitruvian text rather than of the images which disprove its veracity as anything but self-righteous polemic and heedless of the ideological programme beneath the pungent rhetoric, has followed him down the same path.

There are several entailments for the understanding of Roman wall-decoration in an analysis of the ideological motivations behind Vitruvius's work. The conventional account of the "four styles" of Roman wall-painting from August Mau (who first proposed this division in 1882) to the present is to distinguish them by "their use of architectural illusion".[25] Ultimately the criteria – ancient and modern – for illusion (whether as verisimilitude or as decadence) are based in the notions of mimesis and "realism" which are inextricably entangled with the Vitruvian and Plinian versions of the Principate's political programme. "Illusion" is not a neutral category. The consequences of this extend far beyond the history of Classical art, but what should be stressed here is that at its roots "realism" is a formulation borrowed from Hellenistic theory and used in *Roman* times for explicitly ideological reasons. It disguised its Roman politics beneath the claim that it was a neutral and ahistorical category of value which was, in the first place, to be applied to the heritage of *Greek* art.

Second, illusion (which is to say the extent that an image approximates to its "real life" referent) is not necessarily a useful category for determining the relationship of the spectator with the image he or she views. For "illusionism" – especially in its Vitruvian polemical formulation as "realism" – focusses our attention on the relation of image and "reality" and specifically directs us away from that of viewer and image. This is hardly surprising in a political project whose intention is to naturalize viewing, to naturalize the socio-political *status quo*, by presenting the act of being in a house or looking at a picture as simply the relation to a prior, fixed and natural reality.[26] For Vitruvius, viewing must be simple – a matter of giving or withholding one's assent, depending on the extent to which an image achieves the summit of *trompe l'oeil*. But the moment viewing is seen as complex – as a process of desire, as a creative act of the viewer's relationship with the image (rather than as merely the passive registering of the "real")[27] – then the naturalized and normative status of the political system is called into question. This Vitruvius could not afford to do, but – to his dismay – Roman wall-paintings did it all the time.

AFFIRMING SOCIAL DISTINCTIONS: VITRUVIUS'S
PRESCRIPTIONS FOR STRUCTURING
THE ROMAN HOUSE

Before exploring just how Roman wall-painting subverted and questioned the socio-political system, let us examine the ways Romans conceived of the social articulation of the house. It is now generally recognized that "Roman domestic architecture is obsessionally concerned with distinctions of social rank".[28] Roman houses formed the locus for the confrontation of patron and clients and were thus the social focus for the principal ritual of patronage in Roman culture.[29] The classic – though brief – presentation is again the *De Architectura* of Vitruvius.

Vitruvius writes explicitly that "magnificent *vestibula, tabulina* and *atria* are not necessary for persons of a common fortune, because they pay their respects by visiting among others and are not visited themselves by others" (6.5.1). By contrast,

the houses of bankers and financiers should be more spacious and imposing and safe from burglars. Advocates and lawyers should be housed with distinction, and in sufficient space to accommodate their audiences. For persons of high rank who hold office and magistracies, and whose duty it is to serve the state, we must provide princely *vestibula*, lofty *atria* and very spacious peristyles, plantations and broad avenues furnished in a majestic manner – also, libraries and basilicas arranged in a fashion comparable with the magnificence of public structures. (6.5.2)

This remarkable summary of the social spectrum of housing explicitly ties houses to the position of the owner in the social hierarchy. It concludes baldly: "If buildings are planned with a view to the character of all the different classes (*ad singulorum generum personas*) . . . we shall escape censure" (6.5.3). In other words, Vitruvius's avowed project to maintain and support the decorum of the Augustan Principate through architecture becomes an overt attempt to bolster the system of social class in Rome. For Vitruvius, domestic architecture is social status made visible.

At the heart of the Vitruvian presentation, and of Roman social sensibilities generally, lies a distinction which can loosely be translated as "public" and "private".[30] The closer a "private" dwelling comes to being like a "public" building, the grander it is and the higher the implied status of its owner. This is why people holding public office should have

houses "comparable to magnificent public buildings" (6.5.2). The conceptual structure of "public" and "private" informs the whole of Vitruvius's account. Vitruvius's fifth book deals specifically with public works (*publici loci*, 5.12.7; *communia opera*, 6. praef. 7), as opposed to private buildings (*privata aedificia*, 5.12.7; 6. praef. 7).[31] Houses belonging to the category of private buildings (as they do in modern culture) form the subject matter of book six. The Roman house, however, was itself a problematic version of the private building. Some of its parts were "private" (*propria loca patribus familiarum*, 6.5.1), and others were "public" (*communia cum extraneis*, 6.5.1).

In effect, like the Berber house in Pierre Bourdieu's celebrated discussion, the Roman house represented not only "private space" in opposition to the rest of the world, but within its internal space, it stood also as a microcosm of this very opposition by containing both "public" and "private" areas.[32] The Roman house functioned simultaneously on two levels. It was both a vital constituent of the Roman social world (in standing for "private space" and thereby establishing the opposition with "public space"), and at the same time, it was a central cultural mechanism for negotiating the very distinction of "public" and "private" (which it in part was responsible for setting up). This social function is further reinforced by the central importance of the theme of public and private in the painted decoration and architectural embellishment of Roman rooms and walls.[33]

Before we focus further on this theme, however, we should look at Vitruvius's language more closely. The key concepts for the articulation of domestic space in the Vitruvian discussion are those generally rendered "private" and "public", or "common".[34] The relevant passage of Vitruvius is

We must next consider by what principles, in private buildings, those apartments should be constructed which are meant for householders themselves (*propria*), and those which are shared in common (*communia*) with outsiders. For the rooms set aside for the family (*propria*) are those into which no one has the right to enter unless they have been invited, such as *cubicula*, *triclinia*, *balneae*, and other apartments which have similar purposes. The common rooms (*communia*), however, are those into which even members of the public can come without an invitation, such as *vestibula*, *cava aedium*, *peristylia*, and other apartments of similar uses. (6.5.1)

The Latin of this passage reads in full:

tunc etiam animadvertendum est, quibus rationibus privatis aedificiis *propria loca patribus familiarum* et quemadmodum *communia cum*

extraneis aedificari debeant. namque ex his quae *propria sunt, in ea non est potestas omnibus intro eundi nisi invitatis*, quemadmodum sunt cubicula, triclinia, balneae ceteraque, quae easdem habent usus rationes. *communia autem sunt, quibus etiam invocati suo iure de populo possunt venire*, id est vestibula, cava aedium, peristylia, quaeque eundem habere possunt usum.

This discussion is extremely interesting. We find Vitruvius constantly glossing his terms (*propria* and *communia*) with explanations that point to their social significance. *Propria loca patribus familiarum* is explained as *in ea non est potestas omnibus intro eundi nisi invitatis* (not everyone has the right to come inside those places unless they have been invited). The emphasis here is on *entry* (*intro eundi*) by invitation to the family's own apartments for a specially selected group of *outsiders*. This meaning is borne out by Vitruvius's representation of the other part of the house with the phrase *communia cum extraneis* – "that area which is shared with outsiders". The explanation of *communia* as *quibus etiam invocati suo iure de populo possunt venire* (to which even members of the public can come without an invitation) implies the accessibility of these rooms to any outsider as well as to members of the family and their guests. As dwellings are in a variety of cultures, the Roman house is a symbolic space which explicates the social distinction of "private" and "public" through the spatial polarity of "inside" and "outside". The house functions as an exclusive precinct (that of the family) open to outsiders in some parts but closed to them in others except under special conditions, such as with the formal granting of an invitation.[35] The whole house is conceived in terms of those places clients may be allowed into and those places they are forbidden (except in the special circumstances of an invitation).

The metaphorical resonance of "public" and "private", with its implications of "inside" and "outside" (or perhaps we should say "available to insiders" and "accessible to outsiders"), reaches deeper than the social definition of house and family to encompass the identity of the individual viewer. The Younger Seneca (*De Ira* 3.35.5) agrees with contemporary anthropology that the viewer is actually constructed with different levels of perception depending upon whether he is "inside" or "outside" the house.[36] Seneca writes:

These same eyes, forsooth, that cannot tolerate marble unless it is mottled and polished with recent rubbing, that cannot tolerate a table unless it is marked by many a vein, that at home (*domi*) would see under foot only pavements more costly than gold – these eyes when outside (*foris*) will behold, all unmoved, rough and muddy

paths and dirty people, as are most of those they meet, and tenement walls crumbled and cracked and out of line. Why is it, then, that we are not offended on the street (*in publico*), yet are annoyed at home (*domi*)?

Grasping, then, both the broad political agenda within which Vitruvius is working and the specific hierarchy of social status which his architectural and decorative injunctions are designed to uphold, let us confront some of the buildings themselves and the decorations against which he inveighs in his seventh book. When the social and ideological agendas in the Principate's architectural project actually come to be expressed in terms that relate to the pragmatics of actual buildings and spatial organisation, Vitruvius seizes on the crucial distinction of "public" and "private" with its spatial resonance of "inside" and "outside". This spatial resonance characterises not only social and topographic conceptions of the house but also the conception of the Roman perceiver expressed in Seneca's portrait. In the next section we shall explore this problematic as it is constructed by the art and architecture of actual Roman houses.

SYMBOLIC INVERSION: SOME ROMAN HOUSES FROM HERCULANEUM AND POMPEII

On one level, houses – and the various tastes according to which they are decorated – simply exist. They form the lived-in environment in which an individual is brought up and experiences his or her society. But this apparent given, or natural quality, which people feel inherently belongs to things they are familiar with, is in fact the product of habituation and conditioning. What seems natural and normal has been naturalised and made normative through constant exposure, use and experience: There is nothing intrinsically natural about how a house is designed or decorated. We have seen in Roman culture that the domestic house and its paintings were explicitly subjected to planning of a highly ideological and social nature. Vitruvius's text is proof that the Principate encouraged architects to think about how their designs for housing helped to structure and to perpetuate social hierarchies, and about how the way in which they decorated houses conformed to criteria of a deeply political and moralising dimension. But how did the Roman houses themselves, the actual edifices in which all of this complex of ideological

prescription was to operate, exhibit and relate to the rules? How were the houses and their decorations viewed?

Because my purpose is to site Roman art in the context of the cultural categories by which Roman viewers would have seen it, I should make clear at the outset my position on the major art-historical classification according to which Roman wall-painting has been analysed. This is, as noted earlier, the "four styles" first proposed in 1882 by August Mau and accepted more or less by subsequent critics.[37] I accept the usefulness of the "styles" as working categories for describing and grouping the visual material. Nevertheless, although the "styles" have been seen by modern art historians as chronological periods in the evolution of Roman art, this is not how they would have appeared in the beholder's experience. A room such as the atrium of the Samnite House in Herculaneum (Figures 9, 10 and 12), with its "first style" gallery and vestibule and yet its "fourth-style" wall-paintings,[38] is considered to be decorated in two distinct styles only for purposes of modern analysis. The evidence of Pompeii and Herculaneum points not to four separate styles of decoration, but rather to the co-existence and synchronicity at a single date (A.D. 79) of a variety of types of decoration which we choose to label "four styles."[39]

Although the "styles" – being a modern invention – may make some analytic sense to us, they do not offer any insight into Roman ways of looking at, or thinking about, art. Indeed, they confuse our understanding of Roman viewing because they impose on the evidence an entirely modern analytic frame. On the face of it, there is a Roman text defending one of the distinctions which Mau later adopted in formulating his "four styles": This is the celebrated polemic by Vitruvius against the degeneracy of modern painting, which we discussed earlier (*De Architectura* 7.5). Vitruvius distinguishes (as do Mau's "four styles") between different kinds of illusionism – images which imitate "real" things and images which imitate things that could never exist. Thus Vitruvius would appear to be giving contemporary Roman backing at least to Mau's division of "second" from "third style".[40] However, as I have argued, to read Vitruvius as if he were providing an *objective description* of the material (as Mau purports to do) would be utterly misguided. On the contrary, Vitruvius's discussion of art is a classic piece of Roman moral *invective* aimed against that most popular of all Roman *bêtes noires*, "decline". Vitruvius is not *objective* but is *polemical* and ideologically motivated. More significantly still, Vitruvius is only

one voice among several. The line he draws between "realistic" and "unrealistic" illusionism is his own line and need not have been accepted by everyone else. His younger contemporary, the orator Papirius Fabianus, who lived in the first half of the first century A.D., in a similar invective against art draws a different line (this speech is preserved by the Elder Seneca, *Controversiae* 2.1.11–13). For Papirius all illusionism, all imitation, is "unnatural" and "debased". It is clear that Roman views of wall-painting were not a static set of objective descriptions (as critics have taken Mau's "four styles" to be); they were the subject of a fierce polemic within the culture which had not yet formulated a final view of what was right and wrong in art, let alone any standard description. In what follows, I shall use the language of the "four styles" as it is convenient and familiar to the reader, but I do not believe in its validity as an illumination of *Roman* ways of viewing.

Some time, perhaps in the first century A.D., the peristyle of the Villa of the Mysteries in Pompeii with its fluted stone columns was remodelled (Figures 3 and 4). A low wall of some 1.5 metres – the technical term is a "pluteus" – was inserted between the columns and continued all the way round the peristyle. Then the whole lot (wall and columns,

Figure 3. Villa of the Mysteries peristyle, Pompeii, first century B.C. to first century A.D. Photo: Silvia Frenk.

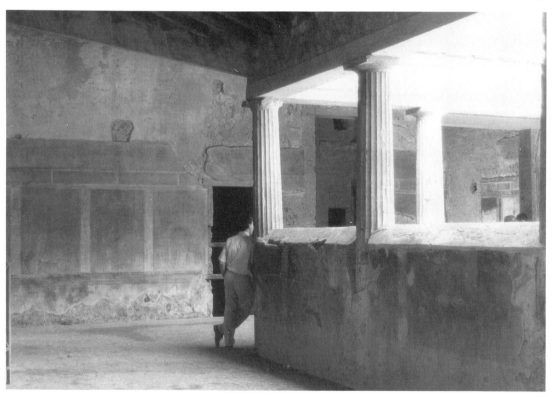

which still extended about another 1.5 metres above the plu-
teus but at their base were part of it) was plastered over and
painted. In effect, the previous cloistered arcade on four sides
had become a square of corridors whose half-walls on the side
closest to the central opening were vividly described by the
excavator, Amadeo Maiuri, as "fenestrato" (windowed).[41]

Such a low-walled peristyle is not unique in Roman archi-
tecture.[42] However, what is remarkable about this particular
structure is that it sets up a "real life" version of the character-
istic painted decoration of a "second-style" room in a Roman
house.[43] The classic description of "second style" presents its
decoration as three-dimensional illusionism in which the
trompe l'oeil of a "complete architectural system was devel-
oped". It is said to adhere to actual or possible structural
forms where, above the frescoed walls and columns, are often
painted a glimpse of the sky, further architectural vistas in
perspective or views into the distance.[44] The effect of being
inside such a room, for instance, the cubiculum of the Villa
of P. Fannius Sinistor at Boscoreale – a room now recon-
structed in the Metropolitan Museum in New York (Plate
1)[45] – is of standing inside a covered enclosed space and
looking out over the *trompe l'oeil* wall. Perhaps beyond this

Figure 4. Villa of the
Mysteries peristyle, Pompeii,
first century B.C. to first
century A.D. Photo: Silvia
Frenk.

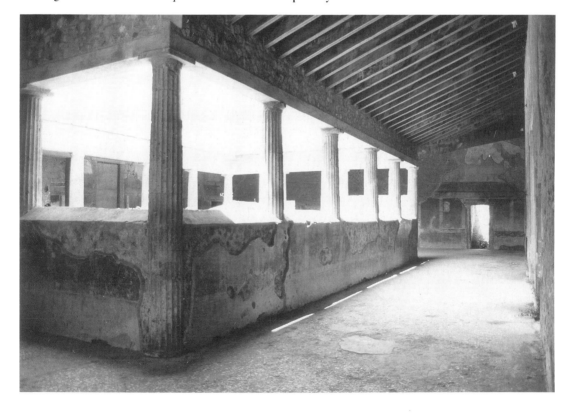

first wall would be a second painted wall "behind" it and beyond that the painted sky and landscape "outside".

The Villa of the Mysteries peristyle recreates in three-dimensional "real life" this "second-style" illusionist structure by presenting the spectator not with a *trompe l'oeil* half-wall opening to an illusion of sky behind, but with the real thing – a low wall between columns.[46] And yet it utterly inverts the process of "second-style" viewing. If one stands inside the central court, around which the peristyle and its pluteus run (Figure 5, *A*), one is actually outside in the open air looking over the wall into the house. Although the beholder stands "inside" the court, his view is not from the inside out (as in a painted room) but from the outside in. When the spectator stands in the portico (Figure 5, *B*) – still within the peristyle court, although outside the central opening itself under the cover of the roof between the house walls and columns extending from the pluteus – his view is over the pluteus from the inside (which is to say, beneath the roof) into the outside (the inner court of the peristyle under the sky). But this is deceptive, because what one actually sees is not landscape outside (as one would in the illusion of some "second-style" rooms, such as Oecus 6 of the Villa of the Mysteries itself) but across the court to the other side of the peristyle and back inside to the relative darkness of the arcade opposite. Were the walls of the peristyle (whether those of the extreme perimeter or those of the pluteus) to have been painted with landscapes at any stage, then the effect would be still more complex, for then interior parts of the house (which one might be viewing from the open air) would bear the painted signs of "outside" – such as foliage or architectural vistas.

The point I am making is relatively simple. Just as Vitruvian textual rhetoric constructed hierarchies of access dependent on the categories of "inside" and "outside" and "private" and "public", so the visual rhetoric of Pompeian architecture played with the same themes. Just as Vitruvius's prose found the categories of "public" and "private" to be problematic (both denoting areas *within* the house and defining the difference between the house and the space *outside* it), so the peristyle of the Villa of the Mysteries emphasises this very complexity. If, in visual terms, "outside" means under the sky as well as outside the house, then some of the house's most internal rooms are "outside" because they are open to the air. As soon as one puts the emphasis on viewing, one discovers that the art of the Roman house highlights an ambivalence

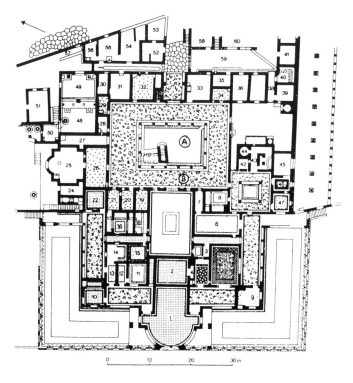

Figure 5. Villa of the Mysteries (after Maiuri). Plan with viewing positions around the peristyle: *A*, inside the central opening of the peristyle; *B*, inside the portico of the peristyle.

Ⓐ = inside the central opening of the peristyle

Ⓑ = inside the portico of the peristyle

and ambiguity of "inside" and "outside" and of "public" and "private". An emphasis on viewing is not anachronistic, for it has been shown that this is precisely the angle from which some of the major Roman poets investigated art.[47] This visual questioning does not simply make problematic the status of particular rooms or buildings. It is, more fundamentally, a questioning of the viewer himself as the one who constructs "inside" and "outside", and thus – obliquely – a questioning of the whole social system in which the viewer has his part. In this sense not only do Roman houses set up and define the structure of Roman society and class, but they also reveal, question and deconstruct it.

The complications of "inside" and "outside" are not confined to actuality. In the *trompe l'oeil* of Pompeian rooms there may be a play of one part of a room being "enclosed" and another being "open to the outside". For instance, in Oecus 6 of the Villa of the Mysteries,[48] the murals in the northwestern half of the room represent an interior peristyle and "behind" that a panelled wall not open to the sky at the top (Figure

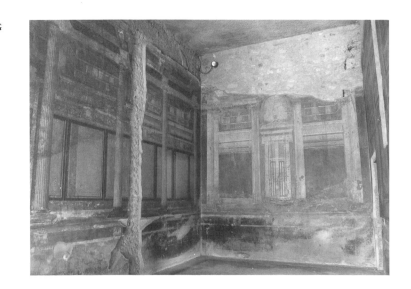

Figure 6. Villa of the Mysteries, Oecus 6, Pompeii, first century B.C. Photo: Silvia Frenk.

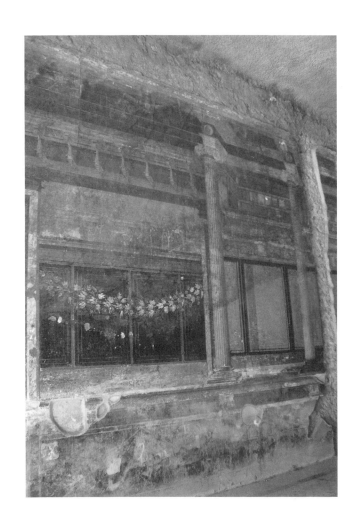

Figure 7. Villa of the Mysteries, Oecus 6, Pompeii, first century B.C. Photo: Silvia Frenk.

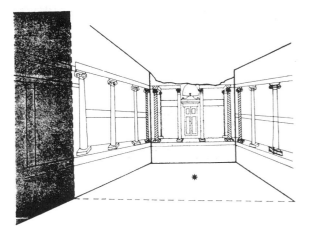

＊ = "ideal" viewing position suggested by the room's perspective

Figure 8. Villa of the Mysteries, viewing positions and perspectives in Oecus 6 (after Corlàita Scagliarini).

6). This is an enclosed room – an "inside". However, the southeastern side of Oecus 6 is painted as an interior peristyle with illusionist frescoes representing a wall and "behind" this an "outside" open to the sky (Figure 7). It is as if we are no longer in an interior room but in one which is at least open to the outside. In addition, in Oecus 6 there is much play of real doors and false doors, with a real door (the one through which we enter) in the southeast wall and a painted door facing it in the northwest wall (Figure 6).

Scholarly discussions have emphasised the play of different kinds of perspective implicit in such divided decorations.[49] In Oecus 6, for example, there is an ideal viewpoint implied by the perspective midway between the side walls and some two-thirds of the way from the door (see Figure 8). The perspective implies that the room was decorated to be seen *as a whole*, encircling the viewer from a particular point.[50] It is because the room is carefully designed and painted *to be* a whole, that the effect of its play of "inside" and "outside" is so complex

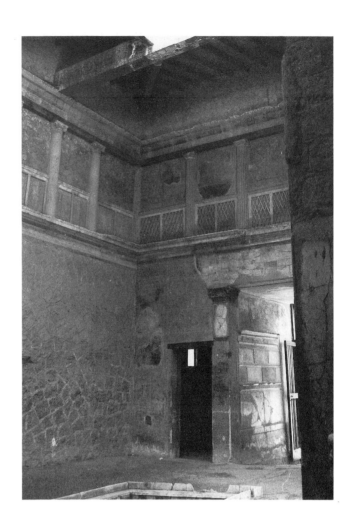

Figure 9. Atrium of the Samnite House, Herculaneum, first century B.C. Photo: Silvia Frenk.

and disturbing. The room's *trompe l'oeil* constructs an architectural decorative scheme which makes its "insideness", its status as an interior room, problematic. Furthermore, within the room there is a questioning of just which parts are more or less interior – as if the frescoes were representing a series of "levels", a hierarchy, of insideness.

When one takes the cumulative decorative effect of this room and of others similarly playing with levels and transgressions of "inside" and "outside" in the Villa of the Mysteries (for example, *cubicula* 8 and 16)[51] and compares it with the inversion enacted by the peristyle, it appears that the problems implicit in these social-architectural categories are being unashamedly emphasised. It is as if the decoration of the house is obsessed with the weirdness, the unnaturalness,

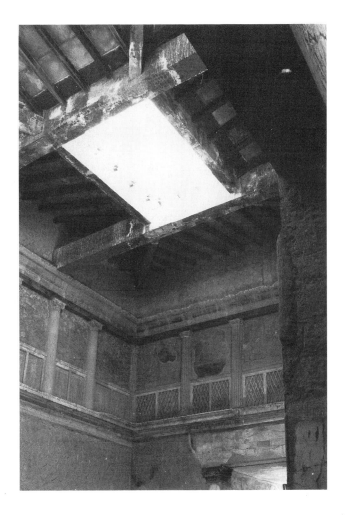

Figure 10. Atrium of the Samnite House, Herculaneum, first century B.C. Photo: Silvia Frenk.

of the categories which define its articulation both as a building and as a social experience.

In the Samnite House at Herculaneum, this complexity within a single room is still more strongly marked because it adds the *frisson* of false and real stucco colonnades.[52] One enters the atrium from a vestibule decorated in "first style" (Figure 9) – that is, where plaster is constructed in three dimensions and painted to resemble marble veneer.[53] This atrium, one of the largest in Herculaneum,[54] is in other respects typical of many houses in both Herculaneum and Pompeii. It has a marble impluvium in the centre of the floor to catch the rainwater and a compluviate roof with a large opening in the middle (Figure 10) to let in the light (and the rain). Of course, one reason for these openings is functional – to

light not only this room but also those adjacent to it. But the corollary is a play on whether this interior space is an inside room or an outside room – a problem that reaches its peak in the high art of the Pantheon in Rome, whose famous oculus, which allows in the light, is open to the elements. Like the Pantheon, all such compluviate rooms have an uneasy or ambiguous status as to whether they are quite inside rooms or outside rooms. The Pantheon, of course, is a public space and a very public building of official worship; but it may be significant that atria, like peristyles, belong to Vitruvius's category of *communia cum extraneis*, or "common with outsiders" (6.5.1).

However, the special interest of the atrium in the Samnite House lies in its decoration at gallery level: On the level of the upper storey, on the side at which one enters and on the two adjacent sides, there is a magnificent false gallery, finished in stucco, of fluted ionic half-columns joined by a low perforated parapet. In a sense this embellishment might be described as the "first-style" equivalent of "second-style" architectural features, such as the perforated fence in the lower foreground of the "Garden Room" from Livia's villa at Prima Porta (Figure 11).[55] But in the fourth wall, opposite the vestibule door and below the compluviate ceiling, the false pilasters and imitation fence break into reality (Figure 12). There is no wall at gallery level for them to decorate; they stand as

Figure 11. Livia's Villa at Prima Porta, garden view and fence (now in the National Museum in Rome), first century B.C. Photo: Alinari-Art Resource, New York.

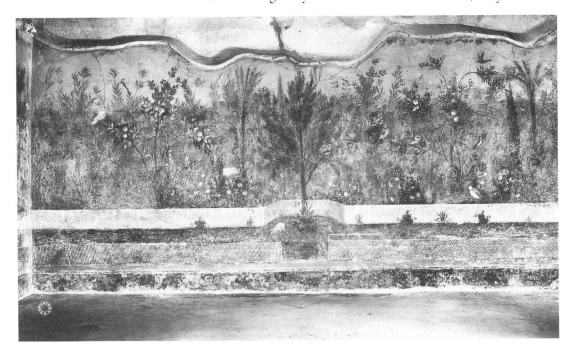

72

themselves – an ornamental feature turned functional, for they hold up the roof. Just as in the part of Oecus 6 of the Villa of the Mysteries where the painted architectural decoration with its stress on the illusion of solid walls abruptly breaks open to reveal the illusion of half-walls and "behind" them the "outside", so here the interior compluviate atrium (open to the outside only through its roof) breaks open its wall on the far side from the street entrance "really" to reveal the outside. Of course, this outside – from the viewer's level, the sky – is actually the space above the tablinum, which is the next room on from the atrium.[56]

In none of this has the decoration abandoned "realism" in that all its motifs, whether in two or three dimensions, imitate

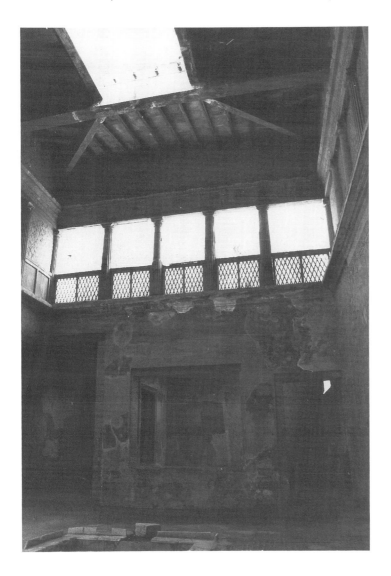

Figure 12. Atrium of the Samnite House, Herculaneum, first century B.C. Photo: Silvia Frenk.

73

the actuality of real architecture. But none of these effects creates the impression of "actual reality". One wonders, in the case of the Samnite House, whether the "real" gallery of stucco pilasters and parapet is imitating the "false" one or vice versa.[57] The illusionism conjures an altogether transgressive world which seems to question the world it imitates, that is, to deconstruct the rules of the reality on which it is self-consciously based. It is an example of what anthropologists have labelled "symbolic inversion".[58] The challenge here is on two levels: first to the notion that the real world can be imitated at all, that "realism" is any more than a pastiche, a set of illusionist tricks which contradict one another. The extreme version of this challenge would be to deny the "reality" of the real world itself and see it as merely a set of constructions, a set which is in its own way as contradictory and ambiguous as are the "realisms" of Pompeian walls. Second, Pompeian illusionism – by playing visually and spatially with the categories of "inside" and "outside", of "private" and "public" spaces, upon which Vitruvian rhetoric deemed the social structure of the Roman house to be based – is implicitly challenging the naturalness of this social structure.[59] In short – like Mannerism, or like the Surrealism of Magritte, De Chirico and Dali when they refused to abandon the naturalistic idiom whose motifs they juxtaposed to such surreal effects[60] – the decoration of Roman houses in the first centuries B.C. and A.D. seems to challenge the viewer by undermining the reality (both social and natural) which it presupposes.[61] As Vitruvius already saw, it is the process of realist *viewing* itself which is at stake in the villas of the Roman middle class.

VIEWING AND DESIRE: THE VIEWER AND THE VIEW

Where does the viewer stand in relation to the surrealism displayed with such exuberance on the walls, in the structure and in the architectural ornaments of his or her house?[62] It has recently been argued of Roman wall-painting that "from the point of view of the social function of decoration what matters is not the visual games played, but the associations evoked, by the decoration: its power not of *illusion* but of *allusion*".[63] This approach indicates an attempt to reintegrate the viewer into the impact of images in Roman houses beyond

being simply the one who approves or condemns as in the
Vitruvian account.[64] However, the ideological programme of
Vitruvian "realism" shows that the visual games are them-
selves socially determined and of central importance as part
of a visual questioning of the categories for social function. In
other words, as I hope I have shown in the preceding section,
the visual games are crucial to the way the Romans con-
structed social meaning.

The question of allusion, therefore – not what an image
alludes to, but what that allusion signifies – is impossible to
separate from the status of that allusion as an illusionistic
picture, as a phantasy rather than a reality. Whereas commen-
tators agree that the views on Roman walls generally evoke
wealth and grandeur, there have been two theories on what
such evocation signifies. The first supposes that illusionistic
pictures offer us in some sense the world they imitate.[65] The
second suggests that such images – because they offer an
imitation and not the "real thing" – actually deny to the
viewer the world they reflect.[66] Paradoxically, these positions
are both in fact true. They represent the poles between which
the viewers' desires must be constantly oscillating.

The essential point of allusion is that it offers not a final
answer or a gradation of levels as does "realism", with its
notion of the perfect and essential copy, but a constant play
with desire. Furthermore, Roman allusion must aim at the
impression of verisimilitude because it constantly proffers the
promise of real things (that landscape, that bowl of fruit, that
vista of a town) just around the corner as it were, just through
the wall. In this sense the illusionism of Roman allusive art is
fundamentally implicated in a materialist view of the most
suitable objects of desire.[67] Even the Divine is locked into this
materialism – so that the famous Priapus in the vestibule of
the House of the Vettii in Pompeii is actually weighing his
phallus against a bag of money. Because Roman houses are
inextricably linked with social-status considerations, and be-
cause better in this context means bigger and more open to
larger quantities of clients, the allusion must work by means
of the illusion of more "outside", of a private space almost
completely public.[68] Our problem is that we cannot pinpoint
precise meanings for such illusions, but we can situate the
sphere of the viewer's desire within which a multiplicity of
such meanings will be evoked. That desire, like everything
else about a Roman house, lies in the materialist realm of
social status.

To go deeper into the operation of desire in the Roman house, we must observe a further link between allusion and the illusionism of Roman walls. Roman murals of all "four styles" tend to represent architectural ornament which either encloses the viewer within a room ("first", early "second" and "third" styles) or offers glimpses into a world outside or beyond, glimpses through illusions of architectural frames that are more or less "realistic" ("second" and "fourth" styles). Thus the images of Roman wall-painting, like the problematics of "inside" and "outside", are essentially a matter of the existence or non-existence of the *view*. Again wall-painting is playing with exactly the same issues as is architecture – one of the marks of an atrium or a peristyle, as we saw earlier, is that it is always a space that allows the viewer to glimpse other spaces, to see more of the house. The view – the nature of a spectator's relationship between here and there, the place from which he or she looks and the place to which the looking is directed – is thus perhaps the crucial determining factor, not only of Roman wall-painting but also of the visual and social articulation of the Roman house.[69]

Roman depictions of houses are obsessed with the view. Here is the Younger Pliny, nephew of the encyclopaedist and a distinguished orator of the last years of the first century A.D., describing the *triclinium* of one of his villas, on the coast at Laurentinum near Rome:

It has folding doors or windows as large as the doors all around, so that at the front and sides it seems to look out onto three seas, and at the back has a view through the inner hall, the courtyard with two colonnades and the entrance hall to the woods and mountains in the distance. (*Epistulae* 2.17.5)

In two letters (2.17 and 5.6),[70] Pliny describes his villas as though one is passing through them – presenting virtually a list of rooms, in order,[71] and frequently emphasising the views through the rooms back to other rooms or out to the garden and the sea.[72] In fact, educated Romans like Pliny were remarkably sensitive to the environmental context of a house, the flow from room to room and object to object. The context is most strongly experienced as a set of views. The Romans' awareness of this topographical sense of flow in architectural space led them to use it in the most remarkable way as a mnemonic tool to structure the way they memorised their speeches. In a culture which put such a strong emphasis on rhetoric in education and intellectual life as did the Roman

world,[73] this gives the importance of a person's relationship with his or her house *as a viewer* a heightened and privileged status. Before looking directly at views in Roman houses, we should venture down the strange side-alley of memory and its relation to the Roman house.

Here is the Roman theorist of rhetoric, Quintilian, writing in the first century A.D., describing the orator's use of the Roman house as a tool for memorising the structure and co-ordination of a Roman speech:

Some place is chosen of the largest possible extent and characterised by the utmost possible variety, such as a spacious house divided into a number of rooms. Everything of note therein is carefully committed to the memory, in order that the thought may be able to run through all the details without let or hindrance Particular symbols which will serve to jog the memory . . . are then arranged as follows. The first thought is placed, as it were, in the *vestibulum;* the second, let us say, in the *atrium;* the remainder are placed in due order all around the *impluvium* and entrusted not merely to *cubicula* and *exedrae* but even to the care of statues and the like. This done, as soon as the memory of the facts requires to be revived, all those places are visited in turn, and the various deposits are demanded from their custodians, as the sight of each recalls the respective details. (Quintilian, *Institutio Oratoria* 11.2.18–20)

The "symbols" Quintilian mentions are specific images or words which can bring back to the orator's mind the subject of his speech or even an actual sentence at a particular point in his discourse (the point, for example, of the *vestibulum* or *atrium* or statue in the house which the speaker has memorised and through which he progresses in his mind's eye as he delivers his oration). This art of memory had a significant place in the Roman art of rhetoric,[74] as is demonstrated by the fact that not only Quintilian in the early Empire, but also two rhetorical treatise writers from the late Republican era discuss it in some detail as part of their general instructions on oratory.[75]

The significance of this art of memory for the art historian and the social historian has not been sufficiently explored. If the Roman house,[76] the layout of a dining-room,[77] the common architectural forms of the late Republic and early Empire,[78] served regularly as the means for ordering and memorising speeches, then equally the order and structure of these very houses, dining-rooms and architectural forms are the three-dimensional embodiment of the process of structuring thought. Just as the periodic sentence and the rhetorical

speech may be co-ordinated and constructed through the memorised vision of a house, so the Roman house in the totality of its rooms and decor (not forgetting the statues, as Quintilian reminds us)[79] is one representation of the structure of Roman rhetoric.

Romans *thought* by means of their houses – their visual and architectural environment. It is this environment (not only houses but all kinds of *loci*, from Simonides's banqueting room to "public buildings, a long journey, the ramparts of a city, or even pictures")[80] which defined the Roman art of memory and which structured Roman discourse. When Romans thought about embellishing their environment – about improving houses, about building new houses, about making gardens – it was precisely the rhetorical process conditioned by the visual memory which they brought to their architecture and art. Just as Roman oratory is conditioned by architectural and visual imagery to a remarkable degree, so the decoration and structure of the Roman house is in its turn conditioned by the rhetorical process which was later to make use of the house as an *aide-mémoire*. In effect, we cannot draw a sharp distinction between the architectural and visual world of the Roman educated elite on the one hand and their mental and rhetorical world on the other. Together they make up the *mentalité*, the particularity and identity of Roman civilization: Each was the precondition and determining impulse behind the other.

There are a remarkable range of issues raised by a closer art-historical examination of the treatises on memory. For example, they offer valuable evidence for the existence of a self-consciously non-literal, metaphorical, system of viewing in the Roman world which subjected the most commonplace and familiar images to a set of symbolic meanings that specifically had no direct relation to the original object. It might be quite normal for a statue off a peristyle to represent the third paragraph of a Ciceronian speech! This is exegetic viewing of remarkable sophistication. And, unlike most exegetic viewing in Classical or Christian antiquity, it is categorically not concerned with religious interpretations or meanings. A second area, one highlighted by the distinguished cultural historian Frances Yates, is the "astonishing visual precision" of Roman viewing to which these works on memory bear witness. In the classically trained memory even the space between *loci* can be measured and the lighting of the *loci* is allowed for.[81] Cicero's emphasis (initially surprising to us) on the sense of *sight* in rhetoric (*De Oratore* 2.87.357) makes the

point nicely. The speaking is based on a viewing: The Roman speech is the rhetorisation of a prior and visually re-lived view.

This rhetorical use of a memorised "visualisation" is a classic instance of the importance of *phantasia* in ancient culture, which we discussed in the previous chapter. The visualisation of the house in the orator's mind *is* a *phantasia*. Instead of bringing this specific *phantasia* to his listeners' minds through ekphrasis, the orator (in this case) presents the visualisation *through the structure* of his speech. In effect, a rhetorical speech is a metaphorical ekphrasis. A speech uses all the skills of ekphrasis (its clarity, visibility and sharpness) to construct an ordered discourse which has a metaphorical relationship to the original *phantasia* of the house.

In particular, I want here to emphasise one aspect of the Roman art of memory and its relation to the Roman house. This is the notion of order or series (*ordo*), which is one of the most important qualities of a house for the oratorical handbooks. It is precisely because the various *loci* (such as the *vestibulum*, *atrium* and *impluvium* suggested by Quintilian) must be memorised in a particular order as one moves through the house, that this movement from *locus* to *locus* can be used to structure a speech. As Cicero puts it, the order of the *loci* will preserve the order of the material to be remembered (*De Or.* 2.86.354). The notion of the series, of the view as it were from one *locus* to the next, is crucial – as the Auctor ad Herennium makes explicit (*Ad. Her.* 3.17.30). Once the viewer-memoriser is sufficiently skilful, he can move (which is to say, give his speech) in any order – "forwards or backwards" (3.17.30) – so that "if the *loci* have been arranged in order, the result will be that, reminded by the images, we will repeat orally what we have committed to the *loci*, proceeding in either direction from any *locus* we please" (3.18.30). In other words, unlike ekphrasis which necessarily freezes the speaker's *phantasia* in a particular order or structure, the range of possibilities for the ordering of paragraphs in a speech allows a much greater flexibility and freedom to the orator's use of his memorised vision, his *phantasia*.

The art of memory co-ordinates a Roman speech and the "order" in which the speech is seen. It is visual and three dimensional – using the awareness of other rooms, other floors and particular features of decoration which one has on entering one room of a house from another. In essence the art of memory is a means of exploiting this three-dimensional environmental sense with all its flexibility to the needs and

demands of rhetoric. What matters about a house, as far as the rhetorical treatises are concerned, is this dynamic sense of movement – from room to room, from object to object – so that the *ductus locorum* (the flow of place to place) matches the *ductus litterarum* (the flow or structure of the speech). This environmental sensibility for the relation of a part of a house to other parts, and to the whole, is an essential element in Roman viewing. It is an important constituent of the notion of the "view" – which is precisely the visual relation of one part of the house or city or landscape to another or to the rest.[82]

Beside the aesthetic or experiential aspect to Roman domestic viewing, and in addition to the remarkable intellectual quality of using one's view of a house as an *aide-mémoire*, there was always (as we have seen) a flavour of social status about how Romans looked at their house. Furthermore, the language by which the paintings that decorated Roman houses were described (at least by Vitruvius in the Augustan period) was the result of a carefully constructed ideological polemic designed to preserve the social and political distinctions of which the Roman houses themselves were part. The paradox is that the language prescribed one set of rules ("realism") while the paintings and architecture played with and challenged those rules ("surrealism"). It remains to bring these strands together in order to examine the importance and yet the ambiguity of the *view* – that complex relationship between the beholder and what he or she sees, between individuals and their social world, in which subjectivity is constructed.[83]

Describing his villa at Laurentinum near Rome (*Epistulae* 2.17), the Younger Pliny repeatedly remarks on the views from his more elegant rooms. A householder as well as an orator, Pliny as viewer was concerned with the environmental flow of his house, with the directing of the view through and out of the house. The *triclinium* (2.17.5), as we have seen, looks to the sea on three sides and on the fourth side looks back all the way through the house to the countryside beyond the atrium. Off this, there is a *cubiculum* with a view of the sea (2.17.6). On the upper floor there are more rooms with prospects of the sea, the garden, the coast and other villas (2.17.12–13). The *triclinium* on the other side of the house away from the sea "has a view as lovely as that of the sea itself, while from the windows of the two rooms behind can be seen the entrance to the house and another *hortus*"

(2.17.15). The main point made of the *cryptoporticus* is Pliny's mention of its windows opening on both sides (but more to the side of the sea) (2.17.16). Furthermore, Pliny's own favourite suite of rooms (2.17.20f.) is distinguished by a "sun-parlour facing the terrace on one side, the sea on the other and the sun on both". Its rooms open onto the sea, the *cryptoporticus*, the neighbouring villas and the woods – "views which can be seen separately from its many windows or blended into one" (2.17.21). When describing his villa in Tuscany (*Epistulae* 5.6), Pliny is no less insistent on the view: "My house is on the lower slopes of a hill but commands as good a view as if it were higher up" (5.6.14). He continues his description:

> from the end of the colonnade projects a *triclinium:* through its folding doors it looks on to the end of the terrace, the adjacent meadow and the stretch of open country beyond, while from its windows on one side can be seen part of the terrace and the projecting wing of the house, on the other the tree-tops in the enclosure of the adjoining riding ground. (5.6.19)

Likewise the *cenatio* "looks on to the small courtyard, the colonnade and the view from the colonnade" (5.6.21).

For Pliny, the articulation of his house, the reason for his pride in it and the most effective method of communicating what he sees as its best qualities are all defined by the view. This emphasis on the view can be seen not only in texts but also in surviving villas and, as we have observed, in their wall-paintings.[84] There is, moreover, a constant emphasis on the relationship of rooms to the light and the sun – a further example of the "environmental sense", this time referring not to a room's view of the outside, but to the outside's penetration of a room.[85] Finally – and again very relevant to the view – Pliny indulges in lavish descriptions of the countryside (both cultivated and wild) in which his villas are set.[86] The villa cannot be separated from its setting, just as its rooms cannot be considered without reference to the light which enters them from outside and the views which they offer onto the outside.[87]

Pliny's concern with the view and the lighting of his villas is not idiosyncratic.[88] Precisely these issues are built into Vitruvius's injunctions about the layout of domestic housing, especially in his sixth book. In Vitruvius there is a repeated emphasis on light: *Cubicula* and libraries should face east; baths and winter rooms should take their light from the sunset

(*De Arch.* 1.2.7; 6.4.1). Picture galleries and rooms needing a steady light (such as weavers, workshops and painters' studios) should be lit from the north (1.2.7; 6.4.2). Spring and autumn *triclinia* should look east, but summer dining-rooms should face north (6.4.2) to avoid excessive light and heat. In villas,

> care is required that all buildings should be well lighted. This is an easier matter with those on country estates because there are no neighbours' walls to interfere; whereas in cities, the heights of party walls or the narrow streets are in the way and obstruct the light.[89] (6.6.6)

Vitruvius's worry about light, especially in towns like Pompeii, causes him to suggest that walls should be opened at the top, especially if beams, lintels or flooring interfere with the entry of light (6.6.6–7). Campanian practice (such as the gallery in the *atrium* of the Samnite House in Herculaneum, Figure 12) gives evidence of this method of lighting a room. Furthermore, the way "second-style" walls are painted with the illusion of an opening at the top to receive daylight seems to indicate a *trompe l'oeil* play with precisely this feature of Roman architecture. Again the discussion and aesthetics of light reflect on the problematics and the play of "inside" and "outside" in Roman domestic space.

The corollary of this emphasis on light and the view in architecture, however is that Roman three-dimensional space is actually constructed with as much *trompe l'oeil* – as much play on forms, spaces and illusions – as is Roman wall-painting. In a remarkable passage, Vitruvius admits as much:

> The appearance of a building (*species*) when seen close at hand is one thing, on a height it is another, not the same in an enclosed space, still different in the open, and in all these cases it takes much judgment to decide what is to be done. The fact is that the eye does not always give a true impression (*veros effectus*), but very often leads the mind to form a false judgment (*fallitur saepius iudicio ab eo mens*). In painted scenery, for example, columns may appear to jut out, mutules to project, and statues to be standing in the foreground, although the picture is of course perfectly flat. Similarly with ships, the oars when under the water are straight, though to the eye they appear to be broken Now whether we see by the impression of images upon the eye, or by the effusion of rays from the eyes, as the natural philosophers teach us, both explanations suggest that the vision of the eyes gives false judgments (*falsa iudicia*). Since, therefore, what is real (*vera*) seems false (*falsa*), and some things are approved by the eyes as other than they really are (*aliter quam sunt*),

Despite the firm insistence on the "real" (oars are straight and not bent whatever the phenomenology of perception may tell us), Vitruvius is nevertheless caught in the double-bind of his own acute understanding that "the vision of the eyes gives false judgments". The moment he orientates his discussion on the spectator, as any good architect must, he is trapped in his own clear sense of the deconstructive complexities of illusion and deception, where the "real" is "false" (as he admits when telling us that apparently three-dimensional *trompe l'oeil* stage scenery "is of course perfectly flat"). Vitruvius's problem is how to relate the phenomenology of perception (to which he must give precedence if he is to design buildings most effectively to accommodate the viewer) with what is "really" the case (his ideological stance in relation both to wall-painting and to the "facts"; for instance, that an oar is "really" straight and not bent). Nothing indicates this problem so clearly as his use of illusionist painting (such as stage scenery) as a programmatic exemplum for how the viewer sees a house. From this exemplum we can be quite sure that Vitruvius is aware that even the paintings which he so praises at 7.5 for their *veritas* (their imitation of the "real" rather than the "false") are – in his own terms – themselves *falsa*, the deliberately designed deceits by which *fallitur saepius mens* (the mind is often deceived).

For Vitruvius, architecture is as much an illusion as painting. Both are a matter of "diminutions and additions to suit the needs" of viewers; both are a matter of the view. Decoration is not separable from or secondary to the building it decorates, because the example of illusionist architectural painting is both the metaphor and the metonym out of which Vitruvius constructs the viewer of architecture and hence the architecture that will suit (and deceive) the viewer. It follows that all the "real life" views that Pliny mentions with such pride are designed with that very (dangerous) sense of illusionism which – in the case of paintings – Vitruvius feels he must constrain between rigidly "realist" boundaries in his polemic of Book 7. Hence in architecture "there follow . . . the adjustment (*apparatio*) of the proportions to the decor so that the appearance (*aspectus*) of eurhythmy may be convincing (*non dubius*) to the observer" (6.2.5). Vitruvian architecture is as much *trompe l'oeil* as painting. But the problem is that

aspectus (like *species* a term which ignores the image-referent relation in favour of the "deceitful" effects of images on viewers) must be a highly problematic concept to one who will shortly be insisting with such moral surety on the virtues of "reality" as opposed to "falsehood".

Vitruvius admits that from the stance of the observer there is no essential difference between the logic of a "real" (three-dimensional and architectural) view and the logic of a "false" (painted) one. Here Quintilian, in his prescriptions on memory, agrees: "What I have spoken of as being done in a house, can equally well be done in connexion with public buildings, a long journey, the ramparts of a city or even pictures. Or we may imagine such places to ourselves . . ." (*Inst. Or.* 11.2.21). All these kinds of views – "real", painted or imagined – are, from the standpoint of the complexities of viewing, substantially the same. But they are all problematic.

In the case of the "realist" art and views approved by Vitruvius (i.e., the "second style"), a view is both access and denial. From a particular place one catches a glimpse of the world – something possible and possessable. That world defines and articulates the place one is, that is, the place from which it is seen. But although the view offers that world, it also simultaneously refuses it – for, by definition, a view implies absence, implies a "somewhere" that is not "here". The viewer is constructed as one to whose desire the world he has glimpsed is simultaneously offered and denied. Thus the viewer is defined as both the one who desires what he sees and the one whose desire is curtailed by the absence of or distance from what he sees (in the case of painting, by the fact that what he sees is not real). Both Roman houses and their images put the viewer into a position of conflict and contradiction. They make that conflict explicit.

In the art which followed the kinds of paintings Vitruvius condemns (i.e., "third" and "fourth" styles), where images partake of the perspectival rules of illusionism but present the viewer with an entirely "surreal" effect, the function of the view is different. Instead of locating conflict in the observer, this art transposes the contradictions to the very walls themselves. What one sees, displayed to such transgressive effect on, for instance, the "architectural" frames of the walls in the Pentheus room of the House of the Vettii in Pompeii is the contradiction of the rules themselves. Mapped onto such "third- and fourth-style" walls is the conflict of the desire that operates by the rules. The laws of illusionism, which govern both wall-painting and house design, whether presented as

mathematical, prescribed by ideology or inscribed in the practice of ancient perspective,[90] are not "innocent". They "make" the world and formulate the seen into a particular relationship with the spectator. Thus, to see according to the laws is to curtail the possibility of "really" (i.e., innocently) seeing what is "really" there (i.e., what exists objectively outside the laws). For the "real" is seen only as represented by the rules. Thus, to see according to the rules is to see the rules themselves displayed in both their tyranny and their contradiction; it is to see that ideally (but impossibly) one might see without the rules; it is to see the possibility of there being more to see beyond the rules and to have that possibility denied, limited, curtailed by the necessary organisation of seeing according to rules without which we could not relate to what we see. This is the deconstruction of viewing (and of the ideologies and rules of viewing) which Vitruvius so detests and which "candelabra upholding pictured shrines" ultimately imply.

THE ROMAN HOUSE AS A CULTURAL SYSTEM

The Roman house was a strange conflation of official policy and private transgression. Its structure and forms explicitly embodied the social hierarchy. In Vitruvius's idealist and prescriptive account, the key term used for decor appropriate to it is *veritas* – the "real" – because *realism*, that is, an illusionism which never loses sight of "real" referents in the natural world, visually implies that the social rules governing the house and its decor were themselves natural, given. Yet the surrealism of actual decoration, like some kinds of postmodernism today, paraded precisely the arbitrariness, the pastiche, the ambivalence of the "real". In doing so, Roman houses – again like postmodernism – playfully made explicit the arbitrariness of the rules which governed the social articulation of the house. In effect, the Roman house deconstructs the viewer into one who looks by certain laws (social, visual, ideological) and one who is confronted by images which in different ways expose the way he looks. The viewer simultaneously sees and sees how he sees, that is, sees how what he sees is problematically constructed. It remains to ask what this deconstruction might mean.

One reading of Vitruvius's polemic would suggest that this deconstruction was perceived as a threat. We might follow the direction of the moral rhetoric and see Roman houses as

always implicitly subversive. We might infer that the system was always paranoid about the flagrant transparency with which its contradictions were flaunted in every house in the land. However, although Vitruvius is certainly evidence for ideological constraints, the fact is that even such art as he fails to condemn was deconstructive in the way it undermined viewing and substituted "false" for "real". Other moral rhetoricians go further. The orator Papirius Fabianus is unwilling even to spare "second-style" paintings. His moral outburst against painting is a truly Platonic condemnation of all imitation:

Men even imitate mountains and woods in their foul houses – green fields, seas, rivers amid the smoky darkness Who could take pleasure in such debased imitations if he was familiar with the real thing (*vera*)? . . . They pile up great buildings on the seashore and block off bays by filling the deep sea with earth; others divert the sea into ditches and artificial lakes. These people are incapable of enjoying anything real (*veris*). Their minds are so twisted they can only get pleasure from unnatural imitation of land and sea in the wrong places. (In the Elder Seneca, *Controversiae* 2.1.13)

By its virulent condemnation, the moral polemic naturalises "unnatural imitation" as quite normal. It is not right, but, like the brothel, it contains the transgressive and subversive inclinations of citizens within an entirely acceptable social sphere. On this reading, the very deconstruction of some central concepts in Roman culture by the Roman house is perhaps domestic architecture's supreme contribution to upholding the system.[91]

Clifford Geertz has argued that "any art form . . . renders ordinary, everyday experience comprehensible by presenting it in terms of acts and objects which have had their practical consequences removed and been reduced (or, if you prefer, raised) to the level of sheer appearances, where their meaning can be more powerfully articulated and more exactly perceived".[92] Roman houses reinforced, represented and made the cultural system comprehensible. By so blatantly exhibiting the contradictions of the cultural rules, they made those rules understandable to every viewer in his or her most intimate space. Thus Roman houses operated on the most generalised social level. As Claude Lévi-Strauss has suggested of Caduveo body painting, Roman domestic decoration (and its deconstruction of not only the viewer but also the concepts by which social differentiation is constructed) presents in the most private space a subversive myth of what might happen in Roman culture "if its interests and superstitions did not

stand in the way".[93] Such phantasies of the impossible on some cultural level (but often in the arts) are a culture's necessary mythic response to its own strong institutions.

Roman houses also had a significant role on the personal as well as on the general level. As with cockfights in Bali in the celebrated discussion of Clifford Geertz, by playing on the social boundaries of "public" and "private", Roman walls enabled Romans to see a dimension of their subjectivity.

Yet because . . . that subjectivity does not properly exist until it is thus organised, art forms generate and regenerate that very subjectivity they pretend only to display. Quartets, still lifes and cockfights are not merely reflections of a pre-existing sensibility analogically represented; they are positive agents in the creation and maintenance of such a sensibility.[94]

In Roman culture, wall-paintings were a primary artefact for generating subjectivity, and Roman viewing was the means by which this subjectivity was created.

VIEWING AND THE SACRED:
PAGAN, CHRISTIAN AND
THE VISION OF GOD

CLASSICAL art history has tended to take the viewer for granted in its analysis of artistic forms and to assume (without discussion) that the viewing eye is unbounded by the constraints of its time and conceptual framework. This chapter examines a different way of viewing from those implied by the "realism" of Vitruvius or the ekphrases of Philostratus. It represents, broadly speaking, a mystic development of the kind of exegetic viewing which we explored in the *Tabula* of Cebes. This method of looking at art is rather unfamiliar to most Westerners today, and I have called it "mystic viewing". In the case study which occupies the second half of the chapter, I apply the conceptual framework of mystic viewing to the mosaics in the apse of the monastery of St Catherine at Mt Sinai, an iconographic programme dating from the sixth century. My contention is that the transformation of Roman art from the first century to the sixth is deeply implicated with a transformation in viewing away from naturalist expectations towards the symbolism inherent in mystic contemplation. The very structure of a work of art as seen by its Christian viewers by the sixth century had become a simulacrum of a spiritual journey which those viewers could be reasonably expected to see themselves as making. This structure is ascertainable from ideas contained in contemporary texts which those viewers may have read or been familiar with from sermons. This is not to imply that such "mystic viewing" had no ideological or political ramifications. On the contrary, in the Christian dispensation, mystic contemplation was an elite ideal by which social and political values were measured, and it served (in its ascetic cognates) as a fierce polemical stick with which to beat ethical "laxity"

in daily life. The very indebtedness of the language of mystic contemplation to the language of the late Roman state can be seen in the most important of all Christian mystical writers, Pseudo-Dionysius. The mysticism of Dionysius is expressed in hierarchies (ecclesiastical and celestial) which are themselves literary reflections of the bureaucratic structures of the empire and the Church.

THE MYSTIC MODEL OF VIEWING

Viewing entails the relationship of subject and object. This relation is always complex, for we cannot see the world with objective eyes – only with our own. The subject sees the object only in his or her own terms, brings to the viewing his or her own ideologies, narratives, contextualisations. The subject cannot see the object directly without interpretation. There is always a gap between the object as seen (the object in the subject's eyes) and the object out there – the object as it is.[1] This gap is not merely the product of modern theory. It was well known in the ancient world and forms the subject of one of the most famous anecdotes in Pliny's *Natural History*, written in the first century A.D. Pliny's story of Parrhasius and Zeuxis is usually used to illustrate the wonders of illusionistic art, but I wish to suggest that the story is also a meditation on the gap between image and reality inherent in illusionism.

In *Natural History* 35. 65–6:

Traditur . . . ipse (Parrhasius) detulisse linteum pictum ita veritate ut Zeuxis . . . flagitaret tandem remoto linteo ostendi picturam.

Parrhasius is said to have displayed a picture of a linen curtain, so realistic that Zeuxis then called to Parrhasius to draw back the curtain and show the picture.

The desire of Zeuxis is not for the image, a linen curtain, but for what the image, the curtain, appears to conceal. He is deceived by his gaze into believing the *trompe-l'oeil* to be real, as his desire (his subjective appropriation of the image he sees) prompts him to penetrate what is behind the curtain. But the Plinian text is more than a narrative of desire – it is the denial of any content to the image and of any object of satisfaction for the subject's desire. The key word, twice repeated, is "*linteum*" – which means not only "linen curtain" (the image on the canvas) but also "canvas" (the material on which the

image is painted). Pliny uses the word with the meaning of "canvas" in an earlier chapter of the same book (35.51). The painted image – which offers so much to the viewer's desirous gaze – deconstructs into the matter on which it was painted. For the *linteum* to be withdrawn would leave only the *linteum*. *Linteum* is *linteum*, curtain is canvas. The gap between matter and matter imagined, the object out there and the object constructed by the subject's gaze, could not have been better portrayed.

Beneath this Plinian model is an assumption about the nature of subjectivity. There must always be a separation. The dualism of subject and object is inevitable, undeniable and intransgressible. But the assumption of dualism is not the only model available in the ancient world. This chapter will be about an alternative model, an alternative notion of subjectivity, and the ideology of viewing which it constructs.

Mystic viewing is predicated upon the assumption that in mystic experience the dualism of subject and object can be transcended into a unity that is neither subject nor object and yet is simultaneously both.[2] One of the most influential and comprehensive formulations of the mystic model is the *Enneads* of the third-century A.D. philosopher Plotinus.[3] A student of Ammonius Saccas in Alexandria in the 230s, Plotinus came to Rome in 244 to teach philosophy. His works were collected, edited and published after his death in 270 by his student Porphyry.[4]

Plotinus insists that the mystic vision, the experience of God, is a union of self and other beyond the dual:

No doubt we should not speak of seeing; but we cannot help talking in dualities, seen and seer, instead of, boldly, the achievement of unity. In this seeing, we neither hold an object nor trace distinction; there is no two. The man is changed, no longer himself nor self-belonging; he is merged with the Supreme, sunken into it, one with it.[5] (*Ennead* 6.9.10)

This union (which Plotinus calls a "super-intellection" or "a thought transcending thought" – *hypernoêsis* [*Enn.* 6.8.16.32]) is beyond language (which can merely point the path) and beyond knowing. This is because

in knowing, soul or mind abandons its unity; it cannot remain a simplex. Knowing is taking account of things; that accounting is multiple; the mind thus plunging into number and multiplicity departs from unity. Our way then takes us beyond knowing: there may be no wandering from unity; knowing and knowable must all be left aside. (*Enn.* 6.9.4.4)

In the experience of union there are no distinctions, there is
no discriminative awareness and there is no self-consciousness
(*Enn.* 5.3.14.1f.; 6.7.35.42f.). There is no recognition of what
is taking place: "Soul must see in its own way; this is by
coalescence, unification; but in seeking thus to know unity it
is prevented by that very unification from recognising what it
has found; it cannot distinguish itself from the object of this
intuition" (*Enn* 6.9.3.11). In the last chapter of the last *Ennead*
(6.9.11), Plotinus describes mystic union as a state without
distinction, without movement, without emotion or desire,
without reason or thought and without self. It is a state
beyond beauty for the philosopher – "a quiet solitude, in the
stillness of his being turning away to nothing and not busy
about himself, altogether at rest and having become a kind
of rest".[6]

VIEWING AND THE SACRED

VISION, UNION AND THE TEMPLE SANCTUARY

In Plotinus the process of mystic union is a process of seeing.[7]
It is a "self-seeing" in which "the seer is one with the seen"
(*Enn.* 6.9.10–11). Here Plotinus, like all Greek mystic think-
ers after Plato, borrows heavily from the sight imagery in
the great allegories of the cave and the charioteer. Plotinus
concludes his last chapter in the sixth *Ennead* with the follow-
ing image: The philosopher ascending to union with the One
is

> . . . like a man who enters the sanctuary and leaves behind the
> statues in the outer shrine. They are the first things he looks at
> when he comes out of the sanctuary, after his contemplation (*to
> endon theama*) and converse there, not with a statue or image, but
> with the Divine itself; they are secondary objects of contemplation
> (*deutera theamata*). That other, perhaps was not a contemplation but
> another kind of seeing (*ou theama alla allos tropos tou idein*), a being
> out of oneself, a simplifying, a self-surrender, a pressing towards
> contact, a rest, a sustained thought directed to perfect conformity,
> if it was a real contemplation of that which was in the sanctuary
> . . . (6.9.11.18f.)

This analogy of temple visiting implies a hierarchy of vision.
From the "secondary contemplation" of the images on the
outside (to which, in the end, the philosopher must return, as
the philosopher-king must go back into the cave in Plato),
Plotinus passes inside to the contemplation of the Divine
itself, which is "not a contemplation but another kind of

seeing".[8] There is an inner movement of "levels" of contemplation paralleled by an outer movement from image to reality. There is a double movement from outside to inside – into the shrine and deeper into the self (*to endon theama*) – and yet, simultaneously, there is a movement out of self, a "self-surrender". It is noteworthy that "the other", which one might expect to be described in objective terms, is in fact presented in terms of personal experience ("a being out of oneself, a simplifying, a self-surrender, a pressing towards contact, a rest, a sustained thought") – the very language attempts to enact the unifying of self and other which is the purpose of the Plotinian path.

In his use of the image of visiting a temple (which recurs at *Enn.* 5.1.6.12f.), Plotinus has tied his discourse of mystic union to the language and imagery of pilgrimage. The ascent, or ladder, of Plotinian contemplation (which prefigures a vast literature in later Christian thought)[9] thus becomes assimilated to the specifically religious and ritual context of pilgrimage and worship in a sanctuary. Although Plotinus's language is still philosophical, his mystical philosophy is no longer to be separated from religion. It is significant that in the late fifth century at least one Church Father should look back explicitly to Plotinus's simile of the sanctuary.[10] Although there may have been fundamental theological differences between Christian and pagan in late antiquity, this Christian appropriation of a metaphor about the subjective effects of religious action shows a deep continuity in the *experience* of personal piety.[11]

The specifically religious theme of visiting temples presents in a very clear form the issue of what the pilgrim is allowed or fit to *see*. In Plotinus this is "the Divine itself". In a closely parallel context of sanctuary visiting from Euripides's play *Ion*, when the chorus enters for the first time, they approach Apollo's temple in Delphi, examine the sculpted reliefs and ask of Ion (currently the temple attendant) if they may cross the threshold. Ion replies that they must sacrifice a sheep and have a question to put to the god. They understand and say: "We are no transgressors of the god's law (*theou nomon*), but are content to delight our eyes with the outward beauties of the temple" (v. 230). "Look at everything (*theasthe*)", Ion replies, "that custom (*themis*) allows" (v. 232). The setting of the scene is close to the image in Plotinus. The chorus is not a philosopher ascending to union and vision; and so their contemplation must be of the "secondary" or "outward" kind, because they have not the necessary sacrifice and question –

the ritual – by which to proceed to the inner vision. The pun on *theou* (god), *theasthe* (see) and *theou* (god) (vv. 230, 232, 234) underlines the problematics of what can and cannot be seen, of the images whose vision is offered (v. 184ff.) and the god (the cult statue) whose sight is denied. In the *Description of Greece* by the second-century A.D. traveller Pausanias, there is much temple visiting of precisely the type dramatised by Euripides. The typology of sanctuaries with the outside (and its images) described but the inside either unviewed or undisclosed (or both) is frequent.[12] In all these cases – from the fifth-century B.C. playwright to the third-century A.D. philosopher – the act of viewing or contemplating (*theasthai*) is associated with man's relation to the Divine (*theos*) in the ritual context of a sanctuary.

In these three authors the relationship of sight and the sacred in temple visiting occurs through art. The desired and, to the uninitiated, forbidden contemplation is that of the cult statue within the temple – which was in Greek religious custom synonymous with the god himself. The importance of Plotinus is that he combined the religious context of pilgrimage and ritual contemplation of sacred images (a theme sufficiently deep in Classical culture for it to span the seven centuries between Euripides and Pausanias) with a philosophical discourse of contemplation which goes back to Plato.

DIVINE PRESENCE: SIGHT AND THE SACRED IN GRAECO-ROMAN CULTURE

Before continuing with our inquiry into mystic vision and sacred images, let us sketch the depth and extent in Graeco-Roman culture of the relation between sight and the sacred. The pun on *theos* (god) and *thea(ma)* (sight, contemplation) is frequently employed in Greek to emphasise the presence of the Divine. Its use extends from Platonic philosophy to Euripidean drama, from the religious myths recorded by Pausanias to Alexandrian Judaism. My intention in the following survey of this pun is to show the centrality of the language of *viewing* for describing the sacred. I mean thus to emphasise a convention of Graeco-Roman thought which is of fundamental importance in providing the basis for the ritual use and mystic viewing of religious *images*.

In the herdsman's speech (vv. 677–774) of Euripides's last play, *The Bacchae*, the Maenads are described performing a series of miracles, such as suckling wild animals, striking water from rocks and routing the herdsmen and tearing their

cattle to pieces. Then – a *deinon theama* (v. 760) – they defeat the armed villagers, whose weapons have no effect but who are cut to the quick by the women's thyrsi. All this is the work of their *theos* (vv. 764, 766). Not only is the *theos-thea* pun operating here to pinpoint the Divine in a passage evoking the effects of religious ecstasy and power, but the whole speech, ironically, is delivered to Pentheus (the disbeliever whose fate – *sparagmos* – is presaged by the cattle torn to pieces) and Dionysus, the god who is causing the action. The description is a witness to and a warning of the dangers of the theophanic presence (albeit in disguise) of the god on the stage.[13]

The pun occurs within a similar context of divine epiphany in Pausanias. In the *Description of Greece* the *theama* of a baby turning into a snake causes the Eleans to defeat the Arcadians (6.20). The Eleans subsequently honour the *theos* – the child who became a snake – by building his temple where the snake vanished into the earth. The divinity of the *theos* is dependent on, defined by, the *theama* of his metamorphosis and disappearance. The god of this place would not have been a *theos* but for the *theama* he performed. Needless to say, the shrine of this transforming and vanishing god is not to be entered. Even the woman who tends the god is veiled (6.20.3); sight, which was once given as a visible metamorphosis to save Elea and then a disappearance into the ground to deify this site, is forever after denied. But the ground and place of that metamorphosis and disappearance are forever sacred, sanctified by the image which must not be seen.

In Judaism, God himself can never be seen.[14] Nonetheless, there is an exuberant Jewish tradition of mystic visions, revelations and apocalypses.[15] In Philo Judaeus, where this tradition meets the language and thought of the Alexandrian Greeks, there is a rich play on *theos* and *theama*, on sight and the divine. Philo, a highly cultivated Jew from Alexandria, was born in about 25 B.C. and died around A.D. 50. He came from a wealthy and prestigious family – his brother Alexander was one of the richest men in the ancient world, and his nephew Tiberius Alexander (having changed his religion) rose to being Roman procurator in Palestine and prefect of Egypt under Nero. Philo himself served as leader of an Alexandrian embassy to the emperor Gaius in A.D. 39–40.[16] Philo's surviving work consists of a great number of exegeses on the major books and themes of the Septuagint.[17] It is our main testimony to the nature of Hellenistic Judaism. Although there is a lively scholarly debate about whether Philo was himself a practising mystic,[18] it is clear that (like his

contemporary Paul at 1 Corinthians 2.6ff. and 3.1ff.) he dis-
tinguished between an initiated elite who are capable of re-
ceiving wisdom (*sophoi*, or *teleioi*) and the immature who must
be kept on a diet of milk.[19] Philo identifies passages in his
own work which he claims are comprehensible only to the
elite[20] and claims that the higher knowledge – which has
given him the authority to interpret (which is to say, to
allegorize) the Scriptures – comes from his own experience of
direct communion with God.[21]

For Philo, sight (*opsis*) is the key to the religious-philosophic
path:[22] "Philosophy was showered down by heaven and re-
ceived by the human mind, but the guide which brought the
two together was sight, for sight was the first to discern the
high roads which lead to the upper air"[23] (*De Specialibus Legibus*
3.185). After describing the ascent of the mind through sight
(clearly, the initiate rather than the milk-fed mind), Philo
finds that physiological sight is itself inadequate and must be
replaced by philosophic inquiry:

> The mind, having discovered through the faculty of sight what of
> itself it was not able to comprehend, did not simply stop short at
> what it saw, but drawn by its love of knowledge and beauty, and
> charmed by the marvellous spectacle (*thean*) came to the reasonable
> conclusion (*logismon eikota*) that all these were not brought together
> automatically by unreasoning forces, but by the mind of God
> (*theou*). (*De Specialibus Legibus* 3.189)

The ascent is not merely a philosophical speculation that God
made the world, it is an apprehension of God:

> But those, if such there be, who have had the power to apprehend
> (*katalabein*) Him through Himself without the co-operation of any
> reasoning process to lead them to the sight (*thean*), must be regarded
> as holy and genuine worshippers and friends of God (*theophilesin*) in
> very truth. In their company is he who in Hebrew is called Israel,
> but in our tongue the God-seer (*horôn theon*)[24] who sees not His real
> nature, for that as I said is impossible – but that He is.[25] (*De
> Praemiis et Poenis* 43–4)

For our purposes, the supreme Philonic experience of God –
what must serve as theophany in Alexandrian Judaism – is
linguistically represented in terms of the language of *theos*
and *thea*.[26]

The conceptual formulation of theophany in Philo owes
much to later Platonic philosophy.[27] It is worth noting in
this context a further philosophical, rather than religiously
theophanic, strand in the use of the *theos-thea* pun. One root
of the language of *theama* in both Philo and Plotinus (who

employs the pun to effect at, for example, *Ennead* 1.6.9 or 5.8.10) is Plato. In the *Phaedrus*, Plato uses this language in the myth of the charioteer (247 AD). In the *Republic* the verb *theasthai* recurs several times in the image of the cave (516A and 516B), and he puns twice on *theos-thea* (or words from those roots) in the passage which sums up what the allegory means (517B – *thean . . . theos*; 517D – *apo theion theôrion*).

VIEWING AND THE SACRED: SOME CONCLUSIONS

The primacy of sight in constructing the sacred is central. The evidence collected here, although extremely diverse in the periods, places and contexts at which these different writings were produced, points unequivocally to the importance of sight and viewing (or, at the very least, of the language of sight and viewing) as perhaps the primary means for constructing the Other World.[28] Whether we give a philosophical, mystical or religious predication to the notion of the Other World does not much matter; what is important is that it is supramundane – outside "ordinary" experience, but certainly experientiable to the initiate. All of these texts assume not only the existence of the Other World but also some possibility of contact or communion between self and this Other World (if most would not accept Plotinus's notion of complete union). In this sense all the evidence which speaks of sight and the sacred is borrowing from a conceptual framework (which I illustrated earlier by reference to Plotinus) where at least in some respect there can be movement out of the dualism of subject and object and into some kind of unity beyond self and other. In fact, the image of movement as ascent out of self, out of the physical and into the spiritual, is common to most of the writers I have used from Plato to Philo, Plotinus and the Christian Fathers.[29]

For understanding religion in Classical culture, the crucial role of sight in constructing the sacred is of great significance. A statue or other work of art may be as important as or more important than a text in the evidence it can offer to our understanding of the sacred. But we must never forget that we are working here in a profoundly different conceptual framework from the Plinian dualism that underlies the narrative of Parrhasius and Zeuxis. There, desire can never be fulfilled, and the *trompe l'oeil* is the more deceptive the more realistic it appears. In sacred art, not only is it possible for the initiate to see what he or she desires (the epiphany) but in the true depths of mystic vision the practitioner can lose all sense

of the self that did the desiring as well as the object of desire.[30] It is quite right for Plotinus to question his imagery at that point (*Ennead* 6.9.10) – for when there is no seer and no seen it is perhaps tautologous to speak of "vision".

CHRISTIAN THEOPHANY

CONCEPTUAL FRAMEWORKS

In my review of the language of *theos* and *thea*, I have deliberately avoided by far the greatest body of its occurrence – namely in the Patristic writers from Clement and Origen onwards. My intention was to justify the importance of sight imagery in the non-Christian religious culture of the ancient world, before turning to examine a Christian work of art in its Christian framework. One of the continuities between pagan and Christian culture in antiquity is a deep sense of the pervasiveness of the sacred. The holy is constituted through private piety and supremely through the personal vision, the theophany, of a devotee. Such personal piety, which we readily associate with Christian prayer or icon worship, comes out vividly in a passage from the *Apology* of the pagan Apuleius (about A.D. 160): "It is my custom wherever I go to carry with me the image of some god hidden among my books and to pray to him on feast days with offerings of incense and wine and sometimes even of victims" (*Apology* 63).

In Christianity, the image of a personal vision serves as a major metaphor for spiritual ascent in Paul: "For now we see through a glass darkly, but then face to face" (1 Corinthians 13.12). It is the paradigm for Christian conversion in Paul's vision on the road to Damascus (Acts 9.3ff., 22.6ff.).[31] In early monasticism, the ascetic path is conceived as a constant preparation to appear before God.[32] In Chapter 10 of *The Life of St Antony*, a highly influential and popular hagiography written (perhaps by Athanasius) shortly after its hero's death in 356 and presenting Antony (as he was thereafter to be accepted canonically) as the paradigm of the ascetic "athlete" of Christ, the culmination of the struggle against temptation is a mystic vision of the ray of divine light (*aktina phôtos*) and a voice from Heaven.

I should like to discuss the meaning of theophany and the mystic vision of God in the Christian tradition in relation to a mature work of art from the sixth century. Whatever qualms about images were felt in the early Church,[33] by the mid-

sixth century they were all but forgotten amidst a tremendous rise in the cult of icons.[34] The theoretical foundation for images as a means of mystic contemplation of the Divine is above all to be found in the works of Pseudo-Dionysius the Areopagite. The Dionysian corpus, which arose around 500 A.D. probably in Monophysite Syria, was universally believed to be the work of Dionysius the Areopagite – one of Paul's few Athenian converts (Acts 17.34). As such it provided virtually apostolic authority for a mysticism which combined the Neoplatonism of Plotinus with the allegorism of Alexandrian writing from Philo to Origen.[35]

Like Plotinus before him, Pseudo-Dionysius is a firm believer in a mystic union that transcends subject and object.[36] The aim of the Dionysian hierarchy, whether celestial or ecclesiastical, was "as far as possible, assimilation (*aphomoiôsis*)[37] to God and union *henôsis* with him".[38] The path to God is through a ladder of images:[39]

Our human hierarchy, on the other hand, we see filled with the multiplicity of perceptible symbols (*symbolôn*) lifting us upward hierarchically until we are brought as far as we can be into the unity of deification (*epi tên henoeidê theôsin*) . . . it is by perceptible images (*eikosin*) that we are uplifted as far as we can be to the contemplation of the divine (*epi tas theias theôrias*). (*De Ecclesiastica Hierarchia* 1.2 [*PG* 3.373AB])

Here contemplation of the Divine is the end of the same hierarchy of symbols as is unification itself. The one is the other. Although visual images are not specified as the means of ascent,[40] they are certainly not excluded.[41] Pseudo-Dionysius follows the Plotinian theme of *deutera theamata* (*Enn.* 6.9.11), images which are sympathetic to the "nature of soul" and so attract the soul most easily into a link with the god who is present in the image (*Enn.* 4.3.11).[42] Within a generation or two after the appearance of the Dionysian corpus, Hypatius of Ephesus – archbishop from c. A.D. 531–8 and one of Justinian's most trusted theological advisers – was justifying images in language reflective of the very thought of Dionysius:

We allow even material adornment in the sanctuaries . . . because we permit each order of the faithful to be guided and led up to the divine being in a manner appropriate to it [the order] because we think that some people are guided even by these [material decorations] towards intelligible beauty and from the abundant light in the sanctuaries to the intelligible and immaterial light.[43]

The path of Pseudo-Dionysius through images and symbols, like those of Plotinus and Philo, transcends the activity of the human mind and knowledge itself. It partakes, like all mystic thought after Plato, of the imagery of light:

But as for now, what happens is this. We use whatever appropriate symbols we can for the things of God. With these analogies we are raised upward towards the truth of the mind's vision (*epi tên tôn noêtôn theamatôn alêtheian*), a truth which is simple and one. We leave behind us all our notions of the divine. We call a halt to the activities of our minds and, to the extent that is proper, we approach the ray (*aktina*) which transcends being. Here, in a manner no words can describe, preexisted all the goals of all knowledge and it is of a kind that neither intelligence nor speech can lay hold of it nor can it at all be contemplated since it surpasses everything and is wholly beyond our capacity to know it.[44] (*De Divinis Nominibus* 1.4 [*PG* 3.592CD])

No less than in Plotinus, the Christian ascent of Dionysius is a movement from material symbols to a spiritual reality – the "truth of the mind's vision" – where subject and object are united, are "simple and one". Language, knowledge, the activity of mind and being itself are transcended in the ray of divine light.

This theory, of which Pseudo-Dionysius was the most influential exemplar, is presented as mystical and apolitical. In fact, insofar as it has a politics, this appears as an injunction to keep the mysteries of divine union secret from the uninitiated.[45] Yet its ideological impact was all the more potent for its secrecy. The monastic elite in the Christian empire, who were also largely the literary elite, not only formed opinion but also established the very terms of discourse (including social and political discourse) through their prolific writings. Moreover, as theological positions developed, these became inseparable from other kinds of political and ideological stances. The very choice to cast the Christian theology of unification in terms of *hierarchies* of union reveals the impossibility of separating the language of the state's social agenda in this world from a discussion purporting to be about access to the Other World.[46]

THE MOSAIC AT SINAI

The Christian-Neoplatonic theory of mystic union with God through vision formed an underlying conceptual framework to the ways viewers looked at sacred art. Just as life could be

a spiritual path to closer union with God, so the forms of religious paintings can be constructed as a hierarchy leading to a vision of such union. Let us apply this Pseudo-Dionysian framework to the iconography and meaning of a specific image from the sixth century. The mosaic of the Transfiguration in the church of the Monastery of St Catherine at Mt Sinai (Plate 2; Figures 13 and 17) is the major Justinianic image in an imperial monastic foundation built by Justinian, which merits a relatively lengthy description in the panegyric about the emperor's buildings written by Procopius, *De Aedificiis* (5.8.1–9).[47] Procopius tells us:

On this Mt Sinai live monks whose life is a kind of careful rehearsal of death, and they enjoy without fear the solitude which is very precious to them. Since these monks had nothing to crave – for they are superior to all human desires and have no interest in possessing anything or in caring for their bodies, nor do they seek pleasure in any other thing whatever – the Emperor Justinian built them a church which he dedicated to the Mother of God, so that they might be enabled to pass their lives therein praying and holding services. (5.8.4–5)

For the monks, the Sinai Transfiguration was both the major decoration of the apse in which their services took place and the main intercessory receptacle for their prayers. If the life which is presented as "a kind of careful rehearsal of death" is a life of prayer and liturgy, the focus of that life at Sinai was the mosaic which I explore.[48]

Until the erection of the iconostasis and the cross which surmounts it in the seventeenth century, the attention of a worshipper entering the church at Sinai would have been directed down the line of the nave to the fully visible mosaics in the conch of the apse and the wall above.[49] Just as the mosaic is the centre of the liturgical and intercessory functions of the church, so it is its visual focus. The eye of the beholder is arrested by the gaze of Christ, who looks directly out of the apse at the congregation (see Plate 2 and Figure 17). The image of the Transfiguration refers to a story recorded in all three synoptic Gospels;[50] this is Matthew's version:

Jesus taketh Peter, James and John his brother, and bringeth them up into an high mountain apart, and was transfigured before them: and his face did shine as the sun, and his raiment was white as the light. And, behold, there appeared unto them Moses and Elias talking with him. (17.1–3)

In the mosaic representation, Jesus stands in the middle of a blue mandorla on the gold ground, with Elijah on his right

and Moses on his left (Figure 17). John is kneeling beside Elijah and beside Moses is James, while Peter is splayed beneath Christ awaking from sleep in accordance with the text in Luke 9.32 (Figure 18). Around the image is a frame of medallion busts – in the arch the twelve apostles (with Luke, Mark and Matthias replacing Peter, James and John, who are presumably unnecessary because they already appear in the main mosaic); and at the base of the apse-conch is a group of prophets from the Old Testament, with Longinus, the abbot of Sinai, represented in a square halo in the right-hand corner (from the viewer's point of view) and the deacon John in the left-hand corner.[51] Above the apse-conch is a triumphal arch with two flying angels presenting orbs to the Lamb of God in the centre (Figure 13). Beneath the angels at the bottom corners of the arch are a pair of roundels without inscriptions which Kurt Weitzmann identifies, probably correctly, as John the Baptist (to the viewer's left) and the Virgin (to the right).[52] This would make the scene a proto-deesis. Above the triumphal arch are two further representational panels. That on the viewer's left shows Moses loosening his sandals before the burning bush (Figure 15), that on the right depicts Moses in a

Figure 13. Apse and triumphal arch mosaics, Monastery of St Catherine at Mt Sinai, sixth century A.D. Photo: Courtesy of the Michigan-Princeton-Alexandria Expedition to Mt Sinai.

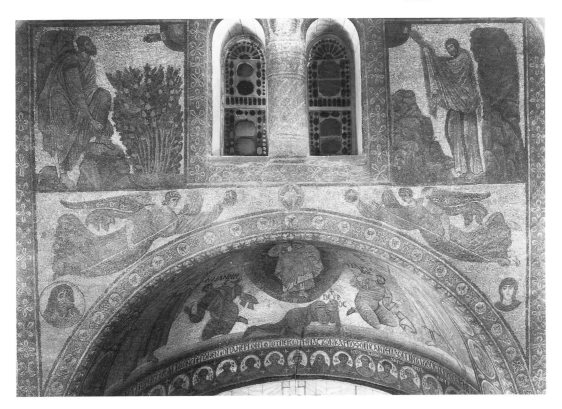

cleft of rock at the peak of Sinai receiving the tablets of the Law (Figure 16).

The Sinai apse has been properly studied only in recent years, after the University of Michigan–Princeton University expedition to Sinai led by George Forsyth and Kurt Weitzmann in 1958, when the mosaic underwent restoration and was for the first time adequately photographed.[53] The only extensive discussion of the monument is in the work of Weitzmann. He believes that "the artist's great sensitivity" points to the "highest artistic skill by the leading artist of an eminent atelier". Weitzmann concludes that "only Constantinople could have supplied such highly trained craftsmen".[54] He suggests that "a learned cleric . . . advised the artist on the accuracy of the iconography and supplied him with the basic and, in this case, manifold ideas".

Taking a hint from this suggestion, I will consider the iconography and thematic structure of the Sinai mosaics in the light of the patristic textual commentaries likely to have been available to those who made the mosaics and those who looked at them. This method has not to my knowledge been attempted before in a systematic way as a means of interpreting and understanding particular monuments of Byzantine art. My aim is to provide an interpretation of the mosaics according to contemporary – that is, sixth-century – ideology, rather than one grounded in modern critical categories.

Sinai is a very special place (Figure 14). It was on the peak above the monastery that Moses received the tablets of the Law (Exodus 34; Procopius, *De Aedificiis* 5.8.8). The monastery's rather awkward location in a valley is a result of its including the site of the burning bush (Exod. 3.1f.) at the eastern end of the church.[55] On the mountain next to Sinai is the traditional site of Elijah's cave in Horeb, where the prophet fled from King Ahab (1 Kings 19.8f.). Not surprisingly, Sinai was a centre of pilgrimage from very early times – all these sites are described and located with their appropriate biblical narrative in a surviving fragment of the pilgrim journal of Egeria, a woman, probably from Gaul, who visited the East between A.D. 381 and 384.[56] Yet despite the sanctity of the place, we can still generalise from Sinai, for its very importance makes it a paradigm of the modes of worship and exegesis which became so pervasive in Christian antiquity.

The Transfiguration – the supreme theophany of the New Testament barring only the Resurrection – was a theme ide-

ally suited to Sinai. Its narrative included Sinai's two prophets, Moses and Elijah. Furthermore, Sinai was a place specifically associated with theophany – the site where Moses conversed with God for forty days and nights (Exod. 24.16–18); the site where Moses, standing in a "cleft of rock", saw the "back parts" of God but did not see his face (Exod. 33.13–23), and the site from which when Moses descended out of the mountain "the children of Israel saw the face of Moses, that the skin of Moses' face shone" (Exod. 34.35). Likewise in the story of Elijah, the prophet stayed in Horeb for forty days and nights, spoke with God and was commanded to stand upon the mount and watch the Lord pass by (1 Kings 19.8–14). In the sixth-century Sinai mosaic, Moses, Elijah and the three apostles in the image – as well as all the worshippers in the church – were confronted with a theophany of God as Christ the Incarnate Son, whom in the new covenant following the Incarnation all could see not merely from the "back parts" but rather "face to face".

Before investigating the Transfiguration itself – the quintessential Christian *theama of theos*, when the divine nature of Christ appeared through his human nature[57] – it is worth looking at the Moses theme of the two panels sited above the apse on the church's eastern wall.[58] So far as I know, no commentator has discussed these panels save to note them in passing. Yet Moses as the paradigm of what can be achieved in the mystic ascent is a central subject of both Christian and Jewish mystic writing.[59] The Sinai programme takes two of the most important moments in the Exodus narrative of Moses – the

Figure 14. The Monastery of St Catherine at Mt Sinai, from the east. Photo: Robin Cormack, Conway Library, Courtauld Institute.

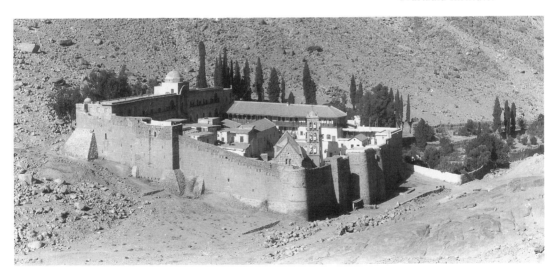

two which are associated with the site of the monastery and, at the same time, with the theme of theophany. I shall examine the Sinai images of Moses in relation to one of the most important and influential contemplative works of the Patristic era, Gregory of Nyssa's *De Vita Moysis*.[60] Gregory (c. 330–95 A.D.), was a member of a remarkable Christian family – his sister St Macrina and his brother St Basil the Great were among the most important figures in later fourth-century monasticism. The *De Vita Moysis*, which anticipates Pseudo-Dionysius in its blend of Alexandrian exegesis (owing much to Philo and Origen) and Neoplatonic philosophy (on the model of Plotinus), has been regarded as the culmination of Gregory's mysticism.[61] In later centuries, Gregory's work was much read and highly regarded. By the eighth century, he was "universally celebrated as the 'Father of Fathers' ".[62]

THE BURNING BUSH

In the panel above the triumphal arch on the viewer's left, which illustrates Exodus 3.1–6, Moses is facing right and removing his sandals before the burning bush (Figure 15). He is looking up at the hand of God which is raised in blessing in the top right-hand corner. The scene is not unique to Sinai – it occurs, for instance, in the roughly contemporary mosaics of the church of San Vitale in Ravenna.[63] For Gregory of Nyssa (*De Vita Moysis* 1.20) the event of the burning bush is an "awe-inspiring theophany" (*phoberan . . . theophaneian*) and "a strange sight". It is an illumination of the prophet's senses (both sight and hearing [1.20]) as well as of his soul (2.20) by the grace of the rays of light from the bush. As a result, Moses is empowered by the vision of God (*dynamôtheis têi ophtheisêi theophaneiai*) to release his countrymen from bondage in Egypt (1.21). Gregory's spiritual commentary on the episode is still more revealing: "It is upon us who continue in this quiet and peaceful course of life that the truth will shine, illuminating the eyes of the soul with its own rays. This truth, which was then manifested by the ineffable and mysterious illumination which came to Moses, is God" (2.19). Thus the burning bush (the bush still flowering in Sinai during the sixth century in its little court behind the eastern end of the church)[64] is a representation of, a sign for, what is possible for "us" (whether we be pilgrim worshippers or ascetic monks at Sinai "whose quiet and peaceful course of life" is, as Procopius put it, "a kind of careful rehearsal of death"). That the bush burned for Moses with a light which was God (2.20–1)

is a sign that the contemplative path of the contemporary worshipper can also shine with divine light (2.26).

What then does the mosaic sign at Sinai mean? For Gregory, the burning bush is a type of the Incarnation (*De Vita Moysis* 2.20) and of the Virgin birth (2.21).[65] It is a miracle in nature that implies the mysteries of the Faith. But it is also a prescription for the spiritual path:

That light teaches us what we must do to stand within the rays of the true light. Sandaled feet cannot ascend the height where the light of truth is seen, but the dead and earthly covering of skins, which was placed around our nature at the beginning when we were found naked because of disobediance to the divine will, must be removed from the feet of the soul. When we do this the knowledge of the truth will result and manifest itself. (2.22)

What Moses learned by the light of the theophany was more than a mere vision, it was that "none of the things which are apprehended by sense perception and contemplated by the understanding really subsist, but that the transcendent essence and cause of the universe, on which everything depends, alone subsists" (*De Vita Moysis* 2.24). In an exegesis loaded with Neoplatonic images and terminology, Gregory expounds the apprehension and discrimination through mystic theophany of "real Being . . . that is, what possesses existence in its own nature" and "non-being . . . that is, what is existence only in appearance, with no self-subsisting nature" (2.23).[66] The Mosaic theophany of the burning bush – the call for Moses to enter his vocation as liberator and prophet (Exodus 3.7f.) as well as his confrontation with the Name of God (Exodus 3.14–15) – is a vision of the senses (*De Vita Moysis* 1.20) that is an education for the soul (2.20); it is a vision of physical light that is a step on the ascent to the metaphysical – the divine – light.

The event becomes, in Gregory's propaganda for spiritual ascesis, simultaneously a proof, a paradigm and a prescription for mystic contemplation:

In the same way that Moses on that occasion attained to this knowledge, so now does everyone who, like him, divests himself of the earthly covering and looks to the light shining from the bramble bush, that is to the radiance which shines upon us through this thorny flesh and which is (as the Gospel says) the true light and the truth itself. (*De Vita Moysis* 2.26)

As Christian (and hence initiate) viewers – be they pilgrims or monks – stood in worship before the image, before the very bush which the image represents, the panel informed

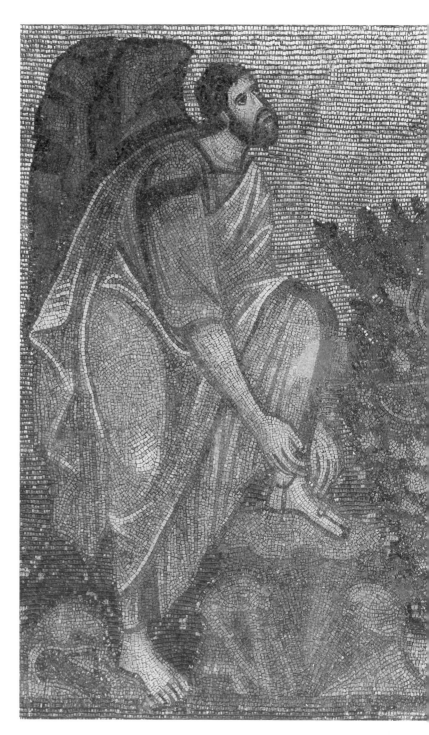

Figure 15. Mosaic of Moses
before the burning bush,
Monastery of St Catherine at
Mt Sinai, sixth century A.D.
Photo: Courtesy of the
Michigan-Princeton-
Alexandria Expedition to Mt
Sinai.

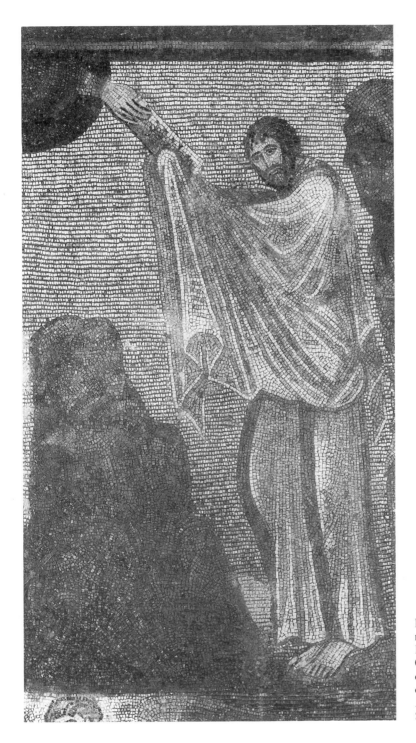

Figure 16. Mosaic of Moses
receiving the tablets of the
Law, Monastery of St
Catherine at Mt Sinai, sixth
century A.D. Photo: Courtesy
of the Michigan-Princeton-
Alexandria Expedition to Mt
Sinai.

them of how far they could still go on the mystic path. Truly to *see* this image was to see what it proclaimed – the "true light which lighteth every man that cometh into the world" (John 1.9). Ultimately, the end of the Christian ascent and of Gregory's Christian exegesis of the burning bush is the image of Christ transfigured in his divine nature which occupies the apse. For ultimately, "I am the way, the truth and the life: No man can come unto the Father, but by me" (John 14.6).

ON THE SUMMIT OF SINAI: THE TABLETS OF THE LAW

If the message of the burning bush could prove so complex in its implications for the viewer, this was still more the case with its sister panel of Moses receiving the tablets of the Law (Figure 16). It is on the viewer's right-hand side above the apse, and it represents the prophet facing left in the middle of a vast cleft of rock where he is receiving (with covered hands) the tablets of the Law from the hand of God in the top left corner. This scene, which like that of the burning bush is relatively common in early Christian art (it also appears at San Vitale in Ravenna, for instance), is narrated in Exodus 33.21–34.6.[67]

For Gregory, the ascent – the attaining to the summit of Sinai – is an entry into the "inner sanctuary of the divine mystical doctrine" (*De Vita Moysis* 1.46). It is here that Moses confronts what "transcends all cognitive thought and representation and cannot be likened to anything which is known" (1.47). In a still "higher initiation", the prophet is granted the vision of the tabernacle – "the inaccessible and unapproachable holy of holies" (1.49). "Having surpassed himself by the aid of the mystical doctrines", he emerges from the theophany "to deliver the Laws" (1.56). The ascent of Sinai is the supreme symbol of the spiritual path – a way to knowledge (2.154, 158), a purification (2.154–7), a "progress in virtue" (2.153) and a contemplation of God: "The knowledge of God is a mountain steep indeed and difficult to climb – the majority of people scarcely reach its base. If one were a Moses, he would ascend higher and hear the sound of trumpets" (2.158).

The path is not for the multitude (cf. *De Vita Moysis* 2.159–61).[68] It is for those who have progressed (whether as pilgrim traveller or monastic ascetic) to the foot of Mt Sinai, into the church half-way up the mountain, to these mosaic images. If

the image of the burning bush stood for the call to climb the
spiritual mountain, then the icon of Moses at the peak receiv-
ing the tablets of the Law represented the summit of this
ascent. Together the two panels stood for the beginning and
the goal of the path that took viewers to Sinai. They signified
what being at Sinai *meant*, what it was to see God. The Moses
panels proclaimed the viewers' condition as initiate climbers
on a spiritual ascent. To be in the presence of the Sinai
images at the site of the burning bush and the Hebrew camp
in the Wilderness, is to be called to proceed up the mountain
of divine ascent into the "luminous darkness" (2.163), into
"the mysterious darkness of unknowing" (Pseudo-Dionysius,
De Mystica Theologia 1.3 [PG 3.1000A]).[69] To be so privileged,
so advanced as to view these images, is to be under the
spiritual obligation of the Mosaic *epektasis* – the constant spiri-
tual progress that Moses supremely represents in the Gre-
gorian exposition: "He [God] would not have shown himself
to his servant if the sight were such as to bring the desire of
the beholder to an end, since the true sight of God consists in
this, that one who looks up to God never ceases in that desire"
(*De Vita Moysis* 2.233).

Iconographically, the feet of the climber who has ascended
Sinai are bare, for sandals (the encumberment of "dead skins")
are "an impediment to the ascent" (*De Vita Moysis* 2.201).[70] In
Gregory's exegesis, "he who has progressed this far through
the ascents we have contemplated carries in his hand the
tables, written by God which contain the divine law" (2.202).
In Sinai, Moses is represented at the moment of receiving
the Law. The result of this act, in Gregory's exegesis, is
transfiguration – "Moses was transformed to such a degree of
glory that the mortal eye could not behold him" (2.217; Exod.
34.29f.). The theme of the transfiguration of Moses prefigures
that of Christ in the Sinai apse. For Gregory, the receiving of
the tablets is the cue for a series of Christological compari-
sons. The carving of the new "tables of human nature" (2.216)
after the repentance of the Hebrews for their idolatry (2.203)
foreshadows the Virgin birth (2.216). As the "restorer of our
broken nature", who "restored the broken table of our nature
. . . to its original beauty" (2.217), Moses prefigures Christ.
Thus the patristic readings of the Old Testament narrative
already tie it to the coming of Christ. In the Sinai mosaics,
this link is made explicit and visual by crowning the entire
programme with the Transfiguration.

Gregory sees Moses transfigured as a result of receiving the

Law (*De Vita Moysis* 2.217; Exod. 34.29f.) "In his surpassing glory he becomes inaccessible to these who would look upon him. For in truth as the Gospel says [of the Second Coming: Matthew 25.31] when he shall come in glory escorted by all the angels, he is scarcely bearable and visible to the righteous" (2.217–18). That the righteous who had come to Sinai in the sixth century could see the icons of Moses and Christ transfigured was a sign of their righteousness, of the possibility that they – like Moses on Sinai – could become assimilated entirely to God. As Pseudo-Dionysius put it in *De Theologia Mystica* (1.3 [= *PG* 3.1001A]), Moses on Sinai

breaks away from what sees and is seen, and he plunges into the truly mysterious darkness of unknowing. Here, renouncing all that the mind may conceive, wrapped entirely in the intangible and invisible, he belongs completely to him who is beyond everything. Here, being neither oneself nor something else, one is supremely united by a completely unknowing activity of all knowledge, and knows beyond the mind by knowing nothing.[71]

The lawgiver is depicted in the midst of a cavernous cleft of rock on the mountain peak. Weitzmann believes this imagery to be influenced by the scenery at Sinai.[72] For St Gregory such an explanation would not be sufficient. In response to the prophet's request to "shew me thy glory" (Exod. 33.18), God tells Moses "it shall come to pass, while my glory passeth by, that I will put thee in a clift of rock and will cover thee with my hand while I pass by. And I will take away mine hand and thou shalt see my back parts: but my face shall not be seen" (Exod. 33.22–3; *De Vita Moysis* 2.219ff.). After an attack on any literal interpretation of this passage (*De Vita Moysis* 2.222–3), Gregory expounds its significance. In attaining to the cleft of rock and the vision of the "back parts" of God, Moses demonstrates the upward thrust of the soul's rise through its desire for God (2.224–6). There is no limit to this ascent, to the steps on the "ladder which God set up" (2.227). The whole of Moses's life becomes a paradigm for the ascent of this ladder (2.228–30).

In a reversal of the narrative order in Exodus, higher still than his shining with glory, is the thirst for a further vision of God – despite the fact that it was precisely with the vision of God that Moses "constantly filled himself to capacity" (2.230). The request to which the cleft of rock is the fulfilment is the archetype of Gregorian spiritual desire,[73] of the Gregorian path itself (see especially 2.239).[74] The cleft of rock is of immense significance, for the promise of which it is part is

"more magnificent and loftier than every theophany which
had previously been granted to his great servant" (2.241). For
Gregory, the rock is Christ (2.244, 248) and a host of other
"prizes" which come in attaining the "crown of righteousness"
(2.246). The rock encapsulates, through a series of quotations
in Gregory's text, a totality which may stand for the whole
Law both old and new (2.247–51). It is a totality which, not
only for Gregory but also in the Sinai mosaic, is fulfilled only
"when the lord who spoke to Moses came to fulfil his own
law" (2.251), that is, by Christ. The vision represented in the
panel of Moses at the summit of Sinai is the ultimate revela-
tion vouchsafed to humanity before the Incarnation.

Even before we turn to investigate in detail the image of
the Transfiguration in the apse-conch, it is clear that the Sinai
programme offers us a hierarchy of images, more specifically,
a hierarchy of theophanies:

1. The burning bush (Figure 15) = The call to prophetic
 ascent.
2. Receiving the Law (Figure 16) = The ultimate summit
 of mystic vision.
3. The Transfiguration (Figure 17) = The new ultimate
 that took place in the Incarnation – the seeing of God as
 Christ "face to face".

None of the iconography is incidental: The details (such as
the bared feet or the cleft of rock) are essential to the signifi-
cance of what is being represented. The viewer is being taken
through a hierarchy of images which represents the ladder of
his or her own spiritual path as monk or pilgrim towards the
vision that encapsulates and fulfils all.

THE TRANSFIGURATION

The very structure of the image works as a simulacrum for
the viewer's own spiritual journey. The spiritual progress of
Moses, in the narrative which led from the burning bush to
the giving of the Law, is parallel to the physical progress of
the pilgrim who climbs Mt Sinai from the monastery.
Whereas the images of Moses represent a hierarchy of spiri-
tual ascent, the image of the Transfiguration may be read as a
paradigm of what is revealed in the Christian version of spiri-
tual contemplation – that is, the vision of the incarnate
Christ. Moreover, as I shall argue, the particular iconographi-
cal and scriptural details selected for the Sinai Transfiguration
emphasise not only the vision (Christ transfigured) but also

the process of looking itself. The image of the Transfiguration becomes a visual exegesis and exemplum of the act of spiritual viewing.

In discussing the meanings of the Transfiguration mosaic (Plate 2; Figure 17), I shall employ the same method as I used in the Moses scenes. After isolating features of narrative or iconography in the image, I shall examine them in the light of the patristic textual commentaries likely to have been available to those who made the mosaic and those who looked at it.[75] In this way I hope to provide an interpretation of the image according to contemporary ideology before I attempt to integrate this into a general discussion of the programme of the Sinai apse as a whole. In the first step of isolating the principal narrative and iconographic features, I am in debt to the structuralist methods of biblical analysis developed by Edmund Leach.[76]

One significant feature of the Transfiguration narrative in all three synoptic Gospels (Matt. 17.1; Mark 9.2; Luke 9.28) as well as in much of the patristic commentary, is the mountain (Tabor) on which the Transfiguration took place. Weitzmann notes that one unusual element in the Sinai representation is the absence of any indication of Tabor.[77] He is right insofar as the Sinai mosaic includes no depiction of a mountain, but the green strip at the base of the image surely represents the peak of the mountain where the actual theophany took place. Some later representations of the theme, such as the eleventh-century mosaic in the Nea Moni, also show only a green strip for the peak, although it is true that in general the later iconography does include an image of the whole mountain. Thus we could explain the iconographic rarity by resort to a functionalist argument. We could look to the fact that Sinai is a monumental mosaic (like the Nea Moni) in a relatively unusual position (the apse – the only other apse Transfiguration is in the Church of Sant' Apollinare in Classe near Ravenna), which did not allow room for a representation of the full mountain. The spiritual point, however, is surely that this icon is already on a mountain, as is the viewer who is in its presence. If we take the significance of "mountain" to be not simply literal but symbolic, then it is entirely natural for this specific image to concentrate on the peak.

One of the figural meanings of the notion of mountain in early Christian and Jewish writing seems to be to provide a setting for the penetration of this world by the Other World.[78] As Leach remarks, Sinai is especially significant because this mountain is within the wilderness that is itself

already "marked off as altogether Other"; in effect, "the mountain of God, Mt Sinai . . . is . . . a world apart within a world apart".[79] Ideologically, to be at this place at all is to have ascended the mountain with Peter, James and John. Practically, in terms of the difficulties of travel in the sixth century, Sinai was isolated and remote. The group of people with access to this image on this mountain were in effect either pilgrims or monks – that is, the chosen. Excluding any image of the whole mountain (which would be a distancing sign for the viewer because it implies being away at a distance), the Sinai image seems to be going out of its way to include its worshippers in the theophany on the summit. There is no hierarchy of levels within the image (unlike the vast majority of later representations of the theme, where the apostles are in a different, lower, plane from the transfigured Christ and the prophets);[80] on the contrary, the Sinai mosaic collapses all the figures onto the same plane.[81] Just as the chosen apostles (the viewers of the Transfiguration) are included in the mosaic – in the vision which they view – so by implication the viewers of the Sinai apse may be included in the mystic experience of the vision that they are offered through this image.[82]

Figure 17. Apse mosaic of the Transfiguration, Monastery of St Catherine at Mt Sinai, sixth century A.D. Photo: Courtesy of the Michigan-Princeton-Alexandria Expedition to Mt Sinai.

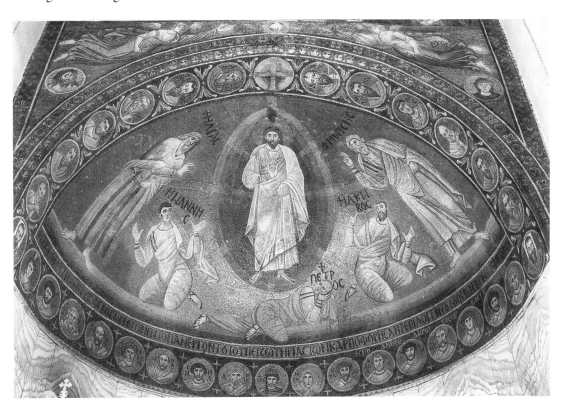

A second unusual feature of the Transfiguration iconography at Sinai is the representation of Peter awaking from sleep directly beneath the transfigured Christ (Figure 18). This is in accordance with the text of Luke 9.32, as Weitzmann notes.[83] The vast majority of later instances of the iconography of this scene show Peter addressing Christ and standing to one side beneath him (in accordance with the texts in Matt. 17.4; Mark 9.5; Luke 9.33).[84] That the designers of the Sinai programme should have chosen this moment out of the sacred narrative, unlike all those who chose the iconographies for so many later images of the Transfiguration, seems particularly significant. Luke's version of the Transfiguration story is designed as a specific contrast to his version of the Agony in the Garden on the Mount of Olives (22.39–46) where the apostles who accompany Christ cannot remain awake despite his injunction to them to pray. As the patristic commentators noted, it was important that the still imperfect disciples should have witnessed at least once in their lifetimes the manifestation of Christ's divinity in his human nature.[85]

The significance of the metaphor of sleeping and waking to the theme of mystic vision is of central importance. For Philo and Clement of Alexandria, the difference between the initiate and the multitude, the "virtuous man" and the "many ignoble and idle souls", lies precisely in the fact that the former is awake and the latter in a deep sleep.[86] In the Gospels, waking from sleep is a metaphor for waking from death – itself perhaps an image for waking into the true vision of God.[87] More importantly, the language of waking (*grêgorein* – in the Authorised Version, "watching") characterises a group of Christ's most important recorded sayings, which refer specifically to preparing oneself to receive God. This language is echoed in Paul and Revelation.[88] As Ambrose of Milan (339–97) asserts, it was while the apostles were awake that "they saw his majesty, for no one can see the glory of Christ unless he stay awake".[89] In the specifically monastic context of Sinai, it is worth referring to a text written at the monastery by one of its most famous and important saints, less than a century after the erection of the mosaic. In steps 19 and 20 of the *Ladder of Divine Ascent* (PG 88.937A–945A), John Climacus is specifically concerned with sleep as a hindrance to prayer. He writes "we must struggle with sleep" (19.2) and concludes "this is the twentieth step. He who has mounted it [that is, conquered sleep to attain spiritual vigil] has received light in his heart" (20.20). In effect, in an influential contemplative work written at Sinai shortly

after the mosaic was made, the conquest of sleep is tied to the vision of light – just as in the mosaic (and in its Lukan prototype) the waking from sleep is tied to the light of the Transfiguration.

In one strand of interpretation by the commentators, sleep is "that great heaviness which came upon them [the apostles] from the vision", the weighing down or putting to sleep of the *bodily* senses by the "incomprehensible splendour of divinity".[90] This refers to a particular mystical exegesis of the notion of sleep which figures with some prominence in Gregory of Nyssa (whose Christian name means "Awake").[91] In one sense the challenge to the initiate is to wake from sleep to the true light (*In Canticum Canticorum, Hom.* 11. *PG* 44.996A–997B), but in another it is to put the body to sleep so as to let the soul alone enjoy the spiritual vision. Hence, interpreting this quotation from the *Song of Songs* (5.2) "I sleep, but my heart waketh", Gregory writes: "Thus the soul, enjoying alone the contemplation (*theôria*) of Being, will not awake for anything that arouses sensual pleasure. After lulling to sleep every bodily motion, it receives the vision of God in a divine wakefulness with pure and naked intuition" (*In Cant. Cant. Hom.* 10, *PG* 44.993D). In the Sinai image, not only the

Figure 18. Detail of apse mosaic of the Transfiguration, St Peter waking from sleep, Monastery of St Catherine at Mt Sinai, sixth century A.D. Photo: Courtesy of the Michigan-Princeton-Alexandria Expedition to Mt Sinai.

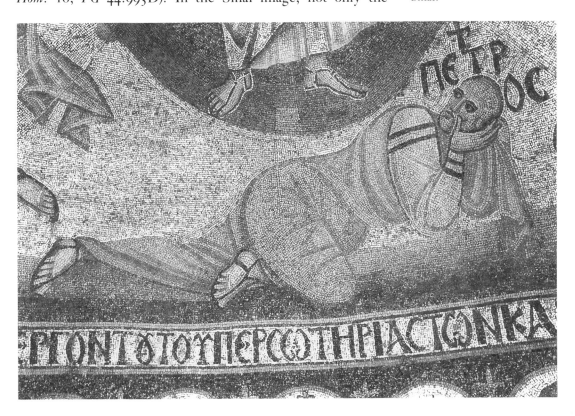

waking but also the sleeping itself is a figure for the reception of the vision of Christ.

The image at Sinai offers its viewers not only a vision of Christ in his divine nature "face to face" (the fulfilment of the Sinaitic visions of Elijah and Moses, of their Old Covenant), it also offers a representation of what it is to view. The icon is programmatic in that it points out to the monastic audience exactly what they must do to attain the vision of God. They must wake from sleep with Peter in order to ascend to the light. As Climacus assures his readers, at the peak of the Ladder of Divine Ascent is a vision – the vision that Jacob saw (30.36), the vision that John describes (30.31):

And now, finally, after all that we have said, there remain these three that bind and secure union of all, faith, hope and love; and the greatest of these is love, for God is himself so called. And, as far as I can make out, I see the one as a ray, the second as a light, the third as a circle; and in all one radiance and one splendour . . . (*PG* 88 1153D–1161B)

For Pseudo-Dionysius, this light is what the mystic initiate may partake in – what the viewer may experience just as the apostles experienced the Transfiguration:

We shall be fulfilled with his visible theophany in holy contemplations, and it shall shine round about us with radiant beams of glory just as of old it once shone round the disciples at the divine Transfiguration. And then, with our mind made free of passion and spiritual, we shall participate in a special illumination from him, and in a union that transcends our mental faculties. There, amidst the blinding, blissful impulses of his dazzling rays we shall be made like to the heavenly intelligences in a more divine manner than at present. (*De Div. Nom.* 1.4, *PG* 3.592 C)

In fully confronting the Transfiguration of Christ, the viewer is himself transfigured.

This light, which is so essential both to the visual language of mystic contemplation and to the exegesis of the Transfiguration, is represented in several ways in the mosaic.[92] In the first place, there is Christ's mandorla, which represents the "bright cloud" out of which came the voice saying, "This is my beloved son, in whom I am well pleased; hear ye him" (Matt. 17.5; Mark 9.7; Luke 9.34–5).[93] Second, there are the rays – of which one descends upon Christ from the cross above, while the seven others emanate from Christ illuminating the space and figures around. Just as light was essential to the Mosaic vision of the burning bush and transfiguration to Moses' vision on the peak of Sinai, so the Transfiguration of

Christ is the conflation and culmination of the two Mosaic experiences uniting light with transfiguration – the one who is transfigured being the one who is the light.[94]

The Church Fathers are particularly rich in their comments on the light.[95] For Gregory of Nazianzus (c. 330–89), light is an image for the ladder from God (who is light) to the angels to man (*phôs*), encapsulating also the "beacon fires of the heavens", the commandments of God to man, the burning bush and the pillar of fire in Exodus, the chariot of fire by which Elijah ascended to heaven, the star at the Nativity, the Transfiguration, the conversion of Paul, the sacrament of baptism and Heaven itself.[96] For Cyril of Alexandria (died 444) – offering less a summary of the entire faith through the image of light than an image of purification through vision – the mind which sees the Transfiguration "is transformed into a certain elect and godly radiance so that even its garments [i.e., I take it, its clothing of flesh] are illumined in the beams of that light, and they too seem to flash with light".[97]

It is already clear that this segment of Christ's narrative history was so written, so represented and so read as to transcend or rather encapsulate the entire history.[98] The sleeping apostles (Luke 9.32) presage the Agony in the Garden and hence the Passion (Luke 22.45–6). The end of the Transfiguration narrative in Matthew (17.9) and Mark (9.9–10) is explicit in referring forward to the Resurrection and the Ascension. The voice from the cloud is the same voice from the same cloud speaking the same words as at the Baptism (compare, e.g., Matt. 17.5 with Matt. 4.17).[99] Insofar as the Transfiguration at Sinai is specifically partnered by the Old Testament images of the visions of Moses, its particular focussing of the Christological narrative centres on the issue of viewing, for the Sinai image is both the representation of a vision and at the same time an image, a paradigm, of what it is to view a vision.

Viewing at Sinai is a matter of ascent – our ascent to this church half-way up the sacred mountain, Moses' ascent to the burning bush in this very place and to the summit later on, and the apostles' ascent "into an high mountain apart" (Matt. 17.1). Viewing is to wake from the sleep of the many – the waking of the apostles to the reality of Christ's divinity and our own awakening to the mystic union with the light of Transfiguration promised by Pseudo-Dionysius. And viewing is to see – after the ascent and the waking there is the vision of the light, the vision for which Moses constantly strove in Gregory of Nyssa's account and which is offered

to the apostles and the prophets in the image, and to the congregation on the floor of the church beneath them, "face to face" with God as Christ the Incarnate Son. The Sinai apse is not merely the image of a vision, it is – for the initiate and participant worshipper – the vision itself.

SOME CONCLUSIONS ON THE SIGNIFICANCE OF THE ICONOGRAPHIC PROGRAMME AT SINAI

When we take the narrative scenes at Sinai together, the two Mosaic panels clearly represent a development, an ascent towards the full vision of the transfigured Lord in the apse. In spatial terms this is a spiral (see Figure 19), moving from the image of the burning bush through the panel of Moses with the tablets (both on the wall above the apse) down into the apse-conch itself (which opens out beneath the wall). If this backwards movement were continued, it would lead to the actual bush that burned for Moses, which in the sixth century was believed to be still flowering in a court behind the apse. Topographically, the development of this spiral moves from the burning bush (the site of the church) to the peak of Sinai (where the tablets were delivered) to Christ in the church (again at the site of the bush). The movement is from the bush on the slope of the mountain, to the peak of the mountain to a scene meant to be on the peak of the mountain but with no mountain represented, a scene that *is* in this church (at Sinai rather than Tabor, although it *was* at Tabor), a scene that is every- and anywhere at all and any time (although it is of course quite specifically here and now at this viewing time for any viewer). In short, there is a development from specific events specifically valid at Sinai to a general event (despite its historicity), generally and eternally valid throughout Christendom.

The image of the transfigured Christ is, simultaneously, a paradigm for what is seen in mystic vision, a proof for what was seen (by those who ascended the spiritual mountain, like Moses, Elijah and the apostles), an exhortation to the Christian generally of what can be seen if the spiritual mountain is ascended and a prescription of what initiate Christians present in this church at this time ought to see by virtue of their having come here at all to see it. The faculty of *sight* becomes in this context not merely a means for constructing the sense world but, more significantly, a way of constructing the path to the Divine (through light and contemplation) and a con-

struction of the Divine itself (incarnate through light into the
sense world).

The mosaics at Sinai are an exegesis in their own right.
They show a particular, a unique, selection and combination
of events (i.e., of Scripture) as well as of the patristic com-
mentaries on those events. They serve to create their own
commentary, their own ladder of visions *through* images
(parallel to such ladders as that of John Climacus, as the
Mosaic *epektasis* of Gregory of Nyssa and as the hierarchies of
Pseudo-Dionysius). Insofar as the Transfiguration icon is self-
reflexive – representing within itself (in the three waking
apostles) an image of how it should itself be seen – the image
is an exegesis in the *visual* medium of images of what it is to
view, of the act and process of mystic viewing. Finally, in its
representation of the Incarnate Christ (who is and sums up all
these things), it is a visual exegesis of God.

It is worth remarking here that the mosaic goes out of its
way to include representations (in the apse-conch and the
medallions on its rim) of all four Gospel writers. The image
inscribes the texts on which it is predicated and of which it is
an exegesis. It represents them (symbolised by their authors)
as well as being a representation of them; and it represents
Moses – the great exegete and writer of the Old Testament
whose prophecies Christ had come to fulfil.[100]

In exegetic terms images can do what texts cannot. The
"simple" programme of Sinai – which can be completely
taken in within a single glance if one is rightly positioned in
the church – can simultaneously encapsulate, enact, embody,
activate and make visible and viewable a *whole body of texts*.
The instantaneous, non-diachronic nature of the image (what
should perhaps be called its *iconicity*) collapses the totality of

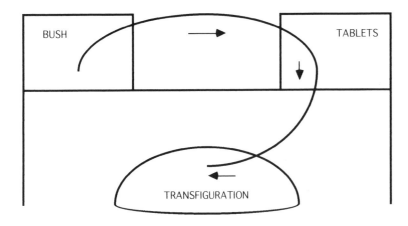

Figure 19. Diagram of the
Sinai mosaic programme.

these narratives and narratives about narratives into a single sacred space and time. That time is *here* and *now* at this mountain top where (for Moses and Elijah) all narratives collapsed into the confrontation with deity, which we are offered here "face to face".

The spiritual ideology of this iconic ascent is ultimately to give up the narrator and narrative constructions, which are forever dependent on the dualism of subject (the narrator) and object (the narrated). The call at Sinai is to abandon all of this and to confront what is beyond narrative, text and knowledge, beyond the self that does the narrating and the knowing. Ultimately the Sinai apse is an image of (and an aid to) the *henôsis* and *theôsis* described by Plotinus and Pseudo-Dionysius which is the experience of union with Godhead beyond the splitting of self and other. Ultimately this iconic presentation and this iconic style is the very antithesis of the Plinian naturalism with which we began. For that was art predicated upon a dualist conceptual framework, and this image assumes not only the possibility but also the imperative to go beyond dualism to union.

This union of self and other, which is the key to the conceptual framework both pagan and Christian that underlies mystic vision, cannot be described (because it is beyond the dualism of observer and observed, describer and described), but it can be experienced. Spiritual union is thus an inexplicable ideal. One should add that it was an ideal available only to a very narrow elite of spiritual practitioners (women, probably, as well as men). Moreover, it could be appropriated (because of its very unenunciability) to all kinds of political ends whose manipulative aims were hardly in keeping with the final claim of eliminating the duality of subject and object. Cyril of Alexandria, for instance, one of the early Church's most ruthless politicians, was a major theologian of that most spiritual of Christian sacraments, the eucharist.[101]

In Sinai the theophanic ladder of images takes the viewer to Christ, represented in the apse programme both as the transfigured Lord and as the eucharistic lamb (in the centre of the triumphal arch above the apse-conch, adored by two angels; see Figure 13).[102] The lamb above the sanctuary is Christ, the sacrifice that saved all humanity. It stands also for the eucharist which Christ enjoined upon his followers at the Last Supper before his Passion.[103] In liturgical terms it would be precisely during the enactment of the liturgy whose culmination is the eucharist that the viewer would stand before the

mosaics in the Sinai apse. Thus the lamb represents what is
happening *now* in the church. It stands for the sacrifice of
Christ by whom we are eternally saved and for the continu-
ously re-enacted sacrifice of the eucharist by which we are
daily to be fed. If mystic vision is the attainment of union
with Christ beyond the distinction of subject and object, the
eucharist is precisely the means by which such union may be
achieved. For what we eat and drink is His Body and His
Blood and thus "we come to bear Christ in us; because His
Body and Blood are diffused through our members; thus it is
that, according to the blessed Peter, 'we become partakers of
the divine nature' [2 Peter 1.4]" (Cyril of Jerusalem, died 386,
Mystagogical Catechesis 4.3, *PG* 33.1100A). In partaking of the
eucharist, the viewer is transformed.

For Pseudo-Dionysius, the eucharist no less than mystic
vision is a "participation in Christ" (*De Caelesti Hierarchia* 1.3.
PG 3.124A) which "grants us communion and union *(koinônia
kai henôsis)* with the One" (*De Ecclesiastica Hierarchia* 3.1. *PG*
3.434D). Ultimately, as in mystic vision, this union is "illumi-
nation", "the passing on of the light of God to the initiates"
(*De Ecc. Hier.* 3.1. *PG* 3.425AB). Significantly, repeating Plo-
tinus's simile of the outer images and the inner sanctuary (*De
Ecc. Hier.* 3.3.2. *PG* 3.428C; cf. *Ennead* 6.9.11), Dionysius
presents the eucharist as a matter of direct vision and light:
"Show yourself clearly to my gaze. Fill the eyes of our mind
with a unifying and unveiled light" (*De Ecc. Hier.* 3.3.2.). By
the late fifth century, the sacramental vision of Christian
Neoplatonism revealed the liturgy and the eucharist to be
operating in precisely the same way as sacred images.[104]

The liturgy of the eucharist, performed before the images
of the lamb and of Christ transfigured, is the ultimate ritual
act of mediation between the worshipper at Sinai and the
God of whom the worshipper is the living image (Genesis
1.26–7). It is revealing that in the mosaic, apart from the
transfigured Christ, none of the figures within the narrative
scenes addresses the viewer with a frontal gaze. The narrative
panels are paradigmatic and prescriptive but not intercessory
in the way that frontal images and icons are. However, John
the Baptist and the Virgin Mary on the triumphal arch and
the apostles and prophets in the rim of medallions around the
apse-conch all engage the viewer frontally. There is a geneal-
ogy of intercession here. The movement is from the prophets
represented beneath Christ (David, of whose seed he was
born [Romans 1.13], is in the significant position immediately
below him) through Christ himself to the apostles in the

medallions on the rim. John the Baptist, the "forerunner", and the Virgin (the immediate predecessors of Christ) are specially emphasised by being placed in the triumphal arch. Christ himself is the supreme link – uniting the intercessional signification of the mosaic with its theophanic programme. It is significant that just as Moses stands upon the rock, so Christ is above St Peter. The line of apostolic succession and mediation with the holy passes through Christ to the apostles but also to the rock (Peter) of Christ's Church (John 21.15ff). The very enactment of the liturgy and the eucharist (Christ's living Church and Body) in the presence of the worshipper is the final stage of this development, for the worshippers at Sinai *are* Christ's living Church. Peter's waking from sleep beneath Christ is thus not simply an image for the possibility of theophanic viewing but also of the living Church as awake and present to the living Christ.

Ultimately, the cardinal image on which the whole scheme at Sinai is pivoted is the lamb adored on the triumphal arch. For it is to Christ, "the lamb of God which taketh away the sins of the world" (John 1.19), that the theophanic ladder of Moses and Elijah ascends. It is in the lamb as eucharist that the congregation are saved and partake of Christ. The lamb as the Body which the worshipper eats is Christ in us. The union of self and other to which these images are attempting to direct the viewer is in the end eucharistic. For the eucharistic lamb represents Christ in us and us in Christ; it is the ritual intercession of the saints for us with Christ and of Christ for us with God.

Through the figure of Christ in the Transfiguration run two genealogical lines. One looks up from David to the "seed of David" Christ (transfigured in his own lifetime) to the lamb (Christ for us now). One looks down from the cross at the peak of the medallion rim (whose three-shaded blue ground symbolises the Holy Trinity)[105] through Christ (the second Person of the Trinity) to St Peter (the rock of the Church which is the embodiment and operation of Christ for us now). In this, the thematic centrality of the lamb, as bodily link with Christ (the eucharistic bread) and the sacrifice which saved man, is paramount. Finally, if we read the triumphal arch as a deesis, the lamb represents Christ as supreme intercessor, between and above the Baptist and the Virgin Mary. Again, the lamb is the focus for the intercessional imagery in the church.

I have tried consistently to emphasise the contemporary significance of the mosaic for its sixth-century viewers. It is a

material object, embodying and refining a complex textual exegesis, which served as an ideal and a paradigm. Again, one may note that however splendid an object and an ideal it might be, it could serve as a pawn in many games. For instance, the present is inscribed in the Sinai programme not only by its dedicatory inscription but also by the appearance of images of the abbot Longinus and the deacon John. These men may have been laudable clerics, honoured by their peers in these images in recognition for their generous patronage. They may equally have been using the mosaic – not only its visual splendour but even its spiritual message – to serve ends of their own in the complex world of Byzantine ecclesiastical politics. We cannot know. But certainly the Sinai apse was *not* an abstruse compilation of obscure texts about the distant past. It was made and intended as an image for the present, with a message for the present, representing Christ as the eternal God-man (the second Person of the Trinity), as the sacrificial-eucharistic lamb and as the Sinaitic vision proffered to Moses twice, to Elijah, to the apostles at Tabor and to the congregation here and now in this church.[106]

SOME CONCLUSIONS

This chapter began as a discussion of a model of perception which I have called mystic viewing where the duality of self and other is transcended, or rather, unified, in a vision of the sacred. After tracing the history (of at least the language) of the relationship between sight and the sacred, I have tried to show the ways in which mystic viewing can work in relation to an important Christian programme of images dating from the sixth century A.D. I believe the Sinai apse to be a fundamentally different object in its conceptual underpinnings from the "realist" Pompeian wall-paintings discussed in Chapter 2 and from the illusionist panel-paintings described by Philostratus and explored in Chapter 1. In Sinai the very structure of the work of art serves as a parallel for the spiritual path of its viewers. Neither its style nor the way it was viewed can be separated from the implications of the spiritual journey it represented. The extraordinary unity of style, theme and viewing in mature early Christian art is radically different from the contradictions, desires and *trompe l'oeil* of Roman domestic decoration. Where the transgressions of the decor of the Roman house allowed the consumer a place from which to assess critically his or her social location, the erosion

of the possibilities for a transgressive gaze in Christianity undoubtedly could be interpreted as a coercive move.[107]

I have not discussed either style or form at length, although it is in terms of these that the difference between "Classical naturalism" and "Medieval abstraction" is usually seen. I want to suggest that style was dependent on how an object was conceived and how it was viewed. The key to an understanding of the transformation of Roman art – its shift from illusionistic verisimilitude to abstraction – is not in the observable formalism alone but also in the underlying conceptions, views and ideologies of the people who commissioned, who made and who looked at works of art.

In the specific arena of early Byzantine art with which I conclude, I hope to have shown at least one thing. An image need not be merely an illustration of a text but may be (as the Sinai apse is) a "text" in its own right – a particular polysemic arrangement and commentary that demands to be read within the ideology of its time and in its own unique way. By the sixth century, Byzantium was an "exegetic" culture, in which every event, text and image could be read as an exegesis of the one fundamental and real event – namely, the Incarnation as represented by the narrative of Christ's life and Passion.[108] Every part of that narrative implied the totality just as every part of God's creation implied the whole:

Are not two sparrows sold for a farthing? and not one of them shall fall on the ground without your Father. (Matt. 10.29)

VIEWING AND IDENTITY: THE TRAVELS OF PAUSANIAS; OR, A GREEK PILGRIM IN THE ROMAN WORLD

The mere act of enumeration . . . has a power of enchantment all its own.

Michel Foucault[1]

ONUMENTS, houses and works of art help to construct a collective sense of subjectivity within culture. We have seen, in the case of Roman houses, some of the complexities and inversions through which this process of creating subjectivity operates. Likewise, religious objects, which require initiation and exegesis to be understood, work to form a rather narrower shared subjectivity within an exclusive group of "believers". We have seen such religious viewing both in the pagan context of the *Tabula* of Cebes and in the mature Christian images of Sinai. The kinds of viewing which Roman houses and Byzantine mosaics generate are remarkably different, but they share the strategy of inscribing the beholder into a complex social context, into a subjectivity which is – whether broadly or exclusively – shared with other members of the culture. However, monuments may work not only on the *collective* level by propagating generally accepted sensibilities. They may also work on the *individual* level, helping an individual to construct a private and more personal sense of self.

Images and monuments embody a history. They affirm the past and the living presence of the past in the present-day. They are the most visually potent assertion of a culture's relationship with its past and hence are a paramount cultural mechanism for evoking the historicity of identity – for grounding collective subjectivity in a historical valorization.[2] Of course, works of art (including literature and music) are not the only group of artefacts that support identity in this way through their evocation of a sense of history. But they are perhaps the most powerful of such bulwarks precisely

because they are privileged and special relics. They embody the authority of a cultural canon.

Individuals are caught between the shared subjectivity of collective tastes in the present, this historical identity embodied in the visual environment, and the particular accidents of their own personal upbringing and prejudices. The result of this conflict may be an acute sense of how works of art and the material remains from the past, which imbue the modernity of any culture, seem to pull one's own self-definition and identity in different and even in conflicting directions. The identities generated by different kinds of viewing – the broader formulations shared by Graeco-Roman culture as a whole and the narrower demands of religious initiation, for instance – may therefore be in contradiction in a single person.

A truly splendid example of such a conflict of possible identities (deeply related to and explicitly explored in terms of ancient monuments and works of art) is the *Description of Greece* written by the traveller Pausanias in the second century A.D. Different groups of viewers, at different times or at the same time, may see the same thing differently (depending on their starting points, assumptions and identities). But in Pausanias we find a single individual, more obsessed with ancient art than almost anyone writing after him, offering a multiplicity of viewings which themselves hint at the rather different strands in his sense of identity. Here, in a discourse which enumerates the most worthy sights of Greece, we can trace for a single person a number of ways of viewing which may even conflict with each other.

In exploring Pausanias, this chapter examines the largest single collection of images in any text surviving from antiquity. Pausanias provides a huge range of references to art – from cult images carefully described, like Phidias's ivory-and-gold statue of Athena Parthenos (1.24.5f.), to frescoes extensively discussed, in particular, Polygnotus's famous paintings on Homeric subjects in Delphi (10.25–31). There are numerous stories about the miraculous powers of images, such as the image of the horse of Phormis at Olympia, which sends real stallions mad with desire (5.27.3) or an image of Artemis Orthia that needs human blood to prevent it from becoming very heavy (3.16.9f.). There are also large numbers of images grouped according to different categories, for instance, all the images of Zeus from Olympia (5.22.1–24.11), as well as quantities of temples and sanctuaries.

My aim, however, is not to exploit Pausanias's richness as

a source for *particular* images and descriptions but rather to explore his formidable evidence as to *how art was seen*. The way Pausanias structures his subject-matter, if we examine his methods of discourse rather than simply look at the objects he describes, reveals his ways of viewing as well as what he viewed. Pausanias offers us a guide to the formation of Greek religious identity as a resistance to the realities of Roman rule. His text consistently relates that sense of Greek identity both to the localities of Greece and to the myth-histories which those localities evoke. The *Description of Greece* provides a link between the external signs of the holy (statues, temples and sacred spots) and the inward experience of the holy. It offers a key to the formation of religious or initiate subjectivity and to the transformation of art from images which imitated naturalistically what could be seen to images which represented symbolically what viewers wanted to see. These themes, all products of different strands and influences in the experience of Greek identity, are not coherent in any simple way. In fact, there seems to have been a deep conflict in the sense of identity available to Greeks in the second century of the Roman Empire – a clash of Greek past and Roman present, of socio-political realities and religious beliefs – which emerges in Pausanias's narrative, giving it an unexpected complexity, profundity and fascination.

PAUSANIAS

For about thirty years between A.D. 150 and 180 the Greek writer Pausanias travelled throughout mainland Greece describing and enumerating the monuments which he found of interest.[3] He recorded his impressions of those monuments together with a great many vignettes, myths and anecdotes in a *periêgêsis* (a description) in ten books. With the recent and notable exception of Paul Veyne,[4] critics have tended to see Pausanias as a bit of a pedant – an accurate, if plodding, observer of monuments,[5] who cluttered his text with "irrelevant" digressions into myth and history.[6] The historical accuracy of his digressions has been frequently attacked; their archaeological and topographical accuracy, however, has been much lauded and used as a basis for further research.[7] Archaeologists have culled Pausanias for descriptions with which to evoke what a site such as Delphi was like in the second century.[8] Historians of religion have also found much of religious and anthropological interest in the stories Pausan-

ias records.[9] Such approaches have generally focussed on particular stories or monuments described in Pausanias. Their interest thus is not in his manner of approach nor in his means of viewing, but in the objects he views. Those few attempts to present an overview of the whole text and its aims have examined the personality of Pausanias, the fact that he was a traveller and the historical and archaeological trustworthiness of his observations.[10]

Behind the many interests of his text, however, there lies a second-century *viewer* of antique monuments. This chapter will focus on the ways of viewing which the text implies. It will examine how different images and monuments modulate not only the strategy of viewing Pausanias uses but also, more deeply, the sense of identity which underlies his viewing. Pausanias's acknowledged intention, stated clearly in his first book, is to represent *panta ta hellênika* – "all things Greek" (1.26.4).[11] No critic has sought to examine the text of Pausanias as a *representation* of *panta ta hellênika*, that is, as a unique attempt to systematise, represent and encapsulate all that was interesting to the Greek speaker about Greece during the height of the Roman Empire. A representation is not merely an object to be looked at or read. It is also the expression of a view. It is an interpretation of the object represented. I am not concerned here primarily with the objects that Pausanias describes but rather with Pausanias's strategy, his system of conveying meaning, his semiotics for representing the objects.

We can learn from Pausanias not so much the objective facts about monuments prior to their literary existence in his text as we can observe the very act of representing them. The discourse which represents objects in words is the rhetorisation of a view – it is the "nomination of the visible".[12] In exploring Pausanias's representation of images we can examine his *viewing* of those images. Moreover, because viewing is necessarily based upon often unconscious presuppositions, we can discover something of the attitudes (both conscious and unconscious) to which those images would appeal. The literary representation of a series of visible objects implies a prior viewing of those objects and all the ideological assumptions that such a viewing entails.

Before we can begin, however, it is necessary to dispute an apparently universal assumption about the kind of book Pausanias was writing. The usual view of Pausanias regards him as an antiquarian,[13] writing a guidebook ("the Greek Baedeker"),[14] in an age of literary and linguistic antiquarianism – the so-called Second Sophistic.[15] At this period, travel

for the sake of educated tourism became increasingly popu-
lar,[16] perhaps on the model of the extensive imperial journeys
which had become a necessary part of the emperor's role.[17]
This view of Pausanias, a reasonable estimate in many re-
spects, is, however, deeply misleading. It rightly assimilates
Pausanias's travels with the kind of learned tourism so well
evoked by his earlier compatriot, the essayist and biographer
Plutarch (c. A.D. 47–120), in this sketch:

> . . . Cleombrotus of Sparta . . . had made many excursions in
> Egypt and about the land of the cave-dwellers, and had sailed
> beyond the Persian Gulf; his journeyings were not for business, but
> he was fond of seeing things and of acquiring knowledge; he had
> wealth enough and . . . so he employed his leisure for such pur-
> poses; he was getting together a history to serve as a basis for a
> philosophy which had as its aim theology, as he himself named it.
> He had recently been at the shrine of Ammon and it was plain that
> he was not particularly impressed by most of the things there. . . .
> (*De Defectu Oraculorum* 2.410AB)

Pausanias may be compared with this type of traveller in
the wealth and leisure he must have enjoyed in order to
conduct his travels and in his interest in writing. But here the
comparison ends. He differed from the pattern implied by
Cleombrotus in two fundamental respects. First, most unusu-
ally, Pausanias chose to travel in and write about *his own native
land*. He himself was aware that this was somewhat peculiar:

> The Greeks appear apt to regard with greater wonder foreign (*hyper-
> oria*) sights than sights at home (*oikeia*). For whereas distinguished
> historians have described the Egyptian pyramids with the minutest
> detail, they have not made the briefest mention of the treasury of
> Minyas and the walls of Tiryns, though these are no less marvel-
> lous. (9.36.5)

Greek writers prefered to turn their gaze upon the foreign
than upon self. The strangeness of Pausanias's enterprise lies
in his recording the monuments and rituals of his own society
rather than those of other peoples.[18] He was self-consciously
exploring Greek identity through looking at "all things
Greek" rather than implicitly defining it by contrast with
things Egyptian or Scythian (as, for example, Herodotus
does).[19]

Second, Pausanias's interests lay in religious sites and cere-
monies. Although Plutarch's readers encounter Cleombrotus
at the oracular shrine of Delphi and the account of him men-
tions a trip to a temple of Ammon, Cleombrotus's interests
are not essentially religious. The discussion he conducts at the

opening of the essay centres on arcane mathematical problems concerning the length of the year (410C–411D). When asked about the oracle of Ammon, he "made no reply and did not look up" (411E). In fact the essay in which Cleombrotus is featured is about the obsolescence of oracles in the Greece of Plutarch's time. By contrast, as critics have not failed to note, Pausanias's interest is almost obsessively (though not exclusively) in things religious.[20]

The religious bias of Pausanias differentiates him significantly from travellers of more generally antiquarian interests. He was not simply an outsider seeking interesting information, he was (like his Latin-speaking contemporary Apuleius)[21] a potential insider, an initiate in at least some of the sanctuaries he visited.[22] A religious tourist visiting sacred sites is *not* simply a tourist: He or she is also a pilgrim. When visiting the cave of Demeter Melaine at Mt Elaius, Pausanias tells us that "it was mainly to see this Demeter that I came to Phigalia" (8.42.11).[23] The trip "to see this Demeter" has been a long journey west of Megalopolis in Arcadia (which included the visit to the temple of Bassae at 41.7). The cave Pausanias found was sacred (42.1 and 42.3: *hieron*), for here Demeter hid after her lovemaking with Poseidon and in grief for the rape of Persephone. And yet there was nothing to *see*. The horseheaded wooden cult image, which Pausanias described from hearsay (42.4–5), was destroyed by fire, and its replacement, a bronze by the sculptor Onatas which was the result of an inspired vision (42.6–10), "no longer existed in my time, and most of the Phigalians were ignorant that it had ever existed at all" (42.12). Yet the site was holy; it had a number of special rites, a priestess and three assistants. Pausanian travel was as much about making contact with the sanctity embodied and located in a specific place as it was about tourism. Pausanian viewing (as in the expression "to *see* this Demeter") is as much about perceiving the (in this case, invisible) presence of the Other World, the holy, as it is about looking at art.

In effect, Pausanias's historical context belongs as much with the many pilgrims of antiquity who sought cures for their ailments, explanations for their dreams and visions of gods in the great cult centres (particularly of Asia Minor),[24] as it does with the antiquarian intellectuals among whom he is so often put. His account, far from being merely a catalogue of monuments, gives us first-hand literary access to the world of pagan pilgrimage. In this sense, it can perhaps be best compared with the earliest Christian pilgrim accounts of jour-

neys to the Holy Land in the fourth century A.D.[25] But these
pilgrims travelled *somewhere else* – to a holy land which was
not their own.[26] It is Pausanias's insistence on *his own land*, on
a journey into his own cultural roots, which makes his text
both unusual and rewarding.

As anthropologists of Hindu and Buddhist pilgrimage have
shown, there is a deep sense of place in the kind of religious
travel that takes a pilgrim like Pausanias to the sacred centres
of his or her *own* land (as opposed to the Muslim and Chris-
tian model of a journey to a holy land that is essentially
"other", elsewhere).[27] In the East Asian model, pilgrimage
becomes "an encounter between the individual and his geog-
raphy, a cultural mode by which people express their per-
sonal identification with the continent . . . a means by which
geography is made a part of their psyche and culture".[28]
Further, the orientation in space provided by pilgrimage is
more than merely geographic or cultural. It directly concerns
the religious, spiritual and moral assumptions which are such
a frequent aspect of Pausanias's commentary on what he de-
scribes[29] and which the philosopher Charles Taylor has tied
to the notion of identity.[30] In short, pilgrimage is a journey
into one's identity in its topographic, cultural and spiritual
resonances. And the journey of Pausanias to the sacred sites
of Greece is no exception.

In antiquity, Pausanias was unique. Although there were
several examples of *periegetic* (or descriptive travel) literature
from the third century B.C. and after, in writers such as
Polemo of Troy (of the second century B.C.), no one appears
to have produced anything more comprehensive than a mono-
graph on a single monument or a limited area.[31] Moreover,
the interests of writers of such descriptions may well have
been significantly different from those of Pausanias, to judge
by the extant portions of a second-century B.C. account of
Attica and Boeotia which has been preserved for posterity
under the name of Pseudo-Dicaearchus.[32] This description,
full of "slight highly coloured sketches" with a "strong leaning
to gossip and scandal" (as J. G. Frazer puts it),[33] has great
human interest; it exhibits almost no interest in religion. And
yet Pausanias owes much to such ethnographic writing, of
which the most important tradition flourished in Alexandria
under the Ptolemies and which is best represented today by
the great geography of Strabo.[34] Pausanias's work is ethno-
graphically and descriptively much richer than either the bare
guidebooks and lists produced to enumerate monuments and
districts in the major cities of the empire[35] or the bald cata-

logues of coastal towns (with their precise entries about items for import and export) made by merchant travellers.[36] Pausanias combines the precision and aim for comprehensiveness implicit in such practical guide books with the more lively descriptive ambitions of Greek literary ethnography.

The unique achievement of Pausanias lies not just in his attempt to describe the *whole* of Greece but also in his balance between a comprehensive enumeration, the retelling of myth-histories and the presentation of his travels experientially. His strategy is to select and compile the "most noteworthy" sights and to crystalise the "most famous legends" around the images that encapsulate or enact them.[37] Pausanias's declared intention of representing "all things Greek" is impossible to fulfil. It is clear that the Pausanian *panta* (everything) must be a very selective kind of viewing:

To prevent misconception, I added in my account of Attica that I had not mentioned everything in order, but had made a selection of what was most noteworthy. This I will repeat before beginning my account of Sparta; for from the beginning the plan of my work has been to discard many trivial stories current among the several communities, and to pick out the things most worthy of mention – an excellent rule which I will never violate. (3.11.1)

Pausanias is presenting an ideology of place in which the nostalgic myth-history of Greece could be located in the still-surviving monuments. The images that Pausanias describes embodied visually (and textually after this work had been written) the presence, and the present past, of a place. Pausanias's Greece is the past glorified *qua* past, but living and present still in the sacred presence of its sacred images. This is one reason, ideologically, why Pausanias's obsession is above all with religious images.[38] These works of art are not merely a decoration on the landscape – they transform the landscape with the presence of a particular god or story or myth.[39]

IDEOLOGY AND PLACE

Let us examine a specific instance of Pausanias's "locational" viewing – the sanctuaries at Mt Cronius in Elis: "At the foot of Mt Cronius, on the north . . ., between the treasuries and the mountain, is a sanctuary of Eileithyia, and in it Sosipolis, a native Elean deity, is worshipped" (6.20.2). Pausanias is precise in his placing of the sanctuary – it matters that we

should know it is at the foot of the mountain, to the north, between the treasuries and the mountain. The text carefully places the sanctuary, homes in on the location geographically and discovers a "native Elean deity". This is the cue for a further placing of the main goddess of the *temenos* (sanctuary), Eileithyia, as being specifically Olympian. Even the customs and rites described are special to this place: "Now they surname Eileithyia Olympian, and choose a priestess for the goddess every year. The old woman who tends Sosipolis lives herself in chastity by an Elean custom, bringing water for the god's bath and setting before him barley cakes kneaded with honey" (6.20.2).

Having located his monument and its deity geographically and culturally, Pausanias is again specific about the topography of the temple:

In the front part of the temple, for it is built in two parts, is an altar of Eileithyia and an entrance for the public. In the inner part Sosipolis is worshipped, and no one may enter it except the woman who tends the god, and she must wrap her head and face in a white veil; maidens and matrons wait in the sanctuary of Eileithyia chanting a hymn; they burn all manner of incense to the god, but it is not the custom to pour libations of wine. (6.20.3)

It matters that the temple is in two parts – the public and the inner, where no one may enter except the veiled priestess. The narrative has constantly placed its subject, but we find when the text finally penetrates to the inner sanctum that, despite a description of all manner of rituals, the viewer cannot enter; there can be no description and no viewing of the holy space. The centre of Pausanian locative viewing is both sacred and absent. Even the priestess cannot face, cannot view, the god in any normal sense – she must be wrapped in veils.

Reaching the centre and simultaneously the limit of the describable topography, the text branches into the mythic topography – the explanation of why this specific place and why this specific god.

The story is that when the Arcadians invaded the land of Elis, and the Eleans were set in array against them, a woman came to the Elean generals, holding a baby to her breast, who said that she was the mother of the child but that she gave him because of dreams to fight for the Eleans. The Elean officers believed that the woman was to be trusted, and placed the child before the army naked. When the Arcadians came on, the child turned at once into a snake. Thrown into disorder at the sight (*theama*), the Arcadians turned and fled, and were attacked by the Eleans who won a very famous

victory, and so call the god (*theos*) Sosipolis [i.e., "Saviour of the City"]. On the spot where after the battle the snake seemed to them to go into the ground they made the sanctuary. With him the Eleans resolved to worship Eileithyia also, because this goddess to help them brought her son forth unto men. (6.20.3f.)

In an epiphany, sight (*thea*) and the Divine (*theos*) are one. In the Greek language, viewing cannot be divorced from the sacred – there is a permanent pun. Here the vanishing of the snake mirrors the invisibility of the inner shrine, for these are the signs of the sanctity of this particular place. And yet the holiness of this locus (which it is, above all, the function of this description to reach – the tenor of the whole text has been to focus the attention of the viewer-reader towards what is "other", what is special, about this place) is tantamount to its unviewability, to the impossibility of penetrating the *temenos* in body or in eye. For the Other World to be present, it must be invisible; it cannot be seen in the terms of this world. And yet, in the seeing (*thea*) is the god (*theos*). This paradox lies at the heart of Pausanian viewing. We shall return to it.

For the time being, however, in this temple at the foot of Mt Cronius, we can feel the specialness of this place. The eye, although it can give us a taxonomy of location – can evaluate, enumerate and describe locus – cannot penetrate the sacred reality which is the essence of locus as well as the ideological meaning and goal of this description of this place. And we know now that this place is sacred. It is unique in all of Greece for its dedication to these gods, these rites and this myth. The goddess worshipped here is not any old Eileithyia (not the Eileithyia of Athens or Rhodes or wherever), but the specific divine mother of the specific divine being who turned into a snake and saved this place and is still there in his temple, still saving this place – always Sosipolis. Pausanian Greece is a whole geography of such locations. Each is unique – defined by its own god, its own myth-history and its own place in the great canon of glories enacted by the Greek people, which Pausanias makes it part of his business to retell.[40]

STRUCTURING GREECE: THE PHENOMENOLOGY OF PLACE

Like fourth-century Christian travellers to the Holy Land, such as Egeria or the Bordeaux Pilgrim of A.D. 333, Pausanias structures his Greece on the pattern of his own travels. We

move in the text, as the traveller himself journeys, from centre to centre. This is by no means to be expected in a work like Pausanias's description. There is nothing unusual about a pilgrim like Egeria making an effort to write a personal account of the pattern and order in which she experienced the holy places. After all, she had come far from her home (probably in Gaul), and it is likely that she was writing for a circle of pious women, one of whose devotional acts may have been to read her account.[41] But Pausanias was describing a *familiar* world, the classic sites of the Greek mainland, in a text aimed at Greek readers. Moreover, the usual ethnographic pattern in antiquity, as evidenced by Strabo's book on Greece (Book 8 of his *Geography*), deals with the country as a whole, breaking it up either by theme or by area, according to a map.

No other pagan author, so far as I know, emphasises so insistently the personal and experiential nature of seeing what one sees in the order one travelled to see it. Pausanias himself employs a thematic structure in his excursus on Ionia (7.2.2–5, 13). The discussion of Ionia lacks the phenomenology of travel, the sense of "this is how one does it, this comes next on the road". His experiment in an alternative structure shows that Pausanias thought carefully about how to present his description. It matters that Greece be more than an enumeration, that it be an *experience*, a journey into identity.

Book 1 begins by taking us not just anywhere, but into Athens itself – at its port Piraeus. After a leisurely exploration of Athens which moves from the Piraeus (1.1) into the city (1.2) and through the districts of the city such as the Cerameicus (1.3 f.) or the Agora (1.17f.) via a multitude of myths and stories up to the city's heart, the Acropolis (1.22–8), Pausanias takes us out of the centre back into the outskirts. Via the Areopagus (1.28.5f.), the Academy and the graveyard (1.29.2–30.3), we move into the numerous small parishes (*dêmoi*) – Alimus, Zoster and Prospalta, Anagyrus, Cephale and Prasiae and many more (1.31.1f.). Beyond these are the mountains, Pentelicus, Parnes and Hymettus (1.32.1f.), Marathon (1.32.3f.) and Brauron (1.33.1f.) and at 1.34.1 "the land of Oropus, between Attica and the land of Tanagra, which originally belonged to Boeotia (but) in our time belongs to the Athenians." Like pilgrim accounts in Medieval Europe,[42] the text enacts the journey it describes by taking readers along the roads that they would use if they were making the trip themselves. The structure is viewer-oriented. This is no bald enumeration, but an actor-centred account which enacts the very process of travel.

This actor-centred orientation is felt most acutely not so much at the level of the whole text as it is at some of the individual descriptions. When he discusses the altars at Olympia, Pausanias twice reminds us that the order he chooses is not merely descriptive in an immediately obvious way but is experientially determined according to the pattern which a viewer-participant would take in ritual: "My narrative will follow in dealing with them the order in which the Eleans are accustomed to sacrifice" (5.14.4). And again: "The reader must remember that the altars have not been enumerated in the order in which they stand, but the order followed by my narrative is that followed by the Eleans in their sacrifices" (5.14.10).

The point is reiterated. How does one fully visit, fully see, a place? One does it as the locals do it; one fits into an identity. Here, in Olympia, one does it liturgically. If we could identify the altars described here in the archaeological remains, we could map an Elean liturgy which is a more important, more meaningful arrangement of space than mere juncture ("the order in which they stand"). The text's structuring of monuments (here on the small scale of a specific site) offers not only the facts about the monuments (what and where) but also *how* they were viewed (a particular and peculiar order). It maps space and what space contains according to a pattern of viewer experience (here, the locals' ritual). Likewise, the whole text is structured ultimately according to a phenomenologically oriented viewing which is in its turn governed by the sense of identity – the sacredness or cultural importance of particular places and the enactment of particular rituals.

Between the major centres, such as Athens and Megara (1.39.4f.), the road passes through many minor stops and outlying areas – Oropus (1.34), a diversion to the islands (1.35–6), Eleusis (1.38–9). All these belong to Athens (1.39.3), whereas the Megaris is marked as different – independent of the Athenians (1.39.4) and its "neighbour" (6.19.12). The text itself marks the boundary firmly with a sentence that rounds Athens off: "Such in my opinion are the most famous legends and sights among the Athenians, and from the beginning my narrative has picked out of much material the things that deserve to be recorded" (1.39.3).

These borders, as felt by the traveller on the actual land and as announced to the reader by the text, are crucial. What they mark are not merely lines on a map but boundaries and thresholds in the *experience* of Greece. They delimit places not

simply topographically but as locations of culture, of race, of identity. This is why the borders of districts so frequently coincide with the ends of the books in Pausanias's *periegesis*. Even if the land is continuous and the traveller walks the same road from one area to another, the text marks a boundary that is felt. At 2.38.7 (the end of Book 2) and 3.1.1, stone figures of Hermes signal the borders of Argolis and Laconia, as well as the division of Books 2 and 3. At 3.10.6, reference to the same figures of Hermes marks a further boundary – that between the narrative myth-history with which Pausanias prefaces his account of Laconia and the actual travelogue.

The effect of the phenomenology is to present Pausanias's text as a mirror of Greece. The major centres (political and sacred) and the movement between centres imitates the condition of Greece as a land of many *poleis*, a multiplicity of conflicting and often contradictory identities. The text imitates Greece as it moves from place to place. And yet the totality of Pausanias's narrative has totalized Greece, has brought all the separate *hellênika* into one Greece. The act of travelling and the parallel act of writing, "the nomination of the visible", actually undermine the multiplicity and diversity which the text wishes to emphasise. Greece becomes an ordering and cohering of the many *hellênika* into one image – one individual's image – a Greece defined by its otherness to other ethnographies and above all to Rome. The very conflicts of the *hellênika* as tirelessly repeated in the myths and histories of internecine war become a cohesive factor, a shared myth, that brings them together against the Other of non-Greece, which is to say Rome. The divisions of Greece themselves become the definition of a unified identity, a past when it was possible to be divided before the present of integration within a larger and dominant whole.

STRUCTURING GREECE: THE MYTHOLOGY OF PLACE

The actor-centred pattern implies both a *personal* view and the assumption that one's land must be experienced through such a personal view in order to be understood. Implicit here is an emphasis on geography as a mode of identity, on the subjective and affective qualities of place. The investigation of identity can be seen as the core of Pausanias's text. He uses a constant cross-referencing of myths and histories to bring places together. Despite the apparently extempore presenta-

tion, the fact is that Pausanias rigourously avoids repeating stories and frequently refers us forwards or backwards in his text. For example, at Troezen he tells us that "it was here they say . . . that Heracles dragged up the Hound of Hell . . . and as far as the so-called Hound of Hell, I will give my views in another place" (2.31.2). That place is Taenarum in Laconia (3.25.6), where Pausanias gives us some rationalizing as to what the Hound of Hell really was. Did he know at Troezen what he would say at Taenarum? The extent and quantity of such cross-references certainly imply a careful and intricate web – a deliberate structural device – that unites Pausanias's Greece on a quite different and yet complementary level to the experiential travelogue.

Such stories tie the many *hellênika* into a single whole *through* myth-history. They provide readers with what they need to know – an identity, a meaning – by drawing on the general knowledge of a broad mythology of Greece which Pausanias assumes is his readers' cultural background.[43] Pausanias takes great pains to get his myth-historical interpretations right and complete. His care for accuracy here is not different (despite the comments of some modern critics)[44] from his painstaking care to provide precise topographies. For instance, in the account of the history of Laconia with which he prefaces Book 3, he makes sure to tie up any loose ends by referring us elsewhere in his text. We are promised an account of the retirement and exile of Polycaon son of Lelex (3.1.1) and given this at 4.1.1–2.1. "As to the cause of the (Messenian) war, the Lacedaimonian version differs from the Messenian. The accounts given by the belligerents, and the manner in which the war ended" are promised "later in my narrative" (3.3.1 and 3.5). The promise is fulfilled at 4.5.1f. By contrast, Pausanias has already told us how after the death of Cleomenes "the Spartans ceased to be ruled by kings" at 2.9.1–3, and he refers us there instead of repeating himself (3.6.9).

In effect the text enacts not only a journey through topography but also a careful myth-historical interpretation of the meaning of that topography. This interpretation darts in and out of the travelogue structure, reorganising the narrative of monuments and localities according to a pattern not of geography but of mythology – an ideological pattern whereby identity, having already been located by place, is further defined by story. And yet the myths themselves are locational. Despite the detailed cross-referring (which ties the whole of Greece into a single whole *through* its stories), the actual

myths occur topographically according to the traveller's processual account. Their importance is not primarily as narratives but as the narrative valorization, the historical canonization, of a particular place within the totality of "Greece" as a cultural construct.[45] The fact that Pausanias is so alive to his myths, that he remembers and cross-references them so assiduously, shows their paramount importance to his notion of "Greece". He makes sense of his Greece through them.

It is revealing, given how strong is Pausanias's experiential bias, that most of his contextualising stories plunge us into a past that was distant even in his own time.[46] The identity which his text evokes is a myth-historical identity grounded in the past. It is as if, in a modern English novel, readers were being asked to respond to their vividly felt Saxon or Norman origins. A clear instance of the pastness even of present identity in Pausanias is the case of the Corinthians, whose city was laid waste by Mummius after the war with the Achaean League in 146 B.C. and was refounded only in 44 B.C. as a Roman colony by Julius Caesar (2.1.2). Yet, despite its new population and Roman credentials, what is interesting to Pausanias about Corinth are its ancient (pre-Roman) associations and sights which are themselves explained to Pausanias by the present-day Corinthians. By virtue of being in that place, these people have become "Greek" according to the Pausanian definition; the place itself has imparted its truth, its identity, to them. Hence the stories recounted of the loci of Corinth are about Artemis (2.3.2) and Medea (2.3.6f.), Bellerophontes (2.4.1f.) and the ancient history of the Corinthian kings (2.4.3–4).

More powerful still as a myth of identity and location is the extended history of the Messenians (4.1–29). This is a tale of losing one's native land, of exile and of eventual return. It describes "the many sufferings of the Messenians, how fate scattered them to the ends of the earth, far from the Peloponnese, and afterwards brought them safely home to their own country (oikeian)" (4.29.13). Identity here depends on more than geography – it is a myth partly of race, partly of dialect and above all of displacement and return, but it is focussed on locality in the sense of loyalty to the traditions of one's home:

The wanderings of the Messenians outside the Peloponnese lasted almost 300 years, during which it is clear that they did not depart in any way from their local customs (ta oikothen), and did not lose their Doric dialect, but even to our day have preserved the purest Doric in the Peloponnese. (4.27.11)

But this fierce loyalty was not enough. Only when they returned to the full identity of being *in* their proper place could the Messenians return to being fully Greek:

> I was exceedingly surprised to learn that while the Messenians were in exile from the Peloponnese, their luck at the Olympic Games failed. For . . . we know of no Messenian, either from Sicily or from Naupactus, who won a victory at Olympia . . . However, when the Messenians came back to the Peloponnese, their luck at the Olympic Games came with them. (6.2.10)

Identity transcends place. It is competitive in the pan-Hellenic tradition of the Games. But success, a nation's place in the Games (and in the pan-Hellenic tradition), is itself dependent on the correctness of locality. The Messenians are not truly themselves until their return. This return is more than merely a replacement in the right place; it proves to be a return to their form as fully Greek, as competitors and victors in the pan-Hellenic Games.

Deeply implicated in this nostalgic sense of identity is the repeated theme of autochthony – of peoples being born from the soil they inhabit.[47] This recurs in most of the books of Pausanias's *periegesis* from Erichthonius (1.2.6) to the Locrians (10.38.3).[48] Despite the fact that identities can change, it is the earliest traceable link between a people and their environment that Pausanias is most keen to record: "The Stymphalians are no longer included among the Arcadians, but are numbered with the Argive league, which they joined of their own accord. That they are by race Arcadians is testified by the verses of Homer . . ." (8.22.1). It is an ur-past, an autochthonus or at least Homerically sanctified past, to which Pausanias is looking.[49] So his Stymphalians (despite their later choices and actions) are located bang in the middle of Arcadia not simply by race or by the authority of the poetic canon, but by the very structure of Pausanias's own account (where they occupy a place in the middle of Book 8).

IDENTITY PAST, IDENTITY PRESENT: PAUSANIAS AND THE ROMANS

Clearly, in looking to the past for a Greek identity, Pausanias was avoiding the present. The present was the Roman Empire under Hadrian, Antoninus Pius and Marcus Aurelius. The present was a Greece that served, at best, as a culturally influential but otherwise not especially significant province in

a huge system whose centres of power and influence were located elsewhere. Like the Jews, the Greeks were an ancient and independent people whose relations with their Roman rulers were deeply ambivalent.[50] In a passage which seems to anticipate many of Pausanias's concerns, Plutarch put the problem from the Greek point of view:

The statesman, while making his native state readily obedient to its sovereigns, must not further humble it; nor when the leg has been fettered, go on and subject the neck to the yoke, as some do who, by referring everything great or small to the sovereigns, bring the reproach of slavery to their country. (*Praecepta Gerendae Reipublicae* 814F)

The continuous need to balance obedience with limited freedom made for long-term complications in the attitude of Greeks towards their Roman rulers. Like those of Plutarch,[51] Pausanias's relations with the Romans were, not surprisingly, complex.[52]

In his description, Pausanias completely ignores significant monuments that he must have seen, such as the great charioteer group commemorating Marcus Agrippa which stood by the entrance of the Propylaea at Athens (which Pausanias describes at length at 1.22.4f.) or the temple of Rome and Augustus which was placed on the Acropolis right in front of the Parthenon's east entrance.[53] On the other hand, he is generous in acknowledging some major Roman building programmes, such as Hadrian's temple of Olympian Zeus in Athens (1.18.6f.).[54] Romans may be paradigms of virtue and piety like Hadrian ("a benefactor to all whom he rules" [1.3.2], "who was extremely religious in the respect he paid to the deity, and contributed much to the happiness of his various subjects" [1.5.5]) or Antoninus Pius ("a most religious man" with all kinds of virtues [8.43.1–5]). But they may also be exemplars of evil – for instance, the impious Sulla (a man whose "mad outrages against the Greek cities and gods of the Greeks" [1.20.7] are punished by "the most foul of diseases" [9.33.6]) or Nero and Caligula (9.27.4f.). The Romans may offer freedom to Greeks by liberating particular cities, such as Mothone (4.35.3), Pallantium (8.43.1) and Elateia (10.34.2), or even to the whole nation, when Nero "gave to the Roman people the very prosperous island of Sardinia in exchange for Greece, and then bestowed upon the latter complete freedom" (8.17.3). But this very act of bestowal is proof of who is master, and it can be reversed:

The Greeks however were not to profit by this gift. For in the reign of Vespasian, the next emperor after Nero, they became embroiled in a civil war. Vespasian ordered that they should again pay tribute and be subject to a governor, saying that the Greek people had forgotten how to be free. (8.17.3).

This is a deep condemnation – all the more bitter because freedom is inherently part of the Greek nature and identity in the Pausanian myth-history; it is precisely this freedom which Roman domination had eroded.

In fact Pausanias's myth of a total Greece is supremely a myth of how "all Greece *(pasa Hellas)* won independence and freedom", to quote the inscription which Pausanias quotes from the statue of Epaminondas (9.15.6). It is a myth of how the biographies of a few great men, from Miltiades to Philopoemen, transcended the identities of their local loyalties to become "benefactors of all Greece *(koinê tês Hellados)*": "Those who before Miltiades accomplished brilliant deeds, Codrus the son of Melanthus, Polydorus the Spartan, Aristomenes the Messenian, and all the rest, will be seen to have helped each his own country and not Greece as a whole *(ouk athroan tên hellada)*" (8.52.1). This is a fascinating passage. Not only is there an unashamedly moral slant to the pan-Hellenic picture, a praise for motivations that transcend locality, but this shades into an explicitly moral emphasis on the way lives ought to be lived. Pausanias specifically excludes "from being called benefactors of Greece" his namesake Pausanias and Aristeides, the victors of Plataea, because of their subsequent transgressions as well as the participants in the Peloponnesian war against Athens whom he bills as "murderers, almost wreckers, of Greece" (8.52.2–3). There is, furthermore, an inevitable sense of decline and fall. As he is in Plutarch,[55] Philopoemen was the last in the roll-call of the great, and he was already involved in wars with the Romans (8.50–1). It is as if, historically, the myth of Greece must be defined, delimited and ended by its proximity to Rome.

Yet it is precisely the conquest of Greece by Rome – the ending of Greek independence and any dream of real freedom for the country – which constitutes the possibility for the myth of a free Greece once long ago. Greece can only be one whole when it is subservient to an external state, a Macedon or a Rome. Greece is "Greece" (one country and not many *poleis*) only because it is a province in an empire whose various cities are united through having *lost* their freedom. In the new dispensation they can be granted freedom by an omnipotent emperor from elsewhere. Pausanias's backward-looking

project of *panta ta hellênika* is itself conditioned by its Roman context in *being* pan-Hellenic, in doing the whole of Greece, because "Greece" can exist only when its freedom not to be united is over and the myth of a freedom-in-the-past has begun. For the Pausanian project to be possible, all the places (whose stories and sanctities the author so carefully enumerates) must no longer be free and at war (as they were in the myth that Pausanias retails), but must be united by and within a larger power. The very attempt to invent and justify a myth-history of "Greece" is simultaneously the evidence for its defeat: Greece can exist only in the invention, in the myth of Rome. The condition for the Pausanian *periegesis* of Greece is that the Greece which his *periegesis* describes no longer exists.

Only when we begin to appreciate the head-on clash of identities, the complexity and incongruity of conflicting paradigms from past and present reiterated through Pausanias's narrative, which together in their tension created Pausanias's Greece, can we begin to grasp some of the ironies that lie hidden in his text. At Sikyon he notes drily: "The precinct . . . devoted to Roman emperors was once the house of the tyrant Cleon" (2.8.1). The viewing of this temple is ironic in the extreme, and the effect is heightened when Pausanias launches immediately into the story of how Aratus liberated Sikyon and Corinth from tyranny (2.8.2–6). In the Argive Heraion, he notices "statues . . . of various heroes, including Orestes. They say that Orestes is the one with the inscription, that it represents the Emperor Augustus" (2.17.3)! Only rarely does Pausanias reject inscriptional evidence for mere hearsay.[56] In both these cases the conflict, the ambiguity, of past and present as they clash in the identity of the viewer emerges as irony. In all such instances it is the viewer's identity itself which is at stake in the act of interpreting a work of art.

One way out of the impasse of socio-historical identities is to look for a self which is outside history, beyond the decline of Pausanias's beloved Greece into a Roman fief. As we saw earlier, at the heart of Pausanias's ideology of location is the theme of sacred centres. If the political path of the traveller is fraught with identity conflicts which seem to become increasingly less resoluble the longer the journey and text go on, then perhaps religious pilgrimage is the solution to the identity crisis of second-century Greece. The traveller turned pilgrim is no longer in search of a political or historical past that is denied by the present; he seeks rather a sanctified

present past whose sacredness has pervaded these places since the beginning, despite history.

PAUSANIAS AS PILGRIM: IDENTITY AND THE SACRED

Pilgrimage was an important aspect of the religious culture of pagan antiquity. We know of many examples of individuals and groups going to sanctuaries to consult deities, seek healing, or venerate relics.[57] But, with the exception of Pausanias, we possess no text from the pagan world which recounts the process of pilgrimage as a personal journey. Here the contrast between antiquity and the Christian tradition of travel writing is stark. It gives Pausanias's text a unique cultural significance not only as testimony to a specifically *pagan* form and view of pilgrimage but also as a counterpoint to later Christian writing.

One can see the totality of Pausanias's account as a pilgrimage lasting many years.[58] Certainly it has elements of a transformative *rite de passage* in which writer and perhaps reader are changed by their confrontation with the sacred identity of Greece.[59] Pausanias himself comments on his personal transformation after retelling the myth of how Rhea deceived Cronus:

When I began to write my history I was inclined to count these legends as foolishness, but on getting as far as Arcadia I grew to hold a more thoughtful view of them, which is this. In the days of old, those Greeks who were considered wise spoke their sayings not straight out but in riddles, and so the legends about Cronus I conjectured to be one sort of Greek wisdom. In matters of divinity, therefore, I shall adopt the received tradition. (8.8.3).

It is significant that this change of attitude relates to "matters of divinity" and that it marks a shift from rationalistic literalism (the secularist's response to the sacred) to a greater openness towards allegory and metaphor as methods of intuiting religious truth.[60]

It is in the more specific descriptions, however, that one can elucidate more directly the pilgrimage elements of Pausanian viewing. Let us take the journey to Eleusis, which is not only a highly charged centre of mystery initiation but is also marked out by Pausanias himself as one of the two supreme sites of Greece: "On nothing does heaven bestow more care than on the Eleusinian rites and the Olympic

Games" (5.10.1). Pausanias was himself an initiate into the Eleusinian mysteries.[61] Although the text only reaches Eleusis at 1.38, we have been prepared for its importance by the discussion of the Eleusinium at Athens at 1.14.3 and the reference to initiation at the Eleusinian mysteries at 1.37.4. Because "a vision in a dream" prevented Pausanias from describing the contents of the Athenian Eleusinium, the reader is already prepared for Eleusis being religiously special.

This specialness is marked by the very topography the moment the text arrives at Eleusis: "The streams called Rheiti are rivers . . . sacred to the Maid and to Demeter, and only the priests of these goddesses are permitted to catch fish in them. Anciently, I learn, the streams were the boundaries between the land of the Eleusinians and that of the other Athenians" (1.38.1). The geography here is itself sacred – marking an ancient boundary, a liminal threshold between the political world of Attica and the Other World, Eleusis, on its periphery. The ancient political settlement bears out this otherness: "The Eleusinians were to have independent control of the mysteries, but in all other things were to be subject to the Athenians" (1.38.3). Not only in space but also in administration we are being prepared for something altogether Other. The text now proceeds through a number of shrines and temples, and their myths, until it reaches the sacred enclosure itself.

Here Pausanias surprises us: "My dream forbade the description of the things within the walls of the sanctuary, and the uninitiated are of course not permitted to learn that which they are prevented from seeing" (1.38.7). Having set Eleusis up as a world apart – Attic but different, bounded by sacred boundaries within Attica and administered by a separate order within Athenian order – instead of describing this Other, or bringing his reader through "the walls of the sanctuary" into its inner sanctum, Pausanias's text dramatises the otherness of Eleusis in a supreme way. He denies its describability within his own discourse. No mark of otherness is so effective as this statement that the truth of Eleusis cannot be constrained in the act of writing, the act to which the text itself is in perpetual debt. Here, in a radical about-face, Pausanias, who has constantly been the reader's guide, the reader's ally in penetrating *panta ta hellênika*, suddenly changes to become the Other's ally in concealing the mystery of Eleusis from his uninitiated readership. Here, before the sacred which cannot be described, the text's phenomenology – one of its crucial structuring devices – breaks down.

The reader who travels through Greece *with* Pausanias, in his order, at his pace, along his roads, is left *outside* the sacred wall. Pausanias's writing is generally an endeavour of going out to us and making a way for us into the Other of his Greece, its ritual and its art. But his silence here – his articulation within discourse that there is an Other to discourse before which discourse must cease – is the opposite of the usual pattern of his writing, a denial of his writing, a bar to our entry into the heart of a Greece which it was his project to facilitate.

If Eleusis were an isolated instance, we could be pardoned for overlooking its significance. But in fact it offers us the paradigm for a repeated pattern.[62] Like many pilgrimages, it offers a journey to a sacred Other,[63] which is often located on the periphery of a social or political centre but is nevertheless more deeply central to the pilgrim's sense of identity.[64] Such "peripheral centres" where the Other (whether a statue or a set of rites) must remain secret are numerous. In some cases, like Eleusis, Pausanias was an initiate who could not divulge what he knew; in others he was an outsider (like his presumed readers) and himself never knew what lay at the sacred centre. Such cases include the sanctuary of Demeter on Mt Pron outside Hermione ("the object most worthy of mention" [2.35.4]) whose goddess is surnamed Chthonia (i.e., one that defines the land). Pausanias describes a truly remarkable annual festival and cow sacrifice (2.35.5–7), the minor statues and images (35.8), as he builds to the climax: "But the thing itself that they worship before all else I never saw, nor yet has any other man, whether stranger or Hermionian. The old women may keep their knowledge of its nature to themselves" (2.35.8). The very structure of the writing leads to the authority-giving yet absent centre – the valorizing void of deity. Likewise, at the gate of Hermione on the road towards Mases is a sanctuary of Eileithyia: "Every day, both with sacrifices and with incense, they magnificently propitiate the goddess, and, moreover, there is a vast number of votive gifts offered to Eileithyia. But the image no one may see, except, perhaps, the priestess" (2.35.11). Again, the paraphernalia of the sacred (rituals, offerings) lead to that which cannot be viewed or described. These paraphernalia entice and elicit description (their interest is what merits entry into the text), and yet the cause upon which all the ritual and the sanctuary itself are predicated – a deity and the deity's image – are denied to knowledge.

Pausanias's silence is itself a ritual act, the result of a religious *mentalité* of taboo and retribution. It is predicated on his usual word for mystery: *aporrhêtos*, literally "away from speech".[65] Often, as at Eleusis, the Athenian Eleusinium or the mysteries of the great goddesses at the Carnasian grove outside Messene (4.33.4–5), it is a dream which informs Pausanias as to what he may or may not reveal. Several times he remarks emphatically on the consequences of transgression, whether by the physical act of entering a sacredly bounded place or the verbal act of giving the mysteries away. At the sanctuary of Poseidon Hippios near Mantineia (8.10.2f.) into which no one may enter, Pausanias twice repeats the story of how Aegyptus broke this rule, only to be punished by blindness and death (8.5.5 and 8.10.3). Death is the punishment for transgressive entry at the precinct of Lycaean Zeus (8.38.6) and at the sanctuary of the Cabeiri (9.25.9–10). The merely inquisitive too will die (10.32.17), as will those who dare to imitate the mysteries (9.25.9) or who, like Orpheus in one of the myths of his death, profane them through speech (9.30.5).

Such stories articulate a deep cultural sense of taboo surrounding the sacred. What was the sanctity which such taboos protected in pagan culture? Because his silence is scrupulously observed, Pausanias's readers clearly are not intended to know too much unless of course they were to become initiates themselves. However, there is one instance where he does tell us something about the mysterious nature of the sacred centre whose essence is denied to discourse. During the trip to Arcadia, at 8.36.2f. and 8.38.6f., Pausanias juxtaposes two mountains with profound mythical and sacred associations which are in fact quite far apart – Mt Thaumasius near Methydrium north of Megalopolis (where Rhea deceived Cronus about the birth of Zeus) and Mt Lycaeus near Lycosura south of Megalopolis (where Zeus was born). The close connection of the mythical topography transcends the exigencies and actualities of "real" space. These two mountains are a complementary pair. Mt Thaumasius is sacred to Rhea – the goddess and mother who deceived her husband to save her son; Mt Lycaeus to Zeus – the male god, the son reared and saved by his mother's wiles. On the peak of Thaumasius is Rhea's cave "into which no human beings may enter save only the women who are sacred to the goddess" (8.36.3). On the summit of Lycaeus "is a mound of earth forming an altar of Zeus Lycaeus, and from it most of the Peloponnese can be seen" (8.38.7). There is a play of hidden and open in

the contrast of Rhea's interior cave and the expansive view from Zeus's mound. But there is also a progression of secrecy from the cave at Thaumasius where only the sacred women can enter, to the *temenos* of Lycaean Zeus into which no one is allowed (8.38.6) to the secret *rites* performed on the summit of Lycaeus (8.38.7). The *temenos* boasts a truly remarkable marvel:

If anyone takes no notice of the rule and enters, he must inevitably live no longer than a year. A legend, moreover, was current that everything alive within the precinct, whether beast or man, cast no shadow. For this reason, when a beast takes refuge in the precinct, the hunter will not rush in after it, but remain outside, and though he sees the beast he can behold no shadow. (8.38.6)

This sacred precinct is not merely Other by human rules of liminality and entry. By contrast with other sites or rituals – markedly, the hidden cave of Rhea and the secret sacrifices of Zeus Lycaeus – it is open to vision. But it is precisely the rules of seeing that have been transcended. Here sacred space affects and alters material space – it breaks natural laws within the threshold of its own sanctity by abolishing shadows and shortening the length of human life. Here, briefly but memorably, we see the Other World penetrating this world, we see one aspect of the sacred in action.

All these instances (to which we may add the Lernaian mysteries at 2.37.1f. and the rites of the Cabeiri at 9.25.5f.) offer the pattern of an important sacred centre, on the periphery of a political centre, where the core of sanctity – that which underpins the holy authority of the site – is denied to description. In each case Pausanias goes out of his way to describe the place and its customs and to signal what he cannot discuss. Close to this pattern is a parallel structure of the holy where a sacred centre is described in the heart of a political centre. In cases like the Acropolis at Athens (1.22.6f.) or the Acrocorinthus above Corinth (2.4.6f.) or the sanctuary of Asclepius at Sikyon (2.10.2f.), Pausanias does not conceal the heart of the sacred centre, whether it be a cult image as at Sikyon or a number of temples and statues as in Athens. And yet in the vicinity, on the periphery as it were, of these sacred sites *within* cities are a number of crucial absences.

In Athens, the most sacred image (*to hagiôtaton* [1.26.6]) is Athena Polias, Athena "of the city".[66] When Pausanias comes to discuss this image and the ritual related to it, scholars have

noted his silence about its appearance.[67] Moreover, in the description of the Arrephoria, or festival of bearing sacred offerings to this image, there are several secrets surrounding the obscure ritual:[68]

Having placed on their heads what the priestess of Athena gives them to carry – neither she who gives nor they who carry have any knowledge what it is – the maidens descend by the natural underground passage that goes across the adjacent precincts, within the city, of Aphrodite in the Gardens. They leave down below what they carry and receive something else which they bring back covered up. . . . (1.27.3)

At the ritual heart of the city, its sacred identity, are secrets necessarily absent from description or knowledge which are nonetheless crucial to the preservation of sanctity. At the Acrocorinthus it is not rituals but some of the temples and images en route to the peak (the sanctuary of Necessity and Force, the temple of the fates and the temple of Demeter and the Maid [2.4.7]) that are "not exposed to view". In the precinct of Asclepius at Sikyon, just inside the entrance (in the liminal and peripheral position), is a building whose "inner room is given over to Carnean Apollo; into it none may enter except the priest" (2.10.2). This is in marked contrast with the main temple of Asclepius – "when you have entered you see the god, a beardless figure of gold and ivory made by Calamis" (2.10.3).

In all these accounts the secrecy or hiddenness marks an otherness which upholds the sacred. And the sacred is above all a guarantor of identity. When disaster looms for the Messenians in their war with Sparta, Aristomenes, their leader, decides to hide their "secret thing" (*ti en aporrhêtôi*) at 4.20.4. Pausanias comments, "If it were destroyed, the Messenians would be overwhelmed and lost for ever, but if it were kept . . . after a lapse of time the Messenians would recover their country". This "secret thing" is the psychic and spiritual heart of the Messenians – it is the absent centre that defines their identity: "Aristomenes, knowing the oracles, took it towards nightfall and coming to the most deserted part of Mt Ithome, buried it on the mountain, calling upon Zeus who keeps Ithome and the gods who had hitherto protected the Messenians to remain guardians of the pledge" (4.20.4). It matters that the object and its location be secret, that the hiding be done at night and that Pausanias's narrative tells us all and yet misses the crucial identifying precisions of what

and where. For it is Messenia itself, as an identity, that is at stake.

VIEWING AND IDENTITY

Pausanian viewing is the enumeration and classification of *panta ta hellênika*. What might have seemed in principle a simple act of cataloguing has turned out to be the incomparably complex act of meeting the statues, buildings and natural wonders of one's native land on all the conflicting levels of one's identity. The facts of the present and the myths of the past – which together create a socio-political identity and ideology – normally intertwine, reinforcing each other like a double helix. But in this case they do not match. And so the ideology and identity to which they have given birth are not coherent; they are full of contradiction. And this socio-political identity is itself incapable of grasping or describing the sacred – which defines the identity of Pausanias in his aspect as pilgrim and initiate. There are more than forty instances in the ten books of Pausanias where the text is explicit in telling us that this is a monument, object or rite that cannot be described in the terms which can accommodate the rest of the objects in the text.[69]

Pausanias is quite explicit about the limits of his discourse, the boundaries of the ideology which his text has worked so hard to construct. The system of representation designed to do justice to the most noteworthy sites of Greece breaks down precisely at some of the sights that Pausanias deems most worth seeing. At the sacred centres to which the pilgrimage of this descriptive text moves there is an absence, over the sights which are most worth viewing is drawn a veil. Pausanian enumeration is not only a construction of ideology, it is also a catalogue of instances where the ideology fails to apply. What all the instances where Pausanias signals his inability to describe an object have in common is ritual and the difference of an initiated or at least ritually sanctioned viewer from the ordinary person. In every case, either Pausanias falls into the category of the uninitiated or (as at Eleusis) he cannot reveal the contents of the sacred secret to readers who may be uninitiated themselves. For "the uninitiated are not of course permitted to learn what they are prevented from seeing" (1.38.7).

We are offered in Pausanias's discourse two contestant, logically exclusive yet mutually constitutive, sets of signs.

The one is Pausanias's structure of descriptions and myths, the other his pronouncements of what he cannot describe. These are not equal. I should like to illustrate the difference by referring to recent theoretical discussion of the semiotics of the numerical system.[70] The introduction of the sign for zero into the numerical system 1 to 9 in the Middle Ages had fundamental consequences for the history of mathematics. But it was also a radical move in the semiotics of the system. Zero was not only a sign within the new system of signs 0, 1, 2, 3 and so on to 9; it was also a sign outside that system. For 0 signifies the *absence* of the other signs (1 to 9). It is in fact a sign about those signs – a metasign. The new system, including 0, was radically different from the old because it contained within itself a sign about itself, a sign about the absence (the void, zero) that the other signs were unable to signify. Pausanias offers us precisely the same phenomenon. His text is a series of signs, just like the numerical system 0 to 9, whose aim is to classify and describe *panta*. But it contains within that system a second set of signs which function both to signify items mentioned in the flow of the text *and* as signs for the absence, the inappropriateness, of the rhetorical system of descriptions in which they seem to be part. Pausanias's enunciation of his inability to describe Eleusis is a sign about the limits of his discourse.

To signify the impossibility of enunciating the Other World, the holy, is to reveal that the kind of discourse inherent in ordinary Pausanian viewing cannot control the Other World and is insufficient to it. Pausanias offers us two systems of representation in his text: sign and metasign. But the momentous implication for the cultural historian is that these two systems point to two quite different and logically exclusive ways of viewing *in the same individual*. Identity depends in part on context, and the same person's identity in different contexts will be different.

The ordinary viewer is excluded from the otherness of art. He or she must construct a narrative to contextualise objects – to derive meaning from and supply meaning to those objects. This is the function of Pausanias's narrative of *panta* and his use of so-called digressions into history and myth. But this ordinary viewer is specifically excluded from those sacred objects that are open to the initiate viewer.[71] We are not told what initiate viewing is (that *would* be outside the limits of this text!), but it is participant within ritual in a way that ordinary viewing cannot be. In initiate or ritual viewing, the observer consciously gives up the privacy of his or her own

personal view, as well as the ideologically and culturally shared assumptions which have helped to formulate such a view, for a "shared subjectivity" of participants in the ritual process or journey. Ritual is culturally important because it provides a different, an exclusive or a sectarian, cultural framework for the construction of subjectivity and self-identity. Quite different kinds of interpretation of the world "out there" will result.[72]

Clifford Geertz has argued that initiation into "the framework of meaning which religious conceptions define" changes not only the initiated person but also "the commonsense world, for it is seen as but the partial form of a wider reality which corrects and completes it".[73] This is certainly the case with Pausanias. His very need to provide a series of metasigns shows that the discourse of "commonsense" reality is partial and inadequate to cope with the ritual world as experienced at (for instance) Eleusis. The semiotic disjunction points to two parallel ways of viewing, to a fundamental difference in the kind of subjectivity employed by the viewer in respect of his or her relationship with the object.

SUGGESTIVE CONCLUSIONS

This chapter began as an investigation of "viewing" in Pausanias. It has turned out to be about subjectivity – not in the entirely personal sense, but about that part of subjectivity which the individual takes on from outside and constructs himself or herself into. Pausanias's text is evidence for a certain ideology which was designed to provide the reader with a cultural identity, a shared subjectivity, out of which to view art. This is a very generalised and "secular" identity available to anyone within his or her particular world (like being British, or American). But he also constructed a second and much narrower cultural identity, shared exclusively and esoterically by the initiates in certain rites and cults. For the initiate, this is a deeper and more fulfilling reality than the more general sense of the subjective that the main thrust of the text offers. It is a reality that necessarily excludes the uninitiated.

For anyone interested in religion within culture or the tensions between a sacred and a secular art, Pausanias's *periegesis* is a cardinal text. It demonstrates clearly that logically exclusive ways of viewing existed simultaneously in the Graeco-Roman world.[74] The history of art (especially in its analysis of the rise of Christian art) has looked at the evidence

from a formalist analytical angle. It has explored the symbolism of objects and something of their differences in meaning. However, formalism (what an object out there looks like) cannot be divorced and is indeed dependent on the subjective framework of the kind of viewing it allows and the kind of viewing that wants it to be as it is. When we speak of art and the transformation of Roman to Christian art, the epithet "Roman" implies a broad cultural predication whereas the epithet "Christian" implies a specific dogma and ritual. In its origins, "Christian" art was to "Roman" art as Pausanias's metasigns are to his system of enumerative classification: a different, deeper and exclusive identity (as far as the shared subjectivity of Christians was concerned).

The application of Pausanian initiate discourse and viewing to early Christianity allows us to suggest that the formalism of the transformation of Roman art is not a diachronic shift in skill, symbolism or imagination (as has been variously asserted). Rather it indicates a synchronic process of different kinds of viewing within a society. The transformation of Roman art in the third century can thus be seen as a process of the growing ritualisation of a culture increasingly towards ritual or initiate viewing and away from the "ordinary" viewing that predominated throughout most of the Graeco-Roman period. The rise of mystery cults, from Eleusis to Christianity, was a part of this – part of a need at a particular time in a particular society for the more formalised shared subjectivity that ritual initiation provides. Ultimately therefore one can see the formal transformation of Roman art as dependent on a transformation in the structure of subjectivity in Roman culture – a transformation that responded to a much more formalised and even authoritarian religious system such as Christianity.

Something of this transformation in subjectivity can be grasped by comparing Pausanias's approach with that of later Christian pilgrims like Egeria. The later pilgrims too emphasise the phenomenology of travel, describing their journeys personally step by step. Here is an extract from the narrative of the Bordeaux Pilgrim of A.D. 333:

City of Neapolis (15 miles). Mount Gerizim is there, where according to the Samaritans, Abraham offered his sacrifice. There are 1,300 steps leading to the top of the mountain. Nearby, at the foot of the mountain, is the place called Shechem, which is the site of the tomb in which Jacob is buried A mile from there is the place called Sychar, where the Samaritan woman went down to draw water, at the very place where Jacob dug the well, and our

Lord Jesus Christ spoke with her. Some plane trees are there, planted by Jacob, and there is a bath which takes its water from this well. 28 miles from there on the left of the road is the village called Bethar and a mile from there is the place where Jacob slept on his way from Mesopotamia, and the almond tree is there, and he saw a vision, and an angel wrestled with him. (587.2–588.10)

The Christian pilgrim's awareness of the road itself, his constant relation of places to the stories evoked by them[75] and his tying of current landmarks (the 1,300 steps at Mt Gerizim, the plane trees and bath at Sychar, the almond tree at Bethar) to the ancient myths are all very similar to Pausanias. Like Pausanias in Greece, the Christian traveller to the Holy Land attempts to evoke a sense of identity through place and through the myths which give places their meaning in his culture. Moreover, again like Pausanias, the early Christian pilgrims display a remarkably acute sense of and deep interest in ritual. Egeria devotes about half of the surviving portion of her account to the liturgy in Jerusalem (24.1–49.3).[76]

The differences however, are fundamental. Where Pausanias's monuments evoke a mass of conflicting myth-histories referring to oral as well as written traditions, the Christian pilgrims tie their sense of place almost exclusively to Scripture.[77] That is, the Hellenistic culture of Graeco-Roman antiquity, with its diverse range of myths, texts and religions, never had the cohesion of a single canonical scripture to which everything could be referred. Whereas Pausanias travels through his own land (where his native language is spoken, his native myths are alive and his identity is embodied), Christian pilgrimage is to another world altogether – a foreign holy land where, as the Latin-speaking Egeria tells us, sermons are preached in another language (Greek), are translated into Syriac and may also be interpreted in Latin (47.3–5). The Christian identity is constructed in a fundamentally different way – through reading a sacred book originally created in another culture (the Jewish east) and around the topography of a sacred place far from home (Palestine).

Moreover, Egeria has no need for selective mystical silence. Her text, her Christian world and her presumed readership all belong to a circle of initiates. This shift is above all fundamental to the transformation in identity between the pagan second and the Christian fourth centuries. For Pausanias, there is an absolute difference between the secular world of his socio-historical identity and the sacred world of initiation. The latter gives access to an exclusive and esoteric identity shared with a small and self-selecting group of fellow initiates.

It is not available to outsiders. By the time of Egeria, in the late fourth century, we already see the extraordinary "drainage of the secular" which has been seen as the most essential characteristic of the oncoming of the Middle Ages.[78] Despite that Christianity had only escaped persecution less than a century before her, Egeria *assumes* that her readers, indeed that the whole world of her personal experience, will share her Christian initiation. A religion which had begun as an exclusive sect little different from the initiate cults we meet in Pausanias had become a Universal Church. One of Christianity's greatest achievements in transforming the identity of the ancient world was the way it used the intense exclusiveness of the initiate cult, which we see so clearly in Pausanias, to define the world of secular and social experience as well. What had been two worlds – secular and sacred – in Pausanias, had become one sacred world.

THE TRANSFORMATION OF ROMAN ART FROM AUGUSTUS TO JUSTINIAN

FOREWORD

Though God do now hate sacrifice, whether it be heathenish or Jewish . . . throughout all the writings of the ancient Fathers we see that the words which were do continue; the only difference is that whereas before they had a literal, they now have a metaphorical use.

Richard Hooker[1]

The cultural transformation which took place in the Graeco-Roman world between the reigns of Augustus and Justinian is, with the possible exceptions of the Renaissance and the "Greek Revolution" of the fifth century B.C., perhaps the most momentous change in the history of the West. It marks the passage from antiquity to the Middle Ages. The change in this period from "a literal" to "a metaphorical use", which Richard Hooker (writing in the sixteenth century) noted in language, is true also of rites and images, as well as in the ways meaning was generated by them. What generations of theologians like Hooker took to be an essentially religious transformation – an effect of the Incarnation – was also a cultural change in ways of assimilating, interpreting and viewing the world.

The two chapters which together make up this part of the book evoke some aspects of this change as it relates to Roman art. In order to clarify the difference between Classical and early Medieval art (that is, the difference between the poles – aesthetic and temporal – from which and to which Roman art changed), I focus on images at either end and in the middle of the spectrum. In the case-studies of Chapter 5, I approach the

changes in how the emperor was perceived by taking the temperature (as it were) of imperial imagery at three crucial moments – the reigns of Augustus and Justinian, which provide the poles at either end of the transformation of Roman art, and that of Diocletian in the late third century, an important moment of transition. In Chapter 6, I repeat this comparative process by looking at the transformation of sacrificial viewing. Again, my case-studies focus on images from the Augustan and Justinianic periods and from the late third century.

Although the choice of two themes from the many one might select (including landscapes, funerary images and so forth) may seem somewhat arbitrary, the themes of imperial and sacrificial representation nevertheless evoke perhaps the two most important areas of change, namely, politics and religion. In effect, they are variations on the two modes of viewing – that which focussed on material things in the natural world and that which allegorized material things into images of the Other World – which formed the substance of Part I. These two chapters, although presented as comparative discussions of particular case-studies, are intended more broadly – they are to serve as meditations on the transformation in how the political hierarchy, on the one hand, and religious ritual, on the other, were perceived.

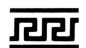

REFLECTIONS ON A ROMAN REVOLUTION: A TRANSFORMATION IN THE IMAGE AND CONCEPTION OF THE EMPEROR

THIS chapter sketches some aspects of change in how the emperor was perceived from the first to the sixth centuries. I explore change by looking at images (using a very limited selection of material, to be sure) and at the way such images might have been viewed. One might argue (quite rightly) that any period of six hundred years would provide evidence of radical change, and (given that fact) the transformations I examine here were hardly greater than might have been expected. But my excuse for the attempt is that one cannot grasp what happened in the passage from antiquity to the Middle Ages by looking at a single "pivotal" moment or a restricted transformative period of change. There was a gradual, complicated and multifaceted *process* of change over several centuries. This process was immensely rich, subtle and nuanced. It is not my project to unravel its complexities here (although I shall look at some aspects of this process in Part III). Rather, I aim to sketch something of the *nature* of this change by looking at its poles. If we can be clear about what Roman culture was in the first century and about what it became in the sixth, then we have a basis on either side of the divide from which to explore the transformation that bridged it.

In this chapter, I take the socio-political theme from Part I and explore its ramifications for the image of the emperor (particularly in relation to religious issues). The ways people represent their rulers is a key to understanding how the positions of those rulers were conceived. A comparative examination of different groups of imperial images in the Roman world is one way of throwing light on the changes in assumptions and ideology that took place in the Romans' sense of

their relations with their emperor. I examine some central examples of imperial representation: from the period of Augustus when the Principate was first established, from the period of the tetrarchs at the end of the third century A.D. at the point just before the empire adopted Christianity and from the time of Justinian, a high point of the Christian empire in the sixth century A.D. The emperors concerned – Augustus, Diocletian and Justinian – were all strong rulers whose reigns were long and whose imperial imagery was revolutionary and pervasive in its time.

A comparative study of the imperial image at these three moments of empire reveals fundamental changes in the notion of what an emperor was and in the ways an emperor's representation could be viewed. The image of Augustus demonstrates a remarkable ambiguity between the emperor's status as citizen and ruler, as man and god. Augustus is all these contradictory roles in a single statue. Such ambivalence is conceptually unstable; but on the other hand it suited the political and cultural needs of a time when deification of human beings was not abnormal and when the emperor had to balance contradictory signs with great care in his attempt to establish a new model of government in the Roman world. By the time of Diocletian, this model of the single image of a man who was also a god had become untenable. The cult room from the temple of Ammon in Luxor reveals a new multiple model of imperial representation in which the emperor is represented separately and in different styles in his divine and human roles. This tetrarchic model, although solving the problem of viewing a single statue in more than one way (as a portrait of a man and an icon of a god), nevertheless failed to resolve the deeper problem of how a man could also be a god. It was only in the Christian dispensation, when the problems about a man being a god had been elevated from political actuality to theological dispute, that the emperor – now firmly and unambiguously a man – could be straightforwardly a mediator with and the imitator of the divine order for his subjects. The images of Justinian and Theodora from the Church of San Vitale in Ravenna reveal a Christian imperial and social hierarchy which has brilliantly clarified the conceptual obscurities and ambiguities of earlier Roman models of the emperor's role.

I make a detailed comparison of these images in their respective art-historical and conceptual contexts in order to emphasise the importance of the viewer in this process of change. Insofar as the discussion will involve some of the

most famous *imperial* portraits that survive from antiquity, it strays into the arena of political propaganda and the propagation of an imperial image. This theme has long been important in art history, and has recently been considerably developed by the work of Paul Zanker on the art of the Augustan Principate.[1] The question of art as imperial propaganda makes an excellent entry into the problems of viewing because it presupposes the crucial role of viewers as recipients of the imperial image and as audience before which the persona of the emperor will be displayed.

THE STATUE OF AUGUSTUS FROM PRIMA PORTA

DESCRIPTION AND INTERPRETATION

There are few more famous monuments of Augustan art than the statue of the emperor discovered in 1863 in a villa above the Tiber at Prima Porta which seems to have belonged to Livia, Augustus's wife (Figure 20).[2] We do not know the date of the image – whether it was made in Augustus's lifetime or afterwards or whether the statue we have is "the original" or a later replica. In the absence of any strong evidence, it seems reasonable to accept the view (with Paul Zanker, p. 188 of the English edition) that the most natural date for the Prima Porta image or its prototype is in the years immediately after 20 B.C. – the year of the events which its breastplate celebrates. I shall discuss ways of viewing the statue within the contexts of Augustus's reign and afterwards.

The statue decorated part of a garden terrace against a wall. It is uncertain how private such a setting was, and critics have argued that the marble image we have is the copy of a public bronze statue that once adorned some piazza in Rome or even Pergamon.[3] I introduce the straw man of non-existent prototypes to illustrate our problem with defining what was or was not a "private" or "public" image. If enough people attended private garden parties at the imperial villa in Prima Porta, the statue would anyway have been publicly accessible.[4]

As has been noted, the Augustan statue is unusually complex.[5] It represents the emperor on a scale larger than that of life (it is seven feet; Suetonius tells us that the emperor's actual height was five feet seven inches [*Augustus* 79]). He is dressed, as in a large number of Augustan and later imperial images, in cuirass and military cloak[6] and appears to be

proclaiming victory to the army or the people, or at any rate addressing the spectator. The pose is related to that of Polyclitus's *Doryphoros*, although Zanker suggests (p. 192) that in the Augustan version he holds not a lance but one of the standards regained from the Parthians. There are many intimations of the emperor's special status – his idealising features, his bare feet (reminiscent of gods and heroes), the sculpted support which is no mere tree trunk but Cupid on a dolphin, alluding to the divine descent of the Julian family from Venus. If the statue's initial impact is political ("his right hand raised in a symbol of power")[7] and simultaneously hints at the roots of this political power in an "Other World" divinity, the iconography of the breastplate (Figure 21) is still more explicit.

In the centre, a Parthian hands back the lost eagle of the legions to a Roman in military uniform accompanied by what I take to be the she-wolf of Rome. The restoration of the standards lost by Crassus to the Parthians was a supreme triumph of Augustus's reign.[8] It is mentioned in the *Res Gestae* (29) and, for example, by Horace in the *Epistles* (1.18.55f., cf. 1.12.27f.) and Ovid in the *Fasti* (5.579–94). But, as Zanker points out (p. 192), what is notable is not so much the historical event as the contextualising of history within the embrace of a mythico-religious iconography. On either side of the standards scene are mourning female figures whose subservience (one has an empty scabbard, and both are in positions of lamentation) seems to indicate conquered peoples, probably Spain and Gaul. In the *Res Gestae* Augustus says:

From Spain, Gaul and the Dalmatians, I recovered, after conquering the enemy, many military standards which had been lost by other generals. The Parthians I compelled to restore to me the spoils and standards of three Roman armies and to seek as suppliants the friendship of the Roman people. These standards I deposited in the inner shrine which is in the temple of Mars Ultor. (29)

In *Epistles* (1.12.25f.), Horace writes:

Cantaber Agrippae, Claudi virtute Neronis
Armenius cecidit, ius imperiumque Phraates
Caesaris accepit genibus minor, aurea fruges
Italiae pleno defudit Copia cornu.

The Cantabrian has fallen before the courage of Agrippa, the Armenian before that of Claudius Nero. Phraates on humbled knees has accepted Caesar's rule and law. Golden Plenty has poured fruits upon Italy from her full horn.

Figure 20 (opposite page). Statue of Augustus from Prima Porta (now in the Vatican Museums), first century B.C. Photo: Alinari-Art Resource, New York.

Whichever conquered peoples we choose to identify with the
two women, *aurea Copia* herself, with her horn of plenty,
rests beneath the standards scene, and Zanker suggests that
the Roman receiving the eagles may be Mars Ultor himself
(p. 189).

Beside the earth goddess, *aurea Copia*, Apollo and Diana
ride respectively on a griffin and a stag. Both are related with
the scene of star gods above the figures of the Roman and
Parthian, where Sol on a chariot is above Apollo and Luna is
above Diana. In front of Luna, Aurora is pouring dew.
Zanker has pointed out that this iconography is closely linked
with the imagery in Horace's *Carmen Saeculare* (and *Odes*
4.6.37–40) written for the secular games of 17 B.C. In the
centre of the upper part of the cuirass relief is the sky god –
mirroring the earth goddess with her cornucopia below.

Zanker argues that the single historical event of the Par-
thian victory has been placed in a context of cosmic space and
eternity – with the gods and stars encircling and embracing
the triumph of Augustan history (p. 192). On the shoulders
of the breastplate sit two sphinxes guarding the new dispensa-
tion of the world as announced on the cuirass and in the
literary passages just cited. For Zanker the Parthian victory is
a precondition for as well as a consequence of the *saeculum
aureum* (Golden Age). A moment in history has been isolated
as a paradigm for the new salvific order ("Heilsgeschichte"),
in which the gods and heavenly bodies guarantee the state of
things. Zanker points out that the Parthian who looks up in
reverence at the Roman eagle he holds is the only active
figure. One may add that the iconography implies that the
Parthians' defeat of Crassus was necessary to the teleology of
Augustan triumph. The very fact that the Parthians kept the
Roman standards, could be read as suggesting their awe and
acquiescence before the superiority of Rome – an awe and
acquiescence actualised under the Principate.

Zanker argues that the *princeps* who wears this image of
victory and the new order on his cuirass is perceived as the
executor of the will of the gods as prophesied, enacted and
guaranteed on the breastplate. One may add that Augustus's
cuirass is in some ways a visual equivalent of the shield which
Vergil's Aeneas is given by the gods in *Aeneid* 8 – a shield
that is both his own protection and the "*famamque et fata
nepotum*" ("the fame and fortune of his descendants", 8.731,
the last words of the book). That *fata* turns out to be the
whole history of Rome from the birth of Romulus and Remus

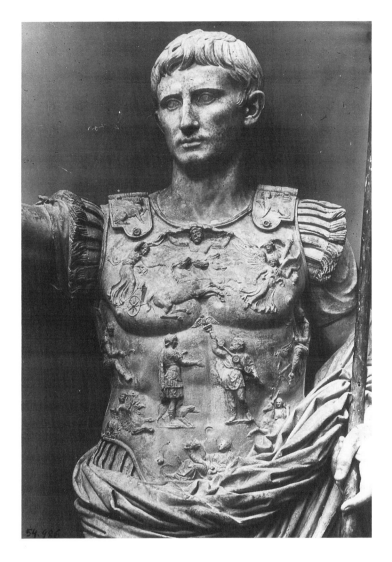

Figure 21. Detail of Prima
Porta Augustus, breastplate,
first century B.C. Photo:
German Archaeological
Institute, Rome.

(630f.) to the battle of Actium (675f.) and culminates in the
triple triumph of Augustus (714). Teleologically speaking, the
purpose of Aeneas in the *Aeneid* is to create the conditions for
the image on his shield to be fulfilled. Just as Augustus in the
Prima Porta statue is executing the will of heaven in fulfilling
the prophecies of his cuirass, so Aeneas in Vergil is the agent
of the gods in bringing about their prophecies as depicted
on his shield. This link between Augustus and Aeneas, his
precursor, is found not only in the *Aeneid* and on the *Ara Pacis*
but also in the Cupid on the Prima Porta statue itself. For
Cupid, the son of Venus, is the stepbrother of Aeneas, ances-
tor of Augustus.[9] From now on, in Zanker's view, it is not

shining deeds that count, but the son of the gods (Augustus, with Cupid by his naked feet) who guarantees the world order "by his simple existence" – "durch seine blosse Existenz". Augustus, thanks to his ancestry through Iulus the son of Aeneas the son of Venus, embodies the concord ("Einvernehmen") of state and gods, of secular and sacred, of the hallowed mythic past (Aeneas) and the political present (itself hallowed in Aeneas's successor, Augustus). The implication is that Augustus's triumph need not be reasserted in ever new spectacular and warlike achievements – for his triumph is the consequence of his close personal link with heaven; it is, like his lineage, like the sphinxes on his shoulder-straps in the Prima Porta image which allude to his private seal,[10] a personal quality.

I have dwelt so long on Zanker's interpretation for two reasons. In the first place it is the most influential and sophisticated discussion to date, and it places the meanings of the statue with great effect in the literature and ideology of its time. But it is also fundamentally problematic. It is based on the following presuppositions, conscious or unconscious:

1. The world order is transformed by a single historical event whose effects are far beyond the limits of the specific happening.
2. This event is the result of action by an individual uniquely linked to heaven – the son of god.
3. The event and its earth-changing consequences are guaranteed by the mere existence, the special nature, of that individual.

I suggest that the Vatican could not have done better. Even Zanker's language (for instance, "Heilsgeschichte", p. 195 of the German edition) is explicitly theological.

There are profound problems for those of us working on antique culture in the post-Christian tradition. One of these may be the extreme difficulty (perhaps the impossibility) of ridding ourselves of subconscious Christian paradigms. Despite the convincingness and elegance of Zanker's interpretation, we cannot so smoothly read back a formula carefully and teleologically constructed by the Church as its own self-justification into pre-Christian (and non-Christian) material. And yet it may be that Zanker's unconscious (or at least unacknowledged) use of a Christian model shows that Christian paradigms can be revealing of some of the deeper issues of Classical antiquity. The effectiveness of Zanker's reading implies how much Christian thought may owe to at least

some aspects of Roman imperial ideology (of which the post-Constantinian Church was of course the child).[11]

INTEGRATING THE VIEWER

Thus far the discussion has followed relatively familiar art-historical lines. The iconography of the image hints at many aspects of Augustus's status – at his divine origins, at his political and military success, at his unique position. But what might all this have meant to Augustus's contemporaries? How does this suggestive symbolism construct the image of the emperor in relation to its viewers, in relation to society? And how, therefore, does the image of Augustus construct the viewer in relation to itself, in relation to its own assertion (in being the image of an *emperor*) of the social and political order? If the answer were single and if viewing were merely a matter of giving assent to a particular image being propagated (to imperial propaganda in this case),[12] then there would be no reason for a detailed examination of Roman viewing. But, despite the assumptions of art historians, it is too simplistic to portray Roman society as a pyramid from whose peak the emperor's dominance was propelled and advertised by his images.[13] This assumes that the multiple meanings of the statue congeal into a single and easily assimilated message. But even if there were such a message intended by artists and patron, its meaning and understanding would be prey to the eccentricities and private readings of viewers.

Let us then examine some of the problems of viewing the Prima Porta Augustus. In one sense the beholder is confronted with a political image. It relates to specific political events and to the enactor of those events, who is also Caesar. It addresses the spectator – going out of its way to make him or her an accessory to, a participant in, the ideological context it generates about those events. The viewer is addressed in the present, by a naturalistic and idealising image in three dimensions (once decorated with pigment and gilding, perhaps to make it look more lifelike). But the breastplate, a relief sculpture in two dimensions, is a narrative of the past. The present (this viewing moment) is validated by the past and valorizes the past.[14] If the past – the narrative on the cuirass – were not valid, this image would have been destroyed or removed (like other images of emperors who failed or were overthrown).[15] The viewer is addressed myth-historically and politically (these are not different) – he or she is contextualised into the ideology of the Augustan Principate and is thus

provided with a narrative through which to interpret the image into his or her own subjectivity. The image establishes its relation with the viewer, and in accepting this relationship, the viewer contributes to, participates in, the ideology of the Principate. In Augustan Rome, the very act of viewing (like the act of reading the *Aeneid* or the *Carmen Saeculare*) is ideological: It participates in constructing the message of the eternal new dispensation proclaimed by the cuirass (or the shield of Aeneas or Horace as laureate). Such collusion in constructing the Augustan message does not entail acquiescence to it, but it does require an acceptance of the new imperial *status quo*. Just as the cuirass of Augustus bears a *signum* – a standard which represents Rome triumphant – so the whole image stands as a *signum*, a sign linking the imperial bearer and redeemer of standards with us. Thus, even on the theory that the statue transmits an imperial message, it is clear that viewing this image is not a matter simply of giving assent to but one of taking part in constructing that message. The emperor is not an isolated *primum mobile* at the summit of a static social pyramid, but rather the social hierarchy is constantly being reasserted and reconstructed within a network of patronage and exchange relations of which viewing the emperor's image is one example.[16]

To understand the significance of this complex relationship between viewers and image, however, we must go deeper than simply observing its implications in constructing meanings. The statue's meaning to a Roman citizen in the early first century A.D. depended crucially upon how Augustus's role was understood. True, he was *princeps*. But did that mean (in the terms of the old Republic which he claimed to have restored) that he was merely *primus inter pares*, first among his senatorial peers, and hedged in by a set of constitutional rules?[17] Or was he a usurping monarch,[18] distanced from the ruled by a wealth of the ceremonial?[19] The meaning of an image like the Prima Porta statue is essentially bounded by the presuppositions about its subject which viewers bring to it. There is no reason why ancient viewers should all have had the same attitude towards Augustus, just as modern historians take quite different lines when interpreting his position.[20] Andrew Wallace-Hadrill has convincingly argued that it was precisely the ambivalence of Augustus's status between citizen and king which may be of the essence in understanding the Principate.[21] This ambivalence would allow a spectrum of possible viewings and meanings for the Prima Porta

statue, from Augustus as remote emperor distanced by the rituals of triumph and power to Augustus the citizen-soldier going out of his way to address the spectator in an ideological context so carefully expressed on the breastplate.

This range of meanings all belong to the socio-political level. They confront the statue as an image of authority within the social order and depend for their nuance on viewers' particular (and varied) attitudes towards the order which surrounds them. After Augustus's death, these meanings would change as the social order changed – with the emperor becoming increasingly a less ambivalent, more obviously supreme monarch. The statue would no longer relate directly with the present but would refer to the present's validation in a triumphant past – the past when the Principate was established. The statue as a whole would adopt in relation to the viewer's present the same role as the breastplate held for the statue in Augustan times. It would represent that essential history upon which the contemporary world was based and by which it was justified.

This socio-political level is not the only one, however, on which viewers would confront this statue. The Prima Porta Augustus is not simply an image of a *man* (albeit an especially important one); it is an image of a man who was also a god.[22] It has been argued that apotheosis – deification – offers a key to understanding the power of the emperors in the capital.[23] Strictly speaking, apotheosis was only possible after an emperor's death. But even before his death an emperor was *theos* to the Greeks.[24] Further, even in his lifetime Augustus was worshipped with cults and temples.[25] At the very least his human status was ambiguous; more even than most kings, Augustus was tinged with divinity.[26] Nothing illustrates the uneasy complexity of this status so well as Augustan poetry. Already in *Odes* 3, published in 23 B.C., Horace announces:

> . . . praesens divus habebitur
> Augustus adiectis Britannis
> imperio gravibusque Persis. (3.5. 2–4)

> . . . Augustus shall be held
> a god on earth for adding to the empire
> the Britons and dour Parthians.

Horace pronounces the *divinitas* of the still-living emperor, only to double back at the outrageousness of it, protecting himself with a future tense and a condition that can hardly be met (and indeed was not met during Augustus's lifetime). By

the *Tristia* of Ovid,[27] published in the last years of Augustus's reign, there is nothing tentative about the repetition of the emperor's divinity:

iuro / per te praesentem conspicuumque deum. (2.53–4)

I swear by thee, a present and manifest god.

or

Caesar, ades voto, maxime dive, meo. (3.1.78)

Caesar, mightiest of the gods, hear my prayer.

Even in his lifetime in Rome Augustus came as close to being a god as his poets could manage.[28] This divinity (albeit ambivalent) can hardly be denied to his statues, for statues and portraits of emperors maintained a living presence – they were seen as direct links back to their prototype, the emperor himself.[29] In the story of Paul and Thecla (of which versions reach back to the late second century A.D.), Thecla, for striking to the ground a crown bearing the image of Caesar, was exposed to the lions. At her exposure she wore a plaque which read "Thecla, the sacrilegious violator of the gods, who dashed the imperial crown from the head of Alexander, who wished to treat her impurely".[30] Even defence against attempted rape is not an excuse for violating the imperial (which is the divine) image. In violating the image (as in the Athenian crisis over the mutilation of the Herms), it is the god himself (the prototype) who is violated.[31] To return to the Prima Porta statue, cult images of the emperor were often cuirassed as were statues outside the context of a temple.[32] Indeed, it is not possible to separate images of emperors into unproblematic categories such as military, civilian or divine: The Prima Porta statue is a classic example of this problem of inseparability.[33]

The result is that the viewer is confronted with an ambiguity as complex as the ambivalence in Augustus's status between citizen and king. But whereas that ambivalence was confined to the socio-political level (to viewers' understandings of the nature of the political order), the ambiguity about whether the emperor be monarch or god is more profound.[34] It confronts the viewer simultaneously in two modes of perception, a socio-political one and a religious one; indeed, it works specifically by conflating these two modes and by implying suggestively that the socio-political world was imbued with the *princeps*' divinity. Most students of the imperial cult

do not see this clash as important,[35] and many would argue that the religious connotations of the Principate are essentially a political ploy for enhancing its authority.[36] Recent scholarship has come to see that the situation is more complex than this. Although the cult of the emperor as god cannot be divorced from politics, it is nevertheless to be interpreted as a genuine (not a cynically motivated) religion.[37] As an analysis of the Roman cultural system this approach represents a good formulation of the problem. But when we enquire what was the effect of an image of this ambivalent man-god on the Roman viewer, then to suggest that the emperor is a complex and ambiguous combination of divine and human, religious and political elements only begs the question,[38] in that in its extreme or pure version, religion is the ritual confrontation of human beings with the holy, the Other World. The worshippers return, as the anthropologist Clifford Geertz puts it, from the framework of meanings which religious conceptions define to the commonsense world and find both it and themselves changed, for the commonsense world is now seen as but the partial form of a wider reality which corrects and completes it.[39] The problem is that the statue of Augustus as a *man* represents the commonsense world of the socio-political order; but the statue of Augustus as a *god* implies a divine order which (at least in its extreme form) may contradict the commonsense one.[40] The imperial cult was patently not at the extreme end of initiate religion – it was not a mystery cult like Mithraism;[41] but insofar as the emperor was a god, we should not too easily dismiss the *otherness* of his divinity.[42] The essential characteristic of the imperial cult *as a religion* (and indeed of civic religion generally in antiquity) was its uneasy and ambivalent conflation of the socio-political world and the Other World, by contrast with other religious systems in antiquity which thrived precisely on a radical separation of these worlds.

For Simon Price, "The divine aspects of the statue are merely hints of [Augustus's] divinity and do not come into direct conflict with official policy" (p. 186). But this is too simple. Even before his death Augustus was as close to being a "god" as it was possible for a human to be. After his death he was one, for even if the statue represented a mere man on its completion, within a few years and for as long as the pagan imperial cult survived it was the portrayal of a god. Thus, in its role as the image of a deity, the Prima Porta Augustus constructs its viewer as worshipper, not as occupant (albeit

on a different rung), of the same social system but as an entirely different kind of being – a human confronted by the Divine. The difference between this kind of address and a socio-political one is fundamental – the latter comes from within the viewer's world and the former does not.

The status of the Prima Porta image is problematic, for the observer is open to being addressed in two contradictory modes:

1. There is the mythico-political contextualisation of the viewer as *homo politicus, civis*, within the new order depicted on the breastplate.
2. There is the viewer's existential confrontation with a divine "Other", an image that is both a location and a definition of the sacred.[43]

The beholder is *not* the same person in these two modes. In the first, he or she is *predicated* as a particular subject (a *civis*, a Roman). The image's relation with the viewer constitutes the particularity and meaning of that predication. This takes place in one world – the secular world of which the beholder is part. But in the second case, the viewer is not predicated in this particular way at all. He or she is simply a human being in the face of the "Other World", an ephemeral being in the face of eternity, a moving and impermanent being in the face of the statue's static permanence. The spectator is no longer a particular person, but a generalised exemplum of humanity (male and female) before the Divine. We have, in this second case, two worlds between which the image stands as a bridge or point of confrontation.[44]

One should add that this tension was not confined to images of Augustus or indeed to Roman imperial sculpture in general. It underlay the Principate's self-presentation in every sphere. However, it was not necessarily perceived as a *problem* in Augustan times. On the contrary, the ambivalence was created precisely to *solve* the quite different problem of inventing the Principate in a republican (which in Rome meant an oligarchic) context, by bolstering its political and military might with some sacred justifications. But, as times changed, the fundamental peculiarity of a living (or recently dead) man being also a god became increasingly problematic. As early as the time of Nero, about a century after Augustus took power, the apotheosis of Claudius could be ridiculed as a "pumpkinification" in Seneca's *Apocolocyntosis*, and the very meaning of imperial divinity could be openly debated in the post-Neronian play *Octavia*.[45]

THE LUXOR TETRARCHS

By the time of the Dominate at the turn of the third and
fourth centuries A.D., the implicit tension in the image of the
emperor was brilliantly resolved. In a room in the temple of
Ammon at Luxor, which was modified and decorated to be a
chamber of the imperial cult under Diocletian (but whose
programme of frescoes is long since lost and must be re-
constructed with the help of J. G. Wilkinson's nineteenth-
century sketches, see Figure 23),[46] the emperor and his com-
panions in the tetrarchy appear to be represented several
times. Where Augustus was at the same time and in the same
statue an individual within history and a deity who tran-
scends history, Diocletian and his fellow tetrarchs were repre-
sented in both these modes but in different places and con-
texts within the chamber.

In the apse of the south wall, the four emperors of the first
tetrarchy, Diocletian, Maximian, Galerius and Constantius
Chlorus, were depicted together in the hieratic style of late
antiquity which foreshadows Christian art.[47] On the east side
of the apse, still on the south wall, according to J. G. Deck-
ers's reconstruction (see Figure 22), two emperors appear to
be enthroned and receiving honour from their subjects.[48]
This theme may well have been repeated on the west side of
the apse, in which case all four tetrarchs would have been
represented twice on the south wall. Along the length of

Figure 22. Reconstruction of
the south wall and apse of the
Luxor cult room, third
century A.D. (after Deckers).

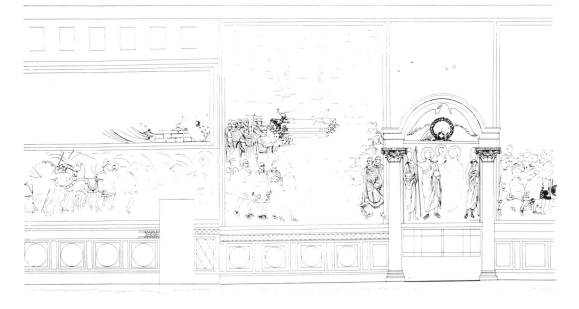

the east wall the Wilkinson water-colours record an imperial procession of armed soldiers beginning from the entrance to the chamber at the centre of the north wall opposite the apse (Figure 23). Wilkinson's sketches do not include a drawing of the west side of the room, but a note which appears to refer to this wall bears the tantalising information: "Mr. Monier told Mr. Harris that the name of 'Diocletian' was on one of the chariot wheels in this fresco".[49] This implies that the west wall carried a parallel procession to that on the east and that Diocletian himself was portrayed in it (for the directions of the processions, see Figure 24).

The mode of representation of the procession is quite different from the hieratic imagery of the south wall. Its images are illusionist, using three-quarter views and three-dimensional space. The procession is a very different theme from that of the four emperors isolated in their imperial gran-

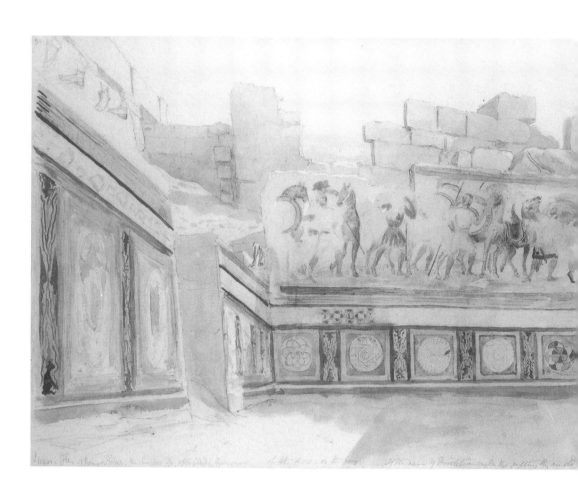

deur. It places Diocletian with his troops, in a secular context, a narrative, a history. The cult niche, by contrast, puts the four emperors together in a context of divine otherness from their subjects. The art of the tetrarchy not only divided the narrative from the symbolic themes in imperial imagery but also employed different methods of representation to enforce this division by using illusionism for the historiated procession and a schematic arrangement for the icons of the emperors as deities.[50]

This tantalising glimpse of a lost tetrarchic programme seems to signal a midpoint in imperial representation between Augustan naturalism and the iconic portrayals of Byzantine emperors like Justinian. Whereas Augustan portraiture significantly failed to resolve the tension between representing the emperor as a man and as a god by simply conflating these contrasting themes into the same naturalistic statue, the art of

Figure 23. J. Gardner Wilkinson's sketches of the Luxor cult room, nineteenth century A.D. Photo: Gardner Wilkinson Papers from Calke Abbey, Bodleian Library, Oxford, by kind permission of the National Trust.

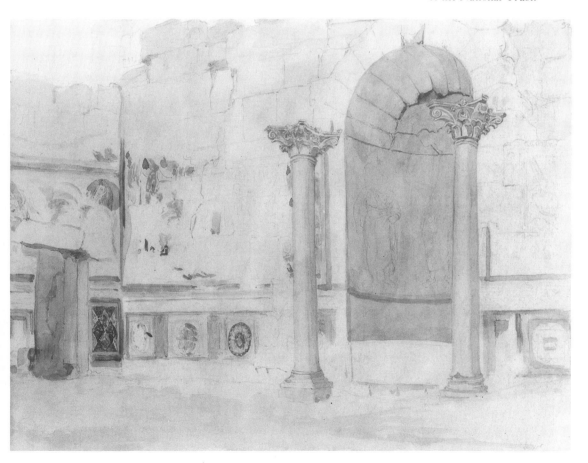

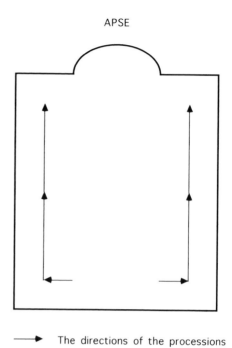

S

APSE

Figure 24. Diagram of the
directions of processions,
Luxor cult room, third
century A.D.

⟶ The directions of the processions

Diocletian rigidly divided these themes by exploiting more than one place for the imperial image and more than one style. But although the tetrarchy appeared to solve the problem, in a sense its art was merely begging the question in a still more radical way than even the image of Augustus. To offer two modes of representing a single individual – one for his humanity and one for his divine nature – is to beg still more blatantly the impossible question of how these modes (the human and the divine) can actually be defining the same person. In effect, how can one human being be both man and god? Tetrarchic art may have solved the particular problem of *viewing* which we discovered in the art of the Principate, but it failed signally to confront the essential ideological instability which underlay the problematic of Augustan viewing. That instability lay in the conceptual fudge by which a man who found himself in the role of emperor was suddenly, by virtue of his position, also a god. The really dramatic change in the imperial image was to come not so much in styles of representation, but in the Christian conceptual resolution of the Roman imperial fudge.

AUGUSTUS, JUSTINIAN AND
THEODORA

TO COMPARE

The Prima Porta Augustus with all its ambiguities represents
a pole at one end of the transformation of Roman art. As
E. H. Gombrich implies, by concluding his chapter "Reflec-
tions on the Greek Revolution" with the mosaics of San Vi-
tale,[51] Ravenna provides a mature example of the pole at the
other end. I shall look in some detail at a specific pair of
images within the broad and complex iconographic scheme of
San Vitale – the portraits of the Emperor Justinian with his
entourage on the north side of the sanctuary (Figure 25) and
the Empress Theodora with her suite on the south side (Fig-
ure 26).[52] If Augustus can stand for the illusionist heritage of
the "Greek Revolution", the Ravenna panels offer "pro-
nounced geometry, order and abstractness".[53] Where Au-
gustus was naturalistically depicted, the representation of
Theodora shows how art "can denaturalize the rendering of a
real event Abstraction is evident at once in the gold
background which replaces here as in the apse the cloudy
blue sky of the lateral wall mosaics".[54] The shift in formalism
from the illusionist to the abstract is transparently clear.

Coupled with this fundamental shift in forms is a shift in
content.[55] Augustus was a man who became a god: Roman
emperors were in effect gods by virtue of their position. But
Christ (represented in the Ravenna apse as universal emperor)
is the unknowable and supreme Jewish God who became man
that humans might know him.[56] The conceptual difference is
fundamental. Augustus (like all his imperial successors in
Rome, including Diocletian) was a man who ascended to
deity through the particular historical circumstances of being
emperor, whereas Christ was God who sanctified man by his
descent into humanity. Augustus moved up and Christ down.
Thus Augustus and the tetrarchs are rooted in historicity;
their divinity is not separable from political and temporal
events. Roman imperial cult is always a sacralisation of actual-
ity in which the worshipper is firmly focussed on this world;
the sacred is vague, untheorised and unsystematic, although
vital.[57] Christianity offers an essentially different system. It
begins with a very strong ("Jewish") assertion of the Other
World which we cannot know. It expends a huge effort on
theorising and explicating the relationships within the Other

World (in Trinitarian theology). God entered history in the body of a man – not a famous historical man that everyone knew (an Augustus, a Diocletian) but, like Mithras, an unknown (a mystical and mythical) man, whose myth, in Christianity's case, was in part his very historicity.[58] What matters about Christ is not his humanity as such, but that through his humanity we have access to what he really is, to God. In Christianity, the higher always justifies the lower. The "facts" are only meaningful because of what they prove – the Resurrection would be only so much magic if it were not God who had risen as a man from the dead. Whereas Roman state religion begins with myth-historical events and makes them sacred, Christianity begins with Faith and finds it enacted in history. Roman civic cult is inductive: It proceeds from actual events to a rather unspecific set of sacred meanings which

Figure 25. Mosaic panel of Justinian and his entourage, presbytery of the Church of San Vitale in Ravenna, north side, sixth century A.D. Photo: German Archaeological Institute, Rome.

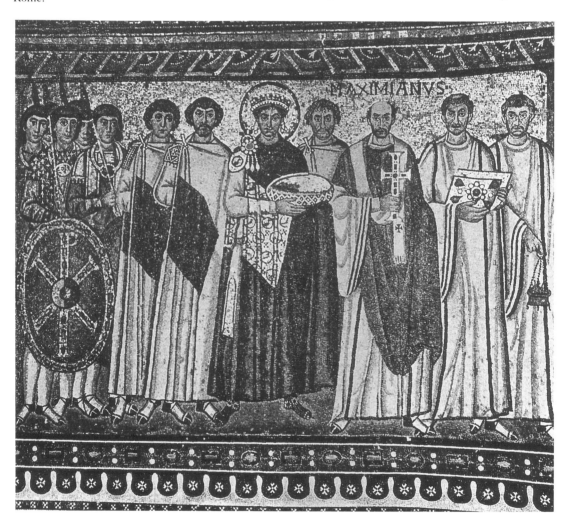

prop up the actual. Christianity begins with God, the only *real* world, and deduces the meanings of this world from that prior axiomatic assumption.

The implications of this difference are huge. In Rome, the pedigree, descent and actions of an emperor (as represented, for instance, in the Prima Porta breastplate or the Luxor procession) are crucial for it is upon them that his *imperium* rests. His divinity follows upon his historicity and is occasionally denied (to great criminals such as a Nero or a Domitian). In the Christian dispensation as represented in Ravenna all this is irrelevant. The emperor and empress have no inscriptions (unlike the clerics – Maximian, Ecclesius and Vitalis). They are nameless courtiers, servants bearing a gift, at the court of the supreme Emperor, Christ himself (see Figure 27). Roman imperial art must always depend to some extent

Figure 26. Mosaic panel of Theodora and her entourage, presbytery of the Church of San Vitale in Ravenna, south side, sixth century A.D. Photo: German Archaeological Institute, Rome.

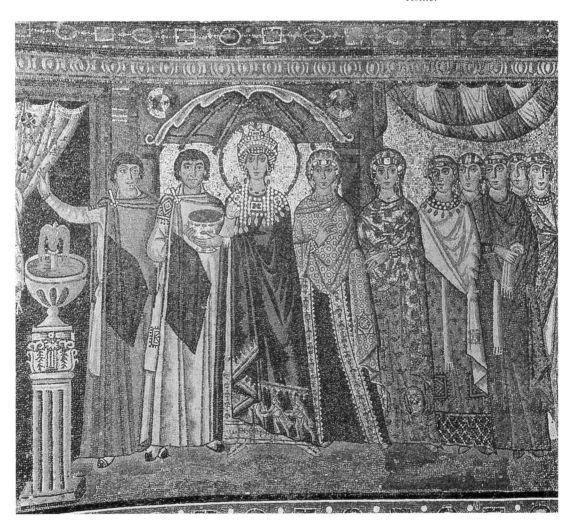

on particularity, on the specificity and uniqueness of different emperors. The system encourages both the naturalism of Roman art and the uneasiness with which such naturalism always approaches the Divine. By contrast, what matters in Christian art is the iconic assertion of the hierarchic order itself. It does not actually matter *who* is emperor – any emperor and empress could occupy the shoes of Justinian and Theodora: They are prescriptive paradigms of how the system is and should be forever, or for as long as it should last. How different this is from the specific events which glorify Augustus: On Theodora's mantle is no assertion of historical achievement but rather the sacred and eternal narrative of the Magi bringing gifts to honour the nativity of Christ. Augustus wears his own history mythologized on his cuirass; Theodora wears a witness to the Incarnation.

Let us now explore aspects of the significance of the Justinian and Theodora panels in comparison with Augustus and the tetrarchs. Where Augustus was man-god in the same statue and Diocletian was a man in one context and a god in another in the same room, Theodora and Justinian are human. In no sense could they be called gods. Nonetheless, their court, depicted in all its military and ecclesiastical splendour on the walls of the apse, is an imitation of the divine court of Christ, the universal Emperor who sits arrayed in imperial purple on a blue globe in the apse-conch (Figure 27).[59] The whole scheme of San Vitale is directed towards him as he receives the church from Ecclesius, its founder, and grants the martyr's crown to Vitalis, its patron saint. Nothing so justifies this Ecclesian church as the presence of its founder and patron in the golden space of the apse; nothing so effortlessly justifies Justinian and Theodora and the world order which their rule represents as their presence in the apse space beneath the feet of Our Lord. As he rules the cosmos, seated on a blue globe, they rule the empire; as he grants gifts, so they bring him gifts. In visual imagery, as in texts, the emperor is imitator of Christ – the kingdom of this world is the image of the Kingdom of Heaven.[60]

Further, through their roles as haloed emperors, Justinian and Theodora function as mediators for common humanity (the beholder-worshipper in the church) with the God who was also man.[61] The rim of the apse-frame which demarcates the image of Christ as Emperor descends to a point on the apse walls immediately above Justinian, to the north side, and Theodora, to the south (see Figures 28 and 29). It visually splits the panels containing the emperor and empress in their

middle, at the very point where Justinian and Theodora are represented. They are walking towards Christ carrying gifts, caught by the mosaicist on the very edge of the innermost space of the apse – actually beneath the space containing the image of Christ. They are the supreme secular liminal figures; the architecture places them both within the sacred space of the apse (for their images are there) and on its boundary (directly beneath the frame of apse-conch). The architecture is visually enacting the status of the emperor as mediator as well as enhancing the incomparable importance of this role by placing the image of the imperial court within the sanctuary. The haloes, the centering of Justinian beneath a vault and Theodora beneath a niche, and the court's sumptuous jewellery, which is matched only by the gems of sacred objects (the jewelled book and cross of the clerics to Justinian's left, the gems of the chi-rho on the soldier's shield to his right, Christ's halo-cross and the jewelled crown he offers to St Vitalis) – all this again serves to emphasise the special, the exalted and hence the liminal, quality of the two emperors

Figure 27. Christ as universal Emperor, apse mosaic of the Church of San Vitale in Ravenna, sixth century A.D. Photo: German Archaeological Institute, Rome.

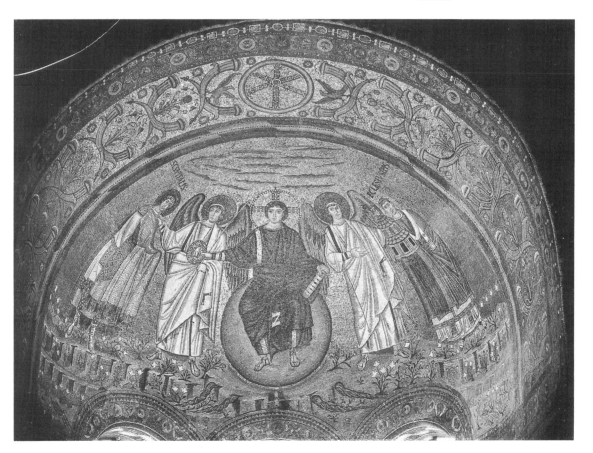

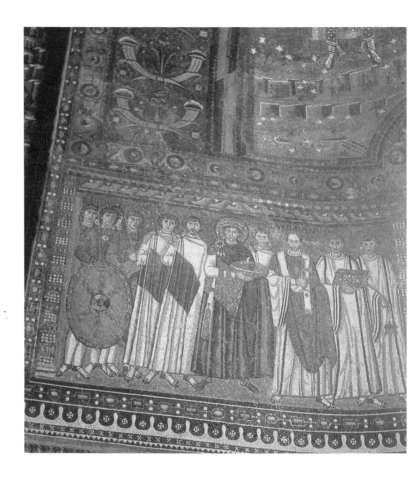

Figure 28. Apse frame with
the Justinian panel, the
Church of San Vitale in
Ravenna, sixth century A.D.
Photo: Conway Library,
Courtauld Institute.

who stand in the here and now as a link between this world
(the temporal) and the world to come (the eternal).

In their respective panels, the emperor and empress are
central. Justinian is preceded by the clergy and followed by
laity – he is the balance, the boundary of the Church and the
state. Theodora follows male chamberlains and is succeeded
by her entourage of ladies; she stands between the public
world of men and the private world of women. The act of
imperial mediation is not merely a mimesis of Heaven and a
vertical link with God; it is also a social act, an imperial
reconciliation of the various parties and groupings in the
state.[62] The image of the imperial pair as mediators in the
apse is a paradigm for both how things are and how they
should be. It is a prescription to the viewer not only of the
rightful divine dispensation but also of the correct social or-
der. A set of role models are offered for different groups of
viewers – women, officials, soldiers and priests. All have

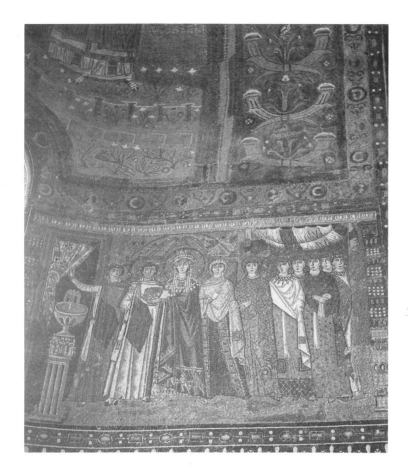

Figure 29. Apse frame with
the Theodora panel, the
Church of San Vitale in
Ravenna, sixth century A.D.
Photo: Conway Library,
Courtauld Institute.

their appointed place in the divine and earthly hierarchy.[63]
Their correct occupancy of that place as represented and
guaranteed by these mosaics is in itself the guarantee of a
golden age of plenty in which sacred and secular fall into their
rightful balance in the court of *Christus Imperator*. The great
arc (Figure 30) which adorns the vault of the apse to the west
of the Christ image has a jewelled cross at its summit with
imperial eagles and bands of descending *cornucopias* all on a
ground of gold. This frame, like the *cornucopias* held by the
Earth on Augustus's breastplate, is no mere decoration; it is
the symbolic enunciation of the Justinianic golden age – the
golden state made possible by the actualising in this world of
what the entire apsidal programme represents in iconic form.

The insoluble problem of the god-man, directly entailed
by the construction of imperial Roman ideology, has been
resolved in Byzantine culture by removing it from the actual
world of human societal interaction to the theological world

of (several centuries of) Christological debate. Whereas Augustus or Diocletian – in Roman cult – was divine executor of the wills of the gods, in Christianity it is Christ who is the God-man. Justinian and Theodora are human agents sanctified by the grace of the God whose will they perform, of the God below whom and in imperial imitation of whom they are represented – bringing gifts to him as he offers a gift to St Vitalis. Whereas the images of Augustus and the tetrarchs are complex, even contradictory in the conflict of the realities to which they simultaneously refer, the Byzantine image is quite simple. Its reality is located in the human realm, but the beings it represents are special by virtue of their imperial status, by virtue of their imperial imitation of Christ and by virtue of having access to the "holy".

In all this the central issue is one of mediation. The whole ideology of imperial mimesis is founded on the crucial presupposition of emperor as mediator. Here the art of Ravenna is fundamentally different from that of Rome. If the emperor is to mediate, he must be human, close to his subjects and not apart. Augustus is located in two worlds at once. Not only is it unclear to what extent he is divine and to what degree human, but his actual relations with both the divine and the human spheres have been left ambiguous. Diocletian occupies two different worlds in two different images in the same cult room. What is unclear in the art of the Dominate is above all how one man could be at the same time what these two very different images represent. By contrast, the Byzantines have resolved such ambiguities in a much clearer conceptual system of a hierarchy of mediation. Justinian and Theodora are located in one world (that of the viewer), but this viewer's world need not be different from the other world which they mediate.[64] It is up to the beholder to be saved – to *see*, in the ritual space of the church confronted by the gaze of Theodora or Justinian, the "holy" as it is manifested in this world after the Incarnation. For the function of the Byzantine image to work, the viewer's involvement is crucial.

Augustus stands outside in a garden. He is distant in that he represents what the viewer can never be (a god through his individual apotheosis or, still more complex, an ambiguous combination of god, *princeps* and citizen). He is isolated in his unique status with not even a Livia to accompany him as Theodora does Justinian. His image marks a space in three dimensions which cannot be viewed at once. The spectator must encircle this locus of the "holy" and construe the narrative of its holiness from the narrative specific to Augustus

which is represented on his breastplate. Theodora and Justinian are portrayed inside – within a ritual space. In Ravenna, everything has been presaged by the Luxor cult room (the interior, the holy space, the two-dimensional programme with narrative scenes on the sides and an iconic theme in the apse, even the *concordia* of four tetrarchs matching the imperial marriage of Justinian and Theodora by contrast with Augustus's isolation). Everything, that is, except the key conceptual difference of the emperor's status.

Despite their being "denaturalized" by their depiction in mosaic in two dimensions on a gold ground and despite their unique position as secular figures in the sacred part of the church where normally laity could not go, Justinian and Theodora are close to the viewer.[65] Each is doing what the other is doing, what the viewer is doing, what their entourage are doing, and what even the narrative of the Magi depicted on Theodora's dress is doing – all are worshipping the Christ represented in the apse. Their gifts are not on the same level as Christ's gift of the martyr's crown, Ecclesius's gift of the church, the Magi's gifts, the clergy's gifts or the gifts of

Figure 30. Arc of cornucopiae, apse mosaic, the Church of San Vitale in Ravenna, sixth century A.D. Photo: German Archaeological Institute, Rome.

viewers as they come to offer themselves to God in the Mass. But they represent a stage in the hierarchy of giving to which the viewer can aspire, by which he or she can feel nearer to God *through the secular order*. Essentially this is a liturgical conception.[66] Where Augustus or the tetrarchs *as deities* are worshipped by their viewers, Theodora and Justinian worship alongside their viewers. Justinian and Theodora are an image not (like Augustus or Diocletian in the Luxor apse) of what the viewer can never be, but of what the viewer ideally is.

The space that the separate images of Justinian and Theodora occupy can be viewed *at once*, unlike the Prima Porta Augustus, but it is only part of an internal space which encloses the viewer. The viewer is viewed and held by the gaze of the icons whose gaze he or she holds. The viewer is encircled by visual emanations of the God in whom he is and who is in him.[67] It is worth noting the "intense gaze of the worshipping Emperor [The image] owes its very strength to this direct contact with the beholder. It no longer waits to be wooed and interpreted".[68] The viewer of the Prima Porta statue is always excluded by the averted gaze of an idealized image whose purpose is to catapult the emperor far above the normal person (the spectator) – into divinity. The viewer of the Theodora or Justinian panel is included – is made participant in the image – not only by the act of worship in which the icon reflects the beholder (and the beholder the icon) but also by the frontal gaze of the haloed emperor. Eye contact is mediation.[69]

The illusionism of the Prima Porta image is an invitation to narrative. The beholder at Prima Porta must construct his or her own contextualising narration from the clues on the breastplate. Whether this narrative is seen as a "free fiction" or as ideologically determined,[70] it is viewed in *personal* terms because its construction by the viewer is predicated on his or her confronting the statue as an individual viewing subject. But at Ravenna it is the very ritual process that constitutes a narrative in which both the image and the initiate-viewer are participant. The viewer is not an individual but a subject whose subjectivity is shared with the other participants in the ritual; the viewer need construct no personal contextualising narrative of his or her own.[71] The ritual space of Ravenna represents an essential difference from the Augustan statue. Even if the Prima Porta image were a cult statue found in a temple, its ambiguous status as a naturalist invitation to narrative would be in conflict with its ritual function as cult icon.

The Luxor room has gone a long way to resolving these problems in pagan imperial portraiture, but there is still a conflict between the image of the emperor as participant in a procession and his status as cult deity in the niche to which the procession travels. At Ravenna, all such conflicts have been resolved. The imperial icon is simply the imitation of the divine icon in the apse – its figures are not even marked by titles. They are Justinian and Theodora only by modern convention (the convention which sees the meaning of an object as inhering most strongly in the moment of its creation); in fact, they represent *any* emperor; they represent the ideal figure of the state itself, the same through time and for all time.

The Theodora and Justinian panels depict a specific moment in Byzantine liturgy – the First Entrance which in early times began the celebration of the eucharistic ritual.[72] The Entrance consisted of large numbers of clergy and laity proceeding into the church and up to the sanctuary.[73] The Theodora and Justinian panels at Ravenna depict different temporal and spatial events in the ceremony. Justinian is following Maximian, his archbishop, in single procession down the nave, while Theodora is "entering one of the doors of the church from the atrium [outside], the location indicated by the fountain".[74] The two panels are not equal. Theodora is outside moving in, Justinian is inside moving up the nave. Yet both images (which are not separable from their prototypes) are placed in the sanctuary, where neither event displayed within the images takes place. The viewer looks at them in the sanctuary; they are there. The apse scheme at Ravenna collapses the diachronic nature of the procession (its linear quality), as well as the separateness of the two processions, into a synchronic and parallel icon. The two panels are a single iconic exemplum to the viewer of what he or she *should* be doing as well as a mirror of what he or she *is* doing.

The iconographic scheme of the mosaics in the presbytery is deeply related to the "eucharistic rite for which they provided the setting".[75] The Agnus Dei is central in the vault above the altar. The side walls are covered with Old Testament prototypes for offering and sacrifice – the hospitality of Abraham, the sacrifice of Isaac, Abel and Melchisedech. Justinian and Theodora offer liturgical vessels and donations (as they would have done in the First Entrance). The liturgy is the key to these mosaics. As the re-enactment of Christ's sacrifice which saved humanity from sin, the liturgy tran-

scended the boundaries of space and time by making the
eternal present in the temporal.[76] The San Vitale mosaics
may have been erected *after* Theodora's death in 548,[77] and
yet she is portrayed as living and parallel to Justinian. The
iconography of San Vitale collapses into a single viewing
event time and space (the diachronic linearity of the First
Entrance procession), the difference between outside (Theo-
dora) and inside (Justinian), the distinction between alive (Jus-
tinian) and dead (Theodora) and the separation of viewer and
image (both are enacting the same process of worship). The
mediation of beholder with Christ is accomplished through
images in the ritual space of the sanctuary where everything
and everyone present (images, viewers and clergy) are partici-
pant in the act of worship.

TO CONCLUDE

What have we learned from this comparison? Criticism has
seen the transformation of Roman art as a formal and stylistic
change, a "decline" in naturalism. What has been missed is an
evolution in *content* – a simplification and clarification from
the conceptual instability of a human being as god to the
logical (and anthropological) stability of a human being as
mediator with God. This role for the emperor as mediator
was foreshadowed in earlier Roman culture by the representa-
tion of the emperor as sacrificer.[78] But again mediation was
but one role in the ambivalent complex of predications (citi-
zen, king, priest, god) by which the Principate was defined.
As Constantine perceived, nothing could raise the status of
the emperor as effectively as reducing him from a *divus* to a
homo but simultaneously elevating him to *homo* with special
access to the Divine – the thirteenth apostle.[79] When Christ
is the supreme being on whose Incarnation the entire world
order is predicated, what better position could there be than
servus Christi? It was in the interests of the Church as much as
of the emperor to emphasise mediation – especially if media-
tion could be limited to a small elite (namely, the clergy). But
such functionalist explanations are only part of the answer.
The image of the Roman emperor (whether Augustus or the
tetrarchs) in deifying one individual or a small group denied
the possibilities for divinity to everyone else. In directing
worship to one person, it set an insuperable barrier between
that person and all others. The Prima Porta statue allows
confrontation with the Other World but not access. Chris-
tianity, in its emphasis on the human mediator, offered the

possibility in principle for everyone to be saved. It offered that possibility specifically to viewers as they confronted sacred images. All present at the liturgy could partake of the presence of Christ. All could in principle become saintly mediators like Justinian, Theodora (the one-time actress) and the numerous holy men of late antiquity.[80] Perhaps this goes some way to explaining the appeal of Christianity over state religion in the later Roman world. Ultimately, how could you not abandon a religion whose main purpose was to deify the emperor, when the alternative was a religion that promised to save you?

With this transformation of content, goes logically the move from naturalism to abstraction – from make-believe "real life" to transparent symbolism. What was needed in imperial images by the sixth century was much less a naturalistic emphasis on the particularity, personality and lineage of the emperor (as had been necessary in pagan Rome), than an iconic stress on the emperor's office and its relationship to the economy of earth and Heaven. Art was called on to evoke not a particular person (as the naturalism of Classical art had been), but an abstract relationship, a specific place within the hierarchy. Far from being a "decline", the symbolism of early Medieval art was an extremely efficient and effective means for conveying such an "abstract" (or at least impersonal) message. Before we can bemoan a degeneration of artistic *style*, we must acknowledge a transformation in *content* for which the iconic abstraction of Byzantine art was much more fitted than its naturalist predecessor.

FROM THE LITERAL TO THE SYMBOLIC: A TRANSFORMATION IN THE NATURE OF ROMAN RELIGION AND ROMAN RELIGIOUS ART

Tᴴɪꜱ chapter charts some aspects of change in how religion was conceived in the Roman world, by comparing representations of sacrifice in the official state cult, in Mithraism and in Christianity with what we know about the ideology and sacrificial practice of these three religions. The comparison is chronological in that I take the Ara Pacis (dedicated in 9 B.C. under the emperor Augustus) as a case study for the imperial state cult, Mithraic cult icons from the second and third centuries A.D. as my case study for Mithraism and the sixth-century church of Sant' Apollinare Nuovo in Ravenna as the case for Christianity. However, what I am comparing are not simply changes over *time* but also changes in *approach* between different but related religious cults. The transformation I analyse is in part a change of artistic representation and style, but more deeply it is a change in how religion was perceived and understood. The religious images a culture produces are themselves dependent on how that culture conceives its religion.[1]

In essence, the imagery of official Roman religion has a literal and imitative relationship with its subject-matter and with religious practice, whereas the images of a mystery cult (such as Mithraism or pre-Constantinian Christianity) have a symbolic or exegetic relationship with what they represent. This difference between the art of official religion on the one hand and that of initiate cults on the other (a difference not necessarily perceptible in the *styles* of their art in that both exhibit a wide range of representation, from the strongly naturalistic to the rather schematic) is a fundamental conceptual breach, which has important consequences for post-Constantinian Christian art. This is because Christianity, an

initiate cult *par excellence*, always produced a symbolic art (the art of the mystery cult) even when it replaced civic religion as the official cult of the empire.

The transformation which I explore can be briefly illustrated by considering pictures of sheep. In the Roman state cult, a sculpted relief of a sheep in a sacrificial procession has a direct and literal meaning. It represents the sacrificial animal being led to slaughter. Of course that will not be its *only* meaning. The metaphoric connotations of sheep are broad in most cultures. But the range of meanings implied by a sheep in a Roman sacrificial relief will always be constrained by the inevitable reference to the act of killing sheep. Art imitates actuality. However, in Christianity an image of the lamb does not have a literal or direct significance relating to wool or mutton; rather it refers its Christian viewer to a world of symbolic and dogmatic meanings far removed from the killing of sheep. If Christian viewers understood Christian imagery in the same way as Roman viewers looked at Roman art, theirs would be a religion of slaughtering lambs and human sacrifice. In fact Christianity is such a religion, but not – emphatically and constitutively not – in any *literal* sense. What has changed is not the sacrificial iconography of religion, but the meanings and understanding of that iconography for viewers within a different religious system. A transformation of what we might call the significatory or semiotic scope of art (or perhaps of the exegetic frame of art's reference – from the literal to the symbolic) can help us to trace an essential change in the social and religious history of the Roman world. When delicately interpreted, changes in art can provide an illuminating bridge into the changing ideology of a culture.

In what follows I shall assess the evidence of Roman civic religion, Mithraism and Christianity using examples of sacrificial images from the first century B.C. to the sixth century A.D. I do not aim to be comprehensive; I am trying to establish an interpretative framework for the understanding of ancient images rather than a catalogue of their meanings. In focussing on the viewer of religious art and on the participant in religious ritual, I am subscribing to a view of religion that takes seriously the claims of religion to mediate with an Other World. In effect, I focus less on the politics and sociological effects of religion (than is currently popular) and more on the phenomenology and ideological assumptions which different kinds of religious viewing may presuppose.[2]

OFFICIAL ROMAN RELIGION: THE
ARA PACIS

All religious art evokes an Other World, which is different
from this world. The particular orientation of that Other
World varies according to what kind of goal or Other a reli-
gion presupposes. Before we examine the sculpture of the Ara
Pacis, it may be helpful to set this altar-temple's religious
orientation into context and by this to suggest something of
the nature of the Roman state cult. The Ara Pacis (Figure 31)
was located in relation to the gigantic solarium of Augustus,
dedicated in 10 or 9 B.C. in the same consular year as the altar
itself.[3] We cannot clearly separate the significance of the Ara
Pacis from the broader context of the Horologium and the
whole Campus Martius complex (including the Mausoleum
and Ustrinum of Augustus), built between 42 and 9 B.C.[4]
This building programme, which cannot be separated (cer-
tainly after Augustus's death) from the emperor's apotheosis,
is a visual enactment of the interpenetration of Augustan
religion with imperial politics. The Ara Pacis, a prime site of
sacrificial cult, always bore the visual and symbolic reminder
that its sacrifice had a socio-political orientation.

When we come to the imagery of the Ara Pacis, its sculp-
tures directly relate either to the theme of sacrifice which
defined its cultic function or to the imperial mythology with
which its context had already imbued it.[5] Like the imagery of
other Augustan altars,[6] the reliefs which we may provision-
ally identify as representing Aeneas, Mars with the twins,
Italia and Roma at the corners of the west and east walls all
refer pointedly to myths propagated under the Principate.
Generally, interpretations of the sculptural programme of the
Ara Pacis have focussed on the mythic-political aspects of
this imagery, or have attempted to identify and re-identify
particular figures in the sculpted frieze.[7] By contrast, I wish
to concentrate on the cultic implications of the sculpture and
the relation of the imagery to the altar's primary sacrificial
function.[8]

I do this in order to be able to compare the Ara Pacis with
sacrificial images from Mithraism and Christianity; but it is
important not to forget that the religious art of the Ara Pacis,
like Roman republican and imperial religious art in general,
was always framed within an explicitly political context.[9] In
fact the political theme of the Ara Pacis is dependent on the

cultic theme, because any politics involved in its inauguration drew on the charisma of the altar's sacrificial implications.

Before we turn to the sculptural decoration of the Ara Pacis, we may note some important features of Roman sacrifice. In Roman religion, the cult statue (which represented the deity whom the sacrificial rite was intended to propitiate) was normally not in the same place as the actual sacrifice. Many reliefs (for instance, that of Aeneas and the Penates on the Ara Pacis, Figure 32) seem to suggest an ideology of divine presence in which the god appears to be there during sacrifice. Yet, at the same time, both the reliefs and the actuality represent this presence as at least a spatial distance from the place of sacrifice. In the image of Aeneas and the Penates, the temple or shrine is behind and away from the sacrificial space of the altar and the act of libation. In the surviving temples excavated at Pompeii, the altar is always within the main sanctuary but outside the *aedes* proper in which the god's image was housed.[10] This arrangement is actually prescribed as an ideal for temple architecture in Vitruvius (*De Architectura* 4.5.1 and 4.9), where the author

Figure 31. The Ara Pacis from the west, first century B.C. Photo: German Archaeological Institute, Rome.

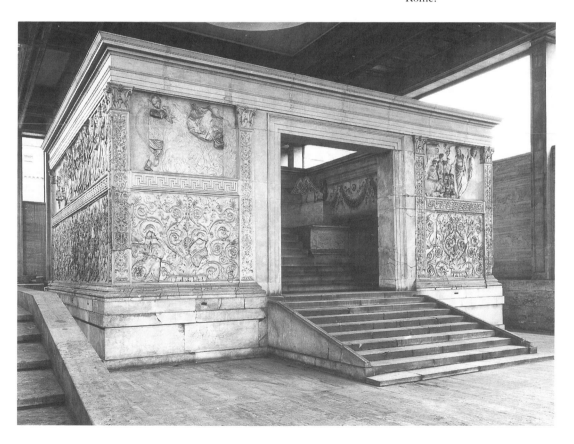

193

makes much of a play between the gaze of the statues within the temple looking out and down on those who sacrifice and that of the worshippers who look up towards the temple and its cult deities – "the very images may seem to rise up and gaze upon those who make vows and sacrifices".

The altar is in one sense the goal of sacrificial action, the point where the *exta* (sacrificial entrails) are finally placed.[11] And yet this is only a preliminary goal in that the actual propitiation is of the god in his temple. Furthermore, the altar may not be the actual locus of killing but rather the place where the *exta* are finally laid after being extracted. The altar is thus distanced as much locationally and temporally from the sacrificial act of slaughter (there may be a considerable time-lag between killing and cooking) as it is present by being the goal of at least some part of the action. I shall touch later on the importance of what I call "deferral" – this quality of the altar as preliminary rather than final goal, as an end-point that points to yet a further end (the deity in the *aedes* at which one gazes), as a completion that hints beyond itself.

In the strictest definition, a *templum* was a piece of land set aside for religious purposes and determined by ritual as a place for taking the auspices. This meant that a *templum* need not possess an *aedes*, or house, for the statue of the god.[12] In the case of the Ara Pacis the absence of an *aedes* complicates the process of "deferral". There was no cult statue within the precinct walls, no obvious end to which the sacrificial process was directed. Clearly, who the final recipient of any sacrifice at the Ara Pacis was to be was deliberately left ambiguous. Among the candidates must have been Pax herself; Mars, the patron deity of the Campus Martius, and, not least, the god Augustus, whose remains were housed in the Mausoleum after A.D. 14 and whose Horologium pointed portentously towards the sacrificial altar on the day of his birth. Not only was "deferral" extended here by removing any deity to be placated from within the precinct walls, but it was further complicated by the multiplicity of divine Others who might receive the oblation.

THE ALTAR SCENE

In the art of Roman religion there are two principal types for the representation of sacrifice: the sacrificial procession and the altar scene.[13] Both are to be found on the Ara Pacis. There are sacrificial friezes both around the altar ("the small procession", Figure 35) and on the exterior of the precinct

walls ("the large procession", Figures 33 and 34).[14] There is, furthermore, a relief panel on the exterior of the sanctuary wall to the right of the main entrance to the precinct which depicts a togaed and bearded man probably pouring a libation onto an altar (Figures 31 and 32). This seems to be the preliminary ritual before the slaughter of the sacrificial animal, here a sow. Over the altar is an oak tree and behind is a temple in which are two male deities. The scene is usually interpreted as the sacrifice of Aeneas to the Penates (Vergil, *Aeneid* 3.389f. and 8.81f.; Dionysius of Halicarnassus, *Ant. Rom.* 1.57.1).[15]

Whatever its mythological associations, the scene of Aeneas pouring a libation has a general relationship to its context. It decorates the walls of the precinct within which the very ritual it portrays was enacted. The scene may have a specific referent (as has often been argued)[16] in the inauguration rites for the Ara Pacis. But it also has a general referent in the act of sacrifice that would take place at different times within the sanctuary.[17]

The position of the Aeneas relief on the outside wall of the precinct is important. When an altar scene is represented on

Figure 32. Aeneas pouring a sacrificial libation, relief from the outer face, west front, south side of the entrance, Ara Pacis, Rome, first century B.C. Photo: German Archaeological Institute, Rome.

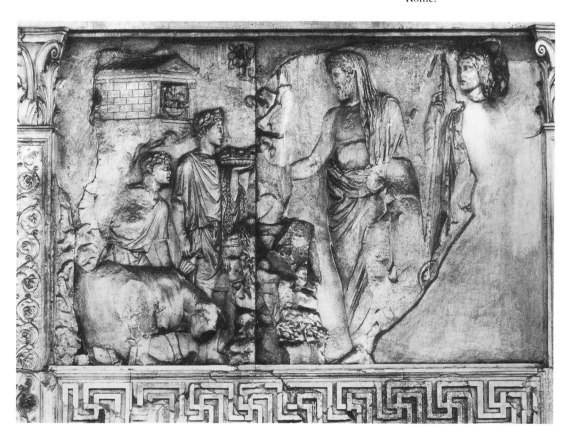

the actual altar, as may have been the case in the lost section of the "small frieze" at the back of the altar within the Ara Pacis, it is clearly a self-referential sign enhancing the altar by representing its function. It emphasises that this block of stone is an *ara*,[18] a special object which can serve as a locus of mediation with the Other World. Art is here used significantly as a means for mapping the sacred. It marks the appropriateness of a particular object and place for its sacred function, by representing that function.

When, as in the Aeneas relief of the Ara Pacis, the altar scene is carved on the exterior walls of a sacred enclosure, it has a slightly different mapping function. It marks not a goal and location of sacred action, but the boundaries of a sacred site, representing on the outside the sacrificial act – the act by which the site is sanctified – which occurs in the inside. It may represent the original sacrifice in some Eliadean sense,[19] in Aeneas's case not the origin of the altar but the origin of the nation and city which the altar's sacrifices uphold and the origin of the ancestry of Augustus who, on his own account, restored the nation ("respublica", *Res Gestae* 1) and the city (*Res Gestae* 19–20) and, of course, was voted this very altar by the city and nation in gratitude (*Res Gestae* 12). But, at the same time, the relief marks not only the "origin" but also the present – the eternal repetition of sacred action through the passage of time within this particular space. It thus represents, defines and enunciates the sacredness of the enclosure by virtue of the signs which the enclosure boasts in its decoration. The present is validated by being the enactment of the "original" past; the past is made meaningful because it is re-lived, re-presented and in the present.

Figure 33. "Large procession", sacrificial procession from the frieze on the outer face of the precinct walls, south side of the Ara Pacis, Rome, first century B.C. Photo: German Archaeological Institute, Rome.

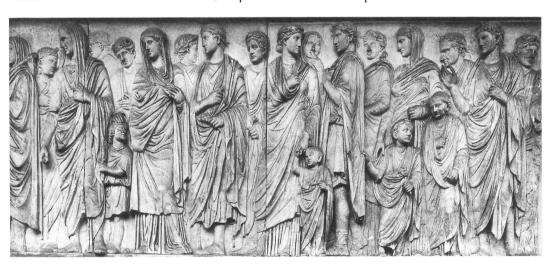

At the same time as it describes function by representation, the Aeneas relief is a prescriptive sign. It looks forward to ritual action and defines and delimits it – setting a representative ideal for the sacrifice which will actually take place. In ritual action (which is always process – a dynamic that leads to and beyond the act of sacrifice), the altar relief is static, not only as a particular furnishing and stage of ritual action but also as a representation of a single frozen moment (even if that "moment" is in fact a symbolic conflation of actual "moments"). The altar relief engages in a play with the viewer as he or she participates in the ritual; it constantly summarises and conflates a multifaceted diachronic rite in a synchronic and schematic space. Ritual is action through time, whereas the image is the static synchronic commentary and prescription for this action; although, when it partakes in the rite (by being a decoration of the Ara Pacis), it may be symbolically "activated". The viewer is of course never an objective or distanced observer – he or she is always a participant, or potential participant, in the ritual.

Figure 34. "Large procession", sacrificial procession from the frieze on the outer face of the precinct walls, south side of the Ara Pacis, Rome, first century B.C. Photo: German Archaeological Institute, Rome.

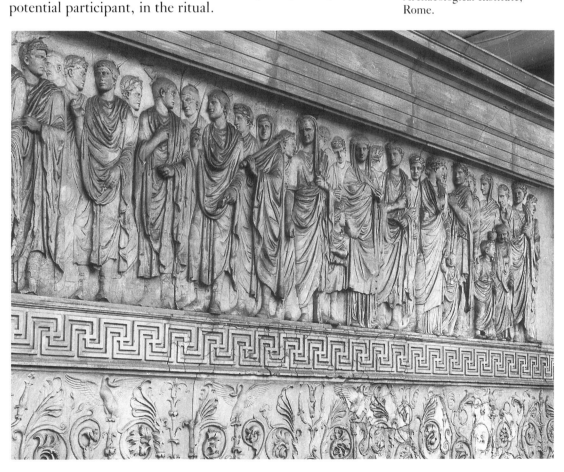

In effect, there is a play of time. The relief foretells in a general way throughout the year on non-sacrificial days what will happen on the special day of sacrifice and also, more specifically, what will happen when the sacrificial procession moves through the gates past the relief to the ritual act at the altar when that appointed day of sacrifice comes. But the image also looks back to what has happened, and it stands therefore for the general truth, the eternal value, of an act which can happen only occasionally. Marking sacred space and action in this way, Roman images function to define the meanings of religion. Their very presence in sanctuaries is a kind of visual theology.

All these meanings are borne by the Aeneas relief of the Ara Pacis in its particular position and context at different times and for different viewers. In terms of the notion of "deferral", it is significant that many of these meanings stand for an act that will happen, or that has happened (in fact, an act that is both past and future, an act that ritually creates the terms for temporality in religion). Even on the day of sacrifice, the relief never actually represents what is happening now where it is happening. Its reference is in a general sense to the kind of act it portrays, but there is always a gap (temporal and spatial) between the image and what it refers to. Indeed, if the image does portray Aeneas and if a sow was not the animal killed at the Ara Pacis, then the gap between the image and its ritual referent (the ritual itself perhaps being as much an enactment of Aeneas's sacrifice as the relief is) would be so much the greater. What matters in the argument about such images being literal is that all these meanings are inevitably tied to some direct relationship whereby a sacrificial image in a sacrificial context *must* reflect the sacrificial action of its context. This relationship is, however, of the most complex kind because it always involves a gap and hence the problematics of deferral.

Deferral is in fact built into the iconography of the scene. Not only are the *aedes* and the gods in it located away from the altar (something at the same time disguised and emphasised by the fact that the image conflates the two locations into a single panel), but the action of libation is specifically not the action of sacrifice. The living sow is not the animal slaughtered as during the act of slaughter. The living sow stands for the preliminary nature of the libation represented (in a scene which is itself placed at a preliminary position outside the door of the precinct). The Aeneas scene, perpetually frozen in an uncompleted sacrifice, stands always as a

pre-sacrifice at the sacred entrance, but it stands also for the perpetual incompleteness of the sacrificial act itself because of the deferral that characterises it. In the Ara Pacis, where there is no *aedes*, there is no cult image, no representation of a god to receive the propitiation of the site. Of course, there must be such a god – but the greater the ideological need to construct that deity imaginatively (as opposed to visually through a cult statue), the greater the factor of deferral.

THE SACRIFICIAL PROCESSIONS

Processions also appear in a wide variety of contexts – on altars (for example, the Ara Pacis), sanctuary walls (for instance, the Ara Pacis), arches (for example, that of Titus in Rome) and columns. They play a tantalising game with the viewer in that they always evoke sacrifice (through the animals, ritual implements and so forth that are represented), and yet the sacrifice is always deferred. Thus the main theme and end of the ritual occasion depicted is always an absent goal.

In the Ara Pacis the effect of such deferral is particularly pronounced. The "large processions" on the long sides of the exterior walls both lead towards the sanctuary door at the west (Figures 33 and 34). However, instead of continuing round the wall onto the western face (as for instance the Parthenon frieze does), the procession is "interrupted" by the panels on either side of the door. To the right as one faces the altar is the scene of Aeneas "sacrificing" and to the left a now very fragmentary relief usually interpreted as Mars with the infant Romulus and Remus. The rhythm of processional movement is disturbed by the static panels with a disruption in or at least switch of subject-matter.[20] In the case of the Aeneas relief (which at least we have in relatively good condition), the scene gives us a sacrifice to which the procession is moving. But it is not *the* sacrifice (because it is not inside the *temenos* but on the outside wall), nor is it a representation of any actual sacrifice (if the relief is rightly interpreted as Aeneas), but rather it is a mythological (or at best myth-historical) act which ideologically validates not only the altar and the procession leading to it but also the Roman viewer who is proceeding past it into the sanctuary.

Inside the precinct, along the low walls at the altar sides and encircling them, is a second frieze procession (Figure 35). It is preserved well in some parts but is very fragmentary or lost in others. Its scale is much smaller than that of the frieze

on the outside wall. Is it the same procession or a different one? Some would like the altar frieze to portray the annually recurring sacrifice and the exterior frieze to show actual people (the imperial family and senators) performing the original rite of consecrating the altar or some other important actual ceremony.[21] Others believe that the friezes represent ideal processions rather than document actual ones.[22] However, it seems unnecessary to insist on the singleness or exclusivity of such meanings. The Ara Pacis was a highly creative complex of sculpture arranged in a careful programme which invited creative interpretation from its viewers. One of the questions deliberately and tantalisingly left open by the altar's structure was the relation of the two friezes. Viewers could make up their own minds.

The frieze on the altar itself inside the precinct is unfortunately fragmentary. In particular, the whole section at the rear of the altar is lost, which means we cannot ascertain the direction of its procession.[23] Both processions (that on the altar frieze and that on the precinct walls, if they are indeed two rather than one) move in the same direction from east to west (see Figure 36). The interior frieze (on the altar itself)

Figure 35. "Small procession", sacrificial procession on the frieze from the walls of the inner altar, outer face, north side of the Ara Pacis, Rome, first century B.C. Photo: German Archaeological Institute, Rome.

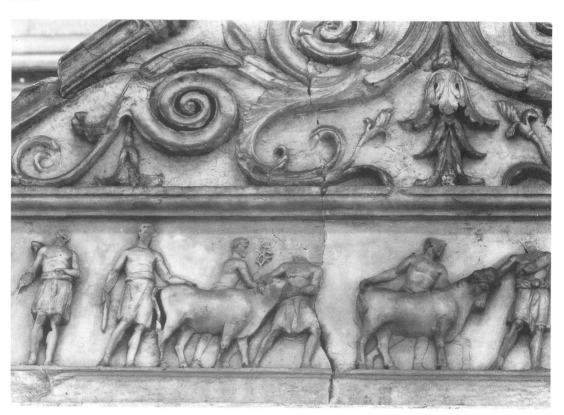

curls round to the heart of the altar. If two different processions were depicted, then the inner one ends at the altar, whereas the goal of the outer one is deferred (although if the frieze represents an actual procession, that too would have ended at the actual altar). If, however, the same procession is represented in different scales on the two friezes, then the outer procession (on the precinct walls) ends at the west (the front entrance), whereas the inner procession begins at the east (by the rear entrance). There would appear to be a problem of continuity.

Figure 36. Diagram of the
Ara Pacis with the directions
of the processions.

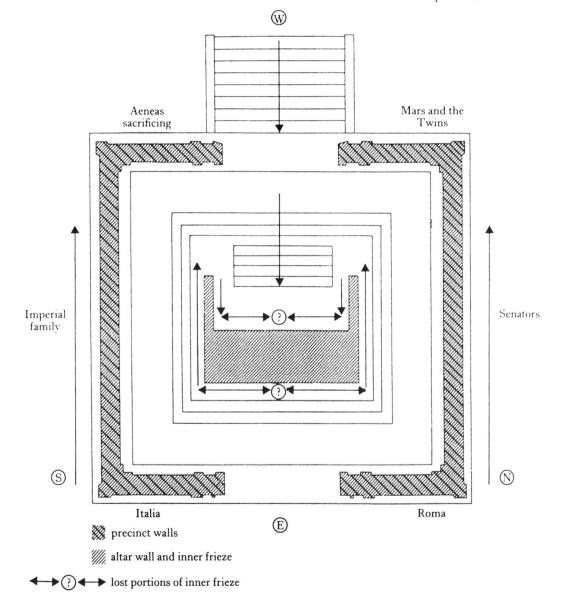

That the friezes offer a complex set of movements which are not easy to interpret, in addition to the framing of the outside processions with "static" images, is evidence not of clear differentiation between the friezes, but of ambiguity in meaning. As the effect of any ritual depends on the participants' response, so the sculptures of the Ara Pacis are open to the viewers' interpretations. The limits to this play of subjectivity are precisely the cultural boundaries of ritual and sacrificial experience which viewers would have brought to the Ara Pacis when they were present during an actual sacrifice, and which we cannot reconstruct. In particular, it would be interesting to know if there was a representation of an altar scene and a sacrifice on the lost part of the altar frieze. If not, then the process of deferral would go a stage further – offering fulfilment only in the sacrificial act of the actual ritual. It is worth noting again that the Ara Pacis inscribes deferral in its very structure, because there is no cult statue in this sanctuary for the sacrifice to go to. At the point where the *exta* were placed on the altar, there was a gap, an absent goal towards which the whole action had been directed.

Figure 37. "Italia", relief from the outer face, east front, south side of the entrance, Ara Pacis, Rome, first century B.C. Photo: German Archaeological Institute, Rome.

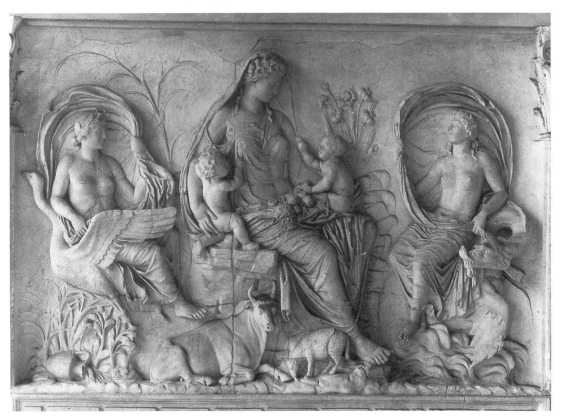

The notion of the gap is important in a further respect. The frieze offers us in the inner-altar wall images of animals – including what is either a bull, an ox or a cow – being led to sacrifice (Figure 35). A cow also appears in the famous relief usually called "Tellus" or "Italia", at the south side at the east (the back) of the altar's exterior wall (Figures 37 and 38).[24] One pre-condition of fruitful plenty in the years of the Pax Augusta is the cow – the animal which ploughs the earth for humans (e.g., Vergil, *Georgics* 1.63ff.) and which the earth nourishes in order that humans can bring it to the sacrificial altar, as in the altar frieze (e.g., Ovid, *Fasti* 4.629f.). In the actual sacrifice, a white cow would probably have been slaughtered within the *temenos*.[25] The death of one of the animals most necessary to human life is a kind of insurance for the continuation of that life.[26] The notion of the gap – of the loss of what is one's own as the guarantee of the preservation of one's own – is built into the ideology of sacrifice. At the heart of sacrifice is the great gap of death, which in the case of sacrificial killing is a kind of aversion of disaster, a shunning of death by the sacrificers through death.

FROM LITERAL TO SYMBOLIC

Figure 38. The Ara Pacis from the east, Rome, first century B.C. Photo: German Archaeological Institute, Rome.

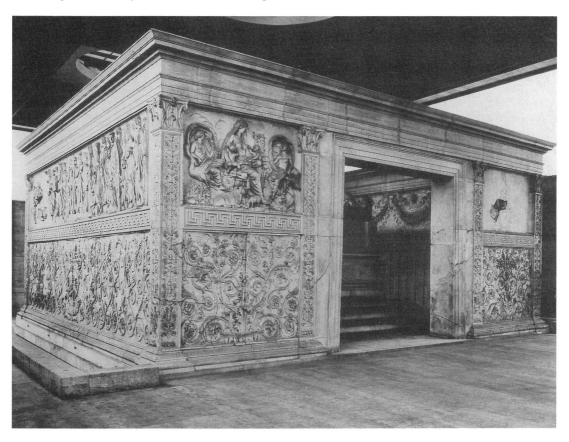

SACRIFICE AND DEATH

The Ara Pacis is eloquent on the subject of death. Around
the inner walls of the enclosure is a frieze of garlands boasting
many fruits hanging between the skulls of dead cows. Above
the garlands are images of *paterae*, or sacrificial vessels (Fig-
ures 39 and 40).[27] Even as sacrifice took place, its participants
were surrounded by the *memento mori* of its results – the
fruitfulness of life bought at the ritual cost of death. Just as
the Aeneas relief both presages and looks back to the sacrifi-
cial action and function of the sanctuary, so the Italia scene
(in the opposite position at the back of the altar to the Aeneas
relief at its front) offers a golden age phantasy of fruitfulness
which in Augustan ideology marked the distant past, the
Augustan present and the immediate future. The fruitful bliss
of the Italia scene, cow and all, is insured by the procession
of cows to their death at this very altar, by the cows becoming
the skulls from which the garlands hang. The visual pun
works in both Latin and English – the garlands *depend* on the
skulls. The cow, a recurring image in its different forms in
the precinct, is a visual metaphor for the reciprocity of sacri-
fice, for what depends on what and for the cost of Augustan
plenty. The scene of Italia could not be there but for this

Figure 39. Bucrania, *paterae*
and garlands, frieze from the
inner face of the precinct
walls, south side of the Ara
Pacis, Rome, first century
B.C. Photo: German
Archaeological Institute,
Rome.

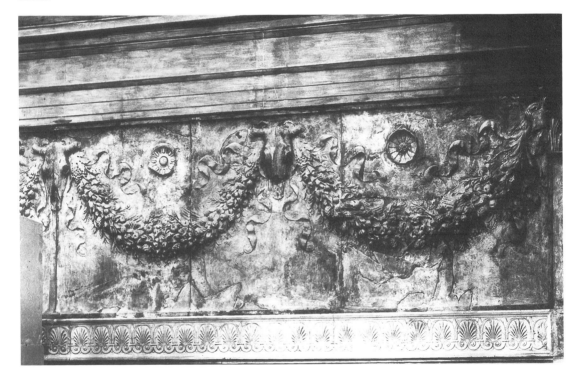

altar; it could have no meaning but for the skulls. In the Ara
Pacis, the cows of fruitfulness, of sacrifice, and the skulls of
the precinct wall represent as one thematic continuity the
sacrificial transaction by which human social life is insured
and linked to the sacred.

Sacrifice in Roman ideology is, however, more than "a
unifying and recreative social phenomenon".[28] At times, in
Roman poetry of the late Republic and early Empire, the act
of sacrifice may define the golden age, when the blood of
animals was spilled for the gods instead of the blood of kin-
dred human beings (e.g., Catullus 64.386-408), or may repre-
sent celebration (as in the sacrifice on behalf of Caesar in
Vergil's *Georgics* 3.22–3). But the image of sacrificial blood is
unstable. In Lucretius, sacrifice – one of the *impia facta* (impi-
ous acts) of religion (1.83) – is tied to the sense of fear
(5.1161–8). In Vergil's *Georgics*, "two interpretations of ox-
slaughter – as impious crime and unifying ceremony – are
balanced at the very centre" of the poem in the form of the
sacrifices at 2.536–7 and 3.22–3.[29] In both *Georgics* 2.536–7
and Ovid's *Metamorphoses* 15.95–142 the combined image of
animal sacrifice and the eating of meat is used to define the

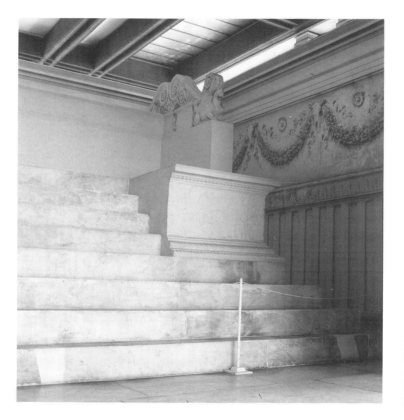

Figure 40. The altar and the
inner face of the precinct
walls, south side of the Ara
Pacis, Rome, first century
B.C. Photo: Silvia Frenk.

205

end of the golden age. At the very least, the image of sacrifice is an ambivalent one. Although it establishes social life through ritual killing, it also evokes the gap of death which gapes before that social life at its boundary and undermines its very foundations, its very meaning, with a great denial. Ritual killing and imagined religious worlds that must be placated seem (like imperial "apotheosis") to be the defence of Roman ideology against the deconstructive fact of death. But it is ironic that death itself must be the prophylactic barrier to death.

In the *Carmen Saeculare*, Horace prays that the prayers of Augustus, entreated of the gods by the slaughter of white bulls, be answered (vv. 49–52):

quaeque vos bubus veneratur albis
clarus Anchisae Venerisque sanguis,
impetret, bellante prior, iacentem
 lenis in hostem.

Whatever he of Anchises' and Venus' pure blood
(a warrior heretofore, now lenient to the fallen
foe) entreats of you with white bulls,
 grant him his prayers.

 (Translated by W. G. Shepherd)

Significantly, the image of blood – which echoes in the references to war and sacrificial slaughter – is transferred to the *princeps* upon whom the success of these acts depends.[30] To be Augustus is an act of blood (in both the kin and carnage senses of the word), and upon the Augustan blood of divine progeniture, war and sacrifice rests the image of the golden age of Augustan plenty (vv. 57–60):

iam Fides et Pax et Honos Pudorque
priscus et neglecta redire Virtus
audet, apparetque beata pleno
 Copia cornu.

Now Faith, and Peace, and Honour,
and pristine Modesty, and Manhood neglected,
dare to return, and blessed Plenty appears
 with her laden horn.

This image of blissful plenty, including Pax, is like the balmy phantasy of Italia on the Ara Pacis: In Horace, as on the altar, Augustan plenty rests on the fact of death. Nor is this problematic relationship confined to political or "Augustan" themes. In *Odes* 1.4 the poet's celebration of the return of

spring turns sombre as the necessity for celebratory sacrifice leads to the inescapable fact of death. There is a brilliant chiasmus whereby the dancing of the deities at springtime (vv. 5–8) leads to the fittingness of human celebrations (vv. 9–10) and the parallel fittingness of sacrifice to appease those deities (vv. 11–12), which in its own right leads to the dance of death (vv. 13–14). The relevant lines (vv. 5–14) read as follows:

iam Cytherea choros ducit Venus imminente Luna,
 iunctaeque Nymphis Gratiae decentes
alterno terram quatiunt pede, dum gravis Cyclopum
 Vulcanus ardens visit officinas.
nunc decet aut viridi nitidum caput impedire myrto
 aut flore terrae quem ferunt solutae;
nunc et in umbrosis Fauno decet immolare lucis,
 seu poscat agna sive malit haedo.
pallida Mors aequo pulsat pede pauperum tabernas
 regumque turris . . .

Cytherea leads the dance by moonlight,
 the seemly Graces hand in hand
With Nymphs tread the rhythm while flamy Vulcan
 inspects the Cyclopes' gloomy works.
Now is the time to deck your glistening hair
 with green myrtle or the flowers
of the liberated earth, to sacrifice to Faunus
 in the shady wood a lamb or a kid.
Pallid death kicks impartially at the doors
 of hovels and mansions . . .

(Translated by W. G. Shepherd)

The ambiguous theme of dance ["Gratiae . . . quatiunt pede" (vv. 6–7) and "pallida Mors aequo pulsat pede" (v. 13)] encloses the parallelism of celebration and sacrifice articulated in the anaphora of "nunc decet" (vv. 9 and 11). The themes of spring and love (vv. 19–20) become inseparable from that of death – both the death which we inflict through sacrifice and the death which dances on the roof of the rich and the poor alike. The verbal imagery of Roman lyric, like the visual imagery of Roman art, is unable to extricate living from the problematic of dying and the implicit negation by which death (whether inflicted by us or upon us) undermines life.

On the face of it, the Italia relief of the Ara Pacis is the least significant part of the altar for a discussion that proposes to be about sacrifice. But, on the contrary, it is precisely because the relief's relation to sacrifice is at the same time so tenuous and so essential that it is important. This scene offers

(as does the fragmentary representation of Roma in the corresponding position on the other side of the rear entrance of the *temenos* – if indeed it is Roma) in the present viewing moment in this very image the goal or rather the resultant effect of the sacrificial action of the rest of the altar. The positive implications of the Italia panel cannot be separated from imagery that reeks of killing. None of the images on the relief – the cow and the sheep (another animal that appears in the sacrificial procession on the altar), the personifications seated on bird and dragon or the central female figure nourishing the infants – whatever their meanings (which are the complex and idiosyncratic construct of a new imperial ideology that was only at that moment in the process of formation) can be separated from the death by which this phantasy of perfection is to be bought. It is a fact of Roman religious ideology that both the act of sacrifice and its literal imagery of death and slaughter must be constantly interpreted to mean life. Not only the Italia relief but also the great panels of acanthus scrolls teeming with birds, frogs, snakes and other life (which form the bottom layer of the outer wall, literally underlying its imagery; see Figure 41) are the visual paradigm of this necessary and constraining interpretation.[31] The art of the Ara Pacis could not work without an intense cultural framework of meaning to keep the anarchy of its possible (negative) implications at bay. It is because religion is about the most essential things, that it shows up so strongly a culture's deeper ideological contradictions in the face of precisely the most essential things.

In concluding these reflections on the nature and complexity of the sacrificial theme of the Ara Pacis, I should like to emphasise two points. First, sacrificial imagery was of immense significance in what Paul Zanker calls "the pictorial vocabulary" under the Principate and came to dominate the decorative schemes of Augustan buildings, even when these were "purely secular" structures.[32] Second, I wish to reiterate that these sacrificial images are grounded in actuality. No interpretation of them can afford to ignore *some* literal significance in their subject-matter and context, *some* aspect of mimesis by which the image reflects its referent. It is this literalness which distinguishes them from the images of Mithraic sacrifice which I want now to discuss.

Finally, let us note that the deconstructive implications of sacrificial imagery offer a significant parallel to the deconstructive problematic of Roman imitative painting which I explored in Chapter 2. In both cases, Roman images offer a

mimetic relationship to their subject-matter. In both cases, that mimesis turns out to be unstable and to imply the potential for its own deconstruction. Roman wall-paintings offered a highly ambivalent commentary on the rules of "realism" by which they were supposed to have been constructed. Roman sacrificial images (at least in the case of the Ara Pacis) cast an equally ambivalent reflection on the activity of sacrifice which they celebrate. Both destabilize any simple or single viewing position, offering viewers the possibility to look not only in collusion with the prevailing ideology governing such images but also against its grain. Both represent the system (the social system in the case of domestic wall-painting, the civic-religious system in the case of sacrifice), and both offer the opportunity to gaze critically and deconstructively at the system. In view of this, we should perhaps be a little wary of the current fashion which sees art and religion as forces marshalled unambiguously in support of Augustus's new imperial regime.[33] On the contrary, the very ambivalence of Roman images – one might even say their embarrassment – at both

Figure 41. Acanthus scrolls, detail of the lower reliefs from the outer face of the precinct walls, Ara Pacis, Rome, first century B.C. Photo: Ashmole Archive, King's College, London.

their subject-matter and the mimetic rules by which they were made, hints at a set of highly complex and multiple positions for the Augustan viewer in relation to the authority of the state.[34]

MITHRAIC SACRIFICE

Let us begin with two observations. First, all of the reliefs of civic sacrifice described in the previous section are located on the *outside* – open to the air. However, unlike Roman temple-sanctuaries, Mithraic cult centres (e.g., Figure 42) were small and enclosed within a roof. Like Christian churches after them, mithraea defined an interior space with an art of the *inside*, which usually needed at least some artificial lighting at least some of the time.[35] This is already a fundamental difference in cultic practice – in its ritual and visual environment. Second, all Roman images of sacrifice in some respect display the quality I described as deferral. There is a gap between the image of sacrifice and the object of sacrifice, between the representation of sacrifice and the sacrifice itself, and between the place of sacrifice and the place of the god being propitiated (whether the god was present in his image in the temple behind the altar, or whether there was no such temple as in the Ara Pacis). I want to argue that in the cults – in Mithraism and in Christianity – this split and the subsequent deferral is abolished. In the first place, the sacrificial (mediating) act is concentrated within the cult space *inside* the mithraeum or church, whereas in Roman temples the altar was always outside the *aedes*. Furthermore, Mithraism and Christianity appropriated the cult *action* of sacrifice to the god as well as to the ritual participants. Thus in the image of the tauroctone (on which I shall focus, Figures 43–4 and 46–7) Mithras is *sacrificer*, and in Christian ideology Christ is the *sacrificial victim*. In effect, the cults seem to be modifying the Roman model of numerous or widespread spaces to diversify and extend the sacred (a model typified by the huge sacred area of the Campus Martius of which the Ara Pacis was a part). Instead they offer a new model of concentrated intensity upon a specific and single place of mediation in which not only is all action focussed on the one sacred space, but even the most fundamental ritual action of the worshipper (sacrifice) is appropriated to the deity.

The image of Mithras killing the bull occupies the cult niche of numerous mithraea at the end opposite the entrance

(often with other images lining the walls or floor). In general (and excluding the different ways it may be framed), the bull-slaying scene – whether a relief, a freestanding sculpture or a painting – shows a remarkably consistent iconography (e.g., Figures 43 and 44). From the viewpoint of the observer, Mithras kills the bull from the left, and under the bull there appear from left to right a scorpion at the bull's genitals, a snake and a leaping dog drinking blood from the wound Mithras inflicts to the bull's neck.[36] It is clear that this scene is "the central icon of the cult".[37] Moreover, this cult image, quite unlike the cult statues of civic religion, is an image of sacrifice.[38] It seems that this fundamental difference along with elements particular to the tauroctone which are quite different from known sacrificial elements of Roman civic ritual (such as the way the animal is killed) "constitute a structured system of differences from the rules of civic sacrifice in the Graeco-Roman world".[39]

My intention here is not to explore the implications of this Mithraic theme as it relates to Mithraic cult practice (such as

Figure 42. Interior view of the mithraeum at Sta Maria in Capua Vetere, third century A.D. Photo: Courtesy of E. J. Brill, Leiden.

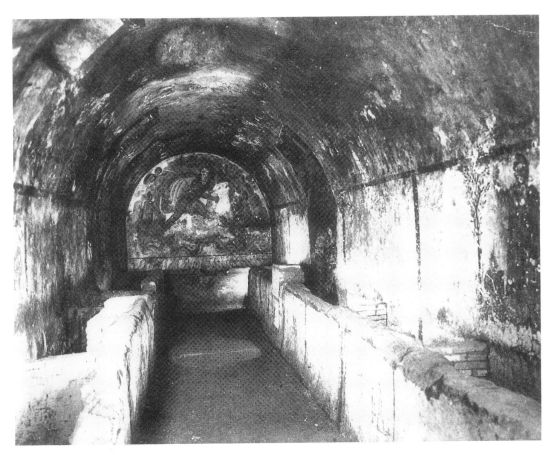

we can reconstruct it). However, because this has some bear-
ing on the similarity of Mithraism to Christianity, it is worth
noting that the sacrifice of the bull seems to be salvific and
Mithraism a soteriological cult.[40] It is worth remarking also
that votives were probably offered to the image (they almost
certainly were not to Roman sacrificial reliefs)[41] and that as
an iconographic scene it is sometimes connected with the
image of the cult meal.[42] There is some archaeological evi-
dence that such cult meals took place in a mithraeum before
the image of the tauroctone.[43] This evidence, suggestive and
tentative though it is, seems to reinforce further the impres-
sion of the tauroctone as a cult icon.

What I want to argue is that the bull-slaying scene is not a
literal representation in the sense that Roman sacrificial reliefs
are. It is essentially symbolic. Here we have an initial prob-
lem. We do not know if sacrifice ever took place within a
mithraeum. There is no evidence that it did so,[44] and no
evidence that it did not. Various bits and pieces discovered in
mithraea such as knives and bones can be explained without
recourse to sacrifice, as votive offerings or as remnants of cult
meals. I doubt myself that it would be possible to kill a bull
in most mithraea (let alone get him into the place), for the
spaces are very small in general, with complex entry arrange-
ments (often involving an entrance off a passage of other
rooms), and are frequently located deep in the basements of
buildings. Even the killing of a cock in such a small indoor
room would have been a messy business – but quite possible.
Therefore we must proceed assuming both possibilities.

Whatever the initiates actually did in a mithraeum (which
no analysis of Mithraic art or Zoroastrian texts will ever tell
us), the tauroctone represents not them but their god. There
are here two fundamental shifts from the practice of Graeco-
Roman sacrificial representation. In the first place, the god is
united with the sacrificial scene, and in the second, he *performs*
the act of sacrifice instead of (or perhaps as well as) being its
recipient. Indeed, he replaces his worshippers as sacrificer.
Mithraic cult offers an icon of remarkable iconographic stabil-
ity (what Richard Gordon calls "stereotypy")[45] with a cultic
and votive function, in the sense of receiving worship.

But what this icon represents is nothing that could ever
have happened in any mithraeum *except symbolically*. Even if
sacrifice did take place, and even if a real bull were killed, no
real scorpion, serpent or dog could have acted as the ones
represented in the image do. Furthermore, the performers of
such a sacrifice would be not the god as in the icon, but his

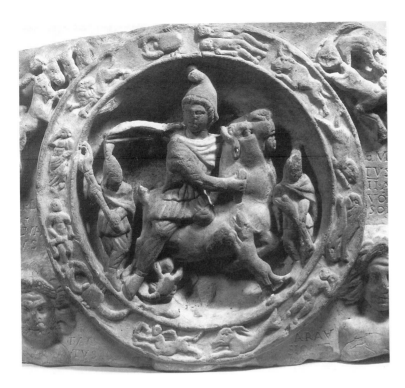

Figure 43. Relief carving of tauroctone from the Walbrook Mithraeum, London. Photo: Courtesy of the Museum of London.

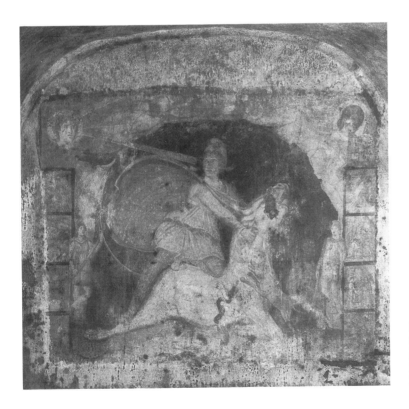

Figure 44. Painted tauroctone from the mithraeum at Marino, third century A.D. Photo: Courtesy of E. J. Brill, Leiden.

worshippers. Thus the referent of the tauroctone is not in any literal sense to a historical space or time (what may have been done in this world by real people) nor is it to the ritualisation of this world (to any actual sacrifice or ritual performance). The referent of the scene where Mithras kills the bull – the space to which it points and where its "reality" is located – is not in this world at all, but is in a mythic and eternal space and time which may carry many meanings.[46] The tauroctone had an astrological significance[47] – it was orientated according to the stars towards an Other World – but this is a very different, non-socio-political, world from the astronomical orientation of the Ara Pacis, the Horologium and the emperor's birthday. Everything about the tauroctone (including the slaughter of the bull by Mithras) is symbolic.

The effect of this sustained symbolism is that unlike the cult images of Graeco-Roman religion, the referent of the tauroctone is not *that particular statue* or relief made divine. The major Roman cult statues unfortunately do not survive. But it seems the case that in Roman religious ideology, the statue *is* the god.[48] In for example the temple of Artemis at Ephesus, in that strange "multimammary" form of the cult image (if "multimammary" is indeed the right description for her appearance), time and space were penetrated by the sacred (see Figure 45 for a Roman copy of the now lost original).[49] The worshipper's relationship to the sacred was a relationship with *this* image. Artemis *of Ephesus* was a local deity – the goddess of this temple – and not Artemis in general. In Graeco-Roman religious art, the statue seems primarily to denote itself; its referent is the image divinised. Even when images of the Ephesian Artemis travel (in a stereotyped iconography), they refer back to the one original and essential image – the *Ephesian* Artemis: a specific goddess in a specific statue in a specific place. This relation of all the other statues to the one essential image back at Ephesus is strongly implied by Pausanias, who finds temples of Ephesian Artemis all over Greece.[50] Pausanias writes:

All cities worship Artemis of Ephesus, and individuals hold her in honour above all the gods. The reason, in my view, is the renown of the Amazons who traditionally dedicated the image, also the extreme antiquity of the sanctuary. Three other points as well have contributed to her renown: the size of the temple, surpassing all buildings among men, the eminence of the city of the Ephesians and the renown of the goddess who dwells there. (4.31.8)

Whatever the conviction of the reasons Pausanias suggests, each of them relates the images of the Ephesian Artemis

Figure 45. Artemis of
Ephesus, Roman copy of the
now lost original. Photo:
German Archaeological
Institute, Rome.

directly back to an original centre – that temple, that city,
that dedication. Artistically, the effect of stereotypy is to
locate the statue in a specific interpretative frame which
points directly back to the ur-statue (with all its particular
associations) in Ephesus. But Mithraism, which also offers a
standardised iconography for its cult image, has no ur-image,
has no literal or specific referent in historical or temporal
space, in actuality or nature. Its cult image is a *symbol* – its
referent is in mythic eternity, beyond time and space, poly-
semic and suggestive. The tauroctone as cult image denotes
not itself, but something else.

215

The effect of stereotypy is that in any mithraeum any-
where in the Roman world (from Walbrook in London [Fig-
ure 43] to Dura Europos in Syria) a worshipper could meet a
symbolically charged icon of the *same* god. But it is an icon
existing in no "real-" or ur-likeness in this world. Mithras is a
god for whom all likenesses are symbols. The symbol points
beyond itself, beyond that specific statue, to a more general
referent true of all tauroctones. Thus the Mithras in any
particular mithraeum is not a particular Mithras special to
that mithraeum (as Artemis of Ephesus is special to the tem-
ple at Ephesus) nor is it divine in its own right. Rather, it is a
symbol of a god who exists beyond and apart from it – and if
it is divine, then it is divine by right of him. Unlike the
Ephesian Artemis, Mithras does not dwell uniquely in a spe-
cial image, although he may allow any of his images to partake
of himself when charged by the worship of his initiates.

Mithraism was, in fact, always a deeply symbolic mystery
religion. Its ur-temple (itself a myth evoking Persia) was "a
spontaneously produced cavern" – a natural site which
needed consecration by Zoroaster to become a *symbolic* sanctu-
ary. Moreover, its significance was not as a thing-in-itself, but
as an *image* of something else – a "likeness of the Cosmos"
(*eikona tou kosmou* – as Porphyry put it, supposedly quoting
Eubulus [*De Antro Nympharum* 6]). Unlike the literal art of
Roman religion whose referent always points in some respect
back to actuality, Mithraic art is a symbolic art whose referent
is firmly and unquestionably located in the Other World.[51]

The tauroctone is interesting, furthermore, because it has
energised the static cult icon by making the deity performa-
tive. The ritual action is now the cult image and the wor-
shipped deity his own worshipper. Here we may note a
fascinating structural difference from Christianity which also
conflates the god worshipped with the ritual and sacrificial act
in similar ways. As in Mithraism, the god is his own sacri-
fice – that is, the dynamic or performative quality of the
paradigmatic act of sacrificial worship (the bull slaying or the
eucharist) has an identity with the person of the cult deity (be
that Mithras slaying the bull or Christ as the eucharistic
bread). But the difference is that Mithras kills whereas Christ
is killed, Mithras is the sacrificer, but Christ is the victim who
died to save the world.[52] In both Mithraism and Christianity,
the ritual act has been highlighted and given increased sig-
nificance by being appropriated to the god which it propiti-
ates. The god is transformed from a static cult image to a god

performing ritual action (whether as sacrificer or as victim). It is the action that deifies; the performance is the deity.

This transformation has fundamental theological repercussions. It is no longer ideologically the case that ritual offers something (a kind of bribe) to the god who is thereby propitiated. On the contrary, if the god's divinity is deeply implicated in his performance of ritual action, then such action (whether literal or symbolic) may represent a means of divinising (*theôsis*) the worshipper by mimesis of his god. To push this too far in the case of Christianity became dangerously heretical (although Pseudo-Dionysius pushed it far indeed); for us to push this too far in the case of Mithraism is likewise dangerous, for there is no evidence to give us any confirmation or disproof. But we do know quite unambiguously that this direction towards the ritual which divinises was precisely the way that a third philosophical cult of late antiquity was moving at the end of the third century, during the last few years before Constantine's conversion.

No intellectual tradition in late antiquity was more distinguished both philosophically and in terms of mystic practice than the Neoplatonic. Already by the time of Porphyry (second to third century A.D.), the pupil of Plotinus, Neoplatonic exegesis had moved conclusively towards the awareness of multiple layers of meaning and polysemy which is an essential characteristic of seeing things in a *symbolic* rather than literal way.[53] In the late third century the leadership of this school passed to Iamblichus of Chalcis. His influence was fundamental in transforming Neoplatonism from an intellectual and philosophical system to one of "theurgy" and ritual practice.[54] Intellectual understanding was not enough, Iamblichus wrote, "rather, it is the perfect accomplishment of ineffable acts, religiously performed and beyond all understanding, and it is the power of ineffable symbols comprehended by the gods above that establishes theurgical union (*theourgikên henôsin*)" (*De Mysteriis Aegyptorum* 2.11, pp. 96.13–97.9, ed. G. Parthey).

Because in Neoplatonic discourse union with the One is the attainment of divinity, we see here a direct parallel in an important didactic text within the cult to the divinising of sacrifice or the ritualising of divinity which we observed in Mithraism and Christianity. In all these cases, the Divine – whether a man who was God, a philosophical concept (the One) or a cult image – is brought closer to the worshipper by becoming, in very different ways in each case, identified with

and adapted to the act of worship. In each case, the key to this union of goal (the god) with means (the ritual) is symbolism. Essential to the spirituality of late antiquity is a symbolic and hence polysemic mode of looking at the world which represents a fundamental move from the grounding in the literal of civic Roman religion.

I have been comparing Mithraic art (our only real key to Mithraic cult) with Christian ideology (our best clue as to Christianity in the years before Constantine) and Neoplatonic theurgical texts. I do not wish to say they are all the same. But it is important that in certain profound ways these cults were moving in a similar direction at the same period, the late second to the late third centuries A.D.[55] Before turning to look at sacrificial themes in Christian art of a rather later period, in the context of what I call "the symbolic mode", I should like to venture one last observation about Mithraism. I have argued that deferral – the existence of a temporal and spatial gap between the god and his offering, as well as between a synchronic image of sacrifice (the altar scene) and its referent (the diachronic process of sacrifice) or the processional scene

Figure 46. Painted tauroctone from the mithraeum at the Palazzo Barberini in Rome, third century A.D. Photo: Courtesy of E. J. Brill, Leiden.

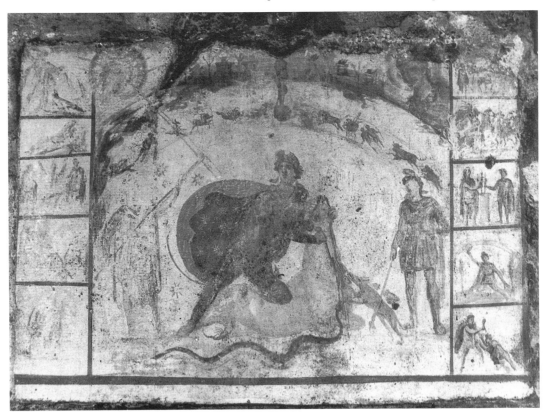

and its goal (the sacrificial act and beyond that the cult statue elsewhere) – is an important aspect of Graeco-Roman civic religion. I have argued that Mithraic practice, by uniting the cult image with the ritual and conflating both this new performative cult image and his worshippers into the single space and time of a small, symbolically charged cult centre, bridged the gap and abolished deferral. And yet, it is not so simple. The symbolic mode establishes the bull-slaying scene as an icon whose referent is in the Other World. The deferral of ritual from image has been eliminated by the abolition of gaps in time and space, by making the image its own sacrifice. But this only means that deferral is transferred. The image is no longer a god but a symbol for the god. The god himself (his essence or being) is elsewhere. Mithraic cult demands a tremendous *faith* and an initiation-ritual practice as complex and symbolic as Iamblichan theurgy or the Christian sacraments in order for that most fundamental gap to be bridged and for the initiate to be brought at last beyond the symbol unto the reality of his god. The intense ideological and exe-

Figure 47. Relief carving of tauroctone from Neuenheim, third century A.D. Photo: Courtesy of Badisches Landesmuseum, Karlsruhe.

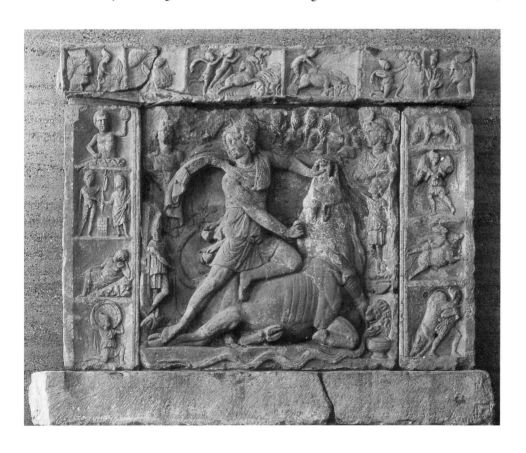

getic constraints imposed by cult practice in the symbolic mode are no less pronounced and faith-dependent than those which we met in examining the Ara Pacis.

Before finally leaving Mithraism for Christianity, let us briefly return from ideology and meaning to the forms of Mithraic art. What I have called the symbolic mode means that a kind of syncretism or conflation of symbolic elements can be added to the basic image of Mithras slaying the bull. In the frescoes of the mithraea in Capua Vetere, Marino and the Palazzo Barberini in Rome (Figures 42, 44 and 46), figures of the torch bearers Cautes and Cautopates are added on either side of the composition.[56] Above the tauroctone are images of heads in all three mithraea – the one on the right being interpreted as Sol (in Marino and the Barberini he emits rays, one of which falls directly on Mithras), the one on the left as Luna. In Capua Vetere, there is a bird (a raven?) beside "Sol", and there are heads at the bottom of the fresco to the left and right sides (interpreted as Oceanus and the Earth goddess). By the sides of the Marino and Barberini images, there are panels containing smaller images in a sequence (four on each side in Marino and five on each side in the Palazzo Barberini). It is as if there were a commentary on the main icon by means of these images. This accretion of side scenes in ladders, the presence of Cautes and Cautopates and the busts of Sol and Luna, are all paralleled by reliefs from Nersae and Neuenheim (Figure 47). Furthermore, the Barberini fresco has a zodiac portrayed arching over and above the tauroctone, perhaps a parallel to the zodiac which encircles the Walbrook relief (Figure 43). I do not mean to enter into the suggestion of meanings for these difficult images. Rather, it is my aim to illustrate the enormous possibilities for symbolic accretion and complexity that are open as soon as images enter a symbolic mode which frees them from a direct literal referent.[57]

There are several aspects of symbolic accretion in such images which it may be worth noting. In the first place, they signify their importance as cult icons through an excess of visual symbols.[58] Such pleonasm offers not only an oversignification of symbolic elements in the visual form of the image but also the endless possibility for overreading – for excess in viewers' interpretations. When there is no limit to meaning, and that absence of limit is expressed through an excess of symbols, this enunciates not only the importance of the image as a sign for the reality to which such symbols refer but also

the boundless depth of understanding to which their Truth offers access. Second, Mithras gazes *away* from the bull which he kills and from every other symbol within the frame (such as the Barberini zodiac, for instance [Figure 46]), in order to look up at "Sol" or out at the viewer. This is true of many tauroctones, but it is especially noticeable in such complex and conflated images.[59] Mithras is both fully involved in his sacrificial act of slaying the bull and yet disengaged in the specific and significant aspect of his gaze not only from his action but also from the other symbols in the image.[60] Thus the figure of the cult deity looks beyond the frame of his reality as "image" and gazes through and away from the symbolic pleonasm which surrounds him. He looks to and beyond the world of the viewer's experience to the Other World of his being as deity. Nothing so affirms the symbolic nature of the taurocte as its chief actor's ambivalent engagement in the narrative field in which he has been represented. Insofar as he is always to some extent disengaged from the narrative field, he always exists beyond that field. Once the killing of the bull is a symbol whose ultimate "reality" is firmly in the Other World, it can be used with a breathtaking (if unrecoverable) virtuosity and sophistication to map and describe the Other World – as in these complex images. Some of the significances of this kind of sophistication *can* be recovered in the case of the symbolic representations of Christianity, where we have texts against which we can compare images.

CHRISTIAN SACRIFICE

Sacrifice is the visible ritual of an invisible sacrifice; that is, it is a sacred symbol.

St Augustine, *Civitas Dei* 10.5

Like its predecessors, including the Roman civic cult and Mithraism, Christianity is a religion of sacrifice.[61] Its texts reiterate this ideology and its images portray it. Even in such early and incompletely surviving cycles as the mosaics of the church of Sta Maria Maggiore in Rome (which date from the redecoration of the basilica under Pope Sixtus III in the 430s), there is a strong emphasis on images which evoke sacrifice in its Christian sense. The scenes of Melchisedech and of Abra-

ham giving bread to the three angels are Old Testament
precursors of the eucharistic rite – the worshippers' offering
of a bread which has become Christ, the sacrificial lamb.
There are moreover several scenes with sheep in the narra-
tives of Jacob and Moses on the walls of the nave and in the
depiction of the heavenly Jerusalem on the triumphal arch.
This concentration on eucharistic and sacrificial imagery is
central to important programmes of mosaic decoration in the
sixth century, such as the apse of the church of Sts Cosmas
and Damian in Rome, or the presbytery of San Vitale in
Ravenna. I do not intend here to present a catalogue or survey
of Christian sacrifice. Rather, I shall evoke (through images of
Christian art once Christianity had become the established
and official religion of the Roman state) some of the differ-
ences of meaning and implication that were constructed
around Christian sacrifice by comparison with its prede-
cessors.

Let us begin though with the symbolic mode. In sharp
distinction from Roman religion (and perhaps from Mithraic
practice), Christianity had abolished the slaughter of animals.
All sacrifice was henceforth to be symbolic. And yet all true
religious action – including the well-lived life and death and
including the very body and identity of the worshipper –
were now "a living sacrifice".[62] In eliminating the literal – the
actuality of animal slaughter – Christianity had generalised
the implications of sacrifice (and of mediation with God) to an
extent unheard of in pagan thinking. The signifier of "sacri-
fice", once freed from any literal anchor or frame in the actual
killing of animals, had become liberated into a polysemic
meaning that could (and did) encompass anything in a rightly
lived life. "Sacrifice" was not simply the symbol for man's
relations with God – in that it defined the supreme sacrament
of worship (the eucharist) which human beings eat in order to
become united with God[63] – but it also defined God's rela-
tions with man (Christ as the sacrifice who died for us).
Furthermore, it stood as a symbol for man's relation to man
in defining the saintly life, for a human's relation to his or
her own body, and for the martyr's death. All these were
"sacrifices" which bring human beings closer to their God.

Let us clarify this ideology of sacrifice by examining its
significance in a major mosaic programme of mature Christian
art. The basilica of Sant' Apollinare Nuovo in Ravenna is a
complex monument. It was built and decorated by the Arian
Gothic ruler of Ravenna, Theodoric (493–526), in the early
sixth century, and it was later rededicated to the Orthodox

cult after Ravenna fell to the Byzantines in 540.[64] During the episcopate of Agnellus (archbishop of Ravenna, 557–570), part but not all of the mosaics were replaced. The mosaic programme is incomplete since the destruction of the apse in an earthquake in the early eighth century. I shall avoid the vexed discussion of Arian versus Orthodox artistic programmes and the debate about precisely which parts of the mosaic belong to which parts of the sixth century. Rather, I shall assume that once Agnellus had substituted for the offending images (of Theodoric and his court?) his own images, representing processions of male and female martyrs, the whole programme as it then stood was to be read as a totality and was to be seen as Orthodox.

The mosaics are arranged in three tiers spanning the length of the nave walls above the arcade (Figures 48–51). They stretch from the entrance at the west to the apse. The lowest tier on the north side shows a procession of twenty-two martyred virgins (all identified in inscriptions above their heads). They walk eastwards from Classe, the port of Ravenna (inscribed "Civitas Classis"; see the detail, Figure 48), represented at the entrance of the basilica in the west. The virgins carry martyr's crowns and join the Magi in the east who form the head of their procession approaching the Mother and Child enthroned between four angels (see Figure 49). On the south side, twenty-five male martyrs (also all named by inscriptions) proceed from Theodoric's palace and the city of Ravenna (inscribed "Palatium" and "Civitas Ravenna", Figure 50) at the west towards Christ also enthroned between four angels (Figure 51). Like the virgins, they bear martyr's crowns and are led by a non-martyr, St Martin of Tours (the patron saint of the church at the time)[65] who makes the twenty-sixth figure.[66]

The impact is one of longitudinal mediation. The viewer enters the church at the west and stands by the door below images of the world he or she knows, the world of the here and now. On the right if one faces the apse is the city of Ravenna and the palace of Theodoric, which in reality stood just outside the building and for which the basilica was originally the chapel (Figure 50). On the left is the port of Classe (Figure 48). As one proceeds up the nave, one leaves this space, the images of this world, and moves through a procession of martyrs (Figures 52 and 53) – women and men who were once part of this world but whose self-immolation in the cause of the Faith has transported them to the Other World. Their very procession (as was their martyrdom) is an

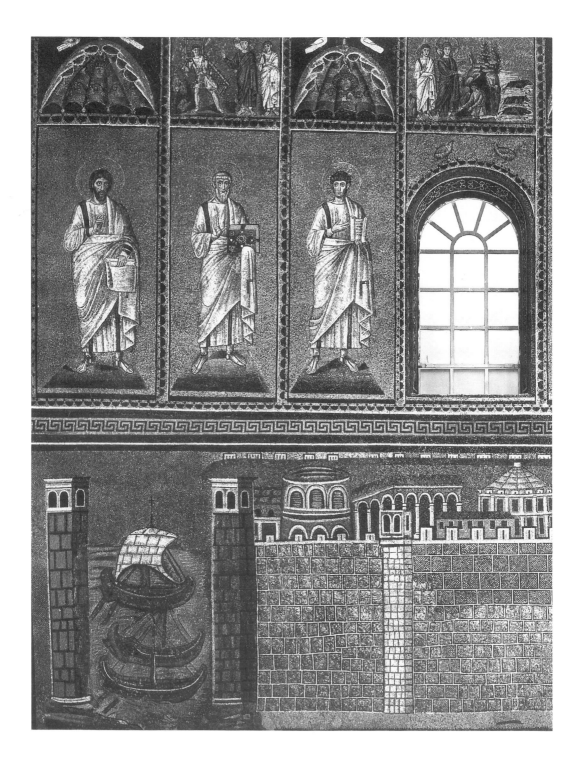

224

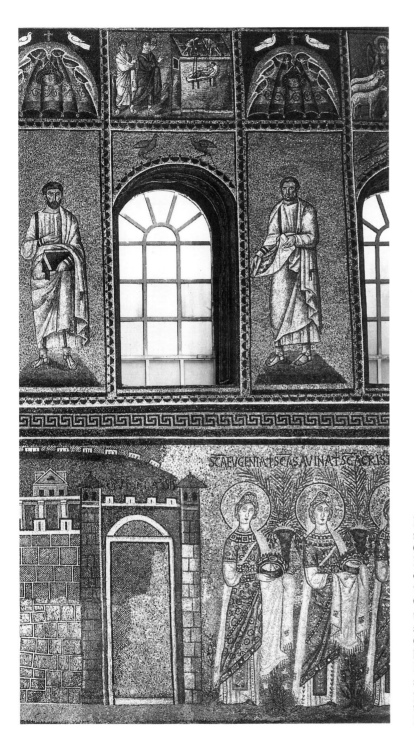

Figure 48. Wall mosaics, north wall, west side, Church of Sant' Apollinare Nuovo, Ravenna, sixth century A.D.: Procession of virgins leaving the city of Classe, bottom tier; unnamed saints with books and scrolls, middle tier; Christological scenes of healing the paralytic at Bethesda, the Gadarene swine and healing the paralytic at Capernaum, top tier. Photo: Alinari-Art Resource, New York.

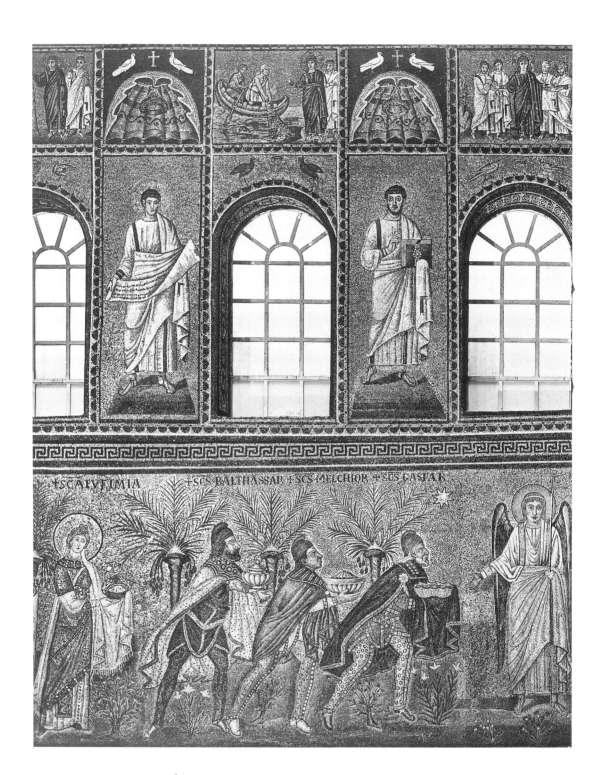

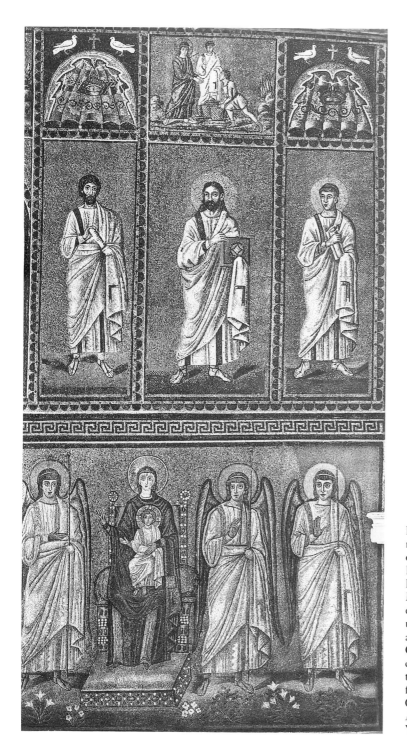

Figure 49. Wall mosaics, north wall, east side, Church of Sant' Apollinare Nuovo, Ravenna, sixth century A.D.: Procession of virgins and Magi to the Virgin enthroned, bottom tier; unnamed saints with books and scrolls, middle tier; Christological scenes of the calling of Peter and Andrew, the miracle of the loaves and fishes and the miracle at Cana, top tier. Photo: Alinari-Art Resource, New York.

227

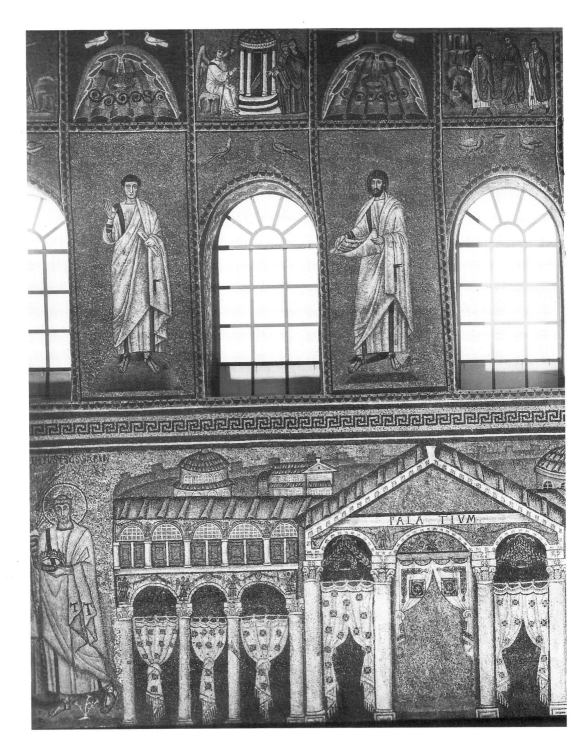

228

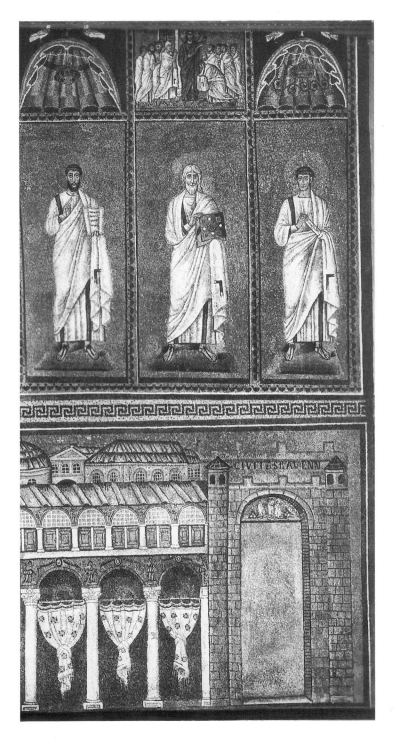

Figure 50. Wall mosaics, south wall, west side, Church of Sant' Apollinare Nuovo, Ravenna, sixth century A.D.: Procession of martyrs leaving Theodoric's palace and the city of Ravenna, bottom tier; unnamed saints with books and scrolls, middle tier; Passion scenes of the women at the empty tomb; the road to Emmaus and the risen Christ before Doubting Thomas and the apostles, top tier. Photo: Alinari-Art Resource, New York.

229

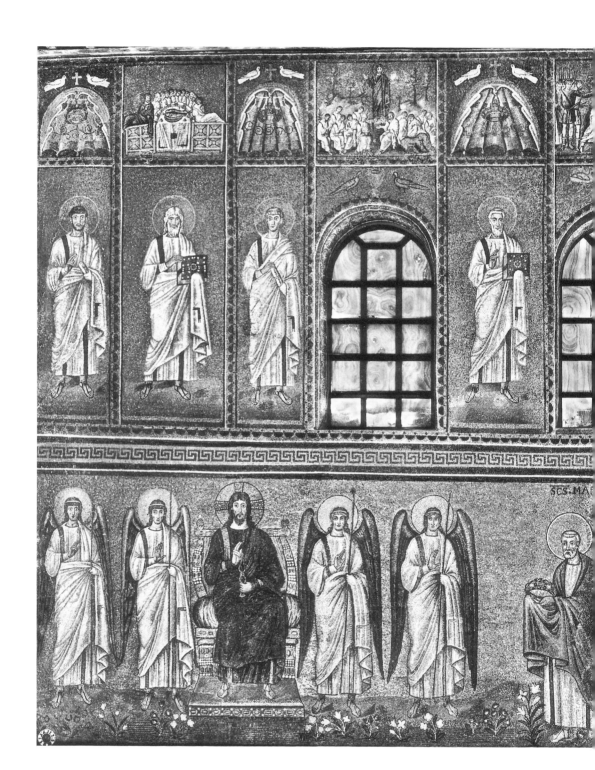

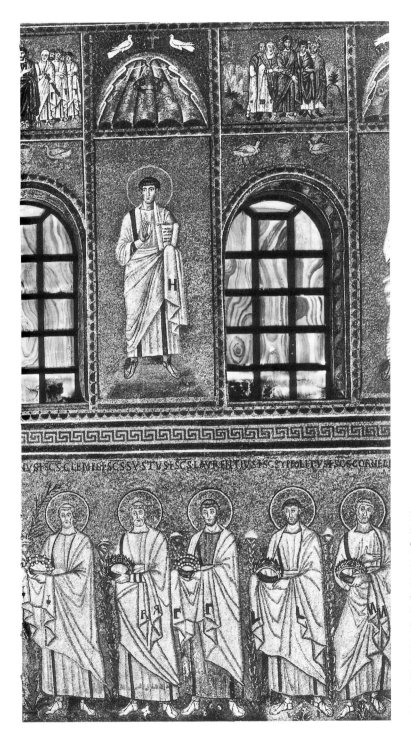

Figure 51. Wall mosaics, south wall, east side, Church of Sant' Apollinare Nuovo, Ravenna, sixth century A.D.: Procession of martyrs led by St Martin to Christ enthroned, bottom tier; unnamed saints with books and scrolls, middle tier; Passion scenes of the Last Supper, the Agony in the Garden at Gethsemane, the kiss of Judas and the arrest of Christ, top tier. Photo: Alinari-Art Resource, New York.

231

intercession for us, as we proceed past them towards the east. What images were once in the apse above the altar, we do not know. But on the nave walls at the east are representations of Christ on the right (Figure 54) and the Virgin on the left (Figure 55), each enthroned between angels. The mediating procession of martyrs has led us through St Martin, the patron of this church, and the Magi, the scriptural witnesses of the Epiphany of the Incarnation, from the representations of this world to the images of the divine reality – the Other World. We have moved from the temporal to the eternal, from the specific (the here and now of Ravenna and its port) to the general (the forever-here-and-now of the presence of God).

This movement is enacted through the mediation of the martyr-victims whose self-sacrifice in imitation of their Lord's self-sacrifice offers not only an assurance of the eternal value of that first martyrdom but also a paradigm for us. Mediation between this world and the Holy is effected in visual terms by a procession of martyrs, but in ideological terms by the *fact* of their sacrifice. This oblation is a prescriptive call for us

Figure 52. Detail of the procession of virgins, Church of Sant' Apollinare Nuovo, Ravenna, sixth century A.D. Photo: German Archaeological Institute, Rome.

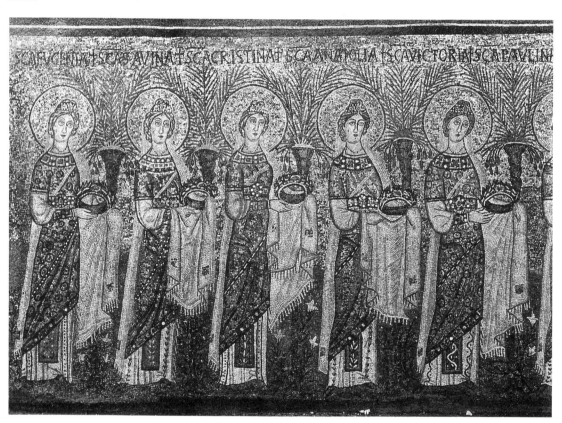

232

to do likewise (even if that likewise be a symbolic rather than an actual martyrdom). We too can become a "living sacrifice" (which is already to dwell in Christ), and through our oblation, we too can transcend this world and enter the other.

All this happens in the sacred space of the church. The magic of that space is that it *does* what it represents, for the space of the church, through representation, conflates the reality of two places (the palace in Ravenna and the port at Classe) and of two elements (the land and the sea) into one space – a sacred space which is greater than and beyond what it represents because it includes them. In collapsing "real" places into one space (whose ritual function as a church is anyway always to enunciate the penetration of this world by the Holy), the church itself becomes a symbol intimating the boundlessness, the infinity, of the Other World. The sacred space collapses time – all time since the Incarnation and especially the specific lives of these specific martyrs and the particular moments of their particular deaths – into one time which is all time and beyond time as well as being now, the present moment of our viewing and our worship and their mediation for us. Again, Christian sacrifice provides the model. Christ who was fully man voluntarily underwent death and rose again fully God. It is the sacrificial act –

Figure 53. Detail of the procession of martyrs, Church of Sant' Apollinare Nuovo, Ravenna, sixth century A.D. Photo: German Archaeological Institute, Rome.

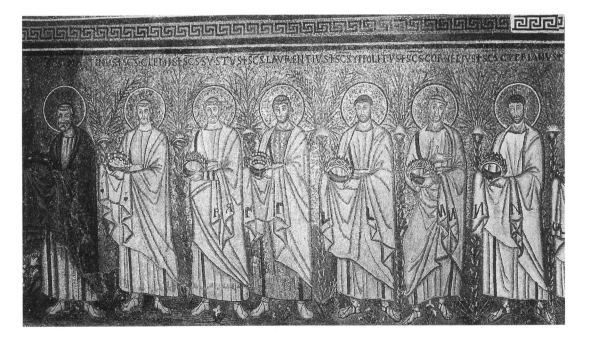

whether the oblation of the good life or the martyr's death – that defines and triggers the transformation from the specific, finite and temporal to the general, infinite and eternal. In Christian ritual, the eucharist assumes a sacramental identity with Christ's sacrificial body when the Holy descends on this world in the mystic act of the Mass.[67]

The dramatic effect of the transformational movement of this lower level of images is heightened and explicated by its relation with the upper tiers. At the top on the south wall of the nave is a mosaic Christological cycle of thirteen scenes recording the Passion, and on the north side a further thirteen representing a selection of miracles and parables. The choice and placing of these themes has liturgical as well as narrative significance.[68] In the middle tier, between the windows of the clerestory, are sixteen nimbed figures on either side of the nave carrying books or scrolls (see Figures 48–51). They are not given inscriptions and have consequently attracted numerous guesses as to their identity.[69] What matters for my purposes is their very lack of identity – the fact that they stand in their haloes unidentifiable and thus unplaceable in time or space between two tiers of images which are tied to

Figure 54. Christ enthroned, Church of Sant' Apollinare Nuovo, Ravenna, sixth century A.D. Photo: German Archaeological Institute, Rome.

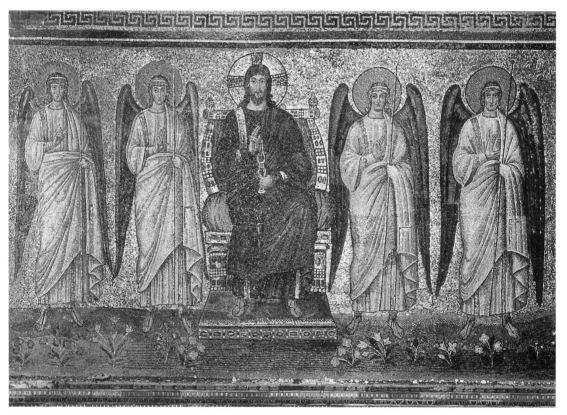

234

very specific times and places (the narrative of Christ's life and Passion; the particular narratives of the martyrs as well as the initial images of Ravenna and Classe). The clerestory figures effect a vertical mediation between the lower processions of martyrs and the upper cycle of the supreme martyrdom. The link between Christ and his martyr-imitators is by definition a connection of the sacred – of the infinite and eternal – a link which transcends time, place or identity. Because we too (a "living sacrifice") on the floor of the church are imitators of Christ, their mediation is also an intercession for us with the supreme sacrifice of the upper tier.

The Christological images of the upper cycle – the images of the ultimate sacrifice – represent the paradigm for the lower processions (the line of martyr-sacrifices) as well as for the worshipper (the "living sacrifice" – who could be said to form the fourth tier below the mosaics). The life of Christ on the left side as one faces the apse is the paradigm of living sainthood and his death on the right the supreme martyrdom. The Christ cycle spans the church longitudinally. It overlooks, prescribes and valorizes the martyr processions and the present itself (the present re-presented in the images of Classe and Theodoric's palace, the eternal present of the interces-

Figure 55. The Virgin and Child enthroned, Church of Sant' Apollinare Nuovo, Ravenna, sixth century A.D. Photo: German Archaeological Institute, Rome.

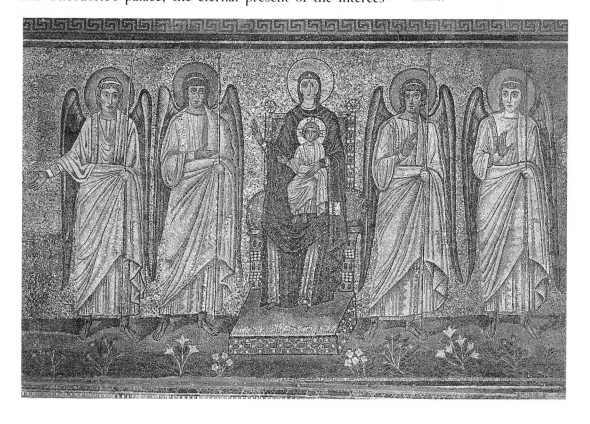

sional line of martyrs and the present of the actual liturgical processions of worshipper-viewers within the church).

It is significant that the two sides of the upper tier are different in both theme and direction. The south wall (on the right) represents the narrative of the Passion. It moves from scenes of the Last Supper and the Agony in the Garden in the east (scenes highly suited to their eucharistic setting by the apse [Figure 51])[70] towards the west. Thus it moves in the *opposite* direction from the procession of male martyrs below it. Whereas the south side represents a linear narrative sequence of the Passion story beginning with the Last Supper and ending after the Resurrection with Christ appearing before Doubting Thomas (Figure 50), the north side – with its images of Christ's life, miracles and parables – seems to eschew such patterning. It could also be said to begin at the east with the first miracle (the marriage at Cana), although that scene is in this position by the apse (as is the miracle of the loaves and fishes next to it) as much for its liturgical as for its narrative significance (Figure 49).[71] Moreover, a glance at F. W. Deichmann's table of the scenes from this "*Wunder*"-*Zyklus* with his references to their Gospel sources shows at once that they form no historical sequence.[72] Not all the subjects are of narrative events: One of the scenes represents a parable (the Pharisee and the Publican [Luke 18.9–14]) and one a famous saying (the Widow's Mite [Luke 21.1–4]); both of these scenes are in fact reflections on the theme of temple and offering. And one scene is an important eschatological prophecy (the Second Coming when the Son of Man shall divide the sheep from the goats [Matt 25.31–46]). The north cycle above the procession of virgins does not offer a directional reading at all, in marked contrast with the processional imagery below it and the Passion opposite. Thus we have in this church a very complex arrangement of directional injunctions from the images (see Figure 56).

It is as if the imagery of this sacred space were dynamically and intricately constructed to refute any simple unidirectional reading. It is even working against the apse-directed bias of the lines of a basilica. Ultimately, sacred space is a symbolic denial of any reference point whatever, of any specificity of time or place, in favour of a transcendent reality which generalizes time into eternity and place into the infinite. And yet the generalization of the specific into the eternal paradoxically makes the specific special, sacred, by its very participation in that which transcends its particularity. This is why Ravenna itself and Classe are the starting points for Sant'

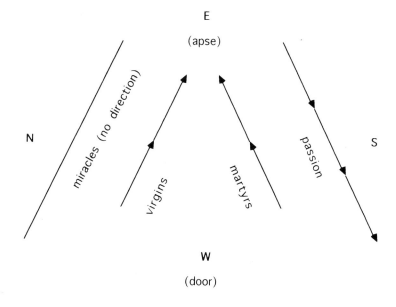

Figure 56. Diagram of the directions of mosaics at Sant' Apollinare Nuovo, Ravenna.

Apollinare Nuovo's martyrological exegesis in images of the divine economy. This is why Sinai, as a specific holy place of pilgrimage, was sacred, despite representing in its peak image and spiritual exegesis a mountain which was not Sinai but Tabor (see Chapter 3). The complexity of and seeming contradiction in the directional injunctions at Sant' Apollinare Nuovo achieve a necessary disorientation of the worshipper-viewer (necessary because *any* orientation or direction by the rules of this world *must* be wrong, falling short of the infinite and boundless ideal of the Other World).

This directional disorientation is reinforced by a further contrast between the continuity of the lower tier (the processions) and the discreteness of the images in the cycle. The scenes of the Christ cycle are static. The space of each is defined by its alternation with a series of repeated motifs representing a cross between two doves surmounting a conch shell from which hangs a martyr's crown. These "decorative" images, with their emphasis on the symbolic intimations and implications of Christian martyrdom, have the visual effect of bounding each scene in the Christ cycle. The cycle's narrative referents (its texts) are thus frozen in a set of single scenes such that each is the representation of that particular sacred moment. There is a play between the cycle of momentary and discrete scenes and the continuing intercessional procession beneath it.

The significance of each particular moment (of each scene
in the Christ cycle), however, lies in its intimating a referent
whose value is not itself (a particular text) but is what it itself
represents – namely, that this man is not man but is God
Incarnate, who, by his incarnation and self-sacrifice, has
saved us from sin and changed us forever (the exegesis or
allegory of a text). The referent of these scenes is not literal,
not a text or body of texts, but the exegetic Truth which
these texts themselves symbolically represent. Meanwhile,
the martyrs – a continuous procession rather than a cycle of
frozen and distinct scenes – also represent something other
than their literal referents. Each saint is not simply him- or
herself, but an imitation of Christ, a reflection of the ultimate
martyrdom portrayed in the same nave.[73]

Again, the images of the saints refer not simply to the
literal truth of their lives and deaths but to the symbolic and
exegetic Truth of what those lives and deaths represent. They
stand for the continuance of the Church, for the apostolic
and martyrial tradition, for the intercessional possibility of
salvation as it relates to *us* – the sixth-century worshippers
beneath them in this church. Lastly, by their very lack of
identity (their lack of a literal referent), the unidentified fig-
ures in the central tier have a symbolic meaning. Further-
more, the fact that these figures carry texts implies the exe-
getic nature of the imagery of the whole building. This
church is the visual exegesis of a body of texts, and its refer-
ents go back to that body of texts and beyond that to what
those texts themselves are the verbal and written symbols for.
The art of Sant' Apollinare Nuovo is essentially symbolic.

Sacrifice is the exegetic motif which underlies and expli-
cates the complexity of this imagery. The upper tier of images
culminates in the Passion of Christ – both the ultimate mar-
tyrdom[74] and the supreme sacrifice.[75] He is the only begotten
Son whom God gave, the Lamb of God who was slain to take
away the sins of the world.[76] The procession of martyrs,
mediating for us as they proceed out of the imagery of this
world into that of the Other World, are his imitators, them-
selves a sacrifice at the heavenly altar.[77] The eucharist enacted
in the apse of the church – at the end of our movement
through this space as well as that of the martyrs – is likewise
a sacrifice, enjoined upon the faithful by God and a sacrifice
which is transubstantially identical with their God.[78] And
lastly, the actual worshipper – the image of God and imitator
of Christ's life (paradigmatically represented of course in the
upper tier of decoration to the north) – is himself a "living

sacrifice".[79] The very action of entering the church, the very
presence of the worshipper in this space and this imagery, is
an oblation. To be there at all is already the performance of a
sacrificial offering for the faithful. It is an offering to the God
who offered himself as the ultimate sacrifice, and it is in
imitation of that sacrifice. In Christian ideology, being is ob-
lation.

The imagery of Sant' Apollinare Nuovo makes sense only
in the exegetic context of the polysemic symbol of sacrifice as
understood by Christianity. Its meaning cannot be divorced
from the eucharistic (thus sacrificial) ritual which takes place
in the church beneath the mosaics. But the images do not
refer *to* the ritual. They refer *with* the ritual to a supramaterial
and transcendent reality for which both image and liturgy
are symbols. One should add perhaps that the liturgical and
exegetic basis of this imagery as predicated on the image of
Christian sacrifice places all the force of its interpretation in
the hands of the Church. Even as such imagery proclaims a
basic equality in salvation for all believers (women and men,
virgins and martyrs) before the divine throne, it attests to the
ritual and intellectual control of the doctrines underlying the
imagery and its ideology in the hands of a small male elite.

CONCLUSIONS

FROM THE LITERAL TO THE SYMBOLIC: CHANGES
IN THE IDEOLOGY OF RELIGION

This chapter has attempted to chart a transformation in reli-
gious representation. Something of this transformation from
the literal to the symbolic will be clearer if we compare three
sacrificial processions: civic Roman, Mithraic and Christian.
In the small frieze on the altar walls of the Ara Pacis (Figure
35), three sacrificial animals – a sheep and two cows – are led
by attendants and men dressed in tunics. It is clear who are
the victims and who the sacrificers. It is clear that in some
respects the scene reflects actual happenings, what Richard
Gordon calls "pseudo-historical events".[80] On the right wall
of the sanctuary of Mithras beneath the church of Sta Prisca
in Rome, there survives in a very fragmentary condition the
only sacrificial procession I know in Mithraic art (Figure 57).
Its condition is so bad that one doubts some of the conclusions
drawn by its excavators as to the subjects represented. Never-
theless, it does seem to be a procession in which at least a ram
and a cock are being brought towards the main cult niche.[81]

We cannot know if such processions took place in the mithraeum or if the sacrifice they offered was actual, symbolic or both. But if the animals represented actually were a bull, a pig, a ram and a cock, as the excavators claim, I should be very surprised if any real procession could have gotten all four animals into the rather small and complex temple and then killed them there. If they could not, then the offerings are symbolic. But in terms of representation (and Mithraic ideology), there is still a distinction of sacrificer from victim. The worshippers are still appeasing Mithras (in the cult niche at the end of the mithraeum) with sacrificial offerings.

The image on the Ara Pacis is both literal and mechanistic. It implies both a real sacrifice and a sacrificial relationship of reciprocity with the god – a giving up of something in return for something else.[82] The Mithraic fresco may or may not have a literal referent in a real sacrifice, but its imagery (the bringing of something of one's own to offer the god) implies a reciprocal relationship similar to that of civic Roman religion. However, the sacrificial processions in the mosaics of Sant' Apollinare Nuovo demonstrate not only the symbolic polysemy of Christian "sacrifice", but also its radical abolition of the ideology of reciprocity. The martyrs and virgins do not bring a sacrifice, they are it.

This is more fundamental than a change in the meaning of images. Roman, Mithraic and Christian religious representations are all in some sense offerings to the god in their own right, all ways of defining sacred space – the space of the god. In their self-conscious reference to the theme of sacrifice, such images relate the decoration of the space wherein ritual action will take place to the ritual itself. Thus the difference between the referents of these sacrificial images – a difference above all of increasing symbolism and exegesis, as I have argued – indicates a difference in the ideology, in the conception, of sacrifice as *actually* enacted by the members of the different cults I have been exploring.

The literal nature of the images of Roman civic sacrifice leads to an important point about the actuality of Roman sacrifice. I have argued that deferral – the inevitable consequence of a literal relation between image and its sacrificial context – is true not only of the images of sacrifice (which never *are* what they represent, being always partial, having always something missing) but true also of Roman sacrifice itself. For the end-point, the final goal of such ritual action (whether the cult image of the god or the god's resultant gift), is always deferred, is always somewhere else. In fact this is

itself the inevitable consequence of a reciprocity conception of sacrifice, because the final goal of the divine favour is always separate from, deferred from, the ritual which has entreated it. Thus in exhibiting the quality of deferral, Roman sacrificial images are profoundly true to the deeper ideological implications of their subject-matter.

Mithraism, like Christianity, abolished deferral. The result of appropriating the worshipper's role of sacrificial action to the god and of placing the cult image within the same space as the act of worship is that sacrifice becomes imitation. In Mithraism this is more obviously the case than in Christianity – for as the god is sacrificer, so too are his worshippers. Nonetheless, there is a difference – for Mithras' sacrifice is a symbol, and theirs (if indeed Mithraists did sacrifice) is a symbolic and not a literal imitation of that symbol. In effect, where Roman religious art imitated (however obliquely) Roman sacrificial practice, Mithraic ritual imitated the Mithraic cult image. It is this fundamental reversal that catapulted *images* in the mystery cults into a position of incomparable importance, for the image is no longer parasitic on actuality, but rather, religious practice becomes in some sense a mimesis of the cult icon.

The abolition of deferral in Mithraism, however, did not mean either a rejection of the Roman civic cult or the exclusion of an ideology of reciprocity. Unlike Christianity, Mithraism was not a cult which excluded all other forms of religious worship or belief; a sacrificial imitation of the god could

Figure 57. Sacrificial procession, mithraeum at the Church of Sta Prisca, Rome, third century A.D. Photo: Courtesy of E. J. Brill, Leiden.

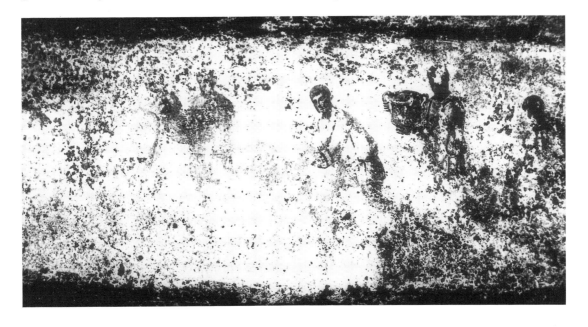

still mean a request for future (hence deferred) favour. Mith-
raism seems to have still used the essential form of Roman
worship – the act of sacrificial slaughter. Here the structural
difference of Christianity from Mithraism is fundamental.
Christ is the victim. The imitation of Christ – in all the
manifold meanings of the term – is to *become* a sacrifice.
Inevitably Christianity introduced a profound shift from the
ritual norms of its environment by abolishing the slaughter
which defined the worship of the other cults (official and
mystery, as well as Judaism). In the ideology of Christianity,
to become sacrifice, in imitation of the supreme sacrifice, is a
possibility open to all – to women as well as to men.[83] It is
the final abolition of deferral, because the gift of grace resides
in the perfection of the sacrificial act. Not only is the act of
sacrifice united with the god in a single place, but the favour
of the god is identical with the perfect fulfilment of the act.

Of course, we have quantities of inscriptions which beg
God for results. The ideology of Christian sacrifice (a doctrine
created and promulgated by the theological writings of the
Church elite) was one thing; the actual attitudes, views and
viewings of the complex mass of people who called themselves
Christians were quite another. Such prayers are evidence of a
co-existent ideology of reciprocity in much actual religious
practice. Indeed, on the level of political art, such reciprocity
was exploited. Justinian and Theodora at San Vitale bear
gifts which in some way are their payment to Christ for the
elevated social position they enjoy.

In Christianity, this all depends on a fantastically complex
body of exegesis and initiation. The function of art, as I have
tried to show, is not to define the god (as it is in Roman and
Mithraic cult images in different ways) but to provide the
necessary exegesis for the worshipper to understand his or
her (divinising or at least grace-bringing) act. Christian reli-
gious art is strongly viewer-directed in that it both prescribes
action and explicates its significance. The images of Sant'
Apollinare Nuovo are to be imitated (in their deeper exegetic
sense of "sacrifice"), and through imitation they teach.

It is important to note that the changes I have charted
cannot be seen as either a decline or an evolutionary ascent.
The images of each of these cults are complex and polysemic.
The differences lie in the kinds of complexity and polyvalence
which they offer. But all are designed to be "read" by wor-
shippers, and all map sacred space by defining it visually. In
this sense, none of these cults differs much from the others –
again, it is in the kind of mapping and the kind of viewer-

response that the important differences reside. In understanding religious images, the crucial factor is not form, style or aesthetics, but the response and reaction of viewers.

SOME SOCIOLOGICAL REFLECTIONS

The religion of the Roman state in the late Republic and early Empire was in certain important ways analogous to Rome's political organisation. Roman syncretism was a cultural phenomenon which brought together an extraordinary variety of races, nations, art forms, styles and religious cults into one broad and inclusive concept of "Roman-ness" (a concept, interestingly, in tension with the heavily exclusive insistence on the *mos maiorum* in conservative Roman ideology). This phenomenon, which in its religious aspect has been termed "openness and flexibility", "toleration" and "pluralism", is analogous to the way the empire assimilated new territories and gave their peoples citizenship.[84] Official religion, such as that of the Ara Pacis, was both public and highly conservative in its extreme punctiliousness over ritual details and the continuity of the ritual tradition.[85]

The visual correlative of such religion, Roman religious art, is characterised by a propensity to overdetermine what we would consider *secular* space (the forum, markets, gardens, baths) with signs that evoke the sacred.[86] The visual environment of the Roman world in its civic and public aspect is notable for its being mapped by a wide diffusion of "thin" signifiers for the sacred, whose meaning, because either not entirely clear or very complex in a culture full of signs for the sacred, is very little different from their status as *sign*. Specifically, religious buildings like the Ara Pacis (as opposed to religion-associated monuments like Trajan's column or Diocletian's column-base) are marked by a profusion of such signs. By contrast, this culture included (without, it seems, much tension) a set of highly charged initiate cults whose visual mapping of the sacred was quite different – as I have tried to illustrate using the example of Mithraism. In essence, these cults employed a "thick" discourse of images and initiations whose constant feature was an interpretative or exegetic mapping of the sacred in terms of highly complex myths, texts or astrologies.

It is worth reflecting on the unprecedented shift in the visual and social environments of the Roman world which followed the religious crisis of the third century and the conversion of Constantine. In effect, a state religion of which

the primary characteristic was a "thin discourse" of images, shrines and rituals (whose function was constantly to define a space as in some sense sacred) was within a few generations replaced by a millenarian initiate cult whose essential significance was a "thick discourse" of endless ritual and allegorical interpretations.[87] These interpretations, by contrast with "paganism", focussed on a single sacred text and a set of sacred acts valid for all time but performed once, valid beyond time but performed within time, by the God (the timeless) who became human (the temporal and temporary) in order to liberate humanity from entrapment within time. From the point of view of the Roman state, the replacement of Roman religion with Christianity over a relatively short period in the fourth century (from its legalisation under Constantine in the teens of the century to its establishment under Theodosius in the nineties) represented a profound focussing and deepening of meaning in religious images and ritual acts. The emperor was removed from divinity but tied closely to the sacred as the secular representative of an absolute and monotheist religious order. Constantine was the "thirteenth apostle".

Roman state religion, by becoming Christianity, acquired the extraordinary energy, focus and fervour of a carefully worked out and highly hieratic initiatory cult. From a culture in which the determining religious fact was that most people were not cult initiates, and that those who were initiates belonged to different and diverse cults, Rome turned into a *religious state* whose determining characteristic was that all citizens were initiates into one exclusive cult. This cult's meaning was greater than and lay beyond the state (unlike the pagan civic religion), and yet it was the state cult. This is more than a transformation in the nature of religion. In the long term, it became a transformation in the nature of *empire* for by Byzantine times "Rome" had moved from being a *territorial imperium* whose primary characteristic was *inclusiveness* (the syncretism that made individuals "Roman" by Romanising and accepting their nationality and their religion). It became a *religious imperium* which functioned *exclusively* by converting individuals to its superior cult and thus tying them to its enormously powerful spiritual and cultural control of the religion by which their own identity was now defined. The incalculable importance of religion in this context is that it defines and frames the self-identity, the subjectivity, of its adherents. The advent of Christianity as the state cult brought with it a nigh-inconceivable transformation in the self-identity of the subjects of the Roman state. An analo-

gous modern parallel would be if the United States decided that its citizens should become Hare Krishnas. Ultimately it is this transformation of subjectivity that accounts for the sociological and conceptual paradigm shifts in the passage from what we call antiquity to the Middle Ages.[88]

If the religious changes in the Roman state during the fourth century were momentous, imagine their effect upon the lives of believing Christians in the three score and ten years between, say, A.D. 290 and 360. From being an initiate cult that had been persecuted and secretive, Christianity became the open and official religion of the empire. From being a diverse collection of loosely linked "churches" holding all kinds of contradictory beliefs, Christianity became, after the Council of Nicea in 325, one universal and apostolic Church exclusive of heretics, schismatics and apostates. From worshipping in temporary shrines and house churches as small as the Dura baptistery and with a small-scale liturgy, the Christian was (within a matter of thirty years) confronted by basilicas the size of soccer fields encrusted in gold and marble with a liturgy which clearly had at least to make an impression in such large buildings. From being a purely spiritual hierarchy of cult initiates, the episcopate found itself in as short a period adopting roles in a complex temporal as well as spiritual hierarchy which included the administration of the Roman state. By the end of the lifetimes of Christians born, for instance, in A.D. 290, their religion (its art, rites, temples, hierarchy – in short, the whole of its phenomenology) would have had hardly any resemblance to how they might have remembered it in the persecutions of their youth.

In the face of such epochal transformations, both in the structure of society and in the individual's relation to that structure, it is not surprising that the functions of art changed or that they veered increasingly to the exegetic. All these changes needed explaining. The essential shift in the art of late antiquity was not a shift of forms (as critics have tended to argue), but one of meanings related to perhaps the most remarkable and radical change in society that the Western world has seen.

EPILOGUE: MODULATIONS OF CHANGE

FOREWORD

. . . cada hoja de cada árbol de cada monte . . .
> Jorge Luis Borges[1]

You cannot see the wood for the trees
> English Proverb[2]

JORGE Luis Borges has a story about Funes, "el memorioso", a man who can perceive and remember "every leaf on every tree in every wood" but who cannot grasp any generalization or generic idea: "He was disturbed by the fact that a dog at three-fourteen (seen in profile) should have the same name as the dog at three-fifteen (seen from the front)". This story has a resonance for the historian, who must always focus his or her sightlines in some way and in doing so must sacrifice either the specificities which made up the world of Funes or the general overviews which Funes could not grasp. In focussing on the trees, a historian is bound to miss something of the wood – not only the forest of which the trees are part but also the bark and trunk out of which the trees are made. Yet in giving our attention to one or the other of these woods (the forest or the trunk), we risk losing sight of the wood on which our eyes do not focus (the trunk of an individual tree or the forest made up of all the trees), not to mention missing the specificity of the individual trees themselves – their branches, buds and leaves.

In this book, I have offered a number of "aerial photographs" of the forest of Roman art. These have been broad overviews at particular moments within a long period of slow yet hardly regular or simple change. Such general views are guilty of the opposite failing to that of Funes el memorioso. They simplify a dog in profile seen at three fourteen into the same dog observed from the front at three fifteen. They do this in order to distinguish that dog from another of the same species seen at six o'clock, as it were. In other words, I have emphasised the broad trends of forest management at the

expense of the interest in particular trees, their different bark and leaves and their individual changes within a narrower space of time. My approach has painted the outlines of change, emphasising its nature and extent; but in doing so it has necessarily simplified the the intricacies of change, giving relatively little attention to the pace, modalities and process of the transformation in Roman art. To show how the art of the Principate and high Empire moved towards the art of the Dominate, and to explore how the images of the tetrarchy developed towards Justinianic art, would require a whole new book. And such a book would be a different project from this one.

In the final chapter of this book, however, I attempt to fill something of this gap by focussing on the modulations and causes of change at one crucial period. I mean to show how one pattern of viewing, initiate viewing – whose contours we have traced from Cebes through Pausanias at Eleusis and Mt Lycaeus to the monks and pilgrims at Sinai – came to subsume and include even the more secular models of viewing (such as those offered by the likes of Vitruvius, Pliny and Philostratus) which had been powerful in the Roman world. The period I choose for this more narrowly focussed chapter is the fourth century A.D., when Christianity had become the established religion of the state but when the tensions between Christianization and pagan practices and images can still be traced in the textual and material culture, before Christianity finally obliterated the living pagan traditions from the Roman world.

"THE TRUTH WITHIN THESE EMPTY FIGURES": THE GENESIS OF CHRISTIAN VISUAL EXEGESIS

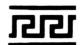

*Now I want you to look at the paintings along the portico,
with which it is adorned in extended line. Crane your neck till
you take in everything with face tilted back. The man who
looks at these and acknowledges the truth* (vera) *within these
empty figures* (vacuis figuris)*nurtures his believing mind* (fi-
dam mentem) *with an image which for him is not empty.*

Paulinus of Nola[1]

ACHRISTIAN writing at the turn of the fourth and
fifth centuries, Paulinus of Nola, like Philostratus,
assumed that images need interpretation. A picture
is empty until the viewer sees truth in it. Then it is no longer
empty for him (*non vacua sibi*), but it feeds the mind of his
faith (*fidam pascit mentem*).[2] The implication of these remarks
by Paulinus is that the meaning of images resides in what the
viewer reads into art perhaps as much as, perhaps more than,
in what apparently is objectively there. A Philostratus might
see an allusive tale of psychological identification with mate-
rial things and a Cebes might see a pagan philosophical alle-
gory leading to truth, whereas a Christian sees the image of
his or her faith in paintings which might be empty to unbe-
lievers but can nurture a believing mind. Perhaps more than
any other ancient writing on art, these comments by Paulinus
indicate an awareness of the arbitrariness of meaning and of
the fact that meaning depends as much on what the viewer
brings to interpretation as it does on the actual object he or
she interprets.

Given Paulinus's admission that viewing depends upon
interpretative choice, upon seeing meaning in and making
meaning out of "empty figures", I want to explore here the
genesis and particularity of Christian viewing as it emerged in
the early Middle Ages. Because viewers bring very different
frames of receptiveness to images, depending upon the social

context in which their confrontation with art takes place, in this epilogue I shall address a number of works of art from very different social and viewing contexts. The first section of this chapter examines images from the world of private dining and toiletry – expensive items of ornate luxury silverware. Such imagery belongs to a broadly temporal rather than a spiritual context, but its increasingly religious iconography points towards the sacralization even of the "secular" in emergent Christian culture. The second section probes images from funerary and liturgical contexts. Here, in the realm of death, ritual and the Christian sacraments, viewing touched upon the deepest areas of Christian identity and subjectivity.

The arts of late antiquity give evidence of a remarkable ferment of styles, religious approaches and "syncretisms". The process of change and its rate were not uniform in all these areas or in every social and functional context. Just as Christianization in the long term affected every level of Roman culture – from the theory of the state to private worship, from relations to the body, sexuality and food to the very structure of discourse – but did so in different ways; so in the long term all the aspects of Roman art were transformed – but also in different ways and at different rates. This is a vast theme, and I can hope here only to give some intimations of its complexity. The discussion of Roman silver aims to show how, at least in this class of objects, there was almost no stylistic change, no formal "abstraction", and relatively little alteration in function. On the other hand, late antique and early Byzantine silver does show the development of new iconographies and an increasingly symbolic use of imagery. I have argued throughout this book that such Christian symbolism, which promoted, for instance, the kinds of exegetic Christian viewing we find at Sinai or Ravenna, was embedded in an allegorical tradition of interpreting art that reached back through the Neoplatonists and Cebes to deep roots in antiquity. The discussion of burial imagery and Christian religious artefacts in Part II examines how Christian viewing modified and transformed the methods of ancient initiate viewing – how it differed from and expanded upon the traditions of pagan antiquity.

Finally, I conclude in this chapter by examining some of the social functions of Christian visual exegesis in its role of bringing a new cultural identity to the late Roman world. Here images had an extraordinarily important role to play, which should not be underestimated in accounts of Christian-

ization.[3] Art, in illustrating biblical events and then combining such events in typological programmes, went a very long way to translating the most complex dogmas of antiquity's most scholarly and textual religion into a visual language that could be understood by both those who could read and the illiterate. By formulating typological combinations of images, based closely or loosely on patristic commentary, as we have seen at Sinai and Sant' Apollinare Nuovo, Christian art made scriptural exegesis of a very high degree of complexity widely available. The deep Christian project of fostering a cohesive sense of identity related to Scripture was thus made accessible even to those without the ability to read Scripture. Moreover, such exegetic cycles of images were used to decorate not only churches but all kinds of boxes, ampullae, pilgrimage relics and the like. Such images apparently adorned holy matter (water, dust or oil from holy places, or a martyr's bone, for instance) with appropriate themes. But in fact they gave that matter its meaning by placing it visually at the heart of complex programmes of Christian doctrine. In this way, Christian art worked – perhaps harder than any other aspect of Christianization – towards what has been described as draining the secular from society, towards eliminating non-exegetic ways of viewing.[4]

FROM SKELETONS TO SCRIPTURE: "PAGAN" AND "CHRISTIAN" IN THE WORLD OF LUXURY DISPLAY

Aphrodite is there, where the Nymphs, I doubt not, have established a shrine to her, because she has made them mothers of erotes and therefore blessed their children. The silver mirror, that gilded sandal, the golden brooches, all these objects have been hung there not without a purpose. They proclaim that they belong to Aphrodite, and her name is inscribed on them, and they are said to be the gifts of the Nymphs.

Philostratus, *Imagines* 1.6.7

Thus Philostratus moves, in describing a painting of the erotes (a familiar theme in Roman art from the second to the fourth centuries), to the goddess with whom such putti are associated in classical culture. Yet when the "Toilet of Venus" occurs on a magnificent fourth-century silver-gilt casket from the Esquiline Treasure, now in the British Museum,

it is remarkable for appearing, in a marine iconography perfectly familiar to Philostratus,[5] above a *Christian* inscription (Plate 3; Figures 58–9).[6] The inscription reads: SECUNDE ET PROJECTA VIVATIS IN CHRISTO (Secundus and Projecta, may you live in Christ) (Figure 58). If viewing depends on the interpretative frame which a viewer brings to a work of art, then the Projecta casket puts into sharp focus the ferment of late antique art in the Christian empire. How could Hellenism, the Graeco-Roman cultural tradition with all its pagan associations, be correlated and integrated with the new exclusive cult that rapidly became the official religion of the empire?

The Projecta casket is an outstanding object. It belongs, like the majority of the material I discuss in this section, to an extremely expensive and elite category of luxury dining and toiletry ware, of which a good deal survives from late antiquity. Such objects were valuable (they survive in large quantities partly because they were buried for their bullion value to keep them safe from marauders).[7] Their importance was perhaps primarily in the realm of *display*.[8] It would be dangerous to define them as "secular", for whether "Christian" or "pagan" (or both), they often were decorated with religious iconography. In later Christian times, even if the dishes on

Figure 58. Venus at her toilet and the Christian inscription, Projecta Casket, fourth century A.D., Esquiline Treasure, British Museum. Photo: Courtesy of the Trustees of the British Museum.

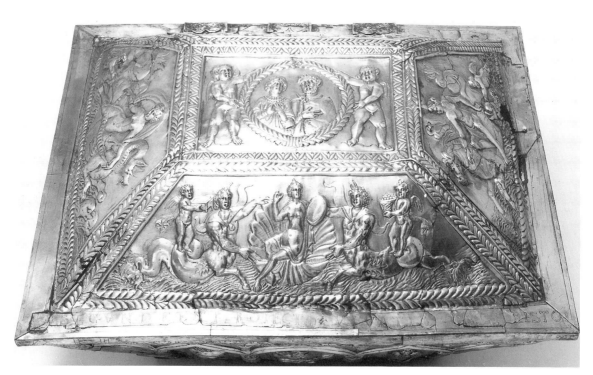

which an ordinary meal was served were not the patens and goblets of the liturgy, the food and the utensils used in dining were nonetheless culturally imbued with intimations of the Last Supper and the eucharist. The Projecta casket, although a toiletry object rather than an object used in dining, portrays its functions and social context through its iconography of women (both Venus and a human woman) at their toilet and of a trip to the baths. But this apparent "secularity" is undercut by the object's potential to entice more religious meanings, both through the iconography of Venus and through the inscription.

The Projecta casket is an oblong box in the form of two truncated pyramids attached at their bases and cut off at their tops to make a rectangular flat surface at each end instead of a point (Plate 3, and Figure 58). There are ten faces to the casket, of which one forms the bottom and the remaining nine are decorated with figural images in relief embellished with chased and engraved ornamentation, as well as gilding. The subjects represented on the four sides of the casket's body (that is, the lower pyramid seem to evoke a single scene in which a woman is seated frontally in an elaborate chair surrounded by standing servants who bring various articles of the toilet to her (Figure 59). This seated figure is fastening a pin to her hair and holding a pyxis. Immediately above her, on the lower lip of the casket's lid (Figure 58) is the Christian inscription on the basis of which we may perhaps identify her

Figure 59. The Projecta Casket seen from the front, fourth century A.D. Photo: Courtesy of the Trustees of the British Museum.

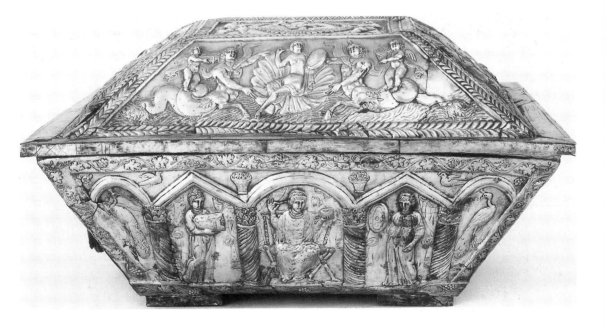

as Projecta. The lid (the upper pyramid) is composed of five faces. At the top are busts of a man and woman framed in a wreath held by two erotes. If the casket is a marriage commemoration, then this couple may indeed be Secundus and Projecta. Beneath them on the lid and immediately above the inscription (and the woman at her toilet below it) is the image of Venus seated nude in a cockle-shell supported by two flanking half-human sea monsters. She too holds a pin in her right hand, recalling the gesture of "Projecta" below her. On her left, Venus turns towards a mirror like that mentioned by Philostratus. The other sides of the lid show, at the back, what appears to be a human procession to the baths and on the two remaining sides nereids riding on sea monsters towards the image of Venus. They appear to be attendant on her, as the servants of the body of the casket are attendant on the seated lady below Venus engaged in a parallel act of self-beautification. Thus, despite the strong imitative relationship of the upper and lower halves of the casket, the upper half is not wholly divine because it breaks the mythological idyll not only with the Christian inscription but also with the procession to the baths.

The Venus scene is clearly given pride of place in the iconographic scheme of the casket. The nereids ride towards her; she is placed, as goddess of love, immediately below the couple at the casket's top; her panel of the casket is marked out by being the one above the inscription, and there is an undoubted iconographic as well as thematic parallel between Venus and the seated woman ("Projecta") beneath her, who is the key figure of the bottom part of the casket. Although the Projecta Venus revels in such silver and gilded accoutrements of the toilet as Philostratus describes (for instance, the mirror she turns to on her left and the pin she attaches to her hair), the inscription tells us not of her but of her owners and their relation to Christ. A viewer like Philostratus might have expected an image of Aphrodite to lead associatively to reflections on her mythic origins and relationships (consider his move at *Imagines* 2.1 from a painting of an ivory statue of Aphrodite to conclusions about Eros, the marine birth of the goddess from the sperm of Uranus and Paphos as the place she came ashore). But the Projecta casket's juxtaposition of Venus with a Christian inscription transforms the expectations and directions of such Philostratian viewing.

This juxtaposition of apparently antithetic religious themes either empties Venus of her pagan and mythic content, reducing her to a decorative device (unlikely given the parallels

between Venus and Projecta, and the thematic importance of Venus as goddess of *love*, on a casket celebrating the relationship of Secundus and Projecta both in imagery and in its inscription). Or it empties the Christian inscription of its initiate implications so that it becomes simply a valedictory invocation (also unlikely because why invoke the name of *Christ* beside the salvific *vivatis* if one does not mean it in a religious sense?). Or it enjoins the viewer to an exegetic interpretation whose aim must be somehow to reconcile these apparently antipathetic pagan and Christian themes. Of course, the Projecta casket has the potential to evoke all three of these viewings. But whatever the direction a viewer's interpretation might take, the casket's conflation of a familiar mythic-religious iconography (traditionally accessible to the kinds of viewing associated with Philostratus) with an initiate Christian invocation (whose salvific *vivatis* points more in the direction of Cebes-like exegesis) has removed the possibility of *simply* or *naturally* reading either the text or the image in its own frame of reference to its full cultural effect. They are not independent, and their juxtaposition has transformed both.

In effect, the syncretism of pagan iconography and Christian faith in such fourth-century images raises a deep question about how such objects were viewed, and by whom, in late antiquity. Late-Roman art offers numerous instances of erotes hunting, harvesting or holding wreathes as they do in the Projecta casket and in the painting which led Philostratus to evoke Aphrodite. For instance, such erotes appear in the floor mosaics of the fourth-century, iconographically entirely "pagan", villa of Piazza Armerina (Figure 60).[9] Yet when such erotes appear in the mosaics of the vault of Sta Costanza in Rome (a mausoleum built in about A.D. 360 whose main themes, now unfortunately lost, were a cycle of Christian images [see Figure 61]);[10] or on the mosaics of the floor of the cathedral at Aquileia;[11] or on the Christian sarcophagi of Constantina (the lady buried in Sta Costanza), Junius Bassus (Figure 62) and the Three Good Shepherds,[12] or in the dedication miniature of the codex-calendar of A.D. 354 (an almanac which included Christian liturgical and ecclesiastical information as well as lists of traditional pagan festivals),[13] they do so in an at least a partly Christian context. They evoke not a Philostratian Aphrodite but themes of Christian cult and burial. The cupids which, in the mosaics of a villa of entirely non-Christian imagery like that at Piazza Armerina in Sicily, would be expected to evoke the pagan-mythological associa-

tions we find in Philostratus, come to be also a mark of Christianity.[14]

In what sense, one might ask, is the Projecta Venus a *Christian* image? The answer to this question points further than simply to one casket or to analogous objects. Rather, it evokes how, in the century after the Peace of the Church and the advent of Christianity as a socio-political force, viewing itself was so transformed that pagan iconographical themes, which some believers found positively anti-Christian, could find themselves Christianized. The Projecta casket puts an invocation to Christ together with an image of Aphrodite that is like those execrated by the second-century Christian apologist Clement of Alexandria as responsible for eliciting "insane passion by their vicious artifices".[15] The kind of imagery which might have seemed natural to the non-initiate religious associations of a Philostratus, and was positively inimical to a Christian polemicist like Clement, was being propelled into a Cebes-like exegetic frame of explanation which would make it acceptable to an initiate Christian.

Figure 60. Vintaging erotes, floor mosaics from the Villa at Piazza Armerina, Sicily, fourth century A.D. Photo: Alinari-Art Resource, New York.

256

The Projecta casket is far from being unique. Among other fourth-century items surviving from the dining-rooms, boudoirs and houses of the Roman upper classes, which combine "pagan" and Christian imagery, are the Hinton-St-Mary floor in the British Museum, with its juxtaposition of Bellerophon and an image of Christ,[16] and Sevso's hunting plate, a huge silver dish (nearly three-quarters of a metre in diameter) from the Sevso Treasure in the collection of the Marquess of Northampton, whose secular scenes of hunting and feasting are juxtaposed against a chi-rho monogram (Figure 63).[17] In addition to such direct combinations of pagan (or secular) imagery with Christian initiate images or inscriptions, are the much larger number of looser connections in which a Christian-inscribed object belongs to what was apparently the *same* collection as contained blatantly pagan images. In the case of the Esquiline Treasure, apparently from a single fourth-century collection of silverware and mostly from the same workshop,[18] a patera with Venus in a cockle-shell, a flask with erotes and a casket with Muses all belonged to the same

Figure 61. Vintaging erotes, ceiling mosaics from the Church of Sta Costanza, Rome, fourth century A.D. Photo: German Archaeological Institute, Rome.

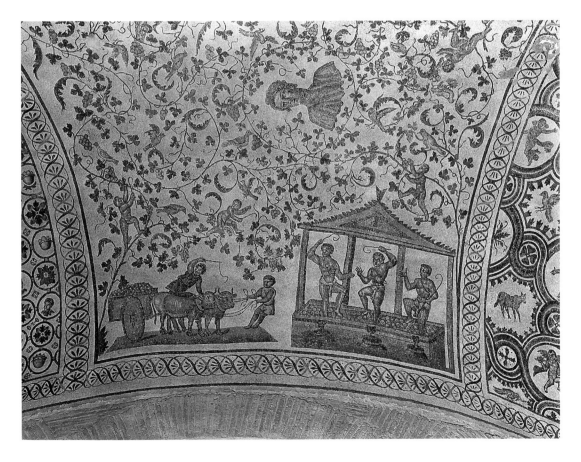

Secundus and Projecta who had asserted their Christianity so conspicuously on their casket.[19] None of these items has a Christian inscription, and yet it is obvious that none of them caused offence to Secundus and Projecta *as Christians*. In this context, we should perhaps be wary of modern anachronism in distinguishing neatly between "pagan" and "Christian" in a way which the viewers of the fourth century simply did not.[20]

The same juxtapositions of "pagan" and "Christian" items occur in a number of other late-antique silver treasures. The Sevso Treasure includes plates with images of Meleager and Achilles as well as a Dionysiac ewer and three pieces decorated with the myth of Hippolytus in addition to its chi-rho–inscribed Sevso plate. The magnificent fourth-century Kaiseraugst Treasure (which may well be related to that of

Figure 62. The sarcophagus of Junius Bassus, Vatican, fourth century A.D. Photo: Conway Library, Courtauld Institute.

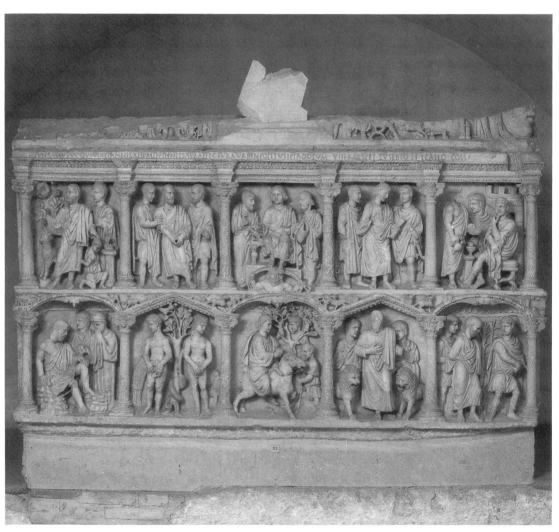

Sevso in date, style and context) has a toothpick with a christogram among its splendid platters with Achilles and Ariadne and Dionysus and its statuette of Venus at her toilet.[21] The Thetford Treasure includes – amid items with images of or dedications to Faunus, Mars, Venus and other pagan deities – a number of spoons with Christian inscriptions.[22] The Mildenhall Treasure, whose great dish depicts a Bacchic revel, includes a number of spoons with a chi-rho between alpha and omega.[23] The Corbridge Lanx, a sumptuous silver dish with Artemis, Apollo and Athena, was discovered with a number of (now lost) objects including a bowl with a Christian monogram.[24]

The cumulative evidence of these fourth-century treasures is overwhelming. On the social level from which they come, that is, in the "private" world of luxury silverware of the boudoir and the dining-table in the Roman villa,[25] it was possible to put explicitly salvific initiate images and inscriptions

Figure 63. Inner medallion of Sevso's hunting plate, Sevso Treasure, fourth century A.D. Photo: Courtesy of the Trustee of the Marquess of Northampton 1987 Settlement and Sotheby's.

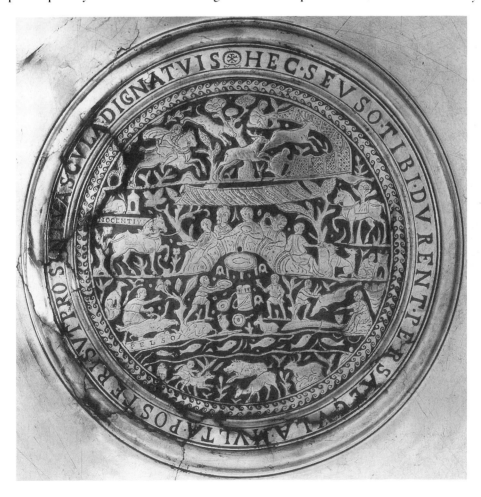

of the kind (but not of the religion) which we found explored by Cebes together with much more generally secular and civic-religious imagery. Perhaps for the owners of these toiletry and dinner sets, like Sevso or Secundus, the chi-rho monogram and the name of Christ were simply another addition to the pantheon of pagan deities. But the point is that such objects were open to be viewed by anti-pagan Christians (like some of the more virulent Church Fathers), by anti-Christian pagans (like the emperor Julian) and by anyone in between. In short, on the social level, where admittedly these objects had *no sacred function*, the kinds of viewings presented through the texts of Cebes and Philostratus – radically antipathetic viewings – were simultaneously available and encompassed.

By contrast, at least from the Christian point of view, such combinations were explicitly condemned in the *sacred context* of a church. In his fourth-century letter to the prefect Olympiodorus, St Nilus of Sinai rejects secular imagery in churches (explicitly mentioning animal and hunting scenes) as "childish and infantile" because such art "distracts the eyes of the faithful". On the other hand, Nilus strongly recommends that Olympiodorus

fill the holy church on both sides with pictures from the Old and New Testaments executed by an excellent painter so that the illiterate who are unable to read the Holy Scriptures, may, by gazing at the pictures become mindful of the manly deeds of those who have genuinely served the true God, and may be roused to emulate those glorious and celebrated feats.[26]

Nevertheless, whatever the case with imagery chosen for places of worship (which Nilus, in rejecting images that "distract" congregations, explicitly ties to the kinds of viewing appropriate to churches), in private houses both completely pagan traditional interpretations and initiate Christian exegesis of the *same* objects were now explicitly and simultaneously possible.[27] In short, the secretive and mystic world of initiation – so central and so silent in the account of Pausanias – had, in a Christian form, become applied to (admittedly luxury) objects, used for the quotidian functions of dining and make-up, in a way that competed directly with traditional secular and religious imagery. This is the visual mark of a profound social change.

Thus far my discussion of silver has focussed firmly on items from the fourth century. I have consciously reversed the approach of previous chapters, which concentrated on

images largely from the first and sixth centuries. However, because the imagery of fourth-century silver clearly raises questions about what kinds of images may have been deemed appropriate for meals and acceptable in the context of Christian elite display, it is worth glancing backwards and forwards to silver dining equipment from the early and the later Empire. Even a cursory look at the Boscoreale Treasure (for some examples, see Figures 64–7), from the first century A.D., now in the Louvre, reveals – despite some important formal differences from later times in the treatment of luxury silver (for instance, in the different shapes of cups) – a remarkable stylistic continuity.[28] Not only do we find a number of familiar iconographic motifs (for instance, the cupids on cups 5 and 6),[29] but the mirror with Leda and the swan seems remarkably close in style to the Paris patera with its image of Venus from the Esquiline Treasure made some three centuries later.[30] Equally startling is the classicizing stylistic continuity of sixth- and seventh-century silverware with earlier work. If one looks at the David plates (Figure 69), dated to the seventh century by stamps and monograms of the emperor Heraclius (610–41 A.D.),[31] scholars have noted that their forms and style recall much earlier imperial silver, like the Missorium of Theodosius of 388 A.D. (Figure 70).[32] Indeed, these plates form the classic case for the continuity of Hellenistic and classicizing styles deep into the Middle Ages.[33]

The evidence of silver is indeed surprising. It offers, over a long period from the first to the seventh centuries, a relatively stable set of functions in elite dining and display and a remarkably stable style. One might almost be forgiven for imagining that nothing much had changed from the period of Augustus to that of Heraclius. Certainly, whatever changes there had been are not in particular evidence either in the social context of aristocratic convivia, prestige possessions and private wealth or in the visual context of formalist styles. However, in this class of objects, the transformation of Roman art can be measured *iconographically*.

Let us take a number of cups from the Boscoreale treasure. No. 15 is a drinking cup with images of animals including a living boar and goose, and a dead rabbit (Figure 64).[34] Like a number of other cups from the treasure, it reflects with a certain irony on the banqueting activity of which it is part – animals like those it represents would have been among those eaten during the feast.[35] No. 104 is another drinking cup decorated with scenes of superb quality in high relief (Figure 65).[36] This cup, one of a pair, represents a Roman emperor

(usually identified as Tiberius) at his departure on campaign and at his triumph. In each scene, emphasis is laid on the act of sacrifice which accompanied these official activities. The cup shows cattle in procession and poised for slaughter. Again there is a relationship between the context in which the cup was used (namely, elite dining or display in a sympotic context) and its subject-matter. Whether or not beef was served at a feast where the cup was used, the image hints at the parallelism of sacrificial meat and dinner. If the bulls' skulls of the Ara Pacis offered a deconstructive commentary on the celebratory ideology of sacrifice, so the cooked meats of the animals served at a feast in Boscoreale had the potential to cast an ironic glance at the themes of several of its drinking cups. Finally, and perhaps most humorously, in this series of dining utensils which celebrate and at the same time put to question or even mockery the dinner they adorn, take cups 7 and 8 (Figures 66 and 67).[37] This pair represents a series of

Figure 64. Cup 15, from the Boscoreale Treasure (now in the Louvre, Paris), first century A.D. Photo: After Héron de Villefosse, 1899.

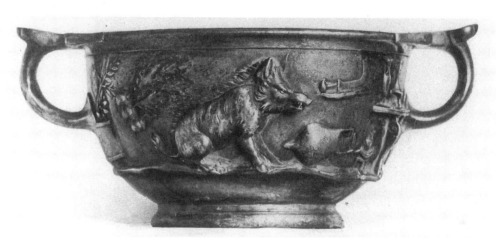

skeletons at the feast. The skeletons indulge in precisely the same stock activities of the symposium that would have been expected of the banqueters themselves. One skeleton crowns his head with flowers while smaller revelling skeletons play the lyre and applaud (on cup 7). On cup 8 a skeleton actually carries a platter of food. Whereas on cup 7 the figures are anonymous – reflecting perhaps the viewer – on no. 8 they are identified with a number of famous philosophers and poets. Both cups have inscriptions enjoining the viewer to enjoy the moment.

If the cups representing animals and sacrifice have the potential to offer an ironic commentary on the Roman ritual of feasting, these skeletal revels undermine the feaster-spectators

Figure 65. Cup 104, from the Boscoreale Treasure (now in the Louvre, Paris), first century A.D. Photo: After Héron de Villefosse, 1899.

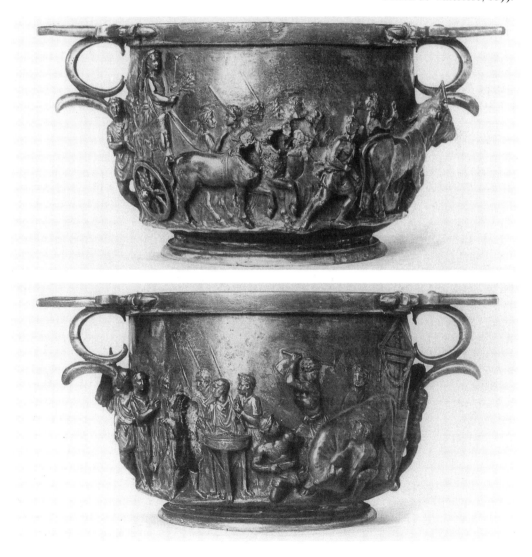

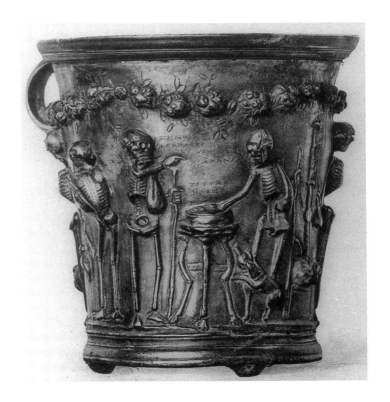

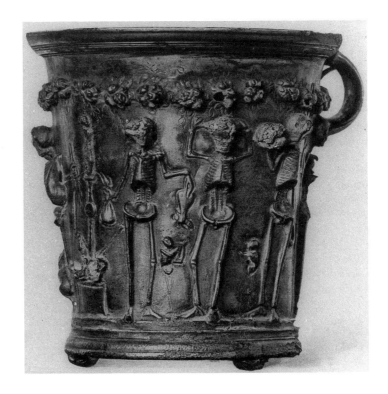

Figure 66. Cup 7, from the Boscoreale Treasure (now in the Louvre, Paris), first century A.D. Photo: After Héron de Villefosse, 1899.

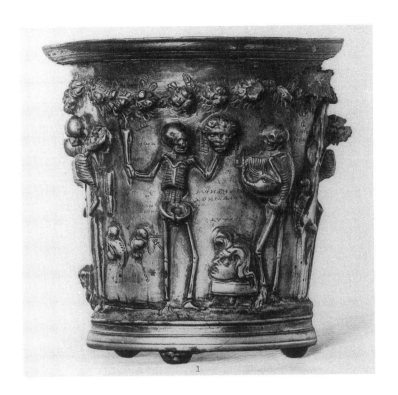

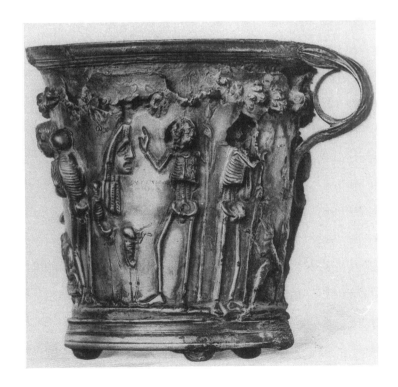

Figure 67. Cup 8, from the
Boscoreale Treasure (now in
the Louvre, Paris), first
century A.D. Photo: After
Héron de Villefosse, 1899.

265

EPILOGUE

themselves. They are by no means unique.[38] One parallel is an incident in Petronius's *Satyricon*, written in the second half of the first century A.D. There, in the episode of Trimalchio's dinner party (34.8–10):

As we drank and admired each detail, a slave brought in a silver skeleton . . .
Trimalchio recited:
> Man's life alas! is but a span,
> So let us live it while we can,
> We'll be like this when dead.

Not only does the silver material of the cups echo that of Trimalchio's skeleton, but their invocations, to enjoy life while one can, recall his. Like the deconstructive qualities of Roman domestic wall-painting and the imagery of civic sacrifice, these elegant silver cups, from the most refined of elite dining contexts in the private sphere of a Boscoreale villa, comment ironically and cast a somewhat uneasy light upon the very activity for which they were designed.

Whatever the complex qualities of late-antique silver, and certainly the Projecta casket portrays a highly sophisticated parallelism between patron and goddess, owner and function and facial make-up and religion, it was this deconstructive flavour to the relationship of iconography and context which was absent by the sixth and seventh centuries. Whereas the luxury dining silver of the first century deconstructively played with themes of banqueting, Christian liturgical silver of the sixth century – such as the Riha and Stuma patens (Figure 68) – endorsed its functions by portraying the archetypal sacred event on which the eucharistic liturgy was founded, namely the Communion of the apostles.[39] Both patens depict Christ distributing the host and the wine to the twelve apostles in a way that parallels and supports the function of these plates as the platters on which the host would have been offered. In effect, the patens would have been used in imitation and emulation of the scene which they portray. Even silver from a non-liturgical context, like the David plates,[40] had sacred subject-matter – although mythological themes do occasionally survive in sixth-century silverware.[41]

The David plates are particularly interesting. A series of nine dishes, they illustrate the early story of David as recounted in the first book of Samuel.[42] The group consists of one large plate (diameter nearly half a metre) depicting David's fight with and victory over Goliath; four medium

266

plates (about a quarter metre in diameter) showing the presentation of David to Saul (Figure 69), the marriage of David and Michal with Saul presiding, the anointing of David by Samuel and the arming of David for battle,[43] and four further small plates. Two of these smallest plates (with diameters of 14 centimetres) represent David slaying the lion and the bear, heroic feats which prelude his conquest over Goliath. The third small plate represents the summoning of David; but the identity of the scene on the last dish has occasioned much disagreement. It represents David's confrontation with a soldier who may be Goliath, Jonathon, Eliab or someone else.[44] The order in which the plates should be seen is thus in some dispute in that it depends on issues of identification.

There is little doubt, however, that the royal theme of David as anointed king and war hero was particularly relevant to the imperial context of the court of Heraclius. Heraclius was himself a warrior monarch who, like David, defeated the heathen Persians by slaying and beheading their general Razatis in single combat in 627. He was later compared with David in literary accounts.[45] Whether or not the David plates were specifically made to celebrate this signal victory, they undoubtedly work to support and validate the imperial position of Heraclius (and implicitly the Byzantine state) by grounding it in scriptural parallels and a sacred paradigm. In effect, they are the temporal equivalent of the spiritual and liturgical world of the Stuma and Riha patens. Where church silver authorized its ritual functions through sacred imagery, the David plates valorize the imperial *status quo* of seventh-century Byzantium through scriptural underpinning. Unlike the reflexive and deconstructive world of first-century A.D. dining ware, these silver plates of the seventh century show a virtuoso use of *sacred* imagery to bolster and support the principal religious and temporal institutions of society.

A comparison of the David plates with the Missorium of Theodosius (Figure 70) is instructive not so much for the stylistic continuity it displays, as for the iconographic transformation it indicates. In the Missorium, Theodosius is represented as himself.[46] He sits facing the viewer frontally beneath the central arch of a gabled pediment. On either side are seated his co-emperors in the imperial dynasty (identified as Valentinian II and Arcadius). All three have haloes, but Theodosius is represented in larger scale and in the centre. Still smaller figures, soldiers, flank Theodosius's co-emperors. Theodosius himself receives a codicil from an imperial official

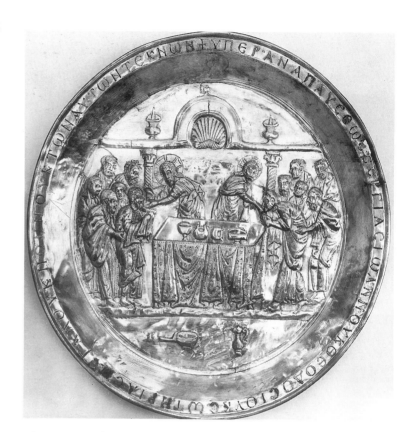

Figure 68. The Riha Paten (now at Dumbarton Oaks, Washington), sixth century A.D. Photo: Byzantine Visual Resources, 1993, Dumbarton Oaks, Washington D.C.

who approaches him from his right. Beneath the imperial party is a reclining personification of the earth, with three cupids who fly up bearing gifts for the emperor. In the corners of the gable, beneath which the emperors sit, two further cupids fly bringing presents of flowers and apples. Theodosius's imperial authority is visually defined by the secular sphere of patron-client relations and of his dynastic position in respect of his co-emperors. The image of Theodosius, like the narrative of Augustus's Prima Porta cuirass, rests on a personification of the world which the emperor rules. In the David plates, all the supports of the imperial world are scriptural. The emperor himself is not and does not need to be represented. Instead, the celebration of biblical monarchy and warriorship becomes inherently a celebration of the Byzantine monarchical system which professes to imitate Israel. The position of Heraclius does not depend, in Byzantine visual ideology, on the post-Augustan imperial paradigm grounded in this world, but entirely upon a series of comparisons with the royal heroes of a sacred narrative that alludes to the Other World.

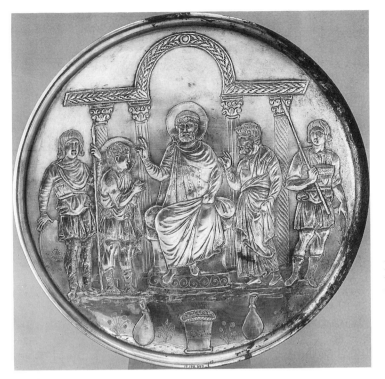

Figure 69. David presented to Saul, from the David plates (now in the Metropolitan Museum), seventh century A.D. Photo: The Metropolitan Museum of Art, Gift of J. Pierpont Morgan, 1917.

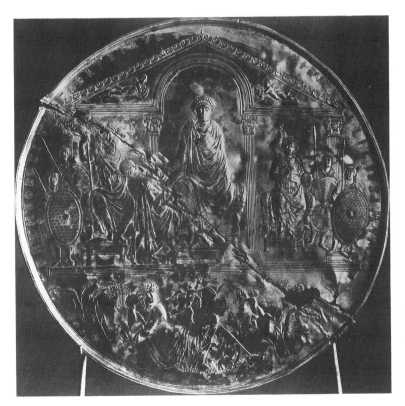

Figure 70. The Missorium of Theodosius (now in the Real Academia de la Historia, Madrid), fourth century A.D. Photo: German Archaeological Institute, Rome.

A key difference between the seventh century and the first century is the overwhelming exegetic importance of *Scripture*. By the time of the David plates and the Riha and Stuma patens, the Bible and its commentarial tradition could be used with a breathtaking virtuosity and range to support and explicate such entirely different realms as the sacred liturgy and imperial ideology. In this context, the complexities of the imagery of fourth-century silverware appear as a search for an appropriate kind of iconography and inscription in a world which had not yet shed its Hellenistic inheritance but was already reaching out towards the Christian paradigms of the Middle Ages. The Projecta casket and the Sevso hunting dish are wonderful examples of the visual clash of identities that inevitably took place in such a context.

One way of explaining, or dismissing, the effects of such "syncretism" in the collections of late-antique silver plate is to downplay the cultic significance of its imagery on the grounds of its apparently "secular" and non-religious function.[47] Even a religious Christian or Neoplatonist need not have seen all the newly formulated dogmas of what Julian calls "the Galileans" in a simple chi-rho monogram, engraved on a platter for fruit. But the chi-rho of the Sevso plate is nonetheless an early mark of an iconographic search for the proclamation of Christian identity not on a sacred or cult object, but even on an item for relatively more "secular" use. In this sense it presages such objects as the David plates. Likewise, despite the complexity of its apparent clash with the image of Venus, the Projecta casket's invocation of Christ heralds the entry of Christian exegesis into even the world of the boudoir.

To understand how the visual and scriptural exegesis of the David plates (or indeed of Justinian and Theodora at San Vitale) could have been generated by late-antique culture, we must look away from the "secular" social context of dining and toiletry, of wealthy private life, to a more clearly sacred and ritual sphere. We find explicitly pagan images combined with Christian iconography in the *cultic* context of the catacombs. There, in wall-paintings and on sarcophagi, the syncretism of such iconography cannot simply be dismissed as the liberal results of an open-minded secular culture. On the contrary, it must have explicitly religious meanings and implications, both for those who put it there and for those who looked at it. In the next section, I examine some elements of the birth and development of allegorical exegesis.

FROM MYTHOLOGY TO SCRIPTURE:
EXEGESIS AND CHRISTIAN IDENTITY

Let us look briefly at the most celebrated example of "syncre-tism" in a burial complex – at the fourth-century frescoes of the Via Latina Catacomb.[48] We thus move from viewing in the private ambience of elite dining to viewing in a funerary context. This is a different kind of situation, which would have elicited different responses in the spectator. It is almost a sacred context, although it cannot quite be equated with viewing in a church because it is unlikely that catacombs were used for liturgical purposes other than burial or the commemoration of the deceased.[49]

The Via Latina Catacomb is unusual, being regular in shape and small by the standards of the great catacombs of Rome (see plan, Figure 71). It has thirteen principal rooms with painted decoration, constructed mainly along a single axis (numbered in the first publication by Antonio Ferrua with the letters *A* to *O*, see diagram). Its paintings seem to date from about A.D. 315 to 370.[50] Iconographically, the pic-ture is complex. Most of its rooms have exclusively Christian and Old Testament cycles of paintings. Two rooms are exclu-sively "pagan" in imagery: *cubiculum N* (see plan, Figure 72), which has a cycle of the myths of Hercules, and room *E*, which has an image that has been interpreted as Tellus or Cleopatra, with a gorgon's head in the vault. Two more rooms, namely, *cubiculum O* and the hexagonal room *I*, have combinations of images which appear to mix "Christian" and "pagan" themes. In the passage to *cubiculum O* are paintings of Persephone and Demeter, while in room *I* a unique scene, apparently representing a doctor or philosopher explaining a human body to his students, is counterposed symmetrically against an image of Jesus giving the law to Peter and Paul.[51]

Scholars have most often assumed that the images point to the different religious affiliations of different patrons.[52] But do Christian and pagan *iconographical* themes refer so straight-forwardly to Christian and pagan *beliefs* and hence to "real" Christians and pagans who were responsible for commission-ing such imagery? Is the insistence on a simple and direct correspondence of iconography and fact convincing in the light of the silver treasures (such as Sevso's hunting plate or the Projecta Venus) where such distinctions are deliberately blurred and conflated? Should we assume that iconography

points *literally* to the meanings and belief-systems one might expect it to conjure in the first instance?

If we adduce the ancient *allegorical* context for interpreting art and myth – a context wonderfully attested by the *Tabula* of Cebes to be entirely pagan as well as Christian – then we can begin to see how such apparently antipathetic themes as a Hercules cycle and an Old Testament cycle of images could go together.[53] The Via Latina Catacomb does not point to an arbitrary syncretism of themes, but to a highly complex exegetic parallelism where salvific cycles of images from different religious contexts were placed side by side deliberately. Let us compare the iconography of two rooms, that of *cubiculum C*, with its programme of biblical images (see diagram, Figure 73), and that of *cubiculum N*, with its paintings of Hercules (see diagram, Figure 72).

As has been recognised, room *C* is an early example of a systematic typological programme of Christian paintings.[54] Although the walls are principally covered in Old Testament themes,[55] the ceiling of the room is adorned with a (now very damaged) image of Christ flanked by roll and codex. Thus the

Figure 71 (below). Plan of the Via Latina Catacomb, Rome, fourth century A.D. (after Ferrua).

Figure 72 (opposite, top). Diagram of *cubiculum N*, Via Latina Catacomb, Rome, fourth century A.D.

Figure 73 (opposite, bottom). Diagram of *cubiculum C*, Via Latina Catacomb, Rome, fourth century A.D.

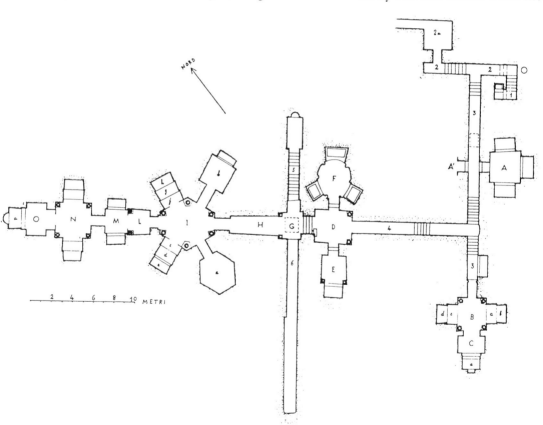

Cubiculum N

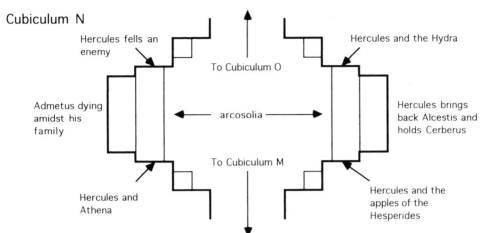

Hercules fells an enemy

Hercules and the Hydra

To Cubiculum O

Admetus dying amidst his family

← arcosolia →

Hercules brings back Alcestis and holds Cerberus

To Cubiculum M

Hercules and Athena

Hercules and the apples of the Hesperides

Vault: Amorini

Beneath Arcosolia: Peacocks

Details: A. Ferrua, 1960, pp. 76-80.

Cubiculum C

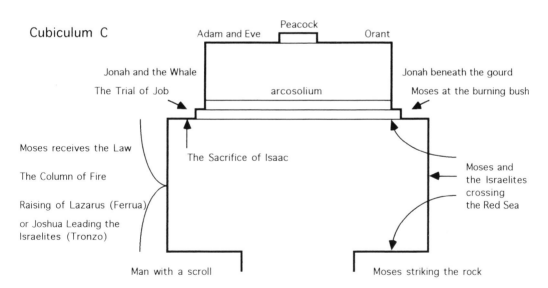

Peacock

Adam and Eve

Orant

Jonah and the Whale

Jonah beneath the gourd

The Trial of Job

arcosolium

Moses at the burning bush

Moses receives the Law

The Column of Fire

The Sacrifice of Isaac

Moses and the Israelites crossing the Red Sea

Raising of Lazarus (Ferrua) or Joshua Leading the Israelites (Tronzo)

Man with a scroll

Moses striking the rock

Vault: Seated Christ with Roll and Codex

Arcolsolium Vault: Good Shepherd.

Details: See A. Ferrua, 1960, pp. 53-7
W. Tronzo, 1986, pp. 51-65

scenes of the room, representing Moses and the Israelites fleeing Egypt for the Promised Land and explicitly Christological prefigurations like the sacrifice of Isaac, are crowned with the image of Christ. Like the Moses scenes of numerous contemporary sarcophagi, such as that of Junius Bassus (Figure 62), the Sarcophagus of Adelphia in Syracuse and the Claudiano sarcophagus in Rome,[56] these Old Testament images prefigure and underlie the New Testament's full presentation of the Incarnate God. Likewise, in the arcosolium (or arched niche in which the burial chamber's tomb was located), explicit typological prefigurations of Christ adorn the walls. Images of Jonah being vomited by the whale and resting beneath the gourd, as well as of Moses before the burning bush, are placed side by side with scenes of the Fall (Adam and Eve) and human suffering (the trial of Job) as well as of a praying orant. In the rear niche of the tomb is a peacock, and crowning its vault – exactly parallel to the Christ of the main chamber – is a good shepherd. Again the Old Testament cycle of the walls finds its completion in the Christian image of the ceiling.

None of this is particularly remarkable perhaps, except that it attests very early (this room is dated to about A.D. 320)[57] to the kind of Christian salvific programmes we have explored at Sinai and Ravenna. Indeed, in its very choice of images (Job, Moses, Adam and Eve, the sacrifice of Isaac, Jonah and the whale) the cycle of *cubiculum C* echoes the standard repertoire of typological catacomb and sarcophagus imagery. However, in *cubiculum N* of the same catacomb (painted in the second half of the fourth century by painters who in room *O* would be consciously imitating the programme of room *C*),[58] we find a similar – apparently salvific – programme, which is entirely pagan. On each side of the room is an arcosolium decorated with images of Hercules. To the left, as one goes through the catacomb towards the last chamber, *cubiculum O*, in the lunette is a scene of a dying man amid his family (Figure 74). In the light of the imagery of the rest of the room, this man is universally interpreted as representing Admetus (whose wife, Alcestis, chose to die in his stead, according to myth, and was rescued from death by Hercules). On the walls to the left and right of this scene are images of a haloed Hercules with his protectress, the goddess Athena (Figure 75), and triumphing over an enemy (who has been identified with Cacus, Antaeus and a number of other foes of Hercules, but might perhaps be Death himself, Figure 76).[59] To the right-hand side of the chamber is an arcosolium

in whose lunette Hercules is represented restoring Alcestis to
Admetus (Figure 77). The hero, again in a halo, holds Cerb-
erus, the hound of Hell, in a scene which conflates the story
of the twelfth labour of Hercules (the overcoming of Cerb-
erus) with that of the rescue of Alcestis. Both stories of course
centre on the overcoming of death. On the left and right of
this scene are images of other labours of Hercules – fighting
the many-headed hydra (Plate 4) and stealing the golden
apples of the Hesperides (Figure 78).

Room *N* attests to nothing less than a salvific allegory in
which a pagan saviour-god, Hercules, not only triumphs over
several monsters but also rescues the soul of Alcestis and in
the process conquers the hound of Hell, conquering death
itself. There are a number of evocative iconographic parallels
with scriptural images elsewhere in the catacomb (for in-
stance, the tree with its serpent from which Hercules takes
the apples is not entirely different from the tree in room *C*,
with its serpent, from which Adam and Eve take an apple
with a very different significance). But quite apart from this,
room *N* as a whole offers the potential for reading a coherent
religious programme of death and salvation. It is hardly diffi-
cult to see the resonance of the theme of Alcestis in a funerary
location or to see its allegorical possibilities in the context of
numerous Christian typological images (such as Jonah and the
whale or the sacrifice of Isaac) in the Via Latina Catacomb.

To read the room as simply the site of pagan burial *by
contrast with* the other rooms (like *C*) is to miss the call these
images make, by their very placement in the same catacomb
beside exegetic programmes of Christian images, for a more
syncretistic exegesis. It is to forget the lesson of the Projecta
casket. To see this cycle as simply a Christianizing paganism
or a paganizing Christianity,[60] is to risk stripping a vital pagan
religious symbolism of any meaningful content on its own
terms. Rather, we have in the Via Latina Catacomb an invita-
tion to exegesis on Christian interpretative lines for images
which are not Christian. The room exhibits the creative po-
tential for religious allegory in the period. Such interpretation
could be syncretising, Christianizing or purely pagan. It
could, in the creative space of late-antique viewing, be all
three. Moreover, although there was a deep tradition of sym-
bolic funerary sarcophagi in the paganism of the second and
third centuries,[61] it is likely – given the context – that the
Via Latina Hercules cycle exhibits at least some "influence"
from Christian art.[62]

When we come to ask what exactly the Hercules scenes

might mean, however, we are stumped for ready or clear answers. Although the lunette on the right (Figure 77) certainly does show Hercules controlling the hound of death and returning a woman, in all likelihood Alcestis, to a man,[63] it is only in the light of this interpretation that the left-hand lunette (Figure 74) can be read as the death of Admetus. In fact, I think the specific death represented is less important than the fact that the two lunettes show on the one hand a scene of dying and on the other a scene of triumph over death. Even less clear are the meanings of the other subjects in room *N*. They show Hercules in triumph over an enemy (it is revealing how many suggestions have been made as to who this might be, Figure 76), fighting the hydra (Plate 4), confronting his goddess (Figure 75) and collecting the apples of the Hesperides in a garden evocatively located at the world's end (Figure 78). Even if we could clearly identify the subject-matter and

Figure 74. Admetus dying; left-hand arcosolium, *cubiculum N*, Via Latina Catacomb, Rome, fourth century A.D. Photo: German Archaeological Institute, Rome.

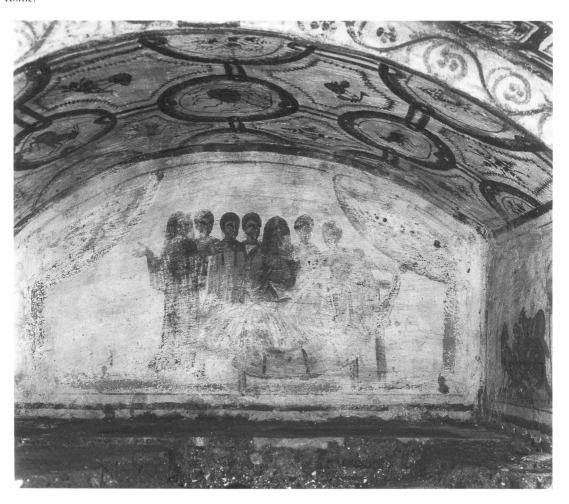

276

particular story of all the images (for instance, the meeting with Athena or the identity of the fallen enemy), we would still not know what the exegesis of these scenes specifically chosen for this place unambiguously meant. One can see their evocative thematic resonance with each other and their ramifications with such Judaeo-Christian themes as the Fall in the Garden. But, unlike the paintings of room *C*, the Hercules cycle lacks a coherent exegetic key in the form of a canonical scripture to which its meanings can be related. With the absence of Scripture also goes the absence of a commentarial tradition designed to interpret and allegorize Scripture, as the Fathers of the Church had devised.

In effect, although the paintings of room *N* are in many ways analogous to those of room *C* (or to those of any of the

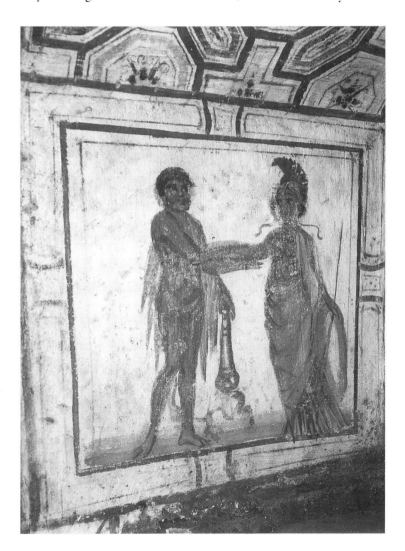

Figure 75. Hercules with Athena, left-hand arcosolium, *cubiculum N*, Via Latina Catacomb, Rome, fourth century A.D. Photo: German Archaeological Institute, Rome.

other Christian-decorated cubicula of the Via Latina Catacomb), in the crucial respect of how the interpretative exegesis should be controlled or grounded, they are radically different. The Hercules paintings offer the viewer a remarkably free hand in creative exegesis – the possibility of drawing on the exegetic context of the Christian images but without their rule book, as it were. And yet their context and function make it clear that these paintings foster an allegorical and in some sense salvific viewing much more like their Christian counterparts in the catacomb than like the kinds of images evoked by Philostratus (see, for instance, his Hercules cycle, *Imagines* 2.20–5).

The Hercules cycle of the Via Latina Catacomb represents a mid-point between exegetic images tied to Scripture and an

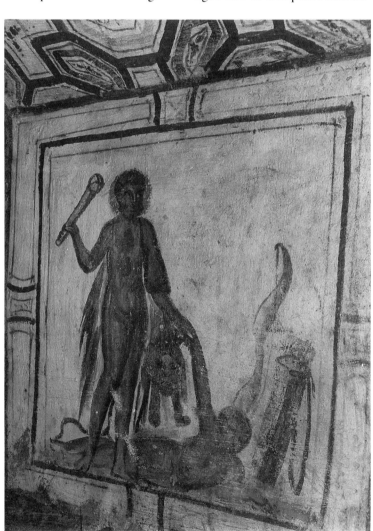

Figure 76. Hercules triumphing over an enemy, left-hand arcosolium, *cubiculum N*, Via Latina Catacomb, Rome, fourth century A.D. Photo: German Archaeological Institute, Rome.

art which reflects upon and plays with the cultural contexts of its society in a much more general way. Like the *Tabula* of Cebes, the paintings of room *N* are an art which evokes exegesis and allegory, but does so from a starting point embedded in the cultural "encyclopaedia" of antiquity – in this case, popular mythology, in the case of Cebes, popular philosophy. Just as Cebes basically makes up his exegesis as he goes along, using the most extraordinarily eclectic and syncretistic mixture of philosophical systems as the basis of his interpretation, so the Hercules cycle allows a creative breadth of allusive and suggestive possibilities – the truth in these empty images being open to the interpretative directions taken by the faith of their viewers' minds.

Yet Christian art was different from this. It radically limited the possibilities for allegory by tying them to the canon of scripture. In doing so, it created religious typology. Again,

Figure 77. Hercules restoring Alcestis to Admetus and holding Cerberus, right-hand arcosolium, *cubiculum N*, Via Latina Catacomb, Rome, fourth century A.D. Photo: German Archaeological Institute, Rome.

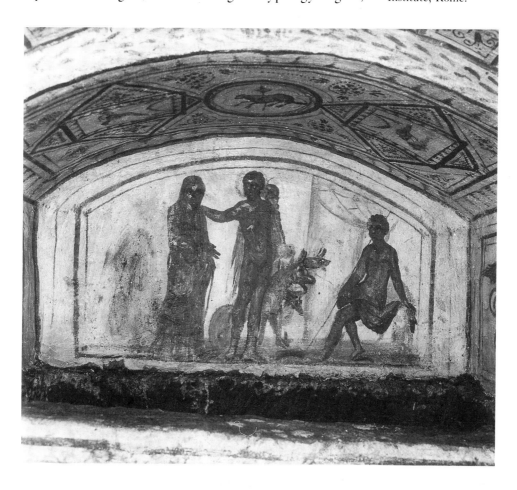

typological images – in which themes from the past prefigure those of the present – were well known in pagan Roman culture. For example, the Arch of Constantine (Figure 79), set up in about 315 A.D. after Constantine's conquest of Rome, uses sculpted reliefs of Trajan, Hadrian and Marcus Aurelius as well as of Constantine in a highly complex typological justification of the new reign through implicit comparison with previous good emperors.[64] But such political typology was, like the interpretation of Cebes, the viewing of the Hercules cycle of *cubiculum N* and the myth-history of Pausanias, embedded in aspects of a general and shared Graeco-Roman culture, what has been called "Hellenism".[65] This was a broad cultural background, as thin or thick, deep or shallow, as you wished it to be, from which one could pick and choose such motifs and meanings as appealed. It was inclusive of any religious, philosophical or artistic trend which emerged in the Roman Empire; it was able to adapt, adopt or ignore such elements of the culture as viewers saw fit. By contrast, in Christianity, in principle, nothing of the Scriptures (or of the dogmas formulated later) could be ignored. In tying typology to Scripture, Christianity was fastening interpretation to salvation; not any particular exegete's version of salvation (like the one-of-a-kind product of a Cebes), but a textually grounded, critically tested orthodoxy.[66]

Let us conclude by briefly exploring some of the social and cultural effects of such Christian visual exegesis. In the Museo dell' Età Cristiana in Brescia is an ivory box known as the Brescia Lipsanotheca (Figure 80).[67] It is a remarkable object, beautifully carved on all four sides and on the lid with Old and New Testament scenes. This casket, which may have contained relics (as was traditionally assumed) or perhaps hosts for the eucharist, evokes a different context of viewing from display silverware or burial tombs. If associated with the liturgy (as a box for blessed bread) and the process of regular worship, the casket would have framed the viewer in a way perhaps analogous to church mosaics or the decorated patens. If, on the other hand, it was a reliquary only rarely seen on special occasions, pilgrimages or feasts of the saint whose bones it contained, it would have had slightly different connotations again. These different kinds of liturgical occasions brought viewers in different frames of mind to objects which could plausibly fulfil multiple viewing functions.

On stylistic and iconographical grounds, the Brescia Lipsanotheca is dated to the later fourth century, not long after

Figure 78. Hercules stealing the apples of the Hesperides, right-hand arcosolium, *cubiculum N*, Via Latina Catacomb, Rome, fourth century A.D. Photo: German Archaeological Institute, Rome.

that equally complex masterpiece of early Christian typological art, the sarcophagus of Junius Bassus (Figure 62). Much has been written on its iconography and meaning. Some have denied it symbolic meaning;[68] others have seen a profusion of symbolic meanings in the compositional juxtaposition of typologies,[69] in the theme of salvation[70] and in the relation of the scenes chosen to early Christian Lent and Easter liturgies.[71] Recently, the casket's programme has been related to church politics in the late fourth century and to Ambrose's resistance against Arianism.[72] I do not wish to quarrel with any of these possible interpretations, though I should register a protest against the denial of symbolic meaning to an object which patently belongs to a great Christian typological tradition. Suffice it to say that the Brescia Lipsanotheca represents

a highly complex typological juxtaposition of Christological themes (in the larger central bands of its four sides) and Old Testament themes (in the two smaller bands at the top and bottom of each side, which frame the main scenes). These Old and New Testament juxtapositions are crowned by a purely Christological Passion cycle on the lid of the box, where the two bands represent the arrest and trial of Christ and Peter's denial.

The range of scholarly interpretations depends on two factors. First, not all the scenes are clearly identifiable given the evolving iconography of early Christian art at this period. Second, the box contains no inscriptions or textual aids to interpretation. Though not as free as the Hercules cycle of the Via Latina Catacomb in the exegetic scope which it offers its viewers (for unlike *cubiculum N* there is clearly one canonical text in which all the "answers" to the casket's meaning are to be found), it is nonetheless relatively open to creative interpretation within a scriptural frame. However, my interest here is not in the precise meanings of its imagery (to whatever extent these can be reconstructed) but in *how* such imagery is being made to work. In other words, I take the typological programme of the Brescia casket as an early but not untypical example of the kinds of Christian programmes of images (already present in the catacombs and such monuments as the Junius Bassus sarcophagus) which would soon be the prevalent form of image making in Christendom.

The Brescia casket, like *cubiculum C* of the Via Latina Catacomb and like the Christological sarcophagi, presents biblical stories through pictures. It combines those stories in a highly complex iconographic programme accessible through visual juxtaposition to everyone who saw the box. In other words, it translated the kinds of typological motifs explored in scriptural exegesis, from the world of texts (created and circulated by the literate elite, and related by them to congregations through homilies and church sermons) to the world of pictures, accessible to everyone. Programmes of images like the Lipsanotheca were not so much a bible for the illiterate as an extraordinarily direct way of transmitting highly sophisticated *methods* for constructing meaning.[73] For instance, there is a resonance, in the front of the Brescia box (Figure 81), in framing the scene of *Noli me tangere* – where the Risen Christ asks not to be touched by Mary Magdalene – between the scene of Jonah being cast into the whale (a type for the descent prior to the Resurrection) above it and below it the scene of the pure Susanna about to be sullied by the touch of

Figure 79. The Arch of
Constantine, Rome, fourth
century A.D. Photo: Conway
Library, Courtauld Institute.

the Elders. The parallelism of Christ with Susanna is further emphasised when, in the lower band of the front, she is brought to judgement before Daniel, just as Christ is brought to judgement on the casket's lid. The difference in these judgements is that Daniel is himself a type of Christ, rescued from a den of lions (the right-hand scene on the bottom band of the casket's front), whereas Christ is to be tried by Pilate. Clearly, the task of constructing connections, of creating meanings, could be endless.

What I am suggesting is that the symbolic and exegetic nature of objects like the Brescia Lipsanotheca was performing immensely significant cultural work in transmitting not particular interpretations but rather that particularly Christian *method* of interpretation called typology. Their sacred subject-matter called into play an initiate and exegetic viewing. That viewing was itself a training in how to see the world, in how to form and modulate a Christian identity in relation to Scripture. Indeed, I would suggest that those who have explored the exegetic implications of Christian discourse have not given sufficient importance to the role of images in making such discourse accessible and normative.[74]

Moreover, exegetically charged cycles of images, like those on the Brescia casket or the Junius Bassus sarcophagus, were *used*. They formed the "decoration" for boxes which contained holy or at least highly charged matter – relics, the deceased bodies of Christian men and women, soil, water or oil from the Holy Land, the sanctified bread of the eucharist. In one

sense these containers derived their significance from the sacrally charged objects they held. Their decoration was secondary to their function as repositories of the holy, as containers of Christian charisma. But in another sense, these decorative programmes of images provided viewers with an interpretative frame in which to see the matter contained by the box, that is, in which to see the material world itself. The body of Junius Bassus, just another Roman aristocrat, became sanctified by virtue of the sacred and salvific themes of his coffin's adornment. The relics, or host, or whatever the Brescia casket was actually designed to hold, were given their significance as sacred Christian objects in part by the cycle of images on the box. Viewers were themselves framed by such programmes of images – their viewings and interpretations were contained within a highly doctrinal and exegetic compass by such imagery. Again, I want to suggest that in this way Christian art performed a more significant social function than is usually recognised in creating a prevailingly Christian way of seeing the world and in helping with the remarkable "drainage of the secular" by which Robert Markus characterises the onset of the Middle Ages.[75]

We cannot compare late-antique Christian typological imagery with examples of similar material from Roman culture in the first century A.D. Unlike silverware, imperial art or sacrificial representations, typology was a radically new element introduced into mainstream Roman culture by Christianity. One *can* compare Christian typological images both with pagan allegorical cycles (as I have done in the case of the Via Latina Catacomb) and with Jewish art, like the frescoes of the synagogue at Dura Europos. But, as I have shown, pagan allegory was a profoundly different process from its Christian counterpart because it lacked the canonical textual basis of a bible and its commentarial tradition. Jewish art, of course, did not lack such a holy text or tradition. Indeed, Christian allegorical writing is immensely indebted to Jewish exegesis, as exemplified, for instance, by Philo Judaeus.

Nevertheless, although Judaism remained a tribal religion, largely exclusive of non-Jews for reasons of kinship and blood, Christianity's exclusivity was limited only to rejecting other belief-systems. It was a religion of conversion. In being appropriated to official status within the Roman Empire and made the state cult, Christianity brought the potential for an intense and close-knit sense of identity appropriate to an exclusive initiate cult to the whole mass of the population of the empire. In large part that sense of exclusivity was fostered

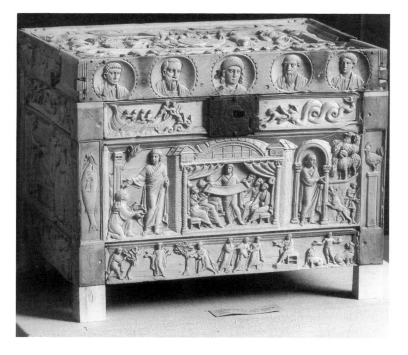

Figure 80. The Brescia
Lipsanotheca (now in the
Museo dell' Età Cristiana,
Brescia), fourth century A.D.
Photo: Conway Library,
Courtauld Institute.

Figure 81. The Brescia
Lipsanotheca, front, fourth
century A.D.: Medallion
portraits of Christ and four
apostles, top tier (in fact, the
edge of the casket's lid);
Jonah swallowed and
vomited by the whale, upper
tier; Christ with Mary
Magdalene (*Noli me tangere*),
Christ teaching and Christ at
the entrance to the sheepfold,
middle section; Susanna and
the Elders, Susanna and
Daniel and Daniel in the
lions' den, lower tier. Photo:
Conway Library, Courtauld
Institute.

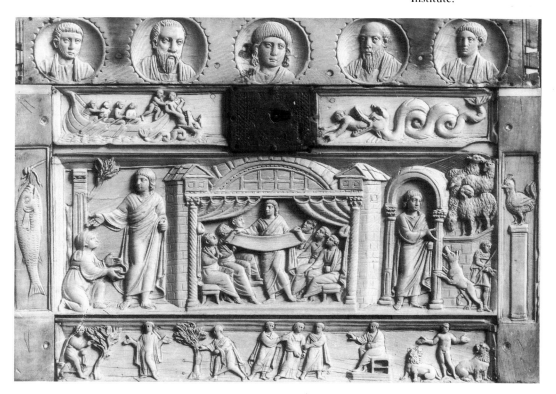

by the complexity of the initiation (the great amount of background narrative knowledge) required to identify scriptural subjects and understand their symbolic connections, their typological meanings. Indeed, cycles like the Dura synagogue frescoes would presumably have been as incomprehensible to non-Jews as the frescoes of the Dura mithraeum are to modern scholars who are not privileged with initiation into the symbolic meanings of Mithraism. The importance of Christian art on a social level lies in its brilliant visual ability to transmit the meanings and connections of typological thinking in Christian culture to anyone who took the trouble to *look*. In doing so, it transmitted Christian identity itself.

Let us return to the text from Paulinus of Nola with which we began. Paulinus instructs his listeners to throw back their heads, even though they may tire their necks a little (*paulumque supina fatiges colla*) so that – with their faces tilted right back – they may take in all the paintings (*reclinato dum perlegis omnia vultu*). The word for surveying the images means literally to "read", to "interpret" (*perlegis*). But the crucial term here is *omnia, all* the pictures. For only with a grasp of a whole cycle of images (the totality of a chamber like *cubiculum C*, of a box like the Brescia casket, of a church programme like that of Sinai or Sant' Apollinare Nuovo) could a viewer hope to see the totality of typological connections. Only that totality could gain a viewer access to the typological truth concealed in the empty figures and thus feed the mind of his or her faith.

I have attempted in this epilogue to trace two aspects of the extraordinarily complex process of the transformation of Roman art. The exploration of silver plate shows how, on the level of this medium and this social context at least, that transformation can hardly be described stylistically at all. Rather, the "abstraction" of Christian art on such items as the David plates lies in their ability to refer not to what the iconography explicitly appears to indicate, but rather to its more figural and oblique meanings, like the imperial status of Heraclius and the sacro-royal nature of the Byzantine state. The development of such a deeply symbolic and typological tradition in Christian imagery is directly due to the growth of exegesis.

In the examination of Christian exegesis, this epilogue has concentrated mainly on complex groups of images and on how Christianity offered both particular challenges to initiate viewing and particular constraints on the acceptable interpretative bases of such viewing. As in many other instances,

so here too did Christian art borrow almost all its forms from the Graeco-Roman environment in which it was born; but, as so often happens, it radically transformed what it borrowed, making from it something deeply and distinctively different. It was above all because of the increasingly exegetic function of Christian images as illustrations and creative commentaries upon Scripture that in the end Christianity did not *need* a mimetic art. Naturalism, the art which imitates and plays with the material world, became slowly irrelevant in a culture that perceived everything in the material world to be a symbol for something which transcended nature. But what the debate about the "abstraction" (the "retreat from naturalism") of Christian art should not blind us to, is the extraordinary and important role that images acquired in Christianity as prime examples for what would become the prevailing exegetic tradition.

BIBLIOGRAPHY

Abbreviations: I have avoided the use of journal abbreviations on the grounds that these are never familiar except to those in whose immediate fields they fall. There is, however, one exception to this:

ANRW: H. Temporini and W. Haase, eds. *Aufstieg und Niedergang der Römischen Welt.* Berlin and New York, 1972 and following.

G. J. D. Aalders. *Plutarch's Political Thought.* Amsterdam, 1982.

M. Adinolfi. "La Metanoia della Tavola di Cebete". *Antonianum* 60 (1985), pp. 579–601.

E. De Albentiis. *La Casa dei Romani.* Milan, 1990.

P. J. Alexander. "Hypatius of Ephesus: A Note on Image Worship in the Sixth Century". *Harvard Theological Review* 45, 3 (July 1952), pp. 176–84.

G. Alfoeldy. *The Social History of Rome.* London, 1985.

A. Alföldi. *Die monarchische Repräsentation in römischen Kaiserreiche.* Darmstadt, 1970.

T. C. Aliprantis. *Moses auf dem Berge Sinai.* Munchen, 1986.

D. Allen. *Structure and Creativity in Religion.* The Hague, 1978.

S. Alpers. "Ekphrasis and Aesthetic Attitudes in Vasari's Lives". *Journal of the Warburg and Courtauld Institutes* 23 (1960), pp. 190–215.

G. Anderson. *Philostratus: Biography and Belles Lettres in the Third Century A.D.* London, 1986.

M. Anderson. *Pompeian Frescoes from the Metropolitan Museum of Art.* New York, 1987.

E. Angelicoussis. "The Panel Reliefs of Marcus Aurelius". *Mitteilungen des Deutschen Archaeologischen Instituts, Römische Abteilung* 91 (1984), pp. 141–205.

S. Angus. *The Mystery Religions and Christianity.* London, 1925.

J. Annas. "Truth and Knowledge". In M. Schofield et al., eds., q.v., pp. 84–104.

K. Arafat. "Pausanias' Attitude to Antiquities". *Annual of the British School of Archaeology at Athens* 87 (1992), pp. 387–409.

S. Ardener, ed. *Women and Space.* London, 1981.

J. H. D'Arms. *Romans on the Bay of Naples.* Cambridge, Mass., 1970.

A. H. Armstrong. *Plotinus.* London, 1953.

———, ed. *The Cambridge History of Later Greek and Early Medieval Philosophy.* Cambridge, 1967.

288

H. F. A. von Arnim. "Kebes". In G. Wissowa, ed., *Paulys Realencyclopaedie der classischen Altertumswissenschaft*, pp. 101–4. Stuttgart, 1921.

B. A. Babcock, ed. *The Reversible World: Symbolic Inversion in Art and Society*. Ithaca, 1978.

M. Bakhtin. *Rabelais and His World*. Cambridge, Mass., 1968.

J. Baldovin. *The Urban Character of Christian Worship*. Rome, 1987.

B. Baldwin. "The Date, Identity and Career of Vitruvius". *Latomus* 49, 2 (1990), pp. 425–34.

C. S. Baldwin. *Medieval Rhetoric and Poetic*. New York, 1928.

S. Bann. *The True Vine: Visual Representation and Western Tradition*. Cambridge, 1989.

F. Baratte. *Le trésor orfèvrerie romaine de Boscoreale*. Paris, 1986.

————, ed. *Argenterie romaine et byzantine*. Paris, 1988.

C. Barber. "The Imperial Panels at San Vitale: A Reconsideration". *Byzantine and Modern Greek Studies* 14 (1990), pp. 19–43.

A. Barbet. *La peinture murale romaine*. Paris, 1985.

T. D. Barnes. *Constantine and Eusebius*. Cambridge, Mass., 1981.

R. H. Barrow. *Plutarch and His Times*. London, 1967.

R. Barthes. *Camera Lucida*. London, 1982.

E. Bartmann. "Sculptural Collecting and Display in the Private Realm". In E. K. Gazda, ed., q.v., pp. 71–88.

T. S. Barton. *Power and Knowledge*. Ann Arbor, forthcoming.

S. Bartsch. *Decoding the Ancient Novel*. Princeton, 1989.

H. Bastet and M. de Vos. *Proposta per una classificazione del terzo stile pompeiano*. Archeologische Studien van het Nederlands Instituut te Rome IV. Gravenhage, 1979.

J. Baudrillard. *Simulations*. New York, 1983.

M. Baxandall. *Giotto and the Orators*. Oxford, 1971.

————. *Patterns of Intention: On the Historical Explanation of Pictures*. New Haven and London, 1985.

N. H. Baynes. "Eusebius and the Christian Empire". In *Byzantine Studies and Other Essays*, pp. 168–72. London, 1960.

M. Beard. "Reflections on 'Reflections on the Greek Revolution'". *Archaeological Review from Cambridge* 4 (1985), pp. 207–13.

————. "Writing and Religion: Ancient Literacy and the Function of the Written Word in Roman Religion". In *Literacy in the Roman World*, pp. 35–58. *Journal of Roman Archaeology* Suppl. 3. Ann Arbor, 1991.

M. Beard and M. Crawford. *Rome in the Late Republic*. London, 1985.

M. Beard and J. North, eds. *Pagan Priests*. London, 1990.

R. Beck. "Cautes and Cautopates: Some Astronomical Considerations". *Journal of Mithraic Studies* 2, 1 (1977), pp. 1–17.

————. "Mithraism since Franz Cumont". *ANRW* 2. 17.4 (1984), pp. 2002–115.

————. *Planetary Gods and Planetary Orders in the Mysteries of Mithras*. Leiden, 1988.

L. Bek, *Towards a Paradise on Earth*. Analecta Romana 9. Odense, 1980.

C. Bérard. *Anodoi: Essai sur l'imagerie des passages chthoniens*. Rome and Neuchâtel, 1974.

B. Berenson. *The Arch of Constantine or the Decline of Form*. London, 1954.

J. Berger. *Ways of Seeing*. Harmondsworth, 1972.

————. "Magritte and the Impossible". In J. Berger, *About Looking*, pp. 155–61. Harmondsworth, 1980.

B. Bergmann. "Painted Perspectives of a Villa Visit: Landscape as Status and Metaphor". In E. K. Gazda, ed., q.v., pp. 49–70,

H. G. Beyen. *Die Pompejanische Wanddekoration vom zweiten bis zur vierten Stil*. The Hague, 1938 (vol. 1), 1960 (vol. 2).

———. "Die Antike Zentralperspektive". *Jahrbuch des Deutschen Archaeologischen Instituts* 54 (1939), pp. 47–72.

R. Bianchi Bandinelli. *Archeologia e Cultura*. Rome, 1979.

U. Bianchi, ed. *Mysteria Mithrae*. Atti del Seminario Internazionale sui "La Specifità" Storico-religiosa dei Misteri di Mithra, con Particolare Referimento alle Fonti Documentare di Roma e Ostia. Leiden, 1979.

A. Billault. "L'inspiration des ekphraseis d'oeuvres d'art chez les romanciers grecs". *Rhetorica* 8, 2 (1990), pp. 153–60.

E. Birmelin. "Die Kunsttheoretischen Gedanken in Philostrats Apollonios". *Philologus* 88 (1933), pp. 149–80, 392–414.

J. M. Blanchard. "The Eye of the Beholder: On the Semiotic Status of Paranarratives". *Semiotica* 22 (1978), pp. 235–68.

M. E. Blanchard. *Description: Sign, Self, Desire*. Approaches to Semiotics 43. The Hague, 1980.

———. "Philostrate: Problèmes du texte et du tableau: Les limites de l'imitation à l'époque hellénistique et sous l'empire". In B. Cassin ed., *Le plaisir du parler*, pp. 131–54. Paris, 1986.

H. Blum. *Die Antike Mnemotechnik*. Spudasmata 15. Hildesheim, 1969.

R. Bocock and K. Thompson, eds. *Religion and Ideology*. Manchester, 1985.

W. den Boer, ed. *Le culte des souverains dans l'empire romain*. Entretiens Fondation Hardt, vol. 19. Geneva, 1973.

A. Boethius. "Vitruvius and the Roman Architecture of his Age". In *DRAGMA* (essays for M. P. Nilsson), pp. 114–43. Lund, 1939.

P. duBois. *History, Rhetorical Description and the Epic*. Cambridge, 1982.

J. Bompaire. *Lucien écrivain*. Paris, 1958.

———. "Quelques personnifications littéraires chez Lucien et dans la littérature imperiale". In J. Duchemin, ed., *Mythe et personnification*, pp. 77–82. Paris, 1980.

L. W. Bonfante. "Emperor, God and Man in the Fourth Century". *Parola del Passato* 19 (1964), pp. 401–27.

H. le Bonniec. *Ovide: Les Fastes I*. Paris, 1965.

J. L. Borges. *Obras Completas, 1923–1972*. Buenos Aires, 1974.

P. Bourdieu. "The Kabyle House or the World Reversed". In P. Bourdieu, *Algeria 1960*, pp. 133–54. Cambridge, 1970.

M. F. C. Bourdillon and M. Fortes, eds. *Sacrifice*. London, 1980.

G. Bovini. *Saggio di Bibliografia su Ravenna Antica*. Bologna, 1968.

H. C. Bowerman. *Roman Sacrificial Altars*. Lancaster, Pa., 1913.

G. W. Bowersock. *Greek Sophists in the Roman Empire*. Oxford, 1969.

———. *Hellenism in Late Antiquity*. Cambridge, 1990.

———. "The Pontificate of Augustus". In K. Raaflaub and M. Toher, eds., q.v., pp. 380–94.

———, ed. *Approaches to the Second Sophistic*. University Park, 1974.

E. L. Bowie. "The Importance of the Sophists". *Yale Classical Studies* 27 (1982), pp. 29–60.

J. D. Breckenridge. *Likeness: A Conceptual History of Ancient Portraiture*. Evanston, 1968.

E. Brehier. *Les idées philosophiques et réligieuses de Philon d'Alexandrie*. Paris, 1908.

O. Brendel. "The Corbridge Lanx". *Journal of Roman Studies* 31 (1941), pp. 100–27.

———. "Origin and Meaning of the Mandorla". *Gazette des Beaux Arts* 25 (January 1944), pp. 5–24.

R. Brilliant. *The Arch of Septimius Severus in the Roman Forum*. Memoires of the American Academy in Rome, vol. 29. Rome, 1967.

———. *Roman Art*. London, 1974.

F. Brommer. "Zur datierung des Augustus von Prima Porta". In Th. Gelzer, ed., *Eikones: Festschrift Hans Jucker*, pp. 78–80. Berne, 1980.

E. W. Brooks. *Historia Ecclesiastica Zachariae Rhetori*. Louvain, 1924.

P. Brown. "The Rise and Function of the Holy Man in Late Antiquity". *Journal of Roman Studies* 61 (1971), pp. 80–101.

———. "Art and Society in Late Antiquity". In K. Weitzmann, ed., *The Age of Spirituality: A Symposium*, pp. 17–27. New York, 1980.

———. *The Cult of the Saints*, London, 1981.

R. Browning. "The Riot of A.D. 387 in Antioch". *Journal of Roman Studies* 42 (1952), pp. 13–20.

———. *History, Language and Literacy in the Byzantine World*. London, 1989.

N. Bryson. *Vision and Painting: The Logic of the Gaze*. London, 1983.

———. *Tradition and Desire*. Cambridge, 1984.

———. "Representing the Real: Gros' Paintings of Napoleon". *History of the Human Sciences* 1, 1 (May 1988), pp. 75–104.

———. *Looking at the Overlooked*. London, 1990.

———. "Philostratus and the Imaginary Museum". In S. D. Goldhill and R. Osborne, eds., q.v., pp. 255–83.

E. Buchner. "Solarium Augusti und Ara Pacis". *Mitteilungen des deutschen Archaeologischen Instituts: Römische Abteilung* 83 (1976), pp. 319–65.

———. *Die Sonnenuhr des Augustus*. Mainz, 1982.

———. "Horologium Solarium Augusti". In *Kaiser Augustus und die Verlorene Republik* (exhibition catalogue), pp. 240–5. Berlin, 1988.

M. W. Bundy. *The Theory of Imagination in Classical and Mediaeval Thought*. Urbana, 1927.

W. Burkert. *Structure and History in Greek Mythology and Ritual*. Berkeley, 1979.

———. *Homo Necans*. Berkeley, 1983.

H. A. Cahn and A. Kaufmann-Heinimann, eds. *Der spätrömishe Silberschatz von Kaiseraugst*. Derendingen, 1984.

H. A. Cahn, A. Kaufmann-Heinimann and K. Painter. "A Table Ronde on a Treasure of Late Roman Silver". *Journal of Roman Archaeology* 4 (1991), pp. 184–91.

C. Calci and G. Messineo. *La Villa di Livia a Prima Porta*. Rome, 1984.

Alan Cameron. "Observations on the Distribution and Ownership of Late Roman Silver Plate". *Journal of Roman Archaeology* 5 (1992), pp. 178–85.

Averil Cameron. "Images of Authority: Elites and Icons in Late Sixth Century Byzantium". *Past and Present* 84 (1979), pp. 3–35.

———. *Christianity and the Rhetoric of Empire*. Berkeley, 1991.

———. "The Language of Images: The Rise of Icons and Christian Representation". In D. Wood, ed., *The Church and the Arts*, Studies in Church History 28, pp. 1–42. Oxford, 1992.

M. B. Campbell. *The Witness and the Other World*. Ithaca, 1988.

H. von Campenhausen. *Die Idee des Martyriums in der alten Kirche*. Gottingen, 1936.

A. Carandini, M. Ricci and M. de Vos. *Filosofiana: The Villa of Piazza Armerina*. Palermo, 1982.

D. Carrier. "Ekphrasis and Interpretation: Two Modes of Art History Writing". *British Journal of Aesthetics* 27, 1 (Winter 1987), pp. 20–31.

M. Carruthers. *The Book of Memory*. Cambridge, 1990.

L. Casson. *Travel in the Ancient World*. London, 1974.

T. Cave. "Enargeia: Erasmus and the Rhetoric of Presence in the Sixteenth Century". *L'Esprit Créateur* 16, 4 (1976), pp. 5–19.

L. Cerfaux and J. Tondriau. *Le culte des souverains dans la civilisation Gréco-Romaine*. Tournai, 1957.

H. H. O. Chalk. "Eros and the Lesbian Pastorals of Longus". *Journal of Hellenic Studies* 80 (1960), pp. 32–51.

J. H. Charlesworth, ed. *The Old Testament Pseudepigrapha*. Vol. 1. Apocalyptic Literature and Testaments. London, 1983.

M. P. Charlesworth. "Imperial Deportment". *Journal of Roman Studies* 37 (1947), pp. 34–8.

C. M. Chazelle. "Pictures, Books and the Illiterate: Pope Gregory I's Letters to Serenus of Marseilles". *Word and Image* 6 (1990), pp. 138–53.

H. F. Cherniss. *The Platonism of Gregory of Nyssa*. University of California, Berkeley, Publications in Classical Philology, vol. 11, no. 1, Berkeley, 1930.

G. F. Chesnut. *The First Christian Histories*. Paris, 1977.

———. "The Ruler and the Logos in Neopythagorean, Middle Platonic and Late Stoic Political Philosophy". *ANRW* 2. 16.2 (1978), pp. 1310–32.

R. Chevallier. *Voyages et déplacements dans l'empire romain*. Paris, 1988.

P. Chuvin. *A Chronicle of the Last Pagans*. Cambridge, Mass., 1990.

D. L. Clark. *Rhetoric in Graeco-Roman Education*. New York, 1957.

J. R. Clarke. "Notes on the Coordination of Wall, Floor and Ceiling Decoration in the Houses of Roman Italy, 100 BCE–235 CE". In M. A. Lavin, ed., *IL: Essays Honoring Irving Lavin on his 60th Birthday*, pp. 1–30. New York, 1990.

———. *The Houses of Roman Italy, 100 B.C.–A.D. 250: Ritual, Space and Decoration*. Berkeley, 1991.

M. Conan, "The *Imagines* of Philostratus". *Word and Image* 3 (1987), pp. 162–71.

W. W. S. Cook. "The Earliest Painted Panels of Catalonia". *Art Bulletin* 6, 2 (1923), pp. 31–60.

D. Corlàita Scagliarini. "Spazio e Decorazione nella Pittura Pompeiana". *Palladio*, n.s. 23–5 (1974–6), pp. 3–44.

O. M. Dalton. "A Second Silver Treasure from the District of Kyrenia, Cyprus". *Archaeologia* 60 (1906), pp. 1–24.

J. Daly. *The Idea of Christian Sacrifice*. Chicago, 1977.

H.-J. Van Dam. *Silvae Book 2*. Leiden, 1984.

R. Van Dam. *Leadership and Community in Late Antique Gaul*. Berkeley, 1985.

J. Danielou. *Platonisme et theologie mystique: Essai sur la doctrine spirituelle de S. Gregoire de Nysse*. Paris, 1944.

W. A. Daszewski. *Dionysos der Erlöser*. Mainz, 1985.

G. Daux. *Pausanias à Delphes*. Paris, 1936.

C. Davis-Weyer. *Early Medieval Art, 300–1150*. Toronto, 1986.

D. Dawson. *Allegorical Readers and Cultural Revision in Ancient Alexandria*. Berkeley, 1992.

J. G. Deckers. "Die Wandmalerei des tetrarchischen Lagerheiligtums im Ammon-Tempel von Luxor." *Roemische Quartalschrift* 68 (1973), pp. 1–34.

———. "Die Wandmalerei im Kaiserkultraum von Luxor". *Jahrbuch des Deutschen Archaeologischen Instituts* 94 (1979), pp. 600–52.

F. W. Deichmann. *Frühchristliche Bauten und Mosaiken von Ravenna*. Baden-Baden, 1958.

———. *Ravenna: Hauptstadt des Spätantiken Abendlandes*. Kommentar I. Wiesbaden, 1974.

———. *Ravenna: Hauptstadt des Spätantiken Abendlandes*. Kommentar II. Wiesbaden, 1976.

R. Delbrueck. *Probleme der Lipsanothek in Brescia*. Bonn, 1952.

M. Detienne and J.-P. Vernant. *La cuisine du sacrifice en pays grec*. Paris, 1979.

P. Devos. "La date du voyage d'Egerie". *Analecta Bollandiana* 85 (1967), pp. 165–94.

E. Diez and O. Demus. *Byzantine Mosaics in Greece: Hosios Loukas and Daphni*. Cambridge, Mass., 1931.

A. Diller. *Studies in Greek Manuscript Tradition*. Amsterdam, 1983.

J. M. Dillon. *The Middle Platonists: A Study of Platonism 80 B.C. to A.D. 220*. London, 1977.

G. Dix. *The Shape of the Liturgy*. London, 1945.

E. R. Dodds. *Pagan and Christian in an Age of Anxiety*. Cambridge, 1965.

G. Downey. "The Pilgrim's Progress of the Byzantine Emperor". *Church History* 9 (1940), pp. 207–17.

———. "Ekphrasis". In *Reallexicon für Antike und Christentum*, vol. 4, pp. 921–44. 1959.

H. A. Drake. *In Praise of Constantine*. Berkeley and London, 1976.

H. Drerup. "Bildraum und Realraum in der römischen Architektur". *Mitteilungen des Deutschen Archaeologischen Instituts: Römische Abteilung* 66 (1959), pp. 147–74.

———. "Der römische Villa". *Marburger Winckelmann-Programm* (1959), pp. 1–24.

L. G. Duggan. "Was Art Really the 'Book of the Illiterate'?". *Word and Image* 5 (1989), pp. 227–51.

K. M. D. Dunbabin. *"Sic Erimus Cuncti . . . The Skeleton in Graeco-Roman Art"*. *Jahrbuch des Deutschen Archäologischen Instituts* 101 (1986), pp. 185–255.

F. Dvornik. *Early Christian and Byzantine Political Philosophy*. Washington, 1966.

E. Dwyer. "The Pompeian Atrium House in Theory and in Practice". In E. K. Gazda, ed., q.v., pp. 25–48.

T. Eagleton. *Walter Benjamin: Towards a Revolutionary Criticism*. London, 1981.

H. L. Ebeling. "Pausanias as an Historian". *Classical Weekly* 7 (1913), pp. 138–41, 146–50.

D. L. Eck. "India's *Tirthas*: 'Crossings' in Sacred Geography". *History of Religions* 20 (1981), pp. 323–44.

K. Eden. *Poetic and Legal Fiction in the Aristotelian Tradition*. Princeton, 1986.

M. Eliade. *The Myth of Eternal Return*. New York, 1954.

S. Ellis. "Power, Architecture and Decor: How the Late Roman Aristocrat Appeared to His Guests". In E. K. Gazda, ed., q.v., pp. 117–34.

J. Elsner. "Image and Iconoclasm in Byzantium". *Art History* 11, 4 (December 1988), pp. 471–91.

————. "Cult and Sculpture: Sacrifice in the Ara Pacis Augustae". *Journal of Roman Studies* 81 (1991), pp. 50–61.

————. "Visual Mimesis and the Myth of the Real: Ovid's Pygmalion as Viewer". *Ramus* 20, 2 (1991), pp. 154–68.

————. "From the Pyramids to Pausanias and Piglet: Monuments, Travel and Writing". In S. D. Goldhill and R. Osborne, eds., q.v., pp. 224–54.

W. Ehrhardt. *Stilgeschichtliche Untersuchungen an römischen Wandmalereien von der späten Republik bis zur Zeit Neros*. Mainz, 1987.

————. "Bild und Ausblick in Wandbemalungen Zweiten Stils". *Antike Kunst* 34 (1991), pp. 28–65.

J. Engemann. *Architekturdarstellungen des frühen zweiten Stils*. Heidelberg, 1967.

————. "Altes und Neues zu Beispielen heidnischer und christlicher Katakombenbilder im spätantiken Rom". *Jahrbuch für Antike und Christentum* 26 (1983), pp. 128–51.

————. "The Christianization of Late Antique Art". In *The Seventeenth International Byzantine Congress: The Major Papers*, pp. 83–105. New Rochelle, 1986.

M. Fattori and M. Bianchi, eds. *Phantasia – Imaginatio: Vo Colloquio Internazionale*. Rome, 1988.

J. R. Fears. Princeps a diis electus: *The Divine Election of the Emperor as a Political Concept in Rome*. Papers and Monographs of the American Academy in Rome 26. Rome, 1977.

C. Fensterbusch. *Vitruv: Zehn Bücher über Architektur*. Darmstadt, 1964.

E. Ferguson. "Spiritual Sacrifice in Early Christianity and its Environment". *ANRW* 2. 23.2 (1980), pp. 1151–89.

J. Ferguson. *Among the Gods*. London, 1990.

S. Ferri. "Plotino e l'arte del III secolo". *La critica d'arte* 1 (1936), pp. 166–71.

A. Ferrua. *Le Pitture della Nuova Catacomba di Via Latina*. Vatican City, 1960.

————. *The Unknown Catacomb*. New Lanark, 1990.

J. Fink. "Hermeneutische Probleme in der Katakombe der Via Latina in Rom". *Kairos* 18 (1976), pp. 178–90.

————. *Bildfrömmigkeit und Bekenntnis: Das Alte Testament, Herakles und die Herrlichkeit Christi an der Via Latina in Rom*. Cologne, 1978.

————. "Herakles als Christusbild an der Via Latina". *Rivista di Archaeologia Cristiana* 56 (1980), pp. 133–46.

R. O. Fink. *Roman Military Records on Papyrus*. Philological Monographs of the American Philological Association 26. Cleveland, Ohio, 1971.

S. Fish. *Is There a Text in This Class?* Cambridge, Mass., 1980.

D. Fishwick. "The Development of Provincial Ruler Worship in the Western Roman Empire". *ANRW* 2. 16.2 (1978), pp. 1201–53.

————. *The Imperial Cult in the Latin West*. Leiden, 1987.

K. Fittschen. "Zur Panzerstatue in Cherchel". *Jahrbuch des Deutschen Archaeologischen Instituts* 91 (1976), pp. 175–210.

J. T. Fitzgerald and L. M. White. *The Tabula of Cebes*. Chico, Calif., 1983.

R. Fleischer. *Artemis von Ephesus und Verwandte Kultstatuen aus Anatolien und Syrien*. Leiden, 1973.

————. "Artemis Ephesia". In *Lexicon Iconographicum Mythologiae Classicae*, vol. 2, 1, pp. 755–63. Munich, 1984.

G. Forsyth and K. Weitzmann. *The Monastery of St Catherine at Mt Sinai: The Church and Fortress of Justinian*. Ann Arbor, 1973.

B. Forte. *Rome and the Romans as the Greeks Saw Them*. Rome, 1972.

M. Foucault. *The Order of Things*. London, 1970.

E. Fraenkel. *Plautinisches im Plautus*. Berlin, 1922.

A. de Franciscis. "La Villa Romana di Oplontis". *Parola del Passato* 28 (1973), pp. 453–66.

———. "La Villa Romana di Oplontis". In B. Andreae and H. Kyrieleis, eds., *Neue Forschungen in Pompeji*, pp. 9–38. Recklinghausen, 1975.

P. M. Fraser. *Ptolemaic Alexandria*. Oxford, 1972.

J. G. Frazer. *Pausanias's Description of Greece*. London, 1898.

———. *Pausanias and Other Greek Sketches*. London, 1900.

L. Friedlaender. *Darstellungen aus der Sittengeschichte Roms*. Leipzig, 1921–3.

P. Friedlaender. *Johannes von Gaza und Paulus Silentarius*. Berlin, 1912.

M. Fuchs. "Philostrate, un critique d'art chez les Sevères". *Revue des Études Latines* 65 (1987), pp. 12–15.

M. M. Gabriel. *Livia's Garden Room at Prima Porta*. New York, 1955.

G. Galavaris. *Bread and the Liturgy*. Madison and London, 1970.

P. Garnsey and R. Saller. *The Roman Empire*. London, 1987.

E. K. Gazda, ed. *Roman Art in the Private Sphere*. Ann Arbor, 1991.

E. Gebremedhin. *Life-Giving Blessing: An Inquiry into the Eucharistic Doctrine of Cyril of Alexandria*. Uppsala, 1977.

C. Geertz. "Religion as a Cultural System". In M. Banton, ed., *Anthropological Approaches to the Study of Religion*, ASA Monographs 3, pp. 1–46. London, 1966.

———. "Deep Play: Notes on the Balinese Cockfight". *Daedalus* (Winter 1972), pp. 1–38.

———. "Art as a Cultural System". In C. Geertz, *Local Knowledge*, pp. 94–120. New York, 1983.

R. Girard. *Violence and the Sacred*. Baltimore, 1979.

S. D. Goldhill and R. Osborne, eds. *Art and Text in Ancient Greek Culture*. Cambridge, 1994.

E. H. Gombrich. *Art and Illusion*. London, 1960.

———. *The Story of Art*. London, 1964.

———. *Norm and Form*. Oxford, 1966.

———. *The Heritage of Apelles*. Oxford, 1976.

———. *The Image and the Eye*. Oxford, 1982.

E. R. Goodenough. *By Light, Light: The Mystic Gospel of Hellenistic Judaism*. New Haven and London, 1935.

———. *An Introduction to Philo Judaeus*. New Haven and London, 1938.

———. "Catacomb Art". *Journal of Biblical Literature* 81 (1962), pp. 113–42.

R. L. Gordon. "Mithraism and Roman Society: Social Factors in the Explanation of Religious Change in the Roman Empire". *Religion* 2, 2 (Autumn 1972), pp. 92–121.

———. "A New Mithraic Relief from Rome". *Journal of Mithraic Studies* 1, 2 (1976), pp. 166–86.

———. "The Sacred Geography of a Mithraeum: The Example of Sette Sfere". *Journal of Mithraic Studies* 1, 2 (1976), pp. 119–65.

———. "The Date and Significance of CIMRM 593 (British Museum, Townley Collection)". *Journal of Mithraic Studies* 2, 2 (1978), pp. 148–74.

———. "Iconographical Notes on the Projejena Reliefs". *Journal of Mithraic Studies* 2, 2 (1978), pp. 13–85.

———. "The Real and the Imaginary: Production and Religion in the Graeco-Roman World". *Art History* 2, 1 (March 1979), pp. 5–34.

———. "Panelled Complications". *Journal of Mithraic Studies* 3 (1980), pp. 200–27.

———. "Reality, Evocation and Boundary in the Mysteries of Mithras". *Journal of Mithraic Studies* 3 (1980), pp. 19–99.

———. "Authority, Salvation and Mystery in the Mysteries of Mithras". In J. Huskinson et al., eds., q.v., pp. 45–80.

———. "The Veil of Power: Emperors, Sacrificers and Benefactors". In M. Beard and J. North, eds., q.v., pp. 199–232.

A. Grabar. *L'empéreur dans L'art byzantin*. Paris, 1936.

———. "Plotin et les origines de l'esthétique médiévale". *Cahiers archaeologiques* 1 (1945), pp. 15–36.

———. "The Virgin in a Mandorla of Light". In K. Weitzmann, ed., *Late Classical and Mediaeval Studies in Honor of Albert Matthias Friend Jr.*, pp. 305–11. Princeton, 1955.

———. "Quel est le sens de l'offrande de Justinien et de Théodora sur les mosaiques de St-Vital?" *Felix Ravenna* 81 (1960), pp. 63–77.

———. *The Beginnings of Christian Art*. London, 1967.

———. *Christian Iconography: A Study of Its Origins*. London, 1968.

———. "Le tiers monde de l'Antiquité à l'école classique et son rôle dans la formation de l'art du Moyen Age". *Revue de l'art* 18 (1972), pp. 1–59.

A. G. Grapard. "Flying Mountains and Walkers of Emptiness: Towards a Definition of Sacred Space in Japanese Religion". *History of Religions* 21, 3 (1982), pp. 195–221.

S. Greenblatt. *Learning to Curse: Essays in Early Modern Culture*. New York and London, 1990.

J. Gros. *La divinisation du chrétien d'après les Pères grecs*. Paris, 1938.

M. van Grunsven-Eygenraam. "Heraclius and the David Plates". *Bulletin Antieke Beschaving* 48 (1973), pp. 158–74.

C. Habicht. *Pausanias' Guide to Ancient Greece*. Berkeley, 1985.

T. N. Habinek. "Sacrifice, Society and Vergil's Ox-Born Bees". In M. Griffith and D. J. Mastronarde, eds., *Cabinet of the Muses: Essays on Classical and Comparative Literature in Honor of T. G. Rosenmeyer*, pp. 209–23. Atlanta, 1990.

S. Hackel, ed. *The Byzantine Saint*. London, 1981.

H. Halfmann, *Itinera Principum: Geschichte und Typologie der Kaiserreisen im römischen Reich*. Stuttgart, 1986.

R. G. Hamerton-Kelly, ed. *Violent Origins*. Stanford, 1987.

F. J. Hamilton. *The Ecclesiastical History of Zacharius Rhetor*. London, 1892.

G. M. A. Hanfmann. *Roman Art*. London, 1964.

N. Hannestad. *Roman Art and Imperial Policy*. Hojbjerg, 1986.

M. Harbsmeier. "Elementary Structures of Otherness". In J. Céard and J. C. Margolin, eds., *Voyager à la Renaissance*, pp. 337–55. Paris, 1987.

P. Harsh. "The Origins of the Insulae at Ostia". *Memoires of the American Academy at Rome* 12 (1935), pp. 7–66.

F. Hartog. *The Mirror of Herodotus*. Berkeley, 1988.

A. Hauser. *Mannerism*. London, 1965.

F. Haverfield. "Roman Silver in Northumberland". *Journal of Roman Studies* 4 (1914), pp. 1–12.

G. Hawthorn. *Plausible Worlds: Possibility and Understanding in History and the Social Sciences*. Cambridge, 1991.

D. E. L. Haynes and P. E. D. Hirst. *Porta Argentariorum*. London, 1939.

J. Heer. *La personnalité de Pausanias*. Paris, 1979.

J. A. W. Heffernan. "Ekphrasis and Representation". *New Literary History* 22, 2 (1991), pp. 297–316.

W. Helbig. *Führer durch die offentlichen Sammlungen klassischer alturmer in Rom*. Vol. 1: *Die päpstlichen Sammlungen im Vatikan und Lateran*. Tubingen, 1963.

G. Hermansen. "The Population of Imperial Rome: The Regionaries". *Historia* 27 (1978), pp. 129–68.

A. Héron de Villefosse. *Le trésor de Boscoreale*. Monuments et mémoires de l'académie des inscriptions et belles-lettres 5. Paris, 1899.

C. J. Herrington. *Athena Parthenos and Athena Polias*. Manchester, 1955.

P. Herz. "Bibliographie zum römischen Kaiserkult". *ANRW* 2. 16.2 (1978), pp. 833–910.

R. Hexter. "*O Fons Bandusiae*: Blood and Water in Horace, Odes III, 13". In M. Whitby et al., eds., q.v., pp. 131–9.

J. Heyward. *A Dialogue Containing the Number in Effect of All the Proverbs in the English Tongue*. London, 1546.

F. N. C. Hicks. *The Fullness of Sacrifice*. London, 1930.

R. Hinks. *Myth and Allegory in Ancient Art*. London, 1939.

J. R. Hinnells. "Reflections on the Bull Slaying Scene". In J. R. Hinnells, ed., q.v., pp. 290–312.

———, ed. *Mithraic Studies*. Manchester, 1975.

R. Hirschon. "Essential Objects and the Sacred: Interior and Exterior Space in an Urban Greek Society". In S. Ardener, ed., q.v., pp. 72–88.

A. Hohlweg. "Ekphrasis". In *Reallexicon zur Byzantinischen Kunst*, vol. 2, pp. 33–75. Stuttgart, 1971.

P. J. Holliday. "Time, History and Ritual on the Ara Pacis Augustae". *Art Bulletin* 72 (1990), pp. 542–57.

J. B. Holloway. *The Pilgrim and the Book*. New York, 1987.

T. Hölscher. "Die Geschichtsauffassung in der römischen Repräsentationskunst". *Jahrbuch des Deutschen Archäologischen Instituts* 95 (1980), pp. 265–321.

K. Holum. "Hadrian and St Helena: Imperial Travel and the Origins of Christian Holy Land Pilgrimage". In R. Ousterhout, ed., q.v., pp. 61–81.

R. Hooker. *Of the Laws of Ecclesiastical Polity*. London, 1593.

K. Hopkins. *Conquerors and Slaves*. Cambridge, 1978.

H. Hunger. *Die hochsprachliche profane Literatur der Byzantiner*. 2 vols. Munich, 1978.

E. D. Hunt. *Holy Land Pilgrimage in the Later Roman Empire, AD 312–460*. Oxford, 1982.

———. "Travel, Tourism and Piety in the Roman Empire". *Échos du monde classique* 28 (1984), pp. 391–417.

R. L. Hunter. *A Study of Daphnis and Chloe*. Cambridge, 1983.

J. Huskinson. "Some Pagan Mythological Figures and Their Significance in Early Christian Art". *Papers of the British School at Rome* 42 (1974), pp. 68–97.

J. Huskinson, M. Beard and J. Reynolds, eds. *Image and Mystery in the Roman World*. Gloucester, 1988.

J. M. Hussey. *The Orthodox Church in the Byzantine Empire*. Oxford, 1986.

C. Imbert. "Stoic Logic and Alexandrian Poetics". In M. Schofield et al., eds., q.v., pp. 182–216.

H. Ingholt. "The Prima Porta Statue of Augustus: Part 2 – The Location of the Original". *Archaeology* 22, 4 (1969), pp. 304–18.

S. Insler. "A New Interpretation of the Bull-Slaying Motif". In M. B. de Boer and T. A. Edridge, eds., *Hommages à M. J. Vermaseren*, vol. 2, pp. 519–38. Leiden, 1978.

A. M. Ioppolo. "Presentation and Assent: A Physical and Cognitive Problem in Early Stoicism". *Classical Quarterly* 2, 40 (1990), pp. 433–49.

Ch. Jacob. "The Greek Traveler's Areas of Knowledge: Myths and Other Discourses in Pausanias's *Description of Greece*". *Yale French Studies* 59 (1980), pp. 65–85.

W. Jaeger. *Two Rediscovered Works of Ancient Christian Literature*. Leiden, 1954.

E. O. James. *Sacrifice and Sacrament*. London, 1962.

L. James and R. Webb. "To Understand Ultimate Things and Enter Secret Places: Ekphrasis and Art in Byzantium". *Art History* 14 (1991), pp. 1–17.

M. Jha, ed. *Dimensions of Pilgrimage*. Delhi, 1985.

F. S. Johansen. "Le portrait d'Auguste de Prima Porta et sa datation". In K. Ascani et al., eds., *Studia Romana in honorem P. Krarup*, pp. 49–57. Odense, 1976.

C. Johns and T. Potter. *The Thetford Treasure*. London, 1983.

R. Joly. *Le tableau de Cèbes et la philosophie religieuse*. Brussels, 1963.

A. H. M. Jones. *Augustus*. London, 1970.

C. P. Jones. *Plutarch and Rome*. Oxford, 1971.

H. Jordan. *Topographie der Stadt Rom in Altertum*. Berlin, 1871.

M. Jost. "Pausanias en Megalopolitide". *Revue des études anciennes* 75 (1973), pp. 241–67.

H. Jucker. "Dokumentation zur Augustus-statue von Prima Porta". *Hefte des Archäologischen Seminars der Universität Berne* 3 (1977), pp. 16–37.

F. Jung. "Gebaute Bilder". *Antike Kunst* 27, 2 (1984), pp. 71–122.

H. Kähler. *Hadrian und seiner Villa bei Tivoli*. Berlin, 1950.

———. "Die Ara Pacis und die Augusteische Friedensidee". *Jahrbuch des Deutschen Archaeologischen Instituts* 69 (1954), pp. 67–100.

———. *Die Augustusstatue von Primaporta*. Koln, 1959.

I. Kalevrezou-Maxeiner. "The Imperial Chamber at Luxor". *Dumbarton Oaks Papers* 29 (1975), pp. 225–51.

J. P. Kane. "The Mithraic Cult Meal in Its Greek and Roman Environment". In J. R. Hinnells, ed., q.v., pp. 313–51.

B. Kapferer. *A Celebration of Demons*. Bloomington, 1983.

A. Kazhdan and G. Constable. *People and Power in Byzantium*. Washington, D.C. 1982.

J. N. D. Kelly. *Early Christian Doctrines*. London, 1958.

G. Kennedy. "The Sophists as Declaimers". In G. W. Bowersock, ed., q.v., pp. 17–22.

J. P. C. Kent and K. S. Painter. *Wealth of the Roman World, A.D. 300–700*. London, 1977.

K. Kerenyi. *Eleusis: Archetypal Image of Mother and Daughter*. New York, 1967.

J. Kestner. "Ekphrasis as Frame in Longus' *Daphnis and Chloe*". *The Classical World* 67 (1973–4), pp. 166–71.

J. Khatib-Chahidi. "Sexual Prohibitions, Shared Space and Fictive Marriages in Shi'ite Iran". In S. Ardener, ed., q.v., pp. 112–35.

E. Kitzinger. *Early Medieval Art*. London, 1940.

———. "The Cult of Images before Iconoclasm". *Dumbarton Oaks Papers* 8 (1954), pp. 85–150.

———. "Byzantine Art in the Period between Justinian and Iconoclasm". *Berichte zum XI Internationalen Byzantinischen-Kongress*, Munich, 1958. , vol. 4, pp. 1–50.

———. *Byzantine Art in the Making*. London, 1977.

G. Koeppel. "Die historischen Reliefs der römischen Kaiserzeit V: Ara Pacis Augustae". Teil I. *Bonner Jahrbücher* 187 (1987), pp. 101–57.

J. Kollwitz. *Die Lipsanothek von Brescia*. Berlin, 1933.

E. G. Konstantinou, *Die Tugendlehre Gregors von Nyssa im Verhaltnis zu der Antik-Philosophischen und Judisch-Christlichen Tradition*. Wurzburg, 1966.

L. Kötzsche-Breitenbruch. *Die Neue Katakombe an der Via Latina in Rom*. Munster, 1976.

T. Kraus. *Pompeii and Herculaneum*. New York, 1975.

M. Krieger. "The Ambiguities of Representation and Illusion: An E. H. Gombrich Retrospective". *Critical Inquiry* 11, 2 (December 1984), pp. 181–94.

J. H. Kroll. "The Ancient Image of Athena Polias". *Hesperia*, suppl. 20 (1982), pp. 65–76.

J. Lacan. *The Four Fundamental Concepts of Psycho-Analysis*. Harmondsworth, 1986.

A. Laidlaw. *The First Style in Pompeii: Painting and Architecture*. Rome, 1985.

R. Lamberton. *Homer the Theologian*. Berkeley, 1986.

R. Lane Fox. *Pagan and Christians*. London, 1986.

N. R. M. de Lange. "Jewish Attitudes to the Roman Empire". In P. D. A. Garnsey and C. R. Whittacker, eds., *Imperialism in the Ancient World*, pp. 255–81. Cambridge, 1978.

K. Latte. *Römische Religionsgeschichte*. Munich, 1960.

A. W. Lawrence. *Greek and Roman Sculpture*. London, 1972.

M. Lawrence. "The Iconography of the Mosaics of San Vitale". *Atti del VI Congresso Internazionale di Archaeologia Cristiana*, Vatican City, 1965, pp. 123–40.

E. R. Leach. *Genesis as Myth and Other Essays*. London, 1969.

———. "Fishing for Men on the Edge of the Wilderness". In F. Kermode and R. Alter, eds., *The Literary Guide to the Bible*, pp. 579–99. London, 1987.

E. R. Leach and D. A. Aycock. *Structuralist Interpretations of Biblical Myth*. Cambridge, 1983.

E. W. Leach. "De Exemplo Meo Ipse Aedificato: An Organizing Idea in the Mostellaria". *Hermes* 97 (1969), pp. 318–32.

———. *The Rhetoric of Space*. Princeton, 1988.

P. W. Lehmann. *Roman Wall Paintings from Boscoreale in the Metropolitan Museum of Art*. Cambridge, Mass., 1953.

K. Lehmann-Hartleben. "The Imagines of the Elder Philostratus". *Art Bulletin* 23 (1941), pp. 16–44.

A. Lesky. "Bildwerk und Deutung bei Philostrat und Homer". *Hermes* 75 (1940), pp. 38–53.

C. Lévi-Strauss. *Tristes Tropiques*. London, 1973.

G. Lewis. *Day of Shining Red: An Essay in Understanding Ritual*. Cambridge, 1980.

R. G. A. van Lieshout. *Greeks on Dreams*. Utrecht, 1980.

R. Ling. "Studius and the Beginnings of Roman Landscape Painting". *Journal of Roman Studies* 67 (1977), pp. 1–16.

————. *Roman Painting*. Cambridge, 1991.

A. M. G. Little. *Roman Perspective Painting and the Ancient Stage*. Washington, 1971.

W. Loerke. "Observations on the Representation of *Doxa* in the Mosaics of S. Maria Maggiore, Rome, and St Catherine's, Sinai". *Gesta* 20, 1 (1981), pp. 15–22.

————. " 'Real Presence' in Early Christian Art". In T. G. Verdon, ed., *Monasticism and the Arts*, pp. 30–51. Syracuse, N.Y., 1984.

N. Loraux. "L'autochthonie: Une topique athénienne. Le mythe dans l'éspace civique". *Annales E.S.C.* 34 (1979), pp. 3–26.

————. *Les enfants d'Athéna*. Paris, 1981.

————. *The Invention of Athens*. Cambridge, Mass., 1986.

S. MacCormack. *Art and Ceremony in Late Antiquity*. Berkeley and London, 1981.

————. "*Loca Sancta*: The Organization of Sacred Topography in Late Antiquity". In R. Ousterhout, ed., q.v., pp. 7–40.

J. A. McGuckin. *The Transfiguration of Christ in Scripture and Tradition*. Lewiston and Queenston, 1986.

C. W. MacLeod. "Allegory and Mysticism in Origen and Gregory of Nyssa". *Journal of Theological Studies*, n.s. 22, 2 (1971), pp. 362–79.

R. MacMullen. "Some Pictures in Ammianus Marcellinus". *Art Bulletin* 46 (1964), pp. 435–55.

————. *Paganism in the Roman Empire*. New Haven and London, 1981.

————. *Christianizing the Roman Empire*. New Haven and London, 1984.

B. D. MacQueen. "Longus and the Myth of Chloe". *Illinois Classical Studies*, 10, 1 (1985), pp. 119–34.

F. de' Maffei. "L'Unigenito consustanziale al Padre nel programma trinitario dei perduti mosaici del bema della Dormizione di Nicea e il Cristo trasfigurato del Sinai – II". *Storia dell' Arte* 46 (1982), pp. 185–200.

H. Maguire. *Earth and Ocean*. University Park and London, 1990.

A. Maiuri. *La Villa dei Misteri*. Rome, 1931.

————. *Roman Painting*. Geneva, 1953.

————. *Ercolano: I Nuovi Scavi 1927–58*. Rome, 1958.

E. S. Malbon. *The Iconography of the Sarcophagus of Junius Bassus*. Princeton, 1990.

K. Manafis, ed. *Sinai: Treasures of the Monastery of St Catherine*. Athens, 1990.

E. Manara, "Di un' ipotesi per l'individuazione dei personaggi nei pannelli del S. Vitale a Ravenna e per la loro interpretazione". *Felix Ravenna* 125–6 (1983), pp. 13–37.

C. Mango. *Byzantium: The Empire of New Rome*. London, 1980.

————. *The Art of the Byzantine Empire, 312–1453*. Toronto, 1986.

M. M. Mango. *Silver from Early Byzantium*. Baltimore, 1986.

————. "Un nouveau trésor (dit de 'Sevso') d'argenterie de la Basse Antiquité". *Comptes rendus de l'académie des inscriptions et de belles-lettres*, pp. 238–54. 1990.

————. "Der Sevso-schatzfund. Ein Ensemble westlichen und östlichen Kunstschaffens". *Antike Welt* 21 (1990), pp. 70–88.

————. *The Sevso Treasure*. Sotheby's. London, 1990.

————. "The Sevso Treasure Hunting Plate". *Apollo* (July 1990), pp. 2–13.

G. D. Mansi. *Sacrorum Conciliorum Nova et Amplissima Collectio*. Florence, 1859–98.

R. A. Markus. *The End of Ancient Christianity*. Cambridge, 1990.

H. I. Marrou. *A History of Education in Antiquity*. London, 1956.

A. K. Massner. *Bildnisangleichung: Untersuchungen zur Entstehungs- und Wihungsgeschichte der Augustusporträts (43 v.Chr.–68 n.Chr.)*, Das Römische Herrscherbild 4. Berlin, 1982.

J. Mateos. *La célébration de la parole dans la liturgie byzantine*. Rome, 1971.

T. F. Mathews. *The Early Churches of Constantinople: Architecture and Liturgy*. University Park and London, 1971.

A. Mau. *Geschichte der decorativen Wandmalerei in Pompeji*. Berlin, 1882.

———. *Pompeii: Its Life and Art*. London, 1899.

R. Merkelbach. *Roman und Mysterium in der Antike*. Munich, 1962.

H. Merki. *Homoiôsis Theôi: Von der platonischen Angleichung an Gott zu Gottanlichkeit bei Gregor von Nyssa*. Freiburg, 1952.

M. Méslin. "Convivialité ou communion sacramentelle? Repas mithriaque et eucharistie chrêtienne". In A. Benoit, M. Philonenko and C. Vogel, eds., *Mélanges offerts à Marcel Simon: Paganisme, Judaisme, Christianisme*, pp. 295–305. Paris, 1978.

J. Meyendorff. *Byzantine Theology*. New York, 1974.

———. *The Byzantine Legacy in the Orthodox Church*. Crestwood, N.Y., 1982.

H. Meyer. *Kunst und Geschichte*. Münchner Archäologische Studien 4. Munich, 1983.

H. Mielsch. "Funde und Forschungen zur Wandmalerei der Prinzipätszeit von 1945 bis 1975, mit einem nachtrag 1980". *ANRW* 2. 12.2 (1981), pp. 158–264.

F. Millar. "The Imperial Cult and the Persecutions". In W. den Boer, ed., q.v., pp. 145–65.

———. *The Emperor in the Roman World*. London, 1977.

———. "State and Subject: The Impact of the Monarchy". In F. Millar and E. Segal, eds., q.v., pp. 37–60.

F. Millar and E. Segal, eds. *Caesar Augustus*. Oxford, 1984.

M. C. Mittelstadt. "Longus: *Daphnis and Chloe* and Roman Narrative Painting". *Latomus* 26 (1967), pp. 752–61.

J. Miziolek. "*Transfiguratio Domini* in the Apse at Mt Sinai and the Symbolism of Light". *Journal of the Warburg and Courtauld Institutes* 53 (1990), pp. 42–60.

U. Monneret de Villard. "The Temple of the Imperial Cult at Luxor". *Archaeologia* 95 (1953), pp. 85–105.

G. Moretti. *Ara Pacis Augustae*. Rome, 1948.

C. R. Morey. *Early Christian Art*. Princeton, 1942.

H. L. Moore. *Space, Text and Gender: An Anthropological Study of the Marakwet of Kenya*. Cambridge, 1986.

K. Morrison. *I Am You: The Hermeneutics of Empathy in Western Literature, Theology and Art*. Princeton, 1988.

K. K. Mueller. *De arte critica Cebetis Tabulae adhibenda*. Virceburgi, 1877.

C. Müller. *Geographi Graeci Minores*. Vol. 1. Paris, 1882.

K. Muller. *Geschichte der antiken Ethnographie und ethnologischen Theoriebildung*. Vol. 2. Wiesbaden, 1980.

C. Murray, "Art and the Early Church". *Journal of Theological Studies*, n.s. 28 (1977), pp. 305–45.

———. *Rebirth and Afterlife: A Study of the Transmutation of Some Pagan Imagery in Early Christian Funerary Art*. British Archaeological Reports 100. Oxford, 1981.

H. Musurillo. *From Glory to Glory: Texts from Gregory of Nyssa's Mystical Writings*. London, 1961.

G. E. Mylonas. *Eleusis and the Eleusinian Mysteries*. Princeton, 1962.

T. S. Naidu. "Pilgrims and Pilgrimage: A Case Study of the Tirumala-Tirupati Devasthanams". In M. Jha, ed., q.v., pp. 17–25.

D. M. Nicol. "Byzantine Political Thought". In J. H. Burns, ed., *The Cambridge History of Medieval Political Thought*, pp. 51–79. Cambridge, 1988.

A. D. Nock. *Conversion*. Oxford, 1933.

N. Norbu. *The Crystal and the Way of Light*. London, 1986.

A. Nordh. *Libellus de Regionibus Urbis Romae*. Lund, 1949.

C. O. Nordstroem. *Ravennastudien*. Figura 4. Uppsala, 1953.

J. North. "Conservation and Change in Roman Religion". *Papers of the British School at Rome*, 44 (1976), pp. 1–12.

———. "Religious Toleration in Republican Rome". *Proceedings of the Cambridge Philological Society*, 205, n.s. 25 (1979), pp. 85–103.

J. Onians. "Abstraction and Imagination in Late Antiquity". *Art History* 3 (1980), pp. 1–24.

M. L. D'Ooge. *The Acropolis of Athens*. London, 1908.

H. P. L'Orange. *Apotheosis in Ancient Portraiture*. Oslo, 1947.

———. *Art Forms and Civic Life in the Late Roman Empire*. Princeton, 1965.

R. Osborne. "The Erection and Mutilation of the Hermai". *Proceedings of the Cambridge Philological Society* 211, n.s. 31 (1985), pp. 47–73.

R. E. Oster. "Ephesus as a Religious Centre under the Principate". *ANRW* 2.18.3 (1990), pp. 1661–1728.

R. Ousterhout, ed. *The Blessings of Pilgrimage*. Urbana, 1990.

E. Pagels. "Gnostic and Orthodox Views of Christ's Passion: Paradigms for the Christian Response to Persecution?" In B. Layton, ed., *The Rediscovery of Gnosticism*, vol. 1, pp. 262–89. Leiden, 1980.

K. S. Painter. "Roman Silver Hoards: Ownership and Status". In G. Brusin and P. L. Zovatto, *Monumenti Paleocristiani di Aquileia e di Grado*, pp. 97–112. Friuli, 1957.

———. *The Mildenhall Treasure*. London, 1977.

———. "The Sevso Treasure". *Minerva* 1 (1990), pp. 4–11.

J. Palm. *Rom, Römertum und Imperium in der griechischen Litteratur der Kaiserzeit*. Lund, 1959.

———. "Bemerkungen zur Ekphrase in der greichischen Literatur". *Kungliga Humanistika Vertenskapssamfundet i Uppsala* 1 (1965), pp. 108–211.

T. A. Pandipi. "Daphnis and Chloe: The Art of Pastoral Play". *Ramus* 14, 2 (1985), pp. 116–41.

H. W. Parke. *Festivals of the Athenians*. London, 1977.

G. Pasquali. "Die schriftstellerische Form des Pausanias". *Hermes* 48 (1913), pp. 161–223.

L. T. Pearcy. "Horace's Architectural Imagery". *Latomus* 36 (1977), pp. 772–81.

J. Pelikan. *The Christian Tradition*. Vol. 1, *The Emergence of the Catholic Tradition (100–600)*. Chicago and London, 1971.

———. *The Christian Tradition*. Vol. 2, *The Spirit of Eastern Christendom (600–1700)*. Chicago, 1974.

———. *Imago Dei*. New Haven and London, 1990.

E. Pernice and W. H. Gross. "Beschreibungen von Kunstwerken in der Literatur. Rhetorische Ekphraseis". In U. Hausmann, ed., *Allgemeine Grundlagen der Archaeologie*, pp. 433–47. Munich, 1969.

————. "Der Periegese des Pausanias". In U. Hausmann, ed., *Allgemeine Grundlagen der Archaeologie*, pp. 402–8. Munich, 1969.

B. E. Perry. *The Ancient Romances*. Berkeley, 1967.

D. Pesce. *La Tavola di Cebete*. Brescia, 1982.

L. Petersen. *Zur Geschichte der Personifikation in greichischer Dichtung und bildender Kunst*. Wurzburg, 1939.

S. Petrement. *Le Dieu séparé*. Paris, 1984.

A. Pickard-Cambridge. *The Theatre of Dionysus in Athens*. Oxford, 1946.

P. Pierce. "The Arch of Constantine: Propaganda and Ideology in Late Roman Art". *Art History* 12 (1989), pp. 387–418.

L. Poinssot. *L'autel de la gens Augusta à Carthage*. Tunis, 1929.

J. Pollini. "The Findspot of the Statue of Augustus from Prima Porta". *Bulletino della Commissione Archeologica Communale di Roma* 92 (1987–8), pp. 103–8.

J. J. Pollitt. *The Ancient View of Greek Art*. New Haven, 1974.

C. Praechter. *Cebetis Tabula quanam aetate conscripta esse videatur*. Marburg, 1885.

T. Preger, *Scriptores Originum Constantinopolitanarum*, Leipzig, 1907.

J. J. Preston. "Sacred Centres and Symbolic Networks in South Asia". *The Mankind Quarterly* 20, 3, 4 (1980), pp. 259–93.

S. R. F. Price, "Between Man and God: Sacrifice in the Roman Imperial Cult", *Journal of Roman Studies*, 70 (1980), pp. 28–43.

————. "Gods and Emperors: The Greek Language of the Roman Imperial Cult", *Journal of Hellenic Studies*, 104 (1984), pp. 79–85.

————. *Rituals and Power*, Cambridge, 1984.

————. "From Noble Funerals to Divine Cult: The Consecration of Roman Emperors", pp. 56–105 in D. Cannadine and S. Price, *Rituals of Royalty: Power and Ceremonial in Traditional Societies*. Cambridge, 1987.

K. Raaflaub and M. Toher, eds. *Between Republic and Empire*. Berkeley, 1990.

F. Rakob. "Die Urbanisierung des nördlichen Marsfeldes: Neue Forschungen im Areal des Horologium Augusti". In *Urbs: Espace urbain et histoire*, Collection de l'École Francaise 98, pp. 687–712. Rome, 1987.

T. Ratzka. "Atrium und Licht". In W-D. Heilmeier and W. Hoepfner, *Licht und Architektur*, pp. 95–106. Tübingen, 1990.

E. Rawson. *Intellectual Life in the Late Roman Republic*. London, 1985.

B. P. Reardon. *Courants littéraires grecs des IIe et IIIe siécles après J-C*. Paris, 1971.

O. Regenbogen. "Pausanias". In G. Wissowa, W. Kroll and K. Mittelhaus, eds., *Paulys Realencyclopaedie der classischen Altertumswissenschaft*, supplementband 8, pp. 1008–97. Stuttgart, 1956.

R. Reitzenstein. *Hellenistic Mystery-Religions: Their Basic Ideas and Significance*. Pittsburgh, 1978.

L. Richardson. *Pompeii: An Architectural History*. Baltimore and London, 1988.

G. M. A. Richter. *Perspective in Greek and Roman Art*. London, 1970.

R. M. Rilke. *Letters to a Young Poet*. New York, 1934.

J. M. Rist. *Stoic Philosophy*. Cambridge, 1969.

C. Robert. *Pausanias als Schriftsteller*. Berlin, 1909.

M. Roberts. *The Jewelled Style: Poetry and Poetics in Late Antiquity*. Ithaca and London, 1989.

E. La Rocca. *Ara Pacis Augustae*. Rome, 1983.

G. Rodenwaldt. "Ara Pacis und San Vitale". *Bonner Jahrbücher* 133 (1928), pp. 228–35.

E. Rodriguez-Almeida. "Il Campo Marzio Settentrionale. Solarium e Pomerium". *Atti della Pontificia Academia Romana di Archeologia: Rendiconti* 51–2 (1978–80), pp. 195–212.

D. Rosand. "Ekphrasis and the Generation of Images". *Arion*, 3d ser., 1, 1 (Winter 1990), pp. 61–105.

C. B. Rose. " 'Princes' and Barbarians on the Ara Pacis". *American Journal of Archaeology* 94, 3 (1990), pp. 453–67.

J. Rossiter. "Convivium and Villa in Late Antiquity". In W. J. Slater, ed., *Dining in a Classical Context*, pp. 199–214. Ann Arbor, 1991.

B. Rotman. *Signifying Nothing: The Semiotics of Zero.* Basingstoke, 1987.

G. Roux. *Pausanias en Corinthie.* Paris, 1958.

N. Rudd. "Patterns in Horatian Lyric". *American Journal of Philology* 81 (1960), pp. 373–92.

J. Rudhardt and O. Reverdin, eds. *Le sacrifice dans l'antiquité.* Entretiens Fondation Hardt, vol. 27. Geneva, 1981.

N. Russel. " 'Partakers of the Divine Nature' (2 Peter I.4) in the Byzantine Tradition". In J. Chrysostomides, ed., *KATHEGETRIA* (essays presented to Joan Hussey for her 80th birthday), pp. 51–68. Camberley, 1988.

M. Sachelot. *Les homélies grecques sur la transfiguration.* Paris, 1987.

D. J. Sahas. *Icon and Logos.* Toronto, 1986.

R. P. Saller. *"Familia, Domus* and the Roman Conception of the Family". *Phoenix* 38, 4 (1984), pp. 336–55.

M. R. Salzman. *On Roman Time: The Codex-Calendar of 354 and the Rhythms of Urban Life in Late Antiquity.* Berkeley, 1990.

D. K. Samanta. "Ujjain: A Centre of Pilgrimage in Central India". In M. Jha, ed., q.v., pp. 43–53.

E. Sauser. *Frühchristliche Kunst.* Innsbruck, 1966.

F. Saxl. *Lectures.* Vol. 1. London, 1957.

K. Schefold. *Orient, Hellas und Rom.* Bern, 1949.

————. "Pompeji unter Vespasian". *Mitteilungen des Deutschen Archaeologischen Instituts: Römische Abteilung* 60–1 (1953–4), pp. 106–25.

————. *Vergessenes Pompeji.* Bern and Munich, 1962.

O. Schissel von Fleschenberg. "Die Technik des Bildeinsatzes". *Philologus* 72 (1913), pp. 83–114.

O. Schoenberger. *Philostrat, Die Bilder.* Munich, 1968.

M. Schofield, M. Burnyeat and J. Barnes, eds. *Doubt and Dogmatism.* Oxford, 1980.

B. Schulz. *The Fictions of Bruno Schulz.* London, 1988.

H-J. Schulz. *The Byzantine Liturgy.* New York, 1986.

W. N. Schumacher. "Reparatio Vitae: Zum Programm der neuen Katakombe an der Via Latina zu Rom". *Römische Quartalschrift* 66 (1971), pp. 125–53.

M. Schütz. "Zur Sonnenuhr des Augustus auf dem Marsfeld". *Gymnasium* 97 (1990), pp. 432–57.

B. Schweitzer. "Mimesis und Phantasia". *Philologus* 89 (1934), pp. 286–300.

K. Scott. "Emperor Worship in Ovid". *Transactions and Proceedings of the American Philological Association* 61 (1930), pp. 43–69.

————. *The Imperial Cult under the Flavians.* Stuttgart, 1936.

I. Scott Ryberg. *Rites of the State Religion in Rome.* Memoires of the American Academy in Rome 22. Rome, 1955.

O. Seeck. *Notitia Dignitatum*. Berlin, 1876.

S. Settis. "Die Ara Pacis". In *Kaiser Augustus und die Verlorene Republik*, pp. 400–26. Berlin, 1988.

G. Shaw. "Theurgy: Rituals of Unification in the Neoplatonism of Iamblichus". *Traditio* 41 (1985), pp. 1–28.

K. Shelton. *The Esquiline Treasure*. London, 1981.

———. "Roman Aristocrats, Christian Commissions: The Carrand Diptych". In F. M. Clover and R. S. Humphreys, eds., *Tradition and Innovation in Late Antiquity*, pp. 105–27. Madison and London, 1989.

E. Simon. "Zur Augustusstatue von Prima Porta". *Mitteilungen des Deutschen Archaeologischen Instituts: Römische Abteilung* 64 (1957), pp. 46–68.

———. *Der Augustus von Prima Porta*. Bremen, 1959.

———. *Ara Pacis Augustae*. Tübingen, 1967.

———. *Festivals of Attica*. Madison, 1983.

———. *Augustus*. Munich, 1986.

O. Von Simson. *Sacred Fortress: Art and Statecraft in Ravenna*. Chicago, 1948.

S. Sinding-Larsen. *Iconography and Ritual: A Study of Analytical Perspectives*. Oslo, 1984.

H. Sivan. "Holy Land Pilgrimage and Western Audiences: Some Reflections on Egeria and Her Circle". *Classical Quarterly* 38 (1988), pp. 528–35.

———. "Who Was Egeria? Piety and Pilgrimage in the Age of Gratian". *Harvard Theological Review* 81 (1988), pp. 59–72.

J. Z. Smith. *Map Is Not Territory*. Leiden, 1978.

———. *To Take Place: Toward Theory in Ritual*. Chicago, 1987.

———. *Drudgery Divine: On the Comparison of Early Christianities and the Religions of Late Antiquity*. Chicago, 1990.

R. R. R. Smith. "The Imperial Reliefs from the Sebasteion at Aphrodisias". *Journal of Roman Studies* 77 (1987), pp. 88–138.

R. Sorabji. *Aristotle on Memory*. London, 1972.

———. "Myths about Non Propositional Thought". In M. Schofield and M. C. Nussbaum, eds. *Language and Logos: Studies in Ancient Greek Philosophy Presented to G. E. L. Owen*, p. 308f. Cambridge, 1982.

———. *Time, Creation and the Continuum*. London, 1983.

S. Spain Alexander. "Heraclius, Byzantine Imperial Ideology and the David Plates". *Speculum* 52 (1977), pp. 217–37.

J. D. Spence. *The Memory Palace of Matteo Ricci*. London, 1985.

P. Stallybrass and A. White. *The Politics and Poetics of Transgression*. London, 1986.

J. E. Stambaugh. "The Functions of Roman Temples". *ANRW* 2. 16.1 (1978), pp. 554–608.

O. Statler. *Japanese Pilgrimage*. London, 1983.

L. Steinberg. "A Corner of the Last Judgment". *Daedalus* (Spring 1980), pp. 207–73.

F. Steinmann. *Neue Studien zu Gemäldebeschreibungen des Aelteren Philostrats*. Basel, 1914.

K. Stemmer. *Untersuchungen zur Typologie, Chronologie und Ikonographie der Panzerstatuen*. Archaeologische Forschungen 4. Berlin, 1978.

H. Stern. "Les mosaïques de l'église de Sainte-Constance à Rome". *Dumbarton Oaks Papers* 12 (1958), pp. 157–218.

J. Stevenson. *The Catacombs*. London, 1978.

A. Stewart. *Greek Sculpture*. New Haven and London, 1990.

T. Stoppard. *Artist Descending a Staircase*. London, 1973.

G. Stricevic. "The Iconography of the Compositions Containing Imperial Portraits in San Vitale". *Starinar* (1958), pp. 75–7.

———. "Iconografia dei Mosaici Imperiali a San Vitale". *Felix Ravenna* 80 (1959), pp. 5–27.

———. "Sur le problème de l'iconographie des mosaïques de Saint-Vital". *Felix Ravenna* 85 (1962), pp. 80–100.

G. Striker. "Sceptical Strategies". In M. Schofield et al., eds., q.v., pp. 54–83.

V. M. Strocka. *Casa del Principe di Napoli*. Tübingen, 1984.

D. E. Strong. *Greek and Roman Gold and Silver Plate*. London, 1966.

———. *Roman Art*. Harmondsworth, 1988.

J. Strzygowski. *The Origin of Christian Church Art: New Facts and Principles of Research*. Oxford, 1923.

G. Stühlfauth. *Die altchristliche Elfenbeinplastik*. Freiburg, 1896.

A. Stylianou and J. Stylianou. *The Treasures of Lambousa*. Nicosia, 1969.

S. W. Sykes. "Sacrifice in the New Testament and Christian Theology". In M. F. C. Bourdillon and M. Fortes, eds., q.v., pp. 61–83.

R. Syme. *The Roman Revolution*. Oxford, 1939.

R. Taft. *The Liturgy of the Hours in East and West*. Collegeville, Minn., 1986.

S. J. Tambiah. "Classification of Animals in Thailand". In M. Douglas, ed., *Rules and Meanings*. Harmondsworth, 1973.

C. Taylor. *Sources of the Self*. Cambridge, 1989.

C. C. W. Taylor. "All Perceptions Are True". In M. Schofield et al., eds., q.v., pp. 105–24.

L. R. Taylor. *The Divinity of the Roman Emperor*. Middletown, Conn., 1931.

R. F. Thomas. "The 'Sacrifice' at the End of the Georgics, Aristaeus and Virgilian Closure". *Classical Philology* 86 (1991), pp. 211–18.

M. L. Thompson. "The Monumental and Literary Evidence for Programmatic Painting in Antiquity". *Marsyas* 9 (1961), pp. 36–77.

M. Torelli. *Typology and Structure of Roman Historical Reliefs*. Ann Arbor, 1982.

J. M. C. Toynbee. *The Hadrianic School*. Cambridge, 1934.

———. "A New Roman Mosaic Pavement Found in Dorset". *Journal of Roman Studies* 54 (1964), pp. 7–14.

J. M. C. Toynbee and K. S. Painter. "Silver Picture Plates of Late Antiquity A.D. 300–700". *Archaeologia* 108 (1986), pp. 15–65.

J. Trilling. "Late Antique and Sub-Antique or the 'Decline of Form' Reconsidered". *Dumbarton Oaks Papers* 41 (1987), pp. 468–76.

W. Tronzo. *The Via Latina Catacomb*. University Park and London, 1986.

R. Turcan. "Les sarcophages romains et le problème de symbolisme funéraire". *ANRW* 2. 16.2 (1978), pp. 1700–35.

———. "Le sacrifice mithriaque: Innovations de sens et de modalités". In J. Rudhardt and O. Reverdin, eds., q.v., pp. 341–80.

———. "Salut mithriaque et sotériologie néoplatonicienne". In U. Bianchi and M. J. Vermaseren, eds., *La Soteriologia dei Culti Orientali nell' Impero Romano*, Atti del Colloquio Internazionale su la Soteriologia dei Culti Orientali nell' Impero Romano, pp. 173–91. Leiden, 1982.

T. Turner. "Transformation, Hierarchy and Transcendence: A Reformulation of Van Gennep's Model of the Structure of Rites de Passage". In S. F. Moore and B. Meyerhoff, *Secular Ritual*, pp. 53–70. Amsterdam, 1977.

V. Turner. "The Centre Out There: Pilgrim's Goal". *History of Religions*
12, 3 (1973), pp. 191–230.
———. *Dramas, Fields and Metaphors*. Ithaca, 1974.
———. "Ritual, Tribal and Catholic". *Worship* 50, 6 (1976), pp. 504–25.
V. Turner and E. Turner. *Image and Pilgrimage in Christian Culture*. New York, 1978.
R. A. Tybout. *Aedificiorum Figurae: Untersuchungen zu den Architekturdarstellungen des frühen zweiten Stils*. Amsterdam, 1989.
D. Ulansey. *The Origins of the Mithraic Mysteries*. New York, 1989.
R. Valentini and G. Zucchetti. *Codice Topografico della Città di Roma*. Rome, 1940.
G. Vasari. *Le Vite de' piu eccellenti pittori, scultori ed archittetori*. Florence, 1568.
M. J. Vermaseren. "The Suovetaurilia in Roman Art". *Bulletin de vereeniging tot bevordering der kennis van de Antike beschaving* 32 (1957), pp. 1–12.
———. *Mithriaca I: The Mithraeum at S. Maria at Capua Vetere*. Leiden, 1971.
———. *Mithriaca III: The Mithraeum at Marino*. Leiden, 1982.
M. J. Vermaseren and C. C. van Essen. *The Excavations in the Mithraeum of the Church of Sta Prisca in Rome*. Leiden, 1965.
C. C. Vermeule. "Hellenistic and Roman Cuirassed Statues". *Berytus* 13 (1959), pp. 1–82.
M. G. Verral and J. E. Harrison. *Mythology and Monuments of Ancient Athens*. London, 1890.
H. Vetters. "Die Neapler 'Galleria' ". *Jahreshefte des Oesterreichischen Archaeologischen Instituts* 50 (1974), pp. 223–8.
P. Veyne. "Conduct without Belief and Works of Art without Viewers". *Diogenes* 143 (Fall 1988), pp. 1–22.
———. *Did the Greeks Believe in Their Myths?* Chicago, 1988.
W. F. Volbach. *Elfenbeinarbeiten der Spätantike und des Frühen Mittelalters*. Mainz, 1916.
S. Walker and A. Burnett. *The Image of Augustus*. London, 1981.
A. Wallace-Hadrill. "Civilis Princeps: Between Citizen and King". *Journal of Roman Studies* 72 (1982), pp. 32–48.
———. "The Social Structure of the Roman House". *Papers of the British School at Rome* 56 (1988), pp. 43–97.
———. "Patronage in Roman Society from Republic to Empire". In A. Wallace-Hadrill, ed., *Patronage in Ancient Society*, pp. 64–87. London, 1989.
———. "Pliny the Elder and Man's Unnatural History". *Greece and Rome* 37 (1990), pp. 80–96.
R. T. Wallis. "NOUS as Experience". In R. B. Harris, ed., *The Significance of Neoplatonism*, pp. 121–54. Norfolk, Va., 1976.
C. Walter. "Expression and Hellenism". *Revue des études byzantines* 42 (1984), pp. 265–87.
S. H. Wander. "The Cyprus Plates: The Story of David and Goliath". *Metropolitan Museum Journal* 8 (1973), pp. 89–104.
———. "The Cyprus Plates and the *Chronicle* of Fredegar". *Dumbarton Oaks Papers* 29 (1975), pp. 345–6.
W. Warde Fowler. *The Religious Experience of the Roman People*. London, 1911.
A. Wardman. *Religion and Statecraft among the Romans*. London, 1982.

J. B. Ward-Perkins and A. Claridge. *Pompei 79*. London, 1976.

T. Ware. *The Orthodox Church*. Harmondsworth, 1963.

C. J. Watson. "The Program of the Brescia Casket". *Gesta* 20 (1981), pp. 283–98.

G. Watson. *Phantasia in Classical Thought*. Galway, 1988.

D. Watts. *Christians and Pagans in Roman Britain*. London, 1990.

S. Weinstock. *Divus Julius*. Oxford, 1971.

K. Weitzmann. *Greek Mythology in Byzantine Art*. Princeton, 1951.

———. "Zur Frage des Einfluss jüdische Bildquellen auf die Illustration des Alten Testamentes". In *Mullus: Festschrift Th. Klauser*, Jahrbuch für Antike und Christentum Ergänzungsband 1, pp. 401–15. Munster, 1964.

———. "Prolegomena to a Study of the David Plates". *Metropolitan Museum Journal* 3 (1970), pp. 97–111.

———. *Studies in the Arts at Sinai*. Princeton, 1982.

———, ed. *The Age of Spirituality*. New York and Princeton, 1979.

K. Weitzmann and H. L. Kessler. *The Frescoes of the Dura Synagogue and Christian Art*. Dumbarton Oaks Studies 28. Washington, 1990.

B. Wesenberg. "Zur asymmetrischen Perspektive in der Wanddekoration des zweiten pompejanischen Stils". *Marburger Winkelmann-Programm* (1968), pp. 102–9.

———. "Certae rationes picturarum". *Marburger Winckelmann-Programm*. (1975–6), pp. 23–43.

M. Whitby. "Maro the Dendrite: An Anti-Social Holy Man?" In M. Whitby et al., eds., q.v., pp. 309–17.

M. Whitby, P. Hardie and M. Whitby, eds. *Homo Viator: Classical Essays for John Bramble*. Bristol, 1987.

J. White. *Perspective in Ancient Drawing and Painting*. London, 1956.

L. M. White. *Building God's House in the Roman World*. Baltimore, 1990.

J. E. G. Whitehorne. "The Ambitious Builder". *AUMLA* (Journal of the Australasian Universities Language and Literature Association) 31 (May 1969), pp. 28–39.

M. Wiles. *The Making of Christian Doctrine*. Cambridge, 1967.

J. Wilkinson. *Egeria's Travels*. London, 1971.

U. von Willamowitz-Moellendorf. "Die Thukidideslegende". *Hermes* 12 (1877), pp. 326–67.

D. Winston. "Was Philo a Mystic?" In J. Dan and F. Talmage, eds., *Studies in Jewish Mysticism*, pp. 15–39. Cambridge, Mass., 1982.

T. P. Wiseman. "Conspicui postes tectaque digna deo: The Public Image of Aristocratic and Imperial Houses in the Late Republic and Early Empire". In *L'Urbs. Espace urbain et histoire*, Collection de l'école Française de Rome, vol. 98 (1987), pp. 393–413.

G. Wissowa. *Religion und Kultus der Römer*. Munich, 1912.

L. Wittgenstein. *Philosophical Investigations*. Oxford, 1958.

R. E. Wycherley. "Pausanias and Praxiteles". In *Studies in Athenian Architecture, Sculpture and Topography Presented to Homer A. Thompson, Hesperia*, suppl. 20 (1982), pp. 182–91.

F. Yates. *The Art of Memory*. London, 1966.

Z. Yavetz. "The *Res Gestae* and Augustus's Public Image". In F. Millar and E. Segal, eds., q.v., pp. 1–36.

G. Zanker. *Realism in Alexandrian Poetry: A Literature and Its Audience*. London, 1987.

P. Zanker. "Die Villa als Vorbild des späten pompejanischen

Wohngeschmacks". *Jahrbuch des Deutschen Archaeologischen Instituts* 94 (1979), pp. 460–523.

———. *The Power of Images in the Age of Augustus*. Ann Arbor, 1988. (P. Zanker, *Augustus und die Macht der Bilder*, Munich, 1987.)

———. "Bilderzwang: Augustan Political Symbolism in the Private Sphere". In J. Huskinson et al., eds., q.v., pp. 1–22.

F. I. Zeitlin. "The Poetics of Eros: Nature, Art and Imitation in Longus's *Daphnis and Chloe*". In D. M. Halperin, J. J. Winkler and F. I. Zeitlin, eds., *Before Sexuality*, pp. 417–65. Princeton, 1990.

H. Zimmer. *Artistic Form and Yoga in the Sacred Images of India*. Princeton, 1984.

S. R. Zwirn. "The Intention of Biographic Narration in Mithraic Cult Images". *Word and Image* 5, 1 (1989), pp. 2–18.

NOTES

INTRODUCTION

1. R. Barthes, *Camera Lucida* (London, 1982), p. 12.
2. On the significance of fish in Christianity, see, for instance, A. Grabar, *Christian Iconography: A Study of Its Origins* (London, 1968), pp. 8–9.
3. On problems of interpretation, it is only appropriate (in view of my opening examples) to suggest the work of Stanley Fish – especially the essays in Part II of *Is There a Text in This Class?* (Cambridge, Mass., 1980); on issues of explanation and possibility, see G. Hawthorn, *Plausible Worlds: Possibility and Understanding in History and the Social Sciences* (Cambridge, 1991), esp. Chap. 4, pp. 123–56, for an anti-reductivist discussion of the interpretation of art in response partly to Michael Baxandall's insistence on "critical parsimony" in *Patterns of Intention: On the Historical Explanation of Pictures* (New Haven and London, 1985), esp. pp. 120–1, 131.
4. Note, for instance, Pliny's record of Lysippus's boast that whereas others had represented men as they really were, he made them as they appeared to be (*Natural History* 34.65) or the way artists like Phidias were seen as creative visionaries who visualised the gods they sculpted and added something new to religious experience through this mediation (e.g., Quintilian, *Institutio Oratoria* 12.10.9, or Philostratus, *Vita Apollonii* 6.19). The key case for criticism of artists is of course Plato, *Republic* 10.
5. B. Berenson, *The Arch of Constantine or the Decline of Form* (London, 1954), (entirely on "decline"); E. H. Gombrich, *Art and Illusion* (London, 1960), pp. 123–5; idem, *The Story of Art* (London, 1964), pp. 49–98; E. Kitzinger, *Byzantine Art in the Making* (London, 1977), pp. 7–21.
6. For perhaps the definitive assessment of the debt of Christian art to "the Greco-Roman iconographic language", "a common repertoire of motifs – a koine of the Greco-Roman period", see Grabar, 1968, pp. xlv–xlvii, 5–54.
7. G. W. Bowersock, *Hellenism in Late Antiquity* (Cambridge, 1990), p. 64 (refering to K. Weitzmann, *Greek Mythology in Byzantine Art*

[Princeton, 1951], pp. 3–5); for other commendations of art-historical approaches to late antiquity, see P. Brown, "Art and Society in Late Antiquity" in K. Weitzmann, ed., *The Age of Spirituality: A Symposium* (New York, 1980), p. 17, and M. Roberts, *The Jewelled Style: Poetry and Poetics in Late Antiquity* (Ithaca and London, 1989), pp. 66–9.

8. H. P. L'Orange, *Art Forms and Civic Life in the Late Roman Empire* (Princeton, 1965).

9. J. Strzygowski, *The Origin of Christian Church Art: New Facts and Principles of Research* (Oxford, 1923), pp. 1–27, 30–46; E. Kitzinger, *Early Medieval Art* (London, 1940), p. 8f.; A. Grabar, "Le tiers monde de l'Antiquité à l'école classique et son rôle dans la formation de l'art du Moyen Age", *Revue de l'art* 18 (1972), 1–59; Kitzinger, 1977, pp. 11–13; J. Trilling, "Late Antique and Sub-Antique or the 'Decline of Form' Reconsidered", *Dumbarton Oaks Papers* 41 (1987), 468–76.

10. K. Weitzmann, "Zur Frage des Einfluss jüdische Bildquellen auf die Illustration des Alten Testamentes", in *Mullus: Festschrift Th. Klauser*, Jahrbuch für Antike und Christentum Ergänzungsband 1 (Munster, 1964), pp. 401–15; K. Weitzmann and H. L. Kessler, *The Frescoes of the Dura Synagogue and Christian Art*, Dumbarton Oaks Studies 28 (Washington, 1990), pp. 143–50, 153–83.

11. R. Bianchi Bandinelli, "La crisi artistica della fine del mondo antico", in idem, *Archeologia e Cultura* (Rome, 1979), pp. 181–223, and "Continuità ellenistica nella pittura di età medio e tardo-romana", ibid., pp. 344–423.

12. S. Ferri, "Plotino e l'arte del III secolo", *La critica d'arte* 1 (1936), 166–71; A. Grabar, "Plotin et les origines de l'esthétique médiévale", *Cahiers archaeologiques* 1 (1945), 15–36, abbreviated in idem, *The Beginnings of Christian Art* (London, 1967), pp. 288–91; C. Walter, "Expression and Hellenism", *Revue des études byzantines* 42 (1984), pp. 265–87, esp. pp. 271–6.

13. J. Onians, "Abstraction and Imagination in Late Antiquity", *Art History* 3 (1980), 1–24; Roberts (1989), Chap. 3, "Poetry and the Visual Arts", pp. 66–121.

14. Here I am indebted to a number of recent studies of early Christian art by theologically trained historians, especially Sister C. Murray, *Rebirth and Afterlife: A Study of the Transmutation of Some Pagan Imagery in Early Christian Funerary Art*, British Archaeological Reports 100 (Oxford, 1981), and E. S. Malbon, *The Iconography of the Sarcophagus of Junius Bassus* (Princeton, 1990).

15. This kind of broad chronological approach to issues in late antiquity has occasionally been tried before, notably by G. Rodenwaldt, "Ara Pacis und San Vitale", *Bonner Jahrbucher* 133 (1928), 228–35.

16. G. Vasari, *Le Vite de' piu eccellenti pittori, scultori ed archittetori* (Florence, 1568), ed. G. Milanesi (Florence, 1878), *proemio delle Vite* 5.

17. E. H. Gombrich, *The Image and the Eye* (Oxford, 1982), p. 297.

18. T. Stoppard, *Artist Descending a Staircase* (London, 1973), p. 39.

19. B. Schulz, "The Book", in *The Fictions of Bruno Schulz* (London, 1988), p. 127.

PART I: WAYS OF VIEWING IN THE ROMAN WORLD.
FOREWORD.

1. Pliny's classic account of the rise and nature of Classical art is in his *Natural History* 35.1–148; Quintilian's is *Institutio Oratoria* 12.10.3–9.

2. For a recent repetition of the Plinian story, see Andrew Stewart, *Greek Sculpture* (New Haven and London, 1990), pp. 83–5.

3. See N. Bryson, *Looking at the Overlooked* (London, 1990), pp. 30–2, and S. Bann, *The True Vine: Visual Representation and Western Tradition* (Cambridge, 1989), Chap. 1, "Zeuxis and Parrhasius".

4. See M. Beard, "Reflections on 'Reflections on the Greek Revolution'", *Archaeological Review from Cambridge* 4 (1985), 207–13, esp. p. 211.

5. The Younger Philostratus, *Imagines*, proemium 4: His word for deception is *apatê*.

6. Epiphanius of Salamis, *Letter to the Emperor Theodosius*, frags. 23–7, trans. C. A. Mango, *The Art of the Byzantine Empire, 312–1453* (Toronto, 1986), pp. 41–2.

7. Augustine, *Soliloquies* 2.10.18, in C. Davis-Weyer, *Early Medieval Art, 300–1150* (Toronto, 1986), p. 41.

CHAPTER 1: VIEWING AND "THE REAL"

1. J. L. Borges, *El Golem*, vv. 1–4, from *El Otro, el Mismo*, 1964, in *Obras Completas, 1923–1972* (Buenos Aires, 1974). The lines translate:

 If (as the old Greek says in his Cratylus)
 The name is the essence of the thing,
 Then the letters spelling *rose* are the rose,
 And all the Nile is in the word *Nile*.

2. See especially K. Lehmann-Hartleben, "The Imagines of the Elder Philostratus", *Art Bulletin* 23 (1941), 16–44, and M. Conan, "The *Imagines* of Philostratus", *Word and Image* 3 (1987), 162–71. The most recent edition of the text is O. Schoenberger, *Philostrat, Die Bilder* (Munich, 1968). One attempt to use Philostratus as a means of understanding what the ancients expected from their art is N. Bryson, *Looking at the Overlooked* (London, 1990), pp. 17–30.

3. On the "infamous problem" of the Philostrati, see G. L. Bowersock, *Greek Sophists in the Roman Empire* (Oxford, 1969), pp. 2–4, and G. Anderson, *Philostratus: Biography and Belles Lettres in the Third Century A.D.* (London, 1986), pp. 291–6.

4. In particular, these imitations include the *Imagines* of his grandson, the Younger Philostratus, and the *Descriptions* of Callistratus who quotes him frequently.

5. For a discussion of the discourse of the *Imagines* as a work of rhetoric, see M. E. Blanchard, "Philostrate: Problèmes du texte et du tableau: Les limites de l'imitation à l'époque hellénistique et sous l'empire", in B. Cassin, ed., *Le plaisir du parler* (Paris, 1986), pp. 131–54.

6. The approach that the gallery and paintings really existed is that of Karl Lehmann-Hartleben (1941). He has been followed by K. Schefold, *Orient, Hellas und Rom* (Bern, 1949), p. 184; A. Maiuri, *Roman Painting* (Geneva, 1953), p. 68 (who sees the descriptions as a "catalogue-raisonné"); M. L. Thompson, "The Monumental and Literary Evidence for Programmatic Painting in Antiquity", *Marsyas* 9 (1961), 36–77, esp. 61f.; Schoenberger, 1968, p. 35; H. Vetters, "Die Neapler 'Galleria'", *Jahreshefte des Oesterreichischen Archaeologischen Instituts* 50 (1974), 223–8; and most recently (with the refinement that Philostratus may be describing ceiling paintings), M. Fuchs, "Philos-

trate, un critique d'art chez les Sevères", *Revue des Études Latines* 65 (1987), 12–15. Among the few art-historical doubters of Lehmann-Hartleben's view are H. Mielsch, "Funde und Forschungen zur Wandmalerei der Prinzipätszeit von 1945 bis 1975, mit einem nachtrag 1980", *ANRW* 2. 12.2, pp. 158–264, esp. pp. 237–8, and L. James and R. Webb, "To Understand Ultimate Things and Enter Secret Places: Ekphrasis and Art in Byzantium", *Art History* 14, 1 (March 1991), 1–17: "Philostratos's gallery . . . is surely a convenient fiction" (p. 7). An argument for the authenticity of the paintings on literary grounds which examines discrepancies between what Philostratus seems to have seen and how he interprets it is A. Lesky, "Bildwerk und Deutung bei Philostrat und Homer", *Hermes* 75 (1940), 38–53.

7. For some general reflections on ekphrasis and the history of art, see D. Carrier, "Ekphrasis and Interpretation: Two Modes of Art History Writing", *British Journal of Aesthetics* 27, 1 (Winter 1987), 20–31; D. Rosand, "Ekphrasis and the Generation of Images", *Arion*, 3d ser., 1, 1 (Winter 1990), 61–105; J. A. W. Heffernan, "Ekphrasis and Representation", *New Literary History* 22, 2 (1991), 297–316. On some of the problems of ekphrasis in relation to Philostratus, see S. Bann, *The True Vine* (Cambridge, 1989), pp. 28–32, 108–14. On the theory and practice of ekphrasis in antiquity, the fundamental discussion is still P. Friedlaender, *Johannes von Gaza und Paulus Silentarius* (Berlin, 1912), pp. 83–103. See also G. Downey, "Ekphrasis", in *Reallexicon für Antike und Christentum*, vol. 4 (1959), pp. 921–44; E. Pernice and W. H. Gross, "Beschreibungen von Kunstwerken in der Literatur. Rhetorische Ekphraseis", in U. Hausmann, ed., *Allgemeine Grundlagen der Archaeologie* (Munich, 1969), pp. 433–47; A. Hohlweg, "Ekphrasis", in *Reallexicon zur Byzantinischen Kunst*, vol. 2 (Stuttgart, 1971), pp. 33–75, and H. Hunger, *Die hochsprachliche profane Literatur der Byzantiner*, vol. 1 (Munich, 1978), pp. 170–88. On ekphrasis and Byzantine art, see James and Webb, 1991.

8. For Hermogenes, see the edition of H. Rabe (Leipzig, 1913) (translation in C. S. Baldwin, *Medieval Rhetoric and Poetic* [New York, 1928], pp. 35–6, and, partially, in M. Baxandall, *Giotto and the Orators* [Oxford, 1971], p. 85); for Aphthonius, see the edition of H. Rabe, (Leipzig, 1926) (translation by R. Nadeau in *Speech Monographs*, vol. 19 [Ann Arbor, 1952], pp. 264–85); for Theon, see the edition of L. Spengel, *Rhetores Graeci*, vol. 2 (Leipzig, 1853–4). On the *progymnasmata*, see Hunger, 1978, pp. 75ff., 92ff. On *ekphrasis* in the *progymnasmata*, see D. L. Clark, *Rhetoric in Graeco-Roman Education* (New York, 1957), pp. 201–3, M. Roberts, *The Jewelled Style: Poetry and Poetics in Late Antiquity* (Ithaca and London, 1989), pp. 38–65, and S. Bartsch, *Decoding the Ancient Novel* (Princeton, 1989), pp. 7–10.

9. Translated from Rabe, 1913, pp. 22–3.

10. G. Zanker, *Realism in Alexandrian Poetry: A Literature and Its Audience* (London, 1987), p. 39.

11. See, in particular, C. Imbert, "Stoic Logic and Alexandrian Poetics", in M. Schofield, M. Burnyeat and J. Barnes, eds., *Doubt and Dogmatism* (Oxford, 1980), pp. 182–216, esp. pp. 198–203. On *phantasia* more generally, see A. M. Ioppolo, "Presentation and Assent: A Physical and Cognitive Problem in Early Stoicism", *Classical Quarterly* 40, 2 (1990), 433–49; G. Watson, *Phantasia in Classical Thought* (Gal-

way, 1988), esp. pp. 59–95; K. Eden, *Poetic and Legal Fiction in the Aristotelian Tradition* (Princeton, 1986), pp. 71–9, 96–111; M. W. Bundy, *The Theory of Imagination in Classical and Mediaeval Thought* (Urbana, 1927), pp. 105–16; M. Fattori and M. Bianchi, eds., *Phantasia – Imaginatio: Vo Colloquio Internazionale* (Rome, 1988).

12. *Phantasia* as criterion for truth: See Diogenes Laertius, *Lives of Eminent Philosophers* 7.49 (Zeno), with J. M. Rist, *Stoic Philosophy* (Cambridge, 1969), pp. 133–51, J. Annas "Truth and Knowledge" in Schofield et al., 1980, pp. 84–104, C. C. W. Taylor, "All Perceptions Are True", in Schofield et al., 1980, pp. 105–24, and Watson, 1988, pp. 44–58.

13. On epistemology, see especially Annas, 1980; on methods of inference and logic, see Imbert, 1980, pp. 185–98; on voluntary action, see G. Striker, "Sceptical Strategies", in Schofield et al., 1980, pp. 54–83, esp. pp. 67–9; on psychology, see Eden, 1986, pp. 96–111.

14. See Annas, 1980, p. 84. Compare the way in which *enargeia*, or "visibility", in dreams came to be seen as a guarantee of the apparition's being "real" and hence significant for the dreamer's life; see R. G. A. van Lieshout, *Greeks on Dreams* (Utrecht, 1980), pp. 18–19, 196.

15. Compare Quintilian, *Institutio Oratoria* 6.2.29: "There are certain experiences which the Greeks call *phantasiai* and the Romans visions (*visiones*), whereby things absent are presented to our imagination with such extreme vividness that they seem actually to be before our eyes". On the "transformation of phantasia" "from a term practically confined to technical philosophical debate in epistemology to something more like 'phantasy' in the modern English sense", see Watson, 1988, pp. 59–95. On the Quintilian passage, with further reflections on the relation of rhetoric to images, see J. Onians, "Abstraction and Imagination in Late Antiquity", *Art History* 3 (1980), 1–24, esp. pp. 14–18.

16. See Imbert, 1980, pp. 182–4, 199f.

17. On *phantasia* as the "intuitive insight" of the artist, see J. J. Pollitt, *The Ancient View of Greek Art* (New Haven, 1974), pp. 52–5, 203–5. The typology of such artistic inspiration is best illustrated through the topos of Phidias as artist inspired through his *phantasia*: See Cicero, *Orator* 8–9:

The great sculptor, while making the image of Jupiter or Minerva, did not look at any person whom he was using as a model, but in his own mind there dwelt a surpassing vision of beauty (*species pulchritudinis eximia*); at this he gazed and all intent on this he guided his artist's hands to produce the likeness of the god. . . . There is something perfect and surpassing in the case of sculpture and painting – an intellectual ideal (*cogitatam speciem*) by reference to which the artist represents those objects which do not themselves appear to the eye.

Compare also the Elder Seneca, *Controversiae* 8.2 and 10.5.8; Quintilian, *Institutio Oratoria* 12.10.9; Dio Chrysostom, *The Olympic Discourse, Oratio* 12, esp. 70–1; Philostratus, *The Life of Apollonius* 6.19, and Plotinus, *Enneads* 5.8.1.

18. On this crucial passage of ancient art theory, see E. Birmelin, "Die Kunsttheoretischen Gedanken in Philostrats Apollonios", *Philologus* 88 (1933), 149–80, 392–414; B. Schweitzer, "Mimesis und Phantasia", *Philologus* 89 (1934), 286–300; Pollitt, 1974, pp. 52–4, 201–5.

19. R. M. Rilke, from *Letters to a Young Poet* 1 (Paris, 17 February 1903) (New York, 1934), p. 17.

20. B. P. Reardon, *Courants littéraires Grecs des II^e et III^e siècles après J-C* (Paris, 1971), p. 191.

21. On Philostratus as an interpreter, see Bartsch, 1989, pp. 14–21.

22. S. Alpers, "Ekphrasis and Aesthetic Attitudes in Vasari's *Lives*", *Journal of the Warburg and Courtauld Institutes* 23 (1960), 190f. (quotes on pp. 190 and 194). See also Carrier, 1987, for the view that "for Vasari to write an ekphrasis was to tell what *attitude* we are to take" (p. 24).

23. G. Kennedy, "The Sophists as Declaimers", in G. W. Bowersock, ed., *Approaches to the Second Sophistic* (University Park, Pa., 1974), p. 17.

24. G. Anderson, 1986, p. 263; S. Alpers, 1960, p. 201.

25. On the "espace du discours", see M. E. Blanchard, 1986, pp. 138–41, 144–6.

26. L. Steinberg, "A Corner of the Last Judgment", *Daedalus* (Spring 1980), p. 210.

27. I disagree here with Bartsch, 1989, p. 20 n. 9, quoting a personal communication with J. J. Winkler that *apoblepson autôn* (the latter word in the genitive plural) should mean "gaze *at* those things". It is much more natural to give *apo-* its usual force and take the genitive as one of separation rather than attraction, meaning "look *away* from those things".

28. See J. Palm, "Bemerkungen zur Ekphrase in der greichischen Literatur", *Kungliga Humanistika Vertenskapssamfundet i Uppsala* 1 (1965), 108–211, p. 168.

29. J. M. Blanchard, "The Eye of the Beholder: On the Semiotic Status of Paranarratives", *Semiotica* 22 (1978), 235–68. See also M. E. Blanchard, *Description: Sign, Self, Desire*, Approaches to Semiotics 43 (The Hague, 1980), pp. 127–56.

30. Unlike the Greek travel writer Pausanias (writing a century earlier), Philostratus does not censure his image because it differs from Homer. Indeed, he revels in the difference – the image's and interpreter's autonomy from the canon with which they play. Pausanias is careful to mark where a picture follows its Homeric model (e.g., Nausicaa at 1.22.6), but is critical where it differs:

There is Polyxena about to be sacrificed near the grave of Achilles. Homer did well in passing by this barbarous act. I think too that he showed poetic insight in making Achilles capture Scyros, differing entirely from those who say that Achilles lived in Scyros with the maidens, as Polygnotus has represented in his picture. (1.22.6)

In general, in accordance with his ideological bias in writing a myth-historical evocation of "Ancient Greece" through its contemporary monuments, Pausanias is much more deferential to the canon of texts because they are what valorise his images. At 10.25.2ff. Homer (and other ancient poets such as Stesichorus, Lescheos and the author of the *Cypria*) become an hermeneutic tool to interpret the paintings of Polygnotus at Delphi (viz., the identification of Phrontis at 10.25.2–3; of Meges and Lycomedes at 10.25.5–6). Again, Pausanias frequently marks where the paintings exceed the limits imposed on a theme by the relevant texts (the invention of names – 10.25.3 and 4, 10.30.7; or, of demons in the Underworld – 10.28.7). Pausanias, in fact, uses Homer to explicate a good deal more than simply images. In 8.16.3 the mention of the grave of Aegyptus by Homer is the

reason for Pausanias's trip there and the report of the mound in his text. Likewise Homer can prove that a pile of stones at Thebes (9.18.2) is the tomb of Tydeus or determine a plane tree at Aulis to be still that of *Iliad* 2.307 (9.19.6). In effect there are fundamental differences between ancient writers in their Homeric allegiance. For Pausanias, Homer is a sanctification of Greece to be followed with respect and an arbiter in matters of interpretation. For Philostratus, Homer is an excuse to display learning and an appropriate springboard from which to launch into his own creative interpretation.

31. F. Steinmann, *Neue Studien zu Gemäldebeschreibungen des Aelteren Philostrats* (Basel, 1914), pp. 23–5; Lesky, 1940, pp. 41–4; Schoenberger, 1968, pp. 278–80; G. Anderson, 1986, pp. 261–2.

32. See J. Elsner, "Visual Mimesis and the Myth of the Real: Ovid's Pygmalion as Viewer", *Ramus*, 20, 2 (1991), 154–68.

33. This pun is frequent in literary discussions of art: See, for instance, the proem of Longus's *Daphnis and Chloe;* Lucian, *Rhetorum Praeceptor* 6, *Alexander* 3, *De Domo* 21, *Imagines* 3. Servius Grammaticus remarks explicitly on this ambiguity of the Greek *graphein* in his commentary on the *Aeneid* (*Ad Aen.* 6.34).

34. Compare J. M. Blanchard, 1978, p. 243.

35. For some remarks on the "Hunters" description, see also Onians, 1980, pp. 4–7.

36. For an account of the "promise" of the *Imagines* "that, at certain moments, words and pictures collaborate to produce a hyperreal, sensuously intense experience that goes beyond the limits of both pictures and words" – a promise which turns out to be both "self-mocking and self-defeating", see now N. Bryson, "Philostratus and the Imaginary Museum", in S. D. Goldhill and R. Osborne, eds., *Art and Text in Ancient Greek Culture* (Cambridge, 1994), pp. 255–83, esp. pp. 266–73.

37. Likewise the ekphrasis itself as an object to be read becomes a subjective construct for its reader.

38. J. Lacan, *The Four Fundamental Concepts of Psycho-Analysis* (Harmondsworth, 1986), p. 103.

39. See T. Cave, "Enargeia: Erasmus and the Rhetoric of Presence in the Sixteenth Century", *L'Esprit Créateur* 16, 4 (1976), 5–19.

40. G. Anderson, 1986, p. 265; it is interesting that this rhetorical technique is exactly paralleled in the ekphrases of Vasari's *Lives*, themselves indebted to Vasari's reading of Philostratus, see Alpers, 1960, p. 190f., esp. p. 194.

41. For an ancient parallel of the sophos addressing a group of which one individual is picked out, see the *Tabula* of Cebes, ed. J. T. Fitzgerald and L. M. White (Chico, Calif., 1983), p. 139 n. 14.

42. See O. Schissel von Fleschenberg, "Die Technik des Bildeinsatzes", *Philologus* 72 (1913), pp. 83–114, esp. pp. 102–4, on the importance of the hermeneus.

43. R. L. Hunter, *A Study of Daphnis and Chloe* (Cambridge, 1983), pp. 3–15.

44. *Daphnis and Chloe* as ekphrasis: B. E. Perry, *The Ancient Romances* (Berkeley, 1967), p. 110; J. Kestner, "Ekphrasis as Frame in Longus' *Daphnis and Chloe*", *The Classical World* 67 (1973–4), 166–71; Imbert, 1980, p. 198f.; Hunter, 1983, pp. 38–9; T. A. Pandipi, "Daphnis and Chloe: The Art of Pastoral Play", *Ramus* 14, 2 (1985), 116–41, esp.

pp. 116–17. On ekphrasis in the Greek novels generally, see A. Billault, "L'inspiration des ekphraseis d'oeuvres d'art chez les romanciers grecs", *Rhetorica* 8, 2 (1990), pp. 153–60.

45. See Hunter, 1983, pp. 46–7; B. D. MacQueen, "Longus and the Myth of Chloe", *Illinois Classical Studies* 10, 1 (1985), 119–34, esp. pp. 132–3; F. I. Zeitlin, "The Poetics of Eros: Nature, Art and Imitation in Longus's *Daphnis and Chloe*", in D. M. Halperin, J. J. Winkler and F. I. Zeitlin, eds., *Before Sexuality* (Princeton, 1990), pp. 417–65, esp. pp. 430–44; for a discussion of the meaning of the Greek term *exegetes*, see Pandipi, 1985, p. 117 and n. 7.

46. The Calumny of Apelles: Lucian, *Calumniae non temere credendum* 3–5, quote from 5; on ekphrasis in Lucian, see J. Bompaire, *Lucien écrivain* (Paris, 1958), pp. 707–35.

47. R. Hinks, *Myth and Allegory in Ancient Art* (London, 1939), pp. 115–16.

48. On the purported relation of *Daphnis and Chloe* to actual Roman paintings, see M. C. Mittelstadt, "Longus: *Daphnis and Chloe* and Roman Narrative Painting", *Latomus* 26 (1967), 752–61, and Hunter, 1983, pp. 4–6.

49. On such "learned interpreters" generally, see Bartsch, 1989, pp. 26–31, 42–4.

50. This is the judgment of most authorities: See C. Praechter, *Cebetis Tabula quanam aetate conscripta esse videatur* (Marburg, 1885), p. 130; H. F. A. von Arnim, "Kebes", in G. Wissowa, ed., *Paulys Realencyclo-paedie der classischen Altertumswissenschaft* (Stuttgart, 1921), pp. 101–4; Fitzgerald and White, 1983, pp. 1–4.

51. That such tablets existed in the porticoes of temples at this time seems attested by the *pinakion gegrammenon* mentioned by Pausanias in the Sanctuary of Despoine and its temple of Artemis Hegemone in Arcadia (8.37.1–2), which is said to describe the mysteries. However, it may be that this tablet contained a text rather than pictures (see J. G. Frazer, *Pausanias* [London, 1898], vol. 4, p. 371).

52. On some of its literary aspects, especially the setting, in comparison with a number of other works from the first centuries A.D., see Schissel von Fleschenberg, 1913, esp. p. 87.

53. The monographs are Praechter, 1885 (in Latin), and R. Joly, *Le tableau de Cèbes et la philosophie religieuse* (Brussels, 1963). The current consensus is towards an eclectic-cynic interpretation, see Fitzgerald and White, 1983, pp. 20–7, with the review of J. Mansfield, *Mnemosyne*, 39 (1986), pp. 484–6.

54. On the "shared confusion" of the narrator and his readers here, see Bartsch, 1989, pp. 27–8; on the "original perplexity of the spectators and their subsequent enlightenment", see Hinks, 1939, pp. 119–21.

55. On Cebes and salvation, see A. D. Nock, *Conversion* (Oxford, 1933), p. 180; a recent discussion of the kind of salvation implied in the *Tabula* (but with a Christian bias) is M. Adinolfi, "La Metanoia della Tavola di Cebete", *Antonianum* 60 (1985), 579–601.

56. On personification in ancient imperial art, see J. M. C. Toynbee, *The Hadrianic School* (Cambridge, 1934), pp. 7–160; on personification in Lucian, see J. Bompaire, "Quelques personnifications littéraires chez Lucien et dans la littérature imperiale", in J. Duchemin, ed., *Mythe et*

Personnification (Paris, 1980), pp. 77–82; on the technique in Cebes, see Praechter, 1885, pp. 64–83, and L. Petersen, *Zur Geschichte der Personifikation in griechischer Dichtung und bildender Kunst* (Wurzburg, 1939), pp. 70–2.

57. See D. Pesce, *La Tavola di Cebete* (Brescia, 1982), under *paideia* in the index.

58. On the *Tabula* as allegory, see Praechter, 1885, pp. 83–104.

59. See Fitzgerald and White, 1983, p. 35 n. 51, and p. 149 n. 57.

60. See H. H. O. Chalk, "Eros and the Lesbian Pastorals of Longus", *Journal of Hellenic Studies* 80 (1960), 32–51; R. Merkelbach, *Roman und Mysterium in der Antike* (Munich, 1962).

61. On medicine and astrology, see T. S. Barton, *Power and Knowledge* (Ann Arbor, forthcoming); on dreams, see Bartsch, 1989, pp. 32–4.

62. For Lucian, see *Rhetorum Praeceptor* 6 and *De Mercede Conductis* 42 where in both cases an allegorical picture is painted by means of personifications; for Julius Pollux, see *Onomasticon* 3.95 which is a thesaurus entry on the theme of *agogê* and all kinds of *êgêsis;* for Tertullian, see *De Praescriptione Haereticorum* 39.4 where one of the author's relatives turns Cebes's text into Vergilian verse.

63. On the influence of the *Tabula* in antiquity, see Praechter, 1885, p. 10f., and Fitzgerald and White, 1983, pp. 7–8. On the Latin and Arabic versions, see K. K. Mueller, *De arte critica Cebetis Tabulae adhibenda* (Virceburgi, 1877), pp. 71–9; on Byzantine readings, see G. Downey, "The Pilgrim's Progress of the Byzantine Emperor", *Church History* 9 (1940), 207–17.

64. For instance, Philostratus 1.23 (2) and Cebes 11.1 and 2.

65. See Porphyry, *De Antro Nympharum*, with R. Lamberton, *Homer the Theologian* (Berkeley, 1986), pp. 108–33.

66. See Iamblichus, *De Mysteriis Aegyptorum* 7.1–3. = 249.10–254.10, ed. G. Parthey (Berlin, 1857).

CHAPTER 2: VIEWING AND SOCIETY

1. C. Geertz, "Art as a Cultural System", in idem, *Local Knowledge* (New York, 1983), pp. 94–120 (quote on p. 99). For an application of anthropological theories, such as "value system" and "cultural representation" to space and housing in an ethnographic study, see H. L. Moore, *Space, Text and Gender: An Anthropological Study of the Marakwet of Kenya* (Cambridge, 1986), pp. 107–54 (Chaps. 7 and 8) and esp. pp. 152–4.

2. For the term "deep play" and a brilliant discussion of the relation of a particular art form to its culture, see C. Geertz, "Deep Play: Notes on the Balinese Cockfight", *Daedalus* (Winter 1972), pp. 1–38.

3. Geertz, 1983, p. 99.

4. On the influence of Vitruvius, see E. H. Gombrich, *Norm and Form* (Oxford, 1966), esp. pp. 83–6, quotes from pp. 83 and 119. For a summary of views about Vitruvius, see B. Baldwin, "The Date, Identity and Career of Vitruvius", *Latomus* 49, 2 (1990), 425–34. The standard modern edition is C. Fensterbusch, *Vitruv: Zehn Bücher über Architektur* (Darmstadt, 1964), which dates the work to between 27 and 22 B.C., see p. 5. On the specific theme of Vitruvius and wall-

painting, see the exhaustive discussion by R. A. Tybout, *Aedificiorum Figurae: Untersuchungen zu den Architekturdarstellungen des frühen zweiten Stils* (Amsterdam, 1989), pp. 55–108.

5. Plautus, *Mostellaria* vv. 84–156 – with E. Fraenkel, *Plautinisches im Plautus* (Berlin, 1922), pp. 173–8, and, on the extended metaphor of housing in the play, E. W. Leach, "De Exemplo Meo Ipse Aedificato: An Organizing Idea in the Mostellaria", *Hermes* 97 (1969), 318–32.

6. For example, Cato the Censor, *Orationum Reliquiae*, ed. M. T. Sblendorio Cugisi (Turin, 1982), fr. 139 with commentary pp. 360–3; Cicero, *Pro Sestio* 43.93, for an attack on Gabinus's villa, and Gabinus's attack on Lucullus's villa; Sallust, *Catiline* 12.3–4; 13.1; 20.11; Velleius Paterculus, 2.33.4, on Lucullus as "Xerxes togatus". On Roman villas and the "denouncers of luxury in the Ciceronian age", see J. H. D'Arms, *Romans on the Bay of Naples* (Cambridge Mass., 1970), pp. 40–5, and J. E. G. Whitehorne, "The Ambitious Builder", *AUMLA* (Journal of the Australasian Universities Language and Literature Association) 31 (May 1969), 28–39.

7. Especially *Odes* 2.15; 2.18; 3.1; 3.24; *Epistles* 1.1.83–7 with L. T. Pearcy, "Horace's Architectural Imagery", *Latomus* 36 (1977), 772–81, and Whitehorne, 1969, pp. 30–4.

8. In the Elder Seneca, *Contr.* 2.1.13.

9. Eumolpus's poem in Petronius's *Satyricon* 120.87–9:
"They build in gold and raise their mansions to the stars.
The seas are dammed by dykes of stone
And other seas spring up within their fields –
A rebellion against the order of all things."

See also the Younger Seneca, *Epistulae* 90.8–10; 122.8. For a discussion of the theme of luxury and the natural order in the work of the Elder Pliny, see A. Wallace-Hadrill, "Pliny the Elder and Man's Unnatural History", *Greece and Rome* 37 (1990), 80–96.

10. Papirius Fabianus *apud* the Elder Seneca, *Contr.* 2.1.11–12; the Younger Seneca, *Ep.* 89.21; *De Ira* 1.21.1.

11. The Younger Seneca, *Ep.* 115.8–9.

12. The Younger Seneca, *Ep.* 90.10 – *Culmus liberos texit, sub marmore atque auro servitus habitat:* "A thatched roof once covered free men; under marble and gold dwells slavery".

13. For instance, Lucretius 5.1011–1457; Vitruvius 2.1–3; Tibullus 2.1.37–66.

14. An article which attempts to map Vitruvius's language in this passage to known Roman wall-painting is B. Wesenberg, "Certae rationes picturarum", *Marburger Winckelmann-Programm* (1975–6), 23–43.

15. Pliny, *Historia Naturalis* 35.116, with R. Ling, "Studius and the Beginnings of Roman Landscape Painting", *Journal of Roman Studies* 67 (1977), 1–16, esp. p. 6.

16. Compare Pliny – "thus much for the dignity of this now expiring art" (35.28).

17. The theme of excluding *falsa* from the domain of reality seems quite a topos in Vitruvius's time. Lucretius (5.837–48) finds no problem in the earth's producing various portents and monsters (such as hermaphrodites), but he draws the line ruthlessly at centaurs, scyllas, chimaeras, giants and "creatures of double nature and two-fold body combined together of incompatible limbs" (5.878–924).

18. On the "simple reflection version of realism" (with Gombrich as the

target), see N. Bryson, "Representing the Real: Gros' Paintings of Napoleon", *History of the Human Sciences* 1, 1 (May 1988), 75–104, pp. 77–8; also, idem, *Vision and Painting: The Logic of the Gaze* (London, 1983), pp. 3–12, and (on Gombrich's version of "Plinian vision") pp. 18–35, esp. p. 34. For the development in Gombrich's work towards an increasingly explicit version of the "reflexivity theory of realism", see M. Krieger, "The Ambiguities of Representation and Illusion: An E. H. Gombrich Retrospective", *Critical Inquiry* 11, 2 (December 1984), 181–94, with Gombrich's reply in the same issue, pp. 195–201.

19. On the evolution of art as the "passage from winter to spring" in Pliny, Vasari and Gombrich, see N. Bryson, *Tradition and Desire* (Cambridge, 1984), pp. 7–18; for the influence of Pliny on the Renaissance historiography of art, see M. Baxandall, *Giotto and the Orators* (Oxford, 1971), pp. 51–120, and Bryson, 1983, pp. 1–3. Gombrich's own account of the rise to verisimilitude through the mastery of light and shade is *The Heritage of Apelles* (Oxford, 1976), pp. 3–18; his "Reflections on the Greek Revolution" which led to naturalism are in *Art and Illusion* (London, 1960), pp. 99–125; he has summarised his view in *The Image and the Eye* (Oxford, 1982), p. 297.

20. See P. Zanker, *The Power of Images in the Age of Augustus* (Ann Arbor, 1988), which deals primarily with public art; on the private sphere whose art Zanker argues follows the innovations in public imagery, see Chap. 7 (pp. 265–95), and idem, "Bilderzwang: Augustan Political Symbolism in the Private Sphere", in J. Huskinson et al., eds., *Image and Mystery in the Roman World* (Gloucester, 1988), pp. 1–22.

21. For a discussion of the "moral claims" of Augustan art in which "classicism and archaism became after Actium . . . an outward symbol of the moral revival. The purely formal – i.e. style – became the meaning", see P. Zanker, *The Power of Images*, 1988, Chap. 6, pp. 239–63.

22. This comment in Vitruvius is one of the earliest references to the *divinitas* of Augustus; see, on Vitruvius's celebration of Augustus's "divine election", J. R. Fears, *Princeps a deus electus: The Divine Election of the Emperor as a Political Concept in Rome*, Papers and Monographs of the American Academy in Rome, 26 (1977), pp. 122–3.

23. For Augustus as Jupiter's *secundus*, see Horace *Odes* 1.12.52–3; for Augustus alone administering the state – its wars, laws and morals, see Horace, *Epistles* 2.1.1–4.

24. See P. Zanker, 1988, p. 209, and idem, in Huskinson et al., 1988, pp. 1–2.

25. A. Wallace-Hadrill, "The Social Structure of the Roman House", *Papers of the British School at Rome* 56 (1988), 43–97, quote on p. 69; A. Mau, *Geschichte der decorativen Wandmalerei in Pompeji* (Berlin, 1882). For the fullest account in English, see R. Ling, *Roman Painting* (Cambridge, 1991), and for a good summary of the "four styles", see J. B. Ward-Perkins and A. Claridge, *Pompei 79* (London, 1976), pp. 59–67. On the indebtedness of Mau's account to Vitruvius, see E. Dwyer, "The Pompeian Atrium House in Theory and in Practice", in E. K. Gazda, ed., *Roman Art in the Private Sphere* (Ann Arbor, 1991), pp. 25–48, esp. p. 45 n. 37.

26. L. Bek, *Towards a Paradise on Earth*, Analecta Romana 9 (Odense, 1980), p. 171 (on Vitruvius 7.5): "Painting, like architecture, must

form part of or express the given order of nature, which also marks the social order, and not be mere decoration". For a general discussion of the way space functions "as representation" to naturalize the power relations of a social system, see Moore, 1986, p. 88.

27. See, for example, N. Bryson, 1984, pp. 18–26, and J. Lacan, *The Four Fundamental Concepts of Psycho-Analysis* (Harmondsworth, 1977), pp. 67–122.

28. See especially Wallace-Hadrill, 1988, p. 50 and passim; on the link of the Roman house with social status, see also T. P. Wiseman, "Conspicui postes tectaque digna deo: The Public Image of Aristocratic and Imperial Houses in the Late Republic and Early Empire", in *L'Urbs. Espace urbain et histoire*, Collection de l'école Française de Rome, 98 (1987), pp. 393–413, and R. P. Saller, "*Familia, Domus* and the Roman Conception of the Family", *Phoenix* 38, 4 (1984), 336–55, esp. p. 349f. On the Roman house in general, an excellent survey is E. De Albentiis, *La Casa dei Romani* (Milan, 1990).

29. For the Roman house as locus of patronage in the social system, see A. Wallace-Hadrill, "Patronage in Roman Society from Republic to Empire", in idem, ed., *Patronage in Ancient Society* (London, 1989), pp. 64–87.

30. On the language of "public" and "private" and its social implications, Wallace-Hadrill, 1988, esp. pp. 54–70, 77–86. For the theme of "public and private spheres" in literature and art, see E. W. Leach, *The Rhetoric of Space* (Princeton, 1988), p. 199f.

31. For a good discussion of Vitruvius's categories and terms for architecture in connection with domestic housing, see Bek, 1980, pp. 165–72.

32. P. Bourdieu, "The Kabyle House or the World Reversed", in idem, *Algeria 1960* (Cambridge, 1970), pp. 133–54, esp. p. 143.

33. Wallace-Hadrill, 1988, p. 68: "The language of public and private is of the essence in the Roman approach to wall decoration".

34. M. H. Morgan, *Vitruvius: The Ten Books on Architecture* (Cambridge Mass., 1914), p. 181, and E. Granger, *Vitruvius: De Architectura* (London, 1934), vol. 2, p. 37. See also Bek, 1980, p. 170, and Wallace-Hadrill, 1988, p. 54.

35. For some comparable ethnographic data about what sort of outsiders different cultures allow into their homes, see S. J. Tambiah, "Classification of Animals in Thailand", in M. Douglas, ed., *Rules and Meanings* (Harmondsworth, 1973), pp. 132–7, "the social significance of house categories", and table, p. 147; R. Hirschon, "Essential Objects and the Sacred: Interior and Exterior Space in an Urban Greek Society", in S. Ardener, ed., *Women and Space* (London, 1981), pp. 72–88, esp. p. 86; J. Khatib-Chahidi, "Sexual Prohibitions, Shared Space and Fictive Marriages in Shi'ite Iran", in Ardener, 1981, pp. 112–35, esp. pp. 120–5.

36. Hirschon, in Ardener, 1981, p. 80.

37. Mau, 1882, conveniently summarised in English in A. Mau, *Pompeii: Its Life and Art* (London, 1899), p. 448ff.

38. See D. Corlàita Scagliarini, "Spazio e Decorazione nella Pittura Pompeiana", *Palladio*, n.s. 23–5 (1974–6), 3–44, esp. pp. 19–20 and Fig. 25.

39. I do not mean to suggest that Romans were unaware of chronology. In fact there is copious evidence of later imitations of earlier painting: See W. Ehrhardt, *Stilgeschichtliche Untersuchungen an Römischen Wand-*

malereien von der späten Republik bis zur Zeit Neros (Mainz, 1987), pp. 133–48; K. Schefold, "Pompeji unter Vespasian", *Mitteilungen des Deutschen Archaeologischen Instituts: Römische Abteilung* 60–1 (1953–4), 106–25, esp. pp. 119–22, and idem, *Vergessenes Pompeji* (Bern and Munich, 1962), pp. 140–45.

40. For late "second style" as Vitruvius's target, see A. Boethius, "Vitruvius and the Roman Architecture of His Age", in *DRAGMA* (essays for M. P. Nilsson) (Lund, 1939), pp. 114–43, esp. pp. 116–17, and J. Engemann, *Architekturdarstellungen des frühen zweiten Stils* (Heidelberg, 1967), pp. 115–17. For "third style" as the target, see A. Pickard-Cambridge, *The Theatre of Dionysus in Athens* (Oxford, 1946), p. 226, and Wallace-Hadrill, 1988, p. 72. However, there is a chronological problem in that the latest date for Vitruvius is 22 B.C., and the earliest independently datable "third-style" decoration is put at 12–10 B.C. For an exhaustive discussion of this issue, see Ehrhardt, 1987, pp. 152–62, who uses this passage of Vitruvius to suggest a less rigid distinction of "second" and "third styles" than has been usual. The first account of the "third style" was Mau, 1882, pp. 289–448, summarised in Mau, 1899, pp. 424–7; see also H. Bastet and M. de Vos, *Proposta per una classificazione del terzo stile pompeiano*, Archeologische Studien van het Nederlands Instituut te Rome 4 (Gravenhage, 1979); A. Barbet, *La peinture murale Romaine* (Paris, 1985), pp. 96–177, and Ling, 1991, pp. 52–70.

41. On "il peristilio", see A. Maiuri, *La Villa dei Misteri* (Rome, 1931), vol. 1, pp. 66–71; and now L. Richardson, *Pompeii: An Architectural History* (Baltimore and London, 1988), p. 173.

42. See, for instance, the so-called giardino interno del quartiere orientale of the Villa at Oplontis, no. 32 of the map on p. 11 of A. de Franciscis, "La Villa Romana di Oplontis", in B. Andreae and H. Kyrieleis, eds., *Neue Forschungen in Pompeji* (Recklinghausen, 1975), pp. 9–38 (also Figs. 38 and 39). See also A. de Franciscis, "La Villa Romana di Oplontis", *Parola del Passato* 28 (1973), pp. 453–66, Fig. 1. On Pompeian taste and the peristyle garden generally, see P. Zanker, "Die Villa als Vorbild des späten pompejanischen Wohngeschmacks", *Jahrbuch des Deutschen Archaeologischen Instituts* 94 (1979), 460–523, esp. pp. 481–98.

43. The conventional account of "second style" is Mau, 1882, "Der Architekturstil", pp. 124–288, summarised in Mau, 1899, pp. 452–4. Mau's account has been refined by H. G. Beyen, *Die Pompejanische Wanddekoration vom zweiten bis zur vierten Stil*, 2 vols. (The Hague, 1938 and 1960), and Engemann, 1967. Recent discussions focussing on "illusionism" are Barbet, 1985, pp. 35–93; Wallace-Hadrill, 1988, pp. 69–72, and Ling, 1991, pp. 23–51.

44. For a detailed discussion of "illusionistische römische Wandmalerei der ersten Phase und ihre Vorbilder in der Realen Architektur", see Engemann, 1967, esp. pp. 15–57, where he analyses painted architectural motifs and their relationship to real architecture. On views in such second-style paintings, see W. Ehrhardt, "Bild und Ausblick in Wandbemalungen Zweiten Stils", *Antike Kunst* 34 (1991), 28–65. On Pompeian perspective generally, see Engemann, 1967, pp. 62–90, and H. G. Beyen, "Die Antike Zentralperspektive", *Jahrbuch des Deutschen Archaeologischen Instituts* 54 (1939), 47–72.

45. See P. W. Lehmann, *Roman Wall Paintings from Boscoreale in the Metro-*

politan Museum of Art (Cambridge Mass., 1953), pp. 82–131, Fig. 51, Plates 9–33; M. Anderson, *Pompeian Frescoes from the Metropolitan Museum of Art* (New York, 1987); and Ehrhardt, 1991, pp. 42–6.

46. For a discussion of views which "window" into or onto peristyles ("Peristyldurchblick"), focussed on the House of the Faun in Pompeii, see Engemann, 1967, pp. 154–64; for window views out of houses or rooms, see H. Drerup, "Bildraum und Realraum in der Römischen Architektur", *Mitteilungen des Deutschen Archäologischen Instituts: Römische Abteilung* 66 (1959), 147–74, esp. pp. 147–55.

47. I am thinking of Horace's "ut pictura poesis" (*Ars Poetica* 361–4) and Vergil's treatment of Aeneas looking at the pictures in Dido's temple to Juno in Carthage (*Aeneid* 1.456–93), with E. W. Leach's excellent discussions, 1988, pp. 3–6 and 309–60. For an account of a Roman poet's evocation of a villa (Statius, *Silvae* 2.2), see B. Bergmann, "Painted Perspectives of a Villa Visit: Landscape as Status and Metaphor", in Gazda, 1991, pp. 49–70: "The interpenetration of outside and inside and the shifting focus between art and nature create a blurred, hallucinatory experience in which vista and vision are confused" (p. 63).

48. Maiuri, 1931, vol. 1, p. 58, and vol. 2, Plate 18; Beyen, 1938, vol. 1, pp. 65–72, and, 1960, vol. 2, p. 8 (Plates 15a–b, 17); Barbet, 1985, pp. 38–9 (Fig. 21) and pp. 66–7; Ehrhardt, 1991, pp. 37–42.

49. See B. Wesenberg, "Zur asymmetrischen Perspektive in der Wanddekoration des zweiten pompejanischen Stils", *Marburger Winkelmann-Programm* (1968), 102–9; Corlàita Scagliarini, 1974–6, pp. 3–44.

50. Wesenberg, 1968, pp. 104–5; in general, on the perspective in the Villa of the Mysteries (including Oecus 6), see Engemann, 1967, pp. 68–82, and for some of the effects of the complex scheme in Oecus 6, see A. M. G. Little, *Roman Perspective Painting and the Ancient Stage* (Washington, 1971), pp. 18–19.

51. Beyen, 1960, vol. 2, Plates 13, 16–19; Maiuri, 1931, vol. 1, Figs. 70–4.

52. The Samnite House is published in A. Maiuri, *Ercolano: I Nuovi Scavi, 1927–58*, vol. 1 (Rome, 1958), pp. 197–206. On this feature, see Ling, 1991, pp. 21–2.

53. The classic formulation is Mau, 1882, pp. 11–123, summarised in idem, 1899, pp. 448–52; more recently, Barbet, 1985, pp. 25–32, and Ling, 1991, pp. 12–22. The definitive study is A. Laidlaw, *The First Style in Pompeii: Painting and Architecture* (Rome, 1985).

54. T. Kraus, *Pompeii and Herculaneum* (New York, 1975), p. 123; Maiuri, 1958, p. 201f. On the atrium of the Samnite House, see also J. R. Clarke, "Notes on the Coordination of Wall, Floor and Ceiling Decoration in the Houses of Roman Italy, 100 BCE–235 CE", in M. A. Lavin, ed., *IL: Essays Honoring Irving Lavin on His 60th Birthday* (New York, 1990), pp. 1–30 (p. 2).

55. M. M. Gabriel, *Livia's Garden Room at Prima Porta* (New York, 1955), p. 10, Plates 1–7.

56. See Maiuri's plan, 1958, p. 198, and his discussion, p. 205.

57. On different levels of "simulation", and the way in "hyperreality" that imitations may render their "real" referents artificial, see J. Baudrillard, *Simulations* (New York, 1983), pp. 83–92 (on stucco).

58. See B. A. Babcock, ed., *The Reversible World: Symbolic Inversion in Art*

and Society (Ithaca, 1978): " 'Symbolic inversion' may be broadly defined as any act of expressive behaviour which inverts, contradicts, abrogates, or in some fashion presents an alternative to commonly held cultural codes, values, norms, be they linguistic, literary or artistic, religious, social and political" (p. 14).

59. On this reading, Roman wall-paintings occupy in Roman culture something like the radically utopian and transgressive position identified for the concept of *carnival* in Medieval and Renaissance culture by Mikhail Bakhtin. For Bakhtin (*Rabelais and His World* [Cambridge, Mass., 1968]), carnival is an inversion of official hierarchies: "As opposed to the official feast, one might say that carnival celebrated temporary liberation from the prevailing truth and from the established order; it marked the suspension of all hierarchical rank, privileges, norms and prohibitions" (p. 10; cf. also pp. 217–20). However, as many commentators have noted, there is an obvious political criticism of this position. In the words of Terry Eagleton, *Walter Benjamin: Towards a Revolutionary Criticism* (London, 1981): "Carnival, after all, is a licensed affair in every sense, a permissible rupture of hegemony, a contained popular blow-off as disturbing and relatively ineffectual as a revolutionary work of art" (p. 148). Moreover, as P. Stallybrass and A. White have argued, *The Politics and Poetics of Transgression* (London, 1986): "Most politically thoughtful commentators wonder . . . whether . . . 'licensed release' . . . is not simply a form of social control" (p. 13). All these observations and steps in the argument – transgressiveness, the licensing of transgression and the consolidation of existing power structures through such licensed contradiction – are applicable to Roman wall-painting.

60. On Mannerism, see A. Hauser, *Mannerism* (London, 1965), pp. 24–9; on Surrealism, see Hauser, 1965, p. 351ff., and J. Berger, "Magritte and the Impossible", pp. 155–61, in idem, *About Looking* (Harmondsworth, 1980).

61. For a brilliant discussion of some further complexities in Roman wall-painting, particularly in terms of the problems of originals and copies, see N. Bryson, *Looking at the Overlooked* (London, 1990), pp. 17–59, esp. pp. 35–45.

62. For the adjective "surrealist" used in terms of Roman wall-painting, see Gombrich, 1966, p. 119.

63. Wallace-Hadrill, 1988, pp. 69–77 (quote on p. 69).

64. Vitruvius's beholders either disdain – *inprobantur* (7.5.3), *reprehendunt* (7.5.4) – or approve – *delectantur, probare, probari*, "*recte*" *iudicari* (7.5.4).

65. Wallace-Hadrill, 1988, pp. 70–1: "It is above all to a world of luxury, grandeur and public life that the decorated wall transports us, to the palaces of kings and the temples of the gods."

66. E. W. Leach, 1988: "The luxury of furnishing and ornament imitated by these paintings is far in excess of the practical grasp of villa owners within a provincial society. The expansive designs are not only a fantasy of material wealth but also, one may think, a social fantasy . . ." (pp. 101–2).

67. This materialism is supported by P. Zanker's extensive reflections on the way the middle classes imitated the furnishings and decorations of the villas of the nobility, see 1979, pp. 460–523.

68. Wallace-Hadrill, 1988, p. 71ff.

69. On the importance of the view and the notion of "optical axiality" to the construction and layout of Roman houses, see H. Drerup, "Bildraum and Realraum", 1959, esp. pp. 155–9; Bek, 1980, pp. 181–203; and esp. F. Jung, "Gebaute Bilder", *Antike Kunst* 27, 2 (1984), pp. 71–122; on the view in an imperial context of Hadrian's Villa at Tivoli, see H. Kähler, *Hadrian und seiner Villa bei Tivoli* (Berlin, 1950), pp. 106f. and H. Drerup, 1959, p. 167; for a client's confrontation with the vista from the threshold of his patron's house in Roman "patronal rituals", see Wallace-Hadrill, 1989, p. 64.

70. For a discussion of Pliny's descriptions of his houses, see Bek, 1980, pp. 175–9.

71. 2.17: From *atrium* (2.17.4) to *porticus* (2.17.4), then *receptaculum* (2.17.4) and *triclinium* (2.17.5) of which the views are described in detail; to the left of this are a larger and after that a smaller *cubiculum* (2.17.6) with views; between the larger *cubiculum* and the *triclinium* is a *hibernaculum* which also serves as a *gymnasium* (2.17.7), and beside this is a curved *cubiculum* which serves as a library (2.17.8). From here there is a passage to a *cubiculum* (2.17.9), while the rest of this wing is reserved for slaves and freedmen. The other wing, upper storey and so forth (as well as the Tuscan villa in 5.6) are described in the same detail.

72. For a discussion of some surviving garden views, see Jung, 1984, pp. 98–114.

73. H. I. Marrou, *A History of Education in Antiquity* (London, 1956), p. 194 (rhetoric as "the queen of the subjects"), p. 284ff. (rhetoric in Roman higher education); E. J. Kenney, *The Cambridge History of Classical Literature*, vol. 2, *Latin Literature* (Cambridge, 1982), pp. 5–10 on education (p. 9 for rhetorical education as "mass conditioning"); on the importance of rhetoric to all kinds of Roman writing, see E. Rawson, *Intellectual Life in the Late Roman Republic* (London, 1985), p. 143.

74. Rawson, 1985, p. 145f. For some feats of memory in this period, see the autobiographical account of the Elder Seneca, *Controversiae* 1. praef. 2–3, and for the improvement of a good memory by learning this *ars*, see *Controversiae* 1. praef. 17–19.

75. These are the anonymous Auctor ad Herrenium 3.15.27–3.24.40 and Cicero, *De Oratore* 2.86.351–88.360. The classic discussion is F. Yates, *The Art of Memory*, (London, 1966), pp. 1–26. See also H. Blum, *Die Antike Mnemotechnak*, Spudasmata 15 (Hildesheim, 1969), and now M. Carruthers, *The Book of Memory* (Cambridge, 1990). For the philosophical background, see R. Sorabji, *Aristotle on Memory* (London, 1972), esp. pp. 22–5. On the influence of these texts on Medieval and Renaissance mnemonic theory Yates's book is brilliant; on the bizarre introduction of this Classical art of memory into China by the Jesuits in the late sixteenth century, see J. D. Spence, *The Memory Palace of Matteo Ricci* (London, 1985).

76. Quintilian, *Inst. Or.* 11.2.18–20 and Auctor ad Herennium 3.16.29 "aedes".

77. Cicero, *De Oratore* 2.86.351–4, with Yates, 1966, pp. 1–2.

78. Auctor ad Herennium 3.16.29: "aedes, intercolumnium, angulum, fornicem, et alia quae his similia sunt".

79. On the importance of sculpture to the decor of Roman houses, see E.

Bartmann, "Sculptural Collecting and Display in the Private Realm", in Gazda 1991, pp. 71–88, with references.

80. For this list, see Quintilian, *Inst. Or.* 11.2.21; on Simonides, see Cicero, *De Oratore* 2.86.351–4 and Quintilian, *Inst. Or.* 11.2.11–15.

81. Yates, 1966, p. 4 and p. 8.

82. I should add here that, like Quintilian, I have concentrated on the house as the *locus classicus* for the art of memory, but in fact public buildings, journeys, city ramparts and even pictures were all just as susceptible to the "environmental sense" (*Inst. Or.* 11.2.21).

83. Part of the complexity is that views cut in two directions. V. M. Strocka's suggestion that all parts of the Casa del Principe can be seen from the *Lararium*, i.e., by the Lares (see idem, *Casa del Principe di Napoli* [Tübingen, 1984], (pp. 31–2), has been reversed in R. J. Ling's review (*Gnomon* 59 [1987], 432–3) on the grounds that the shrine is a visual focus – something which does not see but *is* seen – for viewers from different points in the house.

84. On villas, see especially H. Drerup, "Der römische Villa", *Marburger Winckelmann-Programm* (1959) 1–24, and idem, "Bildraum und Realraum" (1959), 147–74.

85. 2.17: 6 – the rising and setting sun; 7 – retaining the sun; 8 – an apse to let in the sun from all sides; 10 – "the bright light of the sun reflected from the sea"; 12 – the warmth of the setting sun; 23 – to catch the rising sun.
 5.6: 15 – inviting in the sun and facing south; 21 – no daylight; 22 – shady from the nearby tree; 24 – bathed in winter sun; 26 – "enjoys the sun's kindly warmth"; 28 – plenty of sun.

86. 2.17: 3, 14, 25–8; 5.6: 2–13, 16–18, 32–40.

87. The Elder Seneca (*Controversiae* 5.5) presents a law case in which a tree belonging to a poor man blocked his rich neighbour's view but provided the poor man with a pleasant prospect (*liceat est pauperem gaudere prospectu*). The rich man had the tree burnt down, and part of the poor man's plea is that the tree is inseparable from his house (*atqui par domus est arbor quae in domo est*).

88. See, for instance, Plautus, *Mostellaria* v. 642 (a house praised for its brightness – *speculo claras, candorem merum*) and vv. 763–70 on the importance of shade to a house; Statius, *Silvae* 2.2.45–9 on the Surrentine villa of Pollius Felix, with the commentary of H-J. Van Dam, *Silvae Book II* (Leiden, 1984) ad loc. See also the legal problems about trees blocking views – Seneca, *Controversiae* 5.5, and Justinian, *Digest of Roman Law* 8.2.17 and 43.27.1.

89. For an archaeological discussion of houses with a focus on lighting, see P. Harsh, "The Origins of the Insulae at Ostia", *Memoires of the American Academy at Rome* 12 (1935), 7–66. The most up-to-date discussion and survey of bibliography on architecture and light in Roman domestic housing is T. Ratzka, "Atrium und Licht", in W-D. Heilmeier and W. Hoepfner, *Licht und Architektur* (Tübingen, 1990), pp. 95–106 – a book which is a good general introduction into issues of lighting from Classical Greek to late-antique archtitecture.

90. The optical rules are set out by Euclid in the *Optica*. On these and ancient perspective, see J. White, *Perspective in Ancient Drawing and Painting* (London, 1956), with references, and Engemann, 1967, pp. 90–5; see also G. M. A. Richter, *Perspective in Greek and Roman Art* (London, 1970), and Ehrhardt, 1991, pp. 30–6.

91. Likewise, Stallybrass and White, 1986, p. 13, suggest that other transgressive phenomena, such as carnival, which are licensed by the system, are a form of the system's own self-consolidation.
92. Geertz, 1972, p. 23.
93. C. Lévi-Strauss, *Tristes Tropiques* (London, 1973), pp. 229–56 (quote on p. 256).
94. Geertz, 1972, p. 28.

CHAPTER 3: VIEWING AND THE SACRED

1. In the formulation of the influential French psychoanalyst, Jacques Lacan, *"what I look at is never what I wish to see"*, there is a gap between what is seen physiologically and the object of the *desire* that provokes our seeing. Lacan's work on the gaze is in Chapters 6 to 9 of *The Four Fundamental Concepts of Psycho-Analysis* (Harmondsworth, 1977). The quote is from p. 103.
2. On the term "mystical", see the discussion of E. R. Dodds in *Pagan and Christian in an Age of Anxiety* (Cambridge, 1965), pp. 69–70. From my point of view, one of the deficiencies of Dodds's generally excellent book (subtitled "some aspects of religious experience from Marcus Aurelius to Constantine") is that it fails to treat viewing and vision.
3. It is worth noting that the non-dualist, or perhaps beyond-dualist, model is not confined to the West. Here, for an Eastern example, is Namkhai Norbu Rinpoche, a reincarnate spiritual master in the *Nyingma* tradition of Tibetan Tantric Buddhism:
 These [Buddhist] paths all have the common aim of seeking to overcome the problem that has arisen as the individual enters into dualism, developing a subjective self, or ego, that experiences a world-out-there as other, continually trying to manipulate the world in order to gain satisfaction and security.
 (Namkhai Norbu, *The Crystal and the Way of Light* [London, 1986], p. 26, cf. p. 12.)
4. For all these facts, see, e.g., A. H. Armstrong, *Plotinus* (London, 1953), p. 12ff. One interesting critical discussion which explores the "abolishing of the subject-object distinction" in Plotinus is R. T. Wallis, "NOUS as Experience", in R. B. Harris, ed., *The Significance of Neoplatonism* (Norfolk, Va., 1976), pp. 121–54.
5. For the *path* towards unity, see *Enn.* 6.9.8.33: "The One is always present, since it contains no otherness, but we are present only when we rid ourselves of otherness." This "ridding ourselves of otherness" (that is, the *via negativa* of apophatic theology – on which, see, for instance, R. Sorabji, *Time, Creation and the Continuum* [London, 1983], pp. 157–9) *is* the Plotinian path. However, what does Plotinus mean by "otherness"? His method is interesting in that it constructs the Divine Other not by polarity (the inversion of self) or by analogy (likeness to self), as was common in Greek discourse (see the discussion of F. Hartog, *The Mirror of Herodotus* [Berkley, 1988], Chap. 6, "A Rhetoric of Otherness", pp. 212–50). Rather, the Divine Other is here the denial of any predicate assertable of the self and what the self knows. The Divine Other of the *via negativa* (which we also find implied in Pausanias's refusal to describe what he is not allowed to see, cf. my discussion in Chap. 4) is *not* an opposite to self *within*

discourse and ideology, but a denial of (an other to) the very discourse and ideology by which self is constructed. For Plotinus to rid himself of "otherness" is actually to eliminate the whole ideological construction of self – for the Divine Other (the One) *is* self beyond all discourse, all ideology, all possibility of saying "self and other". For Plotinus, the real self (the self unified with the One) is something quite apart from the self enunciable in language, thought or ideology.

6. For a claim to have experienced such union once himself, and to have been present on four occasions when Plotinus "attained that goal", see Porphyry's *Life of Plotinus* 23.7ff. For Plotinus's own description of such experience, see *Enn.* 4.8.1.1ff. See also Dodds, 1965, pp. 84–5, with references.

7. The relation of sight with the sacred seems common in ancient writings. See S. Angus, *The Mystery Religions and Christianity* (London, 1925), pp. 133–35 with the numerous references collected there.

8. Actually it is not seeing at all, but "the achievement of unity" (*Enn.* 6.9.10).

9. The ladder image is explicit at *Enn.* 1.6.1.20 and is prefigured in Plato, *Symposium* 211C. It is taken up, for example, in Gregory of Nyssa's *De Vita Moysis* 2.227 where the theologian refers also to Jacob's ladder (*Gen.* 28.12).

10. Pseudo-Dionysius the Areopagite, *De Ecclesia Hierarchia* 3.3.2. PG 3.428C.

11. We find Christian pilgrimage prefigured in Pausanias, for instance, and the probably third-century *De Dea Syria* attributed to Lucian (e.g., section 55); we find the kind of personal piety typical of Christian icon-worship in the second-century *Apology* of Apuleius, where the author describes his devotions to a small statue of Mercury (sections 63–6). For an account of pagan piety, see R. Lane Fox, *Pagan and Christians* (London, 1986), pp. 11–264; for some reflections on continuities between paganism and Christianity, see the essays by S. MacCormack and K. Holum in R. Ousterhout, ed., *The Blessings of Pilgrimage* (Urbana and Chicago, 1990), pp. 7–40, 66–81.

12. For example, 1.14.3–4; 2.35.8; 8.31.5. For discussion, see Chap. 4.

13. In Euripides, the term *theama* seems to occur specifically at those moments when the divine enters the human action with some terrible or marvellous gesture. In the *Hippolytus*, the bull from the sea – who causes the hero's death and is summoned by Theseus' curse before the gods (vv. 882–90) – is described as *kreisson theama dergmatôn* ("a sight greater than the eyes can bear", v. 1217). Likewise, in the *Medea*, the terrible and supernatural effects of the robe Medea sends to Jason's bride are a *deinon theama* (vv. 1167, 1202) – something mistaken for a god-sent (*theo-*) frenzy (vv. 1172, 1208). At the end of the *Iphigeneia in Aulis* – in a passage which has been universally condemned as spurious, but the date of whose composition we do not know – the gods (*theoi*: vv. 1585, 1589, 1592) replace the girl about to be sacrificed with a doe. Again, *thea* (v. 1588) is the word used to describe the miraculous and visual nature of the action.

14. Philo, *De Posteritate Caini*:

It is impossible that the God (*theon*) who is should be perceived at all by created beings. What he says is "See that I am" (*Deuteronomy*, 32.39), that is "Behold (*theasasthe*) my subsistence". For it is quite enough for a man's reasoning faculty to advance as far as to learn that

the Cause of the Universe is and subsists. To be anxious to continue his course yet further and inquire about the essence or quality, in God, is a folly fit for the world's childhood. (168)

15. Apart from such Old Testament apocalypses as Daniel, Ezekiel 40–8, Isaiah 20–7, 34f., 56–66, and the Book of Revelation in the New Testament, see the selection of important apocalyptic texts now translated in J. H. Charlesworth, ed., *The Old Testament Pseudepigrapha*, vol. 1, Apocalyptic Literature and Testaments (London, 1983).

16. On all this, see E. R. Goodenough, *An Introduction to Philo Judaeus* (New Haven and London, 1938), pp. 2–5.

17. A comprehensive treatment of Philo's thought is E. Bréhier in *Les idées philosophiques et réligieuses de Philon d'Alexandrie* (Paris, 1908); see also H. Chadwick in A. H. Armstrong, ed., *The Cambridge History of Later Greek and Early Medieval Philosophy* (Cambridge, 1967), pp. 137–92, and the range of views collected in *ANRW* 2.21.1 (1984).

18. See, for instance, D. Winston, "Was Philo a Mystic?", in J. Dan and F. Talmage, eds., *Studies in Jewish Mysticism* (Cambridge, Mass., 1982). But note E. R. Dodds's doubts, 1965, p. 71 n. 5.

19. For example, in *De Migratione Abrahami* 28–30, *Quod Deus Sit Immutabilis* 55–6. The Philonic ascent is precisely to move from the milk-fed to the initiated category – as described, for example, in *De Agricultura* 8. However, God's relations to his elect are themselves a complex hierarchy, see *De Somniis* 1.191f. In Plotinus the elect are a self-selecting group in that "God is present to all beings, and the power of becoming aware of that presence is a capacity 'which all men possess though few use it' " (*Enn.* 1.6.8.24). Dodds, 1965, p. 79.

20. *De Cherubim* 48: "These thoughts, ye initiated, whose ears are purified receive into your souls as holy mysteries and babble not of them to any of the profane."

21. For Philo's own initiation and "god-possession", see *De Cherubim* 27: "But there is a higher thought than these. It comes from a voice in my own soul which often-times is god-possessed and divines where it does not know"; and *De Cherubim* 49: "I myself was initiated under Moses the God-beloved into his greater mysteries, yet when I saw the prophet Jeremiah and knew him to be not only himself enlightened, but a worthy minister of the holy secrets, I was not slow to become his disciple." For this higher inspiration coming upon him in the very act of writing see *De Migratione Abrahami* 34f., especially 35: "Under the influence of the Divine possession I have been filled with corybantic frenzy and been unconscious of anything, place, persons present, myself, words spoken, lines written". See also R. Reitzenstein, *Hellenistic Mystery-Religions: Their Basic Ideas and Significance* (Pittsburgh, 1978) (English version of the 3rd German ed. of 1926), p. 62.

22. See Reitzenstein, 1978, pp. 403–4, for a discussion of the Philonic ascent through sight.

23. The image of the upper air in connection with the theme of sight is ultimately Platonic – see *Timaeus* 47A. Another high-flown formulation of the "road to philosophy" through the sense of sight is *Questions and Answers on Genesis* 2.34.

24. "The interpretation of the name Israel to mean 'a man seeing God' received its most massive development in Philo." For commentary and references on this, see J. Z. Smith's essay "The Prayer of Jo-

seph", in *Map Is Not Territory* (Leiden, 1978), pp. 24–66 (pp. 37–40 whence the quotation).

25. I am grateful to C. R. A. Morray-Jones for clarifying that in Jewish mysticism of this period the visionary perceives the *kabod* (the *doxa* or glory) of God, but not his innermost essence which is inaccessible. There is a distinction between the manifested glory and the hidden Godhead. This explains Philo's apparently ambiguous attitude to the ultimate vision. *De Mutatione Nominum* 8 – where Moses prays "reveal Thyself to me" and yet "fails to gain his object" – supports the view that God is beyond theophany. But in *De Mutatione Nominum* 3 we are told that "it is the eye of the soul which receives the presentation of the divine vision". In *Questions and Answers on Exodus* 2.39 (refering to Exod. 24.11), Philo certainly describes the ascent of Moses and the seventy elders to the presence of God on the sapphire throne in terms of theophany: "Having attained to the face of the Father . . . they see the Master in a lofty and clear manner, envisioning God with the keensighted eyes of the Mind". Likewise, in the *Questions and Answers on Genesis* 4.1–2 (dealing with the theophany to Abraham in Gen. 18.1–2), Philo undoubtedly emphasises that the mind *can* see God and with him his "ministering powers".

26. See Reitzenstein, 1978, p. 402. *Theasthai* is an interesting verb in Philo. It can be used as an address to the reader – "let us now observe" (e.g., *De Sobrietate* 59) – as it is so often to the interlocutor in Plato's dialogues. It can describe a person's contemplation of God (e.g., *De Confusione Linguarum* 96). And it can describe God's contemplation of the world (e.g., *De Confusione Linguarum* 142; *De Specialibus Legibus* 3.52). I should add that my concentration on texts using this word (*thea-*) has weighted my account of Philo's system towards the anthropocentric (the subject-centred), because generally it is men that do the contemplating of God. For a more objective (or schematic) account of the relationship of Philo's God with the world "in spite of the fact that He was essentially beyond relation", see the brilliant discussion of E. R. Goodenough in Chapter 1 of *By Light, Light: The Mystic Gospel of Hellenistic Judaeism* (New Haven and London, 1935) (quote from p. 11).

27. On the subject of Philo's Platonism, see the chapter on Philo in J. M. Dillon, *The Middle Platonists: A Study of Platonism 80 B.C. to A.D. 220* (London, 1977), pp. 139–83.

28. For a short survey of sight and knowledge in a non-sacred context, see Hartog, 1988, p. 261f.

29. I have used the anthropological language of the "Other" and the "Other World" in this chapter. However, such language is problematic because it has been evolved in an academic discipline whose praxis is predicated on the dualist conceptual framework. Anthropology offers the polarity of this world/Other World and posits the need for a mechanism of mediation. However, in "mystic" thinking the "Other World" consists of the union of self and other – of the "identity of the soul with its divine ground" (in E. R. Dodds's language, 1965, p. 88). In mystic thinking, ultimately, self *is* Other; the "Other World" *is* this world – if only we can be awake to see it that way.

30. The insight that the key to sacred images is their *sacredness* is at the heart of Heinrich Zimmer's classic discussion of Indian art in the

context of ritual and contemplative texts, published as *Kunstform und Yoga im Indischen Kunstbild* (Berlin, 1926) and translated as *Artistic Form and Yoga in the Sacred Images of India* (Princeton, 1984).

31. See, for instance, Gregory of Nazianzus, *De Baptismo, Or.* 40.6 = *PG* 36.364D-365B.

32. See Athanasius, *The Life of St Antony*, 7 = *PG* 26.852A-853C.

33. The classic statement of the "radical rejection of the visual arts by the primitive Church" is E. Kitzinger, "The Cult of Images before Iconoclasm", *Dumbarton Oaks Papers* 8 (1954), 85–150; the quote is from p. 89. This view has been contended by Sister Charles Murray in *Rebirth and Afterlife: A Study of the Transformation of Some Pagan Imagery in Early Christian Funerary Art* (Oxford, 1981), pp. 13–36, and eadem, "Art and the Early Church", *Journal of Theological Studies*, n.s. 28 (1977), 305–45.

34. On which, see Kitzinger, 1954, pp. 86–7, 95–128; A. Cameron, "Images of Authority: Elites and Icons in Late Sixth Century Byzantium", *Past and Present* 84 (1979), 3–35; and eadem, "The Language of Images: The Rise of Icons and Christian Representation", in D. Wood, ed., *The Church and the Arts*, Studies in Church History 28, (Oxford, 1992), pp. 1–42, esp. p. 4. These accounts (concentrating on *texts*) date the rise of icons from after the reign of Justinian, but the vast profusion of *images* under Justinian (including the surviving mosaics at Sinai, Sant' Apollinare in Classe and San Vitale in Ravenna, Parenzo in Istria, Panaghia Angeloktistos at Kiti near Larnaka and Panaghia Kanakaria at Lythrangomi in Cyprus, as well as the Justinianic icons now at Sinai) points to a mid- rather than late-sixth-century beginning for the explosion of the image cult.

35. See J. Pelikan, *The Christian Tradition*, vol. 1, *The Emergence of the Catholic Tradition (100–600)* (Chicago and London, 1971), pp. 344–8.

36. Here Dionysius is closer to Plotinus, who believes in a mystic union – something beyond knowledge or language and yet experiential or intuitive – than he is to Jews like Philo or other Christian mystical thinkers such as Gregory of Nyssa. The latter believes in an ascent to an unachievable summit, "an ever more rigorous striving after (*epektasis*) a God whose infinity sets him beyond intuition no less than beyond knowledge" (C. W. MacLeod, "Allegory and Mysticism in Origen and Gregory of Nyssa", *Journal of Theological Studies*, n.s. 22, no. 2 [October 1971] – quote on p. 363-no. 31, of C. W. MacLeod, *Collected Essays* [Oxford, 1983], p. 310).

37. For a history of the notion of *homoiôsis* (going back to Plato, *Theaetetus* 176B), see H. Merki, *Homoiôsis Theôi: Von der platonischen Angleichung an Gott zu Gottanlichkeit bei Gregor von Nyssa* (Freiburg, 1952).

38. *De Caelesti Hierarchia* 3.2 [*PG* 3.165A]. But see also *De Ecclesiastica Hierarchia* 1.3 [*PG* 3.376A] where assimilation and union with God are tied to the concept of "deification" (*theôsis*). See also Pelikan, 1971, p. 345. On deification in a Christian context, see J. Gros, *La divinisation du chrétien d'après les Pères grecs* (Paris, 1938), and recently N. Russel, " 'Partakers of the Divine Nature' (2 Peter I,4) in the Byzantine Tradition", in J. Chrysostomides, ed., *KATHEGETRIA* (essays presented to Joan Hussey for her 80th birthday) (Camberley, 1988), pp. 51–68.

39. See Kitzinger, 1954, pp. 137–40.

40. The implication of *De Caelesti Hierarchia* 1.31 [*PG* 3.124A] is that such symbols were also liturgical – for instance, the eucharist.

41. Note the frequent reference to objects in the sense world as *eikones*.

42. Ultimately in Plotinus the "innermost self" is identical with the One which is its object of contemplation, see Dodds, 1965, p. 84.

43. Hypatius of Ephesus, *Letter to Julian of Atramytium* from the *Miscellaneous Enquiries:* ed. F. Diechamp, *Orientalia Christiana Analecta* 117 (1938), 127–9; translation and commentary by P. J. Alexander, "Hypatius of Ephesus: A Note on Image Worship in the Sixth Century", *Harvard Theological Review* 45, 3 (July 1952), pp. 176–84; this quote is from p. 180.

44. Compare *De Mystica Theologia* 5 (*PG* 3.1045Dff.).

45. See, for example, *De Ecclesiastica Hierarchia* 1.1 (*PG* 3.372A) and 1.5 (*PG* 3.377AB); *De Caelestia Hierarchia* 2.4 (*PG* 3.145C); *De Mystica Theologia* 2 (*PG* 3.1000AB).

46. An excellent account of the numerous agendas underlying Christian discourse is Averil Cameron, *Christianity and the Rhetoric of Empire* (Berkeley, 1991); on the political dimensions of theology cf. esp. pp. 169–70.

47. On this mosaic, see K. Weitzmann in G. Forsyth and K. Weitzmann, *The Monastery of St Catherine at Mt Sinai: The Church and Fortress of Justinian* (Ann Arbor, 1973), pp. 11–16; K. Weitzmann, *Studies in the Arts at Sinai* (Princeton, 1982), Chap. 1, "The Mosaic in St Catherine's Monastery at Sinai", pp. 5–18; and K. Weitzmann in K. Manafis, ed., *Sinai: Treasures of the Monastery of St Catherine* (Athens, 1990), pp. 61–6.

48. On the relation of the Sinai image to its monastic context (not only because of the significance of Sinai within the *loca sancta* but also because of the figures represented – John the Baptist, Moses and Elijah were all models for ascetic monasticism), see W. Loerke, " 'Real Presence' in Early Christian Art", in T. G. Verdon, ed., *Monasticism and the Arts* (Syracuse, N.Y., 1984), pp. 30–51.

49. Weitzmann, 1973, p. 12.

50. Matthew 17.1–12; Mark 9.2–9; Luke 9.28–36. For a full discussion of the theme both in Scripture and in patristic exegesis, see J. A. McGuckin, *The Transfiguration of Christ in Scripture and Tradition* (Lewiston and Queenston, 1986).

51. The order of the busts in the frame is as follows:

Left *Right*

o (a Cross)

1 1

2 2

3 3

4 4

5 5

6 6

7 8 9 10 11 12 13 14 15 16 17 18 19 20 21 22 23 24 7

Left *Right*
1. Andrew 1. Paul
2. Bartholomew 2. Philip
3. Mark 3. Thomas

4. James
5. Simon
6. Luke
7. John the Deacon (Corner)
Base
8. Daniel
9. Jeremiah
10. Malachi
11. Haggai
12. Habbakuk
13. Jonah
14. Joel
15. Amos
16. David (Centre)

4. Matthew
5. Thaddeus
6. Matthias
7. Longinus the Abbot (Corner)
17. Hosea
18. Micah
19. Obadiah
20. Nahum
21. Zephaniah
22. Zachariah
23. Isaiah
24. Ezekiel

52. Weitzmann, 1982, p. 15; F. de' Maffei, "L'Unigenito consustanziale al Padre nel programma trinitario dei perduti mosaici del bema della Dormizione di Nicea e il Cristo trasfigurato del Sinai – II.", *Storia dell' Arte* 46 (1982), 185–200, p. 186.

53. For a history of the scholarly interest in Sinai and its frustration in the face of "quite unusual internal and external difficulties", see Weitzmann, 1982, Chap. 1. In this paragraph, the quotations are all from Weitzmann, 1973, pp. 12, 16, 14.

54. For an opposite view, which sees Sinai as a local composition, see Loerke, 1984, p. 43.

55. On the site, see Forsyth, 1973, pp. 5–6. Procopius, who was unaware of the burning bush also being at Sinai, had great difficulties in finding a convincing explanation for locating the monastery half way down the mountain. He is reduced (at *De Aed.* 5.8.7) to "terrifying manifestations of divine power" at the actual peak as being the reason for putting the monastery lower down. A functional explanation for the site chosen would point to there being a well there.

56. See the account of Sinai in *Peregrinatio Egeriae*, 1.1–5.12, ed. P. Maraval, in Egérie, *Journal de Voyage* (Paris, 1982), and translated by J. Wilkinson, *Egeria's Travels* (London, 1971), pp. 91–8. For a discussion of Egeria, see H. Sivan, "Who Was Egeria? Piety and Pilgrimage in the Age of Gratian", *Harvard Theological Review* 81 (1988), pp. 59–72. On the date, see P. Devos, "La date du voyage d'Egérie", *Analecta Bollandiana* 85 (1967), pp. 165–94.

57. On which, see McGuckin, 1986, pp. 109–13.

58. For a discussion of "Der Mosesberg und das Katharinenkloster", see T. C. Aliprantis, *Moses auf dem Berge Sinai* (Munchen, 1986), pp. 1–16.

59. In particular, Moses is central to Philo's conception of the mystic ascent – see Goodenough, 1935, pp. 212, 240ff. In Christian writing, Gregory of Nyssa's *De Vita Moysis* has been seen as the crowning work of Gregory's mysticism (see Gregory of Nyssa, *The Life of Moses*, translated by A. J. Malherbe and E. Ferguson [New York, 1978], p. 11 and n. 59 for references), whereas the immensely influential *De Mystica Theologia* of Pseudo-Dionysius uses Moses' ascent to Sinai as the paradigm for spiritual ascent at 1.3 (*PG* 3.1000B–1001A).

60. For a brief survey of Gregory's life, see J. Danielou's introduction to H. Musurillo, *From Glory to Glory: Texts from Gregory of Nyssa's Mystical Writings* (London, 1961), pp. 3–10. On the *De Vita Moysis*, see the

introduction by Malherbe and Ferguson to their translation; W. Jaeger, *Two Rediscovered Works of Ancient Christian Literature* (Leiden, 1954), p. 133ff.; J. Danielou in his introduction to his translation and edition of Gregory of Nyssa's *La Vie de Moise* (Paris, 1955), pp. 7–38. Apart from the latter and *PG* 44.297–430, the most recent edition is H. Musurillo's Gregorii Nysseni, *Opera: De Vita Moysis* (Leiden, 1964).

61. For some remarks on the relation of Gregory of Nyssa's mystical system with that of Plotinus, see Dodds, 1965, pp. 98–9. More generally on his Platonism, see J. Danielou, *Platonisme et Theologie Mystique: Essai sur la doctrine spirituelle de S. Gregoire de Nysse* (Paris, 1944); H. F. Cherniss, *The Platonism of Gregory of Nyssa* University of California, Berkeley, Publications in Classical Philology, vol. 11, no. 1 (1930); E. G. Konstantinou, *Die Tugendlehre Gregors von Nyssa im Verhaltnis zu der Antik-Philosophischen und Jüdisch-Christlichen Tradition* (Wurzburg, 1966).

62. See the Acts of the Seventh Ecumenical Council at Nicaea (787 A.D.), in G. D. Mansi, *Sacrorum Conciliorum Nova et Amplissima Collectio* (Florence, 1859–98), 13.293E (whence the quotation). See also D. J. Sahas, *Icon and Logos* (Toronto, 1986), p. 119, and J. Pelikan, *Imago Dei* (New Haven and London, 1990), p. 71.

63. The closest iconographical comparison is with a representation of the theme on the ivory lipsanotheca now in Brescia, dating from the second half of the fourth century. For a full survey of the iconography of this scene from the third century, see Aliprantis, 1986, pp. 17–21.

64. See Forsyth, 1973, p. 10.

65. On which, see also Gregory of Nyssa, *In Diem Natalem Christi PG* 46.1136BC, and Cyril of Alexandria, *Adversus Anthropomorphitas PG* 76.1129A.

66. See 2.22–6, with footnotes, in *The Life of Moses*, trans. Malherbe and Ferguson.

67. For a survey of the preceding and later iconography of this subject, see Aliprantis, 1986, pp. 33–9.

68. Compare Clement, *Stromateis* 5.12 = *PG* 9.116B; Philo, *Questions and Answers on Exodus* 2.52.

69. On the symbolism of darkness, see Danielou's introduction to Musurillo, 1962, pp. 22–33.

70. By contrast with the San Vitale Moses, who wears sandals even as he receives the Law.

71. Compare Clement, *Stromateis* 6.12 = *PG* 9.325AB.

72. Weitzmann, 1973, pp. 14, 15.

73. It may be remarked in passing that Gregorian desire, although it resembles Lacanian desire in that it can never be fulfilled, is the very opposite of what is proposed by Lacan. For the psychoanalyst, desire ("the desire that is the very essence of man" [1977, p. 107] is felt for what cannot be achieved, for an Other which can never be self. The result is what Lacan terms "lack" (p. 214), "separation" (p. 214), "alienation" (pp. 215, 236). At its root Lacanian desire is a foreclosing, a despair. For the theologian-mystic, on the other hand, desire is the process of the path. Its achievement (also a kind of despair – *apelpismos* [2.220]) is the revelation of there always being somewhere further to go. That is, where Lacan meets an "obstacle" (p. 215) or a foreclosing, Gregory sees desire as always the provision of a greater opening.

335

Whereas Lacan is caught rigidly within a dualist conceptual framework of self and Other, at the heart of the Gregorian notion of desire as opening is the Neoplatonic framework of a place of "assimilation" or "union" beyond self and Other. However, in Gregory such a place cannot be attained in *this* life, so long as man is limited by the body and the flesh.

74. Compare *In Canticum Canticorum* 5 (*PG* 44.876BC). For a discussion of this aspect of mystical experience in Gregory, see R. Sorabji, "Myths about Non Propositional Thought", in M. Schofield and M. C. Nussbaum, *Language and Logos: Studies in Ancient Greek Philosophy Presented to G. E. L. Owen* (Cambridge, 1982), p. 308f.

75. Fortunately those pertaining to the Transfiguration have recently been extracted, collected and translated by J. A. McGuckin, 1986, pp. 146–322. The manuscripts and editions of patristic Greek homilies on the Transfiguration are discussed in M. Sachelot, *Les homelies grecques sur la Transfiguration* (Paris, 1987). A valuable reading of some of the meanings of the Sinai Transfiguration in the light of the Fathers is de' Maffei, 1982, pp. 185–200. One disadvantage of this paper, however, is that it isolates the apse-conch from the rest of the Sinai programme and therefore fails to take account of the Moses scenes.

76. The relevant publications are E. R. Leach, *Genesis as Myth and Other Essays* (London, 1969); E. R. Leach and D. A. Aycock, *Structuralist Interpretations of Biblical Myth* (Cambridge, 1983); E. R. Leach, "Fishing for Men on the Edge of the Wilderness", in F. Kermode and R. Alter, eds., *The Literary Guide to the Bible* (London, 1987). Interesting is the following remark by Leach from the latter:

> The method owes a great deal to the structuralist techniques which Claude Lévi-Strauss has applied to the analysis of the oral mythology of preliterate peoples, but, as far as the Bible is concerned, it is closely related to the typological style of argument employed by the majority of early Christian writers. (p. 579)

77. Weitzmann, 1973, p. 14.

78. The Transfiguration is not the only instance where a special event – a penetration of this world by the Other World – before a very select audience (here, two prophets and the three foremost apostles) is played out on a mountain. Other examples include the Temptation (Matt. 4.8); the Ordination of the Apostles (Mark 3.13; Luke 6.12–13); the Sermon on the Mount – the most extensive passage of Christ's quoted teachings, delivered to the disciples apart from the multitudes on a mountain (Matt. 5.1); the Prophecy of the Second Coming – delivered to the select group of Peter, Andrew, James and John (Mark 13.3–37); the Agony in the Garden – which takes place before the same select group of apostles as the Transfiguration on the Mount of Olives (Matt. 26.30–45; Mark 15.26–42; Luke 22.39–46). See McGuckin, p. 53ff. Of the patristic commentators, Cyril of Alexandria (died A.D. 444) argues that ascending the mountain suggests "a mind [in Christ's chosen audience] which has spurned earthly things and gone beyond all bodily matters to stand alone in stillness" (*Comm. in Lucam* 9. *PG* 72.652D). Proclos of Constantinople (died A.D. 446) in *Oratio* 8.1 (*PG* 65.763f.) makes much of the parallelism of Christ on a mountain with Elijah and Moses on mountains.

79. E. R. Leach, 1987, p. 587. For the meaning of "Sinai" as "inaccessible", see Philo, *Questions and Answers on Exodus* 2.45.

80. See J. Elsner, "Image and Iconoclasm in Byzantium", *Art History* 11, 4 (December 1988), 471–91, p. 474.

81. See E. Diez and O. Demus, *Byzantine Mosaics in Greece: Hosios Loukas and Daphni* (Cambridge, Mass., 1931), p. 61.

82. Weitzmann (1973, p. 14), following John Chrysostom's equation of the Transfiguration with the Second Coming (*In Matthaeum 17. Hom. 56. PG* 58.554), sees the absence of Tabor as an indication that the Sinai Transfiguration represents the Second Coming with Christ actually shown in Heaven. I do not dispute this as a possible reading, but it is only one out of the many whose totality marks the full significance of the image.

83. See Weitzmann, 1973, p. 12, and 1990, p. 62.

84. See Elsner, 1988, pp. 474–5.

85. On their imperfection, see, for example, Origen (third century), *Comm. in Matthaeum* 12.40 (*PG* 13.1076A); Proclos of Constantinople (fifth century), *In Transfigurationem Domini, Oratio* 8.3 (*PG* 65.768C). On their witness, see Eusebius of Caesarea (died 339), *Comm. in Lucam* Chap. 9 (*PG* 24.549AB); Basil of Caesarea (died 379), *Hom. in Ps.44* 5 (*PG* 29.400C); John Chrysostom (died 407), *Ad Theodorum Lapsum* 1.11 (*PG* 47.291) and *In Matthaeum 17.4, Hom.* 56 (*PG* 58.554).

86. Philo, *Questions and Answers on Genesis* 4.2 and *Questions and Answers on Exodus* 2.51; Clement, *Paedagogus* 1.6 (*PG* 8.282C–284B). Note that the image of sleeping and waking occurs also in Plotinus, *Enn.* 4.8.1.1f. in the mystic context of unifying with the One.

87. The Raising of Jairus's daughter: Mark 5.39; Luke 8.52. The Raising of Lazarus: John 11.11.

88. For instance, "Watch therefore, for ye know not the day nor the hour wherein the Son of man cometh", Matt. 25.13. Cf. Matt. 24.42 and 26.41; Luke 12.37; Ephesians 5.8–14; 1 Thessalonians 5.6; Revelation 3.3 and 16.15. Especially appropriate in the monastic context of monks' lives being a rehearsal of death is 1 Corinthians 15.51–6.

89. Ambrose, *In Lucam* 7.17 (*PL* 15.1791B).

90. The first quotation is from John Chrysostom, *In Matthaeum 17, Hom.* 56.3 (*PG* 58.553); the second is from Ambrose as in n. 89.

91. See Danielou, introduction to Musurillo, 1962, pp. 39–41.

92. For a discussion of some aspects of this, see J. Miziolek, "*Transfiguratio Domini* in the Apse at Mt Sinai and the Symbolism of Light", *Journal of the Warburg and Courtauld Institutes* 53 (1990), 42–60, and W. Loerke, "Observations on the Representation of *Doxa* in the Mosaics of S. Maria Maggiore, Rome, and St Catherine's, Sinai", *Gesta* 20, 1 (1981), 15–22.

93. On the mandorla representing the divine light of the "majestas domini", see W. W. S. Cook, "The Earliest Painted Panels of Catalonia", *Art Bulletin* 6, 2 (1923), 31–60, esp. p. 41 (with n. 8 for a collection of patristic references); O. Brendel, "Origin and Meaning of the Mandorla", *Gazette des Beaux Arts* 25 (January 1944), 5–24; A. Grabar, "The Virgin in a Mandorla of Light", in K. Weitzmann, ed., *Late Classical and Mediaeval Studies in Honor of Albert Matthias Friend Jr.* (Princeton, 1955), esp. pp. 309–11.

94. For Christ as the light of the world, see John 1.5; 3.19f.; 9.5; 11.9–10; 12.35–6; 12.45–6.

95. See, for instance, Clement of Alexandria, *Excerpta ex Scriptis Theodoti* 4 (*PG* 9.655); Origen, *Hom. in Genesim* 1.7 (*PG* 12.151–2); Eusebius of

Caesarea, *Comm in Lucam 9* (PG 24.549–50); and Gregory of Nazian-
zus and Cyril of Alexandria, as in nn. 96 and 97.

96. Gregory of Nazianzus, *De Baptismo, Oratio* 40.5–6 (PG 36.363–366).

97. Cyril of Alexandria, *Comm. in Lucam 9* (PG 72.652D).

98. "This moment is truly climactic, an emblem of the homogeneity of
our whole Bible and of the fruition or perfection of its earliest parts
in its end" (Frank Kermode on the Transfiguration in Kermode and
Alter, 1987, p. 397f). Cf. McGuckin, 1986, pp. 116–17.

99. For an excellent discussion of the many ways, emphases and inter-
pretations with which the Fathers draw out both these comparisons
and others, see McGuckin, 1986, Chap. 3, pp. 99–128.

100. See, on Moses, Goodenough, 1935, pp. 180–234.

101. On Cyril as politician, see, e.g., T. Ware, *The Orthodox Church*
(Harmondsworth, 1963), pp. 32–3, p. 44. On Cyril's theology of the
eucharist, see E. Gebremedhin, *Life-Giving Blessing: An Inquiry into
the Eucharistic Doctrine of Cyril of Alexandria* (Uppsala, 1977).

102. For Christ as "the lamb of God which taketh away the sins of the
world", see John 1.29 and 36; also 1 Peter 1.19 and Revelation 5.6.
For Christ as the lamb who redeems sinners within a eucharistic
context in relation to an extended comparison with Moses, see Cyril
of Jerusalem (died 386), *Mystagogical Catechesis* 1.3 (PG 33.1067BC).

103. For the lamb as the eucharist, see, for instance, the discussion of G.
Galavaris, *Bread and the Liturgy* (Madison and London, 1970), p. 65.
On lambs generally in early Christian art, see now the illuminating
discussion of E. S. Malbon, *The Iconography of the Sarcophagus of Junius
Bassus* (Princeton, 1990), pp. 72–90.

104. For a discussion of the theme of light in the present Orthodox
liturgy, using texts going back to the third and fourth centuries, see
R. Taft, *The Liturgy of the Hours in East and West* (Collegeville, Minn.,
1986), pp. 284–91.

105. See Weitzmann, 1973, p. 14, and H. Maguire, *Earth and Ocean*
(University Park and London, 1987), pp. 12–13. They follow John
of Gaza (sixth century), *Ekphrasis tou Kosmikou Pinakos* 1.41–4, ed. P.
Friedlaender, in *Johannes von Gaza und Paulus Silentarius* (Leipzig und
Berlin, 1912), pp. 136–7, with Friedlaender's commentary ad loc.,
pp. 167–8. The text describes the image of a cross on a blue ground
whose "dark blue whirls" (*kuaneais helikessi*) represent the Holy
Trinity.

106. My discussion assumes that an image is not separable from its inter-
pretative context: See L. Wittgenstein, *Philosophical Investigations*,
2.xi (Oxford, 1958), p. 193. As a result, if one accumulates different
and varying contexts for such an image, it will in the end be poly-
semic. It should be added that the meanings of an image will change
with different liturgies and rituals performed beneath it, for they too
alter the context. For an incisive discussion of this with respect to
twelfth-century Roman mosaics, see S. Sinding-Larsen, *Iconography
and Ritual: A Study of Analytical Perspectives* (Oslo, 1984), pp. 34–6.
For some reflections on polyvalence, ambiguity and symbolism in
early Byzantine art, see Maguire, 1987, pp. 5–15.

107. On the Medieval Christian gaze as authoritarian, see, e.g., E. H.
Gombrich, *Art and Illusion* (London, 1959), pp. 124–5.

108. Thus the Gospels themselves, although apparently first-hand narra-
tives, are actually already commentaries *representing* in narrative

(which is to say in a particular type of symbolic) form the entirely abstract mystery of the Incarnation, which is that somehow God had become man. The importance of the Resurrection therefore (to cite the example of the most important Christian festival) lies not in the event (that a man rose from the dead), but in the perception that this event is a *proof* that the man who rose was God.

CHAPTER 4: VIEWING AND IDENTITY

1. Michel Foucault, *The Order of Things* (London, 1970), p. xvi.
2. For a discussion of this historical aspect of monuments and cultural artefacts, see S. Greenblatt, "Resonance and Wonder", in idem, *Learning to Curse: Essays in Early Modern Culture* (New York and London, 1990), pp. 161–8, and J. Elsner, "From the Pyramids to Pausanias and Piglet: Monuments, Travel and Writing", in S. D. Goldhill and R. Osborne, eds., *Art and Text in Ancient Greek Culture* (Cambridge, 1994), pp. 224–54.
3. On date, see J. G. Frazer, *Pausanias's Description of Greece* (London, 1898), introduction (= the Pausanias section of J. G. Frazer, *Pausanias and Other Greek Sketches* [London, 1900]), pp. xvi–xviii, and C. Habicht, *Pausanias' Guide to Ancient Greece* (Berkeley, 1985), pp. 8–11, which summarises earlier literature. Summaries of Pausanias's life and work with bibliography are O. Regenbogen, "Pausanias", in G. Wissowa, W. Kroll and K. Mittelhaus, eds., *Paulys Realencyclopaedie der classischen Altertumswissenschaft*, supplementband 8, (Stuttgart, 1956), pp. 1008–97, and E. Pernice and W. H. Gross, "Der Periegese des Pausanias", in U. Hausmann, ed., *Allgemeine Grundlagen der Archaeologie* (Munich, 1969), pp. 402–8. On the text, its author and the manuscript tradition, see A. Diller, *Studies in Greek Manuscript Tradition* (Amsterdam, 1983), pp. 137–82.
4. P. Veyne, *Did the Greeks Believe in Their Myths?* (Chicago, 1988):

 Pausanias is not a mind to be underestimated, and we do him an injustice when we accept the assessment of his *Description of Greece* as the Baedeker of ancient Greece. Pausanias is the equal of any of the great nineteenth century German philologists or philosophers. To describe the monuments and narrate the history of the different countries of Greece, he combed the libraries, travelled a great deal, cultivated himself, and saw it all with his own eyes. He approaches collecting local legends with the zeal of a French provincial scholar of the days of Napoleon III. The precision of his descriptions and the breadth of his knowledge are astounding. He amazes us, too, by his visual accuracy. (p. 3)

 With this judgement, I concur.
5. Frazer, 1898: "a man made of common stuff and cast in a common mould. His intelligence and abilities seem to have been little above the average, his opinions not very different from those of his contemporaries" (p. xlix).
6. Some have thought the digressions to be the chief interest of Pausanias's work and even to doubt that he saw the monuments he describes. See especially, U. von Williamowitz-Moellendorf, "Die Thukidideslegende", *Hermes* 12 (1877), 326–67 (esp. pp. 344–7); C. Robert, *Pausanias als Schriftsteller* (Berlin, 1909); H. L. Ebeling, "Pausanias as

an Historian", *Classical Weekly* 7 (1913), 138–41, 146–50; the argument is reviewed by Habicht, 1985, pp. 165–75.

7. See Habicht, 1985, Appendix 1 (pp. 165–75), for a summary of the attack on Pausanias; Habicht himself (especially in Chap. 2, pp. 28–63) leads the defence. On the reliability of Pausanias, see also R. E. Wycherley, "Pausanias and Praxiteles", *Hesperia*, suppl. 20 (1982), 182–3, esp. p. 188f.

8. See, e.g., G. Daux, *Pausanias à Delphes* (Paris, 1936) or G. Roux, *Pausanias en Corinthie* (Paris, 1958). For a bibliography of other examples, see nn 1 and 2 of M. Jost, "Pausanias en Megalopolitide", *Revue des études anciennes* 75 (1973), 241–67.

9. In particular, M. G. Verral and J. E. Harrison, *Mythology and Monuments of Ancient Athens* (London, 1890), and Sir James Frazer's six-volume translation and commentary (London, 1898).

10. See Frazer, 1898, introduction; J. Heer, *La personnalité de Pausanias* (Paris, 1979) (on personality and religion); L. Casson, *Travel in the Ancient World* (London, 1974), pp. 292–9 (travel), and Habicht, 1985.

11. Frazer, 1898, p. xxii; Habicht, 1985, pp. 5–6.

12. Foucault, 1970, p. 132.

13. For Pausanias as an antiquarian, see K. Arafat, "Pausanias' Attitude to Antiquities", *Annual of the British School of Archaeology at Athens* 87 (1992), 387–409.

14. On Pausanias as a Baedeker, Murray or Blue Guide, see Frazer, 1898, p. xxiv; G. Pasquali, "Die schriftstellerische Form des Pausanias", *Hermes* 48 (1913), 161–223, p. 161; B. P. Reardon, *Courants littéraires grecs* (Paris, 1971), p. 222; Casson, 1974, p. 292f.; K. Muller, *Geschichte der antiken Ethnographie und ethnologischen Theoriebildung*, vol. 2 (Wiesbaden, 1980), p. 177; Habicht, 1985, p. 20; R. Chevallier, *Voyages et déplacements dans l'empire romain* (Paris, 1988), p. 50; J. Ferguson, *Among the Gods* (London, 1990), p. 77. For N. Loraux, *Les enfants d'Athéna* (Paris, 1981), p. 7, Pausanias is "more useful than the Guide Bleu". Only Veyne, 1988, pp. 3 and 101, openly contests the "injustice" of this assessment.

15. On the Second Sophistic, see G. W. Bowersock, *Greek Sophists in the Roman Empire* (Oxford, 1969); idem, ed., *Approaches to the Second Sophistic* (University Park, 1974), and E. L. Bowie, "The Importance of the Sophists", *Yale Classical Studies* 27 (1982), 29–60.

16. For the "antiquarian tourist" view of ancient travel, see the classic chapters of L. Friedlaender, *Darstellungen aus der Sittengeschichte Röms* (Leipzig, 1921–3), vol. 1, pp. 318–490; Casson, 1974, pp. 229–329, and E. D. Hunt, "Travel, Tourism and Piety in the Roman Empire", *Echos du monde classique* 28 (1984), 391–417, pp. 398–401 on Pausanias.

17. See F. Millar, *The Emperor in the Roman World* (London, 1977), pp. 28–40, and H. Halfmann, *Itinera Principum: Geschichte und Typologie der Kaiserreisen im römischen Reich* (Stuttgart, 1986), esp. pp. 143–56; K. Holum, "Hadrian and St Helena: Imperial Travel and the Origins of Christian Holy Land Pilgrimage", in R. Ousterhout, ed., *The Blessings of Pilgrimage* (Urbana and Chicago, 1990), pp. 61–81.

18. For a brief account of Pausanias's view of Greece in relation to his view of world geography, see Ch. Jacob, "The Greek Traveler's Areas of Knowledge: Myths and Other Discourses in Pausanias's *Description of Greece*", *Yale French Studies* 59 (1980), 65–85, esp. pp. 69–73.

19. On Herodotus and the Other, see F. Hartog, *The Mirror of Herodotus* (Berkeley, 1988).

20. On Pausanias's interest in religion, see Frazer, 1898, pp. xxv–xxviii; Heer, 1979, pp. 127–314; Habicht, 1985, pp. 23, 151f.

21. Apuleius, *Apologia* 55: "I have been initiated into various of the Greek mysteries . . ."

22. In particular, Pausanias appears to have been an initiate into the rites of Demeter and Kore, see Heer, 1979, pp. 132–4, and Habicht, 1985, p. 156.

23. On the Demeter of Phigalia, see Jost, 1975, p. 249, Heer, 1979, pp. 160–7, and W. Burkert, *Structure and History in Greek Mythology and Ritual* (Berkeley, 1979), pp. 125–7.

24. Many aspects of pagan cult and pilgrimage are brilliantly evoked by R. Lane Fox, *Pagans and Christians* (London, 1986), pp. 27–261. For pilgrimage in the context of Graeco-Roman paganism generally, see R. MacMullen, *Paganism in the Roman Empire* (New Haven and London, 1981), pp. 18–34. On some aspects of pagan pilgrimage, graffiti and writings, see M. Beard, "Writing and Religion: *Ancient Literacy* and the Function of the Written Word in Roman Religion", in *Literacy in the Roman World* (Journal of Roman Archaeology Suppl. 3, Ann Arbor, 1991), pp. 35–58.

25. Especially Egeria's "Travels" (translated in J. Wilkinson, *Egeria's Travels to the Holy Land* [Jerusalem, 1981]) and the journey of the Bordeaux Pilgrim of A.D. 333 (partially translated by Wilkinson, 1981, pp. 153–63). For general discussion, see E. D. Hunt, *Holy Land Pilgrimage in the Later Roman Empire, AD 312–460* (Oxford, 1982).

26. For Christian pilgrimage as a journey to an Other World, see M. B. Campbell, *The Witness and the Other World* (Ithaca, 1988), esp. pp. 15–45 on Egeria; for the emergence of a characteristically Christian conception of the Holy Land, see J. Z. Smith, *To Take Place: Toward Theory in Ritual* (Chicago, 1987), esp. pp. 88–95 on Egeria, and R. A. Markus, *The End of Ancient Christianity* (Cambridge, 1990), pp. 139–55 (on "holy places and holy people").

27. On location and sacred geography, see D. L. Eck, "India's *Tirthas*: 'Crossings' in Sacred Geography", *History of Religions* 20 (1981), 323–44, esp. p. 323, and T. S. Naidu, "Pilgrims and Pilgrimage: A Case Study of the Tirumala-Tirupati Devasthanams", in M. Jha, ed., *Dimensions of Pilgrimage* (Delhi, 1985), pp. 17–25, p. 17. On Christian pilgrimage as a journey *elsewhere*, see Campbell, 1988, p. 18.

28. J. J. Preston, "Sacred Centres and Symbolic Networks in South Asia", *The Mankind Quarterly* 20, 3 and 4 (1980), 259–93, p. 269 (quoting B. Aziz, unpublished).

29. For example, Pausanias's comments on fate (e.g., 4.9.6: "human affairs and human purpose above all are obscured by fate, just as the mud of a river hides a pebble", cf. 8.24.13); on modern morality (e.g., 8.2.5: "at the present time, when sin has grown to such a height and has been spreading over every land and every city, no longer do men turn into gods, except in the flattering words addressed to despots"); on piety (e.g., Hadrian, 1.5.5; the Athenians, 1.17.1 and 24.3; or Antoninus Pius, 8.43.5), and impiety (e.g., Sulla, 1.20.7; the Achaeans, 7.10.1; Aristocrates, son of Aechmis, 8.5.11, or Philip, son of Amyntas, 8.7.5).

30. C. Taylor, *Sources of the Self* (Cambridge, 1989), p. 3f.; pp. 27–8, 43–

4: esp. p. 28: "the essential link between identity and orientation. To know who you are is to be orientated in moral space".

31. On Pausanias's predecessors, see Frazer, 1898, pp. lxxxii–xc, and Heer, 1979, pp. 9–12.

32. The fragments of Pseudo-Dicaearchus are edited by C. Müller, *Geographi Graeci Minores*, vol. 1 (Paris, 1882), pp. 97–110, and partially translated by Frazer, 1898, pp. xliii–viii.

33. Frazer, 1898, p. xlvii–viii.

34. On Alexandrian geographies, see P. M. Fraser, *Ptolemaic Alexandria*, vol. 1 (Oxford, 1972), pp. 520–53, and for descriptions of Alexandria itself (in particular, Strabo's Book 17) see ibid., pp. 7–37.

35. On ancient guidebooks to cities, see, for instance, G. Hermansen, "The Population of Imperial Rome: The Regionaries", *Historia* 27 (1978), pp. 129–68, esp. pp. 131–8 and p. 140f. on the enumerative lists of Roman monuments which go under the collective name of "regionaries" and on the comparable *Notitia Urbis Constantinopolitanae*. The "regionaries" are collected and edited by H. Jordan in his appendix to *Topographie der Stadt Rom in Altertum*, vol. 2 (Berlin, 1871); by R. Valentini and G. Zucchetti, *Codice Topografico della Città di Roma*, vol. 1 (Rome, 1940), pp. 63–258, and by A. Nordh, *Libellus de Regionibus Urbis Romae* (Lund, 1949). Such accounts are drawn on by Zachariah Rhetor for his description of Rome in the *Syriac Chronicle* 10.16: See Jordan, 1871, pp. 525–7, and E. W. Brooks, *Historia Ecclesiastica Zachariae Rhetori*, vol. 2 (Louvain, 1924), pp. 131–4, a text translated by F. J. Hamilton as *The Ecclesiastical History of Zacharius Rhetor* (London, 1892). For the *notitia* of Constantinople, see O. Seeck, *Notitia Dignitatum* (Berlin, 1876), pp. 229–43, and for the topographic descriptions of Constantinople that survive in the text of Codinus, see T. Preger, *Scriptores Originum Constantinopolitanarum*, vol. 2 (Leipzig, 1907).

36. See, in particular, the "*Periplus* of the Erithraean Sea", dating from about A.D. 95–130, edited and translated by W. Schoff (London, 1912); G. W. B. Huntingford (London, 1980); L. Casson, Princeton, 1989.

37. This goal is frequently announced, e.g., "The most noteworthy sight in the Piraeus is a precinct of Athena and Zeus" (1.1.3); "The most noteworthy things which I found the city of Epidaurus itself had to show are these" (2.29.1), and, among numerous other instances, 1.39.3; 2.10.4; 2.13.3; 2.15.1; 2.20.7; 2.23.7; 2.25.4; 2.30.11; 3.19.6; 8.54.7; 10.32.1.

38. On the concentration on sacred images, see Frazer, 1898, p. xxvf.; Habicht, 1985, p. 23 (and n. 91 there); Casson, 1974, p. 296.

39. On Pausanias, locative myths and "divine presence", see Lane Fox, 1986, p. 111 f. On the importance of images in pagan cults, see ibid., pp. 66–8. On Pausanias and local myths, see Veyne, 1988, p. 17.

40. This is why it is misconceived to attack Pausanias for historical inaccuracy – his history is no different from myth because both are ways of constructing identity; on Pausanias and history, see Habicht, 1985, Chap. 4 (esp. p. 97 and n. 6 there). But it is too simple to assert that "Pausanias wanted to enliven his descriptions of regions, cities and monuments with historical facts" (ibid., p. 96). This assumes that Pausanias the historian is different from Pausanias the guide (ibid., p.

95), but in fact Pausanias is neither. The distinction of "history" or "tourism" or "pilgrimage" from the rest of Pausanias's ideological thrust is an entirely false one – to the Greek of the second century A.D. creating a nostalgic ideology of sacred and ancient Greece, history, geography and myth were all part of identity.

41. See H. Sivan, "Holy Land Pilgrimage and Western Audiences: Some Reflections on Egeria and Her Circle", *Classical Quarterly* 38 (1988), 528–35, esp. p. 533.

42. See J. B. Holloway, *The Pilgrim and the Book* (New York, 1987), esp. p. xiv.

43. I follow Veyne, 1988, pp. xi–xii and passim in taking the disparate totality of myths, beliefs and truths accepted or criticised by a society as constituting its culture.

44. See Habicht, 1985, p. 97, and the views he quotes in n. 6 there.

45. *Contra* the assumption that Pausanias's narratives are digressions or additions which expand or enliven what is basically a topographic guidebook: e.g., Habicht, 1985, p. 96, or Frazer, 1898, p. xl – "to relieve the tedium of the topographic part of his work Pausanias introduced digressions . . ."

46. Heer, 1979, p. 69f.; Habicht, 1985, p. 102f.

47. On the ancient Greek myth of autochthony in its Athenian context, especially revealing are C. Bérard, *Anodoi: Essai sur l'imagerie des passages chthoniens* (Rome and Neuchâtel, 1974), pp. 31–8, and Loraux, 1981, pp. 7–26, 35–73 (= *eadem*, "L'autochthonie: une topique athénienne. Le mythe dans l'éspace civique", *Annales E.S.C.* 34 [1979], 3–26), 197–253; see also N. Loraux, *The Invention of Athens* (Cambridge, Mass., 1986), pp. 148–50, 193–4, 277–8. On Pausanias and autochthony, see Ch. Jacob, 1980, pp. 73–82.

48. Some further examples of autochthony include Aras 2.12.4; the Aeginetans 2.29.2; Lelex 3.1.1; Phlyus 4.1.5; the Arcadians and Achaeans 5.1.1; Anax of Miletus and Coresus of Ephesus 7.2.5–7; Eumelus 7.18.2; Pheneos 8.14.4; the Plataeans 9.1.1; Ogygus of Thebes 9.5.1; the Thebans sown by Cadmus 9.10.1; Alalcomeneus 9.33.5; Castalius 10.6.4; the first Sardinians 10.17.2; Ledon 10.33.1.

49. On Pausanias's use of Homer, see Robert, 1909, pp. 25ff.; Heer, 1979, pp. 95–7; Habicht, 1985, pp. 133, 143.

50. On the Jews, see N. R. M. de Lange, "Jewish Attitudes to the Roman Empire", in P. D. A. Garnsey and C. R. Whittaker, eds., *Imperialism in the Ancient World* (Cambridge, 1978), pp. 255–81. On Greek identity in the Roman Empire, see R. Browning, "Greeks and Others", in idem, *History, Language and Literacy in the Byzantine World* (London, 1989), pp. 8–11.

51. On Plutarch and the Romans, see R. H. Barrow, *Plutarch and His Times* (London, 1967), pp. 119–49; C. P. Jones, *Plutarch and Rome* (Oxford, 1971), G. J. D. Aalders, *Plutarch's Political Thought* (Amsterdam, 1982), pp. 12–25.

52. On Pausanias and the Romans, see J. Palm, *Rom, Römertum und Imperium in der griechischen Literatur der Kaiserzeit* (Lund, 1959), pp. 63–74; B. Forte, *Rome and the Romans as the Greeks Saw Them* (Rome, 1972), pp. 418–27; Heer, 1979, pp. 66–9; Habicht, 1985, pp. 117–64.

53. On these omissions, see M. L. D'Ooge, *The Acropolis of Athens* (Lon-

don, 1908), pp. 276–7, and R. E. Wycherley, *Pausanias's Description of Greece*, the companion to the Loeb edition, vol. 5 (London, 1971), pp. 29–30, 34.

54. Other examples of praise lavished on Hadrianic buildings are his works in Athens at 1.18.9; his marble temple at Megara, 1.42.5; his road improvements, 1.44.6; his temple of Antinous at Mantineia, 8.9.7; his general improvement of conditions at Corinth, 2.3.5 and 8.22.3.

55. See Aalders, 1982, p. 17.

56. On Pausanias and inscriptions, see Habicht, 1985, pp. 64–94.

57. An excellent account is Lane Fox, 1986, pp. 11–261. On pilgrimage, temple displays and administration, see MacMullen, 1981, pp. 18–48. On the holiness of place in pagan antiquity, see S. MacCormack, "*Loca Sancta:* The Organization of Sacred Topography in Late Antiquity", in Ousterhout, 1990, pp. 9–20; for the relics of the hero Pelops at Olympia, see Pausanias 5.13.4–6 and 6.22.1 with W. Burkert, *Homo Necans* (Berkeley, 1983), p. 99.

58. A good analogy for this is the 1,000-mile pilgrimage to the 88 sacred places of Shikoku in Japan, so vividly evoked by O. Statler, *Japanese Pilgrimage* (London, 1983).

59. An excellent account of pilgrimage as *rite de passage* is V. Turner and E. Turner, *Image and Pilgrimage in Christian Culture* (New York, 1978), pp. 1–39, and V. Turner, "The Centre Out There: Pilgrim's Goal", *History of Religions* 12, 3 (1973), 191–230. On pilgrimage as a transformative journey, see A. G. Grapard, "Flying Mountains and Walkers of Emptiness: Towards a Definition of Sacred Space in Japanese Religion", *History of Religions*, 21, 3 (1982), 195–221, esp. pp. 205–7, and Eck, 1981, pp. 324–6, 334, 340–4. On "the act of accounting for one's travels" as itself a *rite de passage*, see M. Harbsmeier, "Elementary Structures of Otherness", in J. Céard and J. C. Margolin, eds., *Voyager à la Renaissance* (Paris, 1987), pp. 337–55, p. 337.

60. On this passage, see Habicht, 1985, pp. 156–7, and Veyne, 1988, pp. 11, 98–100.

61. See the implications of 1.14.3; 1.37.4; 1.38. Generally on Pausanias and Eleusis, see Heer, 1979, pp. 127–89. For a discussion of the site, its archaeology and the mysteries, see G. E. Mylonas, *Eleusis and the Eleusinian Mysteries* (Princeton, 1962), and K. Kerenyi, *Eleusis: Archetypal Image of Mother and Daughter* (New York, 1967).

62. See Habicht, 1985, p. 156.

63. For pilgrimage as a confrontation with the Other, see, e.g., Grapard, 1982, 205–7; D. K. Samanta, "Ujjain: A Centre of Pilgrimage in Central India", in Jha, 1985, pp. 43–53, p. 52; V. Turner, *Dramas, Fields and Metaphors* (Ithaca, 1974), p. 197.

64. On the peripheral nature of many pilgrimages, see V. Turner, 1974, pp. 193–6.

65. *Aporrhêtos* in a mystery context: e.g., 2.17.4; 2.34.10; 2.38.3; 4.20.4; 4.33.5.

66. On Athena Polias, see C. J. Herrington, *Athena Parthenos and Athena Polias* (Manchester, 1955), and J. H. Kroll, "The Ancient Image of Athena Polias", *Hesperia* suppl. 20 (1982), 65–76.

67. Herrington, 1955, pp. 16–17; Kroll, 1982, p. 65.

68. On the Arrephoria, see H. W. Parke, *Festivals of the Athenians* (Lon-

don, 1977), pp. 141–3, and E. Simon, *Festivals of Attica* (Madison, 1983), pp. 39–46.

69. I note four categories where Pausanias feels that the observer is in some sense debarred from entering or seeing or hearing of a site, and about which Pausanias is consequently reticent:

1. *Seeing:* In several cases the entire contents of a sanctuary are barred to the uninitiated – 1.14.3; 1.38.7; 2.4.7; 2.35.8; 3.14.4; 8.10.2; 10.33.11. Certain images may be partially visible for ritual purposes – 2.11.3; 2.11.6; others may be seen only by priests – 2.13.7; 7.23.9 or by specific groups – 3.20.3.

2. *Hearing:* Certain ritual stories (2.3.4; 2.17.4), words (5.15.11) and names (8.37.9) cannot be divulged to the uninitiated listener-reader.

3. *Entering:* Some sanctuaries cannot be entered at all – 2.4.6; 8.31.5; 8.38.6. Some may not be entered by men (9.12.3) or women on certain days (5.6.7). Some may be closed to all but priests or worshippers – 2.10.2; 2.10.4–5; 6.20.3; 6.25.2; 7.27.3; 10.24.5; 10.32.13; 10.35.7. Some may be entered only on specified days – 8.31.8 (men once a year); 8.41.5; 9.25.3; 10.35.7.

4. *Ritual:* Often rites are secret to the uninitiated – 2.17.1; 2.37.6; 3.20.3; 4.33.4; 8.37.1f.; 9.25.5–6; 10.32.14. Rituals may make the otherwise secret public for a single day – 2.7.5–6; they may allow entrance to a shrine or oracle – 7.26.7 and 9.39.8; they may exclude certain groups at certain times – e.g., men at 7.27.10.

See Lane Fox, 1986, p. 154 n. 21 for some comparable archaeological evidence.

70. B. Rotman, *Signifying Nothing: The Semiotics of Zero* (Basingstoke, 1987).

71. "Ordinary" viewing is not merely inadequate; it is impious – cf. the recurring use of the word *hosion*, for example, 1.14.3 or 9.25.5–6.

72. See C. Geertz, "Religion as a Cultural System", in M. Banton, ed., *Anthropological Approaches to the Study of Religion*, ASA Monographs 3 (London 1966), p. 38.

73. Ibid.

74. In this Pausanias is a precursor of the kinds of divisions which existed quite comfortably throughout late antiquity between Christian and "Hellenic" identities, on which, see G. W. Bowersock, *Hellenism in Late Antiquity* (Cambridge, 1990), esp. pp. 41–70.

75. On the sense of place in fourth-century pilgrimage accounts, see Hunt, 1982, pp. 83–8.

76. On Egeria and the liturgy, see Hunt, 1982, pp. 107–28, and J. Baldovin, *The Urban Character of Christian Worship* (Rome, 1987), pp. 55–64, 83–96 (using Egeria to reconstruct patterns of fourth-century worship in Jerusalem at Easter).

77. See Hunt, 1982, pp. 83–106, and MacCormack, 1990, pp. 20–4.

78. See the excellent account of R. A. Markus, 1990, pp. 1–18, 224–8. Nonetheless, we should note that the Christian pilgrims exemplify a kind of viewing which only became the norm slowly. They were ahead of their time, in that the vestiges of pagan and "Hellenic" modes of viewing and representing the world survived in the Near

East into the sixth and seventh centuries, on which, see Bowersock, 1990.

PART II: THE TRANSFORMATION OF ROMAN ART FROM AUGUSTUS TO JUSTINIAN. FOREWORD.

1. R. Hooker, *Of the Laws of Ecclesiastical Polity*, 4.10.10. (London, 1593).

CHAPTER 5: REFLECTIONS ON A ROMAN REVOLUTION

1. P. Zanker, *Augustus und die Macht der Bilder* (Munich, 1987), now translated as *The Power of Images in the Age of Augustus* (Ann Arbor, 1988). See also the essays of B. A. Kellum and W. Mierse in K. Raaflaub and M. Toher, eds., *Between Republic and Empire* (Berkeley, 1990), pp. 276–307, 308–33.

2. On this excavation in general, see C. Calci and G. Messineo, *La Villa di Livia a Prima Porta* (Rome, 1984); on the excavation of the statue, see H. Kähler, *Die Augustusstatue von Primaporta* (Cologne, 1959), pp. 7–11, and J. Pollini, "The Findspot of the Statue of Augustus from Prima Porta", *Bulletino della Commissione Archeologica Communale di Roma* 92 (1987–8), 103–8.

3. For the original being in Rome, see D. Strong, *Roman Art*, 2d ed. (Harmondsworth, 1988), p. 86; for the eccentric view that places it in Pergamon, see H. Ingholt, "The Prima Porta Statue of Augustus: Part 2 – The Location of the Original", *Archaeology* 22, 4 (1969), 304–18.

4. The bibliography on the Prima Porta Augustus is simply huge. For a survey to 1977, see H. Jucker, "Dokumentation zur Augustus-statue von Prima Porta", *Hefte des Archäologischen Seminars der Universität Berne* 3 (1977), pp. 16–37. A succinct survey of issues is W. Helbig, *Führer durch die offentlichen Sammlungen klassischer alturmer in Rom*, vol. 1, *Die päpstlichen Sammlungen im Vatikan und Lateran* (Tübingen, 1963), no. 411, pp. 314–19. I list only the works I have consulted.

Dating: F. S. Johansen, "Le Portrait d'Auguste de Prima Porta et sa datation", in K. Ascani et al., eds., *Studia Romana in honorem P. Krarup* (Odense, 1976), pp. 49–57; K. Fittschen, "Zur Panzerstatue in Cherchel", *Jahrbuch des Deutschen Archaeologischen Instituts* 91 (1976), 175–210 (esp. pp. 203–8; F. Brommer, "Zur datierung des Augustus von Prima Porta", in Th. Gelzer, ed., *Eikones: Festschrift Hans Jucker* (Berne, 1980), pp. 78–80.

Typology: A. K. Massner, *Bildnisangleichung: Untersuchungen zur Entstehungs- und Wihungsgeschichte der Augustusporträts (43 v. Chr. – 68 n. Chr.)*, Das Römische Herrscherbild 4 (Berlin, 1982), pp. 36–40 on the "Primaportatypus".

Interpretations: E. Simon, "Zur Augustusstatue von Prima Porta", *Mitteilungen des Deutschen Archaeologischen Instituts: Römische Abteilung* 64 (1957), pp. 46–68; *eadem, Der Augustus von Prima Porta* (Bremen, 1959); Kähler, 1959; G. M. A. Hanfmann, *Roman Art* (London, 1964), p. 82f.; J. D. Breckenridge, *Likeness: A Conceptual History of Ancient Portraiture* (Evanston, 1968), p. 189; A. W. Lawrence, *Greek and Roman Sculpture* (London, 1972), pp. 256–7; R. Brilliant, *Roman Art* (London, 1974); D. Strong, *Roman Art* (London, 1976), p. 46f. (p. 86f. of the 2d ed. rev. R. J. Ling [Harmondsworth, 1988]); H. Meyer,

Kunst und Geschichte, Münchner Archäologische Studien 4 (Munich, 1983), pp. 123–40; S. R. F. Price, *Rituals and Power* (Cambridge, 1984) pp. 185–6; N. Hannestad, *Roman Art and Imperial Policy* (Hojbjerg, 1986), pp. 50–6; E. Simon, *Augustus* (Munich, 1986), pp. 53–67, and P. Zanker, 1987, p. 189f (= 1988, p. 188f.).

Also useful for context is S. Walker and A. Burnett, *The Image of Augustus*, British Museum Publications (London, 1981).

5. Brilliant, 1974, p. 112.

6. On cuirassed statues, see especially K. Stemmer, *Untersuchungen zur Typologie, Chronologie und Ikonographie der Panzerstatuen*, Archäologische Forschungen 4 (Berlin, 1978), and the concordance of C. Vermeule, "Hellenistic and Roman Cuirassed Statues", *Berytus* 13 (1959), 1–82.

7. Price, 1984, p. 186.

8. Insofar as the Prima Porta image has connotations of triumph, it is worth noting that triumph in Rome was closely connected with divinity – so, for example, the triumphator would be arrayed as a god. S. Weinstock has shown that many of the honours attached to triumph "could equally well be applied to a triumphator or a king or a god" (see S. Weinstock, *Divus Julius* [Oxford, 1971], p. 6off., 27off., 74, for the triumphator as Jupiter; the quote is from p. 75). In this sense the very intimation of imperial triumph in the statue hints both at divinity and kingship.

9. For a discussion of the shield of Aeneas, see P. duBois, *History, Rhetorical Description and the Epic* (Cambridge, 1982), pp. 28–51, esp. pp. 41–8.

10. Suetonius, *Augustus* 50; with Simon, 1957, p. 61.

11. For a brief discussion of this in the realm of political theory, see G. F. Chesnut, "The Ruler and the Logos in Neopythagorean, Middle Platonic and Late Stoic Political Philosophy", *ANRW*, 2. 16.2, pp. 1310–32.

12. For imperial art as propaganda, see Hannestad, 1986, pp. 9–14 and p. 50 (of the Prima Porta statue), and F. Millar, "State and Subject: The Impact of the Monarchy", in F. Millar and E. Segal, eds., *Caesar Augustus* (Oxford, 1984), pp. 37–60, see pp. 57–8.

13. For "pyramidal structure", see P. Zanker, 1988, pp. 152, 335–9, following G. Alfoeldy, *The Social History of Rome* (London, 1985), pp. 146–56, and A. Wardman, *Religion and Statecraft among the Romans* (London, 1982), p. 81. In general, Zanker's account, by presenting Augustan art as the state might ideally have wished it to be viewed, deprives images of any subversive or conflicting viewings in a way that is culturally and sociologically too simple. No society has ever been so efficiently dictatorial that the image propagated by the government of itself was at once the only image held of the government by every citizen. See further J. Elsner, "Cult and Sculpture: Sacrifice in the Ara Pacis", *Journal of Roman Studies* 81 (1991), 50–61, esp. pp. 50–2 and 60–1.

14. Likewise, reading the *Aeneid* (the present moment for the reader) is itself an ideological act valorizing an epos whose purpose is to validate the Augustan dispensation. But at the same time – for the Augustan reader for whom the *Aeneid* was conceived and written – what the *Aeneid* (the epic past) validates is precisely the Augustan present, the golden age whose supreme achievement is the very *Aeneid* which

the present reader is reading. Augustan ideology is nothing if not wonderfully circular.

15. For such iconoclasm, see K. Hopkins, *Conquerors and Slaves* (Cambridge, 1978), p. 226; on the statues of Julius Caesar destroyed after his assassination by his enemies, see Weinstock, 1971, p. 365; for the removal of Nero's features from his colossus in Rome, see *Historia Augusta: Hadrian* 19.13; on the elimination of reliefs of Nero from the Aphrodisias Sebasteion, see R. R. R. Smith, "The Imperial Reliefs from the Sebasteion at Aphrodisias", *Journal of Roman Studies*, 77 (1987), pp. 88–138, esp. pp. 118 and 128; for the *damnatio memoriae* of Domitian after his murder and the consequent destruction of his statues, see Suetonius, *Domitian* 23.1, Pliny the Younger, *Panegyricus* 52 and Procopius, *Anecdota* 8.13; for the iconoclasm of the statues of Commodus, see *Historia Augusta: Commodus Antoninus* 18.12–13 and 20.4–5 and for visual evidence of the clumsy recutting of a figure of Commodus after his *damnatio memoriae* on a relief in the Palazzo Conservatori, see E. Angelicoussis, "The Panel Reliefs of Marcus Aurelius", *Mitteilungen des Deutschen Archaeologischen Instituts, Römische Abteilung* 91 (1984), 141–205, esp. pp. 152–3; for visual evidence on the Severan Berlin tondo of Caracalla's eradication of the image of his brother Geta after the latter's *damnatio memoriae*, see Hannestad, 1986, p. 260, and for Caracalla's iconoclasm of the images and inscriptions of Geta and the Praetorian Prefect Plautian on the Arch of Septimius Severus and the Porta Argentariorum, see on the former R. Brilliant, *The Arch of Septimius Severus in the Roman Forum*, Memoires of the American Academy in Rome 29 (Rome, 1967), and on the latter D. E. L. Haynes and P. E. D. Hirst, *Porta Argentariorum* (London, 1939); pp. 4–6 and 20–3; on the erasure of the name of Elagabalus, see *Historia Augusta: Elagabalus* 17.4; for the *damnatio memoriae* of Maximian and the iconoclasm of his portraits under Constantine, see Lactantius, *De Mortibus Persecutorum* 42.1 and I. Kalevrezou-Maxeiner, "The Imperial Chamber at Luxor", *Dumbarton Oaks Papers*, 29 (1975), 225–51, esp. p. 244 and p. 247 n. 95 for visual evidence of the destruction of his image.

16. See, on social relations, P. Garnsey and R. Saller, *The Roman Empire* (London, 1987), pp. 107–25, 148–62. For a long meditation on the passiveness of the emperor whose policy decisions are largely in response to pressures from his subjects, see F. Millar, *The Emperor in the Roman World* (London, 1977), with the review of K. Hopkins in *Journal of Roman Studies* 68 (1978), 178–86, p. 180.

17. A view cogently argued by M. P. Charlesworth and H. Stuart Jones in Chapters 4.3 and 5.1–2 of *The Cambridge Ancient History*, vol. 10, *The Augustan Empire 44B.C. – A.D.70* (Cambridge, 1952), pp. 119–43; see also A. H. M. Jones, *Augustus* (London, 1970), pp. 62–85.

18. The theory advanced in 1939 by R. Syme, *The Roman Revolution* (Oxford, 1939).

19. Argued also in the 1930s by A. Alföldi, *Die monarchische Repräsentation in römischen Kaiserreiche* (Darmstadt, 1970).

20. Some of these are conveniently summarised by Z. Yavetz in "The *Res Gestae* and Augustus's Public Image", in Millar and Segal, 1984, pp. 1–36, see pp. 20–6. See now the positions collected and meditated upon in Raaflaub and Toher, 1990.

21. A. Wallace-Hadrill, "Civilis Princeps: Between Citizen and King", *Journal of Roman Studies* 72 (1982), 32–48.

22. K. Hopkins, "Divine Emperors or the Symbolic Unity of the Roman Empire", in idem, *Conquerors and Slaves* (Cambridge, 1978), pp. 197–242, and S. R. F. Price, "Between Man and God: Sacrifice in the Roman Imperial Cult", *Journal of Roman Studies* 70 (1980), 28–43. On Augustus's appropriation of divine qualities, see D. Fishwick, *The Imperial Cult in the Latin West*, EPRO 108 (Leiden, 1987), vol. 1.1, pp. 83–93. For the immediate background to Augustus's divinity in Julius Caesar's aspirations in this direction, see L. R. Taylor, *The Divinity of the Roman Emperor* (Middletown, Conn., 1931), pp. 58–99; Fishwick, 1987, pp. 56–72, and especially, Weinstock, 1971, pp. 281–317, with the important caveats of J. North's review, *Journal of Roman Studies* 65 (1975), 171–7, esp. pp. 173–6.

23. S. R. F. Price, "From Noble Funerals to Divine Cult: The Consecration of Roman Emperors", in D. Cannadine and S. Price, *Rituals of Royalty: Power and Ceremonial in Traditional Societies* (Cambridge, 1987), pp. 56–105, p. 56. For the apotheosis of Julius Caesar under Augustus, see Weinstock, 1971, pp. 346–410.

24. S. R. F. Price, "Gods and Emperors: The Greek Language of the Roman Imperial Cult", *Journal of Hellenic Studies* 104 (1984), pp. 79–85, p. 79.

25. The imperial cult is a huge subject. A bibliography to 1975 is P. Herz, "Bibliographie zum römischen Kaiserkult", *ANRW* 2. 16.2 (Berlin, 1978), pp. 833–910. The situation was different in the eastern (Greek-speaking) and western (Latin) portions of the empire: on the west, a brief historical survey is D. Fishwick, "The Development of Provincial Ruler Worship in the Western Roman Empire", *ANRW* 2. 16.2, pp. 1201–53, and a detailed discussion is idem, 1987, vol. 1.1 pp. 97–164, on Augustus (vol. 1.2 deals with later emperors); on the east, the best discussion is S. R. F. Price, *Rituals and Power* (Cambridge, 1984). On the Oriental and Hellenistic background to the imperial cult, see Fishwick, 1987, vol. 1.1, pp. 3–45; L. Cerfaux and J. Tondriau, *Le culte des souverains dans la civilisation Gréco-Romaine* (Tournai, 1957), pp. 154–267, and L. R. Taylor, 1931, pp. 1–34.

26. On "the inherent sacredness of sovereign power", see C. Geertz, "Centers, Kings and Charisma: Symbolics of Power", p. 123f. in idem, *Local Knowledge* (New York, 1983).

27. Ovid was, of course, hardly disinterested; he was writing from exile, his purpose either to be recalled or to emphasise publicly that Augustus would not recall him.

28. Compare *Tristia* 3.8.12–13 or 5.2.35, with K. Scott, "Emperor Worship in Ovid", *Transactions and Proceedings of the American Philological Association* 61 (1930), pp. 43–69 and L. R. Taylor, 1931, pp. 162–5, 235.

29. See, in the first century A.D., Tacitus, *Annales* 15.29, with Hannestad, 1986, p. 50; in the fourth century, Severian, *Sermons on the Creation of the World* 6.5 (*PG* 56.489), with Hopkins, 1978, pp. 223–4, and St Basil:

The imperial image, too, is called the emperor and yet there are not two emperors: neither is the power cut asunder nor the glory divided. And as the authority which holds sway over us is one, so the glorifica-

tion we address to it is one and not many, since the honour shown to the image is transmitted to its model. (*De Spiritu Sanctu* 17.44f. [*PG* 32.149])

Clearly, the theme was a fourth-century rhetorical trope: For passages to similar effect in John Chrysostom, Anastasius of Antioch and Athanasius of Alexandria, see the eighth-century florilegia of John Damascene, *Orations in Defence of Images* 2.60; 2.66; 3.114. For further discussions of the imperial image in Christian times, see E. Kitzinger, "The Cult of Images in the Age before Iconoclasm", *Dumbarton Oaks Papers*, 8 (1954), 83–150; F. Dvornik, *Early Christian and Byzantine Political Philosophy*, vol. 2 (Washington, 1966), pp. 652–6; S. MacCormack, *Art and Ceremony in Late Antiquity* (Berkeley and London, 1981), pp. 67–73. For disrespect to the imperial image as a sign of rebellion, see R. Browning, "The Riot of A.D. 387 in Antioch", *Journal of Roman Studies* 42 (1952), 13–20, esp. p. 20.

30. Price, 1984, p. 170.

31. See R. Osborne, "The Erection and Mutilation of the Hermai", *Proceedings of the Cambridge Philological Society* 211, n.s. 31 (1985), 47–73.

32. Price, 1984, pp. 181–3.

33. Price, 1984, pp. 185–6.

34. A good discussion of this is Fishwick, 1987, pp. 32–45.

35. A good collection of conflicting views are the papers and discussions collected in W. den Boer, ed., *Le culte des souverains dans l'empire Romain*, Entretiens Fondation Hardt, vol. 19 (Geneva, 1973), with essays by E. Bickerman, G. W. Bowersock, C. Habicht and F. Millar among others.

36. L. R. Taylor, 1931, pp. 35, 237–8; K. Scott, *The Imperial Cult under the Flavians*, (Stuttgart, 1936), preface and passim for the view that "much of this cult . . . was the result of shameless flattery or was dictated by political motives"; J. R. Fears, *Princeps a Diis Electus: The Divine Election of the Emperor as a Political Concept at Rome*, Papers and Monographs of the American Academy in Rome 26 (1977), pp. 320–4; Wardman, 1982, pp. 82–7, on the political advantages of the cult.

37. Hopkins, 1978, pp. 199–200, 215–21; Price, 1980, p. 28; idem, *Rituals and Power*, 1984, pp. 234–48; Fishwick, 1987, pp. 32–45. For a brief but acute analysis of the place of the imperial cult in Roman life, see F. Millar, "The Imperial Cult and the Persecutions", in W. den Boer, ed., *Le culte des souverains*, Entretiens Fondation Hardt 19 (1972), pp. 145–65, esp. pp. 146–9.

38. See D. Fishwick's review of S. R. F. Price, 1984, in *Phoenix* 40 (1986), 229–30, for some of the problems in looking at "collective constructs" rather than at the "participants' perspective".

39. C. Geertz, "Religion as a Cultural System", in M. Banton, ed., *Anthropological Approaches to the Study of Religion*, ASA Monographs 3 (London, 1966), pp. 1–46, p. 38.

40. Hence the "altering quality of ritual" – G. Lewis, *Day of Shining Red: An Essay in Understanding Ritual* (Cambridge, 1980), p. 19. For mystery religions in Roman times displaying exactly this quality of inverting commonsense assumptions and practices, see R. L. Gordon, "Reality, Evocation and Boundary in the Mysteries of Mithras", *Journal of Mithraic Studies* 3 (1980), 19–99.

41. R. L. Gordon, "Authority, Salvation and Mystery in the Mysteries

of Mithras", in J. Huskinson, M. Beard and J. Reynolds, eds., *Image and Mystery in the Roman World* (Gloucester, 1988), pp. 45–80, p. 49.

42. In fact, all rituals, even secular ones, are a way of stressing *otherness*, because they are deliberately marked off from the routines of everyday life – see the definition of B. Kapferer, *A Celebration of Demons* (Bloomington, 1983), pp. 2–7. Thus the imperial cult as *religion* is at the extreme end of a spectrum of "Other-making" ceremonials (some of which in the context of sacrifice are discussed by Price, 1980, pp. 28–43). Here I must take issue with Wallace-Hadrill's view that rituals of condescension reduce the gulf between emperors and subjects (1982, p. 48). On the contrary, by emphasising the need for ritual as the only means of bridging the gulf, such rituals of deference reinforce the *otherness* of the Principate. Because the imperial cult is imperial ritual *par excellence*, it should be noted that conceptually the political rituals of the empire are in fact parasitic on the imperial cult as their sacred exemplar.

43. Compare M. Beard's remarks on "the construction of the gods' appearance" with respect to Greek statues of deities in M. Beard, "Reflections on 'Reflections on the Greek Revolution' ", *Archaeological Review from Cambridge* 4, 2 (1985), 207–13, esp. p. 211, and R. L. Gordon's comments on the identity of deity and image in "The Real and the Imaginary: Production and Religion in the Graeco-Roman World", *Art History* 2, 1 (March 1979), 5–34, esp. pp. 7–16.

44. The ambivalence of the Principate (noted by Wallace-Hadrill, 1982, and Fishwick, 1987, in different contexts) lies in this tension – the tension of the possible relations available to the ordinary person with the logically exclusive discourses (divus, civis, princeps) by which the emperor was defined.

45. In the *Octavia*, Nero claims both to have the power to make gods (v. 449) and to be destined himself to become a god, regardless of his actions (vv. 530–2). Whereas Seneca argues that Augustus became a god through pious actions, peacemaking and avoidance of bloodshed (vv. 472–91), Nero replies (not entirely without historical justification) that Augustus's path to heaven was fuelled by a bloodbath of murders (vv. 502–29).

46. For reconstructions and discussions, see U. Monneret de Villard, "The Temple of the Imperial Cult at Luxor", *Archaeologia* 95 (1953), pp. 85–105; J. G. Deckers, "Die Wandmalerei des tetrarchischen Lagerheiligtums im Ammon-Tempel von Luxor, *Roemische Quartalschrift* 68 (1973), 1–34; Kalevrezou-Maxeiner, 1975, pp. 225–51; J. G. Deckers, "Die Wandmalerei im Kaiserkultraum von Luxor", *Jahrbuch des Deutschen Archaeologischen Instituts* 94 (1979), 600–52. Only Maxeiner doubts the theory that the chamber was a cult room (p. 245).

47. See esp. Deckers, 1979, pp. 640–50.

48. Deckers, 1979, Fig. 34.

49. Kalevrezou-Maxeiner, 1975, pp. 238–9.

50. On style, see Kalevrezou-Maxeiner, 1975, pp. 235 and 251.

51. E. H. Gombrich, *Art and Illusion* (Oxford, 1960), pp. 99–125.

52. The bibliography on these images is large. For a survey of San Vitale to 1968, see G. Bovini, *Saggio di Bibliografia su Ravenna Antica* (Bologna, 1968), pp. 57–60. The standard works are O. Von Simson, *Sacred Fortress: Art and Statecraft in Ravenna* (Chicago, 1948), pp. 23–39; C. O. Nordstroem, *Ravennastudien*, Figura 4 (Uppsala, 1953), pp.

98–102, and especially F. W. Deichmann, *Ravenna: Haupstadt des Spätantiken Abendlandes*, Teil 2, Kommentar 2 (Wiesbaden, 1976), pp. 165–6, 178–87. The San Vitale mosaics are most comprehensively illustrated in F. W. Deichmann, *Frühchristliche Bauten und Mosaiken von Ravenna* (Baden-Baden, 1958), Plates 311–75. A recent interpretation of these images, concentrating on issues of gender, is C. Barber, "The Imperial Panels at San Vitale: A Reconsideration", *Byzantine and Modern Greek Studies* 14 (1990), pp. 19–43. In addition to E. Kitzinger, *Byzantine Art in the Making* (London, 1977), pp. 81–8, and Gombrich, 1960, pp. 124–5, I use also C. R. Morey, *Early Christian Art* (Princeton, 1942); T. F. Mathews, *The Early Churches of Constantinople: Architecture and Liturgy* (University Park and London, 1971), pp. 139–148; MacCormack, 1981, pp. 259–6; E. R. Leach, "Melchisedech and the Emperor: Icons of Subversion and Orthodoxy", in E. R. Leach and D. A. Aycock, *Structuralist Interpretations of Biblical Myth* (Cambridge, 1983), pp. 67–88.

53. Kitzinger, 1977, p. 87.

54. C. R. Morey, 1953, p. 166.

55. This shift in forms is treated very judgmentally by the art-historical authorities. For Berenson (*The Arch of Constantive on the Decline of Form*, Cordan, 1954) it is a "decline", for Kitzinger a "breakdown" (p. 7) and Gombrich – who finds "decline" an "unfashionable" and even "hard" word to use when standing in San Vitale – nevertheless talks of "gingerbread men" (pp. 124–5).

56. For a socio-historical discussion of Christian intellectual developments (especially in terms of the themes of mediation and salvation) in relation to their Roman and late-antique predecessors, see A. Kazhdan and G. Constable, *People and Power in Byzantium* (Washington, 1982), pp. 76–85. On Christ in the early Church, see J. Pelikan, *The Christian Tradition*, vol. 1, *The Emergence of the Catholic Tradition (1–600)* (Chicago, 1971), pp. 226–77; on Christ in Orthodox thought, see idem., *The Christian Tradition*, vol. 2, *The Spirit of Eastern Christendom (600–1700)* (Chicago, 1974), pp. 37–90, and J. Meyendorff, *Byzantine Theology* (New York, 1974), pp. 151–67.

57. "Civic cult, and the imperial regime which was its parasite, tended constantly to politicize religious discourse, subordinating the gods to a theodicy of good fortune" (Gordon, 1988, p. 49).

58. This myth was hammered out in theology: Many Gnostics and others ("docetics") believed that Jesus the man was not Christ and that it was a man and not God who died on the cross. See, for example, E. Pagels, "Gnostic and Orthodox Views of Christ's Passion: Paradigms for the Christian Response to Persecution?", in B. Layton, ed., *The Rediscovery of Gnosticism*, vol. 1 (Leiden, 1980), pp. 262–89, and S. Petrement, *Le dieu séparé* (Paris, 1984), Chap. 3, "Le Docetism", pp. 207–24.

59. The significance of the Christ image is well discussed by M. Lawrence, "The Iconography of the Mosaics of San Vitale", *Atti del VI Congresso Internazionale di Archaeologia Cristiana* (Vatican City, 1965), pp. 123–40, esp. pp. 136–9. See also A. Grabar, *L'empéreur dans L'art byzantin* (Paris, 1936), pp. 202–5, 250; Von Simson, 1948, p. 35, for eschatological implications in the image, and Deichmann, 1976, pp. 178–87.

60. On such mimesis in general, see Kazhdan and Constable, 1982, pp. 157–8. For the development and origins of Christian notions of mon-

archy, see Dvornik, 1966, pp. 611–58, 684–850, and more recently, D. M. Nicol, "Byzantine Political Thought", in J. H. Burns, ed., *The Cambridge History of Medieval Political Thought* (Cambridge, 1988), pp. 51–79. The ideology of imitation whereby the Christian empire was a mimesis of the heavenly order was first formulated under Constantine in Eusebius's "Tricennial Oration" – see *Oratio de Laudibus Constantini*, ed. I. A. Heikel, in Eusebius, *Werke* 1 (Leipzig, 1902), pp. 195–223; a good commentary is H. A. Drake, *In Praise of Constantine* (Berkeley and London, 1976) (translation, pp. 83–102; textual commentary, pp. 30–45; discussion, pp. 46–79); see also Dvornik, 1966, pp. 614–22; T. D. Barnes, *Constantine and Eusebius* (Cambridge, Mass., 1981), pp. 253–5; G. F. Chesnut, *The First Christian Histories* (Paris, 1977), pp. 133–66, and the classic study of N. H. Baynes, "Eusebius and the Christian Empire", in *Byzantine Studies and Other Essays* (London, 1960), pp. 168–72. For the period of Justinian, see Dvornik, 1966, pp. 715–23, 815–28; a most interesting Justinianic text is Agapetus Diaconus, *Hortatory Chapters*, PG 86.1.1163–86 – e.g., Chap. 1: "God gave you the sceptre of earthly power after the likeness of the heavenly kingdom."

61. The empress mediator is a mirror of the Virgin as empress – an iconography of Mary (perhaps Christianity's most important mediator) common in the sixth century; see Dvornik, 1966, p. 658.

62. See J. M. Hussey, *The Orthodox Church in the Byzantine Empire* (Oxford, 1986), pp. 299–303, for the position of the emperor within the *oecoumene*, and the succinct definition of C. Mango, *Byzantium: The Empire of New Rome* (London, 1980), pp. 219–21; on Justinian's particular relations with the Church, see J. Meyendorff, "Emperor Justinian, the Empire and the Church", in idem, *The Byzantine Legacy in the Orthodox Church* (Crestwood, N.Y., 1982), pp. 43–66.

63. In all these socio-political implications there are, of course, significant parallels between the social functions of Justinianic imperial art and, for instance, the imperial processions on the outer walls of the Augustan Ara Pacis, on which see the discussion in Chapter 6.

64. Compare MacCormack, 1981, p. 263, who sees Justinian as representing "his actual, vested power in this world", whereas Theodora is "shown in her glory of this world . . . but at the same time she passes beyond the glory of this world to the glory of the next".

65. Here I differ on the general theme of Byzantine emperors from the view of A. Kazhdan and G. Constable, 1982, pp. 34–5, who believe that "an unbridgeable gulf separated the holy person of the emperor from his humble children and slaves". This may be true in social practice and in certain intellectual assumptions, but the ideology of *mimesis* (which is always reciprocal and on which these mosaics and all Byzantine liturgical and political philosophy is based – see Kazhdan and Constable, 1982, pp. 157–8) means that in principle – and above all in the liturgy – there must be a unifying *likeness* between Christ and his image the emperor, his image the eucharistic bread, his image the humble worshipper in the church. The unbridgeable social gulf is collapsed liturgically into the (at least conceptual) intimacy of likeness.

66. As was grasped by Von Simson, 1948, pp. 29–30; G. Stricevic, "Iconografia dei Mosaici Imperiali a San Vitale", *Felix Ravenna*, 80 (1959), 5–27; and has been refined most lucidly by Mathews, 1971, pp. 146–7.

67. John 14.20: "I am in my Father, and ye in me and I in you"; Matt. 11.24: "He that receiveth you receiveth me, and he that receiveth me receiveth Him that sent me", cf. John 6.56 and 10.30.

68. Gombrich, 1960, p. 125.

69. On the gaze, see especially H. P. L'Orange, *Apotheosis in Ancient Portraiture* (Oslo, 1947), pp. 96–101, 110–12. For some pagan background to the divine implications of the unblinking gaze, see Heliodorus, *Aethiopica* 3.12–13 with R. Lane Fox, *Pagans and Christians* (London, 1986), p. 138, and Julian the Apostate, *Fragment of a Letter to a Priest* 299B–300A, on the divine gaze; for a similar tradition in early Christianity, see the "Acts" of John 88–9, 93, with Lane Fox, 1986, p. 397; on the unblinking gaze in an imperial context, see Ammianus Marcellinus on the *Adventus* of Constantius II to Rome in *Res Gestae* 16.10.10, with MacCormack, 1981, pp. 39–45, R. MacMullen, "Some Pictures in Ammianus Marcellinus", *Art Bulletin* 46 (1964), 435–55, esp. pp. 438–9, L. W. Bonfante, "Emperor, God and Man in the Fourth Century", *Parola del Passato* 19 (1964), pp. 401–27, esp. p. 414f., and M. P. Charlesworth, "Imperial Deportment", *Journal of Roman Studies* 37 (1947), 34–8, p. 36; for the same in an ecclesiastical context of the bishop–holy man, see Gregory of Nyssa, *De Vita S.Gregorii Thaumaturgi*, PG 46.940A–D, with Lane Fox, 1986, p. 530. For the sixth century, see, e.g., Agathias, *Greek Anthology* 1.34, on an image of the archangel Michael: "The eyes encourage deep thoughts and art can convey by colours the prayers of the soul".

70. Gombrich believes that naturalism offers a "free 'fiction' " to viewers in which the image "waits to be wooed and interpreted" (1960, p. 125). I disagree with Gombrich fundamentally about the freedom of this fiction: As I hope my representation of Zanker's analysis of the Prima Porta statue showed, this fiction is to a great extent ideologically determined. Nevertheless, what Gombrich quite rightly saw was the beholder's crucial role and collusion in the illusionist game.

71. For an anthropological discussion of Christian liturgy emphasising the loss of ego and a sense of shared "communitas" in worshippers, see V. Turner, "Ritual, Tribal and Catholic", *Worship* 50, 6 (November 1976), 504–25, esp. pp. 520–4. More generally, on the shared subjectivity of ritual and the way it "collapses sociocentric (i.e relatively 'objective') and egocentric (i.e 'subjective') levels of iconic representations within the same condensed symbolic vehicle" to provide "a means of imbuing the objective, sociocentric order with the subjective meanings it encodes, and of manipulating both dimensions of meaning as a function of one another", see T. Turner, "Transformation, Hierarchy and Transcendence: A Reformulation of Van Gennep's Model of the Structure of Rites de Passage", in S. F. Moore and B. Meyerhoff, *Secular Ritual* (Amsterdam, 1977), pp. 53–70, esp. pp. 61–3; see also Kapferer, 1983, pp. 178–81, for ritual as an " 'objective correlative', a formula of experience and emotion which can also evoke among those who are embraced by it a subjectivity appropriate to the emotion and feeling which . . . [it] formulates".

72. This is T. F. Mathews's position at the end of a remarkable scholarly polemic about the exact event depicted by these mosaics. The arguments were unnecessarily positivist in that they assumed that the images must represent one theme exclusively. A. Grabar emphasised

imperial ceremonial (1936, pp. 106–7), whereas G. Stricevic argued
for the Great Entrance, an important moment in the liturgy ("The
iconography of the Compositions Containing Imperial Portraits in
San Vitale", *Starinar* [1958], 75–7, and "Iconografia dei Mosaici Impe-
riali a San Vitale", *Felix Ravenna*, 80 (1959), 5–27, following Von
Simson, 1948, pp. 29–30). Both parties then polemically restated
their cases (A. Grabar, "Quel est le sens de l'offrande de Justinien et
de Théodora sur les mosaïques de St-Vital?", *Felix Ravenna*, 81 [1960],
63–77; G. Stricevic, "Sur le problème de l'iconographie des mo-
saïques de Saint-Vital", *Felix Ravenna*, 85 [1962], pp. 80–100). These
arguments have since been rehearsed in Deichmann, 1976, pp. 180–
7, and E. Manara, "Di un' ipotesi per l'individuazione dei personaggi
nei pannelli del S. Vitale a Ravenna e per la loro interpretazione",
Felix Ravenna, 125–6 (1983), pp. 13–37, esp. p. 23f. Mathews, 1971,
pp. 146–7, has reviewed and resolved the argument, at least to my
satisfaction.

73. On the First (or Little) Entrance, see J. Mateos, *La célébration de la
parole dans la liturgie Byzantine* (Rome, 1971), pp. 71–90, and Ma-
thews, 1971, pp. 138–52.

74. Mathews, 1971, p. 147.

75. Kitzinger, 1977, p. 82. On these mosaics, see in particular Nords-
troem, 1953, pp. 102–19; Lawrence, 1965, pp. 124–35; Deichmann,
1976, pp. 141–65, 166–78.

76. For some meanings of the liturgy, see G. Dix, *The Shape of the Liturgy*
(London, 1945), Chap. 9, "The Meaning of the Eucharist", pp. 238–
67 (re-enactment of Christ's sacrifice, pp. 243–7); a summary of the
Byzantine liturgy until Justinian is H-J. Schulz, *The Byzantine Liturgy*
(New York, 1986), pp. 3–20, with further discussion pp. 139–63;
more generally on the Orthodox liturgy, see R. Taft, *The Liturgy of
the Hours in East and West*, (Collegeville, Minn., 1986), pp. 334–65 (p.
348 on time).

77. For a discussion of the date, see Deichmann, 1976, pp. 188–9, and
MacCormack, 1981, p. 376 n. 463.

78. On this, see R. Gordon, "The Veil of Power: Emperors, Sacrificers
and Benefactors", in M. Beard and J. North, eds., *Pagan Priests*
(London, 1990), pp. 199–231.

79. On the "thirteenth apostle", see, e.g., D. M. Nicol, "Byzantine Politi-
cal Thought", in Burns, 1988, p. 55.

80. On the holy man, see the classic study of P. R. L. Brown, "The Rise
and Function of the Holy Man in Late Antiquity", *Journal of Roman
Studies* 61 (1971), 80–101; also useful is the range of views in S.
Hackel, ed., *The Byzantine Saint* (London, 1981) and M. Whitby,
"Maro the Dendrite: An Anti-Social Holy Man?", in M. Whitby et
al., eds., *Homo Viator: Classical Essays for John Bramble* (Bristol, 1987),
pp. 309–17.

CHAPTER 6: FROM THE LITERAL TO THE SYMBOLIC

1. A methodological prelude to the enterprise of comparison in religious
studies, focussing on the history of interpretations of late-antique
Christianities, is J. Z. Smith, *Drudgery Divine: On the Comparison*

of Early Christianities and the Religions of Late Antiquity (Chicago and London, 1990).

2. For some surveys of the modern debate about how to approach the study of religion, see, e.g., D. Allen, *Structure and Creativity in Religion* (The Hague, 1978), and R. Bocock and K. Thompson, eds., *Religion and Ideology* (Manchester, 1985).

3. See E. Buchner, *Die Sonnenuhr des Augustus* (Mainz, 1982), p. 10 (= idem, "Solarium Augusti und Ara Pacis", *Mitteilungen des deutschen Archaeologischen Instituts: Römische Abteilung*, 83 [1976], 319–65, p. 322); also idem, "Horologium Solarium Augusti", in *Kaiser Augustus und die Verlorene Republik*, exhibition catalogue (Berlin, 1988, pp. 240–5. Buchner's reconstruction and interpretation has been accepted by subsequent discussions (e.g., P. Zanker, *The Power of Images in the Age of Augustus* [Ann Arbor, 1988], p. 144; E. Simon, *Augustus* [Munich, 1986], pp. 26–9), but for some serious doubts, see now M. Schütz, "Zur Sonnenuhr des Augustus auf dem Marsfeld", *Gymnasium* 97 (1990), 432–57. On the topography of this part of the Campus Martius, see E. Rodriguez-Almeida, "Il Campo Marzio Settentrionale. Solarium e Pomerium", *Atti della Pontificia Academia Romana di Archeologia: Rendiconti* 51–2 (1978–80), 195–212, and F. Rakob, "Die Urbanisierung des nördlichen Marsfeldes: neue Forschungen im Areal des Horologium Augusti", in *Urbs: Espace urbain et histoire*, Coll. de l'école Française, vol. 98. (Rome, 1987), pp. 687–712.

4. On this whole "Baukomplex", see Simon, 1986, pp. 26–46.

5. The principal discussions of the Ara Pacis in English are M. Torelli, *Typology and Structure of Roman Historical Reliefs* (Ann Arbor, 1982), pp. 27–62, and P. Zanker, 1988, pp. 120–5, 158–61, 172–6, 179–83, 203–6. Overviews include E. Simon, *Ara Pacis Augustae* (Tübingen, 1967); E. La Rocca, *Ara Pacis Augustae* (Rome, 1983), and S. Settis, "Die Ara Pacis", in *Kaiser Augustus und die Verlorene Republik* (Berlin, 1988), pp. 400–26. The fundamental publication of the excavations is G. Moretti, *Ara Pacis Augustae* (Rome, 1948); A comprehensive bibliography (to 1986) of what has now become a huge literature is provided by G. Koeppel, "Die historischen Reliefs der römischen Kaiserzeit V: Ara Pacis Augustae", Teil 1, *Bonner Jahrbücher* 187 (1987), 101–57, esp. pp. 152–7.

6. For instance, the altar of the *gens Augusta* set up by P. Perelius Hedulus in Carthage; see L. Poinssot, *L'autel de la gens Augusta à Carthage* (Tunis, 1929).

7. For example, with a large bibliography, C. B. Rose, " 'Princes' and Barbarians on the Ara Pacis", *American Journal of Archaeology* 94, 3 (1990), 453–67.

8. My thinking on Graeco-Roman sacrifice has been much influenced by discussions with Valérie Huet and by R. Girard, *Violence and the Sacred* (Baltimore, 1979); W. Burkert, *Homo Necans* (Berkeley, 1983); M. Detienne and J-P. Vernant, *La cuisine du sacrifice en pays grec* (Paris, 1979); J. Rudhardt and O. Reverdin, eds., *Le sacrifice dans l'antiquité*, Entretiens Fondation Hardt, vol. 27 (Geneva, 1981); R. G. Hamerton-Kelly, ed., *Violent Origins* (Stanford, 1987). On Roman sacrificial procedure, see G. Wissowa, *Religion und Kultus der Römer* (Munich, 1912), pp. 409–32, and K. Latte, *Römische Religionsgeschichte* (Munich, 1960), pp. 379–93.

9. On the politicizing of sacrifice in the Roman Empire, see R. L. Gordon, "The Veil of Power: Emperors, Sacrificers and Benefactors", in M. Beard and J. North, eds., *Pagan Priests* (London, 1990), pp. 201-31.

10. See the excellent diagrams in J. B. Ward-Perkins and A. Claridge, *Pompeii A.D. 79*, (catalogue for the exhibition of the same name, Royal Academy, 20 November 1976-27 February 1977), (London, 1976), pp. 58-61. On the separation of sacrificial altar and temple proper "for reasons of convenience", see H. C. Bowerman, *Roman Sacrificial Altars* (Lancaster, Pa., 1913), p. 5; Pauly Wissowa, "Altar" 2.1649; J. E. Stambaugh, "The Functions of Roman Temples", *ANRW* 2. 16.1 (1978), pp. 554-608, p. 571-2. The implication of "the altar in front of the temple" in I Clement (of Rome) *Ad Corinthos* 41 (c. A.D. 96) is that the same structural arrangement is true (or was thought true by Christians in Rome) of the Temple in Jerusalem before its destruction in A.D. 70.

11. W. Warde Fowler, *The Religious Experience of the Roman People* (London, 1911), pp. 180-81.

12. See Stambaugh, 1978, pp. 554-608, p. 557 and p. 568.

13. I. Scott Ryberg, *Rites of the State Religion in Rome*, Memoires of the American Academy in Rome 22 (Rome, 1955), pp. 190-91.

14. Simon, 1967, pp. 14-16.

15. Ibid., pp. 23-4.

16. Ibid., p. 24.

17. The Aeneas relief "is surely intended to prefigure the main sacrifice which is represented on the two outer faces of the monument" (R. L. Gordon, 1990, p. 209).

18. For "altar" words in Latin, see Bowerman, 1913, pp. 3-5.

19. See M. Eliade, *The Myth of Eternal Return* (New York, 1954), pp. 20-1.

20. On the " 'arrested' movement" of these reliefs – "more an icon than a narrative scene" – see P. Zanker, 1988, pp. 205-6.

21. For example, Simon, 1967, p. 15f., cf. now P. J. Holliday, "Time, History and Ritual on the Ara Pacis Augustae", *Art Bulletin* 72 (1990), 542-57. For the view that the exterior frieze represents the procession on the day Augustus became Pontifex Maximus, see G. W. Bowersock, "The Pontificate of Augustus", in K. Raaflaub and M. Toher, eds., *Between Republic and Empire: Interpretations of Augustus and His Principate* (Berkeley, 1990), pp. 380-94.

22. Torelli, 1982, p. 54; P. Zanker, 1988, p. 121.

23. Because this portion of the altar is lost, I ignore the debate about its possible iconography, on which, see H. Kähler, "Die Ara Pacis und die Augusteische Friedensidee", *Jahrbuch des Deutschen Archaeologischen Instituts* 69 (1954), 67-100, and Simon, 1986, pp. 31-3.

24. For a discussion of some of the complexities of this scene, and some of the identifications given it, see P. Zanker, 1988, pp. 172-6.

25. This is the conclusion scholars draw from a fragmentary inscription probably of Caligula's time: CIL 6.32347a. See, e.g., H. le Bonniec, *Ovide: Les Fastes I* (Paris, 1965), *ad Fasti* 1.720, p. 110. Ovid's own text on the sacrifice to Pax "*perfusa* (or *percussa* with Frazer) *victima fronte*" does not specify the victim, and it may be that other animals than cows were slaughtered at the Ara Pacis. If we follow the iconographi-

cal hints in the imagery, such victims could certainly have included sheep and perhaps pigs. See also Wissowa, 1912, pp. 334–5. The third century A.D. *Feriale Duranum* corroborates this assumption by recording male cattle (bulls or oxen) as being offered to male deities, and cows as the offering for goddesses such as Salus or Pax; see R. O. Fink, *Roman Military Records on Papyrus*, Philological Monographs of the American Philological Assoc., no. 26, (1971), inscription 117, pp. 422–9.

26. Compare Burkert, 1983, pp. 2–3 on the Ara Pacis.

27. On this part of the frieze and more generally on the widespread imagery of "bucrania" (cattle skulls) – but without any sense of a deconstructive or ambivalent meaning – see P. Zanker, 1988, pp. 115–17.

28. See T. N. Habinek, "Sacrifice, Society and Vergil's Ox-Born Bees", in M. Griffith and D. J. Mastronarde, eds., *Cabinet of the Muses: Essays on Classical and Comparative Literature in Honor of T. G. Rosenmeyer* (Atlanta, 1990), pp. 209–23, quote on p. 215.

29. Habinek, 1990, p. 213–15, quote on p. 215. For a different view, see R. F. Thomas, "The 'Sacrifice' at the End of the Georgics, Aristaeus and Virgilian Closure", *Classical Philology* 86 (1991), 211–18 – although this also accepts the ambivalence of the theme of sacrifice in Roman ideology.

30. For the image of sacrificial blood and its transference to new life in a different context, see Horace, *Odes* 3.13 with R. Hexter, "*O Fons Bandusiae:* Blood and Water in Horace, Odes III,13", in M. Whitby, P. Hardie and M. Whitby, eds., *Homo Viator: Classical Essays for John Bramble* (Bristol, 1987), pp. 131–9. On such patterns of life and death in Horace (but without special reference to sacrifice), see N. Rudd, "Patterns in Horatian Lyric", *American Journal of Philology* 81, 324 (1960), pp. 373–92.

31. On the symbolism of vine scrolls in the Ara Pacis and Augustan art in general, see P. Zanker, 1988, pp. 179–83.

32. P. Zanker, 1988, pp. 115–16.

33. In the case of art, I am thinking of Zanker's thesis that the "impact of the new imagery in the west thus presupposed the acceptance of a complete ideological package" (1988, p. 332); in the case of religion, I am thinking of Gordon's view that the representation of the emperor as sacrificer helped to turn religion into a "naked instrument of ideological domination" (1990, p. 207).

34. See further my "Cult and Sculpture: Sacrifice in the Ara Pacis Augustae", *Journal of Roman Studies* 81 (1991), 50–61, esp. pp. 60–1.

35. On mithraea as buildings in relation to Roman private cults, synagogues and early churches, see L. M. White, *Building God's House in the Roman World* (Baltimore, 1990), pp. 47–59.

36. S. Insler, "A New Interpretation of the Bull-Slaying Motif", in M. B. de Boer and T. A. Edridge, eds., *Hommages à M. J. Vermaseren*, vol. 2 (EPRO 68), (Leiden, 1978), pp. 519–38, see p. 521.

37. R. Gordon, "Authority, Salvation and Mystery in the Mysteries of Mithras", in J. Huskinson, M. Beard and J. Reynolds, eds., *Image and Mystery in the Roman World* (Gloucester, 1988), pp. 45–80, p. 49. R. Beck, *Planetary Gods and Planetary Orders in the Mysteries of Mithras* (Leiden, 1988), p. 12. See also Insler, 1978, pp. 519–20, and J. R.

Hinnells, "Reflections on the Bull Slaying Scene", in idem, ed., *Mithraic Studies*, (Manchester, 1975), pp. 290–312, p. 305.

38. R. Turcan, "Le sacrifice mithriaque: Innovations de sens et de modalités", in Rudhardt and Reverdin, 1981, pp. 341–80. See also Hinnells, 1975, p. 305, and Gordon, 1988, pp. 49, 64, 66ff.

39. Gordon, 1988, p. 49; Turcan, 1981, p. 352ff.

40. We have the following hexameter text from the Sta Prisca Mithraeum, presumably referring to the tauroctone: *et nos servasti eternali sanguine fuso* ("and you have saved us by the spilling of the eternal blood"), on which, see M. J. Vermaseren and C. C. van Essen, *The Excavations in the Mithraeum of the Church of Sta Prisca in Rome* (Leiden, 1965), p. 217ff.; U. Bianchi, "Prolegomena", in idem, ed., *Mysteria Mithrae*, Atti del Seminario Internazionale sui "La Specifità" Storico-religiosa dei Misteri di Mithra, con Particolare Referimento alle Fonti Documentare di Roma e Ostia (Leiden, 1979), pp. 3–68, p. 53; and Turcan, 1981, p. 351. On soteriology, see R. Turcan, "Salut Mithriaque et Soteriologie néoplatonicienne", in U. Bianchi and M. J. Vermaseren, eds., *La Soteriologia dei Culti Orientali nell'Impero Romano*, Atti del Colloquio Internazionale su la Soteriologia dei Culti Orientali nell'Impero Romano (Leiden, 1982), pp. 173–91 – but note the doubts concerning Turcan's theory in R. Beck, "Mithraism since Franz Cumont", *ANRW* 2. 17.4 (Berlin, 1984), pp. 2002–115, 2078–9. On salvation more generally, see Hinnells, 1975, p. 311, and R. L. Gordon, "The Date and Significance of CIMRM 593 (British Museum, Townley Collection)", *Journal of Mithraic Studies* 2, 2 (1978), 148–74, p. 154.

41. See R. L. Gordon, "Mithraism and Roman Society: Social Factors in the Explanation of Religious Change in the Roman Empire", *Religion* 2, 2 (Autumn 1972), 92–121, p. 98, and Turcan, 1981, p. 346.

42. Hinnells, 1975, p. 304; J. P. Kane, "The Mithraic Cult Meal in Its Greek and Roman Environment", in Hinnells, 1975, pp. 313–51, p. 345.

43. Kane, 1975, pp. 349–51, and Turcan, 1981, p. 347, who notes price and meal lists as well as bones have been found in mithraea. However, Gordon, 1988, n. 100, doubts the plausibility of the bone claims of nineteenth century archaeologists.

44. Despite the persistent assumptions of scholars such as Turcan, 1981, p. 354, and Gordon, 1988, p. 69.

45. Insler, 1978, p. 521; R. L. Gordon, "A New Mithraic Relief from Rome", *Journal of Mithraic Studies* 1, 2 (1976), 166–86, p. 171.

46. For polysemic and symbolic readings of Mithraic art in general, see the seminal articles of R. L. Gordon: "The Sacred Geography of a Mithraeum: The Example of Sette Sfere", *Journal of Mithraic Studies* 1, 2 (1976), 119–65, and idem, "Reality, Evocation and Boundary in the Mysteries of Mithras", *Journal of Mithraic Studies* 3 (1980), pp. 19–99. For reflections on the multiple layers of meaning of the tauroctone in particular, see Gordon, "A New Mithraic Relief from Rome", 1976, pp. 166–86, p. 176, as well as Beck, 1984, pp. 2079–80, and Gordon, 1988, p. 50 and p. 52 ("ambiguity").

47. On the astrology of the tauroctone, see esp. Beck, 1988, pp. 17–30; idem, "Cautes and Cautopates: Some Astronomical Considerations",

Journal of Mithraic Studies 2, 1 (1977), 1–17, esp. p. 10; Insler, 1978, p. 523; D. Ulansey, *The Origins of the Mithraic Mysteries* (New York, 1989), pp. 15–24, 67–94.

48. See R. L. Gordon, "The Real and the Imaginary: Production and Religion in the Graeco-Roman World", *Art History* 2, 1 (1979), pp. 5–34, esp. pp. 7–8.

49. On Artemis of Ephesus, see R. Fleischer, *Artemis von Ephesus und Verwandte Kultstatuen aus Anatolien und Syrien* (Leiden, 1973) (his dismissal of the supposed "breasts" is pp. 74–87), and more succinctly, idem, "Artemis Ephesia" in *Lexicon Iconographicum Mythologiae Classicae*, vol. 2.1 (Munich, 1984), pp. 755–63, with recent bibliography on p. 757. On the cult at Ephesus more generally, see R. E. Oster, "Ephesus as a Religious Centre under the Principate", *ANRW* 2. 18.3, pp. 1661–1728, esp. pp. 1699–1725.

50. Ephesian Artemis at Corinth, 2.2.6; at Scillus in Elis, 5.6.6; at Alea in Arcadia, 8.23.1; at Megalopolis, 8.30.6.

51. "Whereas the 'political' imagery of public sacrifice referred itself constantly to pseudo-historical events, the universal claims of the Mysteries were inscribed in the cult icon itself" (Gordon, 1988, p. 49). Gordon's shift from "pseudo-historical events" to "universal claims" is precisely what I mean (in art-historical terms) by a move from a literal to a symbolic mode of representation.

52. This structural difference is well noted by M. Méslin, "Convivialité ou communion sacramentelle? Repas mithriaque et eucharistie chrétienne", in A. Benoit, M. Philonenko and C. Vogel, eds., *Mélanges offerts à Marcel Simon: Paganisme, Judaisme, Christianisme* (Paris, 1978), pp. 295–305. Méslin emphasises the important entailment of this difference – that mithraic cult meals cannot be sacramental in the way that Christian meals are, for Mithras is never the victim whereas Christ *is* the bread and the blood which his worshippers eat (p. 305).

53. The principal surviving example of such exegesis is Porphyry, *De Antro Nympharum*. See the discussion of the history and nature of Neoplatonic allegory in R. Lamberton, *Homer the Theologian* (Berkeley, 1986).

54. See G. Shaw, "Theurgy: Rituals of Unification in the Neoplatonism of Iamblichus", *Traditio* 41 (1985), 1–28, for an excellent discussion and review of the literature.

55. On the analogical nature of religions (Christianities and paganisms) in late antiquity, see Smith, 1990, pp. 111–15.

56. Capua is published in M. J. Vermaseren, *Mithriaca I: The Mithraeum at S. Maria at Capua Vetere*, EPRO 17 (Leiden, 1971). The Marino and Barberini mithraea are published in M. J. Vermaseren, *Mithriaca III: The Mithraeum at Marino*, EPRO 17 (Leiden, 1982) with plates of the Nersae and Neuenheim reliefs mentioned in this paragraph. Sophisticated discussions of mithraic images with side panels of smaller scenes are R. L. Gordon, "Panelled Complications", *Journal of Mithraic Studies* 3 (1980), 200–27, and S. R. Zwirn, "The Intention of Biographic Narration in Mithraic Cult Images", *Word and Image* 5, 1 (January–March 1989), 2–18.

57. What I describe as "symbolic accretion", S. R. Zwirn puts as "a number of standard elements . . . and a range of other variable addi-

tions" making "a network of linkages between image and 'revealed' information" (1989, p. 9).

58. For this point on the correlation of importance with excess (to the point of redundancy) in visual programmes, see P. Veyne's discussion of Trajan's column on pp. 3–4 of "Conduct without Belief and Works of Art without Viewers", *Diogenes* 143 (Fall 1988), 1–22.

59. That Mithras' gaze engages the spectator rather than his own action was noted by R. L. Gordon, "Iconographical Notes on the Projejena Reliefs", *Journal of Mithraic Studies* 2, 2 (1978), 13–85, esp. p. 74.

60. This is well discussed by Zwirn, 1989, p. 9.

61. On the ideology of sacrifice in early Christianity, see, e.g., F. N. C. Hicks, *The Fullness of Sacrifice* (London, 1930), esp. Pts. 2 and 3; J. Daly, *The Idea of Christian Sacrifice* (Chicago, 1977); E. Ferguson, "Spiritual Sacrifice in Early Christianity and Its Environment", *ANRW* 2. 23.2 (1980), 1151–89; S. W. Sykes, "Sacrifice in the New Testament and Christian Theology", in M. F. C. Bourdillon and M. Fortes, eds., *Sacrifice* (London, 1980), pp. 61–83. A useful summary of Christian views from the New Testament to the Reformation is E. O. James, *Sacrifice and Sacrament* (London, 1962), pp. 117–28.

62. On the body as "living sacrifice", see Romans 12.1; on the life of love – all members of "one body" – see Romans 12.1–10 and on this love as an imitation of God who so loved man that he sent his only begotten son to be the propitiation of our sins, see 1 John 4.7–12 and Ephesians 5.1–2; on good deeds as sacrifice, see Philippians 4.18 and Minucius Felix, *Octavius* 32; on death as a libation poured out to God, see Philippians 2.17, 2 Timothy 4.6 and the sustained imagery of Ignatius's epistle *To the Romans* (written on his way to martyrdom in the early second century), 2 "a libation poured out to God" and 4 "by the beasts' instrumentality, may I be made a sacrifice unto God". For martyrdom as sacrifice in the early Church, see H. von Campenhausen, *Die Idee des Martyriums in der alten Kirche* (Gottingen, 1936), Chap. 3, pp. 56–105. On the ideology of martyrs as the body of Christ (cf. the eucharistic sacrifice), see P. Brown, *The Cult of the Saints* (London, 1981), p. 72. On martyrdom as an enactment of Christ's death in early Christian typology and iconography, see E. S. Malbon, *The Iconography of the Sarcophagus of Junius Bassus* (Princeton, 1990), pp. 48–9, 66–7.

63. The earliest reference to the eucharist as sacrifice is in the sub-apostolic *Didache* (c. 100–140 A.D.), 14.1. For a brief discussion of the origin and development of this theme, see James, 1962, pp. 198–215.

64. For a discussion of dates, bibliography and early texts, see F. W. Deichmann, *Ravenna, Hauptstadt des Spätantiken Abendlandes*, Kommentar 1 (Wiesbaden, 1974), pp. 128–30. His full text summarises and evaluates previous discussions – on the mosaic processions, ibid., pp. 141–54. For illustrations, see idem, *Frühchristliche Bauten und Mosaiken von Ravenna* (Baden-Baden, 1958), Plates 97–115. The best interpretative discussion in English is still O. von Simson, *Sacred Fortress: Art and Statecraft in Ravenna* (Chicago, 1948), pp. 69–110.

65. Agnellus (ninth century), *Liber Pontificalis Ecclesiae Ravennatis*, De Sancto Agnello Episcopo, 86, ed. A. Testi Rasponi, in L. A. Muratori, ed., *Rerum Italicarum Scriptores*, tomo 2, parte 3, vol. 1 (Bologna, 1924), p. 218.

66. The figures in the lowest tier are as follows:

	North	South
East	Virgin Enthroned with 4 angels	Christ Enthroned with 4 angels
	Caspar ⎫	Martin
	Melchior ⎬ the Magi	Clemens
	Balthasar ⎭	Systus
	Euphemia	Laurentius
	Pelagia	Hypolitus
	Agatha	Cornelius
	Agnes	Cyprianus*
	Eulalia	Cassianus
	Caecilia	Iohannes
	Lucia	Paulus
	Crispina	Vitalis
	Valeria	Gervasius
	Vincentia	Protasius
	Perpetua	Ursicinus
	Felicitas	Nabor
	Justina	Felix
	Anastasia	Apollinaris
	Daria	Sebastianus
	Eumerentiana	Demiter
	Paulina	Polycarpus
	Victoria	Vincentius
	Anatolia	Pancratius
	Christina	Crisogonus
	Sabina	Protus
	Eugenia	Iacinthus
		Sabinus
	Port of Classe	City of Ravenna and Theodoric's Palace.

*Cyprianus is mistakenly omitted in Deichmann's list, 1974, p. 149.

67. For the eucharist as sacrifice, see J. N. D. Kelly, *Early Christian Doctrines* (London, 1958), pp. 211–16, on the pre-Constantinian Church and pp. 440–55 on attitudes in the fourth and fifth centuries; see also M. Wiles, *The Making of Christian Doctrine* (Cambridge, 1967), pp. 118–19, on early Christian versions of what was later termed in the Roman Church "transubstantiation", and pp. 121–3 on sacrificial connotations.

68. Von Simson, 1948, pp. 76–80. For a detailed commentary on these cycles, see Deichmann, 1974, pp. 154–88.
The sequence is as follows:

	South	North
West	Incredulity of Thomas	Healing of the Paralytic at Bethesda
	Road to Emmaus	Gadarene Swine
	Two Marys at the Sepulchre	Healing of the Paralytic at Capernaum
	Carrying of the Cross	Separating of Sheep from Goats
	Christ before Pilate	Widow's Mite

Judas' Repentance	Pharisee and the Publican
Peter's Denial	Raising of Lazarus
Prophesy of Peter's Denial	Christ and the Samaritan Woman
Christ before Caiaphas	Healing of Woman with an Issue of Blood
Arrest of Christ	Healing of the Blind Man
Betrayal	Calling of Peter and Andrew
Gethsemane	Miracle of Loaves and Fishes
Last Supper	Miracle at Cana.

69. Deichmann, 1974, pp. 152–3 for summary.

70. Von Simson, 1948, p. 76.

71. Ibid.

72. Deichmann, 1974, p. 154.

73. On this see von Simson, 1948, p. 97 and p. 101; for martyrs as imitators of Christ, see the *Martyrdom of Polycarp* 17.3.

74. As early as the second to third century *Martyrdom of Polycarp*, 1 ("the Martyrdom which we read of in the gospels"), Christ's death was seen as a martyrdom to be imitated.

75. For the New Testament, see 1 Corinthians 5.7; Ephesians 5.2; 1 John 1.7 and 2.2; 1 Peter 1.18–19. In the Apostolic Fathers, see Barnabas 5 (a text included in our earliest surviving complete New Testament, the *Codex Sinaiticus*). In the most influential of the Latin Fathers, see St Augustine, *Civitas Dei* 20.26 (*PL* 41.700), *Quaestiones in Heptateuchum* 3.57 (*PL* 34.704), *Contra duas epistolas Pelagionorum* 3.6.16 (*PL* 44.600) and *Sermo 374: De epiphania Domini* 2.3 (*PL* 39.1667–8).

76. John 1.29 and 3.16–17 – cardinal texts which early found their way into liturgies and commentaries.

77. Ignatius, *To the Romans* 2 and 4; *Martyrdom of Polycarp* 14.

78. See Cyril of Jerusalem (fourth century), *Mystagogical Catechesis* 5.7–8 for liturgical reflections on the eucharist as sacrifice. In the Western Church the views of Augustine (fourth to fifth century) were particularly influential – for the word "sacrificium" used consistently of the eucharist, see *Civitas Dei* 22.10. See also, in the context of Sant' Apollinare Nuovo, von Simson, 1948, p. 92.

79. In addition to this biblical text (Romans 12.1), the Western Church saw this theme strongly emphasised by Augustine. See his commentary in *Civitas Dei* 10.6, and *Sermo 48: De verbis Michaeae Prophetae VI,6–8 "Quid dignum offeram Deo . . ."* 1.2 (*PL* 38.317).

80. Gordon, 1988, p. 49.

81. The procession was first published in a rather speculative article by M. J. Vermaseren, "The Suovetaurilia in Roman Art", *Bulletin de vereeniging tot bevordering der kennis van de Antike beschaving* 32 (1957), 1–12. It is discussed with more interpretation than is warranted by Vermaseren and van Essen, 1965, pp. 16off.

82. This is defined by M. F. C. Bourdillon as "calculated sacrifice": "when something of value is surrendered in expectation or hope of greater gain". See pp. 11–12 of his introduction to Bourdillon and Fortes, 1980.

83. Note that Mithraism, by contrast, seems to have excluded women.

84. On the relation of religion with political organisation, and the terms "openness and flexibility", see M. Beard and M. Crawford, *Rome in*

the Late Republic (London, 1985), p. 29; for "toleration" and "plural-ism", see J. North, "Religious Toleration in Republican Rome", *Proceedings of the Cambridge Philological Society* 205, n.s. 25 (1979), 85–103.

85. For its public nature, see Beard and Crawford, 1985, pp. 30–4; for its ritual conservatism, see J. North, "Conservation and Change in Roman Religion", *Papers of the British School at Rome*, 44 (1976), 1–12.

86. Compare P. Zanker's remarks on motifs evoking sacrifice, in P. Zanker, 1988, pp. 115–17.

87. On the development of Christian discourse, see especially Averil Cameron, *Christianity and the Rhetoric of Empire* (Berkeley, 1991).

88. See now the reflections on identity of R. A. Markus, *The End of Ancient Christianity* (Cambridge, 1990), pp. 1–18, 224–8.

PART III: EPILOGUE. FOREWORD.

1. J. L. Borges, "Funes El Memorioso", in *Obras Completas, 1923–1972* (Buenos Aires, 1974); p. 484. As translated by A. Kerrigan in "Artificios" from *Fictions* (London, 1962): "every leaf on every tree in every wood" (p. 103).

2. From J. Heyward, *A Dialogue Containing the Number in Effect of All the Proverbs in the English Tongue* (London, 1546).

CHAPTER 7: "THE TRUTH WITHIN THESE EMPTY FIGURES"

1. Paulinus of Nola, *Carmen* 27 vv. 511–15.

2. See the excellent discussion of this in K. Morrison, *I Am You: The Hermeneutics of Empathy in Western Literature, Theology and Art* (Princeton, 1988), pp. 267–70.

3. There is little discussion of the role of images in (e.g.) R. MacMullen, *Christianizing the Roman Empire* (New Haven and London, 1984) or in R. A. Markus, *The End of Ancient Christianity* (Cambridge, 1990), despite this book's concern with issues of identity, the cult of martyrs and the Christianization of time. See, however, R. Van Dam, *Leadership and Community in Late Antique Gaul* (Berkeley, 1985), pp. 230–5, on the uses of art and architecture in the sixth century to construct sacred space in the cathedral at Tours, and Averil Cameron's comments on the importance of images as part of Christian discourse in *Christianity and the Rhetoric of Empire* (Berkeley, 1991), pp. 57–9, 150–2, 226–7.

4. On the "drainage of secularity", see Markus, 1990, pp. 15–18, 226–8.

5. See, for example, the hymn to Aphrodite's birth at *Im.* 2.1.4.

6. The Esquiline Treasure was discovered in Rome in 1793. See, on the casket, K. Shelton, *The Esquiline Treasure*, catalogue no. 1 (London, 1981), pp. 72–5; eadem, "Roman Aristocrats, Christian Commissions: The Carrand Diptych", in F. M. Clover and R. S. Humphreys, eds., *Tradition and Innovation in Late Antiquity* (Madison and London, 1989), pp. 105–27, see pp. 105–8.

7. On questions of value, see K. S. Painter, "Roman Silver Hoards: Ownership and Status", in F. Baratte, ed., *Argenterie romaine et byzantine* (Paris, 1988), pp. 97–112, with the corrective by Alan Cameron, "Observations on the Distribution and Ownership of Late Roman Silver Plate", *Journal of Roman Archaeology* 5 (1992), 178–85.

8. See, e.g., J. M. C. Toynbee and K. S. Painter, "Silver Picture Plates

of Late Antiquity, A.D.300–700", *Archaeologia* 108 (1986), pp. 15–65, p. 15.

9. See A. Carandini, M. Ricci and M. de Vos, *Filosofiana: The Villa of Piazza Armerina* (Palermo, 1982): There, erotes appear fishing in the mosaics of room 29 (p. 174, Pl. 88), room 40b (pp. 249–54, Pl. 149–52, 154) and room 4c of the thermae (pp. 356–8, Pl. 211, 217); erotes appear vintaging in rooms 47 and 49 (pp. 306–9, Pl. 188) and 57e (pp. 318–22, Pl. 193).

10. On the mosaics of Sta Costanza, see H. Stern, "Les mosaïques de l'église de Sainte-Constance à Rome", *Dumbarton Oaks Papers* 12 (1958), 157–218.

11. See, e.g., G. Brusin and P. L. Zovatto, *Monumenti Paleocristiani di Aquileia e di Grado* (Friuli, 1957), pp. 105–11 (Pl. 47 and 8).

12. E. S. Malbon, *The Iconography of the Sarcophagus of Junius Bassus* (Princeton, 1990), pp. 91–103.

13. On the codex-calendar, see now M. R. Salzman, *On Roman Time: The Codex-Calendar of 354 and the Rhythms of Urban Life in Late Antiquity* (Berkeley, 1990). On the Christian sections, see ibid., pp. 39–50.

14. The Junius Bassus sarcophagus is strong evidence for the explicit Christianisation of such cupids: The columns which frame and mark out the imagery's central scenes (both in location and in theme), that is, the carvings of Christ entering Jerusalem in triumph and delivering the Law to Peter and Paul, are celebrated as special by having cupids carved on them; see Malbon, 1990, pp. 120–1.

15. See the long diatribe against pagan statues and paintings, including Aphrodite, in Clement of Alexandria, *Protrepticus* 4.47 and 4.50–4. Aphrodite is particularly guilty for being "a guide for amorous men to the pit of destruction" in a passage where Clement recalls a number of instances where men attempted to make love to her statue (on this theme, see J. Elsner, "Visual Mimesis and the Myth of the Real: Ovid's Pygmalion as Viewer", *Ramus* 20 [1991], 154–68). But Clement's attack includes not only the other Olympian deities but also such images as nymphs, naiads and the nereids on the Projecta casket (4.52).

16. See J. M. C. Toynbee, "A New Roman Mosaic Pavement Found in Dorset", *Journal of Roman Studies* 54 (1964), 7–14, and compare the parallel images from the now lost floor from Frampton with Neptune, Bellerophon and a chi-rho monogram, on which, see J. Huskinson, "Some Pagan Mythological Figures and Their Significance in Early Christian Art", *Papers of the British School at Rome* 42 (1974), pp. 68–97, esp. pp. 76–7, 85–6.

17. M. M. Mango, *The Sevso Treasure*, Sotheby's (London, 1990); eadem, "Un nouveau trésor (dit de 'Sevso') d'argenterie de la Basse Antiquité", *Comptes rendus de l'académie des inscriptions et de belles-lettres* (1990), pp. 238–54; eadem "Der Sevso-schatzfund. Ein Ensemble westlichen und östlichen Kunstschaffens", *Antike Welt* 21 (1990), pp. 70–88; eadem, "The Sevso Treasure Hunting Plate", *Apollo* (July 1990), 2–13; K. S. Painter, "The Sevso Treasure", *Minerva* 1 (1990), 4–11; H. A. Cahn, A. Kaufmann-Heinimann, K. Painter, "A Table Ronde on a Treasure of Late Roman Silver", *Journal of Roman Archaeology* 4 (1991), 184–191.

18. See Shelton, 1981, pp. 47–70.

19. Ibid., catalogue nos. 3 (p. 78), 16 (pp. 82–3) and 2 (pp. 75–7).

20. See the remarks of Shelton, 1989, pp. 105–8, and E. S. Malbon, 1990, pp. 140–2.

21. Discovered in 1962; see H. A. Cahn and A. Kaufmann-Heinimann, eds., *Der spätrömishe Silberschatz von Kaiseraugst* (Derendingen, 1984), no. 39 (the toothpick), and nos. 63, 61 and 64.

22. Found in East Anglia in 1979; see C. Johns and T. Potter, *The Thetford Treasure* (London, 1983). The items with fish or crosses are nos. 67 and 69. See also D. Watts, *Christians and Pagans in Roman Britain* (London, 1990), pp. 146–58.

23. Discovered in Suffolk in the 1940s; see K. S. Painter, *The Mildenhall Treasure* (London, 1977), nos. 27–9.

24. Found in Northumberland in 1735; see O. Brendel, "The Corbridge Lanx", *Journal of Roman Studies* 31 (1941), 100–27; F. Haverfield, "Roman Silver in Northumberland", *Journal of Roman Studies* 4 (1914), 1–12.

25. For some social and architectural context, see J. Rossiter, "Convivium and Villa in Late Antiquity", in W. J. Slater, ed., *Dining in a Classical Context* (Ann Arbor, 1991), pp. 199–214, and S. Ellis, "Power, Architecture and Decor: How the Late Roman Aristocrat Appeared to His Guests", in E. K. Gazda, ed., *Roman Art in the Private Sphere* (Ann Arbor, 1991), pp. 117–34.

26. *PG* 79.577–80, translated by C. A. Mango, *The Art of the Byzantine Empire, 312–1453* (Toronto, 1986), p. 33.

27. For a salutary reminder as to the richness of this co-existence and its longevity (well into the sixth century), see G. W. Bowersock, *Hellenism in Late Antiquity* (Cambridge, 1990), pp. 41–69; generally on the last pagans in the Christian empire, see P. Chuvin, *A Chronicle of the Last Pagans* (Cambridge, Mass., 1990).

28. For a brief summary of silverware in the first century A.D., see D. E. Strong, *Greek and Roman Gold and Silver Plate* (London, 1966), pp. 133–59. On the Boscoreale Treasure, see A. Héron de Villefosse, *Le trésor de Boscoreale* (Paris, 1899) (= *Monuments et mémoires de l'académie des inscriptions et belles-lettres* 5), and F. Baratte, *Le trésor orfèvrerie romaine de Boscoreale* (Paris, 1986).

29. Héron de Villefosse, 1899, pp. 52–7, Pl. 5–6.

30. Ibid., no. 22, pp. 90–2, Pl. 20, and Shelton, 1981, no. 3, p. 78, Pl. 21.

31. On the David plates, see O. M. Dalton, "A Second Silver Treasure from the District of Kyrenia, Cyprus", *Archaeologia* 60 (1906), 1–24; A. and J. Stylianou, *The Treasures of Lambousa* (Nicosia, 1969); S. H. Wander, "The Cyprus Plates: The Story of David and Goliath", *Metropolitan Museum Journal* 8 (1973), 89–104; M. van Grunsven-Eygenraam, "Heraclius and the David Plates", *Bulletin Antieke Beschaving* 48 (1973), 158–74; S. H. Wander, "The Cyprus Plates and the *Chronicle* of Fredegar", *Dumbarton Oaks Papers* 29 (1975), 345–6; S. Spain Alexander, "Heraclius, Byzantine Imperial Ideology and the David Plates", *Speculum* 52 (1977), 217–37; J. P. C. Kent and K. S. Painter, *Wealth of the Roman World, A.D. 300–700* (London, 1977), pp. 102–15; H. L. Kessler in K. Weitzmann, ed., *The Age of Spirituality* (New York and Princeton, 1979), pp. 475–83, and Toynbee and Painter, 1986, pp. 21, 50–7.

32. For example, K. Weitzmann, "Prolegomena to a Study of the David Plates", *Metropolitan Museum Journal* 3 (1970), 97–111, p. 106.

33. See E. Kitzinger, "Byzantine Art in the Period between Justinian and Iconoclasm", *Berichte zum XI Internationalen Byzantinischen-Kongress* (Munich, 1958), vol. 4, pp. 1–50, esp. pp. 4–5; Weitzmann, 1970, p. 97f.

34. Héron de Villefosse, 1899, pp. 79–81, Pl. 15.

35. Compare ibid., nos. 11–14, and especially 16, which is a pair with 15 (pp. 73–9 and 81–3).

36. Ibid., pp. 141–8, Pl. 34–6. See also T. Hölscher, "Die Geschichtsauffassung in der römischen Repräsentationskunst", *Jahrbuch des Deutschen Archaeologischen Instituts* 95 (1980), 265–321, esp. pp. 281–90; P. Zanker, *The Power of Images in the Age of Augustus* (Ann Arbor, 1988), pp. 221–9.

37. Héron de Villefosse, 1899, pp. 58–63, Pl. 7–8. See also K. M. D. Dunbabin, "*Sic Erimus Cuncti* . . . The Skeleton in Graeco-Roman Art", *Jahrbuch des Deutschen Archaeologischen Instituts* 101 (1986), 185–255, esp. pp. 224–8.

38. See ibid. for a detailed exploration of the theme.

39. On these patens, see M. M. Mango, *Silver from Early Byzantium* (Baltimore, 1986), no. 34 (Stuma Paten), pp. 159–64, no. 35 (Riha Paten), pp. 165–70; Toynbee and Painter, 1986, pp. 21–2, 57–8 and Pl. 30b–c.

40. On the David plates as non-liturgical court art, see Kitzinger, 1958, p. 5; Toynbee and Painter, 1986, p. 21.

41. For some examples, see Weitzmann, 1979, pp. 162–4.

42. For identifications, see Wander, 1973, pp. 90–4; van Grunsven-Eygenraam, 1973, pp. 159–70; Spain Alexander, 1977, p. 217 n. 3; Kent and Painter, 1977, pp. 102–15; Kessler in Weitzmann, 1979, pp. 475–83; Toynbee and Painter, 1986, 50–7.

43. Note that the identification of this last scene is contested. Van Grunsven-Eygenraam, 1973, p. 169, sees it as the covenant with Jonathon.

44. Kent and Painter, 1977, p. 110: "David and a soldier"; Wander, 1973, p. 91: "David and Eliab"; van Grunsven-Eygenraam, 1973, p. 166: "David and Goliath"; Kessler in Weitzmann, 1979, p. 483, and Toynbee and Painter, 1986, pp. 53–4: "David and Jonathon".

45. See Wander, 1975, pp. 345–6; on further parallels between Heraclius and David, see Wander, 1973, and Spain Alexander, 1977.

46. See Shelton in Weitzmann, 1979, pp. 74–6; Toynbee and Painter, 1986, p. 16 and pp. 27–8.

47. We should, however, be wary of "secularity" in the context of a Christian culture which adapted the imagery of dining such as we find it on Sevso's hunting plate, or the mosaics of Piazza Armerina, to the imagery of the Last Supper (as, for instance, in the sixth-century Rossano Gospels or the mosaics of Sant' Apollinare Nuovo). Clearly, eating from a plate (like the seventh-century David plates) with religious iconography was problematic – analogous perhaps to the problem of walking on floors with symbols of crosses. Note that representing crosses on the pavement was prohibited by the emperor Theodosius II in A.D. 427, a ban repeated by the Quinisext Council in 692 (see C. A. Mango, 1986, p. 36).

48. This catacomb was discovered in 1955; see A. Ferrua, *Le Pitture della Nuova Catacomba di Via Latina* (Vatican City, 1960); L. Kötzsche-Breitenbruch, *Die Neue Katakombe an der Via Latina in Rom* (Munster,

1976); W. Tronzo, *The Via Latina Catacomb* (University Park and London, 1986); A. Ferrua, *The Unknown Catacomb* (New Lanark, 1990).

49. See J. Stevenson, *The Catacombs* (London, 1978), pp. 19, 24.

50. Tronzo, 1986, pp. 10-17.

51. Discussion of the Via Latina Catacomb has gone principally in two directions: discussions of the iconography and its origins, and explorations of its interpretation and meaning. Important studies from this latter point of view are W. N. Schumacher, "Reparatio Vitae: Zum Programm der neuen Katakombe an der Via Latina zu Rom", *Römische Quartalschrift* 66 (1971), 125-53; J. Fink, "Hermeneutische Probleme in der Katakombe der Via Latina in Rom", *Kairos* 18 (1976), 178-90; idem, *Bildfrömmigkeit und Bekenntnis. Das Alte Testament, Herakles und die Herrlichkeit Christi an der Via Latina in Rom* (Cologne, 1978); idem, "Herakles als Christusbild an der Via Latina", *Rivista di Archaeologia Cristiana* 56 (1980), 133-46; J. Engemann, "Altes und Neues zu Beispielen heidnischer und christlicher Katakombenbilder im spätantiken Rom", *Jahrbuch für Antike und Christentum* 26 (1983), 128-51.

52. Ferrua, 1960, p. 94; A. Grabar, *The Beginnings of Christian Art* (London, 1967), p. 225; Huskinson, 1974, p. 82; J. Engemann, "The Christianization of Late Antique Art", in *The 17th International Byzantine Congress: The Major Papers* (New Rochelle, 1986), pp. 83-105, p. 92; Ferrua, 1990, p. 159.

53. On allegory, see now D. Dawson, *Allegorical Readers and Cultural Revision in Ancient Alexandria* (Berkeley, 1992); on pagan traditions of allegorical reading see ibid., pp. 23-72, and R. Lamberton, *Homer the Theologian* (Berkeley, 1986); on Christian allegory and figural discourse, see Dawson, 1992, pp. 127-240, and Averil Cameron, 1991, pp. 47-88; on the typological nature of early Christian images, see A. Grabar, *Christian Iconography* (London, 1968), pp. 109-48, and Malbon, 1990, esp. pp. 42-4 and 129-36.

54. See Tronzo, 1986, p. 64.

55. The themes belong wholly to the Old Testament if one accepts Tronzo's interpretation against Ferrua's that the right-hand wall shows Joshua leading the Israelites rather than the raising of Lazarus: See Ferrua, 1960, p. 55, and 1990, p. 90; Tronzo, 1986, pp. 53-8.

56. See Malbon, 1990, pp. 78-82 (on the Junius Bassus sarcophagus, whose Moses scenes are represented by lambs), Pl. 4 (Adelphia), Pl. 3 (the Two Brothers sarcophagus, another with Moses themes), Pl. 34 (Claudiano).

57. See Tronzo, 1986, pp. 10-15.

58. On the replication of room *C* in room *O*, see Fink, 1978, pp. 34-5; Tronzo, 1986, pp. 1-3. Tronzo's monograph is essentially an exploration of this question. On the painting styles of rooms *A-C* and rooms *D-O*, see ibid., pp. 23-49.

59. For Cacus, see Kötzsche-Breitenbruch, 1976, anhang 10; for Antaeus, see Schumacher, 1970, pp. 131-2, with p. 131 n. 15 for a summary of other suggestions.

60. On the Hercules images as Christian uses of pagan myths, see E. R. Goodenough, "Catacomb Art", *Journal of Biblical Literature* 81 (1962), 113-42, esp. p. 133; on "Herakles als Christusbild", see Fink, 1980, pp. 133-46.

61. See the discussion by R. Turcan, "Les sarcophages romains et le

problème de symbolisme funéraire", *ANRW* 2. 16.2 (1978), 1700–35, with his useful review of previous literature. On pagan influence over the programmes of early Christian sarcophagi, see F. Saxl, *Lectures*, vol. 1 (London, 1957), pp. 45–57.

62. Compare the pagan soteriological implications of the series of six mosaic panels discovered recently at Nea Paphos in Cyprus, perhaps similarly "influenced" by Christianity: See W. A. Daszewski, *Dionysos der Erlöser* (Mainz, 1985); Bowersock, 1990, pp. 49–53. Likewise, the mid-third-century programme of Jewish frescoes from the synagogue at Dura Europos has been seen as a response to Christianity, see K. Weitzmann and H. L. Kessler, *The Frescoes of the Dura Synagogue and Christian Art*, (Dumbarton Oaks Studies 28) (Washington, 1990), pp. 178–83.

63. Though I see no reason why it should not also represent Hercules restoring the soul of the person buried in the tomb.

64. See P. Pierce, "The Arch of Constantine: Propaganda and Ideology in Late Roman Art", *Art History* 12 (1989), 387–418, esp. pp. 389–91, 415–17; Malbon, 1990, pp. 150–1 (on typology).

65. See Clover and Humphreys, 1989, p. 10; Bowersock, 1990, pp. xi–xii and passim.

66. For a brilliant account of Christian typological viewing, restricted to a deep analysis of a single exceptional monument, see Malbon, 1990.

67. See J. Kollwitz, *Die Lipsanothek von Brescia* (Berlin, 1933); R. Delbrueck, *Probleme der Lipsanothek in Brescia* (Bonn, 1952); W. F. Volbach, *Elfenbeinarbeiten der Spätantike und des Frühen Mittelalters* (Mainz, 1916), no. 107, p. 56; C. J. Watson, "The Program of the Brescia Casket", *Gesta* 20 (1981), 283–98.

68. Kollwitz, 1933, pp. 33–4.

69. G. Stühlfauth, *Die altchristliche Elfenbeinplastik* (Freiburg, 1896), pp. 46–50.

70. E. Sauser, *Frühchristliche Kunst* (Innsbruck, 1966), pp. 178–9.

71. Delbrueck, 1952, pp. 133–6.

72. Watson, 1981, pp. 284–93.

73. On the vexed question of art as the "book for the illiterate" in the Middle Ages, see now L. G. Duggan, "Was Art Really the 'Book of the Illiterate'?" *Word and Image* 5 (1989), 227–51, and C. M. Chazelle, "Pictures, Books and the Illiterate: Pope Gregory I's Letters to Serenus of Marseilles", *Word and Image* 6 (1990), 138–53, with references.

74. In the *Cult of the Saints* (London, 1981), p. 67, Peter Brown sees art as proof of the new relationship between a saint and his worshippers (rather than as part of the dynamic which created notions of sainthood). Averil Cameron, 1991, sees the close parallelisms of textual and visual imagery in late antiquity (the "series of images" in both discourse and art, p. 57; the "small step from the pervasive metaphor of Christian language to the symbolic repertoire of early Christian art", p. 59). She alludes to the way "the visual presentation of Christian themes was to become an important element in their diffusion" (p. 150).

75. Markus, 1990, pp. 1–17, 224–8.

INDEX

DATE DUE

JUN 0 1 2015	